NEW YORK'S NEW EDGE

NEW YORK'S NEW EDGE

Contemporary Art, the High Line, and
Urban Megaprojects on the Far West Side

DAVID HALLE AND ELISABETH TISO

THE UNIVERSITY OF CHICAGO PRESS
CHICAGO AND LONDON

DAVID HALLE is professor of sociology at the University of California, Los Angeles, and director of the summer travel program UCLA in New York: Cities and Cultures. He is also an adjunct professor at the City University of New York's Graduate Center and School of Professional Studies and the author of *America's Working Man* and *Inside Culture*, also published by the University of Chicago Press. ELISABETH TISO is an art historian who has taught at Parsons, Fordham University, and UCLA in New York. She has published reviews and articles on contemporary art and architecture in *Art in America*, *ArtNews Magazine*, *Parole gelées*, and other academic publications.

The University of Chicago Press, Chicago 60637
The University of Chicago Press, Ltd., London
© 2014 by The University of Chicago
All rights reserved. Published 2014.
Printed in the United States of America

23 22 21 20 19 18 17 16 15 14 1 2 3 4 5

ISBN-13: 978-0-226-03240-5 (cloth)
ISBN-13: 978-0-226-03254-2 (e-book)
DOI: 10.7208/chicago/9780226032542.001.0001

Library of Congress Cataloging-in-Publication Data

Halle, David, author.
 New York's new edge : contemporary art, the High
Line, and urban megaprojects on the far West Side / David Halle and Elisabeth Tiso.
 pages cm
 Includes bibliographical references and index.
 ISBN 978-0-226-03240-5 (cloth : alkaline paper) — ISBN 978-0-226-03254-2 (e-book)
1. Urban renewal—New York (State)—New York. 2. Historic districts—New York
(State)—New York. 3. West Side (New York, N.Y.) 4. Chelsea (Manhattan, New York,
N.Y.) 5. Chelsea Historic District (New York, N.Y.) 6. High Line (New York,
N.Y. : Park) 7. Gansevoort Market Historic District (New York, N.Y.) 8. Jacob K. Javits
Convention Center (New York, N.Y.) 9. Moynihan Station (New York, N.Y.) 10. Hudson
Yards Development Corporation. I. Tiso, Elisabeth, author. II. Title.
 HT177.N5H35 2014
 307.3'416097471—dc23
 2013048753

A UCLA Senate grant helped support this book's publication.

♾ This paper meets the requirements of
ANSI/NISO Z39.48–1992 (Permanence of Paper).

To Louise and Philip, our spouses, with love and gratitude

CONTENTS

ACKNOWLEDGMENTS

Our thanks to Rick Bell, Andrew Beveridge, Michelle Bogart, Robert Boyle, Peg Breen, Vishaan Chakrabarti, J. Lee Compton, Paula Cooper, Joseph Dixon, Jameson Doig, Nancy Foner, Gagosian Gallery, Barbara Gladstone, Marcela Gonzalez, Jack Gray, Paul Haacke, Carla and Malcolm Halle, Jo Hamilton, Douglas Heller, Kira Hwang, James Jasper, Phil Kasinitz, William Kornblum, Wilfredo Lugo, Raju Mann, Miles Manning, Matthew Marks, Julian and Gabriel Mathews, Philip Mirrer-Singer, Florent Morellet, Peter Mullan, Michael Navas, Joann Milano Neal, Kenneth Laurence Neal, Jean-Daniel Noland, Martin Novar, Bob Qu, Damu Radheshwar, Joe Restuccia, Linda Schapiro, Silas Seandel, George Sweeting, Robert Tierney, Camilo Vergara, Kathryn Wylde, and David Zwirner Gallery.

INTRODUCTION

Developing New York's Far West Side: Contemporary Art, the High Line, Megaprojects, and Urban Growth

New York has always been a city characterized by the new and innovative. This book is about the Far West Side of Manhattan, the latest frontier for no fewer than three kinds of urban and cultural developments (fig. i.1).

First, Chelsea became the largest Contemporary Art commercial art gallery district in the world. Second, a pair of iconic "preservation" projects turned the High Line, a disused above-ground rail line, into the city's most visited park per acre just three years after it opened in 2009 (attracting 4.4 million visitors in 2012) and created the Gansevoort Market Historic District (in 2003), which, ironically, then attracted one of the most lavish nightclub scenes in the world and helped persuade Google to set up its East Coast headquarters just to the north.

The third kind of Far West Side development is a series of megaprojects, including a plan for the Hudson Yards, the largest unbuilt site in Manhattan, to become the country's biggest and densest real estate development (12 million square feet), and for the broader Hudson Yards area to generate 50 percent (24 million square feet) of all the new office space projected for the city by 2040. Other Far West Side megaprojects include two mass-transit projects. The first of these, the extension of the number 7 subway line to 11th Avenue and 34th Street, is on track to open in 2014 just nine years after it began construction, a stunning success in a city that these days finds it hugely difficult to build new subway lines. The second mass-transit project, expanding capacity at Penn Station, the busiest train station in the country, remains mired in problems and so far is a stunning failure—efforts to achieve it have been ongoing since 1992. The contrast between the fates of these two Far West Side mass-transit projects is a lesson in why megaprojects in New York are difficult to achieve and what is needed to pull them off.

Each of these three kinds of developments—Chelsea's dominant art gallery district, iconic historic preservation projects, and megaprojects—raises critical issues about how to foster urban growth while limiting

growth's negative consequences and avoiding mistakes of the past. Each too, when carefully examined, explodes some key myths whose false underpinnings mostly only appear in a detailed account, which is a central justification for the case studies in this book.

New York's mayor, Bill de Blasio, famously made the issues of rising inequality, housing unaffordability, and excessive tax breaks for developers cornerstones of his 2013 election campaign. Case studies such as those in this book are the only way to properly evaluate such central issues, which are quite complex. The Hudson Yards in particular is a lesson in the difficulties of drawing too simple conclusions.

The developments on which we focus are interconnected in fascinating ways, and cannot be fully understood unless considered in relation to each other. For instance, they are all located in, or on the edge of, the area known as the Far West Side of Manhattan, and many are physically intermingled. The High Line actually runs through almost all of them. Further, they affected each other in numerous, sometime surprising, ways. For example the opening of the High Line's first section in 2009 and its second section in 2011 (section 3 at the Hudson Railyards is currently being built) boosted Chelsea's art gallery district just when the art market was sagging from the financial and economic crisis that started in 2007, and it also helped attract the Whitney Museum of American Art to move from Manhattan's Upper East Side down to the High Line's entrance in the Meat Market by 2015 (fig. i.2), all of which helped Chelsea's gallery district fend off a challenge from the Lower East Side's growing commercial gallery district. Such outcomes also underline the important role that nonprofit organizations (e.g., the High Line, the Whitney) often play in American cultural development and planning.

The period on which this book focuses includes Michael Bloomberg's mayoralty—January 2002 to December 2013—and the three developments analyzed here provide a chance to evaluate some signature projects of that mayoralty. For example, rezoning projects: by mid-2013 an amazing 37 percent of the city had been rezoned (often from industrial to commercial/residential), including the two rezonings analyzed here that made the Hudson Yards development possible. By April 2013 the Bloomberg administration had also created forty-one historic districts, far more than any of its predecessors, who, in order of districts created, were Koch (27), Lindsay (23), Giuliani (18), Dinkins (10), Beame (7), and Wagner (1). The Gansevoort Market Historic District, one of the developments we analyze, was the first created under Bloomberg. Affordable housing was another issue under debate during Bloomberg's mayoralty—and the Hudson Yards provides a fine case study for assessing this debate.

Fig. i.1. The Far West Side: Chelsea gallery district, megaprojects, and preservation projects, including the High Line and the Meat Market.

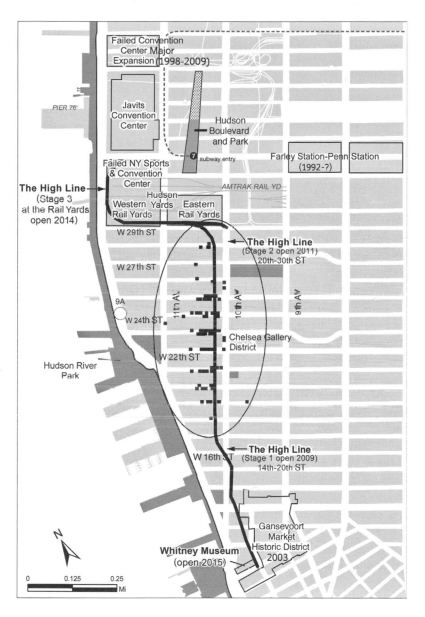

Fig. i.2. Whitney Museum of American Art's new contemporary and modern art building, designed by Renzo Piano, next to the High Line in the Meat Market. Courtesy Whitney Museum and Offices of Renzo Piano.

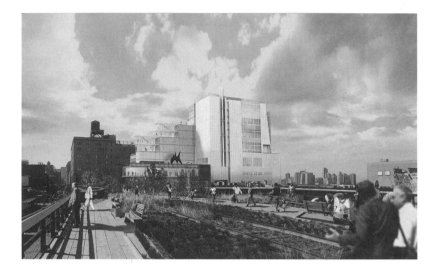

The rest of this introduction sets out in detail some of the key issues these three developments raise.

THE RISE OF CHELSEA'S COMMERCIAL ART GALLERY DISTRICT AND CONTEMPORARY ART

Chelsea became the most important Contemporary Art gallery district in the world with startling speed. Between 1996 and 2004, the number of commercial galleries in Chelsea grew from 12 to at least 200, dwarfing other art districts in the United States and elsewhere and supplanting SoHo, once the most dynamic gallery neighborhood in New York City (see figs. 1.1, 1.2). Marveling at the Chelsea phenomenon, the *New York Times* art critic Roberta Smith wrote in 2004 that "a contemporary art scene on this scale has never happened before, and it's hard to imagine it ever happening again" (Smith 2004).

One indicator of Chelsea's predominance is the number of its galleries that exhibit at Art Basel, Switzerland. This is the world's leading annual fair for Contemporary Art and operates a ferociously competitive admission process for galleries wishing to exhibit. One gallery owner quipped: "It is easier to get into an Ivy League college than Art Basel!" Art Basel 2013 included 53 galleries from New York City, the largest number by far from any city in the world. Of these New York galleries, easily the most, 26,

were Chelsea galleries. The Chelsea total alone slightly exceeded the number from all of Berlin (25), the city with the next largest number of galleries at Art Basel, followed by London (20), Paris (19), and Zurich (9). After New York, the only other US cities represented were Los Angeles (3), Chicago (1), and San Francisco (2).[1] France's influential newspaper *Le Monde*, not inclined to exaggerate American cultural influence, routinely called New York "the world capital of Contemporary Art" and Chelsea the city's "commercial gallery center" (*Le Monde* 2010).[2]

In this context, Chelsea's megagathering of publicly accessible, commercial galleries presents a magnificent opportunity for systematic research on Contemporary Art—on the artworks, their audience, the galleries, and the artists—an opportunity perhaps not to be repeated should the Internet eventually undermine commercial galleries as it has undermined physical bookshops and record stores. For example, Chelsea's galleries offer a fine chance to survey the audience for the art and especially to ascertain the art's meaning for the audience. Artworks, of course, have an objective existence, but much of their dynamism derives from the meaning that the audience assigns to them. Yet throughout the history of art we rarely know more about this than can be gleaned from the comments of a limited, albeit important, group—the artists, patrons, purchasers, dealers, or critics. We typically lack any systematic knowledge of the views of the interested general public.

To remedy this, we interviewed several samples of the Chelsea gallery audience. We also supplemented the Chelsea audience interviews with a survey of collectors at New York's then major international art fair, the Armory Show, in 2010.

Money/Real Estate and the Meaning of the Art:
Two Stories about Contemporary Art

Among the major research issues raised by Chelsea's commercial gallery center, we sketch out three here. First, how far is art about money? As the art market boomed, especially from 2002 to 2007, media attention increasingly focused on the rising prices of art and its investment potential. The works of Damien Hirst, Andy Warhol, and Jeff Koons are prime case studies here. For example, in August 2007 Hirst apparently sold for $50 million the world's most expensive work of Contemporary Art, a platinum cast of an eighteenth-century human skull encrusted with over eight thousand diamonds, triggering a spate of media articles. The news, which emerged soon after, that Hirst himself had been part of the consortium that "purchased" his work, occasioned further articles on art and money, but with ethics now added as a topic. When the art market began deflating in 2008,

much writing still focused on art as money, though now on the question of how far prices would fall. By 2013, as the market recovered, discussion returned to how high prices would go. The strong implication of this discussion is that, for the audience, interest in art these days is basically about its investment potential, as in the opinion that "gone is the time when art was appreciated as art, not as an investment" (Atlas 2012).

On the contrary, based on our audience interviews in this study we argue that there are two stories about Contemporary Art, both of which need to be told. The first story is, indeed, about money and investment and changing prices of real estate and commercial rents, all of which are critically salient, though especially for the galleries. This story, for example, underpins the move from SoHo to Chelsea of New York's dominant commercial gallery center for Contemporary Art.

The second story is about the meaning of the art to those who view and purchase it. This story turns out to be about the way art resonates with thematic aspects of people's lives, and usually has little to do with art as money. Further, this story can only be discerned through interviews with the audience for the works—both the audience who view the art in galleries but do not usually purchase it, and the collectors who purchase it. One reason this second story is seldom told is that the relevant interview data are rarely collected, leaving the "art as money story" to dominate. We narrate both these stories in the next two chapters.

Contemporary Art and the Eclipse of Styles

Chelsea's rise as a commercial gallery district, which began in the mid-1990s, coincided roughly with the establishment of "Contemporary Art" as the dominant category in the art world for classifying the art of the time. (In this study when referring to Contemporary Art as a classificatory category we capitalize it.) Reflecting this, a plethora of museums of Contemporary Art opened during this period in the United States and around the world, especially in cities with aspirations as artistic and cultural leaders. For example, in just nine months at the height of the frenzied art market, three major museums of Contemporary Art opened. The first, in New York City's Bowery/Lower East Side in December 2007, was the New Museum of Contemporary Art, designed by two star Japanese architects, Kazuyo Sejima and Ryue Nishizawa (fig. 9.2). In Los Angeles the Broad Contemporary Art Museum, part of the Los Angeles County Museum of Art, opened in February 2008, designed by Renzo Piano. In London Charles Saatchi reopened his Museum of Contemporary Art in a new location in the former garrison building of the Duke of York, whose seventy thousand

square feet of exhibition space made it one of the largest Contemporary Art museums in the world.

Amidst all this activity, but insufficiently noticed and commented on, has been the distinct way that Contemporary Art is defined. Almost every Chelsea gallery owner we interviewed defined it broadly and inclusively as the art produced by all artists still living or fairly recently dead, a definition that reflects the term's general usage in the art world. Such inclusivity is rare in the history of art over the last two hundred years, which has mostly proceeded by foregrounding, in series, subgroups of the work of living artists, namely styles and artists associated with those styles (e.g., Impressionism, Cubism, Abstract Expressionism, Pop Art). Those advocating for each new style as it appeared typically claimed (or implied) that the work of the living artists producing the new style was superior to, and more interesting than, the work of other living artists. Noting, by contrast, the relative decline of styles nowadays the philosopher Arthur Danto said:

> Today [with the arrival of Contemporary Art] everything is permitted. Artists [became] free to make art in whatever way they wished. . . . That is the mark of contemporary art, and small wonder, in contrast with modernism, there is no such thing as a contemporary style. (Danto 1997, 15)

Still, that leaves unexplained why this inclusivity has occurred. In this study we suggest that Contemporary Art's embrace of all living or recently dead artists and their work is plausibly related to its coinciding with a dramatically booming art market (albeit punctuated by brief recessions). In such a context, when art sells relatively easily, the drive to highlight, or "brand," a particular subsection of work and artists (i.e., promote "styles") loses urgency. Everything has a chance to sell, and inclusivity-eclecticism reigns. This explanation carries the prediction that, if the art market remains difficult for an extended period (as opposed to a brief recession), styles will show signs of re-emerging (as in, for example, "Street Art's" current trajectory) and will move to dominance, and the category "Contemporary Art" will eventually fade, though this may take many years to happen. (Danto, by contrast, argued that Contemporary Art's eclecticism is here forever.)

Flux in the World of Contemporary Art: Change and Disequilibrium

A third issue raised by Chelsea is that of flux and change in the art world. Chelsea's dominance in the commercial art world clearly could not last, and especially after about 2006, a host of challenges to its position emerged. As a result, Chelsea's art world is not in equilibrium, reflecting

the fact that neither is the Contemporary Art world in general. So this book also sets Chelsea in the context of these changes, some of which involve issues of "globalization."

Some challenges to Chelsea are radical, calling into question the whole commercial gallery/dealer model of displaying and selling art that has dominated in the twentieth century and on which Chelsea is based. This model, whereby market-oriented, privately owned galleries adopt, and if need be nurture, a limited roster of artists, display their works for sale, and receive a cut (typically 50 percent) of any sales, emerged in the mid-nineteenth century. It did so in part to compensate for the decline of church sponsorship and private patronage as a source of artistic commissions, and in part as a reaction against the perceived stodginess of government-sponsored institutions as arbiters and sponsors of art.[3]

Nowadays the Internet, a different market-oriented model, is the most potent challenge to Chelsea and its commercial gallery-based model, since the Internet has the potential, by bringing together artist (seller) and collector (purchaser) in direct transactions, to cut out entirely the traditional middle role of the commercial gallery. Charles Saatchi offered one of the strongest recent attempts to do this in 2005 with his free website, Saatchi Online, which allowed any artist to upload his or her art, and then negotiate directly online with interested sellers, with no commission going to the gallery. At its peak it contained the work of about sixty-five thousand artists. Yet, in a fascinating case study of why art is different from books or movies, attempts to sell art over the Internet to new customers have had only modest success (Saatchi Online as a free site closed in 2010), floundering on the fact that, since most artworks are unique, people usually prefer to see them in person before making a purchase. Nonetheless, efforts to establish the web as the dominant site for selling art continue, since the stakes, and the lure of evolving technology, are high. Artsy, based on an effort to scientifically classify viewers' tastes, or "art genes," and backed by a host of financial luminaries with star gallerist Larry Gagosian as advisor, went live in mid-2012, followed by Amazon Art in 2013. Neither so far has replaced galleries or made major inroads into the art market.

Another different but major challenge to the commercial galleries came from the auction houses—Sotheby's and Christie's and the initially innovative and aggressive Phillips de Pury. Galvanized by the huge profits to be made from the sale of new Contemporary Art, this "duopoly plus one" (as it could be described up to 2008, though Chinese auction houses have moved up fast since then), pushed beyond their traditional role in the secondary (resale) market into the primary market for new art, long the sole domain of commercial galleries.

There were also challenges from the burgeoning world of international

art fairs. Although composed of commercial galleries, these fairs are basically a venue for individual galleries to operate away from their local roots and at the more exalted level of a circuit of global host cities. Whether such fairs will complement, or undermine, commercial galleries operating at the local level in gallery neighborhoods such as Chelsea is a key issue.

As well as these radical threats to the basic gallery model, there was a series of more traditional pressures on Chelsea from rival art gallery "neighborhoods" such as New York's Lower East Side, or neighborhoods in other "global" cities such as London or Shanghai, vying to supplant Chelsea's dominance as an art gallery neighborhood.

These various challenges, none of which has yet overrun Chelsea and its commercial gallery model, constitute the core of the dramatically changing world of Contemporary Art. They also underline that the current stage of "globalization" in the art world, when examined, involves two key issues, the rise of the Internet and the rise of China.

HISTORIC "PRESERVATION" (HIGH LINE, MEAT MARKET)

The second type of Far West Side development discussed here consists of two historic "preservation" projects, the High Line and the Gansevoort Market. The High Line was a long-disused freight rail line, raised on stilts and running mostly along 10th Avenue from the Gansevoort Meat Market around 4th Street all the way to the Javits Convention Center at 34th Street. In 1999, two young Chelsea residents, Josh David and Robert Hammond, heard a proposal by CSX, the railroad that owned the structure, to convert the High Line into an elevated park instead of tearing it down as Rudy Giuliani's administration wanted to and as had happened to almost all similar disused elevated rail lines in the city's past. Hammond and David convinced the Bloomberg administration to support the conversion idea and by 2009 the first section of the new High Line park opened, followed by the second section in 2011. By 2012 the High Line, if ranked as a cultural attraction, which is increasingly how it was presenting itself, at 4.4 million visitors lagged only the Metropolitan Museum of Art's 6.1 million, and was being widely studied around the world as a project that exemplified every feature of first-class planning (Garvin 2013, 202–3).

The other iconic Far West Side preservation project which we discuss is the creation of the Gansevoort Market Historic District in 2003. This quickly became a major nightlife center, popularized in the television series *Sex and the City* and then later linked to Manhattan's growing high-tech corridor, which includes Google's US East Coast headquarters just north of the Market's boundary. The Gansevoort Market Historic District,

like the High Line, was promoted successfully by two young residents, Jo Hamilton and Florent Morellet, who together thought of the initial idea.

Preservation projects such as the High Line and Gansevoort Market raise the question of how to strike the proper balance between preservation and development. They also show how hard it is to bottle up history, since neither turned out as expected, although this may not matter. For example, the High Line succeeded only because of a development deal that opened the way for a series of new high-rise buildings, mostly condominiums, by "starchitects" such as Frank Gehry, Jean Nouvel, Shigeru Ban, Annabelle Selldorf, and Norman Foster on the cutting edge of architectural design. Indeed, both preservation projects studied here are major counterexamples to the belief that preservation and economic development are incompatible.

Further, both the High Line and Gansevoort Historic District suggest that, even when the preservation project formally happens, what emerges in a dynamic city like New York is often a turbulent, and in many ways uncontrollable, brew. This is not a reason to avoid these projects, but it does raise issues to ponder. A 2011 show by the architect Rem Koolhaas of successful "preservation" projects argued, convincingly, that a feature of those projects that work is some flexibility, basically "the desire for the 'preserved' . . . to not be embalmed, but to stay alive and evolve" (Koolhaas and Shigematsu 2011).[4] Note that the High Line, unlike the Gansevoort Market, never formally came under the jurisdiction of New York City's Landmarks Commission, which is a key reason why it was able to evolve in such a strikingly creative way.

Historic preservation projects also raise the question of how many, and how extensive, they should be and who benefits from them. Some critics, for example, complain that preservationists are antigrowth and would like to turn much of New York into a giant, embalmed museum piece. Preservationists often respond that they are protecting the city from avaricious developers whose only concern is to build whatever maximizes their profits. Both sides have a point.

A different criticism is that a successful preservation project can make an area so desirable that it becomes affordable only for the wealthy. For example, in a May 2007 *New York Magazine* article just before the real estate and economic crash, Adam Sternbergh expressed the unease with which many people viewed the flood of condominium developments associated with the High Line.

> The High Line . . . will one day look to us like a monument to the time we live in now . . . of essentially unfettered growth. A time when a rusted

railbed could beget a park, and a park could beget a millionaire's wonder-land." (Sternbergh 2007)

This too is an important issue.

MEGAPROJECTS AND CAN NEW YORK BUILD THEM? THE HUDSON YARDS, PENN/ MOYNIHAN STATION, AND OTHERS

The third type of development discussed here is a remarkable group of megaprojects attempted over the last three decades (fig. i.1). We define a megaproject as "a very big project in the context of where it is being planned or built, and with a significant public component (via, e.g., financing, or authority such as zoning)."[5]

Several of the Far West Side megaprojects discussed in this book are in or around the Hudson Yards, to Chelsea's north, which covers fifty-nine city blocks, a huge 360 acres. One of these megaprojects included a massive rezoning of most of the area, from manufacturing to commercial (office). The motive was concern that the city was running out of space for office buildings, and as a result that white-collar jobs were migrating from the city, especially to New Jersey. A second of these megaprojects was an effort to expand New York City's existing Javits Convention Center from the eighteenth largest in the country, absurdly small for the country's biggest city. A third megaproject was an attempt to build a multiuse New York Sports and Convention Center that was both the centerpiece of New York City's eventually unsuccessful bid to host the 2012 Olympic Games and also intended as the New York Jets football team's permanent home base.

Just to the east of the Hudson Yards is another megaproject, long seen by some planners as New York City's most important. This involves an effort to move part of Penn Station, the busiest transportation facility in the United States, a block west to the Farley Post Office, a magnificent Beaux Arts building just a few blocks from the Hudson Yards. This would make amends for the bulldozing in 1963 of the original Penn Station, a destruction widely seen as a blunder that left New York as one of the few global cities with only one imposing train station, Grand Central.

Almost all the megaprojects mentioned above either never happened or took decades. The New York Sports and Convention Center was enormously controversial and its eventual demise, in 2005, at the hands of state assembly speaker Sheldon Silver, was not unexpected. The Javits Center expansion also failed in such a fiasco that some people then questioned Javits's future on the Far West Side. Also, efforts to move Penn Station

from its outmoded facility at Penn Plaza (between 7th and 8th Avenues and 31st to 33rd Streets) to the grand Farley Post Office Building have been underway since 1992. Ironically, when part 1 of the project, linking Penn Station underground to the post office, finally began in late 2012, a group of critics emerged to argue that the entire project is misconceived and that instead Madison Square Garden should move out of Penn Plaza, which would allow a dazzling new Penn Station be rebuilt on-site. Even ardent supporters of this plan acknowledge it is not likely to happen in less than two decades. Such slowness and dithering underlines a widespread view that the United States in general has second-rate infrastructure in dire need of upgrading and lags tremendously many other advanced societies, especially China.

It is important to stress that, despite these failures, some megaprojects did occur. For example, the Hudson Yards rezonings happened (in two stages, in 2005 and 2009). The first iconic buildings associated with the rezonings are sited on Related's development around the High Line's third stage and started to appear in 2013, although the full results of the rezoning, in terms of new buildings, are expected to take up to thirty years to be completed.

Also, the Hudson River Park runs the entire waterfront from roughly the World Trade Center site past Chelsea and up to the Hudson Yards. By 2012 most sections of the Hudson River Park had been completed, to a generally enthusiastic reception.[6] The High Line too, which began as a preservation project, morphed into a highly successful megaproject. The rebuilding of the World Trade Center site, a key megaproject to the south of the area covered in this study, is finally on track, though only because the very capable Port Authority took over direction of that mammoth project after 2005 with a consequently huge diversion of its resources from other needy transportation projects in the city and region.

Yet overall this is a mixed record of achievement. Obviously a central question is why megaprojects so often fail or take so long to happen. The conventional answer, which blames local or neighborhood opposition, especially nimbyism, is too simple. There is a series of reasons, not just one, why megaprojects fail. Among the most important are jurisdictional squabbles between various government agencies, political lobbying and cronyism, destructive competition between politicians willing to sabotage each other's projects, incompetent leadership, the presence of a private-sector corporate entity that is both crucial and yet unwilling to cooperate, changes in the economic environment, especially the real estate boom-bust cycle, and the fact that a project is excessively ambitious. Neighborhood opposition and nimbyism can also be important, though in most of the cases considered here it was not.

This is a daunting list of forces that can undermine a megaproject, which is why it is also important to notice and celebrate those occasions when a project succeeds, with consequent lessons as New York and the United States struggle to build and rebuild infrastructure. Overall these Far West Side megaprojects offer insight into the central issue of how far New York City is able to build megaprojects in an age that no longer tolerates the ruthless centralization of power associated with Robert Moses, who, as head of a series of public authorities, pushed through a vast array of transformative projects in the city and region in the mid-twentieth century, despite never being elected to a public office.

HURRICANE SANDY AND MEGAPROJECTS

Hurricane Sandy has just placed a new megaproject—flood protection—at the top of the agenda of those the city needs. Sandy hit the New York–New Jersey region on October 30, 2012, as one of the worst natural disasters since the original Dutch settlers arrived. Chelsea's ground-floor art galleries, especially those from 19th to 26th Street, which are very near sea level, were flooded by tidal waves six to eight feet high. There was huge damage to artworks stored in basements. For example David Zwirner's gallery on 19th Street was closed for six weeks.

New York's waterfront location, like that of most global cities, has been the foundation of its commercial success. Still, with four of its five boroughs located on islands (only the Bronx is part of the continental mainland), it currently ranks number five among 140 port cities around the world in terms of susceptibility to storm surges, and its future as a major global city is in doubt without new protective measures (Gapper 2012). Cities such as London, Rotterdam, Hamburg, and Tokyo have all built storm barriers, levees, and sea walls.

In June 2013 the city issued a comprehensive set of remedial and protective proposals, *A Stronger, More Resilient New York* (NYC 2013). The measures proposed included offshore breakwaters or wetlands, beaches and dunes to act as shields, floodwalls, bulkheads and tidegates, The report estimated that the first phase would take ten years and cost about $19 billion. Obviously aware of some of the obstacles facing megaprojects, the city stressed the need for strong mayoral/central control and clear government agency accountability without overlapping responsibilities, and for keeping state involvement to a minimum. The city also said it had already identified $10 billion of the needed funds. Despite this impressive planning and the clear urgency of the project, whether these proposals can avoid the daunting set of obstacles that so often undermine megaprojects in New York and elsewhere remains to be seen.

THE DEATH AND LIFE OF JANE JACOBS: GROWTH AND PRESERVATION

A final reason to consider together the three types of projects discussed in this book—Chelsea's art galleries, preservation projects, and megaprojects—is that by 2004 Mayor Bloomberg's administration saw them all as key parts of its plan for the Far West Side, which the administration considered a model of the difficult but crucial process of balancing growth and preservation. The administration's Department of City Planning (DCP) under Amanda Burden also argued that its balanced approach here, that included some megadevelopment and some preservation, was in line with the views of the great urbanist Jane Jacobs, as expressed in her classic *The Death and Life of Great American Cities*. This interpretation, though accurate, will surprise some who have long portrayed Jacobs as a proponent of vibrant local neighborhood life, which she was, while also depicting her as an opponent of big projects—tall new buildings and modern architecture, and urban growth—which she definitely was not, provided these were well conceived and did not destroy neighborhoods. Like the DCP, Jacobs favored a balanced approach that included both preservation and growth.[7]

What Jacobs valued above all about cities is their diversity, density and dynamism. She was absolutely not opposed to new buildings, including skyscrapers, or modern architecture and materials (e.g. glass), all of which are crucial for diversity. She merely insisted that a healthy neighborhood should also have a good proportion of small, old buildings too. For example, the main theme of chapter 10 is that "in a successful city district ... some of the old buildings, year by year, are replaced by new ones—or rehabilitated to a degree equivalent to replacement. Over the years there is, therefore, constantly a mixture of buildings of many ages and types." Chapter 11 advocates high population densities in cities, and is completely open to, indeed foresees, very tall buildings to achieve that goal. Jacobs's only reservation is that she does not want only tall buildings (as she does not want only small buildings), and she does not want all the tall buildings to look alike, but she clearly expects vibrant city neighborhoods to have their share of tall, new buildings. When she poses the question "How high should city dwellings go?" her answer is that "the dwelling densities should go as high as needed to stimulate the maximum potential diversity in a district." She wrote that twenty-two stories was about the maximum feasible limit for "elevator" apartment buildings in her day, but she expected this limit to rise, as it had continually in the past.

In her book, Jacobs throughout praised Midtown Manhattan, which had by then surpassed downtown as New York's major office center. Jacobs argued that Midtown's success lay in its ability to foster various primary

uses, while downtown/Wall Street's failure was its focus on offices, without the diversity that residential buildings could add (chapter 8). She likewise criticized the Upper West Side of Manhattan for the opposite lack of diversity, as dull because almost entirely residential. Midtown's diversity, in Jacobs's view, consisted of a combination of high rise office buildings, a thriving entertainment industry often housed in "blockbuster" format (Times Square, Rockefeller Center, Radio City Music Hall), and some tall residential buildings along with smaller structures too. This is hardly quiet "village life."

It is true that Jacobs used the West Village where she lived as a case study of a safe neighborhood, but her argument is that the Village's lessons, its "eyes on the street" that made it safe, should be incorporated into any successful, diverse neighborhood. For example she felt strongly, as does today's Department of City Planning, that the first floor of commercial buildings in reasonably densely populated urban neighborhoods should contain stores, restaurants and bars open until late at night, key to the kind of "eyes on the street" that make cities safe and vibrant. But *The Death and Life of Great American Cities* is not dogmatic about whether the buildings containing these stores should be low or tall.

Jacobs was also an early advocate of smart growth. She believed in the superiority of cities over suburban and rural life, but recognized that making city life available for as many people as possible, in the context of rapid population growth, entailed higher urban densities in the city and especially in its outer (though still within the city borders) urban rings whose often low densities should, in her view, be beefed up. She nevertheless believed that beyond the city boundaries low-density suburban life was inevitable, should be left as low-density, and was fine for those who preferred it. But if low-density suburban life expanded continually then the countryside would vanish, which was not desirable. She wrote: "It is silly to . . . lose all the true countryside of metropolitan areas too, as we have been steadily losing it at about 3000 acres a day for the past ten years" (Jacobs 1961, 220). In short, cities must be dense for two main reasons—first so the maximum number of people can live there and benefit from the diversity, and second in order to save the countryside from excessive suburban development.

The Bloomberg administration's general perspective on the Far West Side, in addition to getting Jane Jacobs right, embodied some of the latest views on planning. For example, a central attraction of placing megaprojects on the Hudson Yards section of the Far West Side—consisting mostly of railyards and areas zoned manufacturing—was that this seemed likely to minimize neighborhood and other disturbance. The city hoped, in this way, to meet the "do no harm" standard (i.e., avoid or fully mitigate any

significant disruption) to which urban megaprojects have been basically subject, in principle at least, since the 1970s and 1980s in reaction to the excesses of post–World War II "urban renewal," which often included massive displacement of residents (Altshuler and Luberoff 2003).

The administration's perspective was likewise consistent with progressive definitions of "planning" that try to avoid the errors of past planners, some of whose blunders resulted from considering a project in a vacuum, including failing to weigh the project's impact on the surrounding community. For example, Alexander Garvin, one of New York's most respected planners, who early on had suggested developing the Hudson railyards, defines planning broadly as "public action that generates a sustained and widespread private market reaction, which improves the quality of life of the affected community, thereby making it more attractive, convenient, and environmentally healthy" (Garvin 2002). So it makes sense to consider and evaluate these Far West Side projects as a group and in the broader context of each other, as intended by the city's planners.[8]

THE BIG PICTURE—CHANGE AND DISEQUILIBRIUM, AND VARIETIES OF "GENTRIFICATION"

Overall, these three different kinds of developments—art gallery district, megaprojects, and preservation efforts—raise a host of issues beyond those already mentioned, for those interested in cities and culture. There is the question of achieving the proper balance between growth and protecting older buildings and neighborhoods and vulnerable populations. There is the question of the interplay between market or commercial forces and other, quite different forces over a range of topics, from what shapes audience interest in Contemporary Art to how to achieve Moynihan Station. There are questions about the proper role of government in the urban planning process, especially given the striking unpredictability of some of the events that shaped the Far West Side in key ways. There are questions about the appropriate role of neighborhood organizations (especially the city's Community Boards) in the process, and the whole topic of assessing the city's process for reviewing land use projects (ULURP), a process which looks fairly sensible—especially when contrasted with the state's.

This study also, inevitably, raises important questions of "gentrification" and "globalization." These terms are often used very loosely, conflating several issues that should be considered separately. In this study we carefully define these terms and separate out the various important issues that are sometimes conflated.

For example "classic gentrification" was first coined by the British sociologist Ruth Glass in 1964 to refer to changes in inner London where middle class residents replaced working class and poor residents.[9] The areas of the Far West Side analyzed in this chapter did not primarily involve this kind of gentrification, often because they were originally zoned manufacturing, so there were few if any residents to displace. The Lower East Side, however, did involve "classic gentrification." More common on the Far West Side as analyzed here was "commercial gentrification," where landlords replace one set of commercial tenants with another set paying higher rents, as in the replacement of meatpackers in the Gansevoort Market district with commercial art galleries who then, in a process of "super-commercial gentrification," got replaced by high-end clothing stores and titans of the computer industry such as Apple. One reason not to lump these various changes together as undifferentiated "gentrification" is that we may evaluate them differently, believing for example that working class residents should have some protection from "classic gentrification," while "commercial gentrification" should generally be allowed to run its course (although the Bloomberg administration did decide to protect the heart of Chelsea's commercial gallery district from "commercial gentrification" in the form of developers wishing to build expensive condominiums).

These case studies highlight too the major role of "public and private entrepreneurs." These included Jo Hamilton and Florent Morellet in landmarking the Gansevoort District; Robert Hammond and Joshua David in preserving the High Line; Robert Boyle in the Javits Center; and private entrepreneurs such as Matthew Marks in the development of Chelsea as a gallery district. All these successful, mostly public, entrepreneurs knew how to work creatively, often within the political process, and in doing so made a major contribution.

On the research methods level, this is a study of change and attempts to promote and stop it. Since much of the Far West Side covered here was not in equilibrium during the period of study, we tried to produce a realistic account which captured the many moving parts and their interactions, including "globalization." Whenever we thought our study was too broad or complex, we reminded ourselves of anthropological classics such as Edmund Leach's *Political Systems of Highland Burma*, which covered change and disequilibrium over hundreds of square miles, not just one section of Manhattan (Leach 1965).

PART I
CONTEMPORARY ART

CHAPTER ONE
Chelsea as New York's Dominant Contemporary Art Gallery Neighborhood: A Real Estate and Finance Story

Congratulations! You own a garage on 22nd Street!

—Gallery owner Matthew Marks's lawyer, 1994

It is hard to know what the art world will look like in the future. I believe there will always be a place for the traditional kind of art dealer who represents artists. Artists will always need someone to run interference between them and the rest of the world.

—Matthew Marks, 2013 (Dreishpoon 2013)

TWO STORIES ABOUT CONTEMPORARY ART

The rise of Chelsea, and decline of SoHo, as New York's dominant Contemporary Art gallery neighborhood is a real estate and financial story primarily, albeit a fascinating one.[1] Told in this chapter, it is about rents and landownership and talented entrepreneurial gallery owners such as Matthew Marks, Paula Cooper, and Larry Gagosian, and the price of art compared with that of designer clothing. More recently it is also about the future of the commercial art gallery, in the context of such challenges as the movement to sell art online and the growth of annual art fairs. We call this the first story about Contemporary Art. Since it coincided with the most expansive art market ever, it is easy to conclude this is also the story of the meaning of the art. That would be a mistake. The chapter after this discusses the art in Chelsea and its meaning for the audience, and shows that for most people, including the majority of the collectors who purchase it, the art is not basically about money and investment. Instead it has far more to do with representing viewers' lives. We call that the second story about Contemporary Art.

THE LOGIC OF GALLERY CONCENTRATIONS

Commercial art galleries tend to concentrate in particular locations, a tendency that economist Richard Caves calls "the logic of art centers" (Caves 2000). Galleries specializing in Modern Art and the host of new art styles that followed concentrated in cities such as Paris, New York, London, and Berlin, with Paris dominating until World War II, and New York thereafter. Within these dominant cities the process of concentration continued, with a tendency for gallery neighborhoods to emerge that specialize. In New York, Old Masters have been on the Upper East Side for decades, while Contemporary Art is concentrated nowadays in Chelsea with 306 galleries by mid-2014 (though the Upper East Side is now showing much Contemporary Art too).

Still, in the long run in New York City a gallery neighborhood can lose its dominant position, and especially in the field of Contemporary Art this seems to happen. There the center of new art moved from 57th Street in the 1950s (with Abstract Expressionism as the dominant style) to SoHo in the 1960s and Chelsea in the late 1990s (see figs. 1.1 and 1.2; table 1.1. and

Fig. 1.1. Number of art galleries, by gallery areas, Manhattan and Brooklyn, 1978–2012 (January).

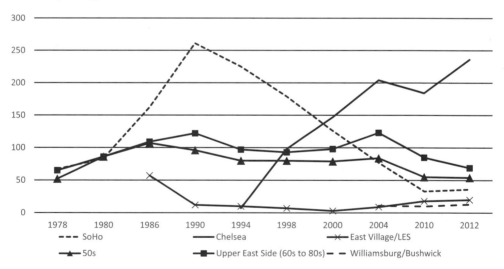

Data source: Art Now: Gallery Guide. Gallery Guide is the best data source for charting the number of galleries before 2013 because it compares many neighborhoods, goes back decades, and is the most prestigious guide, so almost all economically successful galleries subscribe. Even so, the *Gallery Guide* undercounts galleries in every neighborhood, since a gallery must pay an annual listing fee to be included. The true number of galleries in Chelsea is roughly 40% higher, based on actual counts we made in selected buildings. By 2013 online sources were disrupting *Gallery Guide's* dominance. Table 1.1 uses the most inclusive online sources for 2014.

Fig. 1.2. Art gallery neighborhoods, Manhattan, Queens and Brooklyn, 2008. A major nonprofit art institution often paves the way for the emergence of a dominant commercial gallery neighborhood (e.g., Metropolitan Museum for the Upper East Side, Dia for Chelsea, New Museum for the Lower East Side).

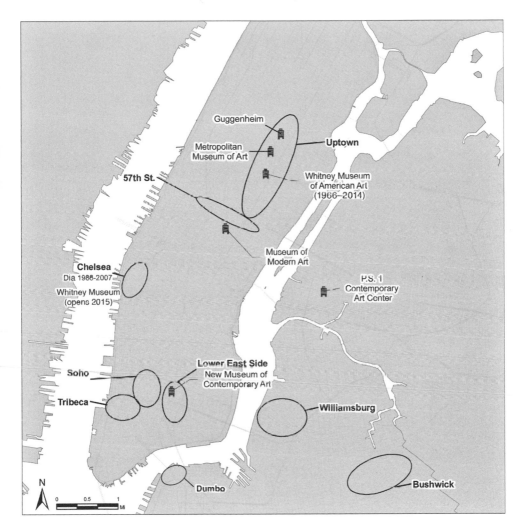

Szántó 1996 and 2003). When one site loses dominance, galleries do not disperse, but a new dominant center emerges, at least so far.

Why this concentration of commercial galleries occurs is not evident. The standard economic model predicts that retail organizations in general, of which commercial galleries are one type, are far more likely to disperse than to cluster. This is so the retail outlet can be the sole seller, or one of a limited number of sellers, of that product located near any particular

Table 1.1. Number of art galleries, by gallery areas, Manhattan and Brooklyn, 2014 (May)

Gallery area	Galleries	Upper-floor galleries (%)
Manhattan		
Chelsea	384	43
SoHo	97	25
East 50s	112	48
Upper East Side (60s to 80s)	276	18
Lower East Side	105	8
Brooklyn		
Bushwick	49	31
Williamsburg	30	5
Dumbo	22	40

Note: Manhattan data are from *Yelp*, Brooklyn data from *wagmag*, the currently most inclusive sources—online and no listing fee.

group of customers. It does not usually make sense for several stores selling liquor or meat or bakery products to open next to each other, where they must compete for the same pool of local customers and match each other's prices.

In studying why, by contrast, some retail organizations such as art galleries tend to cluster, economists have found that the dispersal forces can be overridden if two conditions are met. The first is when customers for a particular type of product wish to view a wide range of those products, sold by a variety of dealers, before making their choice. It then makes sense for the dealers to cluster, minimizing the purchasers' travel and shopping costs. Even for customers located far from the concentration, making a trip to one location where many products and dealers are clustered is probably efficient if a large amount will be spent on the item. This condition clearly applies to the world of Contemporary Art and is encapsulated in the practice of "gallery hopping," whereby viewers go from one gallery to another in a dominant gallery neighborhood (or at the higher agglomeration level of annual international art fairs, discussed later).

The second condition needed for the clustering of retailers selling the same category of product is that each seller's items are differentiated from those of other sellers, the more different the better. If, on the contrary, each retailer were selling the same or similar items, then consumers would gravitate to the retailer with the lowest prices, and the others would go out of business. Works of Contemporary Art meet this condition more than almost any other product. They are distinct from each other in a host

of ways (e.g., subject matter, style, artist who produced the work, status of the gallery displaying it), especially given the heterogeneous definition of Contemporary Art. Almost every work is unique (though not, of course, works produced in limited editions). In economist Richard Caves's words: "Pervasive product differentiation in the art market (*infinite variety*) curbs price competition" (Caves 2000, 30).[2]

This hyper product differentiation is fortunate for commercial art galleries, since it somewhat protects them from the ongoing Internet revolution, whose ability to act as a site where items may be purchased has undermined traditional vendors of other cultural products, for example physical stores that sell music, movies, and books. Technology does not yet allow most purchasers to view artworks online in enough detail to make an informed choice when they are not already familiar with that artist. Buyers typically still need to see the art in person.

These two factors—viewers' desire to see a broad range of works of art before making a purchase, and the highly varied nature of artworks—explain the emergence of dominant gallery cities (such as New York), and within such cities the emergence of a dominant commercial gallery neighborhood (such as Chelsea for Contemporary Art).

In other cities such as London or Paris or Berlin, contingents of commercial galleries selling Contemporary Art also cluster, though often without one area necessarily becoming dominant. Paris has smallish clusters of Contemporary Art galleries in several neighborhoods. The London Contemporary Art gallery scene is divided into two main, somewhat diffuse areas, the West End section (e.g., Savile Row/Piccadilly Road) and an East End section (e.g., Hoxton Square). Berlin's Contemporary Art galleries, after clustering in the Mitte district right after the city's reunification, later dispersed into several clusters, partly differentiated from each other by the status of the galleries in each cluster, as geographer Melanie Fasche has pointed out (Fasche 2013). Such clustering differences probably reflect the fact that these cities lack New York's dominance of the field and the consequent pressure for a single gallery area to be the dominant place to which collectors and other viewers must go.

LEAPFROGGING, AND WRONG TURNS IN NEW YORK

There seem to be strong, long-run destabilizing forces that produce a tendency for the center of the commercial gallery scene to shift location in New York. A striking feature of this shifting is that when the center moves, it "leapfrogs" to another neighborhood some distance away and often quite undeveloped commercially. Leapfrogging is unusual for commercial

real estate in New York. Far commoner is for retail establishments to open near existing commercial developments in an "organic" movement (creeping not leaping), rather than to periodically shift en masse to an underdeveloped location.[3]

This leapfrogging, whatever its causes, creates a particular dynamic for commercial galleries, forcing them to constantly wonder how long the current center will hold and, if it moves, to where. For a gallery intent on being in the dominant, successful gallery neighborhood, the process is fraught with difficulty and uncertainty, presenting an abundance of possible "wrong turns," of which there are two main types. One involves being a pioneer somewhere that never, in the end, becomes the new dominant gallery neighborhood, perhaps fading after initial promise. This is the "overestimation" error. The East Village in the 1980s was an example, as it failed to supplant SoHo. In Chelsea's case, so was Williamsburg in the early 1990s and probably the Lower East Side since 2007, both of which once seemed to have the potential to supplant Chelsea but have not.

A second type of wrong turn for a gallery is the "mistiming" error, that is, arriving too early or too late into what does become the new dominant gallery neighborhood. Arrive too late, and rents or purchase prices of buildings have become prohibitively expensive. Too early, and there are not enough customers to sustain business, as in Larry Gagosian's first move to Chelsea in 1985.

For a gallery, successfully negotiating this process somewhat resembles playing the game Chutes and Ladders, but with the added problem that the correct path is partially hidden and changes. Finding and staying on it is hard, full of possible wrong turns and costly detours.

Finally, although the commercial center of Contemporary Art moves and reconstitutes, the reconstituted center does not, typically, just replicate the old one. There are, for example, a number of ways in which Chelsea differs from SoHo, which it replaced. Above all, SoHo was pioneered by artists who moved into spaces where they lived and worked, and were then joined by galleries. By contrast, Chelsea lacks artists living, or working, in the neighborhood. With a few exceptions such as Jeff Koons, who maintains a large studio there, artists could not afford the general area of Chelsea from the start, let alone after it developed as a gallery neighborhood. In any case, the core of Chelsea's gallery neighborhood was, and still is, zoned to forbid residential properties, so living there is illegal. Instead, Chelsea represented the triumph of the commercial galleries, at least for now. "For now" because, as Chelsea developed, the traditional model of a gallery center located in a physical neighborhood was challenged by new types of centers, including international art fairs and the Internet. In this sense Chelsea bears the marks of its time as part of a process in motion.

STAGE 1, 1985–1993: THE NONPROFIT DIA MOVES TO CHELSEA

In 1985 the Kitchen, a nonprofit organization that showed performance art, moved from SoHo to Chelsea on West 19th Street, at a time when almost no commercial art galleries existed there. A year later the far more important nonprofit Dia Art Foundation also moved from SoHo to Chelsea (see fig. 1.3). Dia's move was eventually critical for Chelsea's development as a gallery neighborhood.

Dia was founded and funded in 1974 by Dominique de Menil's daughter, Philippa, and Philippa's then husband, the dealer Heiner Friedrich. The de Menils were a French family who had made a fortune in the Texas oil industry (as owners of the oil conglomerate Schlumberger) and were major art patrons in Houston and Europe. Dia had an important presence in Europe and spaces in SoHo for many years. But in the mid-1980s it had financial problems associated with the declining price of oil, so was seeking a new space in which to reorganize and expand. Chelsea was far less expensive than SoHo, so Dia converted a four-story building, on 22nd Street between 10th and 11th Avenues, into its first large-scale, rotating exhibition space in New York City, opening as Dia Chelsea in 1987.

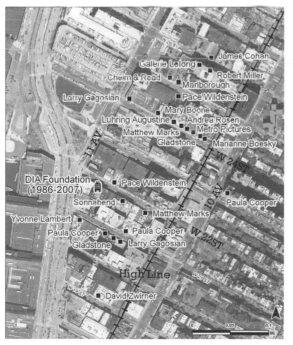

Fig. 1.3. Star Chelsea galleries, 2009.

Nonprofits and American Culture

In 2000 a young Frenchman, Frédéric Martel, who had begun a four-year term as France's cultural attaché in Boston, decided to examine his country's prevailing view that American culture was basically shaped by market forces, in contrast to French culture, which was heavily government-funded and organized. After traveling widely through the United States, he concluded that the French view of American culture was misleading, because it overlooked the key role of nonprofits in America. He published his findings in a 622-page book *Culture in America*, whose title echoed, for the domain of culture, Tocqueville's broad study of American democracy (Martel 2006).[4]

It is true, Martel argued, that the direct role of the federal government in culture in the United States is far smaller than in France. For example, the entire budget of the US National Endowment for the Arts (founded in 1965), at around $125 million in 2005, was just 40 percent of what the French government gave to Paris alone for culture that year. But a key role in American culture is played by nonprofit foundations, philanthropists, corporate sponsors, universities, and community organizations, which receive indirect government support in the form of tax incentives. So although a European-style culture ministry is not found in the United States, indirect government support of nonprofits and other tax-exempt organizations is, Martel concluded, a major reason why in America "cultural life is everywhere."

The role of the nonprofit Dia in Chelsea's development as a commercial gallery neighborhood exemplifies Martel's point (as do the later key roles of the nonprofit Friends of the High Line and the Whitney, as well as the New Museum of Contemporary Art opening in 2007, in the emergence of the Lower East Side as a gallery area). These nonprofits are performing important planning functions too, as analysts have stressed.[5]

1980s and 1990s Chelsea: Not "Classic" Gentrification

Overall, the movement of art galleries to this section of Chelsea was not "classic" gentrification, where middle-class and richer residents displace working-class and poorer residents, since there were almost no residents to displace. (By contrast, the later development of art galleries on the Lower East Side associated with the opening of the New Museum had affinities with classic gentrification.) The section of Chelsea to which Dia relocated in 1986, west of 10th Avenue, was far off the cultural map. Zoned mostly for manufacturing (see figure 1.4), not commercial or residential, it contained primarily large warehouse and industrial production

Fig. 1.4. Zoning prior to the rezoning of the Special West Chelsea District.

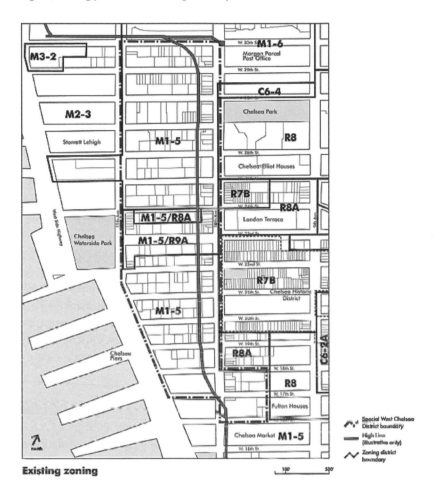

Existing zoning

Note: M1 areas permit light manufacturing and typically include repair shops and wholesale service and storage facilities. Offices and hotels are also permitted. M1-5 and M1-6 allow development to an FAR of 5 and 10 respectively. (FAR is the ratio of interior square footage to the ground area of the plot. An FAR of 5, for example, means a developer could put a five-story building on the entire plot or a ten-story building on half the plot.) C districts permit commercial and residential uses. C6 districts permit high-bulk commercial uses, including corporate headquarters, large hotels, and department stores. C6-4 allows development to an FAR of 10. R refers to residential districts. R1 has the lowest density and R10 the highest. For all these zoning definitions see *Zoning Handbook* (2011). Fig. 3.7 shows this area after it was rezoned in 2004 as part of the deal with the Chelsea Property Owners to save the High Line.

buildings. The latter included some garment manufacturers, who were permitted to have "commercial" showrooms in their buildings—art galleries counted as showrooms.

There were also many garages and auto repair shops in this section of Chelsea. They began to appear on the Far West Side as early as 1921, and within a few years much of the available space below West 71st Street and west of 10th Avenue converted to automobile-related industries, including dealers. This part of Chelsea, like the Meat Market further south, also contained a nightlife of illicit sexual activities drawn to an area with few residential buildings whose occupants might insist on respectability in the neighborhood.

Dia's move to Chelsea seemed prescient later, but defied cultural logic at the time. SoHo was the center of New York's Contemporary Art world, and the main alternative to SoHo for those seeking a less costly area was the East Village, although that was starting to fizzle by the mid-1980s.

There is a design/production workshop in Chelsea (i.e., not a gallery) that dates from this pre-Dia stage. Located on West 22nd Street just opposite the building to which Dia moved, it still flourishes. Its owner, Silas Seandel, makes ornate glass and metal furniture there—tables, chairs, and mirrors—and has a street-level showroom from which he sells some of his work. Seandel described the combination of waning industrial activity during the day and nighttime sex that characterized the area when he moved there in the late 1970s:

This was another dirty, grimy neighborhood in those days. From 1952 to the 1960s, just when I started, New York City was transitioning from heavy manufacturing/garment/print to residential and financial. But there were some remnants here in Chelsea like Mr. Glass, or Michael's which made adding machines for businesses. Michael's went out of production when computers came in, and sold their building to the Dia Foundation.

I came here because I'm a sculptor. I needed a ground, cement floor and high ceilings. I wanted to be in Manhattan to be in close contact with architects and designers. I'd been living in another section of Chelsea since 1970, but my studio was in Long Island City and it was a terrible commute.

People say how high real estate is now, but every period is hard in New York. In 1978 when I moved here (to this building) it was almost impossible to find a building. I drove a motorcycle, and my wife and I looked everywhere. If one auto shop went out of business it just turned into another one. The realtors didn't even put it on the market. In desperation I sent out 200 fliers to real estate agents saying "I got the dough, you give me the building." One guy called and said, "There's something available—you've got 10 minutes to take it." I grabbed my wife. West of 9th Avenue was really

no-man's-land in those days. My wife said she'd go as far south as 14th Street and as far north as 34th Street, but not west of 9th Avenue. I said to her, "It's between 10th and 11th." She said: "I'm not going!" But then she came and saw this and said, "It's terrific and there's no downside."

S and M bars were here when I bought this place. The neighborhood was dark, dreary, gritty, with guys in ridiculous outfits. There were three costume bars—you had to wear a costume to get in—all on 11th Avenue by the highway. There is one left now [2002]. You'd routinely see guys in state troopers outfits. They were pretty harmless. But the visual impact of seeing them night after night was disconcerting. My son got used to it quickly. Once one pushed him into a doorway, but when he said "My dad's upstairs," he ran away. It was forbidding, but not dangerous. Muggers don't and didn't come because there is no one to mug.

To afford this building, I had to have my shop here, live here, and rent part of it out as a residence. But I needed a variance to rent it as a residence because it was zoned industrial. In those days the city planners thought if you allowed an area to go residential there'd be no industrial, so they made it hard to get a variance, but they didn't realize that the industry had all left already. This was the only residential unit on the block, except for the Single Room Occupancy on the corner, which is still there for the longshoremen.

Giuliani's mayoralty after 1993 was key in raising the respectability of the area. As Seandel noted: "Eleventh and Twelfth Avenues were a hotbed of prostitution until Giuliani came in and pushed them away." So again, a noncommercial institution (in this case city government) crucially paved the way for commercial development.

Although Dia put lots of money into converting the Chelsea building into an exhibition and cultural space, for almost a decade until 1994 it and the Kitchen remained two lonely, nonprofit outposts in Chelsea, with an occasional quasi-cultural neighbor such as Seandel's workshop, but no successful commercial galleries.

Gagosian's "Mistiming" Wrong Turn

A brief exception to the absence of commercial galleries was Larry Gagosian, who in 1985 opened a gallery in Chelsea on 23rd Street, just west of 10th Avenue next to the Half King pub. Few people came and the gallery quickly closed. Only much later in 1999, after Chelsea developed a critical mass of galleries, did Gagosian, who had the capital to recover from this setback, reopen in Chelsea, this time to enormous success (Douglas 2008).[6]

This error, by an already well known gallery owner who later became legendary for his business acumen, underlines how easily a gallery can make a locational "wrong turn." Gagosian made the mistiming error—arriving too early into what later became a dominant gallery neighborhood. Later, after Chelsea took off, plenty of galleries realized they had made the opposite mistiming error, arriving too late to afford the rent for a desirable ground-floor space, or to purchase a building.

Gagosian's aborted solo effort underlines another point, the importance of being accompanied by a network of other galleries, and especially some "stars." On the whole, after galleries began moving to Chelsea, they did so in clusters locating alongside each other, especially if they were moving to a section or building that had few or no galleries. Since each gallery likely brings or attracts a clientele of viewers, a group move reduces, though does not eliminate, the risk of being alone in a new location with little or no "gallery hopping" audience. Matthew Marks's successful move to Chelsea, discussed below, exemplifies this point. Researchers, of course, have long understood the general importance of networks in social and economic life.

STAGE 2, 1993–1997: THE COMMERCIAL GALLERY PIONEERS; MATTHEW MARKS, NETWORKS OF RELATIONSHIPS, BUYING GARAGES

In 1990, Matthew Marks had opened his first gallery, on the East Side on Madison Avenue at 78th on an upper floor of a well-known gallery building, the Wittenborn. Commercial rents in SoHo were then affordable, and Marks could have taken a large, ground-floor space there. Instead he decided that, as a new gallery, he should start smaller, so he took the Upper East Side space. But by 1994 he needed more room. As he explained: "One of the famous artists I started showing was Brice Marden. It occurred to me, if he's got five paintings he wants to show, I'd be in trouble since I didn't have the space. I thought, 'Now I'm ready for SoHo.'" To Marks's chagrin, SoHo's "commercial gentrification" was in process, a key part of which involved clothing boutiques and furniture stores—able to afford higher rents—replacing galleries. The galleries already there were protected until their leases expired (most had signed five-to-ten-year leases). So the debacle awaiting most of them was not yet fully apparent, especially since in the past SoHo rents had been known to fall after rising for a while.

Still, galleries like Marks's seeking to enter SoHo could not afford the rents landlords were charging for new leases. To Marks back then it looked as though he had mistimed SoHo, trying to move there too late to get an

Fig. 1.5. Matthew Marks Gallery in Chelsea. Photo by Elisabeth Tiso.

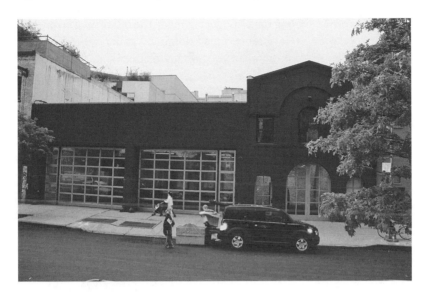

affordable lease, though in retrospect he was fortunate not to be able to move to a doomed gallery center. He explained how it appeared at the time:

> I called the real estate agent in 1993. "Could you fax me a list of what's available in SoHo?" All of a sudden, it's not SoHo, it's Chinatown [to the South] that they're sending me. Not a single thing in SoHo even worth driving by. It wasn't even a question of money. There were no spaces. Between 1990 and 1994 boutiques and furniture stores all moved in. An Italian furniture company is in the space I originally saw in 1990. I just couldn't find anywhere.[7]

Looking back in 2001, Marks, then age thirty-eight and now himself a star of the Chelsea and international gallery scene, recounted how he came to Chelsea after talking with Dia's Charles Wright at a holiday party in 1993:

> He said: "There's this gorgeous garage in Chelsea near us that we'd have taken if we were looking for space, but we're not." So next day I go there. It's a gray day, there are huge leaks in the garage roof, fumes from trucks, and a creepy guy in charge. I decided I'd take it. Why? Well, it seemed obvious it would look just like it looks now [i.e., like a gallery; see figs. 1.5, 1.6].
>
> The guy who owned it didn't know what an art gallery was! The negotiations went on for six months. Even the core people like my lawyer didn't know what an art gallery was. At the end he said ironically, "Congratulations! You own a garage on 22nd Street!"

Fig. 1.6. Chelsea Garage, 24th Street and 12th Avenue. Many "star" gallery owners who moved to Chelsea in waves 1 and 2 purchased garages, which they converted to galleries. Photo by David Halle.

I originally planned to rent there. I spent a few months trying to negotiate the rent. Then the lawyer did a title search and found the owner owed lots of money to the city in back taxes on another building where he stored his trucks. My older sister is an economist; she helped me with the leases and with negotiations. When she heard about the title search she said, "Forget it!" I got hysterical. I said, "I've told all the artists. I have to have it or I'll die!"

She looked at my finances and said, "You can only do it if you buy it. You have to put every cent into it, and you'll have to sell everything you have." She told real estate people with experience, "My brother wants to sink his life savings into a garage on 22nd Street!" Everyone in real estate said, "You're out of your mind." I said, "I don't care. I'm not a real estate person, I'm an art person." Now of course people say, "How come you didn't tell me about this place?"

I'm thirty-eight now. I was twenty-seven, twenty-eight when I began. I think I'm slightly gutsier than other dealers. I've been doing this since I was a kid. I grew up in New York and it's the only thing I do. I had immense success at it, and I figured, "What's the worst that can happen? Big deal, I'll go bankrupt. So I'll go work for some large dealer. If I try and fail, I'll still be only thirtyish."

I show a whole range of artists, from those of my generation to Ellsworth Kelly. The younger the artist, the more concern there was that this move to Chelsea was not a good idea. For a young artist, if your dealer is opening in some far West place where you think no one will go you say, "Yuck, do I have to show there?" The young artists don't realize SoHo was also an invention. You have to be old enough to have lived through it, to realize the center of the art galleries moves and it doesn't matter where it is at any particular time, e.g., Madison Avenue, 57th Street. But if you're a thirty-year-old artist, you can't see that there was ever a time when SoHo wasn't for artists.

My first show here in Chelsea was Ellsworth Kelly in October 1994 and, as an older artist, he was fine with the move. During the installation someone started talking to Ellsworth—in those days the street was completely empty. It was a reporter from the *New York Times* real estate section. The article quoted Ellsworth saying "It doesn't matter where the gallery is, it matters what the art is. I've been showing in New York for fifty years, uptown, downtown, Midtown and so on."

Researchers who study how innovations spread have stressed the importance, if the process is to succeed, of two key factors—individuals willing to take risk, and stars in the field willing to adopt the innovation (Rogers 2006; Zucker and Darby 2006; Clark 1984).[8] Chelsea's development as an art gallery district exemplifies this.

A few months after buying the Chelsea garage, Matthew Marks encouraged two friends who were star gallery owners in SoHo—Paul Morris and Pat Hearn—to move to Chelsea. With her SoHo lease expiring and the landlord seeking a steep increase, Pat Hearn had intended to move south to Chinatown, which in hindsight would have been a major wrong turn. But Paul Morris wanted a gallery near a museum like Dia, and Pat Hearn liked that idea too. So she and Paul Morris bought and divided a garage on West 22nd Street a few doors from Matthew Marks and opened in October 1994. Then in 1995 Paula Cooper, who had opened the first SoHo gallery in 1968 and was now a star owner, gave up on SoHo and bought an almost collapsed, two-story Chelsea garage at 534 West 21st, just one street south of Dia. She converted it into a two-story gallery with 7,550 square feet.

Despite this handful of pioneers, there was still plenty of skepticism in the art world about Chelsea's potential. A 1996 *New York Magazine* article described Chelsea as a place "even the cops are scared to go. . . . It's like Blade Runner on the Hudson." SoHo gallerist David Zwirner was dismissive. "First of all," he complained, "you should be able to take a train—the closest subway stop is the C and E line at 23rd and 8th Avenue." Later in 2002 Zwirner joined the rush to Chelsea.

Anyway, the first group of galleries was soon followed by another important group, which came to be known as "wave 2" of Chelsea's gallery growth, settling two streets north of the first wave. In 1997 Barbara Gladstone, whose ten-year SoHo lease on Greene Street was ending, together with Metro Pictures and Matthew Marks (looking to further expand), bought a 150-foot-wide garage at 515 West 24th Street and converted it into three galleries. In the same year Andrea Rosen and the co-owners of the Luhring Augustine Gallery purchased a garage at 525–531 West 24th Street and split the building. Several of these garage remodelings were designed by star architect Minimalist Richard Gluckman, including those of Paula Cooper and, later, Larry Gagosian.

By now, after the initial, risky leapfrog of pioneer galleries from SoHo to Chelsea, Chelsea's art gallery district was developing in a gradual ("organic") process with galleries (mostly from SoHo, a few from elsewhere) opening near each other on the current edge of the core expanding out from Dia on 22nd Street. From time to time a few courageous souls would venture in a "mini-leapfrog" to start "little gallery outposts" just two or three streets beyond the current core's outer border.

Learning from the SoHo rent-escalating debacle, now in full process, these first two gallery waves insulated themselves from the commercial rental market by buying their own buildings, sometimes in partnership with each other. Buying was feasible because Chelsea prices, per square foot, were far lower than SoHo's, and the buildings available for sale (mostly two-story garages) were far smaller, and therefore more affordable, than SoHo's grand, cast-iron buildings.[9] Anyway there was little alternative, since for the first few years after 1993 there was almost no rental market of buildings with landlords who had spaces suitable for galleries. The owners of Chelsea's many large warehouse buildings had not yet started to convert spaces there to gallery use.

That most of the early galleries, who were often stars or became stars, purchased their spaces gave Chelsea's gallery scene a solidity that SoHo's had lacked. As Lucien Terras, who opened a new gallery, D'Amelio Terras, in Chelsea in 1996, said in 2000:

> A big difference is that here in Chelsea, Mathew Marks, Paula Cooper, Andrea Rosen, Luhring Augustine, and Metro Pictures own their spaces. It will make this neighborhood more stable than SoHo. The landlord isn't going to say you can't stay anymore. Robert Miller was just kicked out of 57th Street because the landlord rented the space to Coach—they sell leather handbags.

(In late 2012 Terras, faced with rising rent in Chelsea, closed his gallery and joined David Zwirner's growing empire as a partner.)

Fig. 1.7. Gagosian's Chelsea Gallery, Richard Serra exhibition, 2006. Like several Chelsea galleries, Gagosian's gallery approaches in size a small museum. Photo by Elisabeth Tiso.

CHANGING IRONIES OF JOSEPH BEUYS

Signaling the growing importance of environmental art, in 1988 Dia commissioned a project by the artist Joseph Beuys for the street outside its new Chelsea location. Beuys lined 22nd Street between 10th and 11th Avenues with basalt (rock) columns, alongside which were planted young trees (fig. 1.8). The columns, according to Beuys, should be removed when the real trees are grown, and meanwhile, resembling volcanic rocks and recalling Paleolithic and Neolithic cultures, they underline the earth's age, basic elements, and what might happen if nature is not respected and renewed. Beuys belonged to Fluxus, a radical political group intent on moving art out of museums and galleries and into the social world, and aiming to change a system in which art is a product of a consumer society that needs paintings to decorate walls, exchange for money, or inject momentary, psychic uplifting. By contrast, "[real] art is," Beuys said, "a genuinely human medium for revolutionary change completing the transformation from a sick world to a healthy one" (*Quartetto* 1984, 106).

So it was ironic that Dia facilitated Chelsea's later development as a commercial gallery center, part of what Beuys and Fluxus disliked. Still, the ironies of Beuys's work changed as Chelsea evolved, as we will see. Another irony is that almost no passers-by these days, or probably from

Fig. 1.8. Joseph Beuys's basalt rock columns, each paired with a newly planted tree, part of his worldwide piece titled *7,000 Oaks*, first presented at the art show *Documenta 8* in Germany in 1987. The project plants trees all over the world with "a global mission to effect environmental and social change," as explained on Dia's website. Photo by Elisabeth Tiso.

the start, have an inkling of what these stones are intended to mean, still less that they are artworks.

SOHO'S RISE AND FALL AS A GALLERY NEIGHBORHOOD, 1959–1999

Most of the first and second wave of galleries coming to Chelsea were refugees from SoHo's commercial gentrification, driven out as their landlords realized they could get more rent from expensive clothing stores. It was not inevitable that it would be Chelsea that would replace SoHo as New York's dominant commercial gallery neighborhood for Contemporary Art, but SoHo's demise as a dominant commercial art gallery neighborhood was now inevitable. To understand this, and some important differences between Chelsea and SoHo as centers of Contemporary Art, it makes sense to briefly consider SoHo's rise and fall as a commercial gallery neighborhood, which spanned about forty years, from 1959 to 1999.

The most important difference between Chelsea and SoHo is that SoHo was pioneered by artists who came to live there, with the galleries following. By contrast, few artists moved to live in Chelsea when the galleries

did, since even if they had been able to afford it, the area of Chelsea to which the galleries moved was zoned manufacturing, so residences were illegal. This had also been true of SoHo, but for reasons discussed below it was not fully enforced there, and was then modified.

Stage 1, 1959–1971: Artists as Urban Squatters

SoHo's start as an art district began in 1959 with the announcement of a major government action: master builder and urban planner Robert Moses's intent to implement a plan, which officials had been discussing since the 1920s, to build a ten-lane Lower Manhattan Expressway, lined with huge apartment towers. This would have wiped out major sections of the industrial district that later became known as SoHo, and also parts of neighboring Little Italy and Chinatown. Years later many of SoHo's cast-iron buildings came to be prized for their aesthetic qualities, but almost no one expressed this view at the time. A 1962 study titled "The Wastelands of New York" observed that "there were no buildings worth saving" on Mercer, Spring, and Broome Streets, whose buildings should be replaced by high-rises.

At this point, artists—painters, photographers, sculptors, dancers, and others—moved into SoHo's apparently doomed cast-iron buildings, converting them to loft residential and/or work spaces. The artists saw that deserted factory lofts met their needs for large spaces and rock-bottom rents, while landlords found a group to pay rent, however little, for otherwise unmarketable spaces in run-down buildings. In a typical building, artist-tenants paid $67 per month for 400 square feet (i.e., $2 per square foot per year). The expectation was that when construction of the Lower Manhattan Expressway began, the artists would go. Their new SoHo spaces anyway violated the city's zoning codes, which allowed only manufacturing (M) there, not residential. Indeed, evictions of artists for living in SoHo illegally were common. When Christo and his wife Jeanne-Claude, who later became celebrity artists, moved to SoHo in 1964, they put a sign "Photo Studio—Do Not Enter" on their apartment door so the Buildings Department inspector would not barge in before they could conceal their bedding (Haden-Guest 1996; Bernstein 2010).

These expectations were overturned by the movement, in which Jane Jacobs played a prominent role, that opposed and finally in 1968 defeated the Lower Manhattan Expressway, a project which several of its opponents argued would "Los Angelize" New York City. Then in 1971 the Department of City Planning, responding in part to pressure from the artists, legalized their situation, changing SoHo's zoning to a special category of manufacturing—M1-5A and M1-5B, with the A and B designations permitting

artists to live there so long as the DCP had certified them as artists. Actually, this certification requirement was for years widely ignored, including by the DCP, so that anyone was allowed to live in SoHo, until around 2010, when a zealous Buildings Department inspector started to enforce the requirement.[10] So from 1971 SoHo lofts traded freely on the residential market, eventually turning several of the pioneering artists into real estate millionaires and partly laying the long-run basis for SoHo's demise as a gallery neighborhood, since loft owners could usually make far more money selling them as condos than renting them to art galleries. So SoHo involved a complex shift, partly from manufacturing to residential (somewhat like the High Line area) and partly from lower-end commercial (galleries selling art), to higher-end commercial (clothing stores, etc.)— that is, "commercial gentrification."

Stage 2, 1971–1981: The Golden Age; Galleries Move In

The first SoHo Artists Street Festival, held in May 1970, was a huge success, drawing many viewers and purchasers of art. After 1971, SoHo became an attractive location for a growing number of art dealers too, some of whom later became legendary. Even before 1971, a handful of pioneer gallerists had moved in. Paula Cooper, after working on the staff of an Upper East Side gallery, opened the first SoHo gallery in 1968, on Prince Street, which was high risk since the Lower Manhattan Expressway was still a real possibility, though she did not buy her space until three years later.

Looking back in 2000 after having joined the exodus to Chelsea, Cooper stressed three key aspects of SoHo in those early days: the sense of excitement, the camaraderie between young artists and young dealers, and SoHo as an incubator of new art styles:

> The first space I had in SoHo was in 1968; I had 10,000 square feet and paid $300 a month in rent [36 cents a square foot per year]. Artists were moving in illegally. I was very young, it was very inexpensive. Then in 1971 I bought a space in SoHo.
>
> I had started in New York in 1959 as a young staffer in a gallery uptown. I moved to SoHo because the space was more flexible. It was a very small world then with all the things that were happening—Abstract Expressionism, Pop Art, Minimal Art, performance art, and a terrific burst in the dance world at the end of the sixties and in the seventies, with Merce Cunningham. It (the art world) was interdisciplinary. That's no longer true. It's a huge world now; the art world is enormous, there are the fairs and so on, and far more specialized.

Starting a gallery is perfect for a young person. It's a very social life, you can have an idealistic approach. You're generally dealing with living artists, it's very challenging. We and the artists were contemporaries. They were beginning, so was I. Our children played together, we'd have big dinners. Nowadays, with the younger artists I show, I'm like a mother [Is it financially lucrative?] Not with the younger ones; it's a struggle.

SoHo then entered its Golden Age, with major dealers, artists, and customers all interacting in the same neighborhood, which had never happened before in New York and would likely never happen again. SoHo's roomy spaces fitted the requirements of much of the new art, such as allowing space for installations. SoHo too pioneered a new design for the exhibition space, namely the large white box or cube—art in a neutral space. At the same time, artists found that SoHo enabled them to sell directly to the public, circumventing the galleries if they chose to.

SoHo's open relation between artists and galleries extended to the audience, as SoHo's galleries pioneered a low pressure attitude that allowed the audience to feel comfortable just looking at art, not buying. This was "SoHo wandering," an attitude that Chelsea later developed much further. As Charles Simpson's classic study of SoHo's art scene put it:

> The ambience of SoHo galleries is in striking contrast to that prevailing in the uptown galleries, especially those which sell old masters. In the latter's salesrooms, the atmosphere is funereal. By contrast, SoHo galleries try to make art-viewing an unintimidating, secular experience. . . . SoHo wandering has become an alternative to museum going, an alternative with a social dimension. (Simpson 1981, 16–18)

Around this time, prices of Contemporary Art, which had been climbing rapidly (roughly 300 percent from 1982 to 1985, albeit from a low base), now rocketed roughly 1,000 percent from 1986 to 1989 in a classic bubble (fig. 1.9). SoHo's galleries mushroomed too, rising from 75 in 1982 to peak in 1990 at 262, which exceeded the combined total of all the established "Upper East Side" Madison Avenue area galleries (60th to 89th Streets with 136 galleries) plus all the galleries in the 50s (with 101 galleries).

Stage 3: Decline

Even in the midst of the boom, the seeds of SoHo's decline as a gallery neighborhood were being sown. Expensive boutiques with designer clothes began to open. These, with a far higher volume, tended to be more profitable than galleries despite the booming art market. Opening too

Fig 1.9. Prices of Contemporary Art, 1982–1994, in English pounds.

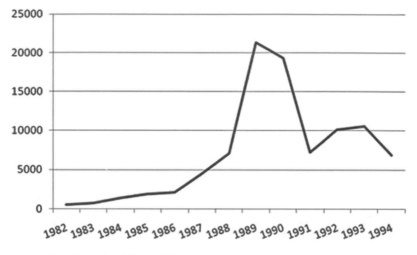

Source: Based on Ashenfelter and Grady 2010.

Note: The data, in English pounds, reflect the average price of each item sold at auction sales of Contemporary Art at Christie's London. Note that auction sales (i.e., of secondary, previously-owned works) are different from sales made by galleries (i.e., of new work). Data on gallery sales are closely guarded by galleries and almost never made public. Still, it is reasonable to suppose that the two kinds of data move very roughly in the same direction, which is why auction data are widely used in the art world as a rough proxy for the health of the art market.

were tourist trade developments such as Japanese, Chinese, and French restaurants. The manufacturing operations that remained (e.g., a boiler repair shop) gave a patina of "authenticity" that could validate a perception that SoHo retained some of its manufacturing history. Compare the prized "grittiness" that, later in the early 2000s, advocates of turning the Meat Market into a historic district said the waning meatpacking businesses conferred on the neighborhood.[11]

SoHo's False Decline: The East Village "Wrong Turn," 1981–1987

The East Village now made a brief mark as an art gallery neighborhood, challenging SoHo from the early 1980s to the mid-1980s, but fizzling when many of the important galleries that had moved there returned to SoHo. The East Village was an "overestimation" wrong turn.

As in SoHo, the artists moved to the East Village before the galleries did. A major impetus for the East Village's flowering was an explosion of

art school graduates in the early 1980s, many coming to New York from elsewhere attracted by the buoyant market for Contemporary Art. SoHo residential rents at that time were not especially high, but were not rock-bottom either, so many newcomers could not afford SoHo. By contrast, little or no capital had been put into the Lower East Side (which included the East Village) since the 1920s and in the case of some properties, since the 1880s (Abu-Lughod 1994).

This laid the basis for the opening of numerous commercial art galleries in the East Village in the early 1980s. Many East Village storefront galleries were begun by artists themselves and their friends. Already in 1961 Claes Oldenburg opened his *Store* there, in which he sat selling a range of ordinary objects—foodstuffs, lingerie, and so on—most made from muslin silks in plaster over a wire frame and painted with enamel, a defining moment in the emergence of Pop Art. Many galleries explicitly opposed SoHo's more corporate gallery model. The East Village also represented an explosion onto the art scene of new groups with a punk and political sensibility to the art. It also might have been the first time that gays and women had a major, serious presence in art.[12]

The East Village's undoing as a commercial gallery center was the steep decline in SoHo rents that followed with a roughly two-year lag the stock market crash of October 1987, when the Dow Jones fell 22 percent in one day ("Black Monday"). SoHo rents stopped rising from 1987 to 1989, and then fell sharply (around 25 percent) until 1993–1994 (fig. 1.10). A nation-wide economic recession followed, officially beginning in July 1990, and ending in March 1991.

Prices for Contemporary Art collapsed, losing roughly two-thirds of their value from 1989 to 1994 before leveling off (fig. 1.9).[13] As SoHo rents declined, landlords there courted art galleries from the East Village with lower rents. Meanwhile rents had risen in the East Village—partly because "vacancy decontrol" eliminated rent control on apartments that became empty—making SoHo rents seem more reasonable. By the late 1980s the East Village had failed as an alternative, and SoHo reasserted itself as the major art gallery neighborhood, until the mid-1990s.

SoHo's Real Decline, 1994–1999: "Commercial Gentrification" and Exodus to Chelsea

It was the economic recovery from the 1989–1992 recession that really undid SoHo as an art gallery neighborhood and pushed the galleries to Chelsea. This recovery triggered a long real estate boom in New York City. SoHo now became so desirable a place to shop and work that landlords

Fig. 1.10. Commercial rents: Soho, Chelsea gallery section, and Meat Market, 1990–2013.

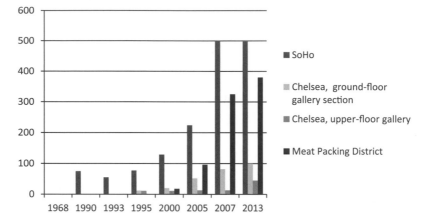

Source: Based on Molotch and Treskon (2009), supplemented with data from the Real Estate Board and our own data from a sample of gallery owners telling us what they paid for a new lease.

could command far greater commercial rents from high-end, relatively high-volume clothing boutiques than galleries, as Matthew Marks discovered in 1994. SoHo commercial rents rose roughly 140 percent from 1993 to 2000, and then roughly 290 percent from 2000 to 2007 (fig. 1.10). This was basically commercial gentrification. SoHo as a dominant art neighborhood now entered a near-terminal stage as the number of galleries fell to 218 in 1998, 72 in 2004, and 28 in early 2011.

The havoc wreaked by rising commercial rents, in the mid-1990s and later, on those SoHo galleries—the vast majority on commercial leases and not owning their spaces—is affirmed by interviews with gallery owners and managers who fled SoHo for Chelsea in search of affordable space. Their comments are replete with references to "greedy landlords/developers" who do not care about art. For example, Jim Kempner moved his gallery to a rented ground-floor space in Chelsea on 23rd Street in 1996: "I had a small gallery in SoHo, way up on the tenth floor," he said. "Then the landlord came in one day and doubled my rent! I thought 'I gotta get out of here!' So I came to Chelsea."

Miles Manning worked for the Danish Contemporary Art gallery in SoHo in the early 1990s. The DCA rented the ground floor of 420 Broadway, SoHo's most famous art gallery building, containing a star cast of gallery owners. Manning explained the perils of a gallery subject to the commercial rent market:

Our landlords (two Dutch businessmen) started coming to us in the second year of our lease, in 1997, to get us up to the fourth floor, but they really wanted to get us out. The DCA had a two-year lease with a three-year option beyond that. Meanwhile most of the ground-floor galleries in other SoHo buildings were closing or moving, because the fashion stores were moving in. We saw the handwriting on the wall. Mary Boone was across the street. She had the same landlord as we did. Her lease came due, they had a fight, and René Lazard, the German fashion designer, moved in.

There were twenty-eight to thirty galleries in Chelsea then. Finally the landlord said (to us), "We want you to get out. What will it take?" We said, "If you find us comparable space in Chelsea." They offered us $250,000, plus their realtor found this space for us. Here we have five thousand square feet and we're paying a third less than in SoHo. November '97 we opened our doors, and since then, all around us, more and more galleries have moved in.

We were lucky. One month after we got our deal, Leo Castelli and the others in the building heard that the landlords were going to rent out now vacant space to Esprit [the clothing chain]. They went wild. They served court papers to stop it on the grounds that in the lease they had the right to control the look of the building.[14]

Moving early was our luck. Otherwise our lease would have played out last year [2000] and the gallery would have ended. We wouldn't have been able to afford to move here. Survival stories in the art world are about knowing when to act and leave. Those who don't make it right end up as footnotes in history! [The DCA was eventually closed by the Danish Government in the mid-2000s, as the government decided to promote art abroad by giving grants to artists.]

Most gallery owners who fled SoHo for Chelsea commented on the changed SoHo audience in the mid-1990s and beyond, as high-end shoppers, whom gallerists mostly despised, now largely replaced those who came to look at the art. Paula Cooper described SoHo in 1995, the year she decided to move her gallery to Chelsea after twenty-seven years, as "gaggles of ladies with shopping bags!" Barbara Gladstone, who rented space for her gallery in SoHo from 1983 to 1996 until high rents drove her to Chelsea, commented:

When I moved to SoHo [from 57th] it was very quiet. Then once rents got so high [her landlord wanted to triple her rent], there'd be fifty people in the gallery, and no collectors, because the crowds were going from one shop to the next and didn't know the difference between a gallery and a furniture store. The real collectors couldn't get in. Anything is better than that.

Art Gallery Rental Buildings in Chelsea

Meanwhile, as Chelsea's reputation as a commercial gallery center grew, by 1996 landlords of the large warehouse buildings there began to package them as art gallery buildings, specifically cultivating galleries as tenants. This provided a rental market especially for smaller galleries on the upper floors. These galleries typically had limited resources, so landlords often chopped their upper floors into numerous modest spaces, which was one reason the number of Chelsea galleries could grow so large. Most landlords probably would have preferred to turn their buildings into residential condos, but Chelsea's manufacturing zoning forbade this. Even so, the art galleries were generally paying more rent than the dwindling band of older, manufacturing tenants.

For example, Gloria Greene and her husband had long owned a large building on West 26th Street which they originally used as a warehouse for a fashion merchandise business that they eventually sold. As early as 1995 she decided to open her own gallery in the building (located a mini-leapfrog of four blocks from the gallery core), and by 2000 they were renting space there to several other galleries. Looking back in 2000, she described how a few years earlier the Chelsea commercial gallery scene had been huddled around Dia on 22nd Street:

> When we opened our gallery here, Greene Naftali, in 1995, the only art gallery activity was on 22nd Street, where the Dia is. Matthew Marks, Pat Hearn, everyone made the Dia the center.
>
> People would say to us: "It's such a big distance to get to you from 22nd Street." I'd say: "It's only two blocks, you're a New Yorker, it's not like California where people drive everywhere." Then as soon as we had our gallery, people started opening galleries here. Now we have about twenty-five galleries renting in this building, and a lot more art-related businesses— architects, planners, designers. The Lelong gallery is coming from the Upper East Side and we have Robert Miller from 57th Street.

Around this time the owners of the huge, famous Starrett-Lehigh Building capitalized on the growing gallery scene, and then the dot-com revolution. Starrett-Lehigh is a nineteen-story landmarked brick-and-concrete Modernist structure, which rises like a multitiered wedding cake on the block bounded by West 26th and 27th Streets and 10th and 11th Avenues (fig. 1.11). (It was featured in the 1957 classic Cary Grant and Deborah Kerr movie *An Affair to Remember*.) Built in 1931 as a warehouse and manufacturing center, with railroad tracks streaming merchandise into the building's bottom floor from the river, it never fulfilled its promise. With the construction, by the newly founded Port Authority, of the

Fig. 1.11. The massive Starrett-Lehigh Building (far right, middle ground). In the mid-1990s it started renting space to galleries at bargain rates. Photo by Camilo Vergara.

Holland Tunnel (1927), George Washington Bridge (1931), and Lincoln Tunnel (1937), the Hudson River waterfront traffic and warehouses like Starrett-Lehigh that serviced it suffered severe competition from long-distance trucking.

Since Starrett-Lehigh was a few blocks from the core of the art gallery scene, commercial gallery rents there were roughly 50 percent lower than in buildings closer. Galleries that moved to Starrett-Lehigh in 1997 paid less than $12 a year per square foot, often for very large spaces, albeit on upper floors.

By 2000, however, as the dot-com boom neared its peak, rents for new leases in Starrett-Lehigh had quadrupled or more, going to $36–$60 per square foot per year. As well as dot-com companies, fashion leaders such as Ralph Lauren and Hugo Boss moved in. So did Martha Stewart, who caused excitement by habitually driving her SUV straight into the freight elevator and parking it next to her office, which occupied the entire ninth-floor, 150,000-square-foot headquarters of her company Omnimedia.

Conflicts broke out between the new dot-com or fashion tenants and older tenants, often holdovers from the manufacturing era. For example, Martha Stewart complained to management about noise from the tenth-floor tenant above her, a die-manufacturing operation, ABC Die Cutting. The plant's owner, who had been in the building for fifteen years and

was paying rent of just $6 a year per square foot, countered that Starrett-Lehigh's greedy new owners were using noise as an excuse to get rid of him before his lease expired.[15] "They suddenly claim I'm making too much noise," he complained. "At what point as rents rose from $6 to $40 did I start making too much noise?"

STAGE 3: CHELSEA ASCENDANT, 1998–2004, AND THEN DOMINANT AFTER 2004

By late 1998, four years after Matthew Marks arrived, Chelsea had seventy galleries and looked as if it had staying power as an art gallery district. For galleries who moved to Chelsea in this stage the risk was now less whether Chelsea was the right place (the "overestimation" wrong turn) and more about arriving too late in an ascendant gallery neighborhood (the "mistiming" wrong turn). The challenge was increasingly to find a suitable location within Chelsea. Few new arrivals could afford a hot spot, defined as next to or near star galleries, so they often had to take a space on the expanding periphery of Chelsea's gallery neighborhood and hope the art audience and other incoming galleries would follow and turn what was still an industrial quasi wasteland into a place for gallery hopping. They were also gambling that the part of Chelsea to which they moved would not attract more affluent uses such as hip retail clothing stores, allowing landlords to raise rents to levels unaffordable for most galleries.

Galleries that settled in outposts of the Chelsea gallery neighborhood north of Dia gambled correctly. For example, in 2004 a small group moved to ground-floor spaces at 617 West 27th Street and its next-door building, one block north of the gallery district's periphery. As with many of the earlier gallery moves to Chelsea, these relocations were network-related events. John Connelly moved to a ground-floor space there from an upper floor in Gloria Greene's gallery building on 26th Street, and then spearheaded Foxy Production's move to the ground floor of the large building in which his gallery was located. Wallspace, as part of this move, descended from an upper floor at 547 W. 27th Street to a ground-floor space on the same block. "It's a little outpost on 27th Street, a community," said Janine Foeller, Wallspace's co-owner. "We all support one another, from exchanging information to borrowing pedestals."

Even these galleries that colonized to the north would have lost their bet had Mayor Bloomberg succeeded in building the New York Sports and Convention Center (with the Jets football team), planned as a Hudson Yards megaproject around 33rd just beyond the northeastern border of the gallery area. There was widespread agreement from gallery owners that retail rents would have risen sharply in response to demand for stadium and

Fig. 1.12. Price growth for Contemporary, postwar, Modern, nineteenth-century, and Old Masters artworks, 1998–2013.

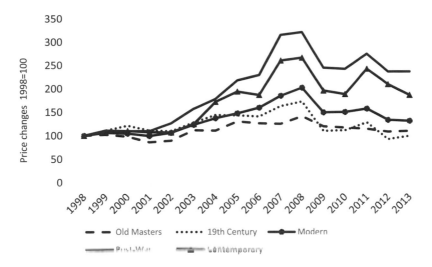

Source: Artprice, http://imgpublic.artprice.com/pdf/agi.xls?ts=2013-11-13%2004:50:49. The data show the average price of artworks sold at major auctions worldwide each year. Roughly, here Contemporary refers to works by artists born after 1945, postwar to works by artists born between 1920 and 1944, Modern to works by artists born between 1860 and 1919, nineteenth-century to artists born between 1760 and 1860, and Old Masters to artists born before 1760.

convention-related businesses, probably displacing galleries on this northern edge (and perhaps even in much of the Chelsea gallery district core further south, especially those renting). By 2013 the area was well established as part of Chelsea's gallery neighborhood, although now it was the developing Hudson Yards a few blocks north that was a major unknown, with the potential to drive rents to unaffordable levels for the galleries. Less fortunate than galleries that moved to the north of the gallery core was a group of galleries that ventured south from 1997 to 2002, opening an outpost in the Meat Market district on 14th Street between 9th and 10th Avenues. This was a risky, medium-size leapfrog from the core of the gallery district that ended badly for almost all of them as that part of the Meat Market neighborhood became "fashion central" and ground-floor commercial rents there rose 500 percent from 2000 to 2005, becoming twice as high as Chelsea ground-floor rents (fig. 1.10). Their landlord evicted them to make way for expensive clothing stores paying higher rents.

By 2004, the rush to Chelsea was in full swing. The market for Contemporary Art was buoyant. After a brief nine months of uncertainty associated with the 9/11 World Trade Center attack, prices doubled from

2002 to 2004 and then rocketed from 2007 to 2008, far exceeding price increases for Modern, nineteenth-century, and Old Masters, though the market for post–World War II art was even more buoyant (fig. 1.12). This art price bubble, finally deflated by the 2007–2008 financial crisis, looked rather like the bubble in US house prices during that time (Shiller 2008), as well as the 1982–1989 art bubble already described.

Chelsea now had the aura of the new dominant Contemporary Art district in New York, the location where almost any New York Contemporary Art gallery had to be. Illustrative is Theresa Chong, a well-established painter who exhibited in a gallery on 57th Street, but wished it were in Chelsea. She commented in 2004:

> I show in a gallery uptown. But everyone is moving here to Chelsea. There's a group mentality, every other week another gallery pops up here. I'd like to show in Chelsea myself. The Upper East Side is dead city. Before, 57th Street had its own life, the Fuller Building was full of activity when we were in school. But there are just a handful of galleries there now.

THE WILLIAMSBURG WRONG TURN

Many in the art world now decided that Williamsburg in Brooklyn, which for a while had been touted as the "next Chelsea," was instead just another wrong turn (the overestimation type). Williamsburg peaked in 2004 at just over 2 percent of all the New York galleries. By 2014, at 30, it lagged Bushwick's 49 (table 1.1).

Williamsburg took a major blow when a group of its best galleries relocated to Chelsea around 2003–2004, helping solidify Chelsea's dominance. Williamsburg's attempt to move from a small, cutting-edge gallery district to become the next SoHo or Chelsea had, in part, stumbled against the "not-Manhattan" factor, the reluctance of many in the New York cultural scene to frequently visit cultural institutions in the four "outer boroughs" of the city—the strongholds of what Manhattanites dub the "bridge and tunnel" crowd. Back in 2000 Klemens Gasser, a Chelsea gallery owner, predicted: "The artists may live in Williamsburg, but it's hard to have an artistic center outside Manhattan. The collectors won't travel far; they want to stay in Manhattan." One reason Williamsburg galleries moved to Chelsea was that they could rent a small, upper-floor space in one of Chelsea's big warehouse/industrial buildings at about the same rent, or even less, than a ground-floor (storefront) Williamsburg space.

A leading defector was Bellwether, one of Williamsburg's most promising art galleries, which moved to Chelsea in June 2004. Bellwether's owner, Becky Smith, explained:

I moved to Chelsea because its critical mass wasn't worth fighting anymore. The art world is in many ways incredibly inflexible. The last two shows in Williamsburg were the final straw. The art was so good, it killed me that hardly anyone saw those shows. You could say we were having "bridge issues" getting people to come. In Brooklyn we'd get just a hundred people a week, and three hundred at an opening. In Chelsea we get between one and two thousand a week and five hundred to a thousand at an opening. That growth in traffic has changed everything for us.

I couldn't have started anywhere but Williamsburg. It was a great place to experiment. But when I realized I had bigger ambitions, I couldn't stay.

Bellwether moved to a ground-floor space in Chelsea, though on the edge of the district, at 10th Avenue between 18th and 19th Streets, reflecting the dilemmas associated with arriving late in an ascendant gallery district. The rent was $49 a square foot per year ($9,500 a month for 2,300 square feet), almost three times what Smith had paid in Williamsburg for a similar space.

THE GALLERY HIERARCHY—STARS, OWNERS, AND RENTERS, GROUND-FLOOR AND UPPER-FLOOR—AND INSTABILITY

By 2005 a Chelsea gallery hierarchy had crystallized, consisting of three economic/ownership tiers. The third and least-favored tier consisted of upper-floor galleries that paid rent, generally in a large converted warehouse or manufacturing building, often now marketed by its landlord as a "gallery building." These galleries were mushrooming, which spelled potential for economic destruction as they risked expanding beyond a viable customer base. The second economic tier was galleries that paid rent in these same buildings, but on the ground floor. The first, and most favored, tier was ground-floor galleries that owned their own spaces, usually in converted garages. Most in this tier were "star galleries," as measured by reputation in the art world (as were a few of the galleries who rented ground-floor space).

Upper-Floor Galleries

The upper-floor/ground-floor divide was a major feature of Chelsea's gallery structure. The relatively modest rents paid by upper-floor galleries provided an opportunity for almost anyone to try being a gallerist. A 1,500-square-foot space for from $8 to $24 per square foot per year in 2005 involved rent that, averaging $2,000 a month, was

comparable to a residential studio. This, together with the booming art market and Chelsea's reputation as the dominant gallery neighborhood for Contemporary Art, was a major reason why the number of Chelsea galleries exploded, as would-be art entrepreneurs saw a chance to run a creative business.

Still, their relative inaccessibility became an increasing problem for upper-floor Chelsea galleries. As the number of galleries grew, the "gallery hopping" audience could more than exhaust their curiosity with the ground-floor galleries. By 2007 almost all the upper-floor galleries complained about the difficulties of attracting an audience. For example, a member of the Blue Mountain Gallery, a thirty-artist co-op venture on West 25th on the fourth floor, commented:

> When we first moved here in 1999, there were only nine galleries on the entire street. Now there are nine gallery buildings on the street, each full of galleries! When things multiplied, being on the fourth floor was a challenge. People said "I'm going to see galleries on 24th, 25th, and 26th Streets," and they could see all the ground-floor galleries without ever going to upper floors. So it was harder to get people up here.

Indeed, galleries renting on upper floors perfectly exemplified the economic textbook theory of perfect competition, which holds that if firms are free to enter a particular market and the costs of doing so are low, the number of firms will expand until the rate of profit each earns drops to zero or thereabouts. In this sense the major economic problem facing small, upper-floor galleries was, at least until 2011, less that of "greedy" landlords raising rents and more an influx of competitors reducing already slender profits. After 2011 as the surrounding area (High Line, Meat Market) boomed, nongallery businesses increasingly moved in too. For example, designer Stella McCartney set up her workshop ("atelier") in an upper-floor space, and by 2012 upper-floor rents were double their 2007 levels. At this point upper-floor galleries began complaining about avaricious landlords too. As one commented: "These days landlords here think they own gold, and probably they do." This was the process of commercial gentrification, as businesses able to afford higher rents displaced galleries that could not.

Ground-Floor Renters

Ground-floor galleries had the enormous accessibility advantage that often customers could, from the street, see what was being shown, and walk right in. Still, being a ground-floor gallery paying rent in a large gallery building was not easy. The obvious disadvantage was the high rents. The

price per square foot was often three to five times that of an upper floor, and the ground-floor spaces landlords offered were typically three to four times larger than upper-floor spaces, making for a far bigger overall rent bill.

Being subject to the full force of the commercial real estate market put these galleries, which tended to be those that came to Chelsea after 2000, under strong economic pressure. As Stefania Bortolami, who, after serving as director of Gagosian's Upper East Side gallery, opened her own gallery on a ground floor, commented:

> If you open a ground-floor gallery, you'd better commit your life to it, because you have to pay the rent. You can open on an upper floor from 3 p.m. to 6 p.m. and have a show every two months, and have a real job somewhere else. That is different from being open six days a week. Ground floor means commitment.

In 2001 the CUE Art Foundation moved into a prime, 5,000-square-foot ground-floor location at 511 West 25th Street, and signed a five-year lease paying $21.60 per square foot per year, with fixed annual increases. In October 2006 the foundation agreed to a new lease at $40 per square foot per year, an 85 percent increase in five years. CUE's executive director commented:

> The best thing about us is our space/location and the worst thing about us is our space/location. During the last lease extension we talked about staying or moving. We decided on staying another five years until 2012. Still, our annual rent is now $198,000 and we have 5,000 square feet with a 3 percent increase each year.

By 2012 average ground-floor gallery rents had roughly doubled compared to 2005, reaching $100 per square foot. Ground-floor galleries were now competing for rental space with the growing fashion and high-tech sectors. Chelsea landlords were increasingly now granting only short-term leases, as they bet that the High Line's success would turn the area into a gold mine akin to Madison Avenue or West Broadway in SoHo.

Star Galleries

The concept of a star gallery is explicitly used in the art world. A smallish group of galleries have reputations placing them at the top of the hierarchy in a class of their own. We identified seventeen star Chelsea galleries in 2009. For objectivity, the list was selected for us by two experts. A different group of experts would probably not have picked an identical list, but we believe there would be agreement on the vast majority in the list, and certainly on the top ten. The star galleries included Paula Cooper, Matthew

Marks, Barbara Gladstone, Larry Gagosian, Metro Pictures, Robert Miller, Marlborough, Mary Boone, Andrea Rosen, Luhring Augustine, James Cohan, Pace Wildenstein, Cheim & Read, Galerie Lelong, Sonnabend, Marianne Boesky, and David Zwirner. (See figure 1.3 for their locations.) We added the Swiss gallery Hauser & Wirth when in 2013 it opened a 23,000-square-foot megagallery on West 18th Street.

Of these eighteen star galleries, all but four owned their spaces in one- or two-story structures that were mostly converted garages, which meant that they had typically moved to Chelsea early enough to be able to find, buy, and convert a building before the supply of affordable properties dried up. Only four star galleries moved to Chelsea after 2000. They were Galerie Lelong, which moved in 2001, David Zwirner in 2002, Marlborough in 2007, and Hauser & Wirth, all of whom initially rented ground space, though David Zwirner graduated to ownership. Hauser & Wirth's 2013 lease has an eviction clause after five to six years, since landlords now view the spaces next to the High Line as explosively lucrative.

Zwirner's case illustrates the combination of luck, capital, and willingness to risk that a gallery coming late to Chelsea needed to purchase a ground-floor space. Zwirner opened a gallery in SoHo in 1993, and although long skeptical of Chelsea's potential, he finally moved there in 2002, renting space in a two-story building not then for sale, in an off-center location at 525 West 19th Street, south of the main action. Then in 2003 the global Internet corporation InterActiveCorp (IAC) run by Barry Diller announced it would locate its headquarters across the street and construct a glamorous, huge building designed by star architect Frank Gehry, which opened in 2007. Meanwhile in 2006 the building next to Zwirner's gallery, previously occupied by a film company, became vacant, and Zwirner had enough capital to buy it, for roughly $6–$7 million. Then the space next door, formerly occupied by a factory, became vacant, and Zwirner rented it. Then in 2013 he opened on the next block a 30,000-square-foot, five-story megagallery designed by starchitect Annabelle Selldorf, selling pre-owned (secondary) works. This real estate prowess hugely boosted his reputation for business acumen, making him the only dealer possibly in the same league in that respect as the now legendary Larry Gagosian. Zwirner's Chelsea footage is now almost double the 26,000 square feet of Gagosian's main gallery on West 24th Street (though Gagosian added a new 9,000-square-foot showroom on West 21st Street). For comparison, as of 2013 the largest single gallery in the world is White Cube's 58,000 square feet, the size of a football field, in South London (Crow 2013).

As these cases show, several star galleries opened more than one space in Chelsea. In 2004 *New York Times* arts writer Carol Vogel commented:

Not since the 1980s have so many galleries had multiple addresses, and most of the additional locations are, not surprisingly, in Chelsea. For big uptown galleries, a Chelsea presence is de rigueur, as exemplified by the downtown emporia of Gagosian, Mary Boone and PaceWildenstein. For some galleries, one Chelsea showplace is too few: the venerable Paula Cooper has two spaces. Another early Chelsea dealer, Matthew Marks, has three.... Adding branches and off-site project spaces is just one more way the big galleries act like museums.

By 2013, six of the star galleries had more than one Chelsea space—Matthew Marks and David Zwirner led with four each—giving some people the impression that a handful of star galleries were driving to become so dominant as to "own their block."

THE INSTABILITY OF GALLERIES

The business of running a gallery was always precarious. The trend line (fig. 1.1) showing Chelsea galleries increasing from 1995 until the 2007 recession-related bumpiness conceals a strikingly high turnover rate. Of the 128 galleries in Chelsea in 2000, fully half had already gone by 2006, even before the recession, and while a few of these moved elsewhere or remade themselves with a new name, the vast majority just failed. High turnover is, of course, typical of small businesses generally, a third of which fail within two years, while only 31 percent survive at least seven.[16] The failure rate of Chelsea galleries was comparable.

This churning of Chelsea galleries included an influx of new galleries which more than made up for the losses. Even the losses associated with the 2007 financial/economic crisis had been replaced by early 2012. Opening a Chelsea gallery is clearly an attractive idea to many people. As András Szántó has said, a start-up gallery is often simpler than a mom-and-pop store, basically run with an owner plus one or two interns.

A seminal closing came when Becky Smith shuttered Bellwether in 2009, six years after the gallery's heralded move from Williamsburg discussed earlier. Another came a year later as Goff & Rosenthal closed their gallery, with Robert Goff moving to run the Christie-owned gallery Haunch of Venison, which had just moved to Chelsea.

HURRICANE SANDY

When Hurricane Sandy slammed into New York at the end of October 2012, a ground-floor location was a major problem, since Chelsea

Fig. 1.13. Flooding from Hurricane Sandy, October 2012.

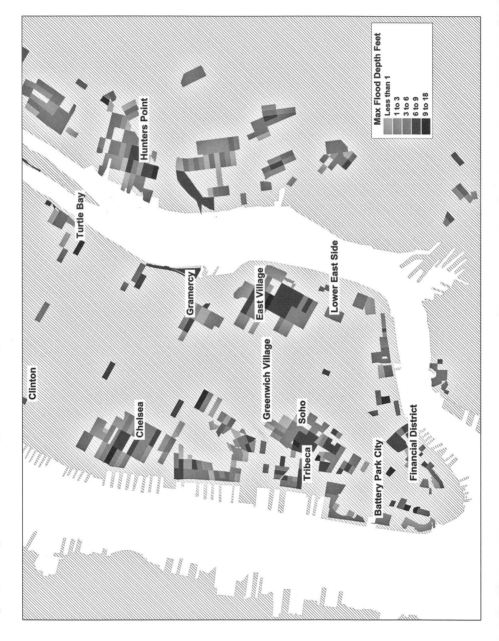

Max Flood Depth Feet
Less than 1
1 to 3
3 to 6
6 to 9
9 to 18

Clinton

Turtle Bay

Hunters Point

Chelsea

Gramercy

East Village

Greenwich Village

Lower East Side

Soho

Tribeca

Battery Park City

Financial District

suffered enormous flood damage (fig. 1.13). For example, Wallspace, Foxy Production, and several of their neighbors on 27th Street, were entirely flooded, as was David Zwirner's basement. Zwirner had the resources to recover very quickly, but Wallspace and the other galleries there did not reopen until January 2013 (Russeth 2013). In June 2013 New York City proposed a comprehensive set of measures to better protect vulnerable areas of the city from future floods, and, though these will take at least ten years to fully implement, will cost at least $19 billion, and will depend on the city's shaky ability to implement megaprojects, for now flooding issues seem unlikely to destabilize Chelsea (NYC 2013).

CORPORATE CHELSEA?

After the mid-2000s, the accusation was increasingly made that the Chelsea gallery world was too "corporate," money-driven, and market-oriented. *New York Times* art critic Roberta Smith reported that this view had already surfaced by 2004:

> The inevitable anti-Chelsea backlash has been on the rise, too. The rap against Chelsea is that it is too big, too commercial, too slick, too conservative and too homogenous, a monolith of art commerce tricked out in look-alike white boxes and shot through with kitsch. . . . As the Lower East Side gallerist Michele Maccarone put it recently: "The Chelseafication of the art world has created a consensus of mediocrity and frivolousness." (Smith 2004)

This charge, which surfaces repeatedly in the art world in other contexts and times, was only partially true for Chelsea, and, if left at that, basically misleading. The Chelsea gallery world, and the art market generally, was far more complex, multifaceted, and interesting than this.

Corporate Chelsea

It was true that at least some star Chelsea galleries were in expansionist mode. Also, they were now vying with museums, mounting often elaborately curated exhibitions in large, ground-floor spaces with very high ceilings that gave little hint of the garages they had replaced. This trend to resemble museums did not start in Chelsea. It was, for example, already apparent in the SoHo galleries, some of which, such as Leo Castelli and Sidney Janis back in the 1960s, often provided expensively produced catalogues with each gallery show, as did Gagosian's East Side gallery. Still, the trend to mount museum-quality shows became more pronounced in Chelsea, plateauing with Gagosian's exhibition of Richard Serra's massive steel beams

(fig. 1.7). The 2013 Serra show included 367 tons of steel, with several forty-foot-long beams, requiring a six-week installation (Crow 2013).

The work of some Chelsea artists was very expensive to produce, creating an entry barrier so young artists could not compete on that terrain. Jeff Koons's art is well known for its production costs. Other examples include Yale photographer Gregory Crewdson, who hires actors to simulate interpersonal dramas set in small-town America which he photographs at a cost of from $50,000 to $100,000 per show; Damien Hirst, who employs an array of assistants; and the British artist Tony Cragg, who, in 2010, had a full-time staff of twenty, including fifteen skilled tradesmen to produce his sculptures (Thornton 2010a). Artprice's 2007–2008 overview of the art market was caustic about such changes in sculpture:

> Today, the type of sculpture that sells for millions is a far cry from the classical conception of the 20th century art expressed by the "moderns" like Brancusi . . . or Giacometti. In the past, the verb "to sculpt" meant hewing, carving, chipping away or scratching, in other words removing mass to reveal an image. Today's big names on the art scene conceive their works and then, to build them, they mobilize an entire workshop in which a wide variety of techniques, materials and dimensions are explored. . . . The monumental compositions . . . in steel by Richard Serra are the perfect expression of the expansion of this artistic medium. . . .

Although artists with superhigh production costs were outliers in Chelsea too, they fueled a perception that the Chelsea gallery scene, often viewed as a proxy for the most successful Contemporary artists, was expensive and "corporate."

Noncorporate Chelsea

Galleries as Free Museums or Shows

Several features of Chelsea were distinctly at odds with the idea that it was "corporate." First, the lavish shows that star Chelsea galleries mounted were free, unlike New York museums, which typically impose an entry fee (in 2012 the Museum of Modern Art charged $25, about the highest in the nation). Gallerist Barbara Gladstone's comment that Chelsea's galleries offer "one of the best free shows in town" was repeated in various ways by many owners. Andrea Rosen argued, plausibly, that this constituted a radical shift in the relationship between gallery and audience:

> The wonderful thing about Chelsea is that there has been a change in the public's attitude to the art. The spaces are accessible. Galleries are free,

unlike most museums. On a typical Saturday a thousand people come through the gallery. Sometimes I say to friends who haven't been here before, "Why not come by the gallery?" Often they're hesitant; they're thinking of the older galleries, where they're expected to buy.

"Collectors" (i.e., those considering buying the art) have the option of separating themselves from the rest of the audience by attending special previews, as do reviewers and critics. They are often contacted by the gallery owner or staff individually before the show opens, with information about works that might interest them. As a result, all, or almost all, the audience in a gallery at any particular time during a show's life are just there for a "free show," as interviews presented below revealed.

Hence Chelsea galleries have a dual role. To the traditional role of the gallery as a place where art is sold has been added the role of the gallery as a place where huge numbers of people can view Contemporary Art, with no obligation to buy or pretend that they might.

Our interviews with a sample of the audience confirmed that the vast majority come to look, not buy. Illustrative are a random sample of twenty-five spectators who came to an exhibition of drawings and sculpture by Claes Oldenburg and Coosje van Bruggen at the Paula Cooper Gallery, in May 2004. The show consisted mostly of small drawings, watercolors depicting food, done on lined paper in Oldenburg's sketchbook. Being small drawings, these were selling for about $15,000, far less than art usually sells for in Chelsea star galleries. So the audience for this show could be expected to be somewhat more inclined to purchase art than the average. (There were also three large, expensive, sculptural items in the show, including a pair of eight-foot blueberry pies, each on a boule of ice cream, priced at $500,000 for the pair.)

Three-quarters of the audience sampled said they never bought art and just came to look. Of the rest, only two bought art on a regular basis. Indeed, for about half the audience, the question whether they came to buy elicited satirical comments on their financial state, as in the following examples.

A female professor of speech pathology at Lehman College, with her husband and another male friend: "No we didn't come to buy; unless the price is in the two digits." (The group laughs heartily.)

A married couple, a photographer and a designer, who live in Greenpoint, Brooklyn: "We come to look, not to buy. We're living in Brooklyn." (Both laugh at the implication that they would not be living in Brooklyn if they could afford to buy the art.)

Of the two collectors in this sample, only one was considering buying anything here. He was a man in his midforties who identified himself as

a "collector" of "Modern and Contemporary Art." He was there with his "art advisor," who explained that she was taking him to as many galleries as they could fit into the next forty-five minutes. His chauffeur was waiting outside. After five minutes in the gallery the pair hurried off. Indeed, this was the only person in all of our audience samples who was actually considering buying an item in the current show.

Four of the audience interviewed bought art occasionally, but never in Chelsea at these prices. Like almost everyone else, they were here just to look.

These findings raise the question of how far providing a free show for almost all the audience was economically rational for the gallery. The answer is unclear. One argument is that packing in viewers, even if almost none intend to buy, creates a buzz about the works and the artist (with "buzz" defined as a generally favorable word of mouth). This then filters to the critics, increasing the likelihood they will review and review favorably, and therefore that the collectors and their art advisors will buy. Several studies have confirmed the importance of buzz in the sale of creative goods generally, not just artworks. Summarizing much of the data, economist Richard Caves (2000, 181) wrote:

> Word of mouth is a far more powerful transmitter of information on creative goods than on goods that lack their cachet as a social catalyst. . . . No wonder that a "buzz"—a critical mass of favorable, or at least involved, discussion—is treasured among those who promote the sale of creative goods. . . .[17]

A second argument for the economic rationality of putting on lavish free shows was that it was a crucial part of the way galleries wooed, and kept happy, the best and most successful artists, who wanted their work to be seen by as many of the general public as possible. Pace Wildenstein's chief curator argued:

> The shows are basically for the artists. Most of the collectors make appointments to see the works, and then a lot of works sell at the opening. The rest of the show is for the artists. All artists want their work to be seen by as many people as possible. They are alone in their studios for two or three years. And the shows get reviewed.

Gallerist James Cohan (2011) commented similarly:

> Ninety-nine percent of the people who go to a gallery will never buy, but the artists would be desperately unhappy if we just sold their work and didn't show it.

A third point is that mounting free shows indeed might not be fully rational from the economic perspective, but simply evolved in an unplanned way.

In any case, this shift in the function of the gallery was institutionalized in current gallery practices. The typical star Chelsea gallery has an unobtrusive reception desk well to the side of the entry so that viewers can walk straight into the gallery, without feeling any need to interact with the person at the desk. Almost never do gallery employees make the classic "Can I help you?" sales approach. The desk usually contains helpful explanatory materials about the artist. Typically in a back room are other offices, including the owner's. In short, the experience of walking around the gallery resembles the unpressured experience of walking around a museum with the bonus that, unlike the typical museum, there is no entry fee.

Avenue for Artists

Another problem with the view that Chelsea is now corporate is that the artists we interviewed there did not see it that way. A sizeable number of artists appeared in our random samples of the audience attending Chelsea shows. They too were almost all there for a free show. We asked them, as we did all the audience members interviewed, an open-ended question about their general opinion of Chelsea. The overwhelming majority of the artists made comments contrasting Chelsea favorably with New York's museums as possible venues for exhibiting their work. They said that the huge number of Chelsea galleries made it far easier for them to get their work displayed than in a museum. For them Chelsea was in that respect a welcome avenue of freedom and artistic mobility. Not one artist expressed the view that Chelsea was corporate or restrictive.

Of course it is possible that artists who believed Chelsea was corporate and restrictive stayed away. Still, an ongoing study of artists in Bushwick, Brooklyn, a neighborhood full of aspiring artists and galleries, found little evidence that the artists there viewed Chelsea as corporate and uncreative. Rather, it was where they generally aspired to show their work, with Bushwick as a stepping-stone to that goal (Robinson and Halle 2010).

Diversity Compared with Museums

A related theme that emerged in the interviews with the audience—artists and nonartists—was that the art and artists shown in Chelsea were far more diverse than those in New York museums, which the Chelsea

audience tended to see as fairly uniformly displaying the canon of successful Contemporary artists. Chelsea, by contrast, was viewed as also displaying the work of new artists who had not yet, and mostly never would, become stars.

Consider, for example, these comments from audience members at a February 2005 show of the work of the British artist Marc Quinn. A woman in her midthirties, who curates the Brigham Young University Museum and was on her second visit to Chelsea:

> I prefer going to Chelsea than to museums. There's more interesting things happening and more diversity, rather than the "Canon of Contemporary Artists" which you get at museums. Here you can see it all. You can go and see Calder [on display at the Gagosian Gallery next door] and established artists, and then you can see artists that are fresh out of school.

A male Brigham Young University sociology student who was visiting New York for the first time:

> Chelsea? It's fantastic. I've just visited the major museums in the last two days. There's greater exploration in Chelsea. MoMA and the Whitney and the Met and all the big museums just show the same artists. Here there is greater variety.

A subcategory of this diversity argument was that star Chelsea galleries were far freer to show "controversial" art than New York's museums, which typically receive public funding and are therefore vulnerable to political attack and need to be careful.

A final, and central, reason why the corporate-Chelsea view is too simple is that it implies that the attraction of the art for the audience, including the collectors, is primarily its financial value as an investment. This is not true, as the next chapter shows.

In part, the charge that Chelsea was corporate and uncreative seemed a branding strategy by cultural institutions trying to challenge Chelsea's domination, especially those in the upcoming Lower East Side.

"GLOBALIZATION" AND THE CHALLENGES
TO THE COMMERCIAL GALLERY MODEL

"Globalization" is a term often used very loosely, as a number of analysts have complained (Quemin 2006 and 2012; Mann 2004 and 2012). This term can be defined, very generally, as "a highly accelerated movement of objects (goods, services, finance and other resources, etc.), meanings (language, symbols, knowledge, identities, etc.) and people across regions and intercontinental space, . . . [in other words] processes of time-space

compression" (Anheier and Isar 2012, 10). Yet radical compressions of time and space are not new, so this broad definition is only helpful if "time" and "space" are specified and placed in a historical context. This is another way of saying that several stages of "globalization," each marked by distinctive time-space compressions, have preceded the current stage.

So what is distinctive about the current stage of globalization? It is clearly marked, in part at least, by the Internet and associated technologies which drastically compress time and space and are certainly potentially truly global. Globalization's current stage is also marked by a specific spatial change involving the emergence of China (and to a lesser extent India, Russia, and Brazil). This underlines that it is not illuminating to label as "globalization" every spatial movement that goes beyond national borders. Instead, it makes sense to distinguish a hierarchy of spatial relations ranging from those that are "international" (between two or more countries), "macroregional" (between several countries but confined to one or a few regions), and truly "global" (extended over most of the world).[18] The rise of China (and possibly India and Russia) represents a macroregional development, as these regions of Asia have become important players in the art world.

At the same time the question of globalization needs to be asked for several aspects of the art world, including use of the Internet, major art fairs, and the artists' place of residence and birth, with the possibility of a somewhat different answer for each aspect.

Overall, a careful analysis of globalization in the art world, in the context of challenges to Chelsea, shows some important new developments while moderating some of the more sweeping claims.

The Galleries and Globalization

Most star Chelsea galleries have outlets in at least two countries, but if "globalization" refers to operating on at least three continents, then in 2014 only two star Chelsea galleries are global, Gagosian and Pace. Gagosian leads, with fifteen galleries on three continents (North America, Europe, and Asia), including galleries in London (two, plus a third opening in 2015), Paris (two), Rome, Athens, Hong Kong, New York (two in Chelsea, three Upper East Side), and Los Angeles (Beverly Hills). Announcing the Athens opening in 2009, Gagosian claimed his was "one of the few galleries that can claim a truly global reach," though with just one Asian gallery and none in Latin America or Africa, some might question if even Gagosian merits the term "global." Pace has four New York galleries (three in Chelsea), two in London, one in Beijing, and one in Hong Kong.

The limited extent of the globalization of Chelsea's galleries fits French

sociologist Alain Quemin's skepticism about applying the term too loosely in the art world. He argues that, despite huge increases in international mobility:

> the world of contemporary art . . . has a center of gravity which revolves around a duopoly formed by the US on the one hand and a small number of Western European countries on the other hand, notably Germany, the UK, France, Italy and Switzerland. In addition, China is a major new presence. By contrast with this western centered duopoly plus China, is an 'artistic periphery' that consists of the remaining countries. . . . India and Russia are of growing importance, but have not yet moved from the "artistic periphery" to constitute centers in their own right." (Quemin 2006)

The Artists and Globalization

We analyzed the place of birth and current residence of all the artists on the roster of star Chelsea galleries, and all the artists on the roster of our sample of upper-floor galleries. The data confirm a duopoly. For the star galleries, 59.7 percent of the artists reside in the United States and 27.5 percent in Western Europe (table 1.2). Within these two regions there is considerable concentration. Of the artists resident in the United States, 62 percent are in New York City and another 12 percent in the rest of the New York region. Twelve percent reside in the Los Angeles region, which is the largest concentration outside the New York region. Of the artists resident in Western Europe, fully 90.2 percent are in just four countries, Germany, the UK, France, and Italy, in that order. Artists residing in China and India, the two best-represented Asian countries, are still a smallish minority of all the artists, 5.4 and 0.2 percent respectively.

The data on where artists were born confirms the same general picture but shows more geographic diversity than the residence data, since there is clearly a tendency for artists to move to certain artistic centers. For example, 4 percent of the artists on star gallery rosters were born in Russia, but none lived there in 2011. Seven of the seventeen star galleries included at least one artist born in China (data from same analysis as table 1.2). Pace and Mary Boone led with three Chinese artists each, followed by Marlborough and James Cohan with two each. Only three star galleries had an artist born in India on their roster, and none had more than one.

The data from a sample of upper-floor galleries (not shown here) also confirm a duopoly, with 53 percent of the artists residing in the United States and 19 percent in Western Europe. Again, there is considerable concentration within these two regions, with 69 percent of the US artists residing in New York, and 90 percent of the Western Europe artists residing

Table 1.2. Place of birth and current residence of all artists on roster of Chelsea's star galleries, 2011

Region	Place of birth	Current residence
United States		
New York City	5.4	37.3
NY region (outside NYC)	12.3	7.4
Northeast (outside NY region)	4.5	0.0
Midwest	7.1	0.8
South	6.9	2.0
Los Angeles	4.4	7.4
California (outside LA)	3.8	2.3
West (outside CA)	3.5	2.5
TOTAL United States	47.9	59.7
Western Europe		
France	2.5	4.5
Germany	9.2	9.3
Italy	3.2	2.8
Netherlands	2.1	1.6
Switzerland	1.3	1.0
United Kingdom	7.1	8.3
TOTAL Western Europe	25.4	27.5
Eastern Europe	1.9	0.8
Russia	4.0	0.0
China	2.8	1.4
India	0.5	0.2
Latin America and the Caribbean	4.0	2.5
Australia and New Zealand	0.9	0.4
Africa	1.3	0.2
Other	10.4	6.8

Note: The current-residence column includes only living artists, but counts them as in multiple locations if they have more than one place of residence.

in five countries (the UK, Germany, France, Italy, and Spain). Almost none of the upper-floor galleries sampled had artists residing in Asia, partly because the cost of shipping (and insuring) the works is enormous. Two exceptions are galleries that specialize in Chinese and Indian art respectively, and so draw all their artists from there.

CHALLENGES TO CHELSEA'S COMMERCIAL GALLERY MODEL

The art world is in flux, and three major developments are challenging the commercial gallery model dominant in Chelsea, though none has yet

displaced it. These developments are the Internet, art fairs, and competition from the mega auction houses, especially Sotheby's and Christie's, and recently in Hong Kong. These developments also bear centrally on the question of "globalization" in the art world and its extent.

The Internet: Saatchi Online, Artsy, and Amazon Art

The Internet, and the revolution in retail selling it has triggered, is the most seemingly potent challenge to Chelsea's commercial gallery center. Before discussing this in detail, there is one widespread use of the Internet for selling new art that is not a radical threat to galleries. This involves galleries sending their clients electronic images (such as jpegs) of new work by an artist with whose previous work the client is already familiar (e.g., through an earlier purchase or visits to gallery shows or art fairs). Here the electronic image has simply replaced the mailing of slides. It is thoroughly embedded in the process whereby a client who already has a relationship of trust with a gallery, and has physically seen other work by an artist represented by that gallery, builds on that to purchase a work seen only electronically. This does not undermine galleries.

The Internet use that threatens the commercial gallery model involves artists or others selling art, viewed on a dominant website, directly to purchasers without the traditional mediation of a physical gallery.

How far this use will lead to the demise of physically located galleries as intermediaries between artists and purchasers is unclear.[19] The two forces that explain the emergence of a dominant commercial gallery concentration such as SoHo and then its successor Chelsea push in opposite directions here. The first force, purchasers' desire to see a wide range of products in one central location before making a decision, suggests that the Internet could be the future if a dominant, online site emerges offering huge numbers of works for sale. It could replace, at a higher level of agglomeration, such sites as a dominant gallery neighborhood like Chelsea where viewers can gallery-hop year round but need to be physically present, or international art fairs where viewers can see a range of galleries and their products from around the world whose breadth even Chelsea cannot match, but again only if the viewer is physically present and only for a few days a year. The Internet, by contrast, presents the possibility of a single megasite where a mass of artworks is viewable and purchasable anytime and without requiring the viewer's physical presence.

Yet constraining the Internet's triumph over physically located commercial galleries is the second force that underpins the emergence of dominant gallery neighborhoods, as well as art fairs, namely, the need to see the artwork in person. Artworks are highly differentiated—almost every

work is unique—and many of the factors that differentiate them cannot be adequately grasped, at least given current technology, unless the work is viewed in person and in far more detail than the Internet currently makes possible. (Some works are, of course, reproduced as limited-edition prints or photographs, but even here the print or photograph typically needs to be viewed in person at its full size.) This is the Internet's limitation as a way of selling art. As a result, it has so far mostly complemented (e.g., by triggering preliminary interest in a work, or by screening artists for display in actual galleries), not undermined, physical galleries as a way of selling art.

The tensions between these two features of online art sales, one (collecting many works in one location) enhancing, the other (the need to view the works in person) constraining, online sales, are apparent in two of the earlist major attempts to sell art over the Internet. These consist of Eyestorm, during the dot-com explosion, and Charles Saatchi, iconoclastic and innovative as always, with his site Saatchi Online (2005–2010). Both attempts seemed promising, but a major problem has been the viewer's desire to see the art in person and in detail before making a purchase. Neither steadily gained momentum. All these sites face the daunting problem of persuading collectors to buy new art, with which they are unfamiliar, without viewing it in person.

Eyestorm's Failed Attempt to Replace Physical Galleries with Virtual Galleries

The first serious effort to sell Contemporary Art online directly to the public and circumvent the galleries was Eyestorm, a company which began with fanfare in December 1999, but declared bankruptcy within three years in 2002, part of the dot-com boom and bust.

Eyestorm's business model was to pursue what it believed was a huge, untapped, low-end Contemporary Art market, which it estimated at $13 billion. This consisted of people hesitant to step into an art gallery but, supposedly, comfortable buying on the Internet in the form of signed, large but limited-edition prints in the $200 to $3,000 range, especially from well-known Contemporary artists. Accordingly Eyestorm also persuaded three star artists, Jeff Koons, Damien Hirst, and David Hockney, to let it market limited editions of their works. The pieces averaged $500, unframed, with at the upper end Damien Hirst's *Lysergic Acid Diethylamide* in a signed edition of three hundred for $3,000 each. Eyestorm also used new reproduction technologies, like digital printing. But by 2002 the company had mostly burned through its initial capital. It is still around, but with far more modest aspirations and assets.

What went wrong? Eyestorm had vastly overestimated the market it

had envisaged—people willing to spend from $200 to $3,000 on limited editions and reproductions. Robert Goff, a former Eyestorm employee who later started his own Chelsea art gallery, Goff & Rosenthal, said:

> The whole Eyestorm business model was based on a faulty premise. They thought there has been such a huge interest in Contemporary Art that this would translate into a mass market, but there is a difference between people wanting to see art, and buying it. Even at the high end, the world of serious collectors, I'd say over the last five years the number of serious collectors worldwide has only gone from about 30,000 to about 40,000, just a 33 percent increase.
>
> It's like thinking there is a mass market for $300 sweaters. The real collectors didn't want that kind of stuff—prints and posters—they looked down on it.

Saatchi's Online Salesroom

Charles Saatchi's physical gallery started a website in 2005, Saleroom Online, that allowed any artist, free of charge, to display up to eight works of art, and then via an e-mail link negotiate directly with, and make a sale to, any potential buyers. By 2009 the art of 65,000 Contemporary artists was viewable on the site. A moving banner displayed thumbnails of every artist's work in random order. The site aggressively promoted the fact that it took no fees, from either artist or purchaser, proclaiming: "Buy Art Free of Commission from Artists Around the World." Customers who liked a work contacted the artist with just a keystroke and used a PayPal-assisted, click-and-buy feature. Saatchi had no involvement beyond hosting the website.

That Saatchi Online took no commission made sense, since Saatchi's physical gallery, founded in 1985, was never basically about selling art. It was, instead, a space where Saatchi displayed Contemporary Art he liked and thought the public should see, starting with US artists and Minimalism and then moving for a while to the Damien Hirst–led Young British Artists. The term "gallery" meant just that: like, for example, Britain's National Gallery. Indeed in 2010 Saatchi donated his gallery to the nation, to be called the Museum of Contemporary Art for London.

Saleroom Online's main focus was work by new artists, who often had no gallery to represent them. (Eyestorm, by contrast, had focused on selling work in multiple editions by famous artists.) So Saatchi argued that he was not competing with, or subverting, galleries, just democratically providing opportunity for any artist. Well-known artists were doubtless

still unwilling to offer their work on Saleroom Online rather than through their regular galleries or dealers.

Although Saatchi's gallery heavily involved itself in what commercial galleries do—facilitating the sale of artists' work—by taking no commission, it did so in a manner anathema to the commercial galleries. So it provided a major test of how far the Internet could sell art.

In 2007 Saatchi decided to find out whether the site's artists were achieving any real-world sales. He explained: "People were always asking, and I got tired of saying, 'I don't know.'" So the staff asked 1,000 randomly selected artists on the site how much they sold through the site per week. The combined sales of the 41 percent who responded were $30,000 a week—an average of roughly $75 per week for each artist. This was not a lot per artist, and certainly not yet a major threat to the main commercial galleries.

Saatchi's experiment revealed a further problem. A single megasite may take the viewer's desire to see a wide range of products to an extreme, flooding viewers with artists and works. Totally democratic in accepting all art, Saatchi's site lacked the filtering mechanism provided by galleries and museums, which select for viewers which artists to display from a usually huge number of contenders. At the same time a viewer of Saatchi's site, unable to see the works in person, lacked the ability to properly judge this mass of works. This is clearly a problem any website selling art will face if it presents a large number of works.

Doubtless in response to this problem, around 2009 Saatchi Online launched two filtering mechanisms. The first, named Showdown, was a regular competition where artists on the site submitted their work for consideration, and visitors to the site voted on the best work. Saatchi then displayed the winning works, temporarily, in a physical space in the Saatchi Gallery, where viewers could see the works in person, and buy them from the artist later. The second filtering mechanism instituted a set of "guest critics for rotating exhibitions" who selected artists from the online site whose work was then also exhibited in Saatchi's physical gallery. In addition, Saatchi Online sponsored a selected group of its artists to display at a Saatchi Online booth at international art fairs such as Zoo Art Fair in London in October 2007, Pulse in New York in 2008, and Scope Basel.

These ranking mechanisms partly turned Saatchi Online into an audition process to determine which of the crowds of artists and works jostling for recognition would be displayed in an actual, traditional gallery setting, either museum-like or commercial. Since all museums and commercial galleries have auditions, Saatchi Online was then, arguably, in part a more democratic filtering mechanism (though some artists complained

that, for example, college students in fraternities were organizing block voting for their art friends). As such, it did not cut out the commercial gallery's middle role between artist and purchaser, but allocated a small part of Saatchi's physical gallery as a place where a limited number of artists' works were for sale without commission.

In short, Saatchi Online did not sell enough art, or the work of major (i.e., well-known) artists, so it did not seriously threaten the commercial galleries.

In any case, by December 2010 Saleroom Online had closed, reopening a few months later as a for-profit venture, like traditional commercial galleries, charging the artists a commission for selling their work, albeit 30 percent, compared to the traditional 50 percent that galleries charged.

What happened? Doubtless the 2007 financial crisis had wreaked havoc with Saatchi's long experiment of running a privately funded, publicly accessible, physical museum. Around this time he gave the entire physical Saatchi Gallery to the British government to become a publicly funded and publicly run museum.

Saatchi clearly also tired of funding a free online site for artists to sell directly to the public. By late 2010 the Saatchi Gallery website was franchised to a Los Angeles–based entrepreneur, Bruce Livingstone, who ran it for a fee.

Livingstone and a group of venture capitalists he had assembled thought they could make money from Saleroom Online. They had been struck by a 2007 *Financial Times* article reporting Saatchi's survey, mentioned above, that showed that each artist on Saleroom Online received an average of $75 per week in sales, or $3,900 per year (Edgecliffe-Johnson 2007). While that was a very modest amount per artist, there were seventy thousand artists showing work on the site in 2007, and the article stressed that the entire site was selling $130 million a year of art, which Livingstone recalculated as $225 million a year.[20]

He and his investors saw an opportunity being lost, since the entire sales price went to the artists, and they decided to convert Saatchi's philanthropic venture into a profitable business, using the brand of Saatchi's name and gallery and charging artists a commission for selling their work. Saatchi himself was now a lead investor in the project. There was clearly room for huge profits on $225 million annual sales.

So in June 2011, Livingstone reopened Saatchi Saleroom Online as a for-profit site for selling art. Any artist could still upload and display their work for sale, but only after signing an agreement that Saatchi Saleroom Online would handle any sale and receive the 30 percent commission, still a better deal for artists, the new site argued, than the customary 50 percent taken by most commercial galleries. Yet the new Saatchi Online was

untested. By July 2011 it had thirteen thousand artists, from one point a view, a lot, but a huge decline from the seventy thousand it had in 2009. Saatchi Online also moved downscale, listing t-shirts, posters, and art priced well under $100.

Artsy and Amazon Art

By early 2011, the dominant view among gallery owners and many others about selling art online was that, while collectors might purchase a work by an artist they knew from a gallery they trusted based on viewing just an electronic image, this use complemented the gallery system. Paula Cooper commented: "People are looking at art on the Internet. Everyone is doing it, and they will buy it over the Internet if it's through someone like a dealer that they trust and who knows what they like." Less likely was the emergence of a single megasite where artists and purchasers exchanged art not seen in person, unmediated by a trusted dealer. One expert pronounced: "That will never happen. It's too impersonal. The art world is very social. Collectors love to say, 'I bought that from Larry, David, or Paula [dealers Larry Gagosian, David Zwirner, and Paula Cooper].'"

Still, the situation is fluid, with many entrepreneurs eager to push the Internet's capabilities. Two well-publicized recent efforts, Artsy and Amazon Art, address the point that collectors like to buy from a gallery they know and trust. In 2010 Artsy, founded by a twenty-four-year old computer scientist, Carter Cleveland, signed up Larry Gagosian as an advisor, with illustrious investors including Google's CEO Eric Schmidt; Dasha Zhukova, founder of Moscow's Garage Center for Contemporary Culture; and Wendi Murdoch, then wife of Rupert Murdoch. The site promised to use "art genome" technology borrowed from the pioneering music site Pandora, which electronically monitors and predicts users' individual tastes. For example, visitors to the site can click on masterpieces by Picasso and Matisse and so on that they like, and then learn in a flash which Contemporary works for sale on the site are similar enough to warrant a look. Artsy opened in mid-2012, and is currently operating mainly in collaboration with the galleries to drive customers to them, not take them away. For example, the website of the 2013 New York Armory Show (New York's premier art fair) featured images on Artsy of about 85 percent of all the art actually on display at the fair (Armory Show galleries were given the option of presenting their works in Artsy galleries). Visitors to the site who were interested in a particular work would click an "inquire" button, and then received an e-mail from Artsy referring the visitor to the appropriate gallery. Artsy receives a commission of 1–6 percent from the gallery if a sale results (the higher the price of the work, the lower the percent

commission). How many people will buy a work without actually seeing it remains to be seen.

The unmoored virtual gallery remains an attractive idea that seems the fulfillment of globalization, a borderless art world. Other online sites include Artspace and Paddle8. In 2013 Amazon launched Amazon Art. Again, the business model involved working with galleries, not undercutting them. By September 2013 Amazon had signed up more than 180 galleries (who pay Amazon a sales commission of 20 percent for works up to $100 and 5 percent for works over $5,000) and was offering over 43,000 two-dimensional works from about 4,500 artists. The difficulties are familiar, including far too many works on the site for viewers to process, and a lack of participation from major collectors, artists, or galleries (there were no star Chelsea galleries, and 95 percent of the works offered cost less than $10,000). Estimated online art sales in the United States for 2012 were less than 2 percent of the $17.4 billion market (Grimes 2013; Higgins 2013).

There is also now at least one online art fair (VIP), held in January 2012 for its second year, which was founded by Chelsea gallerist James Cohan and Silicon Valley venture capitalists (Cohan and Baer 2011). This too has not yet been successful. Gallerist David Zwirner commented: "The fair was unfortunately a waste of time for us this year. We didn't have any significant traffic in the booth, nor did we meet new collectors. I'm uncertain this format will work moving forward" (Esman 2012). Still, it might.

Auction House/Gallery Conflict: Auction Houses Selling Brand-New Work

The auction houses represent another threat to Chelsea's galleries. The auction house "industry" is in many ways the opposite of the gallery "industry." Instead of a plethora of small, almost mom-and-pop, galleries along with a number of star galleries, the auction industry was, at least until recently, a stark "duopoly plus one": Sotheby's, Christie's, and the smaller but dynamic Phillips de Pury. Their sheer concentration gave the trio resources that no individual gallery can match.[21]

Chinese auction houses have recently made a spectacular surge, underlining "globalization's" current stage in the art world as being marked partly by the addition of China to the macroregional duo of the United States and Western Europe. Chinese auction houses now constitute the next seven of the top ten auction houses, after Sotheby's, Christie's, and Phillips, ranked by 2012–13 worldwide sales of Contemporary Art (table 1.3). Underpinning this surge is what Artprice called "the Chinese dream," whereby wealthy Chinese business people and leaders will pay large sums for works by their Chinese compatriots/artists and have little interest in the pantheon of

Table 1.3. Top ten Contemporary Art auction houses, 2012–2013

Rank	Auction house	Turnover (in million Euros)
1	Christie's	353.6
2	Sotheby's	219.5
3	Phillips	90.1
4	Poly	75.5
5	China Guardian	33.5
6	Beijing Council	17.6
7	Beijing Hanhai Art l	16.2
8	Sungari International	15.9
9	Ravenel	13.4
10	Nanjing Jingdian	130.0

Source: Artprice 2013. Data for Contemporary Art defined at fig. 1.12.

Western artists (Artprice 2011–2012). The top ten contemporary artists sold in China in 2012 were all Chinese (Artprice 2013). Also important is that the Chinese state subsidizes and protects, via exclusionary policies, its auction houses from foreign competition. For example Poly International Auction, ranked fourth, was only founded in 2005, but, as part of the Poly Group Corporation (which was founded by the People's Liberation Army, and sells arms, real estate and culture), benefited hugely from the latter's prestige and government subsidies (Artprice 2011–2012). The four most prominent countries for fine art auctions these days, ranked by 2013 auction turnover in dollars, are China (4.1 billion), United States (4.0 billion), United Kingdom (2.1 billion), and France (550 million) (Artprice 2014). How the rise of Chinese auction houses will affect the auction house–galleries conflict, recounted below, is too early to say.

Until the 1980s auction houses posed almost no threat to galleries. Auctions were mostly a wholesale business for liquidating individual estates, including any art. Then in the 1980s Sotheby's developed a very profitable retail business for selling large quantities of preowned art to collectors in spring and fall sales that lasted just a few days (Marks, in Dreishpoon 2013). This now represented a major challenge to galleries, who responded by expanding their own art fairs.

Starting around 2000, galvanized by the huge profits to be made from the sale of new Contemporary Art, Sotheby's, Christie's, and Phillips de Pury made major attempts to move into the primary market for new art, long the sole domain of commercial galleries. They did this in three ways. First, indirectly by taking over and then owning or running commercial galleries (which continued operating under the commercial gallery's pretakeover name). Second, by directly auctioning new art, as in Sotheby's

infamous auction of Damien Hirst's work in September 2008. Third, as in the case of Phillips de Pury, by turning part of themselves into quasi galleries and selling new art directly in a gallery-like manner. At this point, none of these attempts to sell brand-new art seem likely to unseat the traditional galleries, though they created much anxiety among them.[22]

Taking Over Galleries

In the mid-2000s, Sotheby's and Christie's began to take over commercial galleries that sold new art. Sotheby's bought the Maastricht-based Old Masters gallery Noortman's in June 2006. Then in February 2007, Christie's purchased Haunch of Venison, a Contemporary Art gallery operating in London and Zurich, and announced that Haunch of Venison would open a gallery in New York's Rockefeller Center in the fall.

Many commercial gallery owners were outraged that Noortman's gallery, now owned by Sotheby's, would continue to exhibit at the European Fine Art Fair (TEFAF) in Maastricht, until then a place for galleries, not auction houses, and the premier fair for everything from Old Masters to Moderns. Robert Noortman was a board member of TEFAF, and his gallery had a huge booth at the fair. Georgina Adam wrote in 2007 in *Art Market*, "Art fairs are supposedly the trade's [i.e., galleries'] answer to auctions, a way of creating a glamorous event to attract buyers. So the presence of an auction house in a fair—let alone such a prestigious one—was seen as a Trojan horse." Chelsea gallerist Roland Augustine, president of the Art Dealers Association of America, protested: "We have very strong antitrust legislation here in the United States, and I think this situation of auction houses directly owning galleries is sure to raise some eyebrows."

One experienced Chelsea gallery owner expressed both alarm at the harm auction houses, with their purely financial interest in art, might do, and an optimism that the damage would be limited by the unwillingness of good galleries to sell themselves ("their souls") to an auction house. As she said:

> Auction houses buying galleries is very bad for art in general. Everything for auction houses comes down to money and markets. By contrast, the galleries have always been places, more than museums, where artists can do creative things, stage exhibitions with a theme and a narrative, try things out. Auctions houses aren't like that.
>
> Still, Haunch of Venison never was a very good gallery. It's always been very market oriented, not research or experimental. If Christie's buys a good gallery like Matthew Marks or Marian Goodman, it's a problem, but that's not going to happen. A good gallery wouldn't sell to Sotheby's or

Christie's because you're selling your soul. Of course a gallery is commercial, but art should also strive for the sublime, the special. At least good galleries do. There are a lot of extraordinarily good artists with no commercial value. It would be the end of art as we know it if galleries stopped supporting them.

The skeptics were strengthened when, by May 2010, Haunch of Venison was struggling, and its founders, Harry Blain and Graham Southern, left. Its problems included high debt and a general feeling in the art world that a gallery owned by an auction house was anomalous. Writing for the *Economist* magazine, Sarah Thornton (2010b) commented: "An art gallery owned by an auction house is a weird beast. . . . Haunch was kicked out of art fairs such as Frieze, and lost some artists, such as Keith Tyson, a Turner Prize winner, who did not wish to be represented by a gallery owned by an auction house."

In 2011 Haunch of Venison, still owned by Christie's, moved to Chelsea, as just another gallery there. By early 2011 an auction house executive dismissed the whole project of auction houses owning galleries as a "naïve attempt at vertical integration." Then in February 2013 Christie's closed Haunch of Venison, and in November Sotheby's ended its parallel attempt by closing Noortman.

Auctioning Brand-New Art: The Damien Hirst Ruckus

Sotheby's challenged tradition far more blatantly on September 15–16, 2008, directly entering the primary art market by holding a two-day auction of brand-new work, by Damien Hirst. Total sales of the auction, titled "Beautiful Inside My Head," were an amazing $198 million, a record for a single-artist auction anywhere. The event attracted huge attention, especially since it was on the day that Lehman Brothers filed for bankruptcy, plunging the financial world into the worst crisis since the 1930s. It seemed that Sotheby's might have found a formula to circumvent the financial crisis's effects on the art world.

The event also seemed to validate a long-held view by some that the auction process, by setting a work's price in a transparent way, was a vast improvement on the murky way that galleries handle prices for the new works they sell (for example, the eventual price for which a gallery sells a work is not public information), a process which one observer described as stressing the work's "symbolic" value over its market value (Velthuis 2005).[23]

Artprice (2008–2009, 94) called Hirst's audaciousness "a new page in the history of art auctions. . . . For the first time, a living artist short-circuited

the traditional gallery system by selling directly to the 'secondary [auction] market' without submitting his work to the test of the 'primary market.'"

There was, unsurprisingly, much grumbling by commercial galleries, amid suspicion that the bidding in the Sotheby's auction was rigged. For example, it was widely noted that Jay Jopling, owner of White Cube, Hirst's London gallery, bid on twenty of the fifty-six lots sold on the first day. Although Jopling was ostensibly a loser from Hirst's decision to cut him out and sell straight to the open market, he had significant holdings of Hirst's work that would have fallen in value if the sale had flopped. Star Chelsea gallerist Paula Cooper was caustic:

> Who knows what went on behind the scenes. Some people say Hirst's dealer gets a kickback for every client he brings to the auction. It has also been said that Hirst promised people that they would get a second work of their choice [free] if they bought one at auction.
>
> Auction houses are ridiculous. They've turned the art market into something like the stock market. They should be regulated.

Matthew Marks likewise commented that "a lot of auction prices are arranged in advance, just as they are in a private sale" (Dreishpoon 2013).

In any case, it soon looked as if Sotheby's and Hirst had made a mistake. Prices of Hirst's secondary works that sold at auction plummeted shortly after the 2008 auction, and the auction data for 2009–2010 confirmed this collapse, generally attributed not just to the recession but to fallout from "Beautiful Inside My Head's" sale of primary works. *Artprice* (2009–2010, 20) summarized the decline: "After this unorthodox sale, the [economic] crisis hit Damien Hirst's sales especially severely. . . . In 12 months, some of his works fell back to their 2004 price levels wiping out four years of speculative inflation. This past year (July 2009–June 2010) the former star of the market has generated only one 7-figure result."

Looking back on the Hirst auction almost two years later, Sarah Thornton (2010b) wrote skeptically in the *Economist*: "Though the sale made headlines, many wonder how much money Sotheby's actually made from it. . . . A senior Sotheby's specialist admits that the auction was exceedingly high risk. Indeed, it might not have been a success if it had taken place a week later." In 2012, art critic Julian Spalding dismissed the market for Hirst's work as "subprime" in a book titled *Con Art: Why You Ought to Sell Your Damien Hirsts While You Can.*

Perhaps not surprisingly, nothing like the Hirst auction has yet been attempted again. Probably the auction houses (and star artists) decided it was not worth risking their reputations, which are always vulnerable, since the oligopolistic structure of the auction industry nurtures public speculation about behind-the-scenes deals and market manipulation. In

2002 the former chairman of Sotheby's went to jail for leading a six-year price-fixing scheme with Christie's that swindled auction house investors out of over $100 million. As economist Richard Caves put it:

> The rivalry of Christie's and Sotheby's takes place in this context of natural-monopoly structure. Both houses face problems of moral hazard and opportunism, exacerbated by their quasi-monopoly structure. These problems stem from advantages of asymmetrical information that the auctioneer might enjoy against individual sellers and buyers. Advantage could be taken by overclaiming quality or authenticity of auctioned lots, various forms of self-dealing etc. So reputation built up in repeated dealings becomes an important asset for an auction house, especially in its competition with secondary dealers, who have their own needs and opportunities to establish a good reputation. . . .
>
> Consistent with this dilemma, until after WW II both houses operated in a decorous manner that cherished amateurism and traditionalism, traits that scanted efficiency while sustaining reputation and which, incidentally, curbed duopolistic rivalry between the firms. (Caves 2000, 355ff.)[24]

An event like the Hirst auction, raising questions of insider dealing, clearly has the potential to damage the auction house's reputation, and star artists were doubtless chastened too by the fall in Hirst's prices. So this particular threat to the galleries has petered out, at least for the moment.

Becoming Quasi Galleries: Phillips de Pury's "Selling Exhibitions"

Around 2006, Phillips de Pury started a third kind of radical entry into the primary art market by holding exhibitions of new art, displayed at its "auction house" premises but for regular sale anytime over the few weeks of the exhibition, just like a commercial gallery (instead of on preview for sale at an auction). So Phillips added the function of acting somewhat like a primary art gallery, alongside its auction house activities, which continued unchanged.

In so doing, Phillips de Pury continued its recent role as a maverick, run by Simon de Pury. The descendent of a venerable auction house called Phillips and founded in London in 1796, by 1998 it had fallen on hard times and was bought by Bernard Arnault, the French businessman who had built up LVMH, the luxury goods conglomerate. Arnault persuaded Simon de Pury and his partner Daniella Luxembourg, both former Sotheby's officials who ran a Zurich gallery called de Pury & Luxembourg, to join Phillips in early 2001. In order to wrest business from the big two, Sotheby's and Christie's, Phillips started to guarantee sellers major sums before auction.

In 2002 in a financial catastrophe Phillips guaranteed the heirs of Los Angeles collectors Nathan and Marian Smooke roughly $185 million for their mostly Modern collection, losing about $80 million when the auction flopped. Arnault and Luxembourg gave up on Phillips and left. To salvage Phillips, Simon de Pury sold works from his own collection and in 2003 moved the slimmed-down company, renamed Phillips de Pury, to Chelsea on 15th Street next to the High Line, to focus on Contemporary Art. In four years he turned it around, partly by brazenly challenging the current division of labor between galleries and auction houses.

Starting in 2006 Phillips put on exhibitions of new Contemporary Art, like a commercial gallery, in a spectacular section of its Chelsea auction house in a space larger than Gagosian's main gallery. Phillips called these shows "selling exhibitions" to stress that the works were for immediate sale rather than just for inspection by people deciding whether to bid for them at a later scheduled auction. (Phillips in Chelsea continued its auction house activities, holding regular, often highly successful, auctions of pre-owned Contemporary Art.)

Adding insult to injury, Phillips did not take over all the functions of a gallery, just those producing revenue. For example, unlike normal galleries Phillips has no stable of artists—young and established—whose careers and egos it nurtures and encourages, whose archives it manages, and whose work it is committed to exhibit in a show roughly every two years, even if sales are weak, so long as the artist remains in the gallery's stable.

Underlining this difference from a regular gallery, Phillips has legal contracts with the artists whose works it shows, which specify the obligations of each party in regard to this particular show. The existence of contracts highlights the fact that the relationship between Phillips and the artist is limited to the show at hand. By contrast, almost none of the Chelsea commercial galleries have written, legal contracts with the artists in their stable. Of the roughly fifty gallery owners interviewed, none used legal contracts to define their basic relationship with their artists or to cover a specific show. The galleries typically explain this by comparing the gallery-artist relationship to a marriage, hopefully long-term but impossible to keep together if one of the partners, especially the artist, wishes to leave. Economist Richard Caves (2000, 41) reports this absence of legal contracts between artist and gallery to be general in the art world.

Almost every gallery owner we talked to said how difficult this artist-gallery relationship was. The problems are continual. First, most young artists whom a gallery takes on never have a successful show. Those who do often find it hard to repeat with a second successful show. Finally, young artists who have achieved several successful shows, making them "emerging artists," face the artist's "midcareer" problem of sustaining success.

Few can. Adding to the typical gallery owner's headaches is that artists, successful and otherwise, tend to be highly egocentric, supersensitive to criticism, and, because they typically work alone and without institutional support (except from their gallery, if they can get one), prone to fits of depression. One distinguished female gallery owner described dealing with her artists as "mothering" them. A final difficulty in the artist-gallery relationship is that a gallery owner who has, against the odds, successfully nurtured an artist from "young" to "mature" risks losing that artist to a bigger gallery. A Sotheby's staffer told Sarah Thornton (2008), "We don't deal with the artists, just the work, and it's a good thing too. I've spent a lot of time with artists, and they're a bloody pain in the ass." Gallerist Matthew Marks put it more diplomatically: "Working with an artist can sometimes be a challenge, but that's what gets me up in the morning" (Dreishpoon 2013).

Phillips, by opting for legal relationships with artists limited to single shows of works for immediate sale, has, in a seeming coup, selected from the tension-laden artist-gallery relationship the only part that produces income. To stress that its new business model involved more than auctions, Phillips described itself as an "art company that does auctions."

Reactions among Chelsea galleries to Phillips's intrusion into the primary art market was generally skeptical. Gallery owners argued that, on the whole, good artists would not sell their work through Phillips (just as they had argued that good galleries would not sell themselves to auction houses). One experienced Chelsea gallery manager was sanguine, arguing that so far Phillips had not attracted top tier artists:

> Phillips is trying to find a way to eat up the galleries, but it will always be an auction house. A young "hot artist" or "established artist" will never show at Phillips. If any of the artists who showed at Phillips had been asked to show at a good gallery, they would have said yes.

Luhring Augustine's senior manager, Natalia Sacasa, likewise argued that the best artists would avoid having auction houses exhibit and sell their new work, since auction houses are near the bottom of the status hierarchy:

> In the art world, like the fashion world, you have distinct strata. In the fashion world you have the high-end stores, and then you have the department stores, and then you have the knockoffs that sell imitations made of cheap fabrics. The auction houses are like the department stores. They won't make the extra effort to place an artist's work in a proper context— for example, getting it into a museum or facilitating loans of the work for prestigious shows even when the work is not being considered for

acquisition. As an artist if you're just interested in creating a commodity, then you'd go to an auction house.

Still, most Chelsea gallery owners and managers watched carefully the auction houses' various incursions into selling new art, the traditional gallery terrain.

Overall, by 2011 the skeptics seemed to be winning. The three main auction house attempts to encroach on the galleries each proved problematic. First, galleries owned by auction houses were not flourishing. Second, for star artists tempted to sell new work directly through a major auction house, Damien Hirst's collapsed prices were a cautionary tale. Finally, Phillips de Pury was purchased for $60 million in 2008 by Mercury, the huge Russian distributor of luxury goods, with about half the purchase price going to settle Phillips's debt. By 2010 the company had settled down and opened a second, large new space in New York on Park Avenue, where it held auctions (as in its Chelsea space), though it still also held occasional "selling exhibitions" where it behaved somewhat like a gallery. The company argued that Park Avenue was nearer its wealthy client base and anyway mirrored more closely the locations of its rivals Christie's (ten blocks to the south) and Sotheby's (on the Upper East Side). Then in February 2013 Phillips de Pury closed its Chelsea location, abandoning its brazen attempt to sell new art in the heart of New York's dominant gallery district, and took more space (21,500 extra square feet for offices and exhibitions) in its Park Avenue location. Simon de Pury left the company, which now reverted to its pre-2003 name, Phillips.[25] A Phillips executive, Zach Miner, summed up the general problem facing auction houses trying to sell new art, whether through their own gallery, direct auction, or "selling exhibitions": "When the auction houses moved into the primary market for new art they did not fully evaluate the risk to their reputations—the ill-will and mistrust generated—from breaking down the Chinese wall between galleries and auction houses. Everything here is based on reputation and trust, which makes for a fragile economy."

International Art Fairs and Globalization

The growth of International Contemporary Art Fairs (ICAFs), especially rapid in the last two decades, is a third key development that raises questions about the future of Chelsea's commercial gallery concentration. These art fairs are for-profit events organized annually for just a few days, and are relatively new. The first was in Cologne, Germany, in 1969 (Quemin 2013). By 2008 there were over two hundred.

These fairs are composed primarily of commercial art galleries, in principle from any country, allowing them to operate at the more exalted level of an international circuit of host cities and thereby promoting their stable of artists in a market/country outside each gallery's home base. Each fair has an organizing committee/jury that selects the galleries from those who apply, and the galleries then decide which of their artists to display.

Since the core of ICAFs are galleries, they are clearly not a direct assault on the galleries. Indeed, the expansion of art fairs was in part the galleries' deliberate response as auction houses in the 1980s started organizing regular sales of secondary art and then later dared to sell new art. As Matthew Marks commented: "Art fairs have become increasingly important because they are the best way for dealers to compete with the auction houses."

Still, art fairs raise the question of whether they are reducing the importance of the permanent, physical location of the galleries that do participate, and whether they are taking business from galleries that do not (reasons for galleries not to participate include not being selected, or the daunting financial cost of exhibiting). Do these fairs complement, or undermine, the model whereby art galleries are based in a fixed location/ gallery neighborhood (e.g., Chelsea, SoHo, Berlin) from which they do the majority of their business?

Table 1.4 shows the ten largest fairs in 2014, measured by number of galleries exhibiting, which roughly correlates with prestige. Art Basel, Switzerland, is the undisputedly pre-eminent fair. It began in 1970, organized by a private corporation, Art Basel, which still owns the fair. It was mounted in collaboration with the city to attract art business to Switzerland. It grew steadily but was transformed when Sam Keller took over as director in 2000 (stepping down in 2008) and established a widely adopted blueprint for a splashy art fair—hot-ticket parties, cultural events, and VIP treatment of top-notch collectors. In 2002 Keller launched a sister fair, Art Basel Miami Beach, Florida, held each December, which quickly became one of the top five international fairs.

The world of international art fairs is in transition as ownership of the largest fairs consolidates. Two companies, Art Basel and Frieze, now own five of the top seven fairs.

Art Basel recently moved to capitalize on the Chinese and Asian market. In 2013, after purchasing a local Hong Kong fair (Art HK), it turned it into Art Basel Hong Kong, which opened right away as the third-largest IAC in the world. Overall, 46 percent of the 245 galleries exhibiting at Art Basel Hong Kong were from Asia (galleries headquartered outside Asia such as Gagosian Hong Kong are not counted here), while almost all the rest were from Europe or the US. The top eleven countries from which galleries

Table 1.4. Ten largest Contemporary Art fairs (2014)

Rank	Fair	Country	Galleries
1	Art Basel (1970)	Switzerland	285
2	Art Basel Miami Beach (2002)	USA	258[a]
3	Art Basel Hong Kong (2013)	China	245
4	Armory Show (1994)	USA	203
5	Art Cologne (1969)	Germany	200
6	Frieze New York (2012)	USA	192
7	FIAC Foire Internationale d'Art Contemporain (1973)	France	187[a]
8	Frieze (2003)	UK	175[a]
9	Fiera di Bologna (1979)	Italy	172
10	ARCO—Feria Internacional de Arte Contemporáneo (1981)	Spain	164

Source: Websites for each fair.

Note: In parentheses is each fair's founding date.

[a]As of 2013.

came were, in order; China (41), USA (29), UK (25), Japan (21), Germany (14), South Korea (11), India (10), France (10), Switzerland (9), Indonesia (8), and Australia (8). Underlining New York and Chelsea's strength, of the 29 US galleries at Art Basel Hong Kong in 2013, 24 were from New York and 14 of these were from Chelsea (including 9 star galleries).

The Armory Show has long been New York's main international art fair, though is now under serious challenge. The Armory Show began in 1994 when thirty-two art dealers, led by Colin de Land, Pat Hearn, Matthew Marks, and Paul Morris, rented three floors of the Gramercy Park Hotel and showed art for a few days to spark interest while the art market was languishing from the general economic depression of 1989–1992. They called the event the Gramercy International Art Fair. Later, growing more successful, they renamed it the Armory Show, taking the title of New York's path-breaking 1913 show, which had basically introduced Modern, nonrepresentative art to the United States. The Armory Show these days is located on the Hudson River Piers 92 and 94 on Manhattan's Far West Side and is managed by the Chicago-based Merchandise Mart Properties, which is owned by Vornado Realty Trust.

The Armory Show now faces major competition from Frieze New York, which burst on the scene with its first fair in 2012. Frieze New York is the creation of Frieze London, the UK's main art fair since 2003, which is owned by, and the creation of, the publishers of *Frieze Magazine*, Amanda

Sharp and Matthew Slotover. Housed in a huge tent on Randalls Island in the East River, the first Frieze New York (May 2012) was highly successful, arguably offering more creative programming and more scenic water and city views than the Armory Show (which, though on piers in the river, does not offer scenic views). Frieze New York's critically acclaimed 2013 version included 189 galleries, comparable to the Armory's 195 galleries (and exceeding Frieze London's 175). Another sign of success was that 8 of Chelsea's 18 star galleries chose to exhibit at Frieze New York in 2013, compared with only 3 at the Armory Show (and 7 at the Armory's long-time rival the ADA). One commentator pronounced the Armory Show as in an identity crisis, needing to adapt or sink (Farago 2013). Los Angeles gallerist Richard Telles, who paid $50,000 for a medium-size booth at Frieze New York 2013 (a comparable booth at the Armory Show would have cost half that price), was caustic:

> Frieze New York has already surpassed the Armory. The best galleries don't want to do the Armory anymore. Everyone here knows that. The Armory organizers haven't done a good job. For one thing the Armory location is ugly, and the bathrooms are horrible. Rich people don't want to be around ugly. It's all about luxury. Look at the great river views here. And the restaurants they have invited are great. Also, the art here is much better—it's far harder to get in here than to the Armory they are both juried.

While art fairs are booming, how far they will unsettle commercial gallery neighborhoods seems to depend on the size and location of the galleries and neighborhoods. On the one hand, major and especially star Chelsea galleries are enthusiastic about art fairs. As a Pace Wildenstein curator put it: "Art fairs are great for us. Collectors get to see every top international gallery in just two days, as opposed to flying to each city. We do very well at art fairs." Likewise gallerist Richard Telles commented: "The art fair is an easy way to shop and it's an event, and Contemporary Art consumption is huge."

At the same time, Alain Quemin analyzed gallery participation in the top forty-one international art fairs in 2007–2008, and his findings suggest that star Chelsea galleries were in a kind of equilibrium vis-à-vis international art fairs. All the highly visible American galleries participated in at least three international events to "maintain their standing," but without necessarily trying to attend a larger number of events, which they did not need to do, given their local base. Quemin analyzed the 101 galleries that participated in five or more international art fairs, calling these galleries the "most internationally committed." Of the seventeen "star" Chelsea galleries at that time, only five met this standard: Yvon Lambert (9 fairs),

David Zwirner (6), Luhring Augustine (5), Marianne Boesky (5), and Cheim & Reid (5). So Quemin concluded that for major/star American galleries, there is a "threshold effect":

> it is not always the most prestigious or the most powerful galleries that participate the most in the system of international fairs; some highly visible galleries have no need to participate in numerous events (which cost a lot of money in logistical terms) to find buyers. Thus, although the list of the 101 most internationally active galleries (i.e. participating in 5 or more fairs each year) contains 12 American galleries including some highly recognized galleries . . . it does not include the "giant" Gagosian, or very important galleries such as Marian Goodman, Pace Wildenstein, Paula Cooper and Sonnabend.

While a few fairs are a must (for example, fourteen of Chelsea's eighteen star galleries participated in Art Basel 2013), and the major galleries feel they need to participate in at least some fairs to maintain their standing with the collectors and recruit new ones, it is on the whole galleries with weak local markets and dealers that make extensive use of fairs to compensate. This is why American galleries tend not to dominate the participation list to the extent that they dominate in other areas.

Also, exhibiting is expensive, which is a major problem for smaller galleries. Booth fees, operating costs, and travel can be in the tens of thousands of dollars. In 2013 the average size booth (216 square feet) at New York's Armory Show cost $24,000, while a similar size booth at Frieze New York was roughly $45,000 (the smallest booth at Frieze New York was $25,000, the largest $100,000, based on a price per square foot of $216). Nor is there any guarantee that galleries will recoup their costs in term of sales (Schjeldahl 2012). So for small, upper-floor Chelsea galleries, international art fairs present an economic dilemma that compounds their basic problems of being too numerous and in an unfavorable (i.e., non–ground floor) location. They typically would like to participate in at least a few fairs, but costs are a problem and the most prestigious fairs are anyway very hard for a gallery to get into through the acceptance committees. Allen Sheppard, who operates an upper-floor gallery on 25th, commented, "The cash has moved to the art fairs. In terms of connecting with collectors and meeting the dealer at the fair, art fairs have largely supplanted the dealer in the gallery. I don't do art fairs. I really should, because that's where the business has gone."

Finally, art fairs are another opportunity to specify, and be cautious about, the degree of "globalization" of the art world. All the top ten art fairs in 2014 were located in the US, Western Europe, or China, which supported Quemin's detailed analysis of the location of the top forty-one

international art fairs in 2007–2008, as measured by the number of galleries participating. These fairs were hosted in just twenty-one of the world's almost two hundred countries. Except for the US, a few Western European countries, and China, most regions were represented only marginally. Africa was unrepresented. The US led by far with ten fairs. Second, with three each, were Switzerland, Italy, and newcomer China. Germany, France, the Netherlands, and two peripheral countries, Australia and the United Arab Emirates, had two fairs each. These were followed by twelve countries with one major international art fair each, including the UK, Belgium, Austria, Spain, Portugal, Russia, Canada, Mexico, Argentina, Japan, Taiwan, and Singapore. Quemin concluded that despite endless talk of "globalization," the center of gravity of the world of contemporary art for art fairs duplicates that for galleries and artists, namely "a duopoly formed by the US on the one hand and a small number of Western European countries on the other hand (notably Germany, the UK, France, Italy and Switzerland), with China as a major new presence." Outside is an artistic periphery that consists of the world's "remaining roughly 193 countries. India and Russia are growing in importance, but have not yet moved from the 'artistic periphery' to constitute centers in their own right."

Globalization and Threats to Chelsea's Commercial Gallery Model

None of the major threats to Chelsea's commercial gallery district has yet undermined it, though the situation is fluid. After some decline following the 2007 financial crisis and recession, the number of Chelsea galleries has more than recovered, and the projected 2015 opening of the Whitney Museum a few blocks to the south has added luster to Chelsea as an art center. By May 2014 there were 384 galleries in Chelsea, substantially more than the Upper East Side (276), SoHo (97), and the Lower East Side (105), and seemingly an increase over Chelsea's pre-2007 recession peak (see notes to fig. 1.1 and table 1.1 for measurement issues). Star galleries worldwide, of which Chelsea has by far the largest number, are back in expansionary mode (Crow 2013).

The Internet has not replaced galleries as a way of selling art, primarily because artworks are mostly unique and must be seen in person, at least given the limits of today's technology. Future technology may change that. Art fairs on the whole complement, not displace, Chelsea's star galleries. Auction houses would like to break the commercial galleries' traditional lock on new, primary art, but have been chastened by attempts to sell new art at auction (especially by the disastrous ramifications of Sotheby's Damien Hirst auction), or by owning galleries (Christie's dismal experience owning Haunch of Venison). Meanwhile, Phillips de Pury's

effort to behave like a gallery by selling new art in its auction house location remains limited in scope.

Overall, the current stage of globalization in the art world has two major characteristics. First, the rise of the Internet, whose potential is truly global, but which has not, however, yet been unleashed in art the way it has in music, books, and newspapers. The commercial gallery, as the main site for viewing art, is more resilient than the traditional bookstore or record store. The second characteristic of the current stage of globalization in the art world is China joining the macroregional duo of the United States and Europe.[26]

THE RISE OF CONTEMPORARY ART AND THE FADING OF STYLES: A THEORY

Contemporary Art's Inclusivity and Eclecticism

Chelsea's emergence as New York's dominant gallery center for Contemporary Art coincided, roughly, with the rise of "Contemporary Art" as the dominant category in the art world for classifying the work of living artists. (As mentioned, with a small c "contemporary art" was, before the 1990s, routinely used to refer to recent work, but except for a brief period in the late 1920s discussed below, it was not a major artistic category, just an adjective noting a work's newness.)

Contemporary Art as a category is strikingly and unusually broad and eclectic and also readily definable. When asked, almost every Chelsea gallery owner defined Contemporary Art as, basically, the art produced by all artists still living, with artists somewhat recently dead often implicitly, sometimes explicitly, included. Typical comments were: "Contemporary Art is everything by artists still alive," "Contemporary Art is the work of living artists and those not long dead," "Contemporary Art is work by artists now alive."

This inclusivity reflects the dominant usage of the term "Contemporary Art" in the art world. There are, of course, minority exceptions. Some art critics define Contemporary Art as though it were a style with definable, extrinsic features, for example, as "capturing and expressing the presence of the present in a way that is radically uncorrupted by past traditions or strategies aiming at success in the future" (Groys 2010). The problem here is that this definition, or any other of Contemporary Art as a particular style, would exclude several well-known living artists whose work is regularly exhibited in Contemporary Art galleries, such as Cecily Brown and Clifford Ross, whose works are suffused with historical references.[27]

Without question, today's art world stresses Contemporary Art's broad eclecticism by defining it as the work of all artists living or recently dead. By contrast, emerging "styles," and their battles for recognition, permeated the story of art in the nineteenth and most of the twentieth century, as in Impressionism, Cubism, Abstract Expressionism, Minimalism, and the like. These new styles basically foregrounded a subgroup of the artists of their time and typically implied, or explicitly claimed in polemical fashion, that work done by artists in that style was superior to what most other artists of the time were producing, a view often expressed in the context of a belief in an evolutionary progression of art. So each particular style is defined by a series of extrinsic, recognizable characteristics.

A corollary of the shift from styles to Contemporary Art's eclectic tolerance is that no Chelsea-based or Chelsea-inspired "style" of art has emerged, let alone become dominant, unlike the period of SoHo's reign when, for example, Pop Art and Minimalism emerged as new styles.

Reasons for Contemporary Art's Inclusivity

How, then, to explain Contemporary Art's unusual inclusivity, embracing the entire corpus of living artists, and the apparently associated failure of new art styles to emerge to similar prominence in the last two decades? We suggest that this is plausibly related to Contemporary Art's dominance occurring in what is arguably the most effervescent art market that has ever existed.[28] In such a market, art sells relatively easily, so the drive for those in the art world to draw attention to ("brand") a particular subsection of work and artists (i.e., establish a "style") is less pressing.

This suggests the outline of a theory of the conditions under which styles have appeared in the last two centuries of art history. The key variable is the market context, namely, how easy it is for artists to sell their work—(1) very hard, (2) somewhat easier, or (3) fairly easy. In market context 1, when it is very hard for living artists to make money, styles emerge from time to time, in part as ways for artists and dealers to draw the public's attention. In this context selling art is not likely to be a lucrative career, so an extensive and elaborate apparatus of dealers with time and motivation to promote new styles is not likely to emerge. This context, when art is hard to sell, is the causal context for (though does not fully explain) the periodic emergence of new styles in the nineteenth and first half of the twentieth century.

When, in market context 2, it becomes easier, albeit still a struggle, for living artists to make money, as happened from the 1960s through roughly the 1980s in the West, and especially the United States and New

York, networks of dealers, critics, and artists have considerable financial incentive to develop new styles that draw attention to the work they produce, sell, write about, and present to the public. Making money from art is no longer unlikely, though it still requires strenuous effort. During this period, the number of New York galleries selling new work rose from about ninety to almost three hundred, and the auction market for recent art went from slender to active. For example, about a quarter of the Abstract Expressionist artists saw their prices, adjusted for inflation, rise by over 500 percent from 1960 to 1982 (Crane 1987). It now became clear that considerable amounts of money could be made from selling the art of living artists, which was basically a new phenomenon. Before 1960 in the United States recent artworks were sold just occasionally— the Abstract Expressionists in the 1940s had little or no thought that they might make money from selling their works. By contrast, in 2013 auction sales of star American living artists brought in 38.9 million euros for Jeff Koons, 17.3 million for Christopher Wool, and 7.9 million for John Currin (Artprice 2013). Alain Quemin has recently documented today's star artist scene (Quemin 2013).

This change in the art market could explain the much-noticed proliferation of styles in New York in the decades from the 1960s to 1980s as dealers and others discovered that new styles brought in new collectors to buy works. Gallery owner Sidney Janis famously said that each time he presented a new style, a new group of collectors came into his gallery.[29] Branding (primarily style-creation) was undertaken, to varying degrees, by the interested parties—dealers, groups of artists, museum curators, and critics. For example, the dealer Leo Castelli played a key role in branding Pop Art, building on alliances of artists. Along with dealers like Paula Cooper and the Dia Foundation, critics and museum curators likewise played an important role in promoting Minimalism, with exhibitions at the Guggenheim and the Jewish Museum helping launch this new style. Generally, dealers became increasingly active in identifying and aggressively marketing new styles (Simpson 1981, 37).

Finally, in market context 3, as the art market went from presenting opportunities to explosively vibrant, as in the decades after 1980 (albeit punctuated by the severe 1991–1993 downturn and the less severe downturns from 2001 to 2002 and from 2007 to 2011), it was increasingly unnecessary for dealers and others to promote styles in order to sell art. Hence the art world was on the whole content to operate under the general banner of "Contemporary Art"—everything produced by living artists. Many dealers and artists could now make money promoting their art without implicitly criticizing the work of their contemporary colleagues as not part of some preferred style. Gallery owner Douglas Heller in 2013 highlighted aspects

of this shift, including its having raised the status of professional training in art, especially in a digital age: "The market for, and interest in, art has changed hugely. Forty years ago when I was young I could walk into MoMA without paying and sit for forty-five minutes in front of *Guernica*, and no one else would be there. Now there are huge crowds and they pay a lot to come in. Back then you would pay for your children to become a lawyer or doctor, but never an artist. Now parents are proud to say their son or daughter is becoming an artist, especially since digital graphic skills are in such demand."

It may, in this context, not be accidental that probably the last major new style, before Contemporary Art absorbed everything, was developed in, and imported from, the UK. This was the iconoclastic Young British Artists (YBAs), whose "stylistic" hallmark was works that were explicitly controversial. In the UK the economic prospects for artists at that time lagged those in the United States, so everyone still had to work hard to sell art, and developing or promoting a new style was an obvious way to do this. The YBAs started with the 1988 show *Freeze* curated by Damien Hirst in the old Port of London. Among the other artists included were Sam Taylor-Wood, Sarah Lucas, and Tracey Emin. YBAs were importantly also driven by the energy of collector Charles Saatchi, and Jay Jopling, owner of the gallery White Cube, a group whose motives were also partly economic. The YBA's zenith was probably the 1997 show *Sensation* at the Royal Academy of Art in London. Significantly, this show was then imported to New York in 1999 by the Brooklyn Museum of Art's director, explicitly to boost attendance at his museum, whose "outer-borough" location meant its audience numbers lagged museums in Manhattan. Both shows, as intended, aroused much controversy. In short, it seems significant not only that the YBA style was nurtured abroad, where the economic market faced by artists and dealers was not yet as buoyant as in the States, and as a result Contemporary Art's eclecticism was slower to attain dominance, but also that the show was imported by a Brooklyn museum director anxious to counter his museum's marginalization in New York.[30]

This theory implies the prediction that when the art market cools (i.e., trending to market context 2) new styles will show signs of emerging, though if prices start to recover (back to market context 3), this emergence of new styles may lose some impetus. Arguably this underlies the growing current interest in Street Art, which was around for decades as "graffiti" but was repackaged with a new name and began to be promoted in the art world in the years after the 2008 financial crisis.[31] For example, Street Art was featured at Art Basel 2010, and the show *Art in the Streets*, a 2010 exhibition at the Geffen Museum of Contemporary Art in Los Angeles, was MOCA's best-attended show ever. Several commercial galleries now

promote and display Street Art, as do a plethora of new art books and clothing styles and niche delivery trucks.

This theory also explains a brief period in the late 1920s when the category "Contemporary Art" emerged as an umbrella category for all the works produced by living artists. This period too was one of massive economic expansion, when suddenly art by living artists started to sell well and easily (market context 3). It was, of course, choked off by the almost decade-long Great Depression.[32] Arguably the 2007–2011 downturn did not compare to that period, so Contemporary Art remains more or less dominant as an umbrella category.

The art philosopher Arthur Danto has presented a related, but interestingly different, approach to this issue. For Danto "Contemporary Art" involves "the end of art," by which he means that styles (i.e., particular or "master narrative" directions) are now obsolete, part of art history but no longer appropriate in an age when "anything can be art." Our approach differs from Danto's in two ways. It predicts the circumstances under which new styles may re-emerge to prominence: that is, movement from market context 3 to 2 (whereas Danto implies that new styles are gone for good); and it predicts the circumstances under which Contemporary Art as a category may weaken (while Danto implies that it is here indefinitely). Which approach is correct will, of course, take a long time (perhaps decades) to determine.

Finally, our theory of the economic circumstances under which Contemporary Art as an umbrella category has flourished should not be applied in a mechanical or monocausal way to what is a complex topic.[33] It is compatible with theories that stress other reasons for Contemporary Art's eclecticism. One such approach argues that this eclecticism is partly driven by a "global" period in art, with national boundaries receding (Nelson 2006 and Fisher 2005). Another approach stresses that eclecticism is consistent with the decline of the evolutionary model of art, and of the notion of the avant-garde, that dominated since the nineteenth century and which viewed a succession of styles as part of Western art's movement to perfection. The demise of this evolutionary approach also fits theories that stress the West's diminished confidence, associated especially with China's resurgence.

Contemporary Art and Life

ART'S MEANING AND CONTEMPORARY LIFE

From 2001 to 2007 it became increasingly tempting to consider financial gain as the dominant dynamic underlying interest in art, especially Contemporary Art.[1] Prices for Contemporary Art sold at auction rose by roughly 260 percent and postwar art by over 300 percent, far surpassing Modern Art and nineteenth-century art during the same period (fig. 1.12). Star Contemporary artists drew particular attention. The media reported, for example, how four of the five most expensive works sold at auction from mid-2007 to mid-2008 were by Jeff Koons, including the most expensive, *Balloon Flower*, which fetched $23 million, compared with $1.1 million in 2001. Author James Atlas, in a 2012 *New York Times* opinion piece lamenting the expansion of monetary values into spheres where they should not belong, wrote, "Gone is the time when art was appreciated as art, not as an investment."[2]

Yet for the vast majority of the audience for Chelsea art, as interviews reveal, the art is of interest not as investment, but above all because it resonates with ongoing, often major, issues in their lives. The main issues with which the art and audience engage include the landscape, both as the classic "beautiful view" to be enjoyed and as an endangered resource; the abstract and decorative, which is at least partly about brightening people's lives; the modern family and interpersonal life, both typically seen as problematic; sex and erotic life; the role of everyday consumer items in social life; political issues; questions about the basic constituent material of the world; the poor and disadvantaged; and religion.

Even for most "collectors," those who purchase the works, the art attracts primarily for these reasons rather than for its investment potential, although a sizeable number of collectors, having decided they like a work enough to buy it, are then careful to make sure the price is reasonable. The main difference here between collectors and the rest of those interested

in Contemporary Art is that collectors have the funds and desire to make permanent the experience of viewing original works they like and that resonate with their lives, while the rest make do with the fleetingness of visits to gallery shows or museums.

This is not to say that economic issues have no part in audience attraction to the art, but they operate mainly by focusing attention on subject matter that is usually relevant to people's lives. For example, popular interest in the economic value of land (such as suburban homes) is likely one source, as it probably has been for decades, of interest in the classic landscape and its associated beautiful views. The latest manifestation of this in Chelsea is the premium that purchasers of condos in tall buildings will pay for sweeping views (e.g., along the High Line and Hudson River).

Several distinguished thinkers long ago asserted this basic idea that if art becomes meaningful for a viewer, it is typically because in one way or another it resonates with the viewer's experiences of life. These include John Dewey ([1934] 1980) and Clifford Geertz (1983).[3] Still, this dynamic cannot be discerned or fully understood without asking the audience why they like particular works, which is rarely done.[4] For example, John Dewey argued that art was typically meaningful because it was embedded in people's ordinary experience and lives. But he believed this was only true before capitalism. With capitalism, he thought, especially with the rise of the museum and gallery, art was in danger of becoming divorced from ordinary experience. Our research suggests that Dewey had less to be worried about here than he thought.

The absence of systematic audience interviews is a key reason why the default view that art's attraction is basically about the work's financial aura and investment potential has been able to stand. Such interviews are also the only way to explore and explain the popularity of certain topics of Contemporary Art that are recent in art history such as the problematic family and the fully environmental landscape.

The previous chapter told what we called the first story about Contemporary Art, in the context of Chelsea's growth as an art center, showing, for example, how changing prices of real estate and commercial rents underpinned the move of New York's dominant commercial gallery center for Contemporary Art from SoHo to Chelsea. This chapter tells the second story about Contemporary Art, namely its meaning for the majority of the audience. Without it, the first story is incomplete and misleading.

DATA SOURCES

The discussion uses two main sources: first, interviews, with samples of the audience who attended the shows, plus two samples of collectors; and

second, a classification by topic of the art displayed in Chelsea, the results of which are presented in table 2.1. Since neither data source has been presented in a systematic way by previous studies, it is important to say a little about each.

To make the interviews as representative of the Chelsea audience as possible we chose a sample of the shows displayed at the star galleries (listed in the note to table 2.1), and then interviewed audience members selected randomly as they were going through, roughly twenty-five respondents for each show. We chose star galleries because almost all visitors to Chelsea go there, while far smaller proportions attend the rest of the galleries.[5]

In addition, we conducted two off-site samples of collectors, since the vast majority of the audience for Chelsea art came just to view a free show, so there were too few collectors in those interviews to reach conclusions about them. The collector samples were drawn from those attending the 2010 Armory Show in New York, the city's premier art fair, and the 2009 Art Basel Miami show in Miami Beach, both among the most important international shows after Art Basel, Switzerland, the acknowledged leader.

To classify the artworks, we used as a basic source the random sample of shows selected from the Chelsea star galleries. We also for comparison conducted a sample of the shows at upper-floor galleries, since the works displayed there were significantly less expensive than those at the star galleries, and we wanted to note any differences in the art in the two types of gallery.

After selecting the artworks in this way, the main issue was how to classify them by content, which is not entirely straightforward. The obvious starting point is an "objective" study of the works. For example, are they landscapes, depictions of the family, abstract/decorative and so on? However, this takes the classification process only so far, since many of the works are highly ambiguous. For instance, a depiction of a naked or seminaked woman could, in theory, be classified as classical mythology, the nude, erotic art, feminism, or all of these. Further, the categories often intersect (e.g., partially clothed women in a landscape). This is, of course, one reason why artists usually title their work, to endow it with, and usually narrow it down to, particular meaning(s). So in classifying the works we supplemented the "objective" look with a second perspective that considers the artist's intentions, which we obtained from the written materials that accompany most shows, since these typically have the artist's approval. These materials include the titles of the works and other wall text, any catalogue materials, and the press release, which is usually one or two printed pages available on entry and has always been ratified by the artist as an appropriate account of the works for the public. (For further discussion, see the note to table 2.1.)

Table 2.1. Subject matter of the art shows in Chelsea galleries (% of all shows)

	All (n = 111)	Star (n = 51)	Upper-floor (n = 60)
Landscapes			
Classic (beautiful views)	30.0	17.5	41.2
Environmentalist	6.0	9.6	2.9
Conceptual	1.8	3.9	
TOTAL Landscapes	37.8	31.0	44.1
Abstract/decorative	25.8	23.3	32.3
Troubled nuclear family	11.4	20.4	3.3
Sex			
Sexual activity; focus on sex organs	4.3	9.2	—
Nudes (no sexual activity or focus on sex organs)	2.6	5.5	—
TOTAL Sex	7.0	14.8	—
Mass-produced items/Pop Art	6.1	11.1	1.6
Political	6.5	4.5	11.8
Natural forms/man-made basic materials	5.2	5.6	2.9
Poor, those in trouble	3.5	5.5	1.6
Religion	1.3	1.1	—
Other	10.3	13.5	5.8

Note: We classified shows based on the main content of their works. Some individual works covered more than one topic (e.g., a landscape that made a political point would cover two topics). If the topic constituted a third or more of the work, it was counted as a topic, so individual works could be counted as covering up to three topics. If a third or more of the works in a show covered a topic, that topic was assigned 1 point, so a show could count for up to 3 points. Also, some galleries had simultaneous shows by two artists, in which case each show was counted (shows of works by more than two artists were excluded as too complicated). This is why the percentages in table 2.1 sum to over 100. Multitopic shows therefore have more weight in the overall table than single-topic shows. We did this because our aim is to understand which topics are most widespread in Contemporary Art (as displayed in Chelsea); so, if a show has two or three topics, that should be recorded. The above procedures are clearly not the only way of sensibly classifying the art, but we believe other reasonable ways would yield broadly similar results.

We based the sample on shows at all 17 star galleries, and on shows at 20 randomly selected upper-floor galleries. We then selected at random 3 shows from each of the two gallery types, making a total of 111 shows. The star galleries include Paula Cooper, Matthew Marks, Barbara Gladstone, Larry Gagosian, Metro Pictures, Robert Miller, Marlborough, Mary Boone, Andrea Rosen, Luhring Augustine, James Cohan, Pace Wildenstein, Cheim and Read, Galerie Lelong, Sonnabend, Marianne Boesky, and David Zwirner. The star galleries were picked for us by two experts. Different experts would probably not pick exactly the same list, but we believe they would agree on the vast majority.

LANDSCAPES: CLASSIC AND ENVIRONMENTALIST

Landscapes are the most common topic in Chelsea. They formed 31 percent of the shows sampled at star galleries and a huge 44.1 percent of those in upper-floor galleries. These landscapes divide into two main kinds. There is the classic, "beautiful view" of a stretch of countryside, water, or sky; and there is the "environmentalist" landscape, which is increasingly popular. (A third type, the "conceptual" landscape, which conveys a narrative, is far less common, so for space reasons we consider it in chapter 3 in the context of the High Line, which actually combines four landscape types, a key cause of its popularity.)

"Classic" Landscapes

What has now become the "classic landscape as beautiful view" basically emerged to prominence in Western art over the last two hundred years, as in the English painter Constable (1776–1837), strands of Impressionism and Postimpressionism, and the US Hudson River school of the late nineteenth century. Before becoming a genre in their own right, landscapes were usually just background for religious, historical, or mythological themes (Clark 1949; Andrews 1999). In twenty-first-century Contemporary Art as displayed in Chelsea, the classic beautiful view is clearly still immensely popular.

Yet in our survey by no means everyone liked classic landscapes. They were far more common in upper-floor galleries (41.2 percent of all shows) than star galleries (17.5 percent of all shows). A significant minority of the audience considered them dull and passé, as will be seen. Some Contemporary artists in the sample have responded to this by finding ways to spice up the classic beautiful view—for example, by including the troubled family (Gregory Crewdson's photos) or naked figures engaged in sex (Cecily Brown's paintings) or new technology (Clifford Ross's huge digital photos).

Clifford Ross

Consider Clifford Ross's landscape photographs. In a show titled *Mountain* at the Sonnabend Gallery in November 2005, Ross presented nine megasize (6′ × 11′) color photographs of Mount Sopris, Colorado. His overall aim, he says, is to create a "You are there" experience for the viewer. These are classic landscapes, updated with the latest in digital technology. They are also enormously expensive to produce (an ingredient in the criticism that Chelsea is too "corporate").

Ross explains that he was struck by the inability of existing film and digital cameras to take very broad views while still capturing minute detail. So he invented the R1 digital camera system, using military aerial film and a special digital postproduction process. The resulting photographs are "among the highest resolution landscape images in the world," each containing over a billion pixels and encouraging scrutiny of "even the smallest details in the image" (press release).

In the show, Ross explicitly located his work within classic landscape painting, while presenting a "radical reinterpretation of the 19th century landscape tradition practiced by Hudson River School painters Frederic Church and Albert Bierstadt." Ross's photographs accordingly explored three themes. First, the passage of time. For example, *Mountains II, III, and IV* presented identical views of Mount Sopris from before dawn to late afternoon. The second theme was the drama of shifting weather systems. *Mountains V, VI, and VII* show a storm entering the landscape and then departing. The third theme depicted changes when a single mountain is viewed from different angles and distances. Examples are viewable on Ross's website.

Interviews with a random sample of twenty-five audience members reflected a split between those who enjoyed the classic landscape, updated in digital mode, and those who were tired of it. Just over two-thirds liked the show without reservations. All but two of these cited the pleasing views as at least one of the qualities they liked. The second most common quality (cited by just under half of respondents who liked the show) was the technical ability of the photographs to capture both breadth and detail. Also mentioned as positive were the allusions to classic landscape paintings. Several respondents gave more than one of these reasons for their enthusiasm, but the pleasing view was dominant. Consider these comments.

A woman in her thirties, a self-described "housewife" who lives just outside New York City:

> They're beautiful. It reminds me of other landscape paintings, and I love the mountains, so in a personal way they're evocative of how good it feels to be in the environment. I love photography. I'm always amazed when a photographer can capture something on this scale. There's a wonderful sense of color and light.

A man in his twenties who is half black and half Japanese and teaches martial arts:

> I like the pictures because they're calm and serene. You're one with your surroundings; all your senses are heightened. I picture myself as in there doing martial arts, like Ying and Yang.

A female art historian who teaches at SUNY Albany:

> These are very real landscapes, not Disneyland. They transcend the pictur-
> esque. They're a cliché in a way, but so what? Light like that—it's magical.
> They convey the awe-inspiring quality of the landscape. It's not so easy
> to do a photograph that has all these qualities. It's very impressive, very
> beautiful.

Of the third of the sample who disliked, or were indifferent toward, the
works, all but two saw them as banal, the kinds of scenes that art has been
depicting for many years. Still, they usually acknowledged the technical
quality of the photographs.

A man in his sixties, an artist who lives in Maine and owns his own
gallery there:

> The show is boring. I think it's just all big color photos for rich people.
> We're approaching World War I again, and. everyone is fat and happy. The
> photography market is very friendly to that, since no one knows what a
> painting is supposed to look like anymore.

A doctor who lives on the East Side of Manhattan:

> Big is popular right now. It doesn't capture my emotion, and the image
> isn't framed that well. With these photos it's just the size. They're techno-
> logically interesting, but I don't think I would have missed them had I not
> seen them. Maybe it's just that so many people are doing this.
>
> I like the original artists such as Bierstadt [Hudson River school]. They
> represent some of the feel of when you're there. There's so many things to
> see in their paintings.

Two respondents critical of the show had political objections. A woman
in her forties who sells real estate in New York thought the artist's depic-
tion of beautiful views glossed over property ownership and environ-
mental issues. The photos reminded her of ongoing debates in her native
Australia over claims to the land by indigenous people, debates which she
considered had been basically suppressed in the United States, certainly
in New York City.

> He's [Ross] revisiting landscape photography, bringing in scale and un-
> peopled space. I come from the outback of Australia. The emptiness and
> the moodiness of the weather, and dealing with it, it's familiar.
>
> But the work is scary. When you're in Australia there's the indigenous
> people and a whole iconography of unresolved issues. There's a political
> question of ownership which raises issues about indigenous inhabitants
> which aren't being acknowledged here in New York. I mean, what is land

and who owns it, and how we're using up the earth and commodifying the land. We have an expensive existence and we're not treading very lightly. I'm a real estate agent in New York, but I'd never buy and sell in Australia— the land and ownership issues are too political there.

The Classic Landscape and Nonaesthetic Interests

Actually, even in the past, popular interest in the beautiful view was probably seldom as self-sustained and pure as is often implied, so it should be less surprising that a significant minority of the Chelsea audience was unmoved by pure beautiful views. For example, Constable's depictions of the early nineteenth-century countryside drew part of their appeal from an English nationalism concerned about industrialization's threat to the English rural heritage (Pevsner 1978). The US Hudson River school likewise drew some interest from an American version of nationalism, sprinkling their landscapes with noble but doomed savages (Indians) whose wild terrain it was America's "manifest destiny" to control (Ferber 2009, 151).

Interest in the classic beautiful view has also typically been intertwined with, and invigorated by, interest in the economic value of property, albeit in a complex way. For example, the huge popularity of the Impressionists, known for many classic landscapes, coincided with the suburbanization movement that gained momentum throughout the nineteenth and most of the twentieth century. Here the beautiful view arguably served as a standard for suburbanites to measure the value (economic and aesthetic) of their own property, typically a tract development that inevitably fell far short of the ideal, but much of whose economic and cultural value was based on the extent to which it mimicked it, albeit very modestly. The ideal was, for example, echoed in homeowners' front and backyards that might simulate forests (via a few trees), or hills and mountains (via a few rocks), or rivers and oceans (via miniature ponds).

Underlining the theory that the attraction of the classic beautiful landscape often had an economic component is the fact that in the past most property speculation was primarily in land, which is what people prized, not the buildings or homes the land contained, which, until recent decades, were not considered an especially good investment, as economist Robert Shiller (2011) has stressed.

Radical Environmentalist Landscapes: Society's Destructive Impact

The second main type of landscape displayed in Chelsea, "radical environmental" works, foregrounds concern, often alarm, about the natural

environment's deterioration. These landscapes depict the world as threatened by human development in numerous ways—shriveled by suburban growth, crisscrossed by freeways and other transportation devices such as power lines, littered with garbage, polluted by devices that ruin the atmosphere, and subject to apocalyptic nuclear and other holocaust-style shocks. These works were markedly more popular in star galleries (9.6 percent of shows) than upper-floor galleries (2.9 percent of shows).

"Environmental art," where concern about damaged nature is central to the work rather than peripheral, is basically a new genre that has appeared since the 1960s. It clearly reflects a widespread concern at the harm humans have done to their world.[6] Degraded landscapes have, of course, appeared in art long before the recent period. For example, the desert was a common theme in Judeo-Christian art. But the work's point then was not nature's demise, but rather to depict a secluded site where man received enlightenment, miracles, and communication with God.[7]

In the nineteenth century the classic landscape sometimes hinted at environmental themes. But such concerns rarely, if ever, led artists to place the damaged environment center stage in the landscape, as it typically is in the radical environmentalist landscapes of Contemporary Art in Chelsea. Railroad development, for instance, was a *background* motif in some Impressionist paintings, where a train might appear in a corner of the picture, a danger to the beautiful view (though also in these works often a symbol of a prized modernity). Some artists and patrons of the Hudson River school of landscape were explicitly motivated by a desire to document natural scenery before it was spoiled, especially by the railroad. As early as 1836 Thomas Cole, a key Hudson River school artist, after extolling the American wilderness, lamented that "the beauty of such landscapes is quickly passing away—the ravages of the axe are daily increasing" (Wallach 2002).[8] Still, Cole's paintings depicted primarily the beautiful scenery, not the "ravages of the axe." Likewise Ansel Adams's photographs documented the still intact landscape, not its destruction.

Nigel Cooke

A striking example of the modern environmental landscape are the paintings of Nigel Cooke, a then thirty-one-year-old British artist whose show at the Andrea Rosen gallery in 2003 appeared in our sample. The theme of Cooke's landscapes is what he calls "a virulent urban nature . . . where natural processes and human constructs have collapsed into each other in a desolate, even catastrophic way."

Cooke depicts two types of landscapes. The first are seriously damaged, but not totally devastated. They are littered with man-made debris—the

Fig. 2.1. Nigel Cooke, *Silva Morosa*, 2003. Oil on canvas, 72 × 96 inches (183 × 244 cm).

rubble of abandoned buildings, severed heads, skulls, and abandoned cars, with nature growing over this matter (e.g., *Silva Morosa*, fig. 2.1). The second type of landscape is qualitatively more seriously damaged. These are postapocalyptic scenes (we are left to speculate at the apocalypse's cause), mostly desolate but sometimes with an occasional sign of life such as a flower or solitary butterfly.

The artist commented: "I'm often told that my paintings look like certain places in the world, some that I've visited, others that I haven't. Mexico City, Sri Lanka, Central Illinois, Iceland, and Rome have all been mentioned recently. It's because in all these places there are areas where human constructs and natural processes have collapsed into each other through neglect or other kinds of change" (Garrett 2004).

The audience responses mirrored Cooke's intent. The vast majority (80 percent) liked the show, in all cases but one because it resonated with their own concerns about the natural environment. Many mentioned artistic merit also. A male retiree who lives on Manhattan's Upper West Side commented:

> This is the way the world ends, not with a bang, but a whimper. I didn't say that, T. S. Eliot did. [Points to a small red flower in a picture that otherwise

shows a devastated landscape.] The artist is telling us: "That's the only life that's managed to survive." So maybe there's some hope, but it's overwhelmingly weighed down.

A female professor of speech pathology who lives in Manhattan:

> It's devastating, scary. It looks like it's saying: "What have we done to ourselves?" There's just a little glimmer of hope. It's interesting that in most of the paintings there are little brains and birds. The birds are hopeful, the brains I'm not sure. It makes you think. I don't want to live with it! But I'm glad there are galleries and museums where I can go to look at it.

Some said the works reminded them of specific places, debris-littered or decayed, in a current city or broader megalopolis, rather than an apocalyptic disaster. These places included graffiti-marked sections of the inner city, or access roads to the freeway where litter gathered.

For example, a young female designer from Orange County, California, who now lives in Brooklyn:

> It reminds me of growing up in Southern California. This one reminds me of a place where you get on the Pacific Coast Highway [points to the trash and other debris in the woods in *Silva Morosa*]. The painting blends the picturesque and the reality of the scene, and also it's interesting to look for something intriguing in the trash. There's a lot of areas of California like that.
>
> When I went to Europe I was shocked to see how much graffiti was there too. I remember coming into Paris and seeing the graffiti just off the highway. I thought you only had that in Southern California.

A male artist born in Korea found the art reminiscent of Detroit, where he grew up:

> It [the work] seems very familiar. One of my friends in grade school did a project on graffiti in Detroit. [Points to *Silva Morosa*.] This reminds me of that. The landscapes are a bridge between Rothko/abstract expressionism and realistic/representational art.

The audience who did not like the work, 20 percent of the sample, considered the subject matter too downbeat and gloomy. A man in his forties, a freelance writer, said:

> I don't like this. It's depressing. I'm the wrong guy to ask; there's other stuff that is really nice. A few blocks down [in another gallery] there's a Spanish artist who does nice, bright colors. You should go and see his work.

Robert Adams

Another example of environmental landscapes are the photographs of Robert Adams, who has famously spent over forty years documenting nature's survival in the face of onslaughts from human development. As one reviewer commented: "Adams makes smog in California look ethereal and beautiful" (Chuang 2012).

In an earlier show at Matthew Marks Gallery in 2000, Adams foregrounded the destruction of the natural landscape by suburban development. Focusing on the Los Angeles Basin and the Denver metropolitan area, he argued that suburban tract houses and their paraphernalia such as the mall have ruined the natural environment (Papageorge 2002).

Titled *Turning Back*, the show at Matthew Marks (January 2006) that was part of our sample documents the deterioration of forests in states such as Oregon and Washington as compared with when explorers Lewis and Clark encountered them during their famous exhibition (1805–1806) to scout out the West. The wall text explains: "Two hundred years ago, Lewis and Clark recorded finding in the American Northwest a landscape of monumental trees. Most of this ancient forest has since been clear cut, as has later growth. We travel now to confront these facts and look for hope."

Although Adams's show does not stress this, Lewis and Clark's expedition reflects the point that economic value is often a key motivator of interest in the "classic landscape." In particular, they undertook their expedition on behalf of Thomas Jefferson and the US government, whose interest in documenting the West as a development area was sharpened by the 1803 Louisiana Purchase from Napoleon, perhaps the best real estate deal ever made and, amazingly, agreed in just a two-page document.

Adams's show focuses on the mutilation of trees by development. Photos include a road cut through a forest (titled *A Stump Next to Oregon Highway 47, Columbia County*); mature and young trees lying cut down to make way for development (*On Humbug Mountain*) (fig. 2.2); and birds flying (forlornly?) over treeless fields (nowhere to nest?).

Just over half the viewers interviewed liked the show without reservation, almost always because they resonated with Adams's concern about the fate of forests and the environment in general. A woman in her early twenties:

> I really like the theme of how we've exploited nature, what we've done to it. We're slowly starting to take over nature, but you can't live without it.

A female curator at the Museum of Contemporary Photography in Chicago:

Fig. 2.2. Robert Adams, *On Humbug Mountain, Clatsop County, Oregon*, 1999–2003. Gelatin-silver print, 11 × 14 in.

It's a very interesting show. I'll probably include his work in an exhibition I'm doing dealing with the contemporary landscape. It's titled *Landscape and Trauma* and is about how you can document trauma to the landscape. For example, there will be photos of concentration camps in Germany long after the camp has been taken down and you still see a rough disturbance in the landscape.

Still, for almost half of those interviewed the show was uninteresting. The nub of the problem, for most of these, was that cut-down trees were too similar to standing trees. The subject matter failed as an environmental landscape because it was not explicit and dramatic enough about the damage. Nor could it be salvaged as a classic landscape, because that was not what most respondents wanted to see, while those who did sought something more inspiring than trees. Many of the critics spoke about an excess of trees, tree fatigue.

A female lawyer in her fifties who buys art frequently and lives in the affluent New York suburb of Rye:

I'm disappointed with this show. There are too many trees. It's like taking a long walk in the woods. I own a tree or two myself. How can you criticize

someone objecting to the destruction of nature? But I go for the visual merit, not just what is socially relevant

A female photography student in her early twenties:

> The concept of what we've done to nature is interesting, our effect on nature, how its suffered, it's sad. But I prefer his other work. These are just too much nature. I prefer *What We Brought the New World* [Adams's earlier show] because that is about places we live in, i.e., the suburbs.

A few respondents were not interested in environmental issues at all. A female art advisor in her early forties:

> The subject of trees, deforestation, I blanked out. I've just seen fifteen shows in Chelsea and I've been spoiled by large scale. The scale (smallish photographs) here is boring. And it's traditional, black and white.
>
> Some trite little art show isn't going to do much. Artists' political statements are pathetic and pointless. I'm looking for very large scale, abstract canvases [for her client seeking decorative art].

Joel Sternfeld

Another example of radical environmental landscapes in our sample is photographer Joel Sternfeld's work. Yet instead of showing a degraded natural world, he depicts nature that has been arduously protected, often in the face of serious opposition. For example, his photographs of the High Line, showing the abandoned elevated railroad as a natural oasis overgrown with wild vegetation, were the core of the book commissioned by the nonprofit Friends of the High Line to help turn the line into a park, as described in the next chapter. His show *Sweet Earth: Experimental Utopias in America* at the Luhring Augustine Gallery in 2005 portrayed residents of communes trying to preserve a bountiful, but hugely threatened, resource—usually land or water—often despite harassment by more conventional residents and the authorities.

DECORATIVE/ABSTRACT

The second most popular topic of Chelsea shows is decorative/abstract/pure design. Although this has been a staple of art throughout history—Islam's version dates to the seventh century—in the twentieth century an avant-garde for a while elevated it, under the umbrella of "Abstract Art," as the culmination of art. Abstract Art, they argued, was superior to Representative Art. For example, they claimed that when people looked at and liked ("appreciated") Abstract Art their experience was higher quality

(more creative, richer, thoughtful, sublime) than the experience of those who viewed Representative art. Likewise, during the Cold War from the 1950s to the 1980s, the US government cited Abstract Art as evidence of capitalism's superior cultural creativity and freedom, by contrast with the Soviet Union's art, slavishly limited to realistic depictions of the existing world, "social realism" (Guilbaut 1983).

These claims about Abstract Art's superiority were never supported with evidence drawn from people's actual experience viewing abstract art, and are now widely seen as exaggerated (Kleiner 2009). Some people add that the claims were elitist and alienated the broader public who often found Abstract Art puzzling and resented the implication that they were insufficiently educated and talented to appreciate the work. In any case, the view that Abstract Art is superior to Representative Art has been implicitly abandoned by Contemporary Art, much of which consists of work that is representative. This is also in line with the art world's abandonment (temporary or permanent, it is not yet clear) of its claim through much of the late nineteenth and twentieth centuries that art is getting better and better.

In Contemporary Art as displayed in Chelsea, the abstract/decorative has settled into an important, though not predominant, position. It constitutes 25.8 percent of all Chelsea art, and is popular in both star (23.3 percent) and upper-floor galleries (32.3 percent). Abstract Art is never explicitly presented in Chelsea as superior to other types of art.

Ellsworth Kelly

The work of Ellsworth Kelly—abstract, colorful, and geometric—was the subject of a show called *Diagonal* at Matthew Marks in February 2009, which was part of our sample. The show filled two Marks galleries (24th and 22nd Streets). One gallery included four works, each about five feet by three. An example is a canvas with four horizontal stripes, blue, green, black, and red (fig. 2.3). The second gallery featured eight paintings, each consisting of a black or white rectangle with a contrasting black, white, or colored rectangle laid diagonally on top of the first.

Sixty percent of the audience interviewed liked the works, the vast majority (two-thirds of those who liked the works) because of surface qualities—shape, line, color, balance—even when pressed by the interviewer about possible deeper meanings. This was as true of those who were cultural experts as it was for those with other occupations. Consider these examples.

An art producer/director in her twenties who lives in Manhattan's West Village:

Fig. 2.3. Ellsworth Kelly, *Blue Green Black Red (West Coast Landscape II)*, 2007. Oil on canvas, four joined panels, 90½ × 71⅛ inches (229.9 × 180.7 cm). Private collection. © Ellsworth Kelly.

I love Kelly! [Why?] This makes me feel so happy, perhaps because I'm feeling so grim. I've got sinus problems right now. The work is so simple in its form. I like the shape of the canvases and the layering of forms out of nature that are geometric. [Does she see anything deeper in the works?] I don't think of that so much. I like the colors. [Points to the blue curved piece.] The simplicity of forms, it seems hopeful.

A man in his forties, a former museum curator:

I love Ellsworth's work—its very vibrant, dynamic, open, and the clarity. [Does he see anything deeper in the works?] No, it's a thing in itself. It's not

a tableau to project our fantasies! It doesn't suggest anything other than the experience itself.

A woman in her early sixties who had been an elementary school teacher and then a systems support manager:

> It's really nice, it's soothing, calm. [Why is that?] It's vibrant, I like the largeness of it. I like the symmetry and also that things are uneven. And the bold colors.

A third of those classified here as liking the works for decorative/stylistic reasons initially said, when questioned, that they saw deeper/nonsurface meaning in the works. But when asked to be specific, they just mentioned other stylistic and spatial characteristics. For example, a man in his forties visiting from the Netherlands and himself a minimalist painter said the point of the work was allowing viewers to see alternatives. Still, the alternatives he saw were other surface qualities, especially the gallery floor:

> I like Ellsworth Kelly. I'm a minimalist painter, and he's one of the pioneers of minimalism. The point of this kind of art is you take it at face value or you can read other things into it. It's ambiguous. ["So what else do you see in it?" He glances at the gallery's concrete floor, preserved from its garage days, and then up at the skylight.] You can see how important is the floor and the skylight!

Of the minority (a third of those who liked the works) who said they saw deeper, representative material under the surface and then did actually mention representative (not stylistic) material when asked about it, all but one saw representative material that simply repeated one of the other central categories in Chelsea art—classic landscapes, troubled interpersonal relations, and so on. For example, the curator of a Midwest museum of Contemporary Art believed that abstract art facilitated an especially creative relationship between viewer and artwork. Asked to be specific, he mentioned trees (the classic landscape):

> Well, in some of Kelly's early work the references are well known. In one it was the reflection of trees on the River Seine in Paris, from the period when he lived there. Another was looking out the window of the Museum of Modern Art in Paris.

Of the 40 percent who did not like the Kelly show, the largest group were disappointed. They thought the work was not new or different from Kelly's older work. For example, a medical doctor who lived and worked in Brooklyn:

After a while some artists find a niche and then they coast—it's a factory and they just collect a big paycheck. Also, there's a fine line between art and bullshit, and if I can go home and make the exact thing in my basement, then you wonder.

Overall, these interviews validate Contemporary Art's implicit abandonment of a claim that Abstract Art is inherently superior to Representative Art. This is not to diminish the works, but to stress that they are, for most of their admirers, basically decorative and stylistic, a way of brightening and enlivening people's lives.

THE TROUBLED FAMILY

The nuclear family, depicted in a critical way, is the third most popular topic, 11.4 percent of all the shows, though far more popular in star galleries (20.4 percent of shows) than in upper-floor galleries (only 3.3 percent). These works are striking for avoiding positive portrayals of marriage and the nuclear unit (husband, wife, and children).

The degree of criticism portrayed in the art ranges from highly negative (depictions of tortured and anguished relations), through the merely troubled and the satirized, to families presented both positively and negatively in the same artist's work, which is as favorable as the depictions get.

The troubled family is recognizably commonplace in other areas of modern culture such as movies and literature, but has not yet been fully acknowledged as a major genre in Contemporary Art. Certain Contemporary artists are known for depicting family and interpersonal relations in a critical light. An example is Tracey Emin from Britain, shortlisted for the prestigious Turner Prize, whose 1995 work, *Everyone I Have Ever Slept With, 1963–1995*, was a tent adorned with many names, including several relatives, such as her twin brother and her two aborted children.[9] Despite such well-known cases of individual artists, only when the works are systematically classified is it clear that the troubled family is a major genre in Contemporary Art.

Further, this is basically a new genre in art history. There have certainly, in the past, been particular depictions of troubled, even pathological, family behavior. For example, William Hogarth portrayed dissolute (e.g., drunken) behavior in poor, middle-class and upper-class families in eighteenth-century England. But Hogarth's work was original, not part of a wider genre or school.[10]

Actually, even positive (let alone negative) depictions of the nuclear or quasi-nuclear human family have been prominent, perhaps dominant, only during a few periods and in certain regions. In medieval times, and

especially during the Renaissance from the fourteenth to the sixteenth century, it was not the human family but the Holy Family, patently idealized, especially Mary, Joseph, and Jesus, or Madonna and child, that dominated Western art's depiction of the family. Nonreligious depictions of royal and aristocratic families did become common starting with the Baroque period in the seventeenth century. Still, not surprisingly, the patrons of these works had no wish to commission depictions of a problematic family life. Likewise, family portraits served as inheritance solidifiers and succession boosters in many rich or aristocratic families in England, in particular where the landed wealthy needed an undisputed heir to keep the family farms and territories intact. Later, in the important British and American tradition over the last two centuries, the family, as husband, wife, and children, emerged as a basically middle-class topic full of idealization (Brilliant 2006). For example, dead children were often painted into the picture as though alive. Certainly scrutiny of the works in this Anglo-American tradition can uncover signs of criticism of the institution they depict, but these are rarely the center of the work.

So Contemporary Art's open and pervasive depiction of troubled family life is new. The corollary is that portraying the contented, stable family, unpunctuated by difficulties, unorthodoxies, or satire, is nowadays almost taboo.

Gregory Crewdson

Among the darkest portrayals of families in the shows sampled is Gregory Crewdson's show *Beneath the Roses* (Luhring Augustine 2005). Crewdson's method is to hire actors and construct elaborate movie-style sets, explicitly located in small-town America, which he then photographs. This is very expensive, another example fueling the charge that Chelsea art is "corporate." For this show alone, Crewdson employed over a hundred fifty people, including fifty-five actors, eight set dressers, several "best boys," a lead "greensman," an "aquarist," and a manufacturer of synthetic corpses. For an image requiring rain, the aquarist placed water towers along the street, feeding from sprinklers. In the past, Crewdson's images have featured well-known actors such as Gwyneth Paltrow.

The actors in Crewdson's sets usually play quasi-family roles, and the families are uniformly torn and stricken, with some implication that the problems result from their location in the landscape of small-town America. Crewdson, who teaches photography at Yale, acknowledges his cross-media intellectual debt to movie directors such as Hitchcock, Orson Welles, and David Lynch. Nudity is an additional motif in Crewdson's work—the images abound with seminaked, distraught women.

Fig. 2.4. Gregory Crewdson, *Untitled*, 2004. © Gregory Crewdson. Courtesy Gagosian Gallery.

The following works are illustrative of the show. A child stares from the street at a naked woman (his deranged mother? a dream?) standing in front of their trailer home (fig. 2.4). A man in a suit stands at night in the rain in the middle of the street watching the water (his life?) slosh down the drain. A naked woman, hair graying, stands in a domestic interior, blood dripping from her vagina (*Blue Period*). A pajama-clad husband and wife sit in their bedroom in sadness and depression. A pregnant woman, alone in midstreet at night, contemplates the abortion clinic. A mother and son sit at dinner and stare at someone's (the absent father's?) unoccupied place (fig. 2.5).

The gallery handout confirms Crewdson's intent to present disturbing subject matter:

> Anonymous townscapes, forest clearings and broad, desolate streets are revealed as sites of mystery and wonder; similarly, ostensibly banal interiors become the staging grounds for strange human scenarios. . . . Never anchored precisely in time or place, these and the other narratives of *Beneath the Roses* are rather located in the dystopic landscape of the anxious American imagination.

Audience comments left no doubt that desperation is what they saw in the works. Almost two-thirds of the sample liked the show, and all but two of these stressed the portrayals of alienation, isolation, and deep trouble.

Three-quarters of these also praised the technological achievement of the staged settings and photographs.

A woman in her midtwenties, doing a master's in fine art at Rutgers University:

> It's very theatrical and dramatic. I like it. It's impossible not to like it. [Points to *Blue Period*.] There are hints of what is going on—for example, the shoes. In all the works there is some kind of alienation and loneliness; people are existing in the environment, but disconnected.

A woman in her late twenties, a graphic designer who lives in Brooklyn:

> [Points to mother and son eating a doleful meal (fig. 2.5).] They're stuck on that hulk of meat, waiting for someone to come home, maybe the dad or something. Seems things were started but not finished. Look at the kitchen's condition—everything is half finished. It's unbelievable, the detail, the expressions.
>
> The show is incredible. At first these pictures have this cold, negative look, but once you look closely you realize these people are all going though something, and the beauty is in the detail.

A man in his fifties, an art critic who lives in Boston and runs his own journal, *Maverick Arts*:

Fig. 2.5. Gregory Crewdson, *Untitled*, 2005. © Gregory Crewdson. Courtesy Gagosian Gallery.

It's very impressive work. I like the staging, the production quality. This show was very expensive. Each piece cost about $15,000 to produce.

It's an ongoing confluence of works of live art, popular culture, sexuality, and film—also, small-town America, with rural America and working-class communities.

[Points to a photo of people staring from a neighboring house at a wide-open car door.] There's an incident there; something has happened. The work is accessible; there are scenes everyone can relate to. It's reminiscent of Edward Hopper. And then again it's saying something about America. We're the largest and most vigorous population in the world but not a community. We are the "lonely crowd." Kids nowadays think it's about technology and skateboarding with their iPod and body tattoos without any sense that never in history has the individual been more alone.

A third of the audience had serious reservations about the work, though all respected the technological achievement. They saw a portrayal of troubled family relationships, but found this too gloomy and depressing. A few also objected to what they felt were the negative stereotypes of small-town life in the Northeast. For example, a woman in her mid-twenties:

I'm a student in DC. It's kind of sad. I definitely respect the staging aspect, that's remarkable. But subject matter-wise it's too dark.

A man in his early twenties, a recent Yale graduate, was troubled by the unflattering depictions of small-town life:

I'm very interested in it, but a lot of parts bother me. I'm from a small town in Vermont, and it seems like they're [the photos] feeding city folks their desired portrait of a small town. You know, the older cars and a total absence of post-1980s technology. You'll see those kinds of cars in my town, but you'll also see newer ones too. It bothers me that people in the art world can feel comfortable with this image of small-town life.

Candice Breitz

Another example of the gloomy view of the nuclear family is Candice Breitz's two video installations, *Mother & Father*, at the Sonnabend Gallery in 2005. In *Father,* Breitz presents extracts from the films of six Hollywood actors playing distressed fathers or divorced parents (fig. 2.6). The actors include Dustin Hoffman, Steve Martin, Donald Sutherland and Jon Voight, and the films include *Mommie Dearest, Kramer vs. Kramer,* and *Terms of Endearment.* The men voice a range of paternal frustrations, mostly

Fig. 2.6. Candice Breitz, *Stills from Father*, 2005. Six-channel installation. Duration 11 minutes.

about the problems of divorced fathers trying to relate to their children. The overall effect is a six-screen fugue of lamenting, whose themes include explaining the mother's absence to the kid ("where's mommy"); the fight over custody ("seven years of being away and now she wants to be a mother"); blame and anger at the mother ("I'm not trying to put her down, but his mother doesn't show him a great deal of affection").

Bill Owens

Photographer Bill Owens is as close as an artist in the sample comes to depicting the nuclear family in a positive light. Much of Owens's work deals with newcomers to suburbia. His show *America* (James Cohan Gallery 2005) collects photographs from the four bodies of work for which he is best known, *Suburbia*; *Working (I Do It for the Money)*; *Our Kind of People*; and *Leisure* (Owens 2004). Many of the photographs were taken in Livermore, northern California, from the late 1960s to the mid-1980s, where Owens was a staff photographer for the local newspaper (Owens 1973).

Owens says that he generally presents suburbanites in a positive light, and the work can certainly be interpreted in this way. His affection for suburbanites is apparent in *Fourth of July Party* (1971), where a large group of residents celebrate in front of their tract homes, and in *Parade with Flag* (1972), where a group of about thirty—men, women, and some children—engage in a burlesque parade past the subdivision's houses, re-enacting a famous Civil War painting. Other photos show couples dancing in their basement or barbecuing.

Even so, the same show contains much material allowing a viewer a mixed, even dark, reading, as interviews with the audience confirmed. This material includes suburban children with toy guns (fig. 2.7), goofy-looking people in front of McDonald's, "swinging" couples in a hot tub (fig. 2.8), and lone men watching a stripper.[11]

Ninety percent of the audience sampled liked Owens's work. The only show more popular was Mary Ellen Mark's documentary on Bombay prostitutes (discussed below under the category "sex"). The ambiguity of many of Owens's photographs clearly helped, allowing those who disapproved of suburban culture and those who liked it to resonate with the works.

All the audience sampled saw Owens's work as a commentary on American suburban family culture. Still, when evaluating the culture depicted, the audience split about evenly into three groups—positive, negative, and a mixture of positive and negative. The following are examples of the positive view. An engineer in his forties who lives in Queens:

> It's great—funny to see encapsulated something that is gone, but I lived there. It's familiar but also different. The interiors and the clothing and the hair styles are familiar. [Points to photo, depicting boy with toy gun.] For example, that looks just like my brother looked. Now he drives a Porsche, oh my God!

A male graphic artist who lives in Queens:

Fig. 2.7. Bill Owens, *I don't feel that Richie playing with guns will have a negative effect on his personality*, 1971. Black-and-white photograph, 20 × 16 inches, edition of 15. Copyright the artist. Image courtesy of the artist and James Cohan Gallery, New York/Shanghai.

Fig. 2.8. Bill Owens, *We don't have to conform*, 1981. Color photograph, 30 × 40 inches, edition of 10. Copyright the artist. Image courtesy of the artist and James Cohan Gallery, New York/Shanghai.

It's looking back to the sixties and seventies. I was born in 1964. [Points to *Cookout Couple*.] The guy with the grill reminds me of how quickly time goes by. We used to grill. I grew up in the suburbs in Nassau.

The third of the sample who saw the material as primarily a critique of American society variously stressed militaristic violence and cultural crassness. A smaller subgroup also complained about racism and sexism in suburbia. For a woman in her early twenties, an art student who had just moved to New York from Israel, the photos showed people in only partially successful attempts at upward mobility:

It's very interesting. He has a talent to depict the gap between the gestures people make and their surroundings. [Points to swingers in a hot tub.] They're trying to be something, but there are a few things on the side that disturb the illusion, e.g., the chair at the top [a spindly chair]. That can't be the chair of rich people, unlike the champagne they're trying to drink. And the cement around the pool is not done quite right. It's cheap.

[Points to *Parade with a Flag*.] The posture of the woman in the middle carrying the flag echoes the posture of the man on crutches—[they are both marching in exaggerated fashion with one foot high]. She is carrying the flag, which symbolizes America as the land of opportunity, and then he carries his crutches. It's ironic.

A woman in her midthirties who works at the Getty Museum in Los Angeles as administrative assistant to the director complained about the gun culture and sexism:

I'm struck by the images of children with guns in a suburban context. It's really troubling for me, since I come from the Midwest. I know all about it. [Points to *Strip Club Interiors*.] As a woman there's no getting away from this one, it's such a voyeuristic position. I'm struck by the way men can be in the space, gazing at women, and she's [the stripper] thinking: "Ok, whatever, I'm doing my job."

The rest of the audience saw both positive and negative, about equally. A black man in his forties who lives in Manhattan and writes books on finance saw the photographs as depicting suburban mobility for whites but not blacks:

[The show is] the first wave of white Americans who could get into these suburban houses. It shows a lot of the things we associate with the country—suburban kids, parents in the suburbs. But these people one generation ago were hunters in the country.

[Points to *Bride with Bubble Gum*.] This bride, she's a half generation removed from her previous socioeconomic status—the dress suggests

middle class but the glass and the Kentucky Fried Chicken [she's holding a pack of chicken] reflects their more moderate origins.[12]

He's captured a moment in American society when people were making huge gains, though just for white people [i.e., not blacks].

To summarize, images of the troubled family run a spectrum in the Chelsea sample from deeply troubled (Crewdson), to mixed or ambiguous (Owens). Notable too is that the images are almost always those of someone other than the purchaser or artist (by contrast with earlier nonreligious portrait traditions in art history). People who buy these works, not surprisingly, have little interest in depicting their own troubled relationships, rather than those of others.[13]

The reasons why the troubled family has not, until recently, been a major genre in the history of art are complex. It might be argued that families face more difficulties now than in earlier periods, but the evidence to support this does not really exist. What is true is that in contemporary society the problems of family and associated relationships are more openly discussed and accepted than at any other time in Western history. Three obvious indicators are the divorce rate, which has stabilized at a high level (roughly half of those who marry these days are predicted to eventually divorce, a well-known statistic), the openness of same-sex relationships (not, of course, unique to today's society), and the continuing debate in modern society over male and female gender roles at home and in the workplace (Gerson 2009).[14] Also, the factors that sometimes led patrons in earlier periods to commission portraits depicting a stable family (e.g., a desire to underline the genealogical line for inheritance—economic and/or political purposes—see Brilliant 2006) no longer apply. The result is that portraying the contented, stable family, without at least offsetting critical images, seems basically taboo in Contemporary Art.

SEX

Seven percent of the shows depict sex, making this the fourth most popular topic in Chelsea overall. All these shows were in star galleries, 14.8 percent of all their shows. Upper-floor galleries avoided the subject.

The works classified here as "sex" fall into two types. The first, just over a third of the works shown, are plain "nudes." They show naked or seminaked figures (usually women), but do not depict active sexual relations.

Actually the "plain" nude is fairly recent in art history. Until roughly the mid-nineteenth century artists could generally depict naked women only if they were clad in antiquity or religion or were allegorical, called

Venus, Sabine, Truth, and so on to be acceptable. These can be called the "classic" nude.[15]

The second type of works classified here as "sex" depict actual sexual activity, mostly between men and women, in a few cases between members of the same sex, or sometimes masturbation (a topic of noticeable interest in recent Contemporary Art). This suggests it may be time to recognize "active sex" as a major category in Contemporary Art, and basically a new category in Western art. (Some possible exceptions, historical examples of art depicting active sex, are discussed later.)

A pivotal event in the emergence of active sex was Jeff Koons's 1991 show *Made in Heaven*, which consisted of photographs and ceramic sculptures of Koons and his wife Ciccolina, an Italian pornography star, having sex in various ways.

One reason active sex was in star, not upper-floor, Chelsea galleries was probably that smaller galleries, having fewer economic resources, are less able to risk an unsuccessful show. Research on organizations has consistently found that larger units are generally more innovative than smaller ones, above all because larger units have the resources to fund innovation, take risks, and survive a setback, although there are, of course, well-known exceptions where major innovation comes from smaller organizations (Rogers 2006, 409ff.).[16]

These points are discussed in detail below.

The Plain Nude

Roughly a third of the works classified here as "sex" fall into the category of the plain nude, or naked or almost naked figures not engaged in sexual activity and not depicting themes from religion or antiquity or allegory. Audience interviews reveal that nowadays artists and audience often use plain nudes to ruminate on the position of women in contemporary society. In such cases these nudes imply, and overlap with, versions of feminism. If the art depicts naked men, the subject may also overlap with male homosexuality and attitudes toward it. Plain nudes that do not trigger musings on such topics tend to lack interest from the audience nowadays (unless they are depicted as explicitly available for sex in the various ways characteristic of soft porn).[17]

Lisa Yuskavage: Nude and Feminism

Lisa Yuskavage's show at the Marianne Boesky Gallery in June 2003 is an example of the nude enlivened with a feminist tilt (fig. 2.9). Yuskavage usually paints buxom women, many of whom seem absorbed with nakedness.

Fig. 2.9. Lisa Yuska-
vage, *Wee Babie 1*,
2003. Oil on panel,
7 × 5 inches,
17.8 × 12.7 cm.
Courtesy the artist
and David Zwirner,
New York.

Sometimes they are scrutinizing their breasts, buttocks, or crotches. The
artist says that her work is autobiographical and depicts personal subject
matter of which she was embarrassed and verging on ashamed. The work,
she explains, "has always been about things in myself that I feel incredibly
embarrassed by. . . . I never intended to paint just nudes. I was and always
have been interested in depicting intense psychological states."

In a 2000 catalogue essay, Claudia Gould linked Yuskavage with HBO's
television sitcom *Sex and the City*, which aired from the late 1990s to 2004:
"The first time I saw a large body of Lisa's work, in 1996 at the Marianne
Boesky Gallery, I was . . . puzzled. Why was a woman painting these types
of paintings about women? . . . Now I find myself not only enthralled by
Lisa's images but curating her first one-person museum show. If *Sex and
the City* levels the playing field by giving voice to women and their sexual-
ity, so too does Lisa Yuskavage" (Gould 2000).

Of the audience sample, 62 percent liked the work. All the women who
liked it did so because they empathized with what they believed Yuskavage

was saying about women's private feelings about their bodies and lives. In general they found it appealing that the artist was not idealizing women but presenting them in private situations where, semidressed, they muse about their sexuality and physical imperfections, engaged in less than happy thoughts on those topics. A woman in her late twenties:

> It's gripping, very beautiful, and disturbing. There is something sad about the women, something about their imperfections. They are being caught off guard.

An Asian woman in her early forties who lives in Belgium and visits New York on occasion:

> I like her. It's like a fairy tale. In fairy tales, young girls are not so happy. There is something behind the façade in these paintings, it's deeper. There is the history of the person, the drama. Yuskavage gives the woman as is, not better, not worse.
>
> She's a bit like John Currin. I like his work too; it's the same.

Men liked the work almost as much as women, but for different reasons. Not surprisingly, none of the men were interested in Yuskavage's portrayal of women's inner feelings about sex and their bodies. Instead, they mentioned technique, or the work's erotic quality, or its place in art history.

A man in his forties, originally from Japan, who lives in Queens and works as a graphic artist, found the work erotic, stressed the need to infuse interest into the classic nude, and liked the technique too.

> I like figurative painting well done. Her technique is good. She has a world she experiences. Also, it's sexuality, and that is always attractive. It's erotic.
>
> With the return of figurative painting, it's very easy to do something old-fashioned or not interesting, so artists have to find some concept to sustain the work. In her case, there is a certain weirdness. You just have to differentiate yourself.

Mary Ellen Mark: The Nude as Feminist Documentary

Another show presenting the nude with a feminist perspective is documentary photographer Mary Ellen Mark's *Falkland Road* (Marianne Boesky Gallery 2005). The topic was the brothels of Mumbai's (formerly Bombay) Falkland Road area. Shots included prostitutes waiting for business (fig. 2.10), applying makeup, and with customers. Some photographs depicted the young children of the prostitutes and implied that this could be a generational business into which women were born. The prostitutes

Fig. 2.10. Mary Ellen Mark, *Girls Looking Out of Cages on Falkland Road during the Day, Bombay, India* (from Falkland Road Series), 1978. Cibachrome print, 16 × 20 inches.

themselves were often aged around twelve to fifteen. (This show was classified for table 2.1 as about the poor or disadvantaged, as well as about sex.) In the majority of the photographs the women were mostly clothed, but there were enough nudes to justify classifying the show in that category. There were also a few photographs of sex with customers, but these were relegated to a rear room of the gallery, and the sex was not explicitly depicted, which is why this show is classified here as part of the nude tradition, not sexual activity.

Mary Ellen Mark spent almost ten years visiting Falkland Road before she could earn the trust of some of the madams and prostitutes and gain entry to photograph. Stories about the initial hostility with which she was met are an apocryphal part of the work. The photographs were taken in 1978 and 1979.

This was the best-liked show, by far, of all those for which we interviewed the audience. Everyone praised it, citing one or both of two factors. First the commentary about the plight of the women. Ninety percent of respondents gave this as a reason for liking the work. There was broad sympathy with, and objection to, the suffering and exploitation of the female prostitutes. (The show included a few photos of transvestites, but no one mentioned them.) The audience interviewed drew a line between these feminist issues about the exploitation of women, which they

mentioned frequently, and eroticism, which they did not. Despite several images of women frontally naked, no one volunteered that they found them erotic.

By contrast, noteworthy earlier depictions of prostitutes in recent art history were usually from a male perspective. Picasso's 1907 *Les demoiselles d'Avignon* and Manet's *Olympia* (1863) show prostitutes as powerful figures, possibly even threatening to the male population because of sexually transmitted diseases. Manet died of syphilis. They lack Mark's sympathy for the prostitutes, although we cannot know what attitudes might have been uncovered had audience interviews been done at the time.

The second main reason the audience gave for liking the Mary Ellen Mark show was the photos' technical merit—their colors and the thoughtfulness of their staging. This was mentioned by 60 percent of respondents.

The following comments are illustrative. A man in his thirties, also a documentary photographer:

> It's wonderful. Artistically it's great, but it's all about the content, the despair and tragic situation in which these women live. It's heartbreaking to see them. They're exploited, some by their own choice, and some are brought from Nepal. And it's a rarity to have this in Chelsea; documentary is very hard to show and to sell at the galleries. Galleries have to sell, though this may sell now.
>
> Things haven't changed much in India; it's always relevant to communicate stories like this.

An Asian man in his forties, born in Hong Kong, who works as an artist in Toronto:

> It's powerful! I can see the suffering of life, it goes on generation by generation. The people don't know what they're doing; just like the animals, maybe it's the rhythm of nature. But it's reality.
>
> We are in North America, so people here are surprised, but in India and Africa and all round the world these things are happening all the time. Here you are so sheltered.

In short, these photographs managed to evoke feminist sympathy while basically shuttering out an erotic component.

William Bailey: The Plain Nude as Sometimes Now Dull

William Bailey's show at the Robert Miller Gallery (February 2003) underlines the propensity for the nude these days to be viewed as dull unless livened with other motifs. The show was divided about equally between nudes and the still lifes—depictions of pottery plates, cups, and so

Fig. 2.11. William
Bailey, *Untitled*, 1999.
Pencil on paper,
26¼ × 19¼ inches,
66.68 × 48.9 cm.
© William Bailey.
Courtesy Betty
Cuningham Gallery,
New York.

forth—for which Bailey is more famous and which made his reputation in the 1970s.

The formality of Bailey's nudes echoed the formality of his still lifes. The naked women are highly stylized and literally lifeless, since they are imagined in his head, not drawn from actual people. Their demeanor and faces are vacantly expressionless, and they are presented without a context (*Untitled*, fig. 2.11, is an example). As a result they failed to trigger any feminist musings, still less erotic feelings, in any of the audience sampled.

Only 44 percent of those interviewed liked the show without reservation. In all these cases it was the technique (whether applied to still lifes or nudes) that people praised. No one, male or female, found the nudes erotic, and none of the women (or men) empathized with the depicted women. The following are examples of those who liked the show.

A middle-aged man, staring at a nude woman seated on a chair (*Night in Umbria*, 1992):

I've followed him for years. I love his technique; everything flows from that, no difference for nudes or still lifes—I like the coloration, shadow, light.

A woman from Geneva, a middle-aged sculptor, explained that, given the technical caliber of the nudes, she might even hang one in her home:

Ordinarily I would never think of having a nude painting in my living room or dining room, but I like looking at it, and I might have this in my living room. It goes beyond just being a nude painting. It's beautiful, the shades, the stillness.

The following exemplify the over half of the audience (56 percent) who had serious reservations about the show. Almost all of these liked the still lifes (pottery), but not the nudes, usually because they saw them as sterile and unemotional. The women found them too lifeless and "perfect" to identify with in terms of feminist issues, and the men could not see erotic attraction in these highly stylized images. A male cardiologist in his late fifties, who lives in New Jersey, complained:

It's boring. The nudes look as sterile as these [the still lifes]. They are rigid, almost rectangular. I'm tired of this stuff—it's beautiful, but sterile.

A woman in her late fifties, an artist and chair of the art department at the University of Hertford and a resident of the West Village section of Manhattan:

I like the impact of the still lifes. They look like real things on the table. But I think the nudes should have a little more emotional quality; they're just a bit aloof. It doesn't hit me in the heart. He's done some very lovely things with the composition, the skin quality, but it's a bit cold.

In short, these interviews suggest that the plain nude figure, as a stand-alone motif without additional themes to add interest, is not a compelling topic these days. Naked figures that were not depicted as part of classical mythology or religion or as allegories have only fairly recently become acceptable in Western art, roughly since the mid- to late nineteenth century. So the plain naked figure has had a short life as an object of Western art. One problem it clearly faces nowadays is having to compete with depictions of active sex. In this context, the genre of soft porn—naked figures in sexually suggestive poses (arched backs, enticing gazes, stiletto heels)—is another way of livening the naked figure, as some Contemporary artists have discovered. (For instance, photographer Sante D'Orazio's images of Pamela Anderson were showcased at Chelsea's Stellan Holm Gallery in 2005.)

Sexual Activity

Nine percent of the shows in star galleries depict sexual activity, typically between men and women, occasionally between members of the same sex, and sometimes masturbation.

Cecily Brown's Hybrids: Classic Landscapes plus Sex plus Decorative

Cecily Brown's work is an interesting example of a hybrid: a classic landscape, livened with "sex" and the decorative. Her work might also be seen as a response to the view, discussed above, that both the classic landscape and the plain nude have become dull. The show that appeared in our sample was titled *Art in Review* at the Gagosian Gallery in February 2005.

Born in London in 1969 and the daughter of a famous art historian, David Sylvester, Cecily Brown moved to New York in 1994, where she made a name for herself placing quasi-erotic figures in broad landscapes in Abstract Expressionistic style. Her work also often references earlier classics.

The paintings in *Art in Review* show an arcadian terrain with naked people happily engaged in bacchanalian scenes of sexual pleasure. For example, *The Quarrel* (fig. 2.12) depicts male and female figures in a sexual frolic in the woods, perhaps an updated, edgier reference to Matisse's canonical *Joie de vivre* (1904). A group scene shows a "man" having sex from the rear with a "woman" who is kissing another "man," though none of the genders are especially clear. Also often present in the works are naked human fragments, with a focus on female sexual parts. *Girl Eating Birds* has women's legs in a jungle-like scene, and *Thanks, Roody Hooster* has female body parts crammed around a sandy beach.

Audience interviews confirmed the attractiveness of Brown's package—classic landscapes full of life, especially sexual activity, in a colorful, Abstract Expressionist style. A strong majority, almost 70 percent, liked the work, with some expressing enormous enthusiasm. Consider these examples:

An African-American, New York University student:

> It's great. [What is it about?] I think it's all about life, all aspects of life—love, loss, nature, sex, buildings, death. For example [points to *The Quarrel*] the very green part reminds me of the Florida Everglades, and the top right [a pyramid] reminds me of Egypt. At the bottom is a desert. And there's sex.

A woman in her early twenties who is an art student at the Pennsylvania Academy:

Fig. 2.12. Cecily Brown, *The Quarrel*, 2004. © Cecily Brown. Courtesy Gagosian Gallery. Painting photographed by Robert McKeever.

She's amazing, full of energy; each part of the canvas is full of adventure. Some parts are exciting, fresh, other parts are calm, serene, lots of emotion. Each canvas is a new world ready to navigate through. For example [discussing *Girl Eating Birds*] I've already named this "Paradise." It's like the jungle: there's the floor of the jungle, and I see drums, wild life, lots of color and energy.

An older man in his seventies, a long-time resident of Chelsea and a poet, likewise saw the works as landscapes full of wonderful items:

It's great. I like the energy. I love it. It's all poetry in paint and I'm a poet. [Peers at *The Quarrel*.] This could be "The Garden of Eden" with Adam and Eve.

Only one respondent mentioned the sex alone, an Israeli painter in his fifties who himself currently had a show at a Chelsea gallery:

I like the erotic pieces combined into the abstraction. [Points to *Girl Eating Birds*.] There is a leg, there is a naked body. [Points to *Thanks, Roody Hooster*.] I think there are legs there and nudes. [Slightly disappointed.] Her previous shows were more erotic.

The roughly one-third of those interviewed who disliked the work did so on technical grounds. They thought it was just no good, or pompous and undeserving of its implied references to famous artists. For example, a young man, a journalist:

> I'm down on this. It seems a bit academic, art-schoolish, although they're technically great paintings. It's the first time I've seen her, though she's been famous for five years. I've read all her father's books; he's a famous art historian.

Andy Warhol: Gay Sexual Activity

Another show in our sample that focused on sexual activity—in this case that of gay men—was the Andy Warhol retrospective *The Late Male Nudes*, at Cheim & Read gallery in October 2005. It consisted of photographs of naked and seminaked men, almost always alone, including lots of close-ups of penises and male torsos. Often the men are touching their penises, some apparently masturbating (fig. 2.13). In one photo two men are positioned for anal sex. The show also gave prominent place to a fifteen-minute film, *Blow Job*, which depicts a young man's face as he receives oral sex. Some of the photos were sewn together, a technique with which Warhol experimented.

Whether the audience was straight or gay made a big difference, not surprisingly, to whether they liked it. Twenty percent of the audience sampled were gay, and all of these liked the show. So did another 20 percent of the audience. But this was the least popular show of all, strongly disliked by 48 percent of those interviewed. (The remaining 12 percent were either indifferent or liked parts but disliked other parts.)

Most of those who disliked the show said the photographs were not up to Warhol's usual aesthetic standards. These people had all been drawn to the show because they generally liked Warhol's work. But they found the photographs of mediocre artistic quality—poorly lit, poorly conceived, and poorly designed. They often added that, not being gay, they did not receive any gratification to compensate for the perceived aesthetic mediocrity of the work. Consider the following comments, all from straight members of the audience.

A woman in her fifties:

> It's not my cup of tea. I'm a middle-aged lady who goes to Catholic church every evening. I teach filmmaking [documentary film], and the lighting isn't even well done.

Her husband, a photographer, in his sixties:

Fig. 2.13. Andy Warhol, *Male Nude*, 2010. Black and white photograph. © 2010 The Andy Warhol Foundation for the Visual Arts, Inc. / Artists Rights Society (ARS), New York.

I did a lot of photos of Warhol, but it's [the show] a different aspect of Warhol.

[After it is ascertained that he and his wife are straight.] It's not work that would appeal to me. It's a commercial show to bring in a certain kind of clientele. Warhol was unique in what he did, but these pictures are like Warhol's movies; they're about changing morality, not about art. It's not just because I'm not gay; there's no artistic point here.

[Continuing his point that the works in the show were just there to make money.] Also, they're all stamped by the [Warhol] Foundation, not by Andy. I'm not sure Andy would have put them up for sale. [His wife adds that Warhol would have put almost anything up for sale.] Yes, that's true, there's his urine paintings. He peed on a metal frame and the surface after a while stained. Even those sold. People don't necessarily have taste. If you tell them it's art, they'll say "oh yes."

A straight black man in his forties who sits on the boards of several cultural institutions complained:

It's completely boring! At the time the work was done it was, I suppose, controversial and mildly titillating. But this kind of imagery has now been absorbed into society. For instance, outside the Trump building on 5th Ave at 56th is a huge billboard for Abercrombie & Fitch with a guy in shorts who clearly has an erection. You can see the bulge, although he's wearing pants.

Still, a few of the straight audience found artistic merit in the works. A man in his sixties, an administrator and professional historian who lives on Long Island:

> It's a side of Andy Warhol the public hears about but doesn't see. It's great to show these works. The repetition is reminiscent of Campbell's Soup.
>
> Warhol is one of our major artists. The more we learn about him the better. But he's also interested in ancient Greece and Rome and historical depictions of the body. Warhol had a lot of courage.

The five gay men, all of whom liked the show, were prone, unlike the straight audience, to take a keen physical interest in the men portrayed. For example, they all voiced views on which of the men were handsome. A gay man in his fifties, an artist originally from Scotland who works in one of the nearby galleries:

> It's classic Andy Warhol. I like the show. It's kind of stupid in a way, but Andy Warhol has such as perfect eye for things—he can turn them into interesting looks. And he's got some cute guys like that one and then just some regular guys from the office—look at that one. He's awful. But formally it's beautiful stuff.

A gay man in his late thirties, a professor of educational psychology visiting from Brazil, commented on the hairiness of the male bodies, which he thought would not characterize gay male bodies nowadays:

> What strikes me most is that the photos are not of today; they were taken in the 1980s. For example most of the male bodies [in the pictures] are hairy. But you don't see that on the body today, men are more likely to shave.
>
> I like the show. I like the method, the idea of sewing the photos, though I have no idea why he did that. Also, the photos look like many ordinary people, not much concern here about models.

The Context for "Safe" Sex: Controversial Art without Controversy

A second reason that ground-floor Chelsea galleries could easily display sex-related art, in addition to their being large enough to withstand the

possibility of a flop, was that the heart of the Chelsea gallery section was zoned to exclude residential. There was little risk of offending a neighborhood, since there was scarcely a neighborhood to offend. This is also why the movement of art galleries into Chelsea was not "classic gentrification"—the taking over of working-class residential neighborhoods by middle-class people.

Chelsea's freedom here contrasted with the Lower East Side's gallery section, which developed after the New Museum opened there in 2007, and which did have affinities with "classic gentrification." With only rare exceptions, Lower East Side gallerists, almost all at ground-floor level, explained they could not show "controversial" art since the LES was a residential neighborhood, and in particular one with a series of ethnic groups—Latinos, Asians, Muslims, and Jews—each of whom could take offense at certain kinds of highly visible art, especially given the prevalence of families with young children. This constraint on LES galleries showing controversial art is one reason why the claim that they displayed "edgier" art than Chelsea was oversimple, although as the LES undergoes classic gentrification, the constraint may weaken.[18]

A third reason why Chelsea's galleries could easily display controversial art is that they are not recipients of public funding. For a US show to trigger actual controversy, it helps if a major politician attacks it, as several studies have documented (Dubin 1995; DiMaggio et al. 1999; Halle 2001; Tepper 2011), and this kind of political attack is typically made against shows in publicly supported institutions on the grounds that public funds should not be used for such material.[19] Since Chelsea's galleries were almost all commercial businesses without public funding, they were basically immune to political attacks.

For these reasons, Chelsea galleries that wished to show controversial art reported no problem doing so. Some found this a little too easy. They would have preferred the publicity, and perhaps additional sales, that controversy might have brought.

For example, the Stefan Stux Gallery on West 25th (ground floor) has a reputation for displaying controversial art. Back in 1986, when located in Boston, it showed Andres Serrano's work *Piss Christ*—a crucifix submerged in urine. Soon after, the gallery moved to SoHo, where it devoted an entire room to Serrano, who was among its top sellers.

In November 2008 the Stux Gallery, now in Chelsea, put on a show (part of our sample) by Shimon Okshteyn, the centerpiece of which was a life-size sculpture of the artist masturbating, which the gallery deliberately placed in the front window, clearly visible from the street. The gallery's director, Andrea Schnabl, in an interview conducted next to the statue,

reported regretfully on the various factors that made it hard to rouse controversy, which, in her view, would have brought welcome attention to the show. These included not being in a residential neighborhood, and the generally changing, and she believed more culturally tolerant, times.

> This gallery has a reputation for controversial art. But it's hard to shock people.
>
> There is so much out there, and plenty of people are trying to stand out by shocking, but it's not so simple. [Okshteyn, present during the interview, chimed in, hopefully, that he had seen a few mothers purposefully hurrying their children by as they passed outside.]
>
> The show we did before this one had the crucified Jesus having intercourse with the Statue of Liberty on the American flag! [Aaron Johnson, *Star-Crossed*, 2008.] But no one objected or was shocked. Being shocking is a challenge these days!
>
> Before that we showed [the French artist] Orlan. She tried to shock by depicting herself having plastic surgery,[20] but people weren't shocked.
>
> Jeff Koons was shocking in the eighties with the Italian porn star. But by then she was his wife, and anyway it wouldn't be shocking today. Anyway, seasoned gallerygoers are very broad-minded. Maybe someone who isn't a seasoned gallerygoer would be shocked by some of this.
>
> [Interviewer: "How about the *Sensation* show at the Brooklyn Museum that Mayor Giuliani tried to close down as offensive to Catholics?"]
>
> With *Sensation* the issue was the appropriate use of public money [the museum received an annual stipend from the city], but what can people do against a commercial gallery? They could throw a stone through the window, but they never have. Or they could ask us to put up a sign "parental discretion advised," but they never have either.

Jerry Adams, director of the Cue Art Foundation, one of the few nonprofit galleries in Chelsea, likewise commented in October 2006: "We've had a couple of controversial shows. We had one with a painting of a girl peeing out of a tree. No one turned a hair!"

In June 2013 star gallery Hauser & Wirth, a few months after opening, put on a show by Los Angeles artist Paul McCarthy. Titled *Rebel, Dabble, Bubble*, it contained models of inexpensive tract houses inside which videos played in which women masturbated and sucked huge penises (depicted in Jeff Koons's "balloon dogs" style), while the artist was shown with various liquids such as orange juice thrown on his penis. The show aroused no apparent controversy, though privately several Chelsea gallery owners complained that the depictions of the artist were "gross" and "in poor taste."

Sexual Activity in Contemporary Art

It is probably too early to say if depictions of sexual activity will become commonplace in Contemporary Art. On the one hand, the concentration of this material in star and other ground-floor galleries with resources to withstand controversy and setback suggests that the full transition into mainstream art might be slow or just not happen. So does the fact that, by contrast with Koons's other work, almost none of his *Made in Heaven* material has made its way into major museums (though he destroyed much of it after his bitter divorce).

On the other hand, Takashi Murakami's *Lonesome Cowboy*, depicting a comic-book cowboy triumphantly ejaculating, sold for $13.5 million at Sotheby's in New York in 2008, becoming the third most expensive work auctioned that year. Further, these depictions in Chelsea Contemporary Art are obviously building on popular magazines of the 1950s and later, such as *Playboy*, and on the widespread availability of pornography on the Internet nowadays, all of which suggest the genre's staying power in popular culture.

If depictions of sexual activity do transition into mainstream Contemporary Art, that will be a milestone in Western art. Although images of active sex have appeared regularly throughout history, they have usually been illicit or marginalized in some way, or triggered controversy over their content. For example, Indian art has a well-known erotic tradition which depicts "pairs of men and women (mithunas) embracing or engaged in sexual intercourse in an extraordinary range of positions" (Kleiner 2009). Still, these have been compartmentalized as "Indian/Asian," not Western, and have usually been classified (and hence implicitly sidelined) as a basically religious, not secular, phenomenon, with the figures seen as deriving from the Hindu religion and rooted in symbolizing fertility and the propagation of life.[21] With the birth of photography came a burgeoning pornography industry, but these works were not considered art. Overall, until the advent of Contemporary Art, depicting intercourse was basically taboo in higher art circles and the establishment, and the occasional examples usually triggered controversy. These days, by contrast, the only depictions of sexual activity that raise unease, at least among regular art goers, seem to be child pornography.[22]

MASS PRODUCTION/POP ART

Six percent of the shows, almost all in star galleries, consisted of artists and works that deal with mass-produced consumer items, the genre basically classified as Pop Art. Star artists in this category whose shows

appeared in the sample include Roy Lichtenstein, Claes Oldenburg and Coosje van Bruggen, Jeff Koons, and Andy Warhol.

One school of critics considers Pop Art to be part of the "commodification" of art in contemporary society, with an implication that its subject matter and meaning focus on objects purchased as part of the modern obsession with consumer goods.[23] Our interviews suggest that this view, which sees Pop Art through the lens of what we have called the "first story about art" (money, investment, etc.) is misleading. On the whole, people who like Pop Art's depictions of everyday objects do so because the objects trigger musing on everyday life in all its variety, not just, or even primarily, the monetary aspects. In this sense the meaning of Pop Art for the audience is not qualitatively special, or different from the meaning of most other art. It is just that items classified as Pop Art often depict, and if successful, evoke, aspects of people's everyday lives that other artworks typically do not cover. These include, as our interviews below suggest, eating particular foods, as in Oldenburg's blueberry pies. In short, the meaning of Pop Art for those who like it belongs, like the other main topics of Contemporary Art, primarily to what we call "the second story" of art.

Claes Oldenburg and Coosje van Bruggen

Consider the show by Claes Oldenburg and Coosje van Bruggen titled *Images à la carte* at the Paula Cooper Gallery in May 2004. Oldenburg made his reputation sculpting items of American popular culture. His early works consisted of plaster reliefs of food and clothing and related items such as tubes of lipstick. Like other Pop artists, Oldenburg was intent on broadening the concept of what was considered "art" but he also wanted to expand the notion of where it could be displayed. "Must art do something other than sit on its ass in a museum?" he asked in a 1961 manifesto that echoed the Fluxus movement's goal of getting art out into the social world. That year, Oldenburg opened his famous show, titled *The Store*, in the East Village, for which he created a range of ordinary objects—foodstuffs, lingerie, and so forth—made from cloth and plaster and brightly painted. He sat in the simulated store and sold items, such as $149 for a pile of toast. A commentator at that time, reflecting the view of Pop Art as basically about the commodification of culture (a view not supported by our interviews), discussed *The Store* as an appropriate comment on the function of art as a commodity in a consumer society (Gomez 2002).[24]

Over the years, Oldenburg's sculpture became increasingly monumental, albeit still depicting everyday objects. In recent years he and his wife/collaborator Coosje van Bruggen were especially well known for huge

Fig. 2.14. Claes Oldenburg and Coosje van Bruggen, *Shuttlecock/ Blueberry Pies, I and II*, 1999 (detail). Cast aluminum painted with acrylic poly-urethane, 48 × 24 × 24 in. (121.9 × 61 × 61 cm). Col-lection Claes Oldenburg and Coosje van Bruggen. Photo courtesy the Oldenburg van Bruggen Foun-dation. © 1999 Claes Oldenburg and Coosje van Bruggen.

outdoor sculptures of items such as shuttlecocks, clothespins, spoons, and slices of pie.

The Paula Cooper show consisted primarily of drawings of food—simple restaurant items—from Oldenburg's sketchbook, mostly on lined notebook pages. There were pictures of shrimp cocktail, crab cakes, a banana split, a lemon slice, and an apple core. The press release explained that after Coosje van Bruggen developed food allergies in the late 1980s, Oldenburg began drawing the dishes that she could not eat, so she could enjoy them visually. This function of the art as evoking the pleasurable experience of eating the real items was important for the audience too, as is clear from the interviews below.

The show also included three large pieces, including a pair of blue-berry pies on a boule of ice cream, all about six feet high and four feet wide (fig. 2.14).

Just over half (56 percent) the audience sampled were enthusiastic about the work. The most common reason (given by 70 percent of enthu-

siasts) was its originality, playfulness, and creativity about the everyday objects depicted. For instance, a man in his late twenties, a video artist (referring to the huge blueberry pies):

> It's very whimsical. It reminds me of a stoner fantasy, you know a pot smoker's fantasy. You literally run into a huge pie [laughs].

A woman in her thirties, a Japanese collector who until recently owned a Chelsea gallery and was planning to open one in France:

> I love [the show]. [Why?] It's very familiar, everyday familiar . . . mostly food, and the color is nice—it's great interior decoration.

A woman in her midsixties, Louise Fishman, a well-known abstract artist:

> It's great. I love this. It's beautiful and creative and it shows craftsmanship.

The second most common reason for enthusiasm was that the work evoked the enjoyable experience of eating the kinds of food depicted. A young, female photographer:

> I think it's good. [Explain more.] It's delicious, it tastes good [laughs].

A woman in her early forties who works as a costume designer for television shows:

> I like it very much. [Why?] I like the simplicity, and I like the food because I'm hungry! [Laughs.]

A third of those sampled did not care for the work. For most this was because they did not see it as new. Instead, they saw an artist who had run out of ideas. For example, a male professor who teaches art at the University of Chicago and is himself a sculptor complained:

> It proves what happens when you get old! The traditional assumption of modernism was that you get freer and better as you get older, as with Beethoven and Rembrandt and Picasso. But Mr. Oldenburg proves the opposite. In the past there was a freshness; he was opening the door. I still love the earliest work, the lipstick. That was marvelous, it was freeing. But these drawings I feel are documentary. A lemon being squeezed is funny, but I was expecting more.

Arguably both of the main reasons given by those who liked the work—its allowing viewers to endow everyday objects with a creativity and playfulness, and its evoking the pleasant experience associated with eating—in different ways allow viewers to rescue "ordinary" objects from stodginess and solemnity. Based on those interviews, we hypothesize, in the absence of audience interviews, that Warhol's Marilyn Monroes evoke

popular feelings about stars, while Koons's puppy dogs evoke feelings about pets.

This is a long way from the one-dimensional audience reaction implied, without supporting audience interviews, by critics who view Pop Art through the lens of the "commodification of art." (We lack, of course, interviews with viewers of the "still lifes" of art history at the time those were painted—a comparison would have been interesting.)

Our perspective here on Pop Art sides with a long tradition of critics who have disputed, as overly simple, the common notion that the "public's" experiential participation in contemporary "mass culture" is basically passive and dominated by a manipulative corporate culture (i.e., basically the "commodification of art" perspective).

THE POOR OR DISADVANTAGED

Another main Chelsea genre depicts people in trouble—the poor, drug addicts, the handicapped—basically the flotsam and jetsam of society. These constitute 5.5 percent of the shows sampled in star galleries and 3.5 percent overall.

Damien Hirst: Addicts and Hospitals

Damien Hirst's exhibition *The Elusive Truth*, at the Gagosian Gallery in March 2005, focused on drugs, drug abuse, and the dark side of hospitals. The topics of the thirty-one photorealist paintings included faces of addicts showing them deteriorating (fig. 2.15); rows of pills on a shelf; hospital scenes, including an empty corridor, a dissection table, a brain autopsied into fifteen pieces, and a syringe being injected into a monkey's eye. A somewhat different, minor motif in the show depicted a bloody soccer hooligan and a bloodied suicide bomber and victim. Another minor motif, unrelated to the rest of the show, presented colorful gemstones and crystals.

Hirst is, of course, one of the most discussed Contemporary artists, and his work has been heavily interpreted as sensation-seeking and designed to fetch high prices. Still, there are no previous systematic interviews to determine how the audience views his work.

Our interviews with the audience for *The Elusive Truth* found, as with the other shows and artists considered here, that on the whole, those who liked the work did so because it resonated with their lives. Sensation-seeking and monetary value had little to do with this.

Almost half of those interviewed liked the show; about a third disliked it; and the rest thought it had strengths and weaknesses. Of those who

liked it, the largest group resonated with the medical and drug motif, in one form or another. Some, for example, saw the pills as a commentary on our dependence on such items. A man in his forties who is a sales rep for a contact lens manufacturer said:

> The subject matter is interesting—very medical and pharmaceutical. Our life is more and more involved in these matters. We're very reliant on popping a pill to resolve a lot of our issues. It's amazing how thick the pharmaceutical dictionary is and how many pills there are.
>
> I take a lot of pills myself, vitamins and other pills. When I see them lined up like this, it looks like fun to take! A lot of people are apprehensive [about taking pills], but they look great here.

A similar view came from a man in his twenties, a graduate student of journalism at Columbia University:

> The show is startling. I really like the pill motif. It's an interesting statement on how we overmedicate in this country. I haven't seen his work before. I definitely appreciate the technique. It looks like photos.

Others singled out the drug abuse paintings. A New York artist in his thirties, a former addict who has AIDS, was drawn to the addict paintings but also to *Hospital Corridor* because it depicts the loneliness of illness and death.

The paintings are fantastic, but disturbing. It's a naked examination of death, how we try to stave off death. It's got great emotional impact.

I'm a recovered addict, so it was spooky. [Walks to the room containing the addiction pictures.] This tells the story of addiction, which always leads to death or an institution. I also have AIDS, so I can relate to the pictures. I know about pills.

My favorite one is *Hospital Corridor*. It strikes me as the most terrifying. It's unpeopled. It's got the macabre and death.

A male graduate student, a Catholic by upbringing, liked how Hirst had substituted medical motifs for classical religious subjects:

I'm trying to think of a theme that ties it all together. It seems like the hospital theme does that. Instead of cathedrals, Hirst has hospitals. I like that because it's coherent. Instead of saints you have drugs; it makes sense. Prozac is the new salvation. People are always looking for something to save them, and now you have drugs.

While all those who liked the show praised the medical motifs, a minority of this group also singled out some of the other topics in the show for praise. For example, two women liked the paintings of gemstones and colored minerals (*Cut Gemstones* depicted six beautiful colored gems on a white base, and *Minerals* showed five pretty stones or minerals). One of the women, who teaches art in a public school, said:

The work has that really Pop look, like Andy Warhol. I really like this one [*Cut Gemstones*]. I like the colors and the shapes, and it's a beautiful painting, it's easy to get lost in the shapes and colors; they're kind of floating. It's relaxing, not threatening.

Those who disliked the show thought the subject matter was distasteful, excessively sensationalized, or just dull, especially compared with Hirst's earlier work. One group, for instance, disliked the hospital motif. A woman in her sixties, a retired psychologist, had spent much of her thirty-five-year career working with patients in hospitals. She thought Hirst's work was too unemotionally male, and too involved with technique:

The whole medical technology thing. I was a psychologist and spent years working in a hospital. It's [the work is] very male. Sticking a needle in someone's arm can be both tender and horrifying, but the painting doesn't

get the issue of being close or involved. And the industrial-strength pills are decorative but unemotional.

I'm more interested in issues of what's inside and what's outside, and I like work that's feminine, that deals with inside and outside. As a woman, other people engage with your body, especially the inside.

A woman in her early forties also hated the medical material, partly because she believed it was copied from the medical advertising field in which she worked, and partly because, as a Christian Scientist, there was much there she did not believe in:

> I walked out [of the show] once and forced myself to come back. Why? I don't like the subject matter or the execution. I work in medical advertising; it's all lifted from there. It's been done better in ads through newspapers, not photos.
>
> This exhibition seems lifeless to me. I've seen his stuff before, which I liked, but I feel nothing about this. The dead animals were cool—the animals in formaldehyde. [Hirst's earlier work, such as his pickled sharks.]. They were shocking because they were suspended—and there was something peaceful but also horrifying and monstrous about them. Lots of his other work was edgy. I loved the dots. It felt new. Anyway, I don't like art that deals with medical issues. I'm a Christian Scientist.

ART THAT RESONATES WITH PEOPLE'S LIVES

In summary, for almost all those interviewed about the entire range of art sampled in this study, if people liked the artworks, it was usually because the works resonated, in sometimes complicated ways and sometimes simpler ways, with a mostly limited series of topics that are part of the audience's lives. This was usually unrelated to the price of the work or its investment potential.

The topic of the meaning of art for the audience is, of course, potentially vast and complex, with many nuances. There is, for example, extensive academic literature on "meaning," and "the meaning of meaning" (Lukes 1977). Further, we have chosen not to discuss some minor topics of art in Chelsea such as political or religious art, or art in coercive or somewhat-coercive situations such as in political propaganda, but rather only in the context of people who choose to attend a show.

Nonetheless, further research seems unlikely to undermine the central point made here about why, in general, art resonates for individuals who find themselves face-to-face with works they have chosen freely to view and which they then like. It does so because they see it as speaking to aspects of their lives. We call this "the second story about art," but it

is second only because we present it in our study after considering the gallery shift from SoHo to Chelsea, which features the "first story" about money and rents and profits and so on. Arguably, the ability of art to resonate with people's lives has always been the crux of art's attraction, though without historical interview data we will never be sure. Those who have worried that this aspect of art is receding nowadays, for example, because of commercial pressure, in our view have less need for concern than they think.

THE COLLECTORS

Almost none of the audience whose views are discussed above were major purchasers of the art ("collectors"). They came to look at the works and enjoy them, but not to buy. For one thing, the works were far too expensive for them. How then about the collectors? Is the art for them primarily a financial investment?

The Armory Show Collectors Sample

Obtaining a random sample of collectors required a special effort. Too few collectors turned up in our samples of the audience attending Chelsea shows to form the basis for reliable generalizations. Galleries, meanwhile, are protective of their collectors' identities and almost never willing to provide lists from which to draw a random sample. We did not, therefore, attempt a sample of Chelsea collectors.

Instead, we interviewed a sample of fifty collectors attending New York's 2010 Armory Show, the city's premier international art fair, likely to draw collectors from many countries. Held on Manhattan's Far West Side (Piers 92 and 94), it is also one of the world's premier art fairs, ranked fifth in attendance in 2013 (table 1.4). We also interviewed a sample of fifty collectors at the 2009 Art Basel Miami show in Miami Beach (ranked second worldwide), but the findings echoed those from the Armory sample, so we discuss only the Armory data here.

We interviewed over a three-day period at the Armory Show, including the preview day, which is by invitation only and therefore an opportunity for participating galleries to invite their collectors. To obtain a random sample we positioned ourselves, wearing press cards, in a central location by the booths of four star galleries (two US and two foreign) and asked anyone approaching looking older than their midtwenties if they were collectors, and if so whether we could interview them for a book on Contemporary Art. About three-quarters of those we approached said

they were collectors (including almost everyone on the preview day), and over 90 percent of these agreed to an interview.

The fifty collectors we interviewed included twenty-two professionals, twenty-four people in business and finance, and three self-described philanthropists. We did not ask people their names, but during the interview it became apparent that at least six of the sample were well-known public figures, including a writer, two philanthropists, a Wall Street executive, and a gallery owner. There were twenty-four men, eighteen women, and eight married couples (all heterosexual). The higher number of men likely reflects the fact that men still tend to have more funds available for these kinds of purchases than women, despite huge changes in the labor force. A fifth of the sample resided primarily abroad.

We began each interview by asking the collector about the last two works purchased—what they were and why they had bought them. Overall, the image of collectors as people who buy art mainly as investment, that is, to make a profit from reselling the works, is not borne out by the data. Only six of the sample fit this model.

The other forty-four, the overwhelming majority, buy generally because they like the works and want to own them so they can view them whenever they wish. They all talked with enthusiasm about the art they had purchased, and its artist or creator, in ways that, as with the Chelsea audience, indicated that they liked the work mostly because it resonated with issues in their lives.

That said, the overwhelming majority of those who buy because they like the works and not in order to make money by reselling fall into two main groups. The largest group just buy what appeals to them. The second group also buy works that appeal to them, but before making the final purchase they ascertain that the price is reasonable (i.e., generally fair market). While not buying primarily as an investment, they want to make sure that, having selected a work because they like it, they are paying a sensible price. Often this second group are thinking of the works as a "store of value" (but not necessarily of profit) which can be accessed should they wish to sell. Some of them probably hope that the value will increase, but that is not usually the main reason for the purchase.

The content of the art that the collectors bought was not especially distinctive. It did not differ markedly from the art displayed in Chelsea galleries. This is not surprising, since art in Chelsea galleries is intended to be sold and so is likely to be reasonably representative of what appeals to the collectors (although some galleries will, at least for a while, keep on their roster and show the work of one or two artists whose work does not sell well, if they believe the art is especially good and should be seen).

Thus landscapes and decorative/abstract art (26 percent and 20 percent respectively of the art purchased recently by these collectors) were the two most common types, by quite a long way. Most of the other genres are represented in more or less the same proportions as in the Chelsea art sample.

There was only one major difference between the content of the art purchased by the Armory Show collectors and that of the art displayed in Chelsea and liked by the audience there. Although sex was reasonably well represented among the collectors' choices, all the examples were basically nudes, upgraded, modernized, and enlivened in various ways as in the Chelsea sample. None depicted active sex. It is, of course, possible the people we interviewed avoided mentioning such examples if they had bought them.

Another difference was that some collectors, especially those living outside New York, made an effort to buy works from artists who live in their area or region. For example, a collector from Virginia favored Virginia artists. This reflected a philanthropic urge to do something for their community, and did not affect the content of the works purchased.

In short, collectors on the whole seem to like the same kinds of works as the noncollector audience and typically for the same kinds of reasons. The main difference is that collectors have the funds to purchase the art to view at home and elsewhere, while the rest need to make a special trip to a gallery or museum.

Collecting or Buying for Pleasure, Regardless of Economic Value

A male physician in his fifties who has three homes to furnish with art—on Manhattan's Upper East Side, in Connecticut, and in Utah—exemplifies the close to half (48 percent) of the collector sample who said they purchased the works because they liked them, regardless of whether they would retain, let alone increase, their value. He explained:

> I just buy for pleasure, not for investment. The last work I bought was by Jason Middlebrook [a classic landscape with a touch of abstraction]. It's a watercolor with ink and graphite. The images are nature-driven, with an abstract quality. I like his work because it's beautiful, pure, and the right size.
>
> The second work is by Emilio Perez. It's graffiti-like but abstract [basically abstract/decorative]. I like it because of the colors and the abstract language. And I've met the artist; he's a great guy.

A female business manager in her midfifties who lives in Manhattan:

I don't buy for investment. Collectors never buy for investment, because we have to live with the works every day.

The most recent work I bought was by Alyson Shotz at a benefit auction. She does computer-generated photographs. This one was lace-like and a very feminine pink color [abstract/decorative]. It's gorgeous, and I like the energy of it.

The other most recent work I bought was at Scope Miami. It's by Lyndi Sales, who is South African. It's gorgeous. It's a hand-cut heart, made from the emergency evacuation instructions they provide for every passenger in an aircraft [arguably the troubled family]. The artist lost her father in a Cape Town aircraft crash, and these kinds of works are a way of dealing with her grief.

A couple in their fifties likewise explained that they bought solely because they liked the works. Manhattan residents, they attend the Armory Show regularly. The man is a financial analyst and advisor. The woman teaches tai chi. The man said:

We don't sell the things we own. If we're both drawn to a work, then we buy it.

The last thing we bought was a blue Venus, by Yves Klein [i.e., a "classic nude" sculpture enlivened with gaudy paint. Klein, a French artist, produced nude female torsos covered in blue paint, which he dubbed "blue Venuses." He died in 1962].

I like it because it reminds me of Cyprus and the sea. You know, Venus Aphrodite in mythology landed on Cyprus.

The second item they had bought recently was by a Pakistani artist Shahzia Sikander, from Deitch Projects gallery. The woman explained:

It's a skeletal outline in black of a woman with her feet bound. It's very beautiful. [Why does she like it?] It speaks to the dilemma of women in certain parts of the world [i.e., the poor/disadvantaged].

The art writer Anthony Haden Guest, in his sixties, lives on the Upper East Side of Manhattan. His last two purchases were an environmental landscape and a religious/spiritual painting. He explained:

At my level, buying art is not an investment. I don't have the means. Even if I bought an Ellsworth Kelly, it wouldn't have value, because it would be a print.

The last thing I bought was a photo by Dan Asher, who is remarkably underrated. It showed glaciers, icebergs, and how the polar ice cap is melting [environmental landscape].

Before that, I bought a work by a black street artist. It's a spirit party, very figurative.

Collecting for Pleasure but with Regard to a Fair Price or Enduring Value

The second-largest group of collectors (40 percent of the total) also bought works because they liked them, but, before making the purchase, generally ascertained that the price was reasonable. The art was for them was not necessarily a source of rising value, but they did not want to overpay or buy something that would lose value. For many in this group, attending international fairs was an important way to reassure themselves on these points, since they could compare the prices of works at the Armory Show with works they had recently bought.

Consider a couple in their early sixties who live in Philadelphia and attend the main international art shows, including ARCO Madrid and Art Basel, Switzerland. The wife, a contract attorney, explained:

> We buy what we like. Our intention is not to sell. But we want a fair price.
> We have a lot of art in our house; it fills a couple of galleries. We've been collecting for twenty years. We buy something every year, though the quantity varies—could be ten or one. We'll be running out of space soon, and we'll probably start to sell things.

Another example is a male real estate developer and attorney in his seventies who lives in central Maryland. He explained:

> I don't buy for investment. I focus on artists in central Maryland. I support the artists in the community, locally. Still, I always go to the art fairs at the Armory and ADAA in New York, and to Miami, to see what's out there and compare it to what I buy and compare the prices with what I pay.

The last work he bought was a classic landscape by Henry Niese, an artist in his eighties who teaches at the University of Maryland and lives in a two-hundred-year-old stone farmhouse, where, in his words, he "paints, teaches, and takes care of my sheep." The landscape depicts a barn with a red roof. The collector "loves the way the roof contrasts with the body of the barn."

Collecting for Investment

A very small group, six of those interviewed, fit the model of collectors who purchased mainly for investment potential. Even these collectors also generally liked the works. Consider a Swedish woman, divorced in

her sixties, who lives off investments and resides in Belgium because of its lower taxes:

> Everything I buy must be saleable. I buy for investment. Last year I bought twelve Rauschenberg prints of Chinese urban scenes from a series he did not long before he passed away. I'm a Rauschenberg fan. I gave one to each of my daughters and kept the rest. I'm not selling them now, but they will be a good investment.

The most recent piece she had bought was a photograph of mother and child by Russian artist Nathalia Edenmont. She loved the piece, though it too was intended as an investment.

> It looks like a Russian icon but contemporary. It depicts a twenty-year-old woman with a baby in a beautiful dress. It's breathtaking, with a lot of symbolism. It's a Madonna image, done in a contemporary way.

A female art consultant in her forties or fifties lives on Long Island, New York, and attends the main art shows in Florida, as well as New York's Armory Show. She buys for investment, though the works she picks are ones she also enjoys.

> I collect mostly photography and drawings. I think they are good value. I come here to see the dealers I know, and to see how the economy is doing and the prices and have lunch and fun.

The last work she bought was a black-and-white drawing of a female nude, by Nathan Mabry.

> It's done in a Matisse style. I like Mabry's references to art history. He sees things freshly, and I like how he repeats the classical artists' work but in a modern way. I bought it at Art Basel [Florida].

Although no other studies have systematically asked a sample of collectors why they bought the art they did, the above interviews are consistent with what research exists. For example, economist Richard Caves (2000) summarized studies of the monetary returns to art:

> A number of economists . . . have measured the rates of return that people earn from owning and holding works of art over long periods of time. . . . Most studies of this type yield the same plausible conclusion—that art works earn positive return, although less than ordinary investments [stocks and bonds] over most periods of time that have been calculated. This pattern makes perfect sense to an economist. Investors in artworks get part of their return from capital gains, but also a part from the joys of possessing and contemplating the work of art, so they are willing to hold

art for a lower expected rate of return than that of a humdrum stock or bond.

Likewise a 2010 study of high net-worth individuals (HNWIs) worldwide classified art as one of the main types of "passion item/investments," which are defined as "investments purchased for enjoyment of the assets at least as much as for rising value" (Capgemini and Merrill Lynch 2010). The three other main types of "passion items/investments" are "luxury collectibles" (boats, jets, luxury autos), "jewelry, gems and watches," and "sports" (racehorses, sports teams, sailing). The report noted that "many HNWI's buy and hold art (primarily) as connoisseurs" (i.e., basically without regard for its investment potential), while a large number of HNWIs also view art as a "good financial investment." The report does not distinguish, within this second group, between those who buy entirely for investment and those who, while buying because they like the works, try to be sure the works will at least hold their value and hopefully increase. But there is no reason to suppose the proportions differ markedly from those found in our Armory sample.[25]

Finally, economists Heilbrun and Gray (2001, 184) summarized the data on art as investment over more than three hundred years, from 1652 to 1987, with the warning that collectors needed to make sure they were getting aesthetic satisfaction from the works:

> Art seems indeed to be a risky investment, and the risk seems not to be compensated by a persuasive return. Ownership of artworks may well represent a very rational choice for those who derive a high rate of return in the form of aesthetic pleasure. They should not, however, let themselves be lured into the purchase of art by the illusion that they can beat the game financially.

It is, of course, possible that our interviews with collectors, as well as research by others, are not representative of the very top tier of collectors, individuals whose names appear frequently in the media, such as hedge fund manager Steven Cohen or Los Angeles real estate mogul Eli Broad, or Peter Brant.

Perhaps this rarified elite buy primarily or entirely for investment. No one has asked this group, in a systematic way, why they purchased the works they purchased. Still, it is plausible that the dynamics motivating them are more or less those that motivate the collectors in our sample, with a minority buying purely for investment, but, for the majority, with a liking for the pieces (because they resonate with their lives) as a driving motive. For example, in recent years Jeff Koons's Balloon Dog series, depicting dogs in balloon shapes, has been hugely popular among

megacollectors such as Los Angeles financier Eli Broad (owns a red one), hedge-fund billionaire Steven Cohen (owns a yellow one), and French luxury goods magnate François Pinault (owns a magenta one). Alongside the works' attractions as stores of value it is reasonable to suppose they resonate with collectors' regard for dogs as domestic pets.

CONCLUSION

The megaconcentration of commercial galleries in Chelsea represents the latest stage in a lengthy dialectic in art between commercialism (i.e., market forces and processes) on the one hand and counterforces on the other. Theorists have long pondered the implications of the rise of the market for art, and the corresponding decline of patrons (e.g., the church or aristocracy) as the major means by which art is produced. For example, a number of important twentieth-century thinkers lamented the rise of market forces and the commercialization of art as processed through, for instance, the modern corporation. They tended to believe that this commercial system imposes on a largely passive mass public products that this public would not otherwise purchase, that it flattens out taste and the critical sensibilities of the public, and that it often "contaminates" the works by forcing the artists to produce what the market will sell, not what the artists would like to produce.[26]

These views have been repeatedly criticized as, at the least, exaggerated. For example, it has been said that it is simplistic and condescending to imply that, for the audience, "art and culture" has just one set of meanings (or one "basic" set of meanings) that are somehow attached to the "commodified" cultural products and which the audience simply absorbs. Why should cultural products have just one set of basic meanings, and even if they do, where is the evidence that people more or less passively accept these meanings?[27]

The evidence from Chelsea's commercial gallery system suggests that current reality is fascinating and complex in unexpected ways. We have summarized the complexity by talking about the need to tell two main stories about Contemporary Art.

There are several ways in which the market ("commercialism") is important and even dominant in Chelsea. This is the first story. It includes the sheer numerical presence of the commercial galleries, the fact that they are subject to New York's brutal commercial real estate market, and the rise of the multinational (albeit not mostly "global") gallery, exemplified by Gagosian. These various market-based factors explain why affirmations of the market's power (in all kinds of ways) continue to be plausible and important. So do later, "globalization-type" developments—especially

the rise of international art fairs and attempts to cut out commercial galleries by selling new art on the Internet or through auction houses.

Yet even this first story, based on a close study of the market, is not entirely straightforward, with several factors offsetting a simple picture of market dominance (and its associated view that Chelsea represents the "commodification" of art). There is the role of Chelsea galleries in providing "the best free show in town," a show that at least rivals, and in many ways surpasses, that provided by New York's museums, almost all of which charge an often substantial entrance fee. A related development is that, for most of the artists, the system of commercial galleries, especially in Chelsea's huge numbers, offers a welcome opportunity for the display and sale of their work and constitutes a system that artists view as, on the whole, far more open than that offered by museums.

The most important offsetting factor, however, is our second story about Contemporary Art, based on interviews with the people who attend Chelsea galleries, as well as with collectors. The interviews reveal that the meaning of the art for the audience that views it is usually connected with central issues in the lives of the audience. We do not believe further studies are likely to invalidate this central truth. So critics who maintain that the audience is misunderstood if seen as basically passive receptacles for art are certainly correct.

PART II
"PRESERVATION" PROJECTS

The High Line

Everyone is talking about the High Line. I was in the Middle East recently and they all wanted to know about it. The High Line is a home run!

—Vishaan Chakrabarti, former Manhattan city-planning director, 2009

The High Line succeeded because it was a grassroots movement that also had the support of the cultural elite like Diane von Furstenberg—it's very artsy. Also, when you put back the air rights there is real value added, so the whole real estate community backs it because it enhances the property values, and the administration and city planning are all pro development.

—Robert Boyle, former Port Authority director

THE ISSUES

By late 2003, Mayor Bloomberg's administration had a vision for the entire Far West Side of Manhattan based on three major components.[1] First, there were sections designated for high growth, especially the Hudson Yards and Penn/Farley Station, which were seen as major spurs to development, especially office buildings.

Second were areas designated for medium, semiprotected growth. The city now saw Chelsea's burgeoning Contemporary Art district as a major asset, but one whose products—new art—could not compete with residential development (condominiums), and which the city would therefore try to protect, albeit not at all costs.

The third component of the overall vision was sections designated for low growth or no growth (i.e., preservation), such as a proposed historic district for the Gansevoort Market area, and parks linking the entire Far West Side, especially the newly proposed High Line running north-south (figs. 3.1 and 3.2), as well as the already partially completed Hudson River Park, underway since 1998.

Fig. 3.1. High Line.

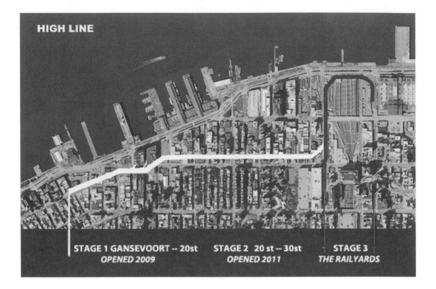

Fig. 3.2. The High Line, with Frank Gehry office building (*background left*), Jean Nouvel condo (*center*), and condos by Shigeru Ban and Annabelle Selldorf (*right*). Billboard by English artists Gilbert and George (*lower right*). Photo by Elisabeth Tiso.

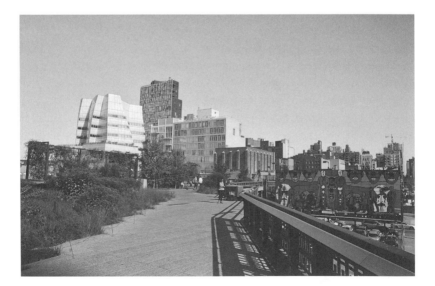

The High Line and the Gansevoort Market Historic District, the two "preservation" projects discussed in this and the next chapter, provide a series of lessons. First, both preservation projects show the difficulty of controlling and limiting history. For example, on the one hand the High Line was an exciting environmental cause. The city typically had torn down such railroads, especially elevated subway lines, when they no longer met transportation needs. By contrast, Mayor Bloomberg's administration was by 2002 committed to preserving the High Line. But what exactly would the preserved High Line be? In 2003 New York historian Kenneth Jackson, expressing the view of many High Line supporters, backed the project because it would enable people to recall vividly the city's history, while preserving the wild flora and fauna that had grown up around the Line and was now seen as a metaphor for urban survival in tough times:

> Just as everyone loves Central Park because its meadows and glades allow us to forget that we are in the midst of a huge city, a High Line Park could become a public open space . . . that celebrates density and diversity, that shows us how nature can persevere in even the grittiest circumstances, that enables us to understand history not through a book or through a movie but through our own eyes. (Jackson 2003)

Opponents, by contrast, complained that the project would merely preserve a "rusted wreck" that encouraged pigeon droppings (Gardner 2005).

Actually, the High Line conversion evolved in a different, third way, as an agreeable, elevated walk offering a series of different views at each section of the Line. Alongside the walkway were glorious new plantings, replacements for the "original" vegetation that had survived the dark days of the old rail line and city's decline but which, it was quickly discovered, could not survive the High Line restoration. The striking views featured an eclectic variety: close-ups of innovative new condo buildings by the world's "starchitects" (fig. 3.2); old "historic" buildings, especially warehouses, although these were dwindling in number; views of the Hudson River to the west and of the city skyline to the east, including the Empire State Building; and by 2013 of construction on Related's megaproject over the Hudson railyards around which the High Line's third section would run.

The starchitect-designed condos appeared alongside the historic rail line because the Bloomberg administration concluded, probably correctly, that in order to overcome opposition to the project from a powerful group who owned the land under and adjoining the High Line and who had organized as the Chelsea Property Owners, it needed to rezone much of the area to allow major condominium developments, to which the Chelsea

PRESERVATION + ART + ENVIRON. + REAL ESTATE

Property Owners could then sell their air rights. This was the West Chelsea Rezoning of 2005, basically a deal allowing developers to initiate a frenzy of high-priced new condominiums alongside and near the High Line, giving it a monied aura.

Perhaps this was not a bad thing. The preserved High Line stimulated some of the boldest architecture in the city. In so doing, it somewhat offset New York's reputation, earned over the previous three decades, for mediocre new architecture. Ironically for preservationists, these starchitect buildings were the sort they had fought and sometimes stopped in nearby areas, including the Gansevoort Market. Nor did the new condos directly displace poor or working-class people in any classic gentrification process, since they were built on land previously zoned for manufacturing and containing warehouses and similar structures, not residences (though some people would say that converting manufacturing space to housing for the middle class and wealthy is also a type of gentrification).

Further, the High Line began to evolve as a major cultural attraction, adding another layer of complexity. For example, it acquired a curator who selected artworks (mostly sculptures) to be placed, each on a temporary basis, along the park.

The High Line now became a different metaphor, one that symbolized a creative planning process that combined preservation with growth. This replaced the old metaphor of survival during tough times. Overall, the cases of the High Line and Meat Market suggest that in discussing proposed historic preservation projects it may be realistic to accept from the start that what will emerge will be "historically themed" in various ways, but not preserved. As sociologist Harvey Molotch commented after reviewing such projects in England: "Ironically, nostalgia can make new things happen. In part, this is because bringing back the past never brings it back as it was. . . . A nostalgic leap backward usually yields, in physical terms, something that had no prior existence. Reinventing the wheel results in a different one" (Molotch 2005). Or as architect Rem Koolhaas put it, preservation projects that succeed often do so "because the 'preserved,' when we choose to preserve it, is not embalmed but continues to stay alive and evolve" (Koolhaas and Shigematsu 2011). "Adaptive reuse," which High Line officials now use to describe their project, is a banner for this approach in an ecologically sensitive world.

A second lesson from the High Line and Gansevoort Market Historic District is that each began as a grassroots idea that the city then decided to support as part of its overall vision that balanced and offset preservation against some high-growth projects. Both projects succeeded only because from the start, or almost the start, they were adopted by a pair of visionary advocates, who happened to be young, with the talent and

Fig. 3.3. Florent Morellet (who pushed to landmark the Gansevoort Market) dressed as Marie Antoinette in a July 14 celebration, flanked by High Line founders Joshua David (*left*) and Robert Hammond (*right*).

persistence to shape the project and also work creatively with the political processes. The High Line's cause was taken up by two Chelsea/West Village residents, Joshua David and Robert Hammond, who, in a David versus Goliath moment, beat the Giuliani administration's attempt to demolish it. The Gansevoort Market's cause was pushed by Jo Hamilton, a sociologist from Southern California (UCLA), and Florent Morellet, a restaurateur from France (fig. 3.3 shows David, Hammond, and Morellet). These four individuals are examples of why urban planners stress the key role of "talented public and private entrepreneurs" if a public project is to succeed (Garvin 2013, 40; Altshuler and Luberoff 2003).

A third lesson of the High Line underlines the importance of nonprofits in America. While the direct role of the federal government in culture in the United States is far smaller than in many European countries, a key role in American culture is played by nonprofits, whose tax incentives constitute indirect government support. The case of the nonprofit

Friends of the High Line, the organization founded by Joshua David and Robert Hammond to lobby for turning the High Line into a park, and which currently mostly runs the High Line (which is now owned by the Parks Department of New York City), further exemplifies this point.

A fourth lesson of the High Line underlines the odds against achieving megaprojects. The High Line did not start as a megaproject, but evolved into a highly successful one by the time its second section opened in 2011, amid a series of other Far West megaprojects that either never happened or took decades. Still, the High Line too came within a hair's breadth of running afoul of three of the many (we stress eleven) reasons that typically doom megaprojects. For example, a common obstacle is the existence of a private corporation that is crucial for the project's success but that stands in its way. The Chelsea Property Owners were just such a group, needing to be bought off in a deal not easily replicable in most other cities. Also, the High Line almost ran into a downturn in the economy, another problem that often dooms megaprojects. From 2005 to 2008 the High Line received a crucial $73.8 million of funding from the city, a huge chunk of the $86.2 million cost of completing stage 1 (table 3.1). These were flush years for the city, when its budget was in surplus (IBO 2007). Had the High Line's funding request, and start, been delayed by just one year, as could easily have happened, it would have run into problems associated with the 2008 financial crisis as the city's budget fell into a deficit of $2.5 billion by 2009 (IBO 2009). In addition, political lobbying and cronyism, a third problem that can undermine megaprojects, nearly did so. Joshua David has said he believes a key reason for Mayor Giuliani's opposition to the High Line, which almost doomed it, was that one of Giuliani's former deputy mayors was a well-paid lobbyist for the Chelsea Property Owners. In short, the High Line flourished against the odds.

A final lesson of the High Line is how easily smart people can be wrong about a creative project. For example, one of the city's most experienced administrators, on hearing the early proposal to turn the High Line into a park, insisted that it would flop because New Yorkers were typically unwilling to climb a flight of steps to attend anything, from an upper-level retail store to a park. Likewise Stephen Ross, head of the developer Related, initially (2006 to 2007) strongly advocated the demolition of section 3 of the High Line running through Related's properties in the Hudson Yards, arguing that this section would detract from Related's development, and was furious when told in 2007 that it would remain. Ironically, by 2012 section 3 of the High Line, under construction, was a major attraction for likely purchasers of condos and offices in Related's properties in the Hudson Yards, to Ross's delight.

Table 3.1. High Line costs by stage and source (in $millions)

Source	Section 1[a]	Section 2[b]	Section 3[c]	Total
City	73.8	38.4	10.0	122.2
Federal	1.1	19.6	—	20.7
State	—	0.7	—	0.7
Friends of the High Line	4.4	8.1	20.0[d]	32.5
Other, private	6.9[e]	—	27.8[f]	34.7
Total as of 2013	86.2	66.8	57.8[g]	210.8[g]
Total projected	—	—	90[h]	243.0[i]

Source: Friends of the High Line. Data as of February 2013.

[a]Gansevoort to 20th Street (construction began fall 2006, open to public June 2009).

[b]20th Street to 30th Street (construction began fall 2007, open to public spring 2011).

[c]High Line at the railyards (construction began Sept. 2012, projected to open 2014).

[d]Commitment to raise.

[e]Developers as part of West Chelsea rezoning.

[f]Related Company and Oxford Properties.

[g]Raised as of February 2013.

[h]Section 3, phases 1–2, estimated at $60 million. Section 3, phase 3, estimated at $30 million.

[i]Projected total cost of sections 1–3.

HISTORY

The High Line was originally built between 1930 and 1934 in order to raise street-level freight trains above 10th Avenue, which had become the scene of so many traffic accidents that it was known as "Death Avenue." As a result, the railroad had been forced to hire men on horseback, dubbed "West Side cowboys," to precede the trains and warn of danger. The High Line was part of Robert Moses's West Side Improvement Project that eliminated 105 dangerous street-level rail crossings in Manhattan (figs. 3.4 and 3.5).[2]

The High Line functioned to bring food and other merchandise, after it was offloaded from the waterfront, to factories and warehouses along New York City's busy industrial West Side, as well as to the Gansevoort Market. It ran from 34th Street down to a major shipping terminal just south of Canal Street.

By the 1960s, the growth of trucking made the High Line, and many of the port facilities it served, obsolete. Its last use as a freight line was in 1980, when it took a carload of frozen turkeys to the Gansevoort Meat Market. The Line's southern section, below 12th Street, was demolished in the 1980s. Since then, the remainder's fate had been uncertain, languishing,

Fig. 3.4. Conditions on 10th Avenue, before the High Line was built, were so dangerous it was called "Death Avenue." The railroad company hired men on horseback to ride ahead warning of the dangers. Photographer unknown.

Fig. 3.5. High Line, 1934. Photographer unknown.

Fig. 3.6. Joel Sternfeld, *A Railroad Artifact, 30th Street, May 2000*. Negative 2000; print 2009; Digital C-print, 39½ × 50 inches. Courtesy of the artist and with the permission of Luhring Augustine, New York. The High Line's early supporters saw this wild vegetation as a metaphor for how an urban core and tenacious residents survived the city's dark days of rampant crime and physical decay from the 1970s to the early 1990s.

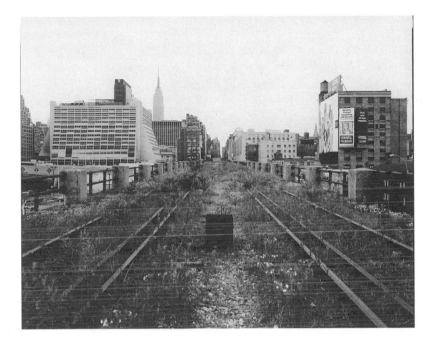

its tracks overrun with wild vegetation (fig. 3.6). At the time of the movement to turn it into a park, it was owned by Conrail and Conrail shareholder CSX Transportation, who managed it.

THE CHELSEA PROPERTY OWNERS

When the High Line was built it obtained a series of easements that allowed it to run through the private property over which it was routed. That property, and any air rights associated with it, still belonged to each owner. Around 1989 the owners were organized as the Chelsea Property Owners by a parking-lot and storage-facility operator in the area, Jerry Gottesman. Their aim was to force the High Line's owner-manager, CSX Transportation, to tear it down so they could develop their land. For example, several parking lots abutting the High Line were prime candidates for development if the High Line were demolished. This was a decade

before anyone suggested preserving the High Line as an above-ground park. In 1992 the Chelsea Property Owners won a court order to demolish the structure, but could not agree among themselves about sharing demolition costs, so the project stalled.

THE FRIENDS OF THE HIGH LINE

A slightly mythic version of how the High Line was saved as an above-ground park has become widespread. According to this version, the two young Chelsea and West Village activists, Joshua David and Robert Hammond, thought of the idea. Actually, converting the High Line to a park was first proposed by CSX, the railroad's owners, and the Regional Plan Association, as David and Hammond recounted in a 2011 book on the High Line (David and Hammond 2011, 7) and in a 2008 interview. CSX had commissioned the Regional Plan Association (RPA) to study possible uses of the High Line, and a representative of the RPA presented several options, including light rail or a park, at a 1999 meeting of Community Board 4 to discuss the Chelsea Property Owners' demolition proposal. CSX was seeking alternatives to demolition, since it did not wish to lose the rail easement that came with the High Line, figuring this unobstructed right-of-way through Manhattan might someday be useful. The RPA thought the park would be the simplest and most appealing use.

By contrast, community board members at that time were inclined to agree with the Chelsea Property Owners that the High Line was an eyesore and health hazard, for example, encouraging pigeon droppings, and should be dismantled.

CSX's above-ground park proposal caught the imagination of Hammond and David, who were in the Community Board 4 meeting audience, but had not met before. As Hammond recounted: "I stayed behind [after the meeting], trying to find someone else who was interested in saving the High Line. There was no one except the guy who had been sitting next to me. He told me his name was Josh, that he lived in the neighborhood, that he was a travel writer" (David and Hammond 2011, 7).

Robert Hammond and Joshua David were both recently out of college. David was there as a writer developing an article about Chelsea. The pair then organized other neighborhood residents, businesses, design professionals, and civic organizations to form Friends of the High Line, a nonprofit (501c) advocacy organization, whose goal was to turn the remaining 1.5 miles of track into an elevated trail park. They also learned of an ongoing Paris precedent where an unused rail viaduct was being converted into an above-ground park called the Promenade Plantée, opening in sections

starting in 1987 and completed in 2000.[3] Hammond believed the High Line could improve on the Promenade Plantée's design. The role of the Friends of the High Line is further evidence of the key role nonprofits can play in urban planning, as with the Dia Foundation's earlier facilitation of Chelsea as an art gallery district.

Hammond had helpful connections. At Princeton his roommate had been Gifford Miller, now the youthful president of the City Council, New York City's legislature, so Miller favored the High Line early on. The Friends of the High Line created an effective board, including, for example, Phil Aarons, a principal in Millennium Partners, a real estate development firm originally founded in 1990 to develop West Side property. So developers were involved early, as well as city politicians.

Aarons had worked for mayor Ed Koch at the New York City Economic Development Corporation, and then moved on to "build complicated real estate projects—Ritz-Carltons and Four Seasons all over the country" (David and Hammond 2011, 9). It was Aarons who, in discussion with David and Hammond, suggested the name Friends of the High Line for the nonprofit, rather than something with "preservation" or "coalition" in the title. As Hammond recounted the discussion: "Phil said you had to think of how City officials would look at you, how the real estate people would look at you. He said you wanted the name to be as neutral as possible, and he suggested Friends of the High Line. . . . Friends groups are common. . . . This name was friendly; it didn't have the word 'park' or 'preservation' in it—there were no lightning rods. I don't know if I loved it at the time, but I understood Phil's logic" (David and Hammond 2011, 11).

The Friends commissioned landscape photographer Joel Sternfeld to illustrate a book they produced celebrating the High Line (fig. 3.6). Sternfeld specialized in environmental issues, and his work was regularly exhibited in Chelsea. Stressing the wild vegetation around the High Line's tracks, the book envisaged a park full of "natural, survivor" plants that hung on, even thrived, during years of grime and neglect. Many early High Line supporters saw this wild vegetation as a metaphor for how a creative and vibrant urban core and some tenacious residents survived the city's dark days of crime and physical decay, especially from the 1970s to the early 1990s. Hammond, for example, said in 2003: "My love of the High Line comes from its juxtaposition of seemingly incongruous elements—a pastoral meadow atop an industrial infrastructure. I love the metaphor of a bubbling brook that runs through the heart of the Meatpacking and West Chelsea art districts. I am interested in preserving an essence of what happens when people leave and the wildness takes over and at the same time gives people access to this wild environment."[4]

This "tenacious survival" motif was the High Line's first metaphor. Given the unpredictability of urban change, it was perhaps almost inevitable that it would later evolve into something different.

MAYOR GIULIANI'S OPPOSITION

A major obstacle to the High Line was Mayor Giuliani. He was not inclined to support preservation projects, which he tended to see as emanating from nimbyist (Not in My Backyard) local residents who, he believed, opposed any change. In particular they had vehemently fought his cherished goal of building a stadium for the Yankees just south of the Javits Convention Center. So Giuliani had no enthusiasm for the High Line, or for landmarking the Meat Market district. Since New York City centralizes power in the mayor, neither project could happen without mayoral support. For example, the mayor appoints and removes the head of the Landmarks Commission as well as the head of City Planning, at least one of whose approval is almost always needed for such projects to have a chance of success. Joe Rose, Giuliani's chair of the City Planning Commission, was quoted in a 1999 *New York Times* article as saying that, because of the city's lengthy efforts to demolish it, the High Line had become "the Vietnam of old railroad trestles. . . . It will have to come down" (Lueck 1999).

Robert Hammond also stressed the role played by lobbyists hired by the Chelsea Property Owners, together with cronyism, in cementing Giuliani's opposition. As he recounted: "People think, oh, Giuliani must've hated the High Line. I don't think Giuliani cared at all about the High Line. Rather, the property owners who opposed the High Line had hired . . . one of Giuliani's former deputy mayors, and paid him a lot of money to lobby Giuliani, and that's why Giuliani was opposed, in my view" (David and Hammond 2011, 25).

Luckily for Hammond and David, Giuliani's mayoralty was set to end in December 2001, and term limits stopped him from running again. So they lobbied the 2001 mayoral candidates. Looking back later, the pair stressed how helpful this electoral timing was, since the candidates were eager for local support. Studies of local advocacy projects in other parts of the country also stress the importance of promoting them during election campaigns (DiMaggio et al. 1999). The Friends of the High Line got all six mayoral candidates to support the project, including Michael Bloomberg, elected mayor in November 2001.

Also helpful was that Amanda Burden, whom Bloomberg appointed chair of the Department of City Planning, lived in the Village nearby, and was an early High Line convert. Burden was an avid follower of urbanist

William Whyte, who championed innovative attempts to make public spaces vibrant and widely used.[5] In an April 2001 City Council hearing on the High Line, one of the Chelsea Property Owners testified: "If you were actually able to make a park on the High Line it would be great for property values. But this will never happen. . . . It's a pipe dream." Burden, at that point just a member of the City Planning Commission, not its chair, responded: "This is a city built on dreams. We should all be following dreams like this one" (David and Hammond 2011, 32).

Then in December 2001 in the final week of his administration, Mayor Giuliani threw a wrench into the process. He signed a demolition agreement with the Chelsea Property Owners seeking to compel CSX to pull down the railroad right away. Giuliani was doubtless urged to act by the Chelsea Property Owners, anxious to kill this upstart preservation project that was jeopardizing their chance to develop, and likely make millions from, their properties.

In response, the Friends of the High Line filed a lawsuit requiring the demolition to first go through the city's Uniform Land-Use Review Procedure (ULURP), the approval process that the City Charter requires major land use projects to pass and which, since it takes about nine months, would keep the High Line intact until Bloomberg took office. The Friends' suit was joined by the City Council under Gifford Miller and by Manhattan Borough president Virginia Fields. It won a favorable court ruling in March 2002, and was then appealed by the Chelsea Property Owners, but by then it had saved the High Line from demolition under Giuliani.

MAYOR BLOOMBERG'S SUPPORT: PUBLIC PROJECTS AS INVESTMENTS

Although Mayor Bloomberg had supported the High Line during his mayoral campaign, in early 2002 soon after his election he said that the economic problems triggered by 9/11 meant that all bets were off. Instead, Bloomberg's deputy mayor for economic development, Dan Doctoroff, requested an economic feasibility study, which he said was key. "Does it make sense," Doctoroff asked, "for the city to support the High Line financially?" This was part of, and became central to, Bloomberg's general approach, which saw government's role as making creative investments to attract and generate employers and jobs, especially in the context of competition with other cities and notably global cities such as London and Hong Kong, but only after determining that tax revenue accruing to the city from the project, albeit over several years, would exceed what the city spent on the project in the short run. As Doctoroff declared in

2004 in the context of the Hudson Yards plan: "Our job . . . is to invest the city's money wisely so that the pie is ultimately bigger than it is today; . . . to invest scarce resources to earn more dollars that will enable us to pay for . . . important priorities—health care, housing, police and fire protection, the list goes on and on."[6]

Since this strategy, which Doctoroff referred to as enabling a "virtuous economic circle" for the city, also typically entailed many opportunities for employers and real estate companies to make profits, it was easy to dismiss as being fundamentally about that (with the goals of creating jobs and financing city services as secondary and even just cover). We suggest that this criticism is basically unfair. Julian Brash's (2011) study of the Hudson Yards reaches a similar, balanced conclusion about the motivations. Brash concludes that Bloomberg's approach—to encourage job creation while making sure government expenditures on economic development projects are "investments" that produce future city tax revenues that more than cover government's initial outlays—was genuine, not just a cover for corporations to make profits. Brash also agrees that Bloomberg, and his Department of City Planning under director Amanda Burden, tried to protect vulnerable neighborhoods and residents from adverse effects of development.[7]

The approach of Bloomberg and Doctoroff was, further, based on what Brash calls two "urban imaginaries," or visions:

1 A general "corporate" vision of the city, that is, the mayor as CEO, government as a private corporation that needs to balance its books and make wise investments, residents and businesses as customers and clients, and the city itself as a product to be branded and marketed to attract employers and new residents.
2 The particular vision of the city, as branded and marketed by Bloomberg with the help of a McKinsey study. New York City, according to this vision, was a "luxury product" in the sense that it was, unfortunately, expensive to live and work in, but worth it, especially for employers, as a place of very high quality with a population of highly skilled, talented, and creative people, and open to everyone including poor immigrants—a true meritocracy.[8]

In response to Doctoroff's challenge, the High Line Friends commissioned a study by Cushman & Wakefield that showed that over a twenty-year period the tax revenue to the city from property development stimulated by the High Line's section 1 would be about $140 million, over twice the High Line conversion cost, then estimated at about $65 million.

(Section 1's actual cost was eventually $86 million—see table 3.1.) Amanda Burden, as head of the Department of City Planning, then played a key role in persuading Doctoroff of the High Line's merits, economic and otherwise, whereupon the Bloomberg administration reaffirmed its support for the project. So at that point the city openly accepted the project as part of a real estate development deal based on the High Line's capacity to generate significant revenue for the city budget, in addition to its intrinsic value as a creative preservation project.

Accordingly, on December 17, 2002, Mayor Bloomberg's administration filed an application with the Federal Surface Transportation Board (FSTB) for permission to transform the High Line into an elevated public walkway. The city's application requested a Certificate of Interim Trail Use for the High Line, which permits out-of-use rail corridors to become recreational trails. As part of the 1983 National Trail Systems Act, the US Congress had passed legislation allowing this, so long as the out-of-use rail corridors were "banked" for possible future transportation needs. Tracks did not need to still physically connect to the national system, but an easement had to be preserved that permitted a connection if needed.

Requesting the Certificate of Interim Use was just the first step in a complex set of procedures required to transform the High Line into an elevated, public open space. Numerous political, legal, and financial challenges had to be met, involving negotiations between CSX, the City of New York, the State of New York, the Chelsea Property Owners, and community groups, before a final design could be developed.

In its Certificate of Interim Use application, Doctoroff said the High Line park would enhance the West Side and that the administration was considering rezoning parts of the area for residential use, which fitted Mayor Bloomberg's plan for growth and specifically for encouraging 65,000 new residential units in the city over the next few years. Still, the city did not yet present, and probably had not fully developed, its grand vision of the Far West Side as a combination of megadevelopment and preservation, although the Hudson Yards megadevelopment plan, including Doctoroff's project for an Olympic stadium, was being openly discussed. For one thing, the Gansevoort Market, a part of that eventual Far West Side vision, was not yet landmarked and would not be until 2003.

In April 2003, Community Board 4 voted to support the High Line preservation plan, which had not yet been packaged with a real estate deal for the Chelsea Property Owners (i.e., the 2005 West Chelsea Rezoning). "The vote was important and the support has been amazing," said Joshua David, who had been a CB4 member since 2001. "We want to create a compelling, beautiful and accessible park."

THE WEST CHELSEA REZONING, 2005:
BUYING OFF AND COMPENSATING THE CHELSEA
PROPERTY OWNERS, AND CITY FINANCING

The biggest obstacle remained the Chelsea Property Owners, who had considerable influence with the key Federal Surface Transportation Board. The owners' then president, Douglas Sarini, an executive with Edison Parking Systems who would clearly benefit if their parking lots adjoining the High Line could be developed once the rail was demolished, denounced the community board vote to preserve the High Line. He insisted that the structure was a dangerous eyesore, derided the Friends of the High Line as "romantics," and complained that key issues, such as the precise cost of converting the High Line into an elevated park and who would pay, had never been adequately answered. One High Line property owner walked into Deputy Mayor Doctoroff's office, dumped a chunk of concrete fallen from the High Line onto his desk, and explained that public hazards such as this were why the High Line should be demolished (Winters 2006).[9]

The owners' lobbying efforts in Washington bore fruit. Erik Botsford, New York City's Department of City Planning (DCP) liaison to Community Boards 2 and 4, narrated: "Sometime in 2003 word came from Washington to the New York Department of City Planning that the FSTB would not grant the Certificate of Interim Trail Use for the High Line conversion to a park unless the largest [though not all] of the Chelsea Property Owners agreed."

Botsford explained: "At this point we [the DCP] hit on the idea of special High Line transfer sites and transfer mechanisms." This became the West Chelsea Rezoning. It was a way to give the Chelsea Property Owners a method of making a profit equivalent to what they might have had if the High Line had been demolished, by allowing them to sell their air rights to special "receiving sites"—basically potential condo sites—that did not directly adjoin the High Line. So the DCP drafted for public approval a new zoning map with "condo receiving" sites (zoned C) replacing several manufacturing/industrial sites (zoned M) (fig. 3.7).[10]

Vishaan Chakrabarti, then head of City Planning for Manhattan, publicly compared this to what was done for Grand Central Station in the 1900s and later, one of the first major transactions in the United States involving the sale of air rights ("taking wealth from the air" in the words of William Wilgus, New York Central Railroad's chief engineer, who came up with the whole idea of allowing the sale of air rights). Under that deal, the owners of New York Central Railroad had been permitted to take the air rights associated with Grand Central Station and sell them to developers wishing to build over and alongside newly created Park Avenue (which

Fig. 3.7. Proposed Zoning and FAR (West Chelsea Rezoning, 2005).

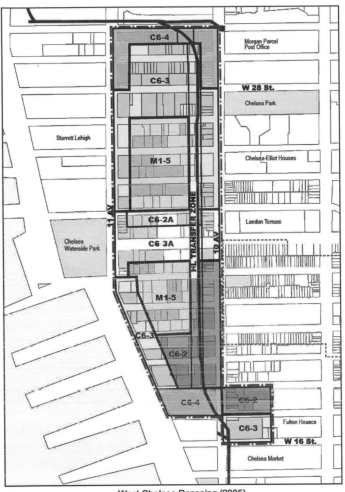

West Chelsea Rezoning (2005)

Note: For explanations of the zoning terms see the note at fig. 1.4. Material entitled Proposed Zoning and FAR used with permission of the New York City Department of City Planning. All rights reserved.

rested on the platform the railroad had constructed over the rail tracks), much of which was some distance from Grand Central Station, the generating source of the rights. Chakrabarti and others at DCP, anticipating new buildings around the High Line, stressed that the Grand Central solution had facilitated a wave of productive development, including what eventually became some of New York City's most architecturally innovative

buildings, for example, two icons of Modernism, the Lever House (1951) and the Seagram Building (designed by Mies van der Rohe in 1958), as well as the Waldorf Hotel. Much later in 2013, based on the success of the High Line–Chelsea Property Owners deal, Chakrabarti and others were advocating the same kind of deal with Madison Square Garden to get a new Penn Station and MSG built.

At the same time, the city carefully structured the West Chelsea Rezoning to provide some protection for the art gallery district, by keeping the gallery district's core zoned M (for manufacturing, which allowed galleries but not residential condos), thereby placing the condo "receiving sites" (C) beyond that core. Erik Botsford explained:

> We didn't want the displacement of the art galleries that would have been likely if we had rezoned everything for residential, so we kept the section where the art galleries are concentrated, 24th to 27th Streets and 20th to 22nd Streets, as M1–5 zoning, as a safe haven. Also, C6-2A [a section zoned at the border of the art gallery core] allows galleries. And some are going in there in a small way in the ground-floor of residential buildings going up. That's because developers see an art district as a bonus for their project . . . i.e., makes it more attractive.

Recognizing the potential for a lucrative deal, the Chelsea Property Owners now said they might drop their opposition to preserving the High Line.

The next step was to get the community board to agree to the West Chelsea Rezoning. Such agreement was not assured, since large condo development was anathema to many community board members. So it was probably no coincidence that Amanda Burden, on behalf of the Department of City Planning, presented the West Chelsea Rezoning proposal to a Community Board 4 forum in September 2003, just two weeks after the Landmarks Preservation Commission had burnished the city's preservationist credentials with community board activists by voting to landmark the Gansevoort Market District. After Burden's presentation, Community Board 4 duly approved the West Chelsea Rezoning. (This was an informal vote, not part of the city's formal ULURP process, which happened later in 2005.)

Three years later, as the condo boom associated with the West Chelsea Rezoning took off, some members of Community Board 4 regretted approving the rezoning. They said they had not really understood its implications, especially the sale of air rights to development sites some distance from the High Line, amid the general desire to make the High Line happen. One of the most powerful, Robert Trentlyon, said: "While the High Line advocates were dealing with the city I didn't realize that 1.5 million

square feet of development rights were given to the developers. So now they're building many high-rise buildings. It's disgraceful how little public benefit there is. Everyone says the Chelsea Property Owners told the city that if they didn't get those development rights they'd tie the project up in the courts for twenty years."

On May 25, 2005, the Department of City Planning formally adopted the West Chelsea Rezoning, whereupon the Chelsea Property Owners dropped their opposition to the High Line. The Federal Surface Transportation Board then promptly granted the Certificate of Interim Trail Use on June 13, 2005, clearly because the Chelsea Property Owners now supported the project. So this deal solved an issue often fatal for megaprojects, namely the existence of one or more private corporations that are critical for the project's success but oppose it.

The West Chelsea Rezoning deal now cleared ULURP and was so well received that in April 2006 the American Planning Association gave a planning award to DCP chair Amanda Burden for the new zoning district and its encouragement of the "reuse of the High Line, an abandoned rail viaduct."

In November 2005 the city formally took ownership of the High Line from CSX Transportation, which donated the structure, and the city and CSX signed a Trail Use agreement. The High Line budget now included stage 2, which raised the total cost from $65 million to $153 million and included a crucial $112 million of city funds (73 percent of the total), $21 million of federal funds, and most of the rest from private donations raised by the Friends of the High Line ($19 million) (see table 3.1).

The High Line, as it turned out, had now just squeaked in before running afoul of a second factor that often dooms megaprojects, namely economic downturns. The city's justification for the above expenditure of public funds remained that the High Line would eventually more than pay for itself in real estate taxes to the city from condo and other projects it was triggering. Still, had the funding requests started two years later, during the national financial crisis of 2007, the city would have had difficulty, practically and politically, in making its huge financial contribution, which stretched over three years, however justified by long-term revenue projections.

CONDOMINIUM DEVELOPMENT AND FOUR TYPES OF LANDSCAPES: "BEAUTIFUL," "ENVIRONMENTAL," "NARRATIVE," AND THE "AMERICAN ROAD"

By mid-2006 the High Line, still three years from opening, had helped trigger a frenzy of building—of condominium, hotel, and office projects—

facilitated by the West Chelsea Rezoning and driven partly by the belief that rich people would pay huge sums for residences with great views. These views serendipitously combined four kinds of landscapes, which together provided a powerful motive for condo residents to pay several million dollars to live above, and walk along, the High Line.

There were the two landscapes that the previous chapter showed as so popular. These were the classic "beautiful view" (e.g., Hudson River and broader city) and the "environmental landscape," namely the High Line itself.

A third type of landscape associated with the High Line is the "narrative" landscape, which incorporates a story, often a fable or moral tale. Actually the High Line's central narrative changed over time. It's original, core fable was the survival tale of how wild flora had persisted through the city's dark days. This narrative morphed into a story of innovative and creative planning as the High Line's reputation as a park grew and it turned out that the wild vegetation, the core exhibit of the first narrative, could not survive the Line's transformation to a park and had to be replaced with new vegetation. Using the language of French anthropologist Claude Lévi-Strauss (1966), who wrote extensively on metaphor in social life, the High Line's core narrative metaphor shifted from a "promenade sauvage" ("wild walk") to a "promenade planifié" (planned walk).

The High Line also embodied a fourth type of landscape, the "American road." In the 1950s and 1960s avant-garde artists like Ed Ruscha and John Baldessari pioneered depictions that featured "the road," typically but not always a highway, as a classic type of American landscape. The High Line creatively incorporated this landscape depiction too, with the railroad as the "road."

A slew of new projects from big-name developers and their star architects now appeared around the High Line, made possible by the West Chelsea Rezoning deal and trading heavily on the Line's views.[11] Developer André Balazs built the Standard Hotel (designed by the Polshek Partnership), which straddled the Line and opened in late 2008. (It was able to straddle the High Line because it was just south of, and outside, the West Chelsea Rezoning, which forbade owners to develop over the High Line.) Two blocks north at 16th Street was the Caledonia, a residential tower whose developers were the Related Companies and Taconic Investment Partners. Further north were condominiums by starchitects such as Jean Nouvel, Annabelle Selldorf, Robert Stern, Neil Denari, and Shigeru Ban. The Nouvel condominium was a new version of the "tower" that preservationists in 2006 had stopped from being built in the Meat Market next to the High Line entrance, after a four-year fight. It now appeared to plaudits from the *New York Times* architecture critic Nicholas

Fig. 3.8. High Line, condo building, and now-closed Getty Gas station, with *Sheep* by artist François-Xavier Lalanne (September 17–October 20, 2013). The gas station will host public art programs until construction starts on developer and art collector Michael Shvo's new condo in 2015, illustrating the often symbiotic relationship between real estate and art in Chelsea. Likewise Della Valle and Bernheimer, architects of the condo building in the figure, say its stainless steel panels simulate images of steam clouds from locomotives that used to run on the High Line. Photo by Elisabeth Tiso.

Ouroussoff, as "demonstrating what a major talent can accomplish when he focuses his mind on a small corner of the city" (2010). Just south of it at 19th Street Frank Gehry's nine-story office headquarters for IAC's new media projects (e.g., Expedia and Lending Tree) and one of the most innovative buildings in the city opened in 2006, shaped like ship sails to echo the nearby waterfront (fig. 3.2). A new condo designed by Annabelle Selldorf at 24th Street opposite Gagosian's megagallery included a "sky garage" adjoining each apartment—residents' cars ascended in a special elevator. In 2010 the apartments there sold for $5 to $17 million. On 23st appeared Los Angeles architect Neil Denari's condo building, which its developer Alf Naman called HL23 (an acronym for the "High Line at 23rd Street"), the building's glass façade widening as it rose. In April 2011 the *Los Angeles Times* architecture critic hailed HL23 as "among the most ambitious of the many buildings spawned by the opening of the wildly popular park," adding that it had reversed assumptions about New York and LA architecture:

It used to be that for young, experimental or otherwise untested architects, L.A. was the place to get an unorthodox design built. In New York, on the other hand, opportunities for those architects tended to be limited to residential or commercial interiors that had no impact on the skyline. . . . HL23 . . . is a sign of how dramatically that equation has changed in recent years. . . . To complete the first ground-up building of his career, the 53-year-old Denari [one of the city's most prominent architects] had to go to New York—to Manhattan, more surprising still, the island that was for decades known among architects as the place visionary dreams went to die. (Hawthorne 2011c)

The money to be made around the High Line attracted not only developers. In 2008 the Museum of the City of New York held an exhibition praising architect Denari's not yet completed HL23. The exhibition's lead funder was the condominium's developer, Alf Naman, who was at the time marketing the apartments to clients. A series of media articles appeared criticizing the condominium frenzy and reflecting mounting fears among many city residents about Manhattan's growing unaffordability. As early as September 2005 an *Observer* article by Matthew Schuerman discussed the escalating price of the lot on which HL23 was built:

Benigno Serrano bought 12,350 square feet adjacent to Chelsea's High Line for just $900,000 in 1986. Last year, he turned down $10 million for it. This year, a developer named Alf Naman finally got it for $12.5 million. And that's just the beginning. Welcome to the great High Line development cash-in! While the elevated railway itself is still just a rusty, weed-covered insurance liability, speculators and developers are already squeezing money from it. (Schuerman 2005)

In a May 2007 *New York Magazine* article, with the city's and nation's real estate boom about a year from crashing, Adam Sternbergh discussed the fusion of the "city as historically themed spectacle" with the flood of condominium developments associated with the High Line:

What you'll get, in other words, is a thoughtfully conceived, beautifully designed *simulation* of the former High Line—and what more, really, do we ask for in our city right now? Isn't that what we want . . . that each new clothing boutique that opens in the space where the dry cleaner's used to be—you know, the one driven out by rising rents—should retain that charming dry cleaner's signage, so you can be *reconnected* to the city's hardscrabble past even as you shop for a $300 blouse? And that each dazzling, glass-skinned condo tower . . . should be nestled in a charming, grit-chic neighborhood, full of old warehouses and reclaimed gallery spaces and

retroactively trendy chunks of rusted urban blight? Isn't that exactly what we ask New York to be right now?

The High Line . . . will one day look to us like a monument to . . . a time when the city was, for many, never safer, never more prosperous, and never more likely to evoke an unshakable suspicion: that more and more, New York has become like a gorgeous antique that someone bought, refurbished, and restored, then offered back to you at a price you couldn't possibly afford. (Sternbergh 2007)[12]

OPENING

The High Line's first section opened in June 2009 and was an instant success, becoming a major tourist attraction. It confounded skeptics who had, for example, insisted that New Yorkers were street-focused and would never patronize anything that involved mounting a flight of steps. The first section was designed by the MacArthur ("genius") award–winning architects Diller Scofidio & Renfro in collaboration with influential Dutch garden designer Piet Oudolf and English landscape architect James Corner. The High Line's beautiful design—from the benches, to the layout of tracks, to the visual splendor of the plantings—has made it into more than just an ordinary park and somewhat of a work of art iself (much improved from its inspiration, the Promenade Plantée in Paris) and one key to the project's success, showing that great design can pay for itself.

The High Line lacks the original wildlife, whose survival during the years of neglect had proved so inspirational. Those plants could not survive the High Line renovation. So the "wildlife" that now greets visitors is a brand-new, imported version. Still, visitors have no way of knowing about these changes, nor is there reason to suppose they would care. The dominant narrative associated with the High Line has morphed from how nature ("wildlife") can survive urban decay to a story of a creatively designed and reshaped "preservation" project, with the reasonable lesson that history cannot and should not be embalmed. The High Line was, in this context, fortunate not to have been officially designated a New York City "landmark," which would have meant that almost any major changes it wished to make would have needed approval from the New York City Landmarks Commission. As a result, it had much flexibility and room for creativity, although since it received federal funds, its project and development were subject to approval from the State Historic Preservation Office.

Surely helping the High Line's reception was that it opened as the real estate recession that started to bite in New York City in September 2008 was in full swing. As a result, populist anger at the city's condo frenzy and

[handwritten margin notes: PRESERVATION PROJECTS .P URBAN RENEWAL ITSELF AS "ART" + SYMBOL]

at developers had abated somewhat as visible signs of the distressed state of development projects abounded. Few large building projects could now obtain financing, not even those that had broken ground and completed the foundation work. The result was a series of gaping holes in the ground throughout Manhattan. In December 2009 the developer of one such hole, a discontinued condo project opposite HL23, unloaded the property for $11.25 million, about half what he had paid in 2005 (*Real Deal* 2010a).[13] Probably helping the High Line's reception was that it was a new attraction and charged no admission fee, suiting the economizing mood of many in a city in economic recession.

Likely helping the High Line too was that Joshua David and Robert Hammond had operated as highly skillful public entrepreneurs, working with City Planning and the City Parks Department, and also raising considerable private funds from wealthy New Yorkers. By September 2012 fashion designer Diane von Furstenberg, whose headquarters were in the Gansevoort Market, and her husband Barry Diller, whose media empire IAC was headquartered in the Frank Gehry building next to the High Line, had donated $35 million.

PUBLIC-PRIVATE PARTNERSHIP

Here the Friends of the High Line drew on, and continued, New York City's tradition of public-private partnerships driving cultural and other public projects. These typically take the form of privately led, nonprofit cultural institutions run by boards composed largely of wealthy New Yorkers who make a sizeable annual contribution in return for board membership, but with the cultural institution housed in city-owned buildings and structures on city-owned land.

The basic template for these public-private cultural partnerships was first struck in 1869 for the Metropolitan Museum. New York City government would construct and maintain museum buildings—just as governments did in Europe—and a private board would build the collections and operate and own the institution, but not the land. By the end of the nineteenth century, the American Museum of Natural History, the Metropolitan Museum of Art, the New York Botanical Garden, and the Bronx Zoo had all been created according to this public-private partnership model (Halle and Mirrer 2012).

As a park, the High Line followed a somewhat different version of the public-private partnership, namely that of the Central Park Conservancy, a model which gives the city far more control than the museum model.[14] Like museums, the High Line is on public land, and its renovation is mostly publicly funded. But unlike most museums, which are owned by

the nonprofit organizations that run them, the High Line is a publicly owned park under the New York City Parks' jurisdiction, with the nonprofit Friends of the High Line operating according to an agreement that has to be renewed every few years, and with the Parks Department carrying out day-to-day management, including trash removal, upkeep of bathroom facilities, and repairs.

The opening of the High Line's second stage in June 2011 cemented its favorable reception. It had clearly become a major tourist attraction and widely praised public amenity. Businesses close to the High Line were acknowledging, too, the branding cachet. In 2011 a small pizza store opened on 28th Street as High Line Pizzeria, and in 2012 a boutique hotel in a Gothic-style building purchased from the adjoining General Theological Seminary opened on 20th Street as the High Line Hotel. The hotel name became obvious, the owner explained, when he saw it could be presented as "the gateway to the High Line," a block away.

BECOMING A CULTURAL INSTITUTION

The High Line by now was starting to present itself not just as a park but as a cultural institution, in part exploiting the synergy with Chelsea's Contemporary Art gallery district, and then later the synergy with the Culture Shed located in Related's Hudson Yards development next to the High Line's stage 3. In 2009 the Friends of the High Line started a program titled High Line Art, which commissioned public art projects on and around the High Line to "creatively engage with the uniqueness of the architecture and design of the High Line and to foster a productive dialogue with the surrounding neighborhood and urban landscape." Among the first projects commissioned by the High Line were billboards at 18th Street where photographers Robert Adams, Joel Sternfeld and John Baldessari displayed poster-size works. In 2012 the Italian art curator Cecilia Alemani, who had extensive experience as an international curator ranging from Frieze in London to the Performa series, was hired to direct High Line Art. For example, a temporary (2013–2014) project titled *Busted* and presented as updating the "dedicatory statues that punctuated the streets of ancient Rome" included contemporary statues by nine artists, one of which depicted Florent Morellet, owner of the now closed but legendary Meat Packing District diner. Reinforcing this transition as an "arts corridor," in late 2013 Jenny Gersten, a theater producer for most of her career, replaced Robert Hammond, who was stepping down as executive director of Friends of the High Line (Joshua David moved from chief development officer to a new position as president) (Cohen and Maloney 2013).

SAVING AND DEVELOPING SECTION 3: THE RAILYARDS

In 2007 most of the likely developers of the Hudson Yards, including Related, wanted to demolish the High Line section that ran alongside the Western Rail Yards, and the city and MTA were inclined to agree. In response, the Friends of the High Line lobbied heavily and creatively to save this section—for example, showing up at public meetings wearing red "Save the High Line at the Railyards" T-shirts. Peter Mullan, the High Line's vice president for planning and design, described this eventually successful effort as one of his proudest moments. Members of the Community Board and their local politicians responded to the pressure: "I would like to see as much of the High Line stay up as possible," said state senator Tom Duane. "I know that there are other stakeholders that don't necessarily agree with that." The MTA diplomatically replied that it was committed to working with the city and other parties to find a solution "that would provide vital funding of the MTA's capital needs and ensure a wonderful addition to the West Side community." Later, by 2012, it was clear to almost everyone that demolishing the High Line's railyards section would have been a blunder, as the huge success of sections 1–2 was apparent and as plans were proceeding for section 3 of the High Line along the railyards. Related's chairman Stephen Ross, who had been furious in 2009 when the Department of City Planning during the ULURP process decided to keep section 3, now recognized the High Line as a huge real estate draw.

By March 2012, the shape of stage 3 of the High Line, which was to begin in September 2012 and open in 2014 at a cost of $90 million, was being publicly discussed. As the architects, Jim Corner and Diller Scofidio & Renfro, stressed, stage 3 was informally titled "Brave New World," since it would run alongside, and would need to be carefully coordinated with, the Related Company's yet-to-be-built mega commercial and residential development above the Eastern Rail Yards. Related's development would include a 1,000-foot-tall commercial Tower C at 10th Avenue and 30th Street, for which the luxury goods firm Coach had signed to be the lead tenant. Of the roughly $90 million total cost of stage 3, Related (and its partner Oxford Properties) was set to pay $27.8 million, the city $10 million, and the Friends of the High Line had so far raised about $20 million.

At a planning meeting for stage 3, Adrian Benepe, head of the city's Parks Department, which owned the High Line, proclaimed that the High Line was now the most visited park in the city per acre, with 3.7 million visitors in 2011. The architects added: "We never expected so many people—we had planned for just 300,000 visitors a year." In view of the media publicity being given to private contributions, Benepe appropriately



Table 3.2. Museum attendance worldwide, top 14 (2012)

Rank	Museum	Attendance (in millions)
1	Louvre (France)	9.7
2	Metropolitan Museum of New York	6.11
3	British Museum (London)	5.6
4	Tate Modern (London)	5.3
5	National Gallery (London)	5.1
6	Vatican Museum (Rome)	5.0
7	National Palace Museum (Taipei)	4.3
8	National Gallery of Art (Washington, DC)	4.2
9	Centre Pompidou (Paris)	3.8
10	Musée D'Orsay (Paris)	3.6
11	Victoria & Albert Museum (London)	3.2
12	National Museum of Korea (Seoul)	3.1
13	State Heritage Museum (St. Petersburg)	2.9
14	Museum of Modern Art (New York)	2.8

Source: Art Newspaper, March 28, 2013.

stressed the public part of the High Line's "public-private" partnership credentials, in particular with the city and federal government having contributed so far roughly 87 percent ($132.9 million) of the costs of sections 1 and 2, with almost all of that ($112 million) from the city. Benepe also highlighted the High Line's success as creative adaption. "It is being copied all over the world. Adaptive reuse is being copied in Singapore, Chicago and other cities."

By early 2013, underlining the High Line's perception of itself as a major cultural institution, its officials were proudly stressing that the High Line, with roughly 4.2 million visitors in 2012, was New York City's second-most visited cultural institution, just a couple of million below the Metropolitan Museum, one of the city's top tourist sites, and well ahead of the Museum of Modern Art. Indeed, although the High Line is not a museum, comparison of its attendance figures with museums worldwide is instructive. If the High Line were a museum, it would have been the eighth-most attended in the world in 2012 (see table 3.2).

The fact that the northernmost part of section 2 ended with expansive views of the Javits Convention Center some ten blocks away, to which the High Line's third and final section would eventually link, underlined a major uncertainty relating to Javits and the related issue of megaprojects. For a while the increasing success of the High Line seemed to offer a solution to a problem long facing Javits—namely, what can convention attendees do in the evenings, given Javits's isolation on the Far West Side? The first solution, suggested during George Pataki's governorship, of a

convention hotel just north of Javits that would point attendees in the direction of Times Square and the theater district, fell through when the developer Silverstein Properties was allowed to build apartments (Silver Towers) on the hotel site. After the successful opening of section 2, in a twist that some planners had hoped for since the High Line was first suggested, there was the probability that Javits convention attendees could walk south on the High Line to the attractions of the Gansevoort Market district. Yet, underlining the fluidity of urban development, in January 2012 this was called into question as Governor Cuomo announced, without consulting Mayor Bloomberg, a plan to replace Javits entirely with a major convention center and casino in Queens. But by mid-2012 this plan had fallen through, and Javits boosters began discussing an idea for a casino next to Javits on Pier 76, currently an NYPD tow pound.

In light of part III's discussion of why most megaprojects in New York never happen, or take decades, it bears repeating that the High Line itself barely escaped three standard factors that routinely block such projects. The Chelsea Property Owners exemplified one such factor, namely the existence of a private corporation that is crucial to success but opposed to the project. The West Chelsea Rezoning bought their support, but only because City Planning had the creativity to suggest it, and because surrounding property values were high enough to offer lucrative air rights with which to buy them off. (The absence of such lucrative transfer sites is one reason why replicating the High Line in other cities may be hard.) Second, the fact that one of Giuliani's former deputy mayors was a highly paid and influential lobbyist for the Property Owners suggests that the High Line also narrowly escaped political lobbying and cronyism as a major blocking factor. And the High Line almost ran afoul of a third key blocking factor, namely project delays until the economic cycle turns down.

The High Line also raises the issue of whether it might be a good idea to compensate owners of structures that some city residents, but not necessarily the owners, wish to remain for aesthetic reasons. Such compensation might not only be fair, as some argued around the time that New York City's landmarks legislation was being discussed, but it might also discourage overzealous landmarking.[15] An obvious problem here is the public cost of compensating owners at market value. Still, the creative solution of allowing owners to sell their air rights to nearby but not necessarily adjacent sites, which worked so well for Grand Central and the High Line, solves the problem of raising funds to compensate owners (at least in a city like New York where real estate values are high) and also facilitates a balance of preservation and development.

Alexander Garvin, among New York's most distinguished planners, recently listed what the best practices in planning should look like (Garvin

2013, 202). Overall, the High Line exemplifies almost all of them. They include a compelling vision, powerful marketing and salesmanship, effective implementation, providing things people want, being ready with the right proposal at the right time, adjusting to meet changing economic and political requirements, compromise and flexibility, and persistence.

The Gansevoort Market: From Meat Smells and Prostitution to Historic District, Fashion Central, Google Headquarters, and Whitney Museum

If you want to make money, buy property where the prostitutes and miscreants are, hold onto it for fifteen years, and you'll make a fortune.

—Jonathan Segal, British investor in the Meat Market disco Ditto for One, July 2004

All great things have to end. I'm ready for a new phase in my life. I'm excited about it, but part of me is sad.

—Florent Morellet 2008, after the landlord raised the rent 700 percent on his iconic diner, Restaurant Florent

In the mid-1980s the Gansevoort Market District began a slow evolution.[1] It was then basically an area where raw meat was packed and sold during the day, while at night activities such as prostitution and transgendered sexual interaction occurred that liked the cover of an inhospitable environment of stinking meat (Sholette 2011).

There were several signs of impending change. One was the 1985 appearance of the supermarket Western Beef, whose business model was based on selling low-cost groceries in neighborhoods where it saw potential although other chains were reluctant to locate. Around the same time, Florent Morellet, a French restaurateur, opened a diner in the heart of the area. Then in the late 1990s, a cluster of commercial art galleries set up a southern outpost of Chelsea's gallery district on 14th Street, and the chic designer store Jeffrey opened nearby.

In 2003 the city's Landmarks Commission designated the area as the Gansevoort Market Historic District (fig. 4.1). The commission had been urged on by Florent Morellet and Jo Hamilton, a young woman who had moved to the area from Los Angeles. Both felt that changes threatened the gritty character of the Market District which they prized. They had the energy and talent to implement a corrective strategy, like Joshua David and Robert Hammond for the High Line.

Fig. 4.1. The Gansevoort Market Historic District, designated September 2003. Night-clubs by 2014: (1) Bagatelle, (2) Provocateur, (3) 675 Bar, (4) Cielo, (5) Hilo, (6) VIP Room, (7) The Griffin, (8) Le Bain, (9) STK, (10) Brass Monkey, (11) Simyone Lounge, (12) Tenjune.

Galvanizing the landmarking movement was the imminent appearance of two Neomodern structures—the Hotel Gansevoort and a condo tower designed by Jean Nouvel. For many supporters of landmarking, the desire to keep out such new buildings was just as important a motive as the desire to preserve the older ones for their aesthetic merits. Indeed, some landmarkers admitted frankly that some of the older buildings were "ugly." This dual motivation—stopping new, modern buildings as well as saving old ones—has not received the attention it ought in understanding the dynamics of preservation and landmarking movements. That is partly because in New York City's legal process for landmarking, the main requirement is typically to show that the building or area that

preservationists wish to landmark is intrinsically worth preserving (however undistinguished and humdrum it may actually be). To argue instead, in the legal process, that the original building should be preserved because the likely replacement buildings will be undesirable on aesthetic grounds is not typically an acceptable position.

Instead of slowing change, the 2003 landmarking boosted the Market District, which gained enormous cachet in a series of steps. It became home to a cascade of supertrendy designer stores and a major tourist destination. Although landmarking had halted the replacement of old buildings by tall new structures in the Market District, developers built a series of high-end hotels just outside the district. One, the Hotel Gansevoort, had gone up just before the district was landmarked. An increasingly vigorous, often boisterous, nightlife of clubs and chic restaurants evolved. The High Line, whose southern entrance began in the market, added hugely to all this momentum when it opened in the summer of 2009, as did the Whitney Museum of American Art's 2006 announcement that it would build a branch next to the High Line entrance, followed by its 2011 decision to relocate its entire museum there by 2015.

By 2009 the meatpackers were just an inconspicuous rump paying way-below-market rent on a city-owned space and owing their survival to the city's desire to keep a remnant of the industry whose retention had been a major justification for landmarking the area (fig. 4.2). (In 2012 the city renewed the lease for these meatpackers for twenty-five years.) Western Beef was replaced by a chic, glass-framed Apple computer store paying an amazing $9–$12 million annual rent for the space. In 2010 Google purchased as its East Coast headquarters a building constructed in 1932, one block to the north of the new Gansevoort Historic District, employing some eighteen hundred people. This building, the former headquarters of the Port Authority before it had relocated to the World Trade Center, had eighteen stories and more square footage than the Empire State Building. Then in 2008 Florent Morellet, by now a local hero among the preservationists, lost his restaurant when his landlady demanded a 700-percent rent increase. At this point many of the preservationists feared that the whole process had facilitated an out-of-control nightlife, with this newly supertrendy area now a star of the global circuit for a brash, super-rich, partygoing elite. But it was probably too late. Only modest damage control was possible. Community Board 2 in 2013 started trying to require that club liquor licenses forbid the sale of alcohol after 2:00 a.m., rather than the current 4:00 a.m. Landmarking and the economics of tourism had blended.

In short, despite being declared a historic district, the Gansevoort

Fig. 4.2. Meatpacking business, 2010. Photo by Elisabeth Tiso.

Market went through a cycle that showed, as with the High Line, how hard it is to control certain kinds of changes.

There is also the question of how much it mattered. The city ended up replacing prostitution and a no-longer viable source of jobs—meatpacking—with a new tourist attraction which brought in revenue and jobs and had the aura to attract titans of the new computer industry like Google and Apple. By 2011 the city was proudly announcing its new, high-technology "ecosystem" corridor, stretching east from Google and Apple around the Gansevoort Market to start-up high-tech businesses located in lofts between 6th and 5th Avenues (called "Silicon Alley" during the dot-com boom), continuing east to the new Cornell Technion-Israel Institute of Technology engineering and computer science campus scheduled to open in 2017 on Roosevelt Island on land donated by the city. No residents were pushed out in the Gansevoort Market process, because almost none were there in the first place, since the area was zoned manufacturing. So, as with the High Line, this was not classic gentrification—the displacement of poor and working-class residents by wealthier ones. It did, however, involve a series of "commercial gentrifications"—the replacement of one set of stores and businesses, starting with meatpacking and prostitution, by others able to pay more rent, and then "supercommercial gentrifications" by still others paying sky-high rents.

Many old buildings were preserved, while some new, sometimes striking, ones appeared, such as the Hotel Gansevoort—viewed as either "jarringly out of context" or "beautiful and well-branded," depending on one's taste, and making for a legitimate aesthetic debate.

This created the mix of old and new buildings which Jane Jacobs saw as one (though certainly not the only) key ingredient of a vibrant neighborhood and which architects, using a similar concept of a "layered" city, often view as the solution to balancing preservation and growth.

HISTORY

The Gansevoort Market originated in 1879 when the city set aside two acres for a farmers' market selling retail regional produce, which was followed in 1889 by a wholesale meat and poultry market. It was named for General Peter Gansevoort, a Revolutionary War hero whose grandson, Herman Melville, later worked on the docks for twenty years. The market was near the Gansevoort Street docks from which it was supplied, although landfill in the next decade continued the creation of two extra avenues, 10th and 11th, which then somewhat separated the market from the water (NYC 2003, 2008). The market's initial link to the docks was the freight railroad that in 1934 was elevated to become the High Line.

Gansevoort Market started to focus on selling meat when the Manhattan Refrigerating Company, taking advantage of the latest technological advances, provided the underground infrastructure for refrigeration in the district in 1906. Older buildings then began to convert to meat market uses. By World War II, poultry and meatpacking had consolidated as the market's main commercial activity.

Although the area's zoning permitted buildings to be much higher, the meatpacking buildings tended to be low, around four stories or less, partly because in the 1930s and 1940s revised building codes mandated expensive upgrades to older, multiple-dwelling buildings. So some owners, hard-pressed during the Depression, removed the upper stories to reduce their tax liability and other expenses. To protect their wares from the elements, the meatpackers added metal sidewalk canopies, later cherished by preservationists as one of the neighborhood's distinctive details.

The meatpackers had long coexisted with people attracted by the area's relative remoteness, narrow streets, gritty atmosphere, and lack of (legal) residents to demand respectability, since the area was zoned manufacturing. A raucous nightlife began flourishing in the 1970s, including prostitutes and underground clubs, catering at first to gay men, then broadening their audience. This was part of the scene Silas Seandel encountered in 1978 further north on 22nd Street when he moved his furniture making

shop into what eventually became the heart of the commercial gallery center. One observer, who later managed a Chelsea art gallery, described the Gansevoort Market's seedier side in the early 1980s: "There was a place called the Hellfire Club in the Meat District. A man was in the tub and you urinated on him. He was into golden showers. It was in the early 1980s, just before AIDS. All these places, the people got zapped by AIDS. Then with Giuliani the whole sex industry went underground."

The writer Paul Haacke described growing up next to the Meatpacking District. His family lived in Westbeth, the giant building complex completed in 1989 which had long served as an industrial research lab for the Western-Electric, AT&T, and Bell Telephone conglomerate. After Bell moved out, Westbeth was converted in the mid-1960s into affordable housing for artists, with Richard Meier, now a starchitect but at the time a young architect, creating over four hundred apartments whose occupants were, for decades, a small, anomalous group of residents by the basically nonresidential meat market. Describing the 1980s and 1990s, Haacke (2010) observed:

> The Meatpacking District of my childhood was still full of wholesale retailers who did indeed wash, display, pack, and sell meat. The streets were pretty smelly and slippery during the day, with dripping carcasses strung up on metal hooks from overhead rafters extending over the sidewalk. At night, however, an altogether different meat market would emerge from the shadows, as partygoers and prostitutes of various ethnicities, sexualities, and genders came out to work and play. As a kid I wasn't really aware of what happened after dark, but even during the day I saw plenty of people wiggling about in feather boas, colorful bras, and sequined miniskirts, or heard the telltale click-clack of high heels traipsing across the cobblestone streets. I usually couldn't tell if they were men or women, especially as most were a little of both. Sometimes I'd cross paths with hookers on my way to school in the morning. Feeling bemused rather than threatened, I simply avoided eye contact and kept my backpack straps tight in hand. . . . For a long time I was also oblivious to the many crumpled condoms littering the sidewalks.

CHANGING CHARACTER

By the mid-1980s the meatpacking businesses in the market were declining, reflecting the general move away from manufacturing and industry in Manhattan. Many meatpackers left for Hunts Point in the Bronx, a trend the city encouraged, since it increasingly thought Manhattan was

destined to contain offices and residential apartments, not industry and certainly not unsavory industries like meatpacking. In 1986 there were 150–200 meatpacking businesses in the Gansevoort Market, by 2001 only about 30, and by 2013 about 6, all consolidated in a single, city-owned building just north of the High Line's main entrance on Gansevoort Street.

In 1985, a year before the Dia Art Foundation moved north from SoHo to Chelsea on West 22nd, paving the way for art galleries, the supermarket Western Beef opened a branch on 14th Street at the corner of 9th Avenue, just inside the northern edge of what later became the Gansevoort Market Historic District. Western Beef's director of operations was unsentimental in his characterization of the place then: "It was a derelict area clogged by trucks in the daytime and prostitutes at night. As soon as sundown hit, you probably didn't want to be there." As late as 2001 observers described the area at night similarly (Dewan 2001).

Also in 1985, Florent Morellet opened his 24-hour diner, Restaurant Florent, in a two-story building at 69 Gansevoort Street. Morellet later described himself as one of the Meat Market's "first gentrifiers." This was the start of commercial gentrification, as slightly higher-end businesses (a diner and cut-price supermarket) appeared alongside the lowest-end businesses—meatpackers and prostitutes.

Born near Nantes, France, Morellet studied urban planning in London, spent a year in San Francisco, where he got his first taste of the restaurant business, then went to Paris, where he opened a restaurant that he described as "a social success but a financial debacle—I was twenty-two years old." He came to the West Village in 1978 and managed a SoHo restaurant, La Gamelle, before opening Restaurant Florent. He liked how Restaurant Florent's neon sign lit the meat hooks across the road, and he quipped about a basic similarity between Americans and the French: "They both love going someplace dirty. Sleazy locations make them feel fabulous" (Rubenstein 2000). Restaurant Florent became a local destination, and his July 14 party, where Morellet dressed as Marie Antoinette and was symbolically executed, became a noted annual event (fig. 3.3). After learning in 1987 that he was HIV positive, Florent famously posted his latest T-cell count on the restaurant's blackboard along with the daily temperature and thought-provoking quotes (Billard 2013).

Gallery Outpost Triggers "Fashion Central"

From 1997 to 2002, a group of commercial art galleries opened in the Meat Market District on 14th Street between 9th and 10th Avenues, near Western Beef. They were enticed there by a local landlord, the Meilman family, who saw galleries as a chance to raise the tone of the area and

increase rents in the family's buildings. The Meilmans were early practitioners of the use of "culture" to "improve" a rundown urban area, which Richard Florida (2002) has systematically and famously theorized as a major tool of urban planning.

The Meilmans were basically engaged in "planned commercial gentrification." They had formerly been in the wholesale meat business and were longtime owners of six buildings on the north side of West 14th Street between 9th and 10th Avenues.

The galleries, in turn, hoped this would become the southernmost tip of Chelsea's now expanding gallery neighborhood. Still, it was a risky move involving a mini leapfrog of about six blocks from the Chelsea gallery area's informal southern border at the time. So the galleries hedged their bets by signing short-term leases with a thirty-day eviction notice clause—in retrospect a major mistake, since they had no protection. Still, as one of them commented ruefully: "If you'd seen the neighborhood at that time, you'd have signed a short lease too! It was smelly."

The Meilmans' rent-raising strategy worked. First Jeffrey, the expensive designer clothing store, opened on 14th Street in 2000, when rents were roughly $18 per square foot per year. Over the next few years came

Fig. 4.3. Stella McCartney's fashion store, Gansevoort Market, opened in 2002. In 2012 McCartney moved to a SoHo location, as her ten-year lease expired and her landlord, the Meilmans, wanted to quadruple her rent to $400 a square foot.

a cluster of high-end designer clothing stores such as those of Stella McCartney, daughter of the Beatle Paul McCartney, and McQueen, the acclaimed British designer, many renting in Meilman buildings. The designer Diane von Furstenberg opened her headquarters around the corner. Locals began to call the area "fashion central" (figs. 4.3 and 4.4).

Two blocks to the south, Pastis, a restaurant styled as a 1930s French bistro, was opened in 1999 by Keith McNally, who specialized in historically themed restaurants (fig. 4.5). Then came more nongay and nonporno nightclubs, and a somewhat mainstream nightlife began to blossom. Real estate values rose, people started taking down the metal canopies, and developers began to propose tall new structures such as hotels and condominiums. By 2003, six years after the first gallery had moved there, commercial rents had risen 600 percent in this section of the market to roughly $80 per square foot per year. Commercial gentrification was in full swing (fig. 1.10).

Fig. 4.4. The Gansevoort Market Historic District, 2009, view from the High Line, looking east along 14th Street. Foreground right is a meatpacking business (closed by 2010). On the left, renting first-floor commercial spaces in buildings mostly owned by the Meilman family, are expensive fashion stores, including Jeffrey and Stella McCartney, which displaced art galleries on short-term leases. Designer Diane von Furstenberg's corporate headquarters are on the right. Photo by Malcolm Halle.

Fig. 4.5. Gansevoort Market Historic District, 2009. Pastis (*center*), restaurateur McNally's 1930s-themed Paris brasserie, closed in early 2014 when its landlord applied to add two glass exterior stories. At the Landmarks Commission's hearing (May 2014), critics called the proposal "out of character" with the mostly brick neighboring buildings. The owner's architects replied that the existing buildings represented several additions over time ("robust discord" of styles), so adding modern glass was fine. They compromised by replacing some of the glass with metal. Photo by Malcolm Halle.

PUSHING FOR A HISTORIC DISTRICT, AND USING ZONING TO PROTECT THE MARKET'S "GRITTY CHARACTER"

The main effort to slow change came from a group formed in the late 1990s by Jo Hamilton and Florent Morellet. Morellet saw echoes of the unfortunate demise of Les Halles, which had once been Paris's central wholesale market, bustling with merchant stalls selling meat, fish, fruit, and vegetables. In 1971, unable to compete in the new economy and needing massive repairs, Les Halles was relocated to the suburb of Rungis and replaced in 1979 by Forum des Halles, a several-story commercial and shopping center widely criticized as ugly and characterless. Morellet and Jo Hamilton feared likewise that the market and manufacturing character of the Meat Market, which they described as "gritty," would disappear. Some of the other supporters of creating a historic district were less concerned about keeping the manufacturing base, but just wanted to preserve

the low-rise, open feel of the area. For example, Keith McNally, owner of Pastis, said that although he was drawn to the area because he once worked as a porter in London's meatpacking district, it was the fear of tall, new buildings that motivated him now, not the loss of meatpacking: "One of the best things again about the neighborhood is not the buildings, it's the vast amount of sky. I would hate to see a high-rise in the neighborhood. At the same time I hate the idea that I come into a neighborhood and prevent other people from coming in. I don't think it's about making it a petrified forest or something. I just would like to see some degree of preservation" (Dewan 2001).

Jo Hamilton likewise said she was not against some change, but wanted to stop the area becoming a version of the affluent, bland, primarily residential and commercial Upper East Side. Like McNally, she wanted to prevent tall buildings, but she also wanted to preserve some of the character-giving meatpacking industry, which she believed meant keeping out residents, since they would inevitably push to get rid of the smelly meatpackers. Of the Save Gansevoort Market movement she said: "[It's] not to stop gentrification. It's to preserve the unique character of the place. It's about 'does this become a generic neighborhood like 1st and 2nd Avenue on the Upper East Side, or not?'" She described Morellet's and her strategy: "We realized that in New York there are only two ways to control land use. First, there is landmarking, with which you can control the look of a building by preserving all the exteriors in their current state. Second, there is zoning, which controls land use and building height."

They moved energetically to use both tools—landmarking and zoning—to slow change. On the landmarking front, they pushed for the area to become a historic district to freeze the existing buildings at their current, mostly low, height and appearance. New York City's landmarks commissioner "serves at the pleasure of" (i.e., is appointed, and can be removed any time, by) the mayor, and is therefore likely to reflect the mayor's attitudes toward landmarking. Mayor Giuliani especially disliked Far West Side preservationists because they objected to a stadium for the Yankees in the Hudson Yards just to the north. So in addition to opposing the High Line restoration, he opposed a Gansevoort Market Historic District, and Morellet and Hamilton lost their first try in 1999.

Preparing their first, and unsuccessful, landmarking attempt, Morellet and Hamilton formed the Save Gansevoort Market group, and enlisted the help of the Greenwich Village Society for Historic Preservation. Then in 1999 they persuaded Giuliani's landmarks commissioner Jennifer Raab to tour the Meat Market. Her initial reaction was cool: "I don't get it," she said, "but if you want to make an argument for it, then OK." After the tour, Raab became negative. As she told Hamilton: "I couldn't see that

meat hooks had historic value." Morellet and Hamilton concluded that, as far as Raab was concerned, landmarking the Meat Market would happen only "over her dead body."

Hamilton and Morellet also concluded that their first attempt would have gone better closer to an election rather than in the middle of Giuliani's final term. They learned this partly from seeing how two years later advocates for the High Line preservation got the support of every mayoral candidate in the months before the 2001 election including Bloomberg. Hamilton commented: "My advice is that if you're going to try to get something done, do it in an election year."

Hotel Gansevoort to the Rescue

In July 2002 a developer proposed Hotel Gansevoort, a thirteen-story glass and steel building, for an empty, irregular-shaped parking lot between 13th and Gansevoort Streets, near the market center (fig. 4.6). A hotel could be built there, given the manufacturing zoning, so the only way to legally stop it was to create a historic district, after which any new building would have to be approved by the Landmarks Commission. But it was too late—the Hotel Gansevoort was approved by the city before Jo Hamilton and Florent Morellet's second, successful attempt at landmarking.

Hotel Gansevoort enormously helped advocates of the Gansevoort Market Historic District, since it vividly showed how easily a tall, modern, out-of-character building could be put up if the area were not landmarked. The finished hotel officially opened on March 12, 2004, with an art show. The glass and steel structure was lit from the outside with what the architects believed was stylish blue lighting.

For advocates of the historic district, by contrast, the hotel's "garish" look vindicated their views and was a sad reminder of what they might have stopped had they landmarked the area a year earlier. Jo Hamilton commented: "Many people hated the idea of the Hotel Gansevoort. It helped to convince the Landmarks Commission. [What's wrong with it?] The materials are wrong. Everything else here is masonry and iron. This isn't. And the balconies don't fit. And the setbacks are wrong."

The hotel, meanwhile, thrived, marketing its presence in the "chic" Meatpacking District (it changed its name to Gansevoort Meatpacking NYC), and stressing its "classic landscape" vistas. In 2013 its website proclaimed: "Touting breathtaking 360-degree panoramic views of New York City and sunsets over the Hudson River, Gansevoort Meatpacking NYC is the first luxury, full service resort in Manhattan's vibrant and historic Meatpacking District. Offering a chic retreat from the urban metropolis that surrounds our property."

Fig. 4.6. The architecturally controversial Hotel Gansevoort opened in 2004. The American Institute of Architects called it "beautifully designed" (in 2010). Preservationists thought it "garish" and "out of place." Photo by Malcolm Halle.

In March 2010 the Gansevoort was one of three hotels featured at an American Institute of Architects (New York chapter) panel discussion called "Cool Hotels," all of which the panel praised as "well-branded and beautifully designed." Michael Achenbaum, the Gansevoort's developer, explained that in planning the hotel the architect had advised: "'Do something that stands out. If you build a contextual building and it fails it is a blatant failure.' So we chose to stand out." Another part of "standing out" involved building a pool on the hotel roof. Achenbaum explained: "I said the pool would give us great free press." The rooftop pool became a signature of what the developers now pushed as a "Gansevoort brand" of hotels, featuring a larger version built later in Miami Beach.

By 2010 the Miami Beach Gansevoort was almost bankrupt, sinking under the weight of condominium projects with which it had been twinned. Still, the original version in New York's Meatpacking District flourished. Even some of the ardent preservationists became more accepting of the architecture, though squabbles with the hotel over its billboard policy continued to sour the relationship.

OPPOSING NEW AND PRESERVING OLD BUILDINGS: THE BARD ACT OF 1956 AND NEW YORK CITY'S LANDMARKS PRESERVATION COMMISSION OF 1965

The Hotel Gansevoort, and the defeated Jean Nouvel condominium tower, described later, underline an important, but rarely acknowledged, point about the preservation movement in New York, and likely elsewhere. It is, and has been, often motivated as much by a dislike of new, modern build- ✗ ings as by a desire to preserve old ones, as Tony Wood's (2008) study shows.

For example, the history of New York City's Landmarks Preservation Commission is usually seen as driven by struggles to preserve old build- ings from development, especially the two magnificent train stations, Grand Central and Pennsylvania Station. It is true that the 1963 demolition of Penn Station provided the decisive impetus for New York City's 1965 Landmarks Preservation Law that established the commission empow- ered to landmark old buildings. By 1975, the commission had designated 447 landmarks and 26 historic districts, bringing more than 10,000 build- ings under its control.

But New York's City Council had legal authority to pass its landmarks law only because of a long history of lobbying for such legislation. That history makes it clear that opposition to new buildings—seen as, for ex- ample, unsightly, too modern, and garish —was at least as powerful a dy- namic as the desire to preserve old ones. Crucial here was the Bard Act, passed by the New York State legislature on April 2, 1956, which gave lo- calities across New York State the authority to enact local laws to protect their landmarks. Without it, the New York City Council lacked the legal au- thority to pass the city's own legislation establishing the City Landmarks Commission.

Bard, the author of the Bard Act, had been in 1913 the secretary of a commission set up by New York's mayor to study the problem of obtru- sive billboard advertising. The commission concluded that, much as they would like, they couldn't regulate billboards until the city had the general power to regulate somehow the aesthetic look of buildings, new and old. Eventually in 1954 Bard drafted what became the Bard Act, passed in 1956 by New York State in response to a major threat to Grand Central Station, giving the city general authorization to pass such regulatory legisla- tion. The bill amended the city's general law by inserting the following section:

To provide—for places, buildings, structures, works of art, and other ob- jects having a special character or special historical or aesthetic interest

or value—special conditions or regulations for their protection, enhancement, perpetuation or use, which may include appropriate and reasonable control of the use or appearance of a neighboring private property within public view, or both. In any such instance such measures, if adopted in the exercise of the police power, shall be reasonable and appropriate to the purpose, or if constituting a taking of private property shall provide for due compensation, which may include the limitation or remission of taxes. (Wood 2008, 141)

The section's provision that protective measures should be "reasonable and appropriate" clearly left enormous room for debate, opening the way for the emergence, described below, of a split between "liberal" and "fundamentalist" preservationists.

In addition to the Bard Act, at least two New York City neighborhoods, Greenwich Village and Brooklyn Heights, played a key role in the background to New York City's landmarks legislation. From the early 1900s a number of residents of Greenwich Village were concerned that older buildings were being knocked down to make way for tall apartment buildings which they disliked intensely. The Greenwich Village Society for Historical Preservation was founded in 1922 in part to try to stop this process. Later, opposition to Robert Moses's plans to widen the road through Washington Square Park was galvanizing, culminating in the movement led by Jane Jacobs which succeeded in closing the park entirely to traffic in 1958.

The preservation movement in Brooklyn Heights was also key. It was a reaction in part against Robert Moses's plans for a highway, in part against Jehovah's Witnesses, who moved their headquarters there in 1909 and put up numerous large buildings, and in part against plans for apartment buildings (Wood 2008; *Real Deal* 2010b).[2] Many Brooklyn Heights preservationists were newcomers to the area and were interested in a measure like the Bard Act that they hoped could be used to save the district from major change—especially the building of newer, large buildings.

Mindful of this history, at a conference in 2005 to mark the fortieth anniversary of the establishment of the Landmarks Commission, architecture critic Paul Goldberger commented: "The deep secret of preservation is how much is done not so much out of love of what you are preserving but out of fear of what will be coming." Likewise, the movement to create the Gansevoort Historic District was driven as much by opposition to proposed new, modern buildings as by a love of the old ones, as the cases of the Hotel Gansevoort and the Jean Nouvel condo tower described below make clear.

DEFEATING THE JEAN NOUVEL CONDO TOWER: KEEPING OUT RESIDENTS

After losing their first attempt at a historic district, Morellet and Hamilton used the second tool—zoning—to continue their efforts to preserve the "character of the area," as they saw it. They opposed new, tall, modern buildings. They were especially against residential projects, particularly condominiums, believing that if permanent residents moved in, particularly wealthy ones with political connections, they would try to get rid of the remaining meatpackers because of the smell and noise. This was a land use issue which zoning could help control (i.e., by stopping attempts to rezone manufacturing areas as residential), whereas landmarking could only control a building or area's look, not its uses.

Their biggest fight was over a 2002 proposal to build what opponents dubbed "the Jean Nouvel tower," named after the French architect whom the developer had hired to design a slender, thirty-one-story, 450-foot-high condominium containing loft-style units selling for $2 million to $4 million each. Nouvel's acclaimed buildings in Paris included L'Institut du Monde Arabe and the Fondation Cartier. His New York tower was planned for 848 Washington Street, near Little West 12th Street, adjoining the High Line and just outside the area that eventually became the Gansevoort Historic District.

Nouvel and the developer argued that they had tried to fit in with the architecture of the Meat Market by proposing a corrugated steel structure for the tower (i.e., an "industrial" look). This was the same argument the New Museum on the Lower East Side later used to justify its out-of-scale building. But the preservationists were unimpressed, and could use zoning to stop the Nouvel tower because the developer was not proposing a hotel, which would be buildable as of right in this area zoned manufacturing (M), but a residential condominium, which he saw as a better financial proposition than a hotel. So the developer needed to apply to the Board of Standards and Appeals, the body that grants zoning variances. This gave the preservationists a chance to lobby the BSA, which they did successfully.

Andrew Berman, executive director of the Greenwich Village Society for Historic Preservation, opposed the tower, in characteristically apocalyptic terms:

> The neighborhood as we know it will cease to exist. You will have people who have paid millions of dollars for their homes who will not want to be woken up at 5 o'clock in the morning by the clanging of meat trucks

making deliveries or walk through "the blood and guts" from the meat businesses on their sidewalks. They will demand that the neighborhood be cleaned up. (Kinetz 2002)

The developer, naturally, insisted this would not happen. "The buyers we will be catering to will be very savvy," he said. "They are going to know what they are getting into."

Jo Hamilton recounted the fight: "We showed up at the first BSA hearing in December 2002, with two hundred people. We said it was a twenty-four-hour neighborhood, and if you put residential there you'll have fights." Foreseeing a negative BSA vote, the developer withdrew his proposal just before the final BSA meeting on the issue.[3]

Several years later in 2010 a version of the Nouvel tower appeared next to the High Line a few blocks north of its originally proposed site in the Gansevoort Market, made possible by the West Chelsea Rezoning deal with the Chelsea Property Owners.

SUCCESSFULLY LANDMARKING THE MEAT MARKET AND THE CITY'S OVERALL PLAN FOR THE FAR WEST SIDE

Bloomberg, elected in 2001, was clearly more open to preservation than his predecessor Giuliani, as evidenced by his support for the High Line during the approval struggle that succeeded in 2005. In 2003 he appointed Robert Tierney as landmarks commissioner. Tierney lived near the Market District, as did Amanda Burden, head of City Planning. Hamilton believed that crucial too in gaining Tierney's support was that Daniel Doctoroff, Bloomberg's newly appointed deputy mayor for economic development, now saw a package. The High Line would link to the north to Doctoroff's cherished, proposed New York Sports and Convention Center and to the south to a Gansevoort Market Historic District.

Morellet and Hamilton decided the time was right to propose again landmarking the Gansevoort District. The Landmarks Commission held its public hearing on the proposal to create the Gansevoort Market Historic District on March 18, 2003.

Morellet and Hamilton revamped the case for landmarking to meet the criticism—hard to deny—that the existing buildings were undistinguished and scarcely worth preserving. They now stressed that the buildings together depicted a particular place. As Hamilton said: "We were going against the tide. Our baby was ugly! Still, even if each building wasn't special, we tried to make the case that the buildings tell a story, create an overall sense of place." Likewise Jay Ship, an architectural historian, testified at the public hearing that "the district is distinctive for its

geographic layout, [and its] historically mixed and varied land use [shows an 1870 map]. The area contains both 1811 grid and earlier non-grid development, has unique open spaces. Visual cohesion is given by brick and Belgian blocks and metal awnings." Ship then talked in great detail about the history of specific buildings, mostly avoiding the question of their architectural merit.

Most of the others who spoke in favor echoed the "distinct sense of place" argument. All the local politicians voiced support (including City Council member Christine Quinn, US congressman Jerrold Nadler, and Manhattan Borough president C. Virginia Fields), followed by a host of preservationist societies. The influential New York Chapter of the American Institute of Architects, a group that often opposes strict preservationist efforts, also spoke in favor.

Those who opposed landmarking stressed that the individual buildings were unremarkable, even ugly; that the area designated was incoherent; and that the Landmarks Law did not permit landmarking an area because of its "sense of place."

Vociferous opponents were the Meilman family, who hoped, now that commercial galleries and designer stores were improving the tone of the Meat Market area, not only to continue raising rents in the six buildings they owned there, but to replace them with new, taller ones. The Meilmans also complained that, during the twelve years since the family had quit the meat business, they had resisted lucrative offers from sex-related businesses and waited for more socially responsible commercial tenants such as art galleries. Now, they said, they were being penalized for responsible behavior. "What the Landmarks ruling does is freeze any potential development. Currently, we are 40 percent underbuilt," said Clifford Meilman, the manager of Meilman Properties. Landmarking would prevent them from developing their two- and three-story buildings to the properties' maximum allowable floor area ratio (FAR) of 5, which could allow buildings of about seven stories. He continued: "Fourteenth Street is a major thoroughfare with subways and buses—it's prime for better use. Now it has basically been frozen. Architecturally and stylistically, this doesn't make any sense."

Later, at the City Council hearing in December 2003, the final stage of the proposal to designate the Gansevoort Market Historic District, the Meilmans' lawyer, in desperation, said a "prominent architect" had characterized the existing buildings in the area as "garbage." City Councilwoman Quinn bristled at the remark. "I find it offensive that any part of my district is called garbage," she said.

The Real Estate Board of New York also opposed landmarking, arguing at the Landmarks Commission hearing that the district had no unified

architectural style. Board member Steven Spinola said: "In terms of distinct buildings, the lofts and warehouses here are not significantly different in type or quality than any others around the city. . . . The meatpacking buildings . . . do not have a special character or interest. . . . Most have very little original fabric from the time period in which they were built. It is unclear why they must be preserved." He added that, although advocates of landmarking were motivated as much by desire to keep out new, tall buildings as to preserve old ones, the Landmarks Commission was not allowed to act on such considerations, which were the province of City Planning.

> Proponents of this historic district oppose various new residential buildings and hotel developments on the basis of height and use and cite the threat of development pressures. They also emphasize maintaining the mix of uses of meat market and studios, galleries, retail spaces, clubs and restaurants. None of these concerns are relevant to a proposed historic district. . . . Bulk of buildings and appropriate land uses are the purview of the City Planning Commission, not the Landmarks Preservation Commission.[4]

The debate raged in the neighborhood too. "It's vital to the future of this neighborhood that it stays commercial and the meatpackers remain," Michelle Dell, the owner of the iconic Hogs and Heifers Saloon at 859 Washington Street, said. "How many Gaps do you need in New York? They price everyone else out of the neighborhood. How can anyone else compete?" A local real estate agent countered: "This city is always changing, and the meatpackers' days are numbered. They'll have to go someplace else. They don't need to be sitting on prime real estate" (Sherman 2003).

Anyway, this time the movement sailed through the Landmarks Commission, who approved it in September 2003, as did the City Council in December. The new Landmarks commissioner, Tierney, was especially proud of this as one of his first major decisions.

The case for a historic district to freeze existing buildings at their current height and exterior look was clearly strong, given the spate of modern, tall hotels built or under construction for the Meat Market. Although construction on the Hotel Gansevoort had barely started by September 2003, the approved plans for a structure explicitly designed to stand out from the existing buildings were galvanizing.

THE CITY'S OVERALL PLAN FOR THE FAR WEST SIDE: A MIX OF PRESERVATION AND GROWTH

It was crucial that city officials had come up with an overall plan for the Far West Side of Manhattan that included a range of projects from

preservation to megagrowth. At one end were preservation-type projects such as the Gansevoort Market, followed by the High Line, which had now morphed into a hybrid preservation-development project. In the middle of the preservation-growth spectrum was the commercial art gallery district, whose core the city had decided to protect by keeping it zoned for manufacturing when designing the West Chelsea Rezoning. The intention was that the galleries, the vast majority of whom rented, would not be swallowed as their landlords switched to the far more profitable land use of condominiums. At the other extreme were megaprojects (e.g., the World Trade Center rebuilding, the Hudson Yards project, and Penn/Moynihan Station) that allowed the kind of growth in jobs and New York's tax base that officials felt the economy of the city required, as well as providing plenty of opportunities for developers and, albeit only after developers and city officials were pushed by neighborhood activists to provide it, some "inclusionary affordable housing" financed by the developers.

The city's overall plan was clear in Mayor Bloomberg and Landmarks chair Robert Tierney's joint news release on September 9, 2003, announcing the Landmarks Commission's decision to create the Gansevoort Market Historic District:

> We are very excited by the critical role that the Gansevoort Market Historic District, with its unique sense of place and historic importance, will play in the development of the Far West Side. This is just the first of several key projects, including the restoration of the High Line, the construction of the Hudson River Park, and the development of the Hudson Yards, that form the core of the Administration's plans for the Far West Side. When completed, these projects will revitalize the West Side of Manhattan, forming a necklace of dynamic waterfront communities, each with its own unique assets.

The Bloomberg administration also clearly believed that its support for preservation projects would, or should, mollify preservationists critical of its more prodevelopment projects. By April 2013, the administration had created forty-one historic districts (with nine additional ones proposed), far more than any of its predecessors, who in order of districts created were Koch (27), Lindsay (23), Giuliani (18), Dinkins (10), Beame (7) and Wagner (1). Many of the historic districts created by the Bloomberg administration flowed from its belief, first exemplified in the Gansevoort District, that such districts offset and balanced the administration's development projects and orientation (Kusisto 2013).

NIGHTLIFE: "THE MONSTER IN THE MARKET"

By mid-2004, the Meat Market had enormous buzz and cachet. It had been landmarked; the Hotel Gansevoort had just opened bringing large numbers of tourists, soon followed by a boutique hotel, SoHo House, located in a now landmarked former warehouse building; and the High Line proposal had gained much traction, though not yet complete approval. Above all, nightclub and restaurant life was thriving. An article by Jesse McKinley (2004) in the *New York Times*'s Style section captured the scene. Already home to a gaggle of trendy nightspots, the meatpacking district

> continues to be flooded by restaurants, scene-y hotels and roped-off lounges and the clientele that loves them. . . . The neighborhood's developers have unwittingly built the Epcot Center of alcoholic fun, with everything from ersatz France (Pastis) and ersatz Goa (Spice Market) to ersatz Miami (the Hotel Gansevoort, the Maritime Hotel) and ersatz London (SoHo House). You have exactly what it feels like on any given night in the meatpacking district: a mobbed, boozy and tragically hip theme park.

Several preservationists and others now decided that one part of the ecology of the Meat Market, the nightclubs and restaurant scene, was growing out of control, while the manufacturing scene, basically meatpacking, was weak, possibly terminal. Reflecting alarm over the nightlife sector's strength, the local paper, the *Villager*, wrote an editorial titled "The Monster in the Market" (July 14, 2004):

> Over the past several years as the community fought to both landmark the Meat Market and preserve the integrity of the area's zoning, it was often repeated how the area has a unique ecosystem. During the day, galleries and boutiques flourish. At night, bars, clubs and restaurants come to life. As if on cue, as the last of the nightlife shuts down at 4 a.m., trucks roll in to the meatpackers' businesses. No one gets in anyone else's way and everything functions smoothly, so the theory goes.
>
> The district was landmarked and so far residential encroachment has been kept at bay in the defeat of a plan to build a 32-story tower on Washington Street [the Nouvel tower]. Landmarking and preserving the area's manufacturing zoning were seen as ways to keep out big residential development—specifically towers—while helping the meatpackers maintain a foothold in a dwindling wholesale market and allowing nightclubs to exist without annoying residents.
>
> But now it's become clear that nightlife is taking over the Market. Ninth Ave is now a bustling club scene with a phosphorescent hotel [The Gansevoort] as its soaring centerpiece. . . . Some residents now fear that,

in their effort to block residential development, by allowing the Market to become a free-for-all party zone that they have created a monster—a bar monster.

Two major proposals to correct the slide toward nightlife emerged. First, the *Villager* and others, in a sharp reversal, began to argue that some condominiums should be allowed, since condo residents were the only group likely to tame the night scene. But it was too late for that. As a historic district the area could not have new, tall condominiums, which were instead being built further north in the area carved out by the West Chelsea Rezoning. So restraining the nightlife was left to residents of the townhouses, many of which were located to the south of, and therefore outside, the Historic District.

"CULTURE" OVER "GRIT": THE WHITNEY ARRIVES; FUNDAMENTALIST VERSUS MODERATE PRESERVATIONISTS

The second corrective proposal, Jo Hamilton's, was to bring in the Flower Market in order to bolster the "manufacturing" presence of the dying meat marketers. The Flower Market was a concentration of over twenty stores selling wholesale flowers about fifteen blocks further north. Located along 6th Avenue in and around 28th Street, it was struggling as rents rose there, especially because of zoning changes that permitted condominiums. Hamilton proposed that the city relocate the Flower Market to a city-owned space next to what would be the southern entrance to the High Line when it opened.

This plan foundered because the city preferred a major cultural organization, the Dia Foundation, for the site. Although Dia's move to Chelsea in 1987 had paved the way for the massive movement of art galleries there, it had grown unhappy with its space on West 22nd, which it considered too small and outdated. Dia's attendance had grown from 16,000 visitors a year in 1987 to 60,000 in 2004.

So in May 2005, Dia duly announced plans to move to the city-owned site next to the High Line entrance at Gansevoort Street. The plans called for possibly demolishing the existing structure, an old meatpacking facility now in disrepair, and building a simple two-story museum with 45,000 square feet of gallery space on two floors. Kate Levin, the city's cultural affairs commissioner, said: "It's a bet on the future. Dia has been a visionary not just in creating museums, but in creating neighborhoods. Having the museum at the entrance to the High Line is a wonderful way to help preserve the character of that community." Still, by October 2006,

the Dia plan had fallen through, due to internal bickering on the Dia board, and Dia focused on a brand-new suburban space it had opened in 2003 north of New York City in Beacon.

Within a month, the Whitney Museum of American Art announced plans to open a branch next to the High Line, in place of the Dia project. Preservationists had repeatedly stopped the Whitney from expanding its home site in the Upper East Side Historic District on Madison Avenue between 74th and 75th Streets. There the Whitney had proposed enlarging the entrance of its Modernist building, with a new and modern entrance designed by the distinguished architect Renzo Piano. But because that expansion would have entailed the destruction of two brownstones that preservationists wanted to save, the Landmarks Commission had blocked the proposal, insisting on a compromise that kept one of the brownstones.

The Whitney's troubles in its Upper East Side home base reflected the fact that the preservation movement had long split into two wings. There was the original "liberal" or "moderate" wing that was dominant when New York City's Landmarks Law was passed in 1965. This wing expected, and was willing to see, some changes in older, landmarked buildings, and also expected that new, modern buildings might appear in neighborhoods located in historic districts. For example, they anticipated that in a vacant lot located in a historic district, a new and tall building could be built that reflected contemporary architecture, on the grounds that some of the best buildings in the historic district had themselves been architectural pioneers in their day and now constituted one reason the historic district was worth designating. The attitude of many (though not all) supporters of the Save Gansevoort Market group fell into this moderate wing, as did Rem Koolhaas's exhortation that the "preserved" not be "embalmed but continue to stay alive and evolve."[5]

There was, by contrast, a "fundamentalist" wing that was basically opposed to any change. The provision inserted in the city law by the Bard Act that landmarking/preservation measures should be "reasonable and appropriate" was vague enough to allow the existence of both "liberal" and "fundamentalist" preservationists.

Nicholas Ouroussoff (2005) blasted the fundamentalists over their unwillingness to allow the Whitney's Upper East Side expansion, and the Landmarks Commission for accommodating the fundamentalists:

> Essentially, for the sake of preserving a humdrum brownstone façade on Madison Avenue, the [Landmarks] commission embraced a substitute design for the museum that transforms a generously proportioned public entrance into a more confining experience. . . . Aside from weakening a promising design, the commission's stubbornness proves that it is unable

to distinguish between preserving the city's architectural legacy and embalming it. . . . Evidently, our preservation policy now favors simplistic rules over thoughtful debate on the city's architectural heritage.

The commission's function is to determine when exceptions should be made—for the benefit of the city's cultural well-being. Its charge is to establish the correct balance between preserving history and allowing architects to flourish here.

A cynic might argue that the commission's vote was pure politics. Preserving the brownstone skirts a confrontation with powerful Upper East Siders.

By July 2010 the Whitney officially committed to building its extension next to the High Line, and a year later decided to move its entire museum there, abandoning the Upper East Side. The Whitney would buy the building next to the High Line from the city's Economic Development Corporation, as well as another abandoned shell structure next door. The city would charge the Whitney roughly half the appraised value of the two buildings.

With 100,000 to 150,000 square feet of gallery space, the new museum would be at least twice the size of the Whitney's home on Madison Avenue at 75th Street, and would be finished within five years (fig. i.2).[6] "This is a return to our roots," said Whitney director Adam Weinberg in 2006. "I believe the High Line will become the greatest park in New York City and we're fortunate to be the anchor at the base." He added that the museum personnel "like the character and the grittiness of the neighborhood" (Amateau 2006).

Meanwhile Dia, now anxious to return to the vibrant Chelsea art scene, in 2011 bought the former Alcamo Marble Building at 541 West 22nd, and in 2013 began a fund-raising campaign to build a new space there. Still, the financial costs of arriving so late were daunting. The board tried to raise $20 million through a November 2013 Sotheby's auction of artworks it owned, which outraged two of Dia's founders, including Heiner Friedrich, who filed a suit, quickly dropped, to stop the auction (Kennedy 2013).

HIGH TECH, "FASHION CENTRAL," DEMISE OF THE MEAT MARKET GALLERIES, AND "SUPERCOMMERCIAL GENTRIFICATION"

Around 2006 an Apple computer store moved into the space where the supermarket Western Beef used to be and turned the building into a 32,000-square-foot shining glass temple to its products. Western Beef retreated to a more modest location a few blocks north, next to public

housing. Apple's high-tech presence complemented the new presence of Google's East Coast headquarters, now located two blocks to the north just outside the Gansevoort Historic District. Apple's arrival triggered a major rent increase on the street, with Apple reputed to be paying somewhere between $275 and $370 per square foot per year by 2008 (compared with the $18 per square foot paid by Jeffrey in 2000), an eye-popping yearly rent of roughly $9 million–$12 million for the building. In the eight years after 2000, commercial rents on 14th Street had risen almost 2,000 percent. By 2013 average commercial rents in the main sections of the Gansevoort District were roughly $380 per square foot per year (the Hugo Boss clothing boutique was paying $550 for a prime location next to Apple), although that still left the average rent lower than SoHo's $500 (fig. 1.10).

The Gansevoort Market's success as a fashion center and then as a burgeoning high-tech area sealed the fate of the small group of commercial art galleries that had opened from 1997 to 2002 on 14th Street hoping to start an offshoot of Chelsea's larger gallery district further north. Their landlord, the Meilmans, having more than succeeded in helping move the street upscale (planned commercial gentrification), evicted them in favor of expensive clothing stores paying much higher rents. This whole process was, in miniature, a version of what had happened to galleries in SoHo much earlier. Then at the end of 2011 the Meilmans quadrupled Stella McCartney's rent as her ten-year lease expired. Refusing to pay the new rent of $400 a square foot, McCartney moved into a smaller space in an out-of-the-mainstream side street in SoHo (Greene Street), paying $240 a square foot, or $600,000 a year (Traster 2011). This was a harbinger of the movement, well underway by 2013, for chain fashion stores such as Levi Strauss to replace the individual designer stores.

By 2009 the Heller Gallery was the sole gallery survivor in this section of the Meat Market. In 1998 Heller had moved in (occupying 7,000 square feet on a ground floor plus basement), although luckily across the street from the Meilman building and renting from a different landlord. Michael Heller recounted the brief rise and fall of this 14th Street gallery section, and how his gallery survived because of a benevolent landlord and because they refused to sign the short lease that the other galleries signed.

> We moved here from SoHo in 1998 when this was still the Meatpacking District. Our SoHo landlord bought out our lease then in order to rent to the British designer Vivienne Westwood at $200–350 a square foot [per year]. The Meat District in 1998 seemed like it would be the southern end of the Chelsea art gallery district. That was a cruel trick!
>
> There was a brief period when five or six galleries were on this block, in the building right across the street. In 1998–99 the Meilmans were trying

to use galleries to promote the neighborhood. Then Jeffrey opened next door and the Meilmans discovered they could get four to five times as much rent from fashion retail. So they raised the rents that much, using a thirty-day vacate clause in the leases, and rented to Stella McCartney and Alexander McQueen and the others.

We're OK because we have a fifteen-year lease, and anyway our landlord likes us. He's an architect and wanted a gallery here in the building so it would look nice. We've been in business a long time and would never have moved here without a long lease.

It's become "fashion central" here, full of designers, very trendy. What really raised rents was when the Apple store opened. Apple wanted to be here too because it was hip and trendy. Apple increased the neighborhood's profile in a different way from the art galleries. Rents here have increased by tenfold since then.

It's funny. The locals told us that when they saw us arrive in 1998, they thought the neighborhood was all over. And now we are the white knight, the last salvation!

Still, when Heller's lease was up in 2013 the landlord sought a rent 400 percent higher than the rent Heller had paid fifteen years earlier, and got it from a chain sports clothing store. So the Heller Gallery, victim again of supercommercial gentrification as it had been in SoHo in the late 1990s, moved to 28th Street and 10th Avenue a few blocks to the south of the now burgeoning Hudson Yards, as several galleries were now doing. Heller's bet this time was that the Hudson Yards would be a hospitable environment for a gallery, yet without rents rising to unaffordable levels.

MORELLET BOMBSHELL

In early 2008, at the peak of the development frenzy surrounding the entire area, Florent Morellet dropped a bombshell. He was about to lose his restaurant lease, which expired at the end of March. The rent for the two-story building had been $72,000 per year. Although he had told his landlady he would pay triple this, she was discussing selling the building to a developer who said he could rent it for $520,000 a year, way beyond what Morellet could pay. Morellet's relationship with the owner soured and the dispute became public. Recalling that he had first signed a lease with the landlady's grandfather, he complained: "Real estate owners would consider me a good tenant. I take care of the building. She's [the landlady] not here, she lives in Massachusetts. I've been paying rent, sometimes early when she asked for it, to the same family for 23 years" (Amateau 2008).

Morellet retaliated by accusing his landlady of having neglected to file

for a *tax certiorari* that would have significantly reduced the property tax he had been paying for many years. He also claimed he had been paying all the real estate tax, instead of two-thirds as called for in the lease. So he stopped paying rent on September 1, 2007. "It was the only way that I could collect," he explained. In November, the landlord brought an eviction suit for nonpayment of rent, and Morellet filed a countersuit for the real estate tax claim.

The dispute garnered enormous media attention, probably because it dramatized a general perception that the area, like so much of Manhattan, had become unaffordable to all but the very wealthy (businesses, as here, or wealthy residents, as in other areas). Still, amid much public hand-wringing and nostalgic regret, Morellet's restaurant closed in May 2008, a victim of commercial gentrification, and Morellet started a new career as an artist. Three years later a movie, *Florent: Queen of the Meat Market*, by David Segal, depicted the era.

GOOGLE TO "SILICON ALLEY"

In December 2010 Google purchased the 1932 megabuilding in which it had its East Coast headquarters, at 111 8th Avenue, between 15th and 16th Streets. This building, used largely as a storage facility until 1997, contained 2.9 million square feet. Each floor was five acres, allowing all Google's employees to work on a single floor and facilitating the "creative interaction" Google prized. The purchase, for which Google paid $1.9 billion, signaled that Google now had deep roots there.

Google's move seemed consistent with the ideas of theorists like Richard Florida that "urban culture," defined broadly, is a major attraction for creative employees. Florida has argued that "place is the key economic and social organizing unit of our time," and that creative people, who then foster economic growth, are attracted to places that are diverse, tolerant, and full of culture (Florida 2002, 2011). His theories have generated much interesting debate and criticism.[7] In any case, in line with Florida's views, Google clearly felt the trendy and creative Far West Side, with attractions like the High Line, Gansevoort Market, and Fashion Central, was where its employees would like working.

Google's purchase also continued the process of "supercommercial gentrification" in and around the Gansevoort Market area. By 2011 Google, which already occupied 22 percent of the building's 2.9 million square feet, was seeking more space for itself there, and so not renewing the leases of older companies in the building. The leasing agent for the nearby Chelsea Market commented on the buzz from Google: "I have heard from a number of companies; they want to be 'in the shadow of Google'" (Kusisto 2011).

Google's move also boded well for the city's employment prospects in the information technology sector, where jobs had grown by 6 percent between November 2009 and 2010, contrasting with just 1.6 percent growth in the city's overall private sector in the same period (Rubinstein 2010; Vatner 2011). There was now a developing technology corridor that ran from the Far West Side and Chelsea (e.g., the IAC corporation in the Frank Gehry building, Google, and Apple) eastward to "Silicon Alley" in the Flatiron district around 5th Avenue, where lofts offered many smaller spaces suitable for start-up companies. Then in 2011 the city extended the band eastward, announcing it had selected Cornell University and the Technion-Israel Institute of Technology to build a two-million-square-foot applied science and engineering campus on city-donated land on Roosevelt Island in the East River. The city pronounced this as an emerging New York high-technology "ecosystem" that, in partnership with local universities, it expected would challenge Boston's and even San Francisco's Silicon Valley.[8]

NIGHTLIFE UNFETTERED

Meanwhile nightclub life in and around the Gansevoort Market flourished with few restraints. A slew of iconic clubs and bars such as Provocateur, Cielo, Plunge at the Gansevoort Hotel, Tenjune, and Kiss & Fly established this as New York's epicenter for lavish, nighttime opulence. Marquee, just a few blocks to the north between 26th and 27th Streets, was the topic for a *Harvard Business Review* case study of eye-popping nightclub spending that documented how "bottle service" customers (a privileged subgroup who were seated) spent an average of $7,500 per table in 2004 (Elberse 2009; 2013). By 2013 Gansevoort Market "whales" (another name for an elite subgroup of nightclubgoers, often international jet-setters, who received special service) spent from $5,000 to $200,000 on a night's drinking. Sociologist Ashley Mears argued that while the "potlatch"—the deliberate destruction of wealth by rich people in simple societies as a symbol of status—is rare in modern societies, it flourishes in the niche of these clubs and in particular in the "bottle train" and "bottle war" phenomenon, as she describes it:

> Each significant bottle purchase . . . is visually celebrated in the club with live sparkler fireworks affixed to the bottle's neck, held high by a stream of visually striking young women; at some clubs a DJ may interrupt the music to announce a big purchase; at one club the purchase of a large bottle was delivered by a club manager wearing a gladiator costume, and carried to the client's table by a bus-boy drawn chariot, announced with sparklers and super-hero themed music and cheered loudly by the crowd.

The purchase by one table may encourage a larger purchase at an opposite table, marked by a bigger visual triumph. This can ratchet up into a bottle war, a ritualized potlatch in which bottles become idioms of rivalry.

It is often too much alcohol for revelers to consume, so they destroy it in other ways, like "champagne showers," where bottles are shaken and sprayed onto the crowd, leading to champagne puddles and "rivers" flowing through the club floor, thus also destroying designer shoes and clothes, and prompting girls to stand even higher up on available chairs. (Mears 2013)

Many residents living near the Gansevoort Market and outside the section zoned for manufacturing that contained the nightlife were extremely unhappy. They complained about a cacophony of loud music, automobile horns, and raucous street behavior that dominated evenings from Thursday through Sunday up to 4 a.m. and spilled well over into the residential sections as, for example, limousine drivers painfully honked their way through the narrow streets to collect clients who expected to be picked up outside the club they were attending. Jo Hamilton commented: "You don't want to be there at night. The neighbors are going crazy."

Hamilton had tried, and was continuing to try, a number of measures to control the situation. These included successfully getting the New York City Department of Transportation to designate the area as a "Neighborhood Plaza," as a result of which some of the street space formerly available for traffic was converted to pedestrian space that included tables and chairs (although this worsened the bottleneck of honking cars at night). A second measure was to pressure Community Board 2, which reviews liquor licenses, to recommend that some licenses forbid the sale of liquor after 2 a.m. (most allow it to be sold until 4 a.m.).

Another issue was the Meat Packing Improvement Association (MPIA), a private association dominated by local clubs and hotels and related businesses that, by arrangement with the Department of Transportation, paid to clean and maintain the Neighborhood Plaza. The MPIA had no requirements to include community representation or transparency, unlike a Business Improvement District (BID), and was free to organize events in the plaza that promoted the businesses there, which further annoyed some residents. By early 2014 the MPIA and the Chelsea Improvement Company (which provided voluntary services for the area up to 17th Street), daunted at the task of raising voluntary contributions to fund the area's burgeoning need for services, were proposing a Business Improvement District that would have legal powers to tax local commercial property owners, to raise from $1.6 to $3.2 million a year. At public meetings to discuss the proposal, local residents expressed concern that a BID funded partly by

nightclub owners was unlikely to address the problems of out-of-control night life.

By late 2013 Hamilton's considered view was that while the effort to create the Gansevoort Market Historic District had started as a process of "people coming together," it had now succumbed to "corporate America" and in particular to the efforts of local clubs, restaurants, and hotels to "squeeze as much money out of the area as possible." Still, she believed remedial efforts might succeed.

Morellet, by contrast to Hamilton, took a positive view of the changes, stressing Gansevoort's nightlife as an economic engine for the city:

> The nightlife is fantastic. When it was mainly a meatpacking district there used to be a lot of jobs, but by the time I was running my restaurant there were only about a hundred jobs left in meatpacking, and then a couple of jobs for people like me. Now there's about a thousand jobs there and ten thousand people having a great time, all creating lots of revenue for the city. New York is the core of a megalopolis of twenty-two million people, and it should be creating jobs and attracting tourists.

Morellet himself no longer cared to live in downtown Manhattan, his home since coming to New York, mainly because he thought it was not the edgy, cutting-edge place he had once cherished, and it was too crowded. So in 2013 he moved to Bushwick, which he saw as resembling the Gansevoort Market as it used to be when he first opened Restaurant Florent. He explained:

> I didn't like hanging out anymore where I used to live—it's packed with too many people. But I'm not angry. When I first came to New York there were thirty to forty neighborhoods I wanted to hang out in; now there are two to three hundred, because the city is in much better shape. Here in Bushwick it's fantastic—it's full of coolness. The concept that nothing should change and people should stay forever in their neighborhood makes me mad—that's liberal bullshit.

CONCLUSION

The High Line and Meat Market, two high-profile preservation projects, suggest several lessons. First, each shows that one or two talented individuals, here David and Hammond for the High Line and Morellet and Hamilton for the Meat Market, can make a difference, though only with key political support, especially the mayor's. Each project underlines the importance of "public entrepreneurs" (Garvin 2002), individuals talented enough to conceive of projects when most others are unaware that

opportunities are available, and then assemble and coordinate the various players and shepherd the project through its approval stages. Hamilton completed a stint as head of Community Board 2; David and Hammond remained as key figures in the Friends of the High Line, guiding the projects they had started (Hammond left in 2013). These individuals also represent the reasonable, moderate wing of the preservation movement, on the whole by contrast with the fundamentalists (e.g., the leadership of the Greenwich Village Society for Historic Preservation, and Landmarks West, from the Upper West Side).

A second lesson of these two projects is that the ability of individuals or institutions to fully control urban outcomes is limited. City neighborhoods are often dynamic places, even when landmarked.

Still, arguably, the High Line and Meat Market were major successes in part because they did not freeze, or "embalm," the spaces and neighborhoods they inhabited. The High Line happened only because the city made a deal with the Chelsea Property Owners. The result is that the vista from the High Line is partly of older buildings (as advocates originally envisioned), but of far more new ones by some of the trendiest architects in the world, which a city like New York should, reasonably, have. Likewise the Meat Market is not, these days, much of a place for meatpacking, despite the fact that preserving that industry was a major impetus for landmarking. Instead, it is primarily a vibrant entertainment, fashion, and tourist destination, full of clubs and restaurants and supporting many local jobs. It, and its surrounds, now also host dynamic high-tech sectors such as Google and Apple. The market has vestiges of the past, such as cobblestones and lower, older buildings, along with many new buildings nearby.

There are, for sure, critics, including the surrounding residents who complain with some justification about the out-of-control nightlife. Others complain that places like the Meat Market are an unfortunate historic mish-mash. Sharon Zukin (2010), for example, in an interesting recent book decries a tendency to promote "historic" buildings as "stage sets" located amid high-end shopping, and likewise "historically themed" restaurants such as Pastis's 1930s-look French bistro set amidst the Gansevoort Meat Market's nightclub scene. This type of "authenticity" Zukin dismisses as contradictory and shallow, and contrasts it with the fading but truly "authentic city" composed of ordinary working men and women.

Still, the Gansevoort Market seems a major improvement on the Meat Market of the 1970s and 1980s—outmoded meatpacking along with sleazy nighttime activities. (In the 2000s the city for the most part relocated the meat market industry to Hunts Point in the South Bronx.) There is no vocal

constituency arguing in New York for the retention of a red-light district, whose demise in the Gansevoort Market was in line with trends in most major world cities, despite well-known exceptions in certain Scandinavian cities.[9]

The city did make some efforts to steer what in some ways was a process of commercial gentrification and then supercommercial gentrification, as commercial galleries replaced earlier manufacturing uses and prostitution, and then high-end clothing stores, nightclubs and themed restaurants, and high-tech uses such as Apple and Google moved in. The city, for example, protected the core of Chelsea's gallery district from condos by retaining the manufacturing zoning there, kept rents paid by the remnant of the meatpackers artificially low, and courted the Whitney Museum by offering city land at below-market prices. Still, none of these efforts carry absolute guarantees to those protected, nor is it clear why they should. The meatpackers' days seem numbered, and the star Chelsea galleries have protected themselves, mainly because they purchased their own spaces—converted garages—which had nothing to do with city policy. Whether the galleries can, in the long run, survive the Internet's retail revolution remains to be seen. Regarding the nightlife, the city probably could and should do more to protect the quality of life of nearby residents without harming what is a major economic engine.

Finally, this was not the more debatable process of classic gentrification with poor and working-class residents replaced by middle-class and wealthy ones, since when the Gansevoort Market Historic District was designated it contained almost no residents—just dwindling manufacturing operations and prostitution. There was only one apartment building, the West Coast, at its edge.

PART III

MEGAPROJECTS: WHY THEY OFTEN DON'T HAPPEN OR TAKE SO LONG IF THEY DO, FROM JAVITS EXPANSION TO MOYNIHAN STATION AND HURRICANE SANDY

The Javits Expansion Fiasco

For New York, the biggest city in the United States, to have the 18th-largest convention center is an embarrassment. During my three years as chairman of NYC & Company, the city's official tourism marketing arm, the uniform view among industry leaders was the Javits center is drastically undersized. Even the state's current plan to expand the center from 760,000 to 1.1 million square feet won't make it stack up to the facilities of other cities. Chicago, for example, has 4.5 million square feet of convention space. Las Vegas has 5.5 million. Some experts have estimated that a 3-million-square-foot Javits center would pump $3 billion a year into the New York economy— not to mention 33,000 permanent jobs and a huge number of construction jobs. With the expansion, we will be able to attract conventions from around the world. . . . The new influx of visitors would be of enormous benefit to our restaurants, stores, hotels, theaters and cultural institutions.

—Tim Zagat (2005)

After all this effort and money, the "Javits expansion" that they finally settled on is a very small amount of new space that looks like a cargo shed at Newark Airport.

—Leading New York architect, September 2009

The Jacob K. Javits Convention Center is the 19th-largest in the country.

—Travel Industry Association of America 2013

FOUR MEGAPROJECTS

In March 2004 Mayor Bloomberg and Governor Pataki held a star-studded press conference at the Javits Convention Center to announce a plan to transform the Hudson Yards on Manhattan's Far West Side. The mayor described this "Hudson Yards program" as "probably the single most important economic project that New York City has undertaken in decades." Although many people debated the merits of its particular parts, few disagreed about the proposal's overall significance. The geographic area alone was huge—360 acres, stretching from 30th to 43rd Street, bounded

on the east by 8th Avenue and 7th Avenue, and on the West by the Hudson River (figs. 5.1, 5.2, and 7.1).

Robert Boyle, head of the Javits Convention Center, quipped as he introduced speakers on behalf of the Hudson Yards program: "The Javits Center hasn't been host to so many high-profile personalities since the Mob ran it." (Boyle had evicted the Mob from Javits in 1995, a huge achievement.) The audience was full of union members waving placards of support for the jobs in construction and tourism they expected the project to bring. Dignitaries present, in addition to the governor and mayor, included the chairman of Empire State Development, Charles Gargano; New York City's deputy mayor for economic development, Daniel Doctoroff; the NYC & Company chairman, Jonathan M. Tisch; the Jets owner, Woody Johnson; the president of the Hotel Association of New York City, Joseph E. Spinnato; and Peter Ward, business manager of HERE Local 6, the union that represented many hotel workers.

Absent from the announced dignitaries was any major representative from the state legislature, an absence whose significance only became apparent a year later as Sheldon Silver, the state assembly speaker, threatened and then torpedoed the stadium part of the Hudson Yards program. Silver was at the Javits announcement, but assigned so minor a role that press reports overlooked him.

The Hudson Yards 2004 program was a synthesis of three main parts, each arguably a megaproject in its own right and under discussion for several years.[1] The first part of the Hudson Yards synthesis involved expanding the Javits Convention Center from the eighteenth largest in the country to the fifth largest. The plan's second part involved a massive rezoning of 310 acres—most of the land in the Hudson Yards area—from industrial to commercial (basically offices) and residential. A central aim here was to capture office jobs that were leaving the city, especially for New Jersey across the river. The Hudson Yards plan's third part, the most controversial by far, involved constructing a New York Sports and Convention Center (NYSCC) on the Metropolitan Transit Authority (MTA) railyards adjacent to Javits. The NYSCC was intended as a "multiuse facility" which could serve as a stadium for the Jets football team; as the main stadium for the 2012 Olympic Games, should New York get to host them; and, with a retractable roof, as the venue for conventions and plenary sessions and concerts. It would be built on a deck to be constructed over the railyards. The mayor and governor, both wearing green Jets neckties, laced their press conference remarks with references to the "Jets coming home" (i.e., back from New Jersey), each mention of which triggered audience applause.

As well as these three parts, the overall Hudson Yards plan came with

Fig. 5.1. Hudson Yards megaprojects.

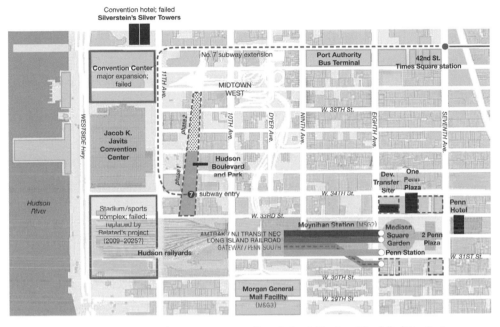

Fig. 5.2. The Hudson Yards 2012. Western Rail Yards (*on left*), site of the failed New York Sports and Conventional Center (NYSCC) proposal, separated by 11th Avenue from the Eastern Rail Yards (*on right*). The Javits Convention Center is north of the railyards just West of 11th Avenue. After the NYSCC failed in 2005, Related Companies agreed in 2008 to a $1 billion deal to develop the Western and Eastern Rail Yards, paying rent to the Metropolitan Transit Authority, who own the yards. Developer Larry Silverstein's twin Silver Towers (*rear center*) opened in 2009 with 1,359 rental apartments, disappointing planners who wanted a convention hotel linking Javits visitors to Times Square. For the Hudson Yards in mid-2014 see fig. 7.5. Photo by Camilo Vergara.

two big infrastructure improvements—extending the number 7 subway to the Far West Side (Javits Center) and building a major new avenue to be called Hudson Boulevard. There was also land set aside for the creation of parkland.

These megaprojects were, for city officials, the key growth and job-creating components of the overall Far West Side package, intended to complement the preservation components (e.g., Gansevoort Market and High Line) and medium-growth components (e.g., Chelsea art gallery section) already discussed.

FROM "SLUM CLEARANCE" TO "DO NO HARM"

In part the Hudson Yards plan was a continuation of Midtown's westward expansion. Midtown had long been centered on Manhattan's East Side along Madison and Park Avenues from roughly 40th to 60th Street, its development driven after 1903 by the transportation hub Grand Central Station. Midtown then started expanding westward in several spurts of office construction during the late 1920s, the late 1960s and early 1970s, and the 1980s and late 1990s, by which time it had reached 8th Avenue.

Along the way, an attempt in 1969 by the administration of mayor John Lindsay to displace what was left of the Far West Side residential neighborhood known as Hell's Kitchen, which stretched west of 9th Avenue from 42nd Street north almost to 60th Street, was beaten back by neighborhood opposition. Hell's Kitchen, whose name reflected the area's nineteenth-century reputation for violence and crime, had originally extended south to 34th Street, but that section had already been destroyed in the 1920s to make way for transportation infrastructure projects such as the elevated West Side Highway, roads serving the Port Authority Bus Terminal and Lincoln Tunnel, and railyards servicing Pennsylvania Station.

Lindsay's failed attempt to finish off Hell's Kitchen was the tail end of the megaproject period of the fifties and sixties when massive residential displacement ("slum clearance") was carried out under the 1949 Housing Act, until finally the community and environmental impacts of these programs provoked intense citizen protests. As a result, in 1972 Hell's Kitchen had won designation as the "Clinton Special District," with provisions for zoning and preservation and against tenant harassment that protected its low-rise, residential, and inexpensive character.

Such changes ushered in, from the mid-1970s continuing to the present, the "do no harm" period of megaprojects. The dominant project types and implementation strategies of this period are generally marked by the awareness of the need—for political, legal and social reasons—to avoid or fully mitigate any significant disruption (Altshuler and Luberoff 2003).

So, carefully skirting the Clinton Special District, and bolstering its claim of avoiding Robert Moses–type proposals that displaced residential neighborhoods, the new 2004 Hudson Yards plan focused on nonresidential areas zoned as manufacturing to the south, and especially the Western and Eastern Rail Yards (Brash 2011, 145–47).

Underlining the project's size and ambition, city officials compared it to the creation of Grand Central Terminal and Park Avenue. In 1903, the state legislature, responding to public outrage at the pollution and filth from the New York Central Railroad in mid-Manhattan, passed a law requiring the railroad to "cover its tracks." This led to the emergence of Manhattan's Midtown business district, which eventually supplanted Wall Street as the largest business district in the country, as it remains today. That project too had involved decking over the New York Central Railroad tracks—above which a grand, new boulevard, Park Avenue, was built, as well as a magnificent new station, Grand Central. The currently proposed Hudson Boulevard was intended partly as a modern Park Avenue. (The city had also drawn lessons from the creation of Park Avenue when devising the air rights transfer deal with the Chelsea Property Owners in 2005—the West Chelsea Rezoning—facilitating the High Line conversion.)

There was another infrastructure project, arguably the most important megaproject of all (at least until Hurricane Sandy in November 2012 dramatized the city's need for flood protection measures), that was highly relevant to the Hudson Yards project, though not formally included in the 2004 grand synthesis. This was the attempt to move Penn Station—the country's busiest train station—one block west from its current site to the Farley Post Office Building, a Beaux Arts architectural jewel to be renamed Moynihan Station in honor of Daniel Moynihan, who, as a US senator, championed the project from 1996 to his death in 2003. Moynihan Station was expected to spur office and residential development all the way to the Hudson Yards and river. It was also seen as restitution for the 1963 demolition of the original, magnificent, Penn Station.

WHY MEGAPROJECTS IN NEW YORK OFTEN DON'T HAPPEN OR TAKE SO LONG IF THEY DO

Yet currently (2014), years after the Hudson Yards 2004 announcement, only one of its three parts, the massive rezoning, has happened. The second part of the synthesis, the NYSCC stadium, was defeated in mid-2005, not too surprising given its controversial status (although the case for it was stronger than many critics conceded, and it passed all the approval processes until Sheldon Silver's veto in the final stage). More surprisingly, the major Javits expansion, the third part of the Hudson Yards

synthesis, was botched and died over a three-year period despite having widespread support.

Regarding the two megainfrastructure projects envisaged as part of the Hudson Yards synthesis, the Moynihan/Penn Station project's first stage (linking Penn Station and the Farley Building underground) did finally began in 2012, twenty years after it was first suggested. Still, by mid-2013 the project's crucial second stage, building a grand station above ground in Farley, was on hold as critics questioned the entire project and proposed, instead, moving Madison Square Garden somewhere else and building a brand-new Penn Station in its place, a project that could not happen in less than twenty years if it happened at all.

On the other hand, the number 7 subway extension from Times Square to 34th and 11th Avenue is set to open in late 2014, just seven years after construction began. This is a major achievement, given New York City's well-known difficulty these days in achieving new subway lines.

The ongoing story of these stymied, hugely delayed, but in two cases successful, projects throws enormous light on the dynamics of urban development and change in New York City. New York City is widely agreed to have great difficulty pulling off megaprojects nowadays, and these particular projects, when scrutinized as case studies, suggest why.

The most common explanation for failed megaprojects assigns responsibility and blame mainly to community opposition, often viewed as nimbyist, and to the related idea that a cultural climate has taken hold that finds it easier to oppose than to construct. This explanation typically argues that much of the problem lies in an overreaction to the tyrannical ways of Robert Moses, some of whose megaprojects destroyed neighborhoods. The reaction against Moses created and strengthened local opposition groups, especially community boards, which, it is often said, too easily object to and block megaprojects, even those conceived under the "do no harm" constraint.[2]

This chapter, and the next three, suggest the need for a broader view. Megaprojects are hard to pull off because several key things can go wrong and become blocking factors, of which local opposition is only one. This multicausal view makes sense, since megaprojects are, by definition, large and complex and therefore subject to a variety of possible problems. The main blocking factors are

- Squabbles between various government agencies (at similar and different levels).
- Mediocre and incompetent leadership.
- Fighting between various politicians.
- Political lobbying or cronyism.

- The presence of a private corporation that is both key to the project's success and willing to block it. For example, Cablevision, owner of Madison Square Garden, was a blocking factor for the New York Sports and Convention Center and for the Moynihan Station project; developer Larry Silverstein was a blocking factor for parts of the Javits expansion, and hugely delayed, though did not kill, the World Trade Center redevelopment; and the Chelsea Property Owners almost prevented the High Line.
- The legal requirement of an environmental review, a lengthy and costly process.
- Changes in the economy associated with the real estate cycle and expansion and bursting of bubbles.
- Landmarked status (as with the Farley Post Office, intended to become Moynihan Station).
- Unrealistically ambitious plans.
- Local opposition. This can certainly be an important blocking factor, though typically only if it gains the support of one or more politicians with blocking powers. After all, New York City's community boards, the main vehicle for local opposition to a project, have only advisory powers in the city's official approval process (ULURP) for major land use changes. They can vote to oppose a project, but that by itself does not stop the project.
- Funding. Megaprojects are expensive, and funding will usually be a struggle whose outcome is related to one or more of the other blocking factors.

This is a long list of blocking factors. The two parts of the Hudson Yards plan that failed—the Javits expansion and the NYSCC—ran into almost all of them, as did the Penn/Moynihan Station project. The post-9/11 World Trade Center redevelopment, though now substantially underway, ran into almost all of them too. It also ran into an extra, unusual factor, that of being a "symbolic-emotional-nationalistic" site, one consequence of which, for example, beginning with Governor Pataki almost right after the attack, was the empowering of the victims' families in making site decisions.

When a megaproject goes wrong it is often convenient to blame neighborhood opposition, especially if the fault actually lies equally or more with squabbling politicians or feuding government agencies or incompetent leadership, all of whom often prefer to find another scapegoat. Actually, only the NYSCC and the Hudson Yards rezoning ran into significant neighborhood and community board opposition, and the Hudson Yards rezoning handled that opposition via creative compromise.

These blocking factors are consistent with the six ingredients which urban planner Alexander Garvin outlined as crucial for a successful public project. Still, some highlight items that are not prominent in Garvin's account. These include squabbles between government agencies, fights between politicians, and the sabotaging activities of a private corporation (Garvin 2002, chaps. 1 and 2).[3]

It should be stressed again that not all these megaprojects failed or failed completely. Only the NYSCC is completely dead. The Hudson Yards rezoning did happen. Stage 1 of the Moynihan Station appeared to begin in mid-2010, though now stuttering. A major Javits expansion could happen someday. The High Line has evolved into a successful megaproject. The Hudson River Park is a successful megaproject, as, much earlier, was Battery Park City. In Brooklyn one centerpiece of the Atlantic Yards project, the multipurpose Barclays Center indoor arena, including the home of the Nets basketball team, opened in September 2012 and is broadly popular, though as of mid-2014 none of the promised "affordable housing" had appeared.

Although the full megaproject might fail, there can be some important partial successes on the project site. An example is Robert Boyle's eviction of the Mob from the Javits Center, which turned Javits from a loss-making to a profitable operation, even though the attempt to build on that success with a major expansion of the center failed.

Whether megaprojects succeed fully or partially, one way of understanding successful projects is to see how they avoided the numerous blocking factors that often doom these projects. The High Line, which runs through the Hudson Yards, came very close to running afoul of three—a troublesome private corporation (the Chelsea Property Owners), budget cuts associated with an economic downturn, and political lobbying/cronyism (a former Giuliani deputy mayor becoming a lobbyist for the Chelsea Property Owners).

A historically contingent factor made it harder to pull off certain kinds of megaprojects during this period, namely the preoccupation of the Port Authority of New York and New Jersey with rebuilding on the World Trade Center site. The Port Authority was created in 1921 to solve the difficulties of achieving transportation megaprojects, yet has been distracted by the mammoth problems of the World Trade Center, for which the Port Authority officially assumed management in 2006 (the WTC was until then plagued by almost all the blocking factors outlined above), and which absorbed huge amounts of the PA's managers, engineers, and budget. In 2010 alone, the PA's capital budget related to the WTC was $1.6 billion— three times the amount allocated for airport modernization and nearly eight times the funds made available for port improvements (Doig, Erie,

and MacKenzie 2012). A 2012 highly critical audit of the Port Authority's general efficiency stressed the huge financial commitments entailed by the WTC rebuilding (Navigant 2012).[4] When US senator Charles Schumer suggested that the Port Authority take over the floundering Moynihan Station project, Mayor Bloomberg successfully resisted on the grounds that the PA could not handle it in addition to the WTC. In late 2011 New York governor Cuomo (openly feuding with Mayor Bloomberg), together with New Jersey governor Chris Christie, appointed a new executive direc-tor of the Port Authority, Patrick Foye, who then did place the Moynihan Station project under the control of the Port Authority. It is not yet clear how effective this will be, so stressed is the Port Authority with its World Trade Center obligations. So here is another, less widely noticed, conse-quence of 9/11.

The PA, even free of the WTC burden, itself is not immune from these blocking factors. For example, Republican governor Christie, from his election in 2010 to the end of 2011, systematically engaged in patronage/ cronyism, getting fifty people hired by the Port Authority, as Jameson Doig, author of the definitive history of the PA, complained (Boburg and Reitmeyer 2012). This abuse continued, exploding in the politically moti-vated closing of lanes to the George Washington Bridge in 2013, and is not likely to increase the PA's ability to do its job.

Finally, Hurricane Sandy has now underlined the need for new flood protection megaprojects, without which the city's long-term future may be in doubt. Figure 1.13 documents the flood areas in the region and shows the vulnerability of the Far West Side. In June 2013 the City of New York published an impressive study titled *A Stronger, More Resilient New York*, proposing flood walls, levees, storm surge barriers, in-water gates, and additional "soft" ecological solutions such as reconstructed wetlands for coastal protection. The study suggested roughly 250 initiatives; the first stage of implementation would stretch over ten years and cost roughly $19.5 billion, of which the city claimed $10 billion was already available (NYC 2013). Still, such megaproposals face the daunting set of obstacles that typically doom "megaprojects" in New York and elsewhere.

This chapter shows how the Javits expansion fell afoul of all the main blocking factors except two (community opposition and landmarking).

RISE AND FALL OF THE JAVITS EXPANSION: 1996–2010

Evicting the Mob

The Javits Center (fig. 5.3) was completed in 1984 to replace the old Col-iseum convention center at West 59th Street and Broadway. By 1998

Fig. 5.3. Javits Center (2010). Photo by Malcolm Halle.

Governor Pataki agreed with a coalition of hotel and convention-based in-terests who wanted to enlarge the new Javits, which was smaller than cen-ters in many US cities so that the city was handicapped in the competition for conventions and the hotel and other business that conventions bring. Since New York State controlled the center and owned the land on which it was built, no significant Javits development could happen without state approval.[5]

That Javits was ready for expansion reflected a major change in its for-tunes. It had been plagued with internal and external problems from the start. The external problems had to do with its isolated location. Visitors had to travel there by taxi, limousine, or bus (no subway or train access), and on arrival found little of interest in the surrounding blocks. As planner Garvin commented, Javits had been sited in such an isolated location pri-marily to meet the "do no harm" criterion of post-1970s megaprojects and to avoid issues regarding the displacement of residents and the lengthy associated litigation. For example, the Lincoln Center for the Performing Arts much earlier had taken two years to approve (1957–59), generated enormous opposition, and directly displaced at least 678 businesses and 5,268 households. The isolated site for Javits avoided most of these dif-ficulties, but at the cost of landing conventioneers in a location with little to do and no hotel to stay in (Garvin 2002, 104).

Javits's internal problems were also serious. Its construction and design were a bureaucratic nightmare, with responsibility divided between two competing government agencies, the Javits Development Corporation (itself a confusing subsidiary of both the State Economic Development Corporation and the Triborough Bridge and Tunnel Authority) and the Convention Center Operating Corporation (created by the state legislature and the governor). As a result there was "no clearcut accountability for successful completion of the center," as one of the reports commissioned to study the problems concluded.[6] The star architect chosen, I. M. Pei, had never designed a convention center; the construction budget overran by 100 percent; and organized crime was extensively involved in the construction and, when the center was operational, with the unions whose members physically installed each exhibition. Because of a slew of restrictive labor practices, the costs of exhibiting there were artificially high, so Javits had never made a profit before 1995 and relied on state subsidy. Around the time Pataki was elected governor in 1995, a series of newspaper articles appeared detailing organized crime's control of Javits, a source of constant complaints from the companies that mounted exhibitions there.

Javits's turnaround was the work of Robert Boyle, Pataki's campaign treasurer, who had a long background in construction and whom Pataki appointed in March 1995 to run Javits. Boyle's Javits plan is worth studying, since it shows what first-rate government leadership can accomplish, especially in light of the New York State government's subsequent (often deserved) reputation as ineffective and corrupt. It also shows, as with David and Hammond of the High Line and Morellet and Hamilton of the Meat Market, how talented individuals, working with political leaders, can make a difference. Boyle's plan, which involved evicting the Mob, was not discussed with the Giuliani administration at the time because of frosty relations between Giuliani and Pataki. Still, when Giuliani later evicted the Mob from the Fulton Street Fish Market (which skeptics had said was impossible because the Mob had been entrenched there for decades), his deputy mayor who managed the process, Randy Mastro, drew on Boyle's Javits strategy.

Boyle's previous construction experience had left him deeply familiar with the Mob's personalities and tactics. He spent his first two months at Javits assessing the situation and coming to see how deeply the Mob had penetrated. There were three unions there—the Teamsters, who delivered materials for the exhibitions; the Stagehands, who unloaded the materials; and the Carpenters, who put together the exhibition stands. At Javits, all three unions were heavily Mob-infiltrated. The national Teamsters were under federal ward, as were the regional Carpenters, as a result of corruption issues. Almost all the seventy-five highest-paid carpenters at Javits

had felony convictions, as did the sixty highest-paid Teamsters. Not only was there a phantom payroll of about $4 million a year, but each time an exhibitor's materials needed unloading, an informal $50 or more payoff had to be made; otherwise, mysteriously, the exhibitor's materials were lost. Some lockers at Javits contained illegal contraband, and workers had informally declared certain sections off limits—it was understood that no one else went there. In addition, there was a fourth-floor section where, during the annual auto show, about forty beds were installed for workers to sleep on while paid double time. A couple of murders had been connected to Javits. Overall, it was a mean place.

Boyle devised a plan to oust the Mob, mainly by means of controlling the money. For example, when Boyle decided that paychecks would no longer be issued to workers unless picked up in person with photo identification showing that the recipient worked at Javits, about $50,000 of the biweekly checks went unclaimed. Boyle worked in close consultation with a labor attorney and two colleagues, one a retired NYPD officer who then worked in the Manhattan district attorney's office. Under the existing system, the unionized (nonadministrative) workers were hired and paid by each Javits contractor. Under Boyle's plan, all these workers would be replaced by a new group who would be state employees of the Javits Center, giving management more control, although Javits would continue to recognize the workers as members of either the Teamsters or Carpenters union. The new plan cut out entirely the third union, the Stagehands, whose work was superfluous.

Boyle held a meeting to discuss the plan in confidence with the existing Javits administrative staff who did the center's payroll and bookings. This was a smaller group of about thirty-five people who were state employees and not Mob-infested. After Boyle explained the plan, one of them said he and his coworkers had waited a long time for something like this, and they volunteered to vet new applications, since they knew who was part of the Mob, an offer that Boyle accepted, warning them that the proposed changes could endanger their lives.

Newspaper ads were placed announcing the day that new hiring would take place. On that day, the lines of applicants stretched blocks around Javits. Applicants entered vetting booths run by the administrative staff, while state troopers kept order. Boyle had asked the administrative staff how they would know which applicants were Mob and was told that they would be the first 150 people in line. As predicted, almost all the first 150 were Mob, and were duly placed in the category to be turned down.

There was a thirty-day waiting period between the interviews and the notification of applicants as to whether they had been hired. When Boyle saw his colleague Myles during that period, Boyle said: "They've [the

Mob] smashed the lights and mailbox at the end of the driveway to my house. They know where I live [Croton on Hudson]." Myles responded, "I guess they also know where I live! Someone's smashed mine too [in Connecticut]." Still, Boyle and Myles stood firm. There were no further intimidation attempts, and the Mob was evicted from Javits.

Boyle then negotiated a new contract with the Teamsters and Carpenters unions, who represented the freshly hired employees. The old thirteen-page contract full of restrictive work practices was pruned to three or four pages. Page 1 set out the wage rate; page 3 said Javits management was in charge. The contract contained just one work rule, a provision that, for safety, when a forklift was used a second worker must be present in addition to the driver. Boyle also announced that the old lockers would soon be replaced with new ones. This gave workers a warning to clear out possible contraband (such as drug materials and guns), which they did. All this was done by July 1995, just four months.

Over the next few years Javits prospered to the point of needing to expand. Costs for exhibitors fell by about 50 percent, mainly by eliminating featherbedding—the actual wage rates remained the same. This increased the demand for conventions. The idea of expanding Javits was strongly supported by hotel and convention-based interests, including unions representing employees in those industries, and construction unions whose members would gain much work from the project.

Giuliani and Pataki Political Squabbling: The Convention Hotel Replaced by the Silver Towers

Enmity between Mayor Giuliani and Governor Pataki now became a major factor blocking a Javits expansion. Pataki disliked Giuliani. For one thing, two weeks before the 1994 election at which Pataki was first elected governor, Giuliani declared support for Pataki's rival, Mario Cuomo, after which Pataki's lead in the polls fell from 12 to 4 points. Partly as a result, Pataki was blocking Giuliani's pet project for a stadium for the Yankees on the West Side. So Giuliani retaliated by blocking the Javits expansion, although without explicitly saying so. It was just that a Javits expansion north required the city's permission to close streets and redirect traffic, which apparently Giuliani would not give so long as Pataki opposed the stadium.

By 1998, Giuliani's opposition had spoiled part of the expansion proposal, the plan for a convention hotel that would link Javits to Times Square. This plan involved the developer Larry Silverstein, who owned an entire block of property just north of Javits between 41st and 42nd Streets and 11th and 12th Avenues, and wanted to develop it. He had bought the

block for $20 million in 1984 when it was vacant and zoned for single-story industrial use. In 1989 it was rezoned to allow residential, so Silverstein wanted to build high-rise apartments. But the property was a key part of the state's vision to link the Javits expansion to developing Times Square, via a newly built convention hotel. The idea was that Javits convention visitors staying in this hotel could easily access the theaters and entertainment of Times Square, remedying two of Javits's major problems: its absence of a convention hotel and its isolation from entertainment for conventioneers.

Before he could develop the property Silverstein needed a permit from the state's 42nd Street Development Corporation, run by Charles Gargano, Pataki's former chief fund-raiser, and since Silverstein had donated to Pataki's election campaign (he also donated to Democrat Cuomo's), he pressed Pataki to get the permit approved. A compromise was arranged in 1997 whereby Silverstein would split his property in half. The eastern half would be set aside for a future convention hotel, which Silverstein could build himself or sell the land and hotel rights to someone else to build. The western half, which he was allowed to develop right away, became the massive, forty-one-story One River Place residential complex, which opened in 2000 as the nation's largest rental building, 921 apartments.

But after about a year Silverstein lost patience for a decision on the eastern half, as Giuliani refused to support the Javits expansion in 1997–1998 discussions. So in June 1998, unwilling to forego further income on the site—reserved for a convention hotel that it made no sense to build unless the convention expansion was certain—Silverstein proposed to build apartments there too, and was given permission by Pataki. This eastern site then eventually became the sixty-story glass Silver Towers behemoth, which opened in 2009 with a staggering 1,242 apartments (fig. 5.2).

This disappearance of a perfect convention hotel site was a major blow to the Javits expansion project, and a clear example of infighting between politicians as a blocking factor on megaprojects. (A late attempt, around 2004–2005, to rectify the error by purchasing the still unbuilt site from Silverstein for roughly $250 million failed, as Silverstein rejected the offer and Pataki refused to use eminent domain.)

Several impartial observers expressed dismay that Giuliani would undermine the Javits expansion to further his Yankee stadium project. Mitchell Moss, director of NYU's Taub Urban Research Center, complained: "It's shocking to think that a baseball stadium is more important than a convention center or stock exchange. New York's future lies in tourism, finance, communications and entertainment, not professional baseball."

Meanwhile, desperate for extra convention space, in 1998 Javits officials accepted a private company's offer to erect a small (400-by-136-foot),

temporary structure, with a vinyl roof and metal siding, on a parking lot between 39th and 40th Streets to the north of the main Javits Center and physically connected to it. The company, George Little Management, which specialized in putting on convention shows, paid the structure's $3.5–4 million cost, in return splitting the rental income from the building with the Javits Center, which paid for the building's management. Robert Boyle called this a "Band-Aid" approach to the center's space problems, while others said it was a "drop in the bucket" compared to what was needed. Given Giuliani's obstructionism, it was all that could be done at the time. (Incredibly, by 2010 Javits's eventual "expansion," after several fiascos, was basically just a new version of this shed.)

Still, by September 2000 prospects for a major Javits expansion had improved. Governor Pataki and Mayor Giuliani stopped sabotaging each other's Hudson Yards projects. Pataki now agreed to support Giuliani's project for a sports arena, to be built on the MTA railyards next to Javits. A central reason for Pataki's change was that the arena's main tenants would now be the Jets football team, a Pataki favorite. In return, Giuliani cooperated with Pataki's Javits expansion north. He also announced that the city and the MTA had worked out a tentative agreement to extend the number 7 subway line from Times Square to the Javits Center and the new sports arena. So political squabbling between Governor Pataki and Mayor Giuliani was removed as a blocking factor.

Yet little happened over the next three years, after Giuliani's second term as mayor ended in December 2001 and Bloomberg's first two years in office were preoccupied with the aftermath of 9/11, as was Pataki, especially with rebuilding the World Trade Center and Lower Manhattan. So blocking factors such as the political squabble between Giuliani and Pataki had delayed the Javits expansion until the economic cycle was no longer favorable, another common blocking factor for megaprojects.

HOK/Boyle's 2004 Javits Plan

By 2004 the economy had improved, and Governor Pataki and Mayor Bloomberg announced the grand Hudson Yards proposal, which, as already outlined, included a major Javits expansion plan. This Javits plan got almost everything right, except that it lacked a glamorous design by a star architect, creating a political problem that eventually became fatal.

The 2004 Javits plan was a sound design with viable funding. The design had been developed over several years by the architectural and engineering firm HOK, a giant international company that had initially been asked to do some Javits renovations, followed by a full expansion. HOK's plan entailed extending the existing Javits north continuously to

41st Street. It was favored by Robert Boyle, who, as head of the Javits Operating Corporation, had selected HOK. Developed in consultation with some of the major companies that mounted Javits exhibitions, HOK's design for a basically horizontal expansion made loading and unloading exhibition materials, which are typically trucked in on huge tractor trailers, relatively easy on a twenty-four-hour basis. This was crucial to keeping costs down and making it possible to book the maximum number of shows. (The horizontal design turned out to be highly significant later, when problems associated with the vertical plan by Rogers, who replaced HOK, unfolded.) HOK's expansion would add 340,000 square feet of exhibition space, bringing the total to 1.1 million square feet. It would also create 265,000 square feet of new meeting space, up from 30,000. This was sorely needed to accommodate large gatherings. For example, the American Association of Orthodontists could not fit into Javits for its annual meeting, but had a tentative agreement to bring its twenty-thousand-member convention there if the expansion went through.

HOK's expansion was budgeted to cost about $1.2 billion. Of this, the city and the state pledged to contribute $350 million each, with the state's contribution coming from refinancing Javits Center bonds. The hotel industry, which had been consulted on the expansion plans from the start and would be its largest beneficiary because of greater demand for hotel rooms in the city, then agreed to a $1.50-a-night hotel room tax, dedicated to paying the remaining $500 million. (It generated about $70 million from April 2005 to 2008.)

In June 2004 the state assembly held public hearings in New York City on the Javits expansion. The bill was then bogged down for a few months by some legislators intent on stripping it of any links to the controversial stadium (NYSCC) next door. Finally, the state legislature approved the Javits expansion bill, in December.

Everything seemed set for the expansion to occur. Almost no one foresaw the fiasco that would unfold. "We succeeded in getting Javits done," said Sheldon Silver, the assembly speaker (while adding, ominously for the NYSCC, "But the stadium is something that's going to live or die on its own. Clearly, the jury is out on that.")

The Rogers/Gargano Fiasco: Political Lobbying and Cronyism, Incompetence, and an Unrealistically Ambitious Project as Blocking Factors

What undid the 2004 Javits expansion plan, now that the earlier blocking factors—the Giuliani-Pataki feud and the economic downturn—were removed, was mainly a combination of three other blocking factors—

incompetent leadership, political lobbying/cronyism, and a new and excessively ambitious plan that installed a star architect, Richard Rogers, who had never designed a convention center. Central to these three blocking factors was Charles Gargano, Pataki's former chief fund-raiser, whom Pataki himself, in obvious cronyism, had appointed chair of New York State's Empire Development Corporation. Later, as these factors sent the project spiraling downhill, the Javits expansion ran into almost all the other blocking factors except nimbyist neighborhood opposition. The following account shows how the project unraveled.

The "Javits Lite" Critique: A Better, Grander Plan, and Access to the River

The first major problem for the newly approved Javits expansion came after the collapse of the New York Sports and Convention Center in mid-2005. Outside critics then circulated several more radical plans for Javits, with many arguing that the site formerly intended for the NYSCC, the Western Rail Yards to the south of Javits (fig. 5.2), was now available for a better Javits expansion than the one just approved by the state legislature, now dismissed by some as "Javits lite." That set the stage for the "unrealistically ambitious project" blocking factor. For example, Kent Barwick, president of the Municipal Art Society, the private planning organization which sees itself as a major guardian of aesthetic standards for the city, commented: "There is a terrific opportunity to reconceive what should happen on the West Side now that the railyards are available."

Several critics, likewise, began to complain that HOK's design was pedestrian, not the star architect work appropriate for a global city such as New York. The Department of City Planning under director Amanda Burden was in the forefront of this critical wave. She wanted an exciting design for an important municipal building in a world-class city, though the city was unwilling itself to pay for such a plan. Continuing this stress on design, Burden later recommended that the DCP should be renamed the Department of City Planning and Design.

Another central complaint of critics was that HOK's plan did not remedy the way Javits was currently walled off from the river. The DCP and others were intent on reversing New York City's long history of placing buildings on or near the water in a manner that created barriers to the rivers. For example, Javits's western side, facing the Hudson River, was a forbidding concrete wall with gates cut into it at intervals for trucks entering from 12th Avenue. Although HOK's plan had proposed a park on the roof that would link to the Hudson River Park, that still left the main Javits western wall unreformed. HOK did plan to "clothe it with

greenery" (i.e., have plants growing up the wall), which critics dismissed as a trivial gesture.

The most radical alternative plan to HOK's was unveiled by the Newman Real Estate Institute at Baruch College in August 2005, and took full advantage of the fact that the Western Rail Yards were available now that the NYSCC would not be built. Dubbed the "flip," it proposed entirely dismantling Javits, whose rectangular building currently ran north-south, and constructing a completely new convention center directly to the south over the two railyards (Western and Eastern) from 12th Avenue to 10th Avenue between 30th and 34th Streets. A central advantage claimed for this Javits flip was that the new Javits would run east-west, perpendicular to the waterfront, and so would not block access to, and views of, the river. Also, it would then be part of an east-west megadevelopment corridor extending from Herald Square west to Madison Square Garden, to the proposed Moynihan/Penn Station, to the new Javits and the river. The flip won plaudits from the Municipal Art Society, state assemblyman Richard N. Gottfried, and others.

It was probably no coincidence that the flip was proposed by academics, since, while visionary, it was hugely expensive and would take years to implement. Behind the scenes, city officials were furious at a proposal that redid the Javits expansion from scratch, with a projected completion date long after the mayor had left office. Also, the price tag of $7 billion (other supporters said it would be somewhat less) was about five times the budgeted cost! Gargano commented wryly: "There's nothing wrong with the idea; the problem is the money." Its advocates responded that after the new Javits was built, the state could tear down the old Javits and sell the waterfront property for an estimated $3 billion to residential developers. This still left a huge net price of up to $4 billion. The certain delay was also a problem. Gargano commented: "We want to move forward as quickly as possible with the northern expansion." Others added, presciently, that the long delays this plan entailed would endanger, and perhaps scuttle, the whole Javits expansion project.

The ingredients had now formed for the "unrealistically ambitious project" blocking factor to intrude, in combination with incompetence and corruption.

As it happened, HOK's original plan had a logistical problem that gave critics the opportunity to argue for reopening the design process. HOK's horizontal expansion entailed moving the MTA (New York City) bus depot and garage, currently located between 39th and 40th Streets. But the MTA had recently invested about $40 million in this depot and refused to move unless it was reimbursed, an expensive proposition. Also, the MTA would need a new location for its bus depot, and attempts to achieve this via a

swap for a state-owned site opposite Javits nearby were proving problematic. All of this constituted the "squabbles between government agencies" blocking factor.

Energized by these criticisms of HOK's Javits plan, Gargano, as chair of the state's Development Corporation, now decided to take over the Javits expansion and sideline HOK's plan and Robert Boyle himself. For Gargano this was basically about power and control in a quest for glory and glamor. The NYSCC stadium, which would have been a striking project, had died. Rezoning the Hudson Yards had been approved in early 2005, but was a lengthy affair for private developers. That left just the Javits expansion, which under HOK's plan was merely a solid, affordable project at a time when critics, including the *New York Times*, were calling for a jewel. Behind the scenes Gargano had the blessing of Doctoroff and Amanda Burden, both excited about introducing a star architect's product.

Sidelining Robert Boyle was important for Gargano, since Boyle had already shown, in an earlier spat over the NYSCC, that he would not scuttle HOK's workable plan in favor of an impractical but glamorous alternative. When the NYSCC had first been proposed as a home for the Jets, Boyle had looked at the drawings and realized that the NYSCC would take away the area just south of Javits, 33rd to 34th Street, which was used as marshalling yards for the trailer trucks bringing material to Javits. Boyle insisted that Javits could not operate without those yards, so the Jets had changed the NYSCC design by putting the yards underground, at their existing location, and agreed to pay for this, a satisfactory solution to all involved.

To take control of the Javits expansion, Gargano got himself appointed chair of the Javits Development Corporation. He then brought in a longtime political crony, Michael Petralia, as president. Petralia had no background in construction or much else relevant to the technical and administrative tasks of expanding Javits. His resume consisted of heading public relations for several governmental agencies, a "spin doctor" as some called him. But he had a relationship with Pataki's then chief fund-raiser, Cathy Blaney, and needed a job. So Gargano did a favor to Pataki and solidified his control of the Javits Development Corporation by appointing a loyalist. At the Development Corporation board meeting where Petralia's appointment was announced, Boyle asked what Petralia's salary would be. He was told this would not be revealed and was shortly after removed from the Development Corporation board, though he remained president of the Javits Operating Corporation, at least for now.

So two megaproject blocking factors—political lobbying/cronyism leading to poor leadership (the replacement of competent Boyle with incompetent Petralia and Gargano) now joined a third (i.e., what was to

be an unrealistically ambitious plan), all paving the way for the ensuing disaster.

As chair of the Javits Development Corporation, Gargano controlled the funds from the hotel tax imposed for the Javits expansion. Gargano also took the surplus funds—$4 million from the Javits Operating Corporation controlled by Boyle—and placed them in his Empire State Development accounts. When Boyle had first taken over Javits in 1995, the Operating Corporation had debts of $1.4 million. By 2005 it had paid these off (mostly thanks to increased exhibition business following the Mob's eviction) and accumulated a $4 million surplus, from which Boyle had been able to pay HOK for designing the Javits expansion.

Gargano now threw out the HOK plan and insisted on a new competition to select a "world-class architect" and a fresh set of plans. At a board meeting Boyle protested vainly: "World-class architect! What do you think HOK is?" At the time, HOK was, indeed, the largest US-based architecture-engineering firm and the world's fourth-largest architectural firm. In 2009 it had two thousand professional staff across a global network of twenty-three offices.

A design committee was hastily assembled to select a new architect. In a major blunder, the committee included representatives of the city and Javits Development Corporation, but no one from the exhibition industry who put on the Javits shows, and they also ignored the Javits Operating Corporation, which ran the day-to-day operations of Javits. This lack of coordination between the two state agencies responsible for Javits repeated what had marred the construction of the original center back in the early 1980s.

Companies bidding for the new Javits expansion contract were told they must have "an international architect" on their team. HOK did submit a proposal, teaming with Norman Foster, another DCP favorite and star architect. But since Foster's office was closed in August when the bids were assembled, what HOK basically submitted was their original plans with Foster's name added. So the committee threw out HOK's submission as not really the work of a star architect.

The Rogers Plan

The winning proposal, selected in September 2005, was from FXFOWLE architects teamed with Richard Rogers, the British star architect who had codesigned the Pompidou Center (basically an art museum) in Paris, and the Millennium Dome in London (basically a giant Ferris wheel), but never a convention center. Two other teams submitted proposals, whose star architects were Rafael Viñoly of Manhattan and Thom Mayne of Los Angeles.

Fig. 5.4. A photographic montage of the first phase of an expansion of the Jacob K. Javits Convention Center.

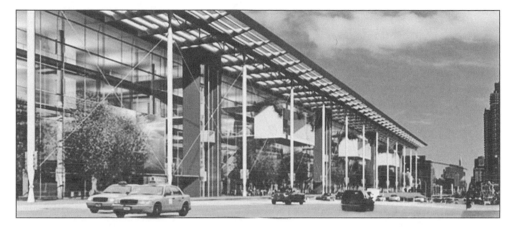

Source: Rogers Fowle Epstein.

Rogers was a DCP favorite, already assigned a heralded project to redesign the underside of the FDR Drive adjacent to the East River. FXFOWLE brought extensive New York City building experience—for example, having designed two Times Square towers (the Reuters building and Condé Nast's 4 Times Square). The Rogers team also included A. Epstein & Sons International in Chicago, who supposedly brought the convention center experience that Rogers lacked, since they were represented as having been the architect for the 2.9-million-square-foot expansion of Chicago's McCormick Place convention center. Later, after Rogers's plan went badly wrong, critics said that Epstein's role in the Chicago expansion had been exaggerated. Anyway, Rogers took the lead in the new design, keeping Epstein in the background.

Rogers dismissed the existing Javits Center as a "mausoleum" (it was coated in blackened glass) and, encouraging comparisons with his colorful Pompidou Center in Paris, said his Javits expansion would catalyze the neighborhood's rebirth. His design added a more transparent glass façade but did not open Javits's western side to the river (fig. 5.4). The most radical, and eventually self-destructive, feature of Rogers's plan expanded the current building vertically, adding a level above the existing structure, on top of which would be a park with westward views of the Hudson River, to satisfy those who wanted Javits to relate to the waterfront. With this new upper level and transparent façade, Rogers could foreground his signature style—colorful internal columns and exposed infrastructure and pipes. The building would also expand horizontally northward five blocks from

34th to 40th Street, but not all the way to 41st, as HOK had planned to do. The advantage here was that Rogers's design would not intrude on the MTA Bus Depot located between 40th and 41st, avoiding the "squabbling government agencies" blocking factor associated with the MTA's reluctance to cooperate. And since Rogers had added a new level of exhibition space on top of the existing Javits, his design provided the same amount of extra space as HOK's, despite the shorter horizontal expansion north.

Rogers also, but fatefully for the project, relocated the marshalling yards where the trailer trucks bringing exhibition materials would assemble. Under HKO's plan, the existing yards, which occupied the entire block south of Javits between 33rd and 34th Streets, had remained, but underground on three levels. Rogers moved them to Javits's northern side to an underground structure between 39th and 40th. The advantage was that the site of the old yards could be sold for commercial development and the proceeds used to offset the greater cost of Rogers's expansion as compared with HOK's. The problem, which Rogers did not anticipate, was that the relocated marshalling yards would be next to the Lincoln Tunnel, creating an unsolvable security hazard.

Rogers's September submission was basically a conceptual design intended to allow a forty-eight-day period for discussion and criticism to be incorporated into the final design. Gargano hailed it as "an unmatched understanding of the project objectives to create a world-class" convention center, as did others, including the DCP and Doctoroff.

Rogers's Critics

But there were plenty of critics, from many, often contradictory, points of view. Rogers's design was attacked as not expensive (i.e., grand) enough, as too expensive, and, crucially, as posing unacceptable security risks because the relocated marshalling yards were too close to the Lincoln Tunnel and made it impossible to search, for possible terrorist attack, tractor trailers delivering exhibition materials to Javits.

In the not grand (and expensive) enough camp, the *New York Times* architecture critic Nicholas Ouroussoff (2006a) complained that the plan was inferior to Rogers's iconic works, especially his signature Pompidou Center in Paris. Ouroussoff said the Javits proposal "might be viewed as a low-key version of the colorful façade of the Pompidou Center . . . but no sane person would call it one of Mr. Rogers's great achievements. . . . Rogers's best buildings, like the Lloyd's insurance building in London and the Millennium Dome in Greenwich, are brash muscular urban machines. So far, the Javits design lacks that structural bravura. . . . [It is] without the poetry that you expect in a major civic building."

Critics on the opposite, too expensive, side noted that the official cost of the expansion had now risen from $1.2 to $1.7 billion, mainly because construction on top of an existing building is far costlier than adding a new building with a horizontal expansion. This is mostly because vertical expansion has to somehow accommodate, or temporarily close down with a consequent revenue loss, ongoing activities in the existing building (here convention shows), while a horizontal expansion can proceed with those activities basically unaffected. Also, people involved with setting up Javits exhibitions complained that a vertical convention center makes mounting shows more expensive because the bulky exhibition materials need to be hauled to an upper floor. So this new design risked returning costs to the uncompetitive levels that hampered Javits before the Mob was evicted.

An additional, and very different, complaint came from Robert Boyle. This concerned security. Boyle said that moving the marshalling yards to an underground structure between 39th and 40th Streets meant they would now be just thirty feet from the wall of the Lincoln Tunnel, creating a huge terrorist target. Anyone (e g , driver, security guard, loader) could easily place a bomb in one of the trailers.

While remaining chair of the Javits Operating Corporation, Boyle had also spent a successful period as head of the Port Authority from 1997 to 2001, during which he oversaw the building of the Air Train to Kennedy Airport, a transportation improvement megaproject. So he had many contacts at the Port Authority, which runs the Lincoln Tunnel. A high-level Port Authority engineer, alerted by Boyle to the plan for a stream of trailer trucks to operate underground next to the Lincoln Tunnel, pronounced the idea crazy. Security experts said that for the plan to be workable roughly eighty thousand additional square feet, including a police station, were needed underground so that security teams could search the trucks entering the marshalling yards. This made burying the garage prohibitively expensive. Critics also said obtaining insurance for exhibition materials located in this way would be impossible after 9/11.

New York state senator Brodsky, who chaired the state assembly Committee on Corporations, Authorities and Commissions, heard of the problems and held hearings in December 2005. He subpoenaed Boyle and told him informally to be truthful, whereupon Boyle testified that placing the underground marshalling yards so close to the Lincoln Tunnel had "fatal impediments," and as chair of the Javits Operating Corporation he would veto the plan, which he believed he had the legal right to do.[7] Shortly after, Governor Pataki removed him as chair, but kept him on the board. Boyle's "firing" and negative view of Rogers's plan were widely reported in the media.

In December 2005 and January 2006 Rogers's office unveiled more specific designs that tried to take account of some of the ongoing criticism. They were not successful. It was going to be hard to satisfy both those concerned about cost increases and those who wanted a grander, more expensive, project. Far more damaging was Rogers's attempt to address the security concerns.

Those who were alarmed about the rise in construction costs, mostly occasioned by the vertical expansion, consisted mainly of officials whose job was to make sure the project had adequate funds to proceed. Since this group included Gargano and the Javits Development Corporation who had hired Rogers, naturally Rogers addressed their concerns. So he trimmed the costs somewhat by eliminating the rooftop park, though keeping the new upper level on which the park would have rested. This angered the critics, who said costs should not be an issue and that the proposal was not visionary enough. In an editorial, the *New York Times* (May 22, 2006) complained:

> When word got out that Richard Rogers would be in charge of revamping the forlorn Javits Convention Center, those hoping for something better for the city and its visitors were heartened. The problem, it turned out, was that Lord Rogers had a shortsighted client—the Javits Development Corporation, a state authority led by Charles Gargano. It apparently decided to focus on what would happen inside the center. . . . The new $1.7 billion design turns its back on the waterfront. . . . The plans call for what is effectively a giant wall—a loading dock on the side facing the water. That is a step back to the days when the shoreline was a dark, industrial place.

Rogers, in a May 29, 2006, letter to the *New York Times*, replied that opening Javits to the river would be prohibitively expensive, above all because it involved closing Javits entirely for construction, involving the loss of all current income from exhibitions. For this, there was almost no chance of obtaining the needed funds (i.e., the "unrealistically ambitious project" blocking factor). He added that his design gestured to opening Javits to the waterfront by constructing a small viewing area at the corner of 11th Avenue and 40th Street, which was all that could practically be done.

While Rogers's attempt to reduce costs inflamed one set of critics, his attempt to address the security issue was a disaster. He proposed a six-story, above-ground marshalling garage between 39th and 40th Streets. In theory the trailer trucks would now be less of a terrorist target, since they would be more visible and no longer underground next to the Lincoln Tunnel. They would ascend and descend a spiral roadway in the six-story garage, which would supposedly allow up to three hundred trucks to load,

unload, and park at different levels of the now more vertical convention center. The structure would also, he said, have space for security checks. Unfortunately, since the above-ground garage would have to be built on space originally assigned for the horizontal part of the Rogers expansion, instead of 476,000 square feet of new space, only 276,000 would now be added, giving the Javits just 1.1 million square feet of exhibit space.

The six-story, above-ground marshalling garage drew a torrent of complaints from those who daily installed Javits exhibitions and was widely derided by convention industry professionals. Critics said that they had never seen anything similar work in the real world. They doubted that trailer trucks could ascend and descend the spiral roadway, which looked too tight for such long trucks. Even if they could, the extra time and effort involved would raise the costs of exhibiting at Javits to prohibitive levels. John O'Connell, COO of Freeman, the general service contractor that produces 80 percent of Javits shows, was sure the vertical plan would not work. "This is a strategic threat to our business. We question the turning radiuses and the ability of truck drivers to go up that thing. It's a challenge to go up even one story. Architects claim all this should be possible, but it's something we haven't seen before. We'd certainly prefer to have a horizontal marshaling yard like everywhere else."

A spokeswoman for Michael Petralia, hapless president of the Javits Development Corporation, said the two-hundred-foot-diameter ramp had worked with computer graphic truck-turning programs, but conceded that no real-life example existed.

Architects often have trademark clothing, such as distinctive eyeglasses. Rogers's architect who handled discussion during this process was known as "the Redman" because he wore red shoes, a red shirt, and red pants. The Redman was unable to satisfy critics that this six-story garage for trailer trucks was viable.

The Javits project was now a mess because of cost and security issues. Projected expansion costs had risen substantially, while the amount of new space achieved by Rogers's expansion had shrunk to far less than HOK's. Meanwhile environmental critics continued to blast the design for failing to open Javits to the waterfront, although doing so was hugely expensive and the project was already way over budget.

Further, the Javits expansion now hit the "real estate cycle" blocking factor, in this case not a downturn but a boom that raised construction costs. Pataki's term as governor was ending, and his outgoing administration had no appetite for dumping Rogers's plan and admitting a blunder. Hence little happened over the rest of the year, except that, because of New York's building boom, construction costs for the project rose about $17 million a month. This was the second time Javits had bumped into the

real estate cycle in its tortuous history—the first was when the Giuliani-Pataki squabbling from 1995 to 2000 had delayed the project until 9/11 made the economic context unfavorable.

The Spitzer Political Disaster

The project, already basically unworkable, now suffered further damage from two blocking factors that had already wreaked havoc, namely incompetence and a new round of squabbling politicians, both associated with Eliot Spitzer's disastrous governorship. In January 2007, Spitzer was inaugurated governor of New York, and in the same month he said that he wanted to conduct a ninety-day review of the Rogers-Javits plan, whose price tag had reached $1.8 billion. He appointed Patrick J. Foye co-chair of the Empire State Development Corporation to replace Gargano and to direct the review, and Barbara Lampen as president of the Javits Development Corporation.

The Javits expansion now went headlong downhill. By April 2007, before Foye had even finished his review, Spitzer, with characteristic arrogance, sided with critics of both plans on the table, HOK's and Rogers's. He called the Javits expansion as envisaged by HOK a "mouse" (i.e., not grand enough) and Rogers's plan an "elephant" (i.e., ungainly), and insisted he wanted a "thoroughbred" of a convention center (Bagli 2007). How he would finance it was unclear.

Then in July 2007, Governor Spitzer's ongoing dispute with New York state senate majority leader Joseph Bruno imploded as Spitzer was revealed to have, improperly, used state police to record Bruno's whereabouts. Since Bruno had a controlling say in state decisions affecting Javits, Spitzer's chances of negotiating a resolution of the Javits chaos were diminishing fast. Worse, the fight with Bruno jeopardized the state's already promised financial contribution to a Javits expansion at the same time that the project's likely costs were rising rapidly and Spitzer was calling for a yet more expensive expansion.

Meanwhile, after April 2007 Foye stopped holding formal meetings of the Javits Development Corporation for a year. As the ninety-day review time elapsed without a review appearing, Foye started to come under heavy criticism from trade show and hotel industry executives and some legislators amidst a growing suspicion, reinforced by later events, that he was out of his depth. Foye in turn placed the blame on having been left with the Rogers design as an expensive and unworkable plan developed by Gargano and Deputy Mayor Doctoroff. Supposed to cost $1.8 billion, Foye said it would actually cost far more, complaining, "It was way above the budget and not something that the state, the city, Javits users or the

hotel industry wanted to support" (Bagli 2008a). While that was true, Foye seemed the wrong person to correct the problems.

Without seeking approval from the Javits Development Corporation, Foye hired marketing consultants and construction experts to review the project. They looked at fifteen alternative plans. In September 2007 Foye reported to a meeting of hotel executives (but not to the Javits Operating Corporation) that the consultants had determined that the "thorough-bred" Javits expansion that Spitzer and other critics such as US Senator Schumer and the *New York Times* had called for, namely more exhibition and meeting room space and a major opening to the Hudson River, would cost $5 billion, which everyone agreed was not economically feasible.

Foye said the best feasible option would now cost $3.2 billion ($2 billion more than HOK's approved plan) and would add considerably less space than HOK's or Rogers's. It would add just 200,000 square feet of exhibition space and 100,000 square feet of meeting room space, as well as a ballroom. People at the announcement expressed dismay at how little extra space would be provided for an expansion that had doubled in price. Nor was it clear where the $3.2 billion would come from, given that Spitzer's contentious relation with State Senator Bruno made additional state funds unlikely. The Hotel Association of New York City, which had funded the original hotel room tax, now insisted they would not authorize an additional tax for a botched process, especially since New York City's tourist economy had become red hot, and filling hotel rooms, the Hotel Association's main motive back in 2004 for agreeing to fund the Javits expansion, was no longer urgent.

So Foye returned to the drawing board. In January 2008 he revealed, again without approval of the Javits Operating Corporation, an even more stripped-down plan which was not even one of the fifteen recommended by the consultants he had hired over a year-long period. There would be a small addition of at most 100,000 square feet (60,000 of meeting space and 40,000 of exhibition space), half what he had suggested in September's already modest proposal, and just a sixth of what was in the HOK and initial Rogers proposals. The space would connect to the current building and be on the block between 38th and 39th Streets. State officials said the scaled-down plan would let them stay within the remaining funds for the project, about $1.6 billion. Foye added that the state, now in a financial panic, also planned a fire sale of two blocks owned by the Javits Center. The state would sell the block bound by 39th and 40th Streets between 11th and 12th Avenues, which would remove the possibility of a future, more ambitious Javits expansion. Also to be sold was the parcel between 33rd and 34th Streets used as marshalling yards, which, if implemented, would seem to make operating the current Javits impossible. The state

would use the proceeds from those sales—estimated at about $800 million—for other economic development projects, including perhaps the recently inaugurated extension of the number 7 subway line from Times Square to 34th Street and 11th Avenue, near the Javits Center.

This plan deservedly received even harsher reviews than the previous ones. Trade show producers and others who used Javits expressed dismay at what seemed to mean that the state had turned its back on the convention industry. Senator Schumer said: "This small amount of expansion space for that much money makes this the worst public real estate deal since the Tweed Courthouse" (Bagli 2008a). Mayor Bloomberg objected vehemently to the sale of land that would preclude a future Javits expansion. An emergency coalition of trade show producers and movers, Friends of Javits, took its case to state legislators, arguing that the design was poorly laid out and would almost certainly lead to a 30 percent increase in production costs, forcing some shows to move to other cities. "If the governor's plan goes through, the trade show business as we know it in New York will wither and shrink," said John O'Connell.

Amid this sea of incompetence, on March 10, 2008, the Spitzer administration imploded as Spitzer resigned two days after being named as a client of a prostitution ring under federal investigation.

Rebuilding the "Temporary Shed"

Finally in March 2009, amid the overall national economic crisis, Barbara Lampen, president of the Javits Development Corporation, came up with a totally stripped-down expansion and renovation plan. The expansion part would basically recreate the "temporary shed" between 39th and 40th Streets that trade show producer George Little had built back in 1998 as a "Band-Aid" while Giuliani and Pataki squabbled, and which had been taken down when it seemed one of the grander expansions would happen. The prefabricated structure would consist of just 80,000 square feet, roughly 25 percent of the 360,000 expansion HOK had envisaged, leaving Javits with a total of 840,000 square feet. One architect dismissed the new, prefabricated shed as the kind you see at Newark Airport's cargo area. The project would also repair the existing Javits building's leaky windows, replace the dark glass with clear glass, and add a "green" roof, an inexpensive gesture to the now-abandoned idea of a rooftop park. Covering six of Javits's twelve acres of roof, this was well publicized as one of the largest green roofs in the country. It would be planted with sedum, would keep heat in the building in winter and out in summer, and would score LEED platinum points. The construction manager explained that "while

no one except maintenance people would be allowed on the roof, it would beautify the view for occupants of the nearby tall condominiums."

The plan at least carried a modest budget. It would cost just $463 million, most of which (about $390) would be spent to renovate the current convention center, repairing its leaky windows and replacing its dark glass windows with clear, energy-efficient panels. It dropped the $700 million in state and city funding that had been part of the original plan and now relied almost entirely on the $1.50-per-night hotel room fee created to pay for the work. "We are focusing on what we can accomplish with the available funds, without precluding what we can do in the future," said Barbara Lampen.

This proposal was greeted with general relief after Rogers's unworkable plan and Spitzer's gyrations. It was workable and modest in cost, while not ruling out a more ambitious future expansion. "It's not how we started out, but it's certainly better than nothing," said one hotel industry representative. "At least we'll get a facelift, some much-needed repairs, and a little more exhibition space" (Engquist 2009).

In July the project was approved by the state's Public Authorities Control Board, with construction to be completed in 2013 (fig. 5.5).

Moving to Queens: The Casino Proposal?

In a bombshell announcement at his January 5, 2012, State of the State Address, governor Andrew Cuomo revealed a plan for the state to partner with the Malaysian private company Genting, which already operated a casino at Aqueduct Racetrack in southeast Queens, to build the largest convention center in the country (3.8 million square feet), centered around the casino. Genting would spend $4 billion to build the complex, including hotels, while the state would provide the land and build the access infrastructure (roads, etc.). After the new convention center was built, Javits would be closed and the land sold for development.

This project was saddled from the start with a central blocking factor: squabbling politicians. Incredibly, Cuomo announced his plan without consultation with Mayor Bloomberg or any of the Javits Convention Center directors or exhibitors. Cuomo and Bloomberg were anyway barely on speaking terms for various reasons, including that, a few months earlier, Cuomo had balanced the state budget by reducing education money scheduled for the city. When Bloomberg's deputy mayor Patricia Harris complained about one of these transactions, a Cuomo aide told her to "go fuck herself." Predictably, by February 2012 Jeff Little, a Javits trade show veteran, and a coalition of Manhattan hotel operators were vehemently

Fig. 5.5. The eventual Javits "expansion" completed in 2010. This very modest amount (80,000 square feet) of new space, described by one architect as "looking like a cargo shed at Newark Airport," is tucked between the existing Javits and Silverstein's One Riverplace apartment building (*right corner*). Photo by Malcolm Halle.

criticizing Cuomo's plan to close Javits, arguing that convention attendees want to be in vibrant Manhattan, not bland Queens (Bagli 2012). Within months the plan collapsed as Genting made demands that could not easily be met, raising the question of whether the company was an unreasonably difficult partner.

CONCLUSION: THE JAVITS BLOCKING FACTORS

By 2013 the Javits Center, which critics had said was unacceptably small as the eighteenth-largest convention center in the country, had slipped to nineteenth! The Javits expansion, in the thirteen years it was in process, ran into all but two of the major blocking factors that can hold up megaprojects. These included squabbles between various government agencies (the MTA bus station versus New York State's Javits Development Corporation); mediocre and incompetent leadership (Gargano, Spitzer, Foye, and Rogers); infighting between politicians (Mayor Giuliani versus Governor Pataki; Governor Spitzer versus State Senate Majority Leader Bruno); political lobbying/cronyism (Pataki's appointment of Gargano,

his former chief fund-raiser, as chair of the State Development Corporation, followed by Gargano's appointment of Petralia, a press officer, as president of the Javits Development Corporation); a private-sector corporation key to the success of a project yet willing to block it (Larry Silverstein building Silver Towers instead of a convention hotel linking to Times Square); three major changes in the economy and real estate cycle as the project stalled (first 9/11's economic shock, then rising construction costs during the 2005–2007 boom, then government budget and private financing crises associated with the 2008 downturn); and attempts to substitute an unrealistically ambitious project (critics wanting Javits opened to the waterfront but without a funding plan; replacing an experienced architect, HOK, with star architect Rogers, who had never designed a convention center).

There were only two blocking factors that the Javits expansion did not encounter. It had no problems with a landmarked building. Nor did it encounter major problems with the neighborhood or community board, since the community board was focusing on trying to stop the NYSCC Center and feared that if it also opposed the Javits expansion it would be seen as against development of any kind, reducing the credibility of its anti-NYSCC campaign. Javits ran afoul of neighborhood/local opposition only indirectly, since it was the demise of the NYSCC, led by community board opposition, that allowed critics to set aside HOK's approved, funded, workable Javits expansion plan and demand a grander one.

On the success part of the ledger, the Mob were evicted, the number 7 subway extension will open in late 2014, Javits's dark windows have been replaced, and a green roof, one of the largest in the country, is under construction.

The Debate over Urban Stadiums: The New York Sports and Convention Center Fight (2004–2005)

The proposed Far West Side stadium will likely be for the Jets and the Olympics, and will have a retractable roof making it multi-use. You can play football there on the good days, and then use it for a second purpose. That would have tremendous economic benefit for the city, namely a big indoor venue. Madison Square Garden holds only 30,000 people. We need a place where 50,000 to 100,000 people can sit indoors and watch something, a concert, a convention, a show. Without such a facility, the city is losing hundreds of millions if not billions of dollars.

—Mayor Giuliani 2000

Opposition to the "stadium" is Nimbyism. They're selfish. They couldn't give a rat's ass about us.

—Caribbean construction worker, February 2005, at NYC council hearings into the NYSCC

The stadium will discourage development, not encourage it. What New Yorkers would want to live in an area overrun by football fans, and from outside the city too? The stadium and fans should go where they are wanted, either New Jersey or Queens.

—Community Board 4 district manager, Anthony Borelli

The findings are neutral with respect to the advisability of stadium investment.

—Economist Dean Baim (1994), author of the authoritative study at the time of the pros and cons of government investment in stadiums

The battle over the New York Sports and Convention Center (NYSCC), though short in duration, was probably the most bitterly fought issue in New York for decades. Supporters and opponents spent over $30 million on media campaigns, an unprecedented sum for a single issue in New York. After the NYSCC's public unveiling at Governor Pataki and Mayor Bloomberg's Javits press conference in March 2004 to announce the en-

tire Hudson Yards program, the fight raged for over a year as the proposal negotiated the approval processes.

Of the three Hudson Yards projects and the Moynihan Station project, this was the only one that met significant neighborhood opposition, the factor so often publicly blamed for the failure of megaprojects. Yet even the NYSCC survived such opposition, only to be finally vetoed by state assembly speaker Sheldon Silver in June 2005 for reasons that likely had as much if not more to do with three other blocking factors—the virulent opposition of a private corporation (Cablevision), political lobbying/cronyism, and squabbles between politicians (e.g., Silver's concern that the Hudson Yards would draw jobs from his downtown constituency). There were, of course, many NYSCC opponents, especially residents of Manhattan's West Side, who believed the stadium project could not stand on its merits and deservedly failed. Still, few of even those opponents argued that Silver's veto was cast strictly on the proposal's lack of merit.

The NYSCC battle also suggests an additional angle on the urban planning view that cultural institutions are a fine tool for "upgrading" an economically stagnant urban neighborhood, as in Richard Florida's writings (2002) discussed earlier. The case of the NYSCC does suggest that, in Manhattan anyway, it is far easier to introduce a major cultural institution, at least one that is "high culture," than a major sports institution. For example, the proposal to locate the Whitney Museum extension next to the High Line entrance encountered little local opposition. Further, after the NYSCC's defeat, the site became a residential and commercial project of the developer Related and included a "Culture Shed" which was explicitly intended to help legitimize the megadevelopment with the surrounding West Side communities (Davidson 2012). Again, the facilitating role of a "cultural" institution, by contrast with that of a sports facility, is apparent. The dynamics of these high-culture versus popular-culture issues have long been analyzed by academics (Gans 1974).

There are, of course, many opportunities for debate. For example, opponents of the West Side stadium would stress "objective" differences between the impact of cultural institutions and stadiums, especially the amount of traffic each brings. In response, stadium advocates stressed that football-associated traffic would occur on average on just ten Sundays a year. Further, a new sports stadium for the New Jersey Nets in Brooklyn's Atlantic Yards (i.e., not Manhattan), also partly sited above MTA railyards, did succeed, opening in 2012 as the Barclays Center, albeit after much opposition. Among the earliest of several plaudits the center received was that it had not brought the traffic chaos that opponents had feared (Berger 2013), and the Municipal Art Society gave the center its 2013 Neighborhood Catalyst award. (Though a different criticism was that the

affordable housing supposed to be part of the package had not happened by late 2013.)

THE STADIUM: HISTORY AND POLITICAL SQUABBLING AS A BLOCKING FACTOR

A stadium on Manhattan's Far West Side, most likely on top of the railyards owned by the Metropolitan Transportation Authority between 30th and 34th Streets (fig. 5.2), was first publicly proposed by New York governor Mario Cuomo in the early 1990s, and then vigorously adopted by Mayor Giuliani in 1994 (Brash 2011, 149). An additional aim of Giuliani's version of the proposal was to keep the Yankees in New York, although Giuliani said the new stadium could be used for football and soccer as well as baseball. The Yankee's Bronx stadium thirty-year lease was due to expire in 2002, and they, especially their principal owner, George Steinbrenner, were unhappy about staying in an aging stadium which they believed was not as prime a New York location as they deserved. So they threatened to leave New York altogether, probably for New Jersey, following similar exits by New York City's two football teams, the Giants in 1976 and Jets in 1984. Giuliani believed the proposed new stadium would entice the Yankees to stay.

The Far West Side stadium proposal was controversial from the start, even though its location above railyards that would not displace a single resident was chosen bearing in mind the "do no harm" constraint to which megaprojects after the 1970s were increasingly subject. When elected in 1995 Governor Pataki opposed the stadium partly because he disliked Giuliani for having supported Mario Cuomo, Pataki's opponent for governor. Pataki was also reluctant to antagonize Bronx voters by facilitating a Yankee departure to Manhattan. So he kept saying that he hoped the Yankees would choose to stay in "their historic home in the Bronx." Since Pataki controlled the MTA, who owned the railyards above which the stadium would be built, his opposition was a big problem for stadium advocates.

A second problem was that some West Side residents and their politicians did not want a stadium anywhere on the West Side, even if built over the MTA railyards. Opponents also tended to argue that the economic benefits to the city of a stadium had been exaggerated and that the economic impact might even be negative, and they often claimed that academic studies showed that stadiums in the United States that were subsidized with public money were usually a swindle of the public by sports owners.

Inflaming the issue, Giuliani announced in 1996 that he wanted to "make Manhattan's West Side the city's sports capital, much as Lincoln

Center is its cultural center." This vision, evoking images of waves of rowdy sports fans and traffic jams, infuriated opponents, who held a rival press conference near City Hall to denounce the project. State senator Thomas Duane, whose political district was in the Far West Side, charged: "Mayor Giuliani is obsessed with stadiums. At any given time, he has half a dozen on the drawing board." Giuliani in turn dismissed the opposition as nimbyist: "Everything I've done they're against. It's almost a signal to me it's the right idea. You've got to keep challenging all the people that sit there saying, 'Ah, can't be done, you can't do it, you shouldn't do it.' Those are the people that are killing the city" (Bumiller 2000).

Nonetheless, by September 2000 Pataki and Giuliani had declared a truce. Pataki now supported a stadium and Giuliani in return no longer obstructed Pataki's Javits expansion and allowed the city and MTA to plan to extend the number 7 subway line from Times Square to the Javits Center and the new sports arena, which would hugely benefit both projects. So infighting between politicians—here the governor and mayor—was removed as a blocking factor.

Key to getting Pataki's support for the stadium was that it would now likely be not for the Yankees, but for the Jets football team, and also for a possible Olympic stadium should New York win a bid to host the 2012 games. Pataki was a Jets fan—the team used to practice in the town of Peekskill in upstate New York, where he had been mayor. Also, a Jets tenancy meant he would no longer be alienating Bronx voters by supporting a Yankee move from the borough. Finally, the proposed stadium building would be multiuse with a retractable roof and could serve as additional convention space (a major Pataki goal) to Javits's south, complementing HOK's planned northward Javits expansion, as Bloomberg and Pataki explained in their March 2004 press conference.

In easing the Yankees out of the proposed stadium, a change with which their owner George Steinbrenner was not happy, two developments were crucial. First was the involvement of Daniel Doctoroff, who, as president of New York City's bid for the 2012 Olympic Games, was pushing for an Olympic stadium. Doctoroff, a young, talented investment banker, had become rich in various positions, working for Lehman Brothers, managing Texas billionaire Robert Bass's money, and as a partner in Oak Hill Capital, where he managed hundreds of millions of dollars in hotels, drugstores, and real estate. Inspired by witnessing the international camaraderie of spectators at a 1994 World Cup soccer match between Italy and Bulgaria at Giants Stadium in New Jersey, he founded and financed the nonprofit NYC2012 using $4 million of his own money and created a board that included Bloomberg, then a wealthy businessman who had never held political office. Doctoroff convinced Giuliani, and in June 2001 the

city submitted a bid to the US Olympic Committee to host the 2012 Olympic Games, with a Far West Side stadium as the bid's centerpiece.

The second key development was that in 2000 Robert Woods Johnson purchased the Jets football team and wanted to return it to New York from New Jersey, where it shared a facility as a junior partner with the Giants. A Manhattan arena was a huge enticement, and the Jets were willing to pay most of the costs of building a new stadium there. For Doctoroff, Giuliani, Pataki, and Bloomberg, having the Jets pay for an Olympic Stadium seemed a bargain for the city.

To help obtain Giuliani's and Pataki's support for the Jets package, the Jets had hired as lobbyist/consultants Peter F. Powers, a former deputy mayor and friend of Giuliani's, and Kieran Mahoney, a Pataki friend.

Giuliani held a news conference in September 2000 announcing that the stadium's latest incarnation would likely now be for the Jets and the Olympics, not the Yankees, and that it would have a retractable roof, making it multiuse. He set out the case succinctly: "It would be open so that you could play football there on the good days," Giuliani said. "You could close it, not only for football, but for a second purpose. That would have tremendous economic benefit for the city," namely a big indoor venue. Noting that Madison Square Garden holds only 20,000 people, he urged: "What we need is a place where 50,000 to 100,000 people can sit indoors and watch something, a concert, a convention, a show." Without such a facility, he said, the city is losing "hundreds of millions if not billions of dollars," adding that a large indoor arena would allow the city to compete for events like the Super Bowl (Bumiller 2000).

THE NYSCC AND ITS SUPPORTERS: 2004

A month after being elected mayor in November 2001, Bloomberg signaled his commitment to the stadium, and to New York's 2012 Olympics bid, by appointing Doctoroff as deputy mayor for economic development and rebuilding. Doctoroff, like the mayor, took a nominal salary of $1 in the job. Doctoroff's appointment had broad support in the corporate world and among Bloomberg's staff. Nat Leventhal, head of Bloomberg's personnel search committee and a board member of NYC2012, commented: "The job required self-starting initiative and creativity and a quality of not being confined by the regular bureaucratic way of thinking. I never had anyone else in my mind" (Brash 2011, 83).

The stadium and Javits expansion were part of the economic growth projects that the city was encouraging on the Far West Side, which, with preservation projects such as the High Line and Gansevoort Market Historic District, the city believed presented a balanced package of growth

Fig 6.1. New York Sports and Convention Center: "Multiuse facility."

offset by preservation. Since the growth projects inevitably included opportunities for corporations and real estate interests, some critics said that was their main purpose. This seems too simple. It is equally plausible that Doctoroff and Bloomberg believed their growth projects were simultaneously ways of creating jobs for residents, of competing with other notably global cities, and of presenting opportunities for corporate profit, which they certainly favored too.[1]

Bloomberg and Doctoroff also believed, as they had insisted with the High Line, that the tax revenue accruing to the city from growth projects, albeit over several years, must exceed what the city spent on the project, especially to get it started. In short, city expenditures should be made as "public investments." For Doctoroff and Bloomberg, getting the Jets to build New York's Olympic stadium was a great deal for the city, and more than justified the city and state's contribution for infrastructure, as they repeatedly said during the fight over the NYSCC.

In making this case, advocates for the NYSCC in 2004 kept stressing that it was a "multiuse facility" integrated into the Javits Convention expansion (fig. 6.1). Hence they insisted on calling it not a "stadium" but the New York Sports and Convention Center. It could serve as a stadium but also, with a retractable roof, as part of the Javits expansion. Supporters said, as had Giuliani, that the ability to host over 60,000 people in a single forum would allow Javits to schedule large gatherings of people who wanted, for example, to hear speakers during annual conventions and

Fig. 6.2. Union workers supporting the NYSCC. Photo by David Halle.

plenary sessions, or attend large concerts. They stressed that this filled a major gap, since the only comparable facility in Manhattan, Madison Square Garden, held only 20,000 people. While true, this set the stage for MSG's owners, the Dolans, to view the NYSCC as a major threat to their business, one they were determined to stop.

In November 2002 the US Olympic Committee chose New York City over San Francisco to represent the US in the worldwide bidding process, with the proposed West Side stadium as a key component of New York's bid. Helpful here was that the New York developer Roland Betts was on the Olympics Committee and Betts and Doctoroff had worked together on World Trade Center ground-zero issues.

So Mayor Bloomberg, Governor Pataki, and the Jets football team were now strong supporters of the NYSCC, as were the major unions who would benefit (construction and hotel workers; fig. 6.2) and many minority politicians who often represented these workers.

THE OPPONENTS

Vocally opposed to the NYSCC was a coalition of local West Siders, led especially by Community Board 4, who feared the NYSCC's effect on their neighborhoods, above all from traffic. Also against were local politicians representing the Far West Side, including City Council member Christine Quinn, state senator Thomas Duane, and state assembly

member Deborah Glick, all following the views of their organized constituents. This coalition had honed its skills in the 1990s opposing Mayor Giuliani's proposed Yankee stadium on the railyards. Meanwhile NYSCC's supporters, in what in retrospect seemed a tactical mistake, presented their case in basically economic terms as a job and revenue booster for the city, but offered little to compensate West Side residents for the NYSCC's presence. Several creative options along these lines could have been, but were not, suggested (e.g., allowing local school sports teams to practice at the NYSCC, setting aside some free Jets tickets for local kids allocated via a lottery, and even pro bono coaching from some of the Jets stars).

By 2004 the *New York Times* was adamantly opposed, although this was a reversal. In 2001 when the NYSCC was first suggested the *Times* (2001a) had called it "a promising proposal for Manhattan's West Side, with a football stadium for the Jets that converts into an expansion of the Jacob Javits Convention Center." Why the *Times* became so anti-NYSCC after initially supporting the idea is unclear, but probably important was that many of its journalists were West Siders and did not want the NYSCC anywhere near them. Opposed too were some sports economists and sociologists who argued that sports stadiums were usually, even always, rip-offs of the taxpayers that enriched the franchise owners.

An additional, key opponent was Cablevision, which, as the owner of Madison Square Garden and the Knicks basketball team, feared competition for its venues from the NYSCC. Cablevision was owned by the Dolan family, whose hostility to a new home for the Jets also had a revenge ingredient, since Charles Dolan, Cablevision's chairman, had competed unsuccessfully with the Robert Wood Johnson family to buy the Jets in 1999–2000.

So one reason the NYSCC dispute was so public and bitter was that each side included a major sports corporation with the resources to fund a huge campaign. The New York State Lobbying Commission's annual report revealed that Cablevision and Madison Square Garden had in 2004 spent $22 million, the bulk on antistadium ads in the media but also on antistadium lobbyists in Albany. The Jets spent less, $6.8 million. These were huge sums for a single issue.

THE INTELLECTUAL CASE FOR AND AGAINST THE NYSCC

Beneath the mudslinging, the core debate involved two main issues. First, the economics of the NYSCC stadium. For example, how much extra benefit (e.g., in the form of tax revenue from the stadium itself, and from development that it might stimulate) would a stadium bring to the city? This is a crucial aspect of most stadium proposals, since they usually

require some public (city or state) expenditure—for example, on infrastructure such as access roads and a rail or subway station—which needs to be justified as an appropriate use of city funds. The main infrastructure required for the NYSCC was the platform over the railyards on which the NYSCC would stand, and the retractable roof.

The second core issue in the debate was the NYSCC's likely effect on the quality of life in the surrounding areas (the "neighborhoods") of the Far West Side. How negative would that be? The following discussion lays out the data on these two central issues.

The Financial Debate

Those city and state officials who favored the NYSCC insisted it was an excellent deal, especially economically, in line with Bloomberg and Doctoroff's view that public funds used for such projects needed to produce future tax revenue for the city at least equal to the initial expenditure (that is, they should be good public "investments," the standard the city had set to justify its $110 million contribution to the High Line). Officials kept stressing that the NYSCC was a multiuse facility that could serve as a second Javits Center expansion where 60,000 people could hear plenary convention speakers in one covered auditorium, which New York City could not otherwise host.

As regards financing, the Jets would pay the entire $800 million for the building and also give $250 million to the MTA in exchange for rights and a very long lease to develop on the Western Rail Yards.

Key was justifying the $600 million that the state and city proposed to contribute for infrastructure—$300 million from the state for a platform over the railyards and $300 million from the city for the retractable roof. City and state officials insisted that having the Jets pay for a building that the city and state could use for conventions and other events was a bargain for the public sector and justified the infrastructure costs.

The city also argued that the public contribution of $600 million was, in itself, a profitable investment for the public. The funds for the NYSCC would not come out of the city or state's current budget (i.e., it would not be "taken away" from schools, fire, and police services, as the opposition claimed) but was a capital expenditure to be financed by a $600 million bond issue. Also, the $43 million annual interest payments on the bonds would be less than, and therefore paid for by, the $66.5 million annual tax revenues generated by the NYSCC. These revenues would consist of $19 million from about seventeen stadium events such as Jets football, $12 million from two giant events such as a Super Bowl, $11 million from three plenary sessions such as conventions, and $23 million from

twenty-five exhibition events. So there would an annual surplus to the city and state of $23 million.

The respected Independent Budget Office (IBO 2005) scrutinized these revenue claims and reduced the predicted tax revenue from $66.5 million to $51.9 million and therefore the public bond-issue's surplus from $23 million to about $9 million, revisions that the city accepted. Nine million dollars, the city insisted, was still a surplus. Over the NYSCC's projected lifetime (to the year 2035), the IBO calculated the surplus as $210 million in 2005 dollars. In its calculations the IBO stressed, as had the city, that if the NYSCC operated only as a football stadium it would make a loss, but operating also as a convention center the NYSCC would make a surplus. In the IBO's words:

> One of the critical questions asked of the proposed New York Sports and Convention Center is whether the fiscal benefits generated by the facility would equal or exceed the public costs. Were the facility to operate only as a football stadium, the answer to that question would be no; without convention activity—or even with a small amount of convention activity—the NYSCC would fall short as a long-term public investment. But the amount of new convention activity needed for the city's and state's investments to break even is less than two-thirds the amount of such activity anticipated by the IBO. At the level of usage projected by IBO, tax revenues generated by the NYSCC would be sufficient to cover the city's and state's anticipated costs and provide total public sector surpluses totaling over $200 million over the project's term of financing. (IBO 2005, 6)

The city also estimated that the NYSCC would create about 7,500 permanent jobs (direct and indirect) and over 13,000 temporary construction jobs. Promising to set aside 25 percent of these jobs for minorities, the Jets won over many minority politicians, including Al Sharpton and Harlem congressman Charles Rangel (though Manhattan borough president Virginia Fields basically sat on the fence).

Opponents, by contrast, attacked the $600 million that the city and state would contribute for infrastructure, which they argued was way too much, and the $250 million that the Jets would pay the MTA for developments rights of the Western Yards, which they argued was way too little.

On the $600 million, opponents mostly avoided detailed discussion of the economics of the case, preferring to attack more generally the idea of any city or state contribution. For example, rather than directly address the city and state's (Independent Budget Office–supported) claim that the $600 million would come out of the capital budget and was a profitable investment, opponents kept saying that the "$600 million" would be taken from the current budget and therefore decrease what was available

Fig. 6.3. West Siders opposing the NYSCC.

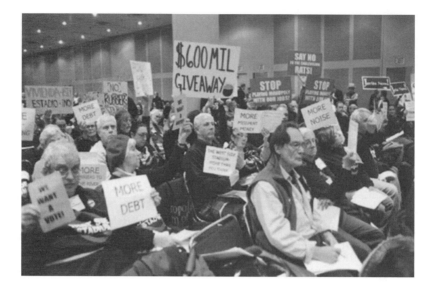

Fig. 6.4. Anti-NYSCC billboard, Manhattan's West Side. Photo by David Halle.

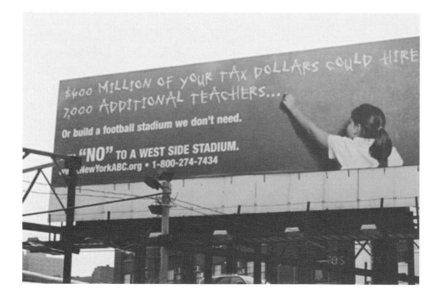

for schools and hospitals. This blurring of the distinction between current and capital spending was a key part of the opposition ad campaign (figs. 6.3 and 6.4).

Are Urban Stadiums Taxpayer Rip-Offs?

Likewise sticking to programmatic statements, opponents continually claimed that research by leading sports economists had shown that urban stadiums partly financed by government are always taxpayer rip-offs that never deliver offsetting economic benefits to the city and neighborhood. Here opponents repeatedly invoked sports economist Andrew Zimbalist, who had earlier dismissed as "utter gibberish" Giuliani's economic case for building a Yankee Stadium on the West Side, and who likewise denounced the NYSCC.

This view that government subsidies for stadiums are always taxpayer rip-offs was debatable. For one thing it misrepresented the academic literature. A careful review by economist Dean Baim of fifteen sporting stadiums built before 1994 concluded that whether a particular city or state recovers its investment in a stadium depends on each situation, which was exactly the city's position vis-à-vis the NYSCC. In particular, Baim argued that whether government (local and/or state) subsidy for a stadium was justified economically usually depended on the size of the external economic benefits, for example extra tax revenue, that the city receives from the stadium. As a result, he concluded, "it should be stressed that these findings are neutral with respect to the advisability of stadium investment" and complained that both advocates and opponents of stadium investment had sometimes made partial use of his findings to argue that stadiums were always a good or always a bad idea, rather than looking in each case at the specific situation (Baim 1994, 217–20).

In arguing that the academic literature showed that stadiums were always taxpayer rip-offs, NYSCC opponents basically misinterpreted a set of studies (especially by Zimbalist) whose main argument is that moving a stadium from one location to another within the same region produces *no net economic gain to the region.* So, for example, if the Jets moved from New Jersey to Manhattan, there would be no net economic gain for the New York–New Jersey region, but a possible gain for Manhattan at New Jersey's expense.

Ironically, this argument implicitly supported the claim of New York City and the state that bringing the Jets back to the Far West of Manhattan would produce economic benefits to New York City, albeit at New Jersey's loss, which was not, understandably, of much concern to New York City or state officials. Urban planner Alexander Garvin had made

this general point three years earlier in an evenhanded discussion in his planning textbook of the pros and cons of stadiums: "The people coming to all but a few sports events come from the same market area [i.e., the local economy]. Nevertheless, a new stadium may add a great deal to the economy of the surrounding city when it attracts sports fans who would otherwise be attending games in other parts of the region" (Garvin 2002).

Garvin was centrally involved, under Doctoroff, in advising the city on its overall plan for the 2012 Olympics, which he strongly favored with the NYSCC as a key component. Perhaps because he was working for the city, he refrained from publicly participating in the detailed NYSCC debate.[2]

Likewise, the "economic substitution" argument by some economists —that a city should not necessarily subsidize the renovation of one of its stadiums because when fans spend money on stadium-related events they are simply diverting funds from other leisure activities in the city—may have validity for renovating an existing stadium in the city. It loses validity if applied to a city attracting a new stadium from another, nearby state, since the city is now recovering expenditures that its own residents are currently making out of state, and probably attracting expenditures from the neighboring state's residents.[3]

Certainly sports franchises are inclined to use the possibility of relocating in order to play political jurisdictions against one another so as to get the best financial deal. This is a valid reason for mistrusting such franchises. But that does not mean a city can never negotiate a favorable deal for itself when building a stadium, especially a city with New York's attractions.

Still, the idea that the NYSCC must be a public rip-off was generally allowed to stand in the public debate, as opponents asserted that the academic literature had shown stadiums to be so.

Compensating the MTA

A separate debate was the adequacy of the $250 million that the Jets would pay the MTA as ground rent for development rights over the Western Rail Yards. This did not become a heated issue at first, partly because $250 million was a substantial sum which, as always, the MTA desperately needed as it raised fares on its buses and trains to offset rising costs. Without a concrete counterproposal for the Western Yards development rights, the Jets cash offer was hard to turn down, although major opponents generally grumbled that it was too little—a "giveaway between two greedy billionaires, Mayor Bloomberg and Jets owner Woody Johnson" was a common jibe.

Then in February 2005 Cablevision, in its efforts to stop the NYSCC, dropped a bombshell. It made a counterproposal for the site, offering to pay the MTA $600 million for development rights to build mostly condo skyscrapers there. About half of this would pay for the platform, leaving the MTA with about $300 million, and no need for the city or state to put in anything.[4]

The MTA briefly considered Cablevision's bid and then rejected it on the grounds that the Jets proposal served the public interest far better. For example, without the stadium there would be no centerpiece of the city's bid for 2012 Olympics, and no extra Javits convention space.

Interestingly, a few years later in 2008, and after the NYSCC was defeated, the developer Related agreed to pay the MTA ground rent for the rights to build tall condos and offices on the railyards, which was basically Cablevision's proposal. Arguably the Jets proposal, with an immediate cash infusion of $250 million for the MTA, was a better deal for the MTA than Related's stream of $1 billion spread over a ninety-nine-year lease with just a small initial payment, though much would depend on the details.[5]

The Neighborhood Effect Argument: Arts Centers, Not Football Fans

Opponents repeatedly denounced the city's plans for the "neighborhood." They said there would be two serious spillover effects from the NYSCC, traffic and rowdy football fans. Traffic was a crucial part of the opponents' objections. How much traffic there would be was hotly disputed. The city's 2004 *Draft Environmental Impact Statement* (NYC 2004) predicted that about 68 percent of fans would arrive by mass transit, rising to 75 percent when the number 7 subway extension was built. These figures were based partly on surveys of Jets season-ticket holders and partly on the NYSCC site being just a ten-minute walk from the mass-transit hub at Penn Station. The city argued that the Western Rail Yards site had deliberately been chosen for its proximity to Penn Station, making the NYSCC the kind of (mass) "transit-oriented" project that environmentally responsible administrations should encourage. Opponents countered that a more accurate figure for fans using mass transit might be as low as 55 percent, based on Boston's Fenway Park. The city, in response, stressed the propensity of New Yorkers to use mass transit, insisting that in no other US city do 80 percent of people come to work this way. It also stressed that extra traffic would occur on a tiny number of days each year, eight Sundays of the regular football season plus any playoff games.

The city also repeatedly argued that the NYSCC site was not a neighborhood in any sense that social scientists would recognize. It was a dismal railyard pit surrounded by tall fencing with minimal street life (fig. 5.2), and had been deliberately chosen as the NYSCC site for that reason. The days when New York City proposed, in the style of Robert Moses, physical destruction of numerous homes and stores to make way for grand civic projects were long gone, NYSCC advocates argued.

It also became clear that a major factor behind some West Siders' opposition to the NYSCC was a distaste for ordinary football fans. At several anti-NYSCC meetings residents expressed fears of beer-drinking fans, especially from New Jersey, roaming the West Side to improvise tailgate parties. For example, Community Board 4's district manager said: "The stadium will discourage, not encourage, development. What New Yorkers would want to live in an area overrun by football fans, and from outside the city too? They [the stadium and fans] should go where they are wanted, either New Jersey or Queens."

Opponents, along these lines, repeatedly said that the stadium should be in another borough, especially Queens. Hearing such views, the construction unions took to calling opponents nimbyist. For example, a Caribbean construction worker at New York City Council hearings into the NYSCC in February 2005 said, "Opposition to the 'stadium' is Nimbyism. They're selfish. They couldn't give a rat's ass about us."

The city countered that a facility in Queens would definitely be an economic waste, unused most of the year except for football games, unlike the NYSCC, which, located next to Javits, would also host convention business.

Richard Florida (2002) and others have written extensively about how cultural institutions can be used to "upgrade" a depressed urban neighborhood. What is apparent, adding an interesting angle to Florida's approach, is that, for some West Siders, the cachet of "culture," at least "high culture," and its audience, was far higher than that of sports institutions and their fans, especially football fans from New Jersey. For example, West Siders were generally happy to have cultural institutions and their audience in the area. The Whitney Museum of American Art's extension, proposed for the edge of the Meat Market, generated almost no neighborhood opposition. The city even made the massive rezoning of the Hudson Yards more palatable to the local community board by adding space for a major "cultural center." By contrast, many West Siders were uneasy about, or hostile to, having sports fans and institutions anywhere near. It is true that a sporting event generates traffic buildups that cultural institutions typically do not. Still, the perceived status gap between cultural and mass

sporting institutions, as well as their respective attendees, clearly fueled opposition to the NYSCC.

The city was, however, somewhat uncreative about offering ways to compensate West Siders for the NYSCC, even though planners understand the need for such compensation. For example, California planner Michael Dear (1992) offers a menu of suggestions for dealing with nimbyism. Likewise New York planner Garvin (2002, 28) cautioned: "Public action is increasingly hard to justify if it achieves only a single purpose without providing additional benefits to the surrounding community." The city and the Jets might, for example, have allowed West Siders to benefit from the Jets' presence by measures such as permitting local schools' football teams to practice at the stadium. How far such offers would have undercut the local opposition is unclear. Still, they were apparently not made.

THE COURSE OF THE BATTLE

The Dolan family (Cablevision, Madison Square Garden) first limited its NYSCC opposition to privately lobbying the mayor to cancel the project. But by May 2004 open warfare had broken out. Cablevision, the city, and the Jets were running television ads making their respective cases, aiming to pressure elected officials—state and city—in the context of the public approval process.

Since the NYSCC was on MTA-owned land, it needed state approval (from the New York State legislature and the state's three-person Public Authorities Control Board [PACB]), and did not need to go through the city's ULURP approval process. Doctoroff and other city officials had originally seen this as a convenient way of circumventing political opponents in the city, since they knew, based on earlier opposition by West Siders to moving Yankee Stadium there, that the NYSCC would be strongly opposed by some city residents. Indeed, in part they had deliberately detached the NYSCC from the larger proposal to rezone the Hudson Yards because the latter did have to go through the ULURP process.

Doctoroff and the others did not, of course, anticipate the NYSCC having fatal problems with the state's PACB. The PACB was created in 1976, a year after New York City's near bankruptcy, in order to monitor the growing debts of New York State's public authorities. Since 1938 public authorities in New York State have had the power to contract debt independently of the state, a power widely used by Robert Moses in the 1950s and 1960s, for example, with the Triborough Bridge Authority. But the PACB has the authority to approve the financing and construction of any project proposed by any of those public authorities (including the state's

Empire State Development Corporation, which was making key NYSCC decisions). The PACB's three voting members include the governor, the speaker of the state assembly, and the leader of the state senate, each of whom has a veto over any proposal.

Cablevision's ads suggested that New York (state and city) could use their $600 million infrastructure contribution for far better purposes than a "stadium for the Jets." These ads ignored the city and state's contention that the funds would come from the capital budget, not the current budget, and that the interest on bonds to raise the $600 million would be more than covered by revenue to the public sector generated by the NYSCC. Instead, the typical ad said:

> What could New York do with $600 million? Rebuild our schools. Put a computer in every classroom or reopen neighborhood fire stations. With $600 million, we could improve community health clinics, and offer more affordable care to New Yorkers. So here's the choice: Invest $600 million in neighborhoods, or spend it on a West Side stadium for the Jets.

Mayor Bloomberg denounced the ads and took to calling Cablevision a "lying monopolist." He complained: "One company, in order to protect their own commercial interest, is trying to stop jobs coming to this city. That's an outrage. Besides, the Garden will only compete with the West Side stadium for a few events a year. And yet, Jim Dolan is driven to spend millions on negative ads—and even more dough on lobbying the elite" (Roberts 2004). Seth Abraham, the former president of Madison Square Garden/ Radio City Music Hall, offered a plausible explanation for Jim Dolan's opposition to the NYSCC:

> Jim Dolan believes the West Side stadium is competition that could dull the shine of the Garden. And this passion burns bright enough for him to take on Mayor Bloomberg and Governor Pataki and anyone else. His real fear isn't the financial competition from Woody's stadium, but of a rival to the Garden's image. What becomes of its mystique as the sports mecca if the New York City skyline is silhouetted with a facility that is bigger, sleeker and the talk of the town? (Roberts 2004)

The battle escalated in early August 2004 when stadium opponents—with Cablevision and its allies as the driving force—hired Arthur Finkelstein, a specialist in political attack ads. Finkelstein was recruited by former senator Alfonse D'Amato, who worked as a lobbyist for Cablevision. The first new ad showed raw sewage pouring into the Hudson River and claimed that the stadium would result in the designation of nearly a hundred sites as "potentially contaminated with hazardous waste."

Actually the ad drew from sections of the 2004 *Draft Environmental Impact Statement*, which discussed the impact of the entire Hudson Yards rezoning, not just the NYSCC. Charles Bagli, the *Times*'s main reporter covering the stadium debate, who usually gave an antistadium slant to his articles, said the ad involved "breathless exaggeration" and only "provides fodder for the stadium supporters to depict the opposition as liars." Mayor Bloomberg called it a "disgrace" and "full of lies."

The *New York Times* ran a barrage of "antistadium" editorials—one a month from January 2004 through February 2005. These typically followed the opponents' tendency to make programmatic statements that did not really address the data. For example, one editorial dismissed, without any data discussion, as "mostly a mirage" the claim that the NYSCC would host conventions and therefore generate revenue, even though the IBO had agreed that it would.[6]

The battle took place in the lobbying arena too and underlined New York State's startlingly corrupt practices, which, for example, allowed lobbyists to make payments to close relatives of politicians making decisions the lobbyists wished to influence. For example, Cablevision, in addition to hiring Finkelstein and D'Amato, who were close to Governor Pataki, hired as an anti-NYSCC lobbyist Kenneth Bruno, the son of Joseph L. Bruno, the powerful Republican leader of the state senate. Despite this lobbying, neither Pataki nor Bruno switched to openly opposing the NYSCC, although in the final PACB vote Bruno abstained, which was effectively a "no" since the vote had to be unanimously positive to pass.[7]

Cablevision had more success with state assembly speaker Sheldon Silver. It hired as lobbyist Patricia Lynch, Silver's former communications director, who was generally agreed to be the lobbyist with the most influence on Silver and whose firm was, in 2009, the second-highest paid lobbying firm in New York, earning $8.5 million in fees and expenses (Campanile 2010). Hiring Lynch certainly did not guarantee a favorable outcome. For example, several years later supporters of congestion pricing (a method of controlling traffic entering Manhattan) hired Lynch to influence Silver, but he vetoed the measure anyway. Still, everyone familiar with state politics knew that, in New York State's "pay-to-play" politics, hiring Lynch substantially increased the chances of Silver supporting a project. It was impossible to know if Silver's law firm was receiving direct payments from the Dolan family as well, since, amazingly, state law at that time allowed Silver to have undisclosed amounts of cash funneled into his law firm without releasing full records. (In 2011 newly elected governor Andrew Cuomo pushed through a measure requiring such disclosure.) In 2010 Lynch paid a $500,000 fine after state attorney general

Andrew Cuomo uncovered an influence-peddling scandal she was heavily implicated in involving corruption in the New York State comptroller's office (*New York Times* 2010).

The Jets, in turn, hired their own lobbyists and consultants with ties to Governor Pataki, though none were related by kin. They included Lou Tomson, a former top aide to Pataki, and Michael McKeon, the governor's former spokesman.

The Jets and Cablevision both courted state and city elected officials, making politically savvy campaign contributions and other efforts. The Jets wooed black and Hispanic politicians in the City Council and in Albany with their claim that the stadium would produce thousands of jobs and promising that many would go to blacks and Hispanics, as well as minority-owned businesses. In February 2005 Herman Edwards, the Jets' head coach, who is black, advocated building the stadium in a speech to the Black, Puerto Rican and Hispanic Legislative Caucus dinner in Albany. The Jets owner, Woody Johnson, and team president Jay Cross, met with key figures like assemblyman José Rivera, the Bronx Democratic leader who headed a black and Hispanic coalition that fought for jobs at New York City construction sites. Soon, Rivera was introducing Johnson to people at Bronx Democratic dinners, while major Bronx politicians endorsed the project.

On November 4, 2004, the state's Empire State Development Corporation (its economic development authority) gave initial approval to the NYSCC plan. This approval came only eleven days before the city and its bid committee, NYC2012, had to submit their proposal for the 2012 Games to the international committee in Switzerland. New York was competing against London, Madrid, Moscow, and front-runner Paris.

The 2005 Mayoral Election

By November 2004 the stadium was firmly implicated in the 2005 mayoral election, so the NYSCC ran into a new "competing politicians" blocking factor for megaprojects, having survived the earlier Pataki-Giuliani feud. In particular, city politicians who opposed the NYSCC now tried to stop the city's $300 million infrastructure contribution to the NYSCC, which created a serious problem.

All the 2005 candidates who were considering challenging Mayor Bloomberg's bid for a second term positioned themselves on the stadium. Bloomberg's leading opponent in the polls was Fernando Ferrer, former Bronx borough president. So Cablevision hired as its vice president for government relations Lorraine Cortés-Vázquez, who was close to Ferrer's political operatives. Bloomberg complained that Cablevision's tactic was

"to hire somebody representing each politician who could possibly affect the decision" (Steinhauer 2004). Ferrer dismissed this charge as "hysterical and baseless," but duly opposed the stadium anyway.

City Council speaker Gifford Miller, another likely mayoral candidate, for a while remained silent on the stadium despite being asked repeatedly by reporters for his position. Then in November 2004 Miller expressed his opposition, in an apparent attempt to keep up with his Democratic rivals. He called for a public referendum on the stadium, but only after Ferrer did, and advocated moving the stadium to Queens after another mayoral candidate, Weiner, did.

In January 2005 the City Council formally approved the Hudson Yards rezoning (for office towers, housing, parks, and a new boulevard), but stipulated that none of the funds from the rezoning could be used for the city's $300 million share of the NYSCC costs. Gifford Miller proclaimed: "Not a dime goes to a stadium. That isn't in the best interests of the city." New York State's Empire State Development Corporation then quickly gave its final approval for issuing $300 million in state bonds for NYSCC infrastructure costs, though it was subject to the state PACB's approval, which eventually proved fatal to the NYSCC.

After having initially said that the city's $300 million contribution to the NYSCC would also come from a bond issue, the city grew quiet, probably concluding that the City Council under Gifford Miller would deny a bond issue. Helping opponents of the bond issue, Richard Ravitch, the respected former head of the MTA, objected that the city would be financially liable to bondholders if the bonds failed.

In early February 2005, after months of questions from council members and financial experts about how the city would pay for its $300 million investment in the NYSCC, Mark Page, the city's budget director, informed a City Council hearing that the city would use a fund known as PILOTs (payments in lieu of taxes). The city clearly hoped it had found a funding source that bypassed Gifford Miller and the City Council. PILOT payments are often negotiated by the city with businesses or institutions that are building projects on city-owned land, sometimes as part of arrangements to keep them from leaving the city. The city provides various incentives and, because the project is on city-owned land, sets an annual payment in lieu of taxes (PILOT) that is usually less than the property taxes on privately owned land. Many of the payments flow to the city's Industrial Development Agency. Although City Council approval is required for budgeting most city revenues, PILOTs had long been a little-known revenue stream over which the mayor has complete discretion.

In March, Gifford Miller countered the PILOT funding idea by proposing legislation requiring a public review of any taxpayer money used for

the stadium, which would mean PILOTs could not be used without City Council approval. He announced that the legislation would "stop the mayor's plan to finance the stadium through a slush fund." Again, the press noted the politics: "Mr. Miller, a Democratic mayoral candidate," advanced this "tough stance on the West Side stadium amid criticism that he has not done enough to block it" (Hu 2005).

Still, everyone knew that the NYSCC's future also relied on the politics of Albany, where each of the three men on the infamous Public Authorities Control Board (PACB) had a veto over any expenditure by a New York State public benefit corporation. The expenditure in this case was the Empire State Development Corporation's proposal to issue bonds to meet the state's $300 million contribution to the NYSCC. On the PACB, Governor Pataki supported the NYSCC, and senate leader Joseph Bruno, though officially undecided, was expected to go along with his fellow Republican, the governor.

The problem was the PACB's third vote, state assembly speaker Sheldon Silver. Doctoroff, in earlier strategy discussions in 2004, had foreseen the main political problem as coming from the West Side's city politicians, which is why the city separated the NYSCC from the broader Hudson Yards rezoning so as to avoid the NYSCC going through the city's ULURP. Doctoroff had predicted that eventually Silver would support the NYSCC, so no major efforts were needed to court him. This was a mistake.

By February 2005, the city, now very concerned, began to more or less "buy" Silver's support. For example, Bloomberg announced that the city would build a school in Silver's Lower Manhattan neighborhood. Silver kept repeating that he was officially undecided. But he was certainly concerned that the NYSCC and Hudson Yards would draw jobs and development from his constituency downtown. For example, in April 2005 Goldman Sachs, which had previously proposed building a headquarters office tower in Battery Park City, dropped its plans on the grounds that the redevelopment of the former World Trade Center site was in limbo. Silver, furious, blamed the city for paying insufficient attention to the site, and to downtown in general (Brash 2011, 241).

Then in February 2005, Cablevision tried to scuttle the NYSCC by offering to pay the MTA $600 million for development rights for an entirely different project on the Western Rail Yards—mostly expensive, privately owned, condo skyscrapers, but not a stadium. Still, at the end of March the MTA board voted unanimously to choose the Jets' bid, saying the Jets' proposal was better for the long-term interests of the MTA and the city.[8]

Cablevision then filed a lawsuit to block the project, accusing the MTA of abandoning its fiduciary duty by snubbing the company's offer of more money for the rights to build condos over the yards. On June 3, a state

supreme court judge ruled that the MTA's decision was legal. This was a major step forward for the NYSCC.

What's more, on March 24 the NFL owners had awarded the 2010 Super Bowl to New York, provided the NYSCC was built, another major step forward.

THE END OF THE NYSCC: THE BLOCKING FACTORS

So the NYSCC was still alive and, despite uncertainty over the city's contribution, had reached the last stage of the (state) approval process. Then on June 6, 2005, Silver vetoed it as a member of the State Public Authorities Control Board, killing the project. No one could be certain why, but the most plausible reason was that he saw the Hudson Yards project as drawing jobs and economic vitality from his own constituency in downtown Manhattan. The day after his veto he said: "Am I supposed to turn my back on Lower Manhattan as it struggles to recover? For what? A stadium? For the hope of bringing the Olympics to New York City?" (Bagli and Cooper 2005).[9] So key here was the "competing-politicians" blocking factor, in the form of Bloomberg and Silver. A secondary reason for Silver's veto was likely Patricia Lynch's lobbying on behalf of Madison Square Garden/ Cablevision and the Dolan family.

The NYSCC's demise was probably also the death knell for New York City's 2012 Olympic bid, although it was not the only problem facing the bid. At least as serious was anti-American sentiment in the International Olympic Committee (IOC), associated especially with dislike for George W. Bush and the Iraq war. Over the next few weeks, New York City tried to salvage its Olympic bid by cobbling together a proposal to place an Olympic stadium in Queens. Still, on July 6, the IOC voted to award the 2012 Olympics to London. The demise of the NYSCC, the lynchpin of New York's bid, had not helped, although the IOC also bypassed front-runner Paris.

Summarizing disappointment over the NYSCC and the Olympics bid, and offering an analysis of the basic problem, New York's US senator Schumer commented: "A culture of inertia has settled on New York. Critics are given more weight than those trying to build. It doesn't matter how small a constituency or flawed an argument the critic possesses." Likewise, Bloomberg in April had complained:

> Most of the people that are criticizing [the NYSCC] have never built anything in their lives, and they are not willing to put their own money up. . . . It takes courage to go and build things. . . . It would be a tragedy if we let the naysayers stop us doing things. What has always been great about New

York has been that we've built the big things and taken the risks. . . . If you don't run any risks you will never make any progress. (Cassidy 2005)

While "culture of inertia" is not wrong as an umbrella term for the various blocking factors the NYSCC ran into, it is more useful to unpack them. The NYSCC met far more neighborhood opposition than any of the megaprojects considered here, and opponents would likely say it deserved to fail on the merits. But such opposition did not kill it, at least not alone. The NYSCC also encountered at least three other of the blocking factors we have outlined. There was ferocious infighting between the candidates for the 2005 mayoral election (e.g., concerning Sheldon Silver's desire to protect downtown office development in his constituency from competing Midtown office development). A disruptive private corporation, Cablevision, was another key blocking factor. Political lobbying/cronyism was possibly also a factor: for example, Silver delivering benefits for Cablevision at the urging of Patricia Lynch, a former prominent staff member whose lobbying firm was on Cablevision's payroll.

The Hudson Yards: Rezonings of 2004–2009 and Beyond: The City's Uniform Land-Use Review Process, Inclusionary Zoning for Affordable Housing, Tax Increment Financing and the Number 7 Subway Extension, and the Culture Shed

The Hudson Yards is a major engine for growth. It is going to happen.

—Robert Steele, deputy mayor for economic development, New York City, November 2011

The Hudson Yards [just the Western and Eastern Rail Yards] . . . is the country's largest and densest real-estate development: 12 million square feet of offices, shops, movie theaters, hotel rooms, museums, galleries, and open space, and 5,000 apartments, all packed into 26 acres . . . the tallest tower will top the Empire State Building.

—Justin Davidson, *New York Magazine*'s architecture critic, October 15, 2012

The two Hudson Yards rezonings—the 2005 creation of the 301 acre "Special Hudson Yards District" (fig. 7.1), followed by the 2009 rezoning of the Western Rail Yards as part of Related's Western and Eastern Rail Yards project (figs. 7.2 and 7.3) facilitated what will be some of the largest developments in New York's history. By mid-2013 some key parts were underway including Related's south office tower built on a platform over the Eastern Rail Yards, the newly created Hudson Park and Boulevard, and the nearly complete number 7 subway extension

Reflecting the high stakes, by 2013 a lively debate had broken out over defining the "Hudson Yards." The Related Companies uses it narrowly to refer to just the Western and Eastern Rail Yards, its core development which it clearly wants to brand. On the other hand, administrative units such as the Hudson Yards Development Corporation and City Planning are defining it far more broadly to include not just the railyards but the rest of the entire Special Hudson Yards District. Finally local Community Board 4 is upset that increasing public attention to the name "Hudson Yards," defined narrowly or broadly, is drawing attention away from the once iconic neighborhood of Hell's Kitchen. So the community board is advocating, for some purposes, use of a hybrid, compromise term, "Hudson Yards–Hell's Kitchen," instead of "Hudson Yards."

MEGAPROJECTS THAT HAPPENED

The two Hudson Yards rezonings that set development in motion raise a series of major issues discussed in detail in this chapter. First, these rezonings are megaprojects that succeeded, at least in the sense that they actually happened, unlike so many projected New York City megaprojects. Indeed, they are the only part of the original Hudson Yards synthesis that actually happened—the Javits expansion ended as a small shed, and the NYSCC failed.

The first and largest by far of the rezonings, the creation of the Special Hudson Yards District, changed a huge area of about 301 acres from manufacturing and commercial to mostly commercial/offices (26 million square feet) plus some residential (13.6 million square feet), as part of the 2004 Bloomberg-Pataki Hudson Yards synthesis. The rezoned area ran roughly from 30th to 41st Street and from 8th to 11th Avenue (adjoining but not including the Javits Convention Center just to the west) (fig. 7.1). The main impetus for this first rezoning was concern that New York City was losing the new office jobs that were key to the city's employment future but that were leaving, especially for mushrooming office towers across the Hudson River in New Jersey where construction, and land costs were much lower than in Manhattan. The rezoned area also included a special corridor (B1–B3) around Penn Station where the city saw a chance to use the "magic of air rights" to fund ambitious plans for a brand-new station there.

In June 2004 this rezoning application entered the city's approval process for major land use changes, ULURP (Uniform Land-Use Review Procedure), and won final approval—a majority City Council vote—seven months later.[1]

The second Hudson Yards rezoning came later in 2009 and was limited to the Western Rail Yards, once intended as the site of the NYSCC but whose defeat now freed the yards to be zoned for an alternate use. In this rezoning, the MTA gave building rights to the developer Related in exchange for receiving rent over a ninety-nine-year period. Related's resulting project, which also included the Eastern Rail Yards (already rezoned in 2004–2005), consisted of mostly residential buildings/condos with some office buildings, and was roughly four times the square footage of Related's already huge Time Warner Center (itself 2.8 million square feet) at Columbus Circle. The Western and Eastern Rail Yards together covered about twenty-six acres (figs. 7.2 and 7.3) and for many rezoning advocates symbolized the potential of the "Hudson Yards" (e.g., as the new Park Avenue) that would emerge after a developer built a platform over the rails. The Western Rail Yards rezoning from manufacturing to residential

Fig. 7.1. "Special Hudson Yards District, Subdistricts, and Subareas." Reflects the Special Hudson Yards District Zoning Text Amendment as adopted by the City Council, January 2005. Used with permission of the New York City Department of City Planning. All rights reserved. The authors have added the major projects, by developer name, built since the rezoning or currently under construction. Developers: Brookfield (Br), Douglaston (Do), Extell (Ex), Glenwood (G), Lalezarian (La), Moinian (Mo), Related (Re), Rockrose (RR), Silverstein (Si), T. F. Cornerstone (TFC), Other (Oth).

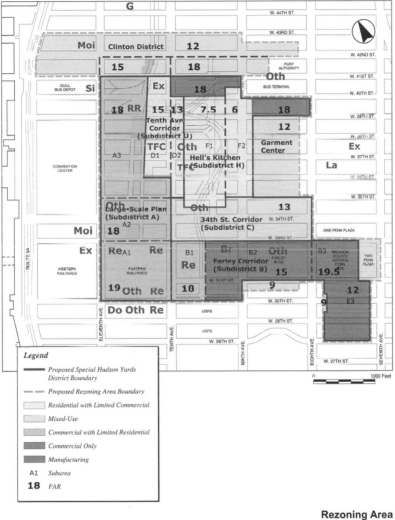

Fig. 7.2. The Related Company's design for the Western and Eastern Rail Yards, 2012. Related Companies and Oxford Properties Group.

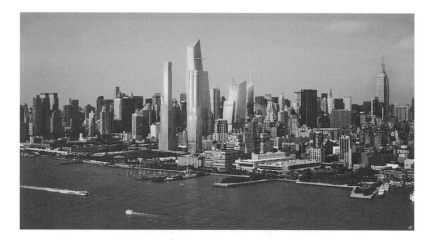

Fig. 7.3. Western and Eastern Yards for Related's development: Site Plan, October 2012. Related Companies and Oxford Properties Group.

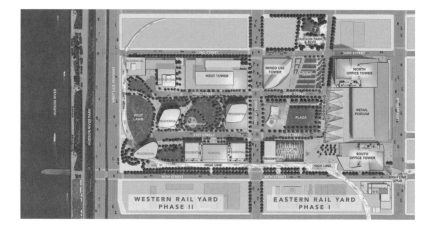

and commercial to accommodate Related's project started ULURP in May 2009 and successfully completed the process in December.[2]

Many of the buildings facilitated by the rezoning were projected to take decades to appear, especially after the economic downturn beginning in 2008 cut demand for commercial/office space. Still, advocates of the rezoning insisted during the downturn that this had not made the rezoning unnecessary. The city, they said, should plan now to capture a share

of future growth in the office market when the economy recovered. By December 2012 they seemed vindicated as, amid much publicity, work started on the first railyards skyscraper, a forty-seven-story tower (South Office Tower, fig. 7.3) on the Eastern Rail Yards at the northeast corner of West 30th Street and 10th Avenue. Leather goods maker Coach was the lead tenant, with other tenants including L'Oreal USA and SAP, the software company, with 75 percent of the 1.7 million square feet leased or sold by late 2013 (IBO 2013b). By mid-2013 momentum was growing. The American Institute of Architects put on a show, *Design in the Heart of New York*, celebrating the proposed skyscrapers on the Eastern and Western Yards, and a megadeal was then completed for Time Warner to move its headquarters from Columbus Circle to become the anchor client (buying over half the space from Related) in the projected eighty-story North Office Tower on the Eastern Rail Yards at West 33th Street and 10th Avenue.

In September 2013, the Independent Budget Office estimated that by 2040 roughly half of all new office space to be built in New York City would be in the Hudson Yards (table 7.1).

THE CITY'S ULURP PROCESS, AND ENGAGING NIMBYISM

These two Hudson Yards rezonings are also an opportunity to discuss ULURP, the city's well-designed land approval process to which major land use changes are subject. During the roughly eight months that the two ULURP applications took to complete, the city introduced several changes in each proposed rezoning, especially adding affordable housing, to make the rezonings more palatable to the local community.

The city's ULURP is a reasonable procedure that allows for considerable local and community discussion and negotiation over major local land use proposals, while limiting uncontrolled nimbyist (not in my backyard) behavior. It was formally established in 1975 as a reaction especially against Robert Moses's imposition of some highly undesirable government projects, and it also reflected the increasing involvement of community boards in the city's development from the 1950s on.[3] Community boards began in Manhattan in 1951 when Manhattan borough president Robert Wagner established twelve Community Planning Councils, later renamed Community Planning Boards. These were the city's first formal participatory vehicles for neighborhood groups. In 1968, as required by the City Charter of 1963, the city was divided into sixty-two community districts and the role of community boards as "advisors" to the city government was statutorily established. Each board was given responsibility for advising the City Planning Commission on "any matter relating to the development or welfare of its district." During the next decade, the boards gained

Table 7.1. Supply and demand for new office space, New York City, projected to 2040, in millions of square feet

Supply	Demand[a]	
Under construction (Sept. 2013)		
1 & 4 World Trade Center	2.4 (5.3)	
Hudson Yards, South Tower	0.5 (1.7)	
Rest of Manhattan	1.5 (3.7)	
Sites likely to be developed		
Hudson Yards[b]	23.6	
East Midtown	3.7	
Rest of Manhattan	11.2	
Brooklyn and Queens	2.9	
Other	2.0	
Totals	47.8	52

Source: All data based on IBO (2013b).

Note: Figures exclude already-rented/purchased space in buildings under construction. Figures in parentheses include the entire space, already rented/purchased and unrented.

[a]The three main industries creating office jobs are information, finance, and professional services. Projecting demand so far ahead is difficult, involving many assumptions. IBO's 52 million square feet assumes an increase of 187,000 office jobs, with each job occupying 200 square feet. But IBO acknowledges that overall demand for new office space could be as low as 30 million square feet (with only 91,000 new office jobs) and as high as 87 million square feet (with 291,000 new office jobs). The square footage each job occupies could also decline, for example, as the need for file space declines. Firms currently leasing estimate 175 square feet per job, but some futurists predict as low as 100, which would reduce the overall office space demand.
[b]Hudson Yards defined here broadly as the areas in the 2005 and 2009 rezonings.

stature as vehicles to express local views on public issues, especially land use. In 1975 ULURP was introduced, which legally requires that, as part of the formal approval process, major land use projects be presented to the local community board for its opinion. Still, that opinion is just advisory and cannot alone stop a project continuing along the approval process.

The main stages of ULURP:

1. The Department of City Planning certifies that a project is ready to start ULURP, including having the required Draft Environmental Impact Statement. (Project cannot start if the DCP will not certify it as ready.)

2. The community board has sixty days to express its view (which is just advisory, project continues anyway).
3. The borough president has thirty days to express his/her view (which is just advisory, project continues anyway).
4. The Department of City Planning has sixty days to vote on the project (determinative—a negative vote kills it).
5. The City Council votes on the project. (A negative vote kills it unless the mayor vetoes the City Council vote within five days in stage 6, whereupon the City Council can override the mayor's veto with a two-thirds majority.)
6. The mayor may veto the City Council vote on the project.

There is a good reason why, when New York City granted community boards a mandatory role in its land use review process, the role granted was purely advisory. It is hard to see how community boards, still less local activist groups, can do effective city-wide planning. The New York City public schools took years to recover from the period in the late 1960s when real control of the schools was handed over to local communities, an experiment now almost universally seen as a disaster. In 2000 when Los Angeles adopted its particular version of community boards (called neighborhood councils), they were in several ways much more democratic than New York's. For example, the community members were allowed to determine the boundaries of their "community," and members of the neighborhood council were elected by local residents. New York community board members, by contrast, are appointed by the borough president (one of the few significant powers left to borough presidents after the demise of the Board of Estimates in 1989). Still, Los Angeles neighborhood councils were also given only an advisory role in the land use review process, since it was believed that to do otherwise was a recipe for chaos and deadlock.[4]

A central reason why local communities can, practically, be given only an advisory role in planning is nimbyism. Nimbyism can be complex (for an excellent analysis see Dear 1992).[5] But its core consists of conflicts over projects that produce widely dispersed benefits but also geographically concentrated costs (usually on a particular neighborhood) such as result from homeless shelters, prisons, airports, sports stadiums, and waste disposal sites. This inequality of cost distribution almost guarantees local opposition, with waste disposal sites being especially sensitive. Further, the nature of democratic institutions usually makes it extremely difficult for nimby-prone projects to win political support. Citizens residing near proposed sites for nimby facilities have a strong incentive to actively

oppose them. In contrast, the benefits associated with these facilities are both broadly distributed and, compared to the local costs, more meager. Consequently, few individuals aside from a project's developer have an incentive to advocate on behalf of a particular project.

A central solution, in theory, to this inequality of cost distribution is for government to propose transfer payments that compensate a neighborhood adversely affected. The idea is that the nimby project creates a public surplus (hopefully economic), and hence it is both fair and politically sensible (in terms of getting the project accepted) to redirect part of that surplus to those bearing, disproportionately, the project's costs. This rationale also elevates the moral status of the transfer payment as fair compensation, not just a political bribe. This overall solution is often called the "bargaining" or "transfer payments" solution. A version of it was adopted in the 2009 Western Rail Yards rezoning, as the city used public funds to help assure subsidized housing for Hudson Yards residents. All of which underlines the fact that opposition can be very productive—neighborhood complaints can result in valuable improvements to proposed worthwhile projects and can draw attention to projects that are bad and mistakenly conceived.

Another solution to nimbyism, very different from the transfer-payments solution, is to simply impose the project by legislative fiat, which ULURP can do, since at the end of the process the City Council makes the decision (subject to a mayoral veto).

New York's ULURP leaves most of the planning and land use initiative in the hands of the mayor and the mayor-controlled Department of City Planning. For example, under ULURP a proposal that the mayor dislikes has almost no chance of succeeding. It might have difficulty even beginning the approval process, since the Department of City Planning, whose chair is appointed by the mayor, can hold it up. If it does begin, it will almost certainly be shot down midway by the City Planning Commission, a majority of whose thirteen members are also mayoral appointees and which has the power to reject a ULURP proposal at that stage. In the unlikely event that it reaches the process's final stage and is passed by the City Council, the mayor can then veto it (though that veto can be overridden by a two-thirds majority of the City Council). All these roadblocks to stop a project that the mayor opposes seem reasonable, since the mayor is the city's highest elected official.

How about the reverse, a project that the mayor supports but the local community opposes? This was a key rationale for setting up ULURP in the first place, to give local communities a formal mechanism to oppose land use projects they disliked, with Robert Moses–type projects that destroyed entire neighborhoods as an extreme case.

So community boards get to express their opinion on a project in ULURP's early stage, but even if their opinion is highly negative, the project continues through the process. At the end of the ULURP process the City Council has to approve a proposal, first by a majority vote. If the City Council votes the proposal down, the mayor can veto the Council's negative vote, which the City Council can in turn override with a two-thirds majority. So ULURP is a mechanism for stopping a highly unpopular proposal that the mayor is determined to implement, but not by making it so easy to do so that projects the city generally needs cannot win approval because of uncontrolled nimbyism.

Another strength of ULURP is that it gives advocates (especially the mayor and Department of City Planning) of a proposal that risks being rejected in City Council plenty of opportunity and incentive to modify the proposal (e.g., by either reducing the scale of the proposed project or adding compensatory measures or both) during the process so as to get sufficient City Council votes, as happened with both parts of the Hudson Yards rezoning. Reflecting this negotiating drama, in both ULURP rezonings, the final concessions were included in a last-minute document finished just before the City Council vote and titled "Points of Agreement," signed by the city in the case of the 2005 Hudson Yards rezoning, and by Related and the city in the case of the 2009 Western Yards rezoning.

A final strength of the ULURP process is that it cannot drag on more than about eight months, since each stage in the process has a maximum time it can take by law, typically one or two months. In short, ULURP encourages the mayor and City Council to negotiate a compromise for a contentious mayoral plan, and especially to suggest compensatory mechanisms for a neighborhood affected, in the context of expressed criticisms of a project. The major has strong powers but cannot dictate.

ULURP avoids the enormous waste of time and effort and irrationality of the state approval process, which derailed the Javits expansion and NYSCC and extensively delayed the Penn/Moynihan Station upgrade, and which allows any one of just three people on the State Public Authorities Control Board (the governor, speaker of the state assembly, or leader of the state senate) to definitively veto a proposal at the final stage of the approval process. The PACB was introduced in 1976 after New York City's near bankruptcy. Many political processes allow a veto at the end by the highest elected official (mayor, governor, president) but almost none give any one of three elected officials the right to cast a veto. Further, many political processes, in order to limit the veto's unreasonable use, usually allow a two-thirds majority of the legislature to override a veto, as ULURP does. By contrast, a veto from the state's Public Authorities Control Board has no override provision.

INCLUSIONARY ZONING FOR AFFORDABLE HOUSING

A third issue raised by the Hudson Yards rezonings is how to provide "affordable housing" in New York in the twenty-first century. In the case of both rezonings, a particularly sensible outcome of the ULURP process was that, reflecting community board pressure, the city added incentives for a large amount of affordable housing. An especially important part of this affordable housing was zoning for inclusionary housing. The relatively new method of inclusionary zoning leverages the private sector by allowing it to build bigger buildings so long as a proportion of the units are affordable. This is the major alternative these days to classic public housing, which can scarcely be built anymore in New York City, both because of lack of land and because of drastically reduced federal funding.

Inclusionary Housing

Inclusionary housing in general basically gives a private developer incentives in return for including a proportion of "affordable" units in the development. An obvious advantage of inclusionary housing is that it addresses the problem of how to provide affordable housing when city and other publicly owned land is scarce, as it now is.

The incentives offered to a developer in order to build inclusionary housing can be of several kinds, including tax-exempt bonds, allowing a larger building through inclusionary zoning, or property tax reductions. The city's earliest program for encouraging inclusionary housing involved not inclusionary zoning but issuing tax-exempt bonds. Called the "80/20 Housing Program," this has been available since 1973. In return for being able to use tax-exempt bonds to finance the project, a developer builds 20 percent of the apartments as affordable rentals for low-income people. The rents cannot be more than 30 percent of the income level that qualifies as low, but the rents return to market rate when the bond's term—usually twenty or thirty years—expires, so they are not permanently affordable.

Inclusionary Zoning

By contrast, the incentives associated with zoning for inclusionary housing allow the developer to construct (as of right) a larger building in return for including some affordable units (which in New York City until 2009 were always rental units) for low- and moderate-income households.[6]

Until the late 1990s, zoning for inclusionary housing was limited mostly to affluent suburbs, especially in New Jersey, California, and Mas-

sachusetts, and was seen as a way to allow some people to live there who could not otherwise afford to, but at minimal cost to the municipality (Schwartz 2009). In New Jersey's case it was a reaction to the state supreme court ruling (Mount Laurel) that every municipality must offer housing for all income groups and meet a "fair share" of its region's housing needs. But recently a growing number of cities, not just suburbs, have adopted zoning for inclusionary housing as a major policy tool, in New York City notably by 2003 and especially with the 2005 Hudson Yards and the Greenpoint-Williamsburg area rezonings (Schwartz 2010, 224–31).

Further, the Hudson Yards zoning for inclusionary affordable housing was shaped to suit the desires of the community board, which meant providing affordable housing not only for low-income people (as in the city's older 80/20 tax-exempt bond program) but also for middle- and moderate-income residents too. The case for including not just low-income residents was that, as CB4's main housing advocate Joe Restuccia put it, "we are a community, not just composed of poor people."[7]

Another advantage of inclusionary housing is that it avoids segregating the poor into their own buildings, as happens with public housing. Still, an ongoing issue is whether there is some informal segregation within inclusionary housing. For example, in 2006 Community Board 4 accused Related of possibly unofficially segregating its Caledonia condominium, located next to the High Line at 17th Street, by situating all the affordable units on the less desirable lower floors (Lerner 2006).

TAX INCREMENT FINANCING (TIF) AND THE NUMBER 7 SUBWAY EXTENSION

A fourth issue raised by the Hudson Yards rezonings is the city's use of tax increment financing (TIF). TIF is a device whereby tax revenues that result from any private development generated by a public project are allocated to finance infrastructure improvements (especially the number 7 subway extension, in the case of the Hudson Yards) that facilitate, and even make possible, the project. Tax increment financing, which applied to most of the Special Hudson Yards District, had scarcely been used in New York City before, but, after being introduced in the Hudson Yards, TIF was used to pay for bonds related to Yankee Stadium and to the Atlantic Yards. The number 7 extension to a new station at 11th Avenue and West 34th Street has a completion date of late 2014, only about nine years after the project got the serious go-ahead, a huge achievement given the well-known difficulty of building new subway lines in New York City (for which the still-not-complete 2nd Avenue subway, started in 1929, has long been a byword).

Still, the TIF process used to fund Hudson Yards infrastructure was not without setbacks. In particular, starting in 2008 the city had to each year supplement from city funds the tax revenue generated by private development, since the latter was insufficient to pay for servicing the bonds the city had issued to pay for the subway extension and other Hudson Yards infrastructure. Some critics complained, as will be discussed later, that this was an unwarranted subsidy to private development, since the city had promised that the funds would come entirely from private-sector tax revenue in the Hudson Yards. The city responded that the subsidy would eventually be repaid when the infrastructure improvements facilitated commercial development, and that it was well worth it.

DEFINING "HUDSON YARDS" (WHAT'S IN A NAME?)

A lively debate emerged over defining the "Hudson Yards" among three of the biggest players, Related, the Hudson Yards Development Corporation, and Community Board 4. By mid-2013 Related was promoting a narrow definition of Hudson Yards as just the Eastern and Western Rail Yards, a branding strategy that Related clearly saw as helpful in marketing its megadevelopment there. The Hudson Yards Development Corporation, by contrast, was using a much broader geographic definition of Hudson Yards that included, and went somewhat beyond, the vast area of the 2005 rezoning plus the Western Rail Yards, and ran from West 42nd and 43rd Streets south to West 28th and 30th Streets, and from 7th and 8th Avenues all the way to the Hudson River Park. Meanwhile Community Board 4 was concerned about eclipsing the historic neighborhood of Hell's Kitchen, and insisted that a proposed "Hudson Yards Business Improvement District" be renamed the "Hudson Yards/Hell's Kitchen Alliance Business Improvement District."

The following account looks at all these issues in detail.

STAGE 1: THE MAJOR HUDSON YARDS REZONING FOR OFFICES, 2004–2005

Background: The Drive to Create White-Collar Office Jobs

The concerns in the late 1990s of city and state officials about an exodus of white-collar jobs, especially to New Jersey, were encapsulated in the June 2001 "Group of 35 Report" (Schumer and Rubin 2001). This report was co-chaired by US Senator Schumer and written under the direction of a coalition of leaders from government, business, academia, real estate, and others.[8]

The report stressed the growing unaffordability of building office space in New York City. By 2001 the average cost per square foot of new office construction in Jersey City was $320, compared with $505 for Midtown and $438 for downtown Manhattan. Even though from 1996 to 2001 commercial office rents in the city rose 78 percent, the city saw just 4 million square feet of new office construction. By contrast, 6.7 million square feet of offices were currently (2001) under construction along New Jersey's Hudson County waterfront, where more land was available with lower building costs.

The report's solution was to create three new central business districts in the city, mostly by rezoning land from manufacturing to commercial/offices. The Hudson Yards, to be called the Far West Side Business District, was seen as the most important of these. The others were Downtown Brooklyn and Long Island City in Queens. The report also stressed the need, if the Hudson Yards rezoning was to successfully stimulate office construction, for transportation and infrastructure improvements, above all extending the number 7 subway line to the Javits Center.

Only in this way, the report argued, could the city capture a reasonable share of the roughly 290,000 office jobs predicted for the metropolitan area over the next twenty years. In Schumer's words: "We're an ideas city in an ideas economy with industries such as financial services, law, and accounting. So long as we stay that way, people are flocking here, many poor immigrants and also young professionals, seeking a better life. Our first concern must be greater job creation" (Schumer press release, December 13, 2004). Schumer addressed the obvious objection that since the economy of the nation and city had entered a downturn around the time of the report's publication, there was no longer a need for new offices. (The national recession officially began in March 2001, ending in November 2001.) In response, Schumer stressed the need for long-term planning: "To say that the vacancy rate is now 15 percent and we should wait until it gets down to 5 or 6 to plan for new growth shows little faith in the future of the city, and furthermore, if we wait for there to be a shortage of office and residential space before building new space, supply and demand will cause prices to go so high that we will lose our potential to grow. The West Side presents the greatest opportunity in New York to create jobs."

In December 2001 newly elected Mayor Bloomberg's Department of City Planning issued a draft plan titled "Framework for Far West Midtown," a first attempt to implement the "Schumer report" (as it was generally now called). The DCP then hired a set of outside consultants in June 2002 to design a master plan to turn the Hudson Yards into a new central business district and mixed-use community. After that, the project was delayed

until 2004, partly to ensure that it was consistent with the developing plans for the NYSCC and Javits expansion.

The 2005 Rezoning from Manufacturing to Commercial/Office and Residential

The eventual 2005 Hudson Yards rezoning plan (the Special Hudson Yards District of fig. 7.1) included a large section for high-density, commercial/ office development. This section ran primarily along an L-shaped corridor, running east-west between West 30th and West 33rd Streets to the MTA's Eastern Rail Yards, and then north, between 10th and 11th Avenues up to 41st Street, across from the Javits Convention Center. It includes sections A, B1, B2, and E on figure 7.1. The A sections were now also intended as the center of a new central business district. New development in this corridor would be restricted primarily to commercial/office use, to ensure that residential (mostly condo) development would not take over, since the central goal was to facilitate large office buildings. Still, to "create a vibrant, 24-hour community" along the lines of Jane Jacobs's vision, the rezoning allowed residential uses in this corridor if they were part of an office development. Other sections of the rezoning, outside the L-shaped corridor, allowed residential uses as part of the city's attempt to address New York City's housing shortage (a long-standing goal of key business leaders, as well as politicians and residents). The old, low-scale residential area known as Hell's Kitchen (only partly shown as D) had special protections. The entire rezoning, designated the Special Hudson Yards District, involved a fifty-block area.[9]

Transit-Oriented Development: No. 7 Subway Extension and Penn/Farley Upgrade

Everyone involved stressed the need for transportation and infrastructure improvements if the rezoning was to stimulate office construction. The catchy phrase "transit-oriented development" started appearing in DCP presentations on the rezoning in 2002, soon after the hiring of Vishaan Chakrabarti, a young architect and planner, previously a partner at the corporate architecture firm Skidmore, Owings and Merrill. By 2004 Vishaan was director of the DCP's Manhattan office and a major advocate of the Hudson Yards plan (Brash 2011, 176–78). He stood out at that time in Manhattan's corporate world by bringing a backpack, not a briefcase, to meetings, underlining the fact that he bicycled to work.

Transit-oriented development's key idea was to counter the movement of office jobs to the suburbs, where employees usually travel to work in

environmentally unfriendly autos ("suburban sprawl"). Instead, office jobs would stay and grow in the city and most workers would arrive by mass transit. Also, New York City would now recapture the income taxes and real estate taxes generated by office space, crucial to the city's operating budget, but presently being lost to the suburbs.[10]

Later, in 2013 Vishaan published a passionate book-manifesto, *A Country of Cities*. He argued that the suburbs and exurbs (defined roughly as areas with an average of one to four dwelling units per acre), based on daily automobile use and an associated reckless waste of natural resources and subsidized especially by the federal home mortgage interest deduction (MID), should give way to "cities" (defined as areas with at least thirty housing units per acre), whose density was sufficient to support rapid mass transit such as a subway network. Half the tax revenue from the eliminated MID should be used to fund the construction of affordable rental housing in the nation's cities (Chakrabarti 2013).

In 2004 there was no subway or train station on the Far West Side, so extending the number 7 subway line to the Javits Center was a crucial part of the proposal. So was the Penn Station/Farley upgrade, seen as a key transportation stimulus for office building in the Hudson Yards, since the site of the projected new station, the Farley Building, bordered the Hudson Yards. So the rezoning plan included a special Farley Corridor from the proposed Penn/Farley Station to the railyards.

The zoning proposal also included a grand, new street, Hudson Boulevard, which would run from 33rd to 39th Street midway between 10th and 11th Avenues, and was loosely modeled on how Park Avenue had been built on top of the New York Central Railroad in the early 1900s. In the zoning's early drafts, Hudson Boulevard was named Olympic Boulevard, reflecting Doctoroff's vision of an Olympic stadium (the NYSCC) linked to a grand boulevard along which the athletes could parade. Although the NYSCC had not yet been defeated when the Hudson Yards rezoning was going through ULURP, the name change to Hudson Boulevard probably reflected the uncertain prospects of the NYSCC and Olympic projects, tangled in controversy. There was also a new park, Hudson Park, that would run along part of Hudson Boulevard.

Tax Increment Financing (TIF) via Commercial Property Tax Rebates (Payments in Lieu of Taxes) and Residential Property Tax Rebates (421a)

These infrastructure improvements, especially the number 7 subway extension, are very expensive (the subway extension was estimated to cost roughly $2 billion), and required a funding mechanism. Despite the

Bloomberg administration's advocacy for the subway project, the Metropolitan Transportation Authority (MTA) had not stressed the extension of the 7 train in its capital planning prior to the rezoning (Independent Budget Office 2013).[11] Given the priority of other projects like the 2nd Avenue subway and East Side Access (allowing the Long Island Rail Road to stop at Grand Central before its Penn Station stop), it could have been years before the MTA committed to funding the number 7 train extension.

So the Bloomberg administration made an unusual, if not unprecedented, proposal. The city would pay for nearly 100 percent of the subway improvements and other investments necessary to catalyze development in the Far West Side. (Normally, improvements to the transit system are funded by a combination of MTA capital proceeds and federal transportation grants.) The city proposed paying for these costs not through its normal budget but through tax increment financing (TIF), which basically uses taxes generated from ensuing development to fund the costs associated with developing an area. The city's version of TIF involved offering developers property tax discounts to build in the Hudson Yards, and then using the balance (after the discounts) of the ensuing tax revenues from new development or from major improvements of existing buildings in the Hudson Yards in order to pay for the infrastructure, especially the subway extension.

To carry out this plan, the administration and the City Council created two new local development corporations. One, the Hudson Yards Development Corporation (HYDC), was charged with managing the planning, design and development of the Hudson Yards area, except for the subway extension, which is overseen by the MTA. The second, the Hudson Yards Infrastructure Corporation (HYIC), was authorized to issue bonds to finance capital improvements in the Hudson Yards area (above all, the number 7 subway extension). HYIC bonds are backed by a formal agreement the city made to transfer to the HYIC all property tax revenue paid by buildings in the Hudson Yards Finance area that are new or substantially renovated after January 19, 2005. Because of legal restrictions, the city used two different mechanisms for this transfer: one (PILOTs) basically covered commercial buildings, and another (TEPs) basically covered residential buildings (IBO 2013a).

(1) PILOTs for Commercial Properties

Developers of qualifying commercial properties can apply to the city's Industrial Development Agency (IDA) to receive full exemptions on their

Fig. 7.4. Hudson Yards Financing District, for tax increment financing of the number 7 subway extension. Source: Hudson Yards Development Corporation, 2005.

property tax obligations, in exchange for making payments in lieu of property taxes (known as PILOTs). The PILOTs due would be discounted (as compared to regular property taxes) for developers of new, or substantially improved, commercial (office) projects in the Hudson Yards, as incentive for them to build there (and technically/legally only available if the developer could show that the project would not occur unless the discount was offered). The tax discount was most generous for the earliest investors and those building further west—that is, further from existing development and public transport and therefore arguably needing more incentive (New York City Industrial Development Agency 2010). Figure 7.4 shows this (Hudson Yards Financing District). The most generous discount is 40 percent from the average tax bill per square foot for Midtown, sliding down to 15 percent, although most developers are likely to get at least a 25 percent discount. (The "Midtown average" is determined once for each building, and the base then increases at the lesser of the annual increase in the Midtown average or 3 percent.)

These PILOTs go to the Hudson Yards Infrastructure Corporation (HYIC) to pay the interest on the bonds (and principal later) it has issued to fund the number 7 subway extension and other Hudson Yards infrastructure costs, including the Hudson Yards Development Corporation itself.

(2) TEPs for Residential Properties

The state law that allows the city to take property off the tax rolls, set up a PILOT structure with a tax discount, and use the revenue for a specific purpose (e.g., servicing the subway bonds for the Hudson Yards) covers only commercial development. The city could not find an easy way around this, but wanted to capture for the HYIC tax revenues from residential development too. So the city decided to allow the use of whatever as-of-right incentives for residential buildings existed for the Hudson Yards (see below), and then created the mechanism whereby the City Council makes an annual appropriation to HYIC of the net tax revenue from all new non-PILOT buildings in the Hudson Yards District that year, to help service the bonds. The transfer is referred to as a tax-equivalent payment (TEP) (New York City Industrial Development Agency 2010).

The main residential development incentive program that was available to the city was the 421a tax abatement, which encourages development of underused or unused land by drastically reducing, for a set amount of time, property taxes due on the new development. The 421a program applies to areas of Manhattan where developers build condominiums, and the city after 2008 also requires that developers do an 80/20 project (20 percent units affordable) to qualify for the 421a. Qualifying developers may be eligible for a (421a) full exemption from taxes on the buildings (but not from land taxes, still payable in full) for up to three years for the construction period, followed by twelve years of full exemption, and then eight years of gradually phased-in taxes. The city was quick to make the 421a program available to builders in the Hudson Yards. In addition, the developers may also qualify for an inclusionary housing zoning bonus to increase their FAR if they add affordable units.

This use by the city of tax rebate programs (such as the 421a residential real estate rebate, and PILOTs for commercial development) in the Hudson Yards was criticized by some people, who charged these programs were unwarranted tax breaks for wealthy developers. Still, from the city's point of view, the tax rebates were worth granting on several grounds. The developments might not have occurred without the tax breaks; the new developments will anyway be paying the land tax (which is not exempted under the 421a); the tax rebates on the buildings will eventually phase out; and the new developments will help trigger other developments such as hotels in and near the PILOT/TEP area that will be paying their full tax bill without exemption.

The city (HYIC), eager to get the subway extension going, since it saw this as both critical for transit-oriented development and a potentially lengthy process, issued the bulk of the bonds to finance the subway

extension before almost any of the development had occurred that would generate the balance of taxes (after rebates) that was supposed to fund the city's interest payments on the bonds. The first $2 billion in bonds were issued in 2006. Since the city was now liable for the bond payments, it became very anxious to generate Hudson Yards development that would provide tax (PILOT and TEP) revenue, and so was eager to grant rebates to developers to get building going.

Actually the first PILOT payments were not likely to emerge until 2017 or 2018, but TEPs did start appearing by 2008, though not enough to avoid the city having to contribute substantial annual funds to the HYIC from the city's budget (again to the disapproval of some critics).

Department of City Planning: ULURP's First Stage

As ULURP's first stage, an applicant must file a Land Use Review Application with the Department of City Planning (DCP) and cannot move to ULURP's next stage until DCP certifies that all documents needed to address all issues related to the application are present. This is why if the mayor or City Planning opposes a project, it may be difficult for it to even begin ULURP.

Data Constraints on Government in a Post-NEPA (National Environmental Policy Act) World

A key required document before any sizeable project can start ULURP is a Draft Environmental Impact Statement. Ever since the passage of the 1969 National Environment Policy Act (NEPA) and its state and local analogues (e.g., SEQRA—the New York State Environmental Quality Review Act), governments cannot behave in Robert Moses fashion even should they wish to. NEPA legally requires government decision makers to analyze, and display to the public for comment, the environmental impacts of a proposed project. "Environmental impact" is defined broadly to include a host of socioeconomic factors, including any likely change to neighborhoods. This forces governments to provide detailed statistical support for their projects. The government must submit a draft document (the Draft Environmental Impact Statement), hear comments, and produce a final document taking account of those comments, which the government agency is legally bound to follow.

These NEPA requirements give communities and individuals some leverage and protection. They can, for instance, sue the government if it does not comply; and, if the data supporting the project are cooked, the opposition can show so in court. For example, NEPA and its state and

local analogues were the basis on which Westway, the proposal to build an underground highway parallel to the waterfront on the West Side of Manhattan, was stopped in 1982, making Westway one of the first big projects to be halted by the NEPA-related legislation. Partly because of NEPA constraints, the three city-proposed megaprojects discussed here that had to go through ULURP (both stages of the Hudson Yards rezoning, and the West Chelsea Rezoning associated with the High Line) were, on the whole, data based.

The city's June 2004 Draft Environmental Impact Statement (DEIS) for the Hudson Yards project was a spectacular work of around six thousand pages in seven volumes, filling a box as large as a coffin, the second-largest DEIS ever produced. (The largest was in support of the federal government's plan to bury nuclear waste under Yucca Mountain in Nevada.) The Hudson Yards DEIS discussed the effects of the proposed office towers, twelve thousand apartments, parks, new streets, and extension of the number 7 subway. It contained careful analysis of the likely impact of the project on the neighborhoods within the Hudson Yards, with details on who would be affected and who would need to be relocated. This huge effort was certainly expended, in part, because the city knew that the project would be intensely scrutinized and the data might be challenged in the courts. (The opposition, by contrast, had no such limits on their use or misuse of the data, as the NYSCC's public fight made clear.)

The Hudson Yards DEIS determined that the rezoning would displace 139 people who were residents of two buildings that would be demolished to build Hudson Boulevard. The city planned to hire a relocation company to find them alternative accommodation, though some community board members were skeptical about what this relocation company would accomplish.

On June 21, 2004, the Department of City Planning certified the Hudson Yards proposal as complete and ready to start the ULURP process.

Community Board Review: Affordable Housing for Poor and Middle-Income People, Opposition to Tall Buildings, and a Cultural Facility

In ULURP's next stage, applications are sent to the affected community boards and to the borough president and City Council. Within sixty days of receiving the certified application, the community board must hold a public hearing and adopt and submit a written recommendation to the City Planning Commission (CPC) and to the others involved (e.g., the applicant, the borough president). Even if the community board disapproves

of a project, it moves forward to the next stage—community boards are advisory in nature. But opponents such as community boards can, and often do, continue to lobby against a project that they have voted against, especially pressuring their local City Council members in the hope that the latter can persuade their colleagues on the full City Council to vote down the project in ULURP's final stage.

Aspects of the Hudson Yards rezoning proposal were opposed by some local residents, led by Community Board 4, whose territory contains the Hudson Yards. In particular, residents opposed the commercial and residential skyscrapers (many projected as roughly thirty to fifty stories) that the rezoning allowed in the high-development sections, such as the L-shaped commercial section, although these were not permitted in neighborhoods such as Hell's Kitchen.

Strikingly, in one area covering two blocks, the rezoning allowed buildings of unlimited height and bulk (the area was between 33rd and 35th Streets and 10th to 11th Avenues). This seemed a bold, or brazen, depending on one's perspective, effort to recapture the days when New York City had the tallest skyscrapers in the world. The Empire State Building at 1,250 feet was the tallest building in the world from 1931 to 1972, but those days were long gone. Even now that the Freedom Tower, on the old World Trade Center site, is finished, at 1,776 feet it is substantially smaller than the 2,717-foot Burj Khalifa in Dubai, which opened in 2010 as the world's tallest building. The two-block area in the Hudson Yards rezoning would in theory have allowed a building taller than Dubai's.

Some residents, in addition to opposing the height of the buildings that the Hudson Yards rezoning allowed, aimed to increase the amount of affordable housing in the new project. They said, as so often in the last fifty years, that the city has an affordable housing crisis, and they expressed a worry that the rezoning would make the area affordable only for the wealthy.

There was also skepticism about the city's plans for relocating the 139 residents whom the DEIS had determined would be displaced. The city proposed to hire a relocation company to help these people, the same company that had handled the earlier Times Square relocation. But Joe Restuccia, the community board's housing expert, claimed that often such "relocation" help meant little more than making appointments for displaced residents to view other apartments, renting at market rates.

Finally, for good measure, some residents repeated that they were adamantly opposed to the "stadium" (NYSCC) which, although not part of this rezoning, was under heated debate and would not be defeated for another year (June 2005).

The community board then voted in favor of the proposal, but with the above points as strong reservations. Actually, the community board might have voted against the entire proposal were they not now focused on stopping the NYSCC and wishing therefore to seem reasonable, and not too nimbyist, to key decision makers, especially to the rest of the City Council. As the head of Community Board 4, Walter Mankoff, explained: "We had to favor something; otherwise we would seem too negative."[12]

Inclusionary Zoning for Affordable Housing: City Policy

The DCP agreed informally to include some affordable housing in the rezoning, and then in further discussion they agreed to raise the amount of it, to introduce unusual guarantees about its longevity (making some of it permanent, not temporary), and to revise the criteria for access to it along the lines demanded by CB4, so that a proportion of the affordable units (all rental) were for middle- and moderate-income residents, rather than entirely for low-income residents as the city had initially proposed.

The DCP's main mechanism to increase affordable housing in the city is zoning to encourage inclusionary housing. This gives a private developer of residential buildings a financial incentive (bonus) to include a certain proportion of affordable rental units for households earning less than, or in cases of middle or moderate-income residents no more than, a certain percentage of the area's median household income. The major financial incentive offered developers is that residential buildings with affordable housing can be larger (which usually means taller), sometimes almost twice as large, as zoning otherwise allows.

So zoning for inclusionary housing basically leverages the private sector to generate affordable housing. A social argument for inclusionary housing is that having poorer residents in the same buildings as wealthier ones avoids segregating the poor into their own buildings, as happens in classic public housing. Still, some critics have charged that within "inclusionary housing" there may be some informal segregation, with those residents who are living in the subsidized housing units being separated in several ways (e.g., different entrances or inferior residences on lower floors) from those who are paying market rates.

Although the promotion of affordable housing in general is long-standing New York City policy, doing this primarily via zoning for inclusionary housing is fairly recent, dating especially from the Bloomberg administration's 2003 New Housing Marketplace Plan. The city has another, older program for encouraging inclusionary housing which involves not zoning but issuing tax-exempt bonds. Called the "80/20 Housing

Program," this has been in use since 1973. In return for using tax-exempt bonds to finance, a developer builds 20 percent of the apartments as affordable rentals for low-income people. The rents cannot be more than 30 percent of the income level that qualifies as low. Also, these units return to market rents when the bond's term (usually twenty or thirty years) expires, so they are not "permanently affordable."

Regarding affordable housing generally, many business and other city leaders have long known that major productivity advantages accrue from the city's huge population and job density. These advantages come both from having lots of jobs and economic sectors close together where people can easily interact, and from having many of those who work in these jobs living reasonably close by, minimizing time-consuming, inefficient commutes. Clearly many of these productivity advantages are highly dependent on having a labor force a significant proportion of whom can afford to live close, or somewhat close, to work. Back in 1980 the New York Chamber of Commerce (later renamed the New York Partnership) in a survey asked businesses what were their major problems. The largest problem turned out to be the difficulty their employees faced in finding housing within their means, which was also a major problem employers faced in recruiting new employees. That was a key finding that led Governor Rockefeller to start state-run affordable housing initiatives, followed soon after by the city. Housing economists Ellen and O'Flaherty have recently argued that in New York City it has been a desire to maintain these productivity advantages (which they call the "production externality" goal), more than the desire for economic redistribution and equity, that has long motivated policy makers and planners to support and continue the city's extensive rent regulation and housing subsidy programs (Ellen and O'Flaherty 2013).

Still, by the time Bloomberg took office, the earlier main options for creating substantial amounts of affordable housing were mostly no longer available, leaving zoning for inclusionary housing as the main option (along with the older 80/20 inclusionary housing program which offered tax-exempt bonds to finance the project if the developer builds 20 percent of the apartments as affordable rentals for low-income people).

Classic public housing, sponsored originally by New York's US senator Robert Wagner's 1937 Housing Act (the Wagner-Steagall Act), was hardly possible anymore, since the federal government had long ago drastically reduced funding for new public housing—especially for high-rise buildings, which had been widely criticized as socially unsuitable (e.g., parents on high floors could not easily supervise their kids playing below). The reduction of federal support for new public housing came in two main blows. First, the Nixon administration halted all public housing funding pending a comprehensive evaluation of the program. Later, Reagan closed

several crucial programs and made across-the-board cuts to public housing funding (Mitchell 1985, 305, 383). So local public housing authorities were focused on the struggle to fund maintenance of existing housing, rather than expansion. This is a pity, since public housing is a success in New York City, with, historically, a reputation for being better managed and maintained (by the New York City Housing Authority [NYCHA], which dates from 1934), than in most other large cities. As of 2010 the NYCHA owned and operated 178,000 apartments, containing a population greater than that of Seattle or Boston (Garvin 2013, 156).

A second problem for a city administration intent on increasing affordable housing was that by the time Bloomberg came to office the stock of housing units and land owned by the city that might be used as sites to create more affordable housing had dwindled. This was another reason for the city to increasingly rely on the private sector via inclusionary housing. The decline of available public sites occurred basically because from 1987 to 2000 New York City engaged in a huge, municipally supported housing production program, the largest in United States history, motivated especially by the business community's desire to retain and attract employees who could afford to live reasonably close to work. Announced in 1985, Mayor Koch's "Ten Year Plan" originally committed the city to invest over $4 billion to build or renovate housing units during the plan's time period. A key goal was to renovate or completely rebuild roughly 100,000 units that the city then owned, and return them to for-profit and not-for-profit owners. Under this plan, the city typically provided land or buildings at a nominal cost to developers, and most of the housing assisted through the program also qualified for property tax abatements and/or exemptions. The initiative was sustained under four mayors (two Republican and two Democratic). In these ways, by 2002 the city's stock of housing units and land that it owned had sharply declined, although, prodded by the community board, the city did find some suitable sites in the Hudson Yards area.

Overall, New York City has spent and continues to spend far more on affordable housing than any other municipality. For example, in 1995 New York City spent $107 per capita on housing, compared to an average of $13 per capita in the next largest thirty-two cities (Schwartz 2010, 231).

The Bloomberg administration, intent on continuing this tradition, sought new ways of identifying land for affordable housing creation, which is how using the private sector via zoning for inclusionary housing came to the forefront. The administration's 2003 New Housing Marketplace Plan, focused first on making more land available for residential use by rezoning manufacturing land for residential, and then encouraging zoning for inclusionary housing there and elsewhere. The overall goal

was to commit to the construction or rehabilitation of 165,000 affordable rental housing units by 2013, a goal that was basically achieved. There was also an "acquisition fund," which drew on foundation and public funds to provide low-interest loans for the purchase of buildings and land for affordable housing. This was, in the mayor's words, "the largest municipal affordable housing plan in the nation" (NYC 2009, 1).[13]

Zoning for Inclusionary Affordable Housing in the Hudson Yards

In response to CB4's demands regarding the Hudson Yards rezoning, the DCP discussed affordable housing concessions during the ULURP process, especially with CB4 and its political representatives in the City Council. But the DCP did not formally agree to concessions until six months later, when the application reached the crucial City Council stage and faced the possibility of a no vote.

CB4 and its allies pressured the city to provide affordable housing to a broader range than just low-income residents, on the grounds that there were plenty of moderate- and middle-income residents in the neighborhood who could benefit from regulated rents. CB4 also called for the rents to be permanently affordable, not just temporary until the bond came due. Finally, they pushed the city to identify and turn over five city-owned sites (three in the 2005 rezoning discussed here, two in the later 2009 rezoning) where the city could build affordable housing for a broad income band.

The eventual 2005 agreement allowed a developer, in those sections of the Hudson Yards rezoning that permitted new residential development, to nearly double the square footage of the new building (increasing the floor area ratio from 6.5 to 12, a substantial size bonus), provided that either

1. at least 20 percent of the building's residential area was rented to "lower income households" (i.e., the standard 80/20 program), or
2. at least 10 percent was rented to "lower income households" and at least 15 percent to "moderate income households," or
3. at least 10 percent was rented to "lower income households" and at least 20 percent to "middle-income households."[14]

Floor area ratios (FARs) had been used in the city since 1961 to regulate building size. The owner of, for example, a 10,000-square-foot lot subject to an FAR of 33 can build a structure with thirty-three times the floor area, or 330,000 square feet. This might translate, very roughly, into buildings like some of the tallest at Times Square, such as Condé Nast's forty-eight-story, 866-foot tower.

So, in return for being allowed to almost double the size of the building, a Hudson Yards developer, under any of the three scenarios above, had to provide at least 10 percent of the units to lower-income households, though in the second and third scenarios units were also provided for moderate- and middle-income occupants. The maximum monthly rent developers could charge was 30 percent of the income limit for each category of household, from lower-income to middle-income households (dubbed the "30 percent standard"). If the developer used both the size bonus associated with the new inclusionary zoning and the older program of tax-exempt bonds to finance 80/20 inclusionary housing for low-income residents, then the agreement stipulated that the low-income apartments created were permanently affordable, rather than having rents that returned to free market rates when the bonds came due for payment.

Despite the dwindling stock of city-owned sites, the agreement associated with the 2005 Hudson Yards rezoning identified three city-owned sites in the Hudson Yards area where city agencies (such as the New York City Housing Authority, the New York City Department of Housing Preservation and Development [HPD], and the Hudson Yards Development Corporation) would organize the building of inclusionary affordable housing. It was agreed that one site, on the west side of 10th Avenue between 40th and 41st Streets, should contain 150 affordable units, including 48 for low-income tenants, 51 moderate-income units (for those earning up to 135 percent of the Area's Median Household Income [AMI]), and 51 middle-income units (up to 165 percent of AMI). All these units would be permanently affordable. A second site, on vacant land in existing public housing (the NYCHA Harborview Site located at 56th Street just west of 11th Avenue), would generate 155 affordable units, including 63 low-income units (up to 60 percent of AMI), 46 moderate-income units (up to 135 percent AMI) and 46 middle-income units (up to 165 percent of AMI). All these units would also be permanently affordable.

Part of the funding for these buildings would come from the sale of a third publicly owned site, now called Gotham West, located between 44th and 45th Streets and 10th and 11th Avenues. The city first acquired this site in 1975 when it condemned a square block of warehouses, factories, and stables in Hell's Kitchen. For thirty years nothing came of various city attempts to develop affordable housing on the site, including a never-completed plan drawn up in 2000 for the city's Economic Development Corporation to turn the site into a complex called Studio City, with a 500,000-square-foot building with space for studios, offices, and television production. In 2005, as part of the Hudson Yards rezoning negotiations, the city sold the site for $35 million to the Gotham Organization, a

fourth-generation family-run business, to develop the project. The basic deal, dubbed Gotham West in city documents, required Gotham to build at least 600 affordable housing units on the site, including 120 low-income units (for residents earning up to 60 percent of the Area Median Income), 240 moderate-income units (up to 135 percent of AMI), and 240 middle-income units (up to 165 percent of AMI). It would also create an affordable housing fund of up to $45 million, to be managed by HPD, for affordable moderate- and middle-income housing in the Hudson Yards area and citywide.

The Gotham West deal took several more years, until the summer of 2011, to iron out and finally close, as Gotham and the community board wrangled over the size and shape of the development. For example, the community board wanted to set a maximum height of fifteen stories; the developer proposed forty-four. Eventually they agreed on a maximum height of thirty-one stories. The overall development would have 1,258 apartments in four buildings, including 556 market-rate rentals (by 2011 market rents were high, one reason Gotham finally moved ahead) in the thirty-one-story tower that would help pay for a now estimated 682 affordable units, and generate $20 million for the fund for affordable housing elsewhere in the city. The project would also include a new 670-seat elementary school, more than 10,000 square feet of private gardens, a row of stores along 11th Avenue, and twenty condos. The financing included tax-exempt bonds from the state Housing Finance Agency and federal tax credits, and was backed by a consortium of banks led by Wells Fargo, which were in turn backed by $200 million in collateral provided by the developer and an investor. The Hudson Yards Development Corporation would lead development of the Gotham West site, working with HPD and the Gotham Organization (Barbanel 2011). Construction started in late 2011 and was scheduled to finish in 2014, as one of the largest residential developments in Manhattan for years.

Overall, in its final agreement the City Planning Commission estimated that the number of affordable apartments to be built as a result of the 2005 Hudson Yards rezoning, including the three special sites discussed above, would be 25 percent of all the new units built, or a total of 3,347 units. Of these, the CPC estimated that 2,262 would be affordable for low-income residents, and the rest for moderate- and middle-income tenants.

In those last-minute concessions just before the rezoning passed in January 2005, the DCP also, reluctantly, met some of the community board's height concerns. Under pressure from the City Council's Land Use Committee, which met before the key City Council full vote, the DCP eliminated entirely the two blocks that allowed buildings of unlimited height,

and instead imposed a floor area ratio (FAR) limit there of 33 (Dunlap 2005). So New York City lost the option of having the tallest building in the world, though the buildings allowed would still be very tall. The DCP also reduced the planned commercial density from 26 million square feet to 24.3 million, which might modestly lower the other tallest buildings.

Challenging opponents' dislike of buildings over thirty stories, DCP director Amanda Burden insisted that taller buildings create the vibrancy and density essential for successful urban neighborhoods, saying, "You have to have density to get vibrancy" (Dunlap 2005). Tall buildings would also provide the city with a tax base to fund new public services and were, Burden insisted, as quintessentially New York as its three-to-five-story walk-ups. This was anyway in line with Burden's reading of Jane Jacobs's classic book *The Death and Life of Great American Cities*, which, Burden argued, called for a mixture of tall, new buildings and smaller older ones. Burden also said that concerns about blocking light and air were addressed, because the new zoning placed the tallest buildings outside the area's low-rise, residential neighborhoods, especially Hell's Kitchen, which the rezoning plan protected and enhanced (e.g., with new parks).

The city also now formally promised (in a Points of Agreement signed by Dan Doctoroff) that the southern section of the Eastern Rail Yards would eventually include a "cultural facility" (fig. 7.3). This was intended to mollify the community board faced with the prospect of a crop of new, tall buildings. The Environmental Impact Statement specified that the "cultural facility" would provide 200,000 square feet of floor space.

By early 2013 this "cultural facility," mentioned only briefly in the Points of Agreement, had morphed into a "Culture Shed" and was increasingly being viewed by Related as a major attraction, less for long-time existing residents and more for likely new purchasers of the expensive condos and offices that Related was planning, albeit amidst some Community Board skepticism. The city too by 2013 was viewing the Culture Shed as a major facility that would, for example, host outdoor cultural performances that required a very large, public space that was not available elsewhere in the city.

Before going to the City Council, where these concessions were finally agreed, the proposal had to complete several further stages.

Borough president review. Within thirty days of receipt of a community board recommendation, the borough president must submit a written recommendation to the City Planning Commission. This is purely advisory, like the community board.

City Planning Commission review. The City Planning Commission, seven of whose thirteen members are appointed by the mayor, must then hold

a public hearing and approve, approve with modifications, or disapprove the application within sixty days of the expiration of the borough president's review period. Disapproval by CPC terminates the project, which is why a proposal the mayor opposes has no chance. The CPC held public hearings in September 2004 on the Hudson Yards rezoning and the number 7 expansion. About three thousand people attended. These included a sizeable group of construction workers with black T-shirts proclaiming "Vote Yes for NYC's Future," eager for the construction jobs the project would provide. An opposing group of mostly neighborhood activists expressed concerns about the height and density of the tallest allowable buildings, and stressed the need for affordable housing in the neighborhoods.

Since the Hudson Yards rezoning application was put together by the mayoral-controlled Department of City Planning, the CPC obviously approved it, voting in November, 10 to 1 in favor.

City Council review. The plan then went to the City Council for review. In December there was a meeting of the City Council Subcommittee on Zoning and Franchise. The audience was divided into the usual two halves. There were construction workers, this time wearing yellow shirts with "New Yorkers for Hudson Yards" on the front and "Vote 'Yes' for NYC's Future, Jobs, Housing, Mass Transit, Parks" on the back. The second half were speakers opposing the height of the tallest buildings and calling for affordable housing.

Two weeks after the hearing the subcommittee voted for the rezoning. After that, the DCP, under pressure from the City Council's Land Use Committee, formally agreed to the long-discussed concessions to meet the community board's criticisms by adding more inclusionary housing (including the two publicly owned sites and the Gotham site) and broadening it to include moderate- and medium-income, not just low-income, residents; eliminating the two blocks that allowed buildings with no height limits; and slightly lowering some of the tallest other buildings allowed. The City Council praised the affordable housing initiatives.

Mayoral review. The final stage in ULURP allows the mayor to veto a council action within five days of the vote, which the council, by a two-thirds majority, can override. Naturally the mayor approved the Hudson Yards rezoning, since his DCP had proposed it. Bloomberg and Doctoroff were thrilled, since this was a key part of, and integrated with, their overall plan for the Hudson Yards. The head of the Regional Plan Association, Robert Yaro, applauded the Hudson Yards zoning approval: "The Hudson Yards plan has moved unusually rapidly. The mayor and Dan Doctoroff are to be congratulated for getting the zoning approval this quickly. It's the city's economic future."

CITY AND STATE PROCESSES CONTRASTED

The city's ULURP is far more sensible and democratic than the state approval process. As mentioned, a project that the mayor dislikes is very unlikely to be approved (for example, it will get rejected at the City Planning Commission Review stage of ULURP), which is reasonable, since the mayor is the highest elected city official. At the same time ULURP provides a democratic constraint—the chance to stop an unpopular mayoral proposal—if opponents can muster a two-thirds majority of the City Council. So ULURP restrains blatant (local) nimbyism, since City Council members who represent an area affected by a project going through ULURP cannot, without widespread support from the other legislators, stop the project. ULURP also gives the mayor an incentive to tailor a proposal to obtain necessary City Council votes and then, if need be, modify it as criticisms emerge during ULURP.

By contrast, the state process ends with a vote by three individuals (Public Authorities Control Board), the governor, the speaker of the state assembly, and the leader of the senate, any of whom can veto the project, which they might have intended to do from the very start but not been willing to say, leading to a huge waste of many people's time. Also, this is arbitrary, especially since there is no provision for a legislative override of a veto, and it also encourages corruption, since it is relatively easy for special interests to "purchase" one vote.

INTERLUDE: RESIDENTIAL DEVELOPMENT AND THE REAL ESTATE CYCLE AS SLOWING FACTOR

Although a major intent of the Hudson Yards rezoning was to make more land available for commercial/office use and stem the flow of office jobs to New Jersey, for the next few years after the 2005 rezoning, the market for condominiums was much stronger than the commercial, office market. So most new development in the area consisted of residential buildings constructed outside the Hudson Yards' new L-shaped commercially zoned corridor on which the city had placed its hopes for creating office towers. Several of these were along 41st and 42nd Streets.

Then as the 2007–2009 financial crisis and real estate crash unfolded, even new high-rise residential/condo buildings met real estate cycle problems. For example, in 2006 Glenwood Management, the city's fifth-largest real estate developer, had begun assembling parcels on the eastern edge of the Hudson Yards, just off 8th Avenue and fronting West 37th and 38th Streets. It built the twenty-four-story, two-tower Emerald Green, which opened in October 2009 into a dismal condo market. Anticipating this,

management had already switched from selling the 509 apartments as condos to renting them. "If we were selling condominiums, we'd want to put our heads in the oven. But you can always rent," said a manager putting a brave face on things (*The Real Deal* 2009). Larry Silverstein's massive twin Silver Towers (fig. 5.2), each 653 feet, likewise opened in 2009 as the tallest rental building in New York's history, built on the site planners had once hoped would contain the Javits Convention hotel and just outside the new Hudson Yards rezoned area, next to One River Place, which Silverstein had completed in 2000.[15]

Another reason that office towers failed to appear was that the key transportation infrastructure, the number 7 subway extension to 11th Avenue and 34th Street and the redone Penn/Farley Station, had not yet happened. Still, a funding mechanism (TIFF) was in place for the number 7 subway extension. So in September 2006 the Hudson Yards Infrastructure Corporation formally agreed with the MTA to provide $2 billion toward the cost of the number 7 (i.e., its basic, estimated cost), with an additional $100 million to cover potential cost overruns. In December 2006, the HYIC duly sold $2 billion in bonds, which were backed by the promise of tax revenues from Hudson Yards development (TIFF). In February 2009 boring started on the subway tunnel.

The city, having now sold bonds to fund the new subway, was anxious to see the developments appear in the Hudson Yards District that would provide the tax revenue (PILOTs in the case of commercial buildings, TEPs in the case of residential buildings) to fund the interest on the bonds the HYIC had issued, especially since until that happened the city had to make up the shortfall out of other city revenues. This became a major factor driving city decisions on the Hudson Yards over the next several years. It was, for example, an important reason why the city was eager to make available to builders in the Hudson Yards its 421a residential tax abatement program. These builders could also qualify for an inclusionary housing zoning bonus to increase their FAR if they added affordable units. By mid-2013 most developers of residential buildings appeared to be going for both bonuses, the 421a and the FAR/zoning bonus.

STAGE 2, 2007–2009: REZONING THE WESTERN RAIL YARDS FOR RELATED'S PRIVATE CONDO/OFFICE DEVELOPMENT, 2009

The mid-2005 failure of the NYSCC, planned for the Western Rail Yards, left that huge, thirteen-acre site open. The city initially wanted to buy it from the Metropolitan Transportation Authority (MTA) but dropped that plan and by early 2007 agreed that the MTA would seek proposals from

private developers to sign a long-term lease with the MTA for air rights to develop over the yards. The request for proposals would be for both the Eastern and Western Rail Yards (twenty-six acres total), since each required an expensive platform over the rails before development could start, so it made sense to see if one developer would build both platforms. The MTA would organize the bidding process—develop guidelines, issue a request for proposals, and select at least one developer.

The MTA wanted to maximize its rent, which meant the development's core would likely be residential (condominiums), with perhaps some office towers, which was basically the package that Cablevision had proposed back in February 2005 for the site when trying to undermine the NYSCC during that fracas. In addition to paying rent to the MTA and funding the platforms, the selected developer would make payments in lieu of taxes (PILOTs) to the city to help finance the number 7 subway line, like other developers in the broader Hudson Yards area.

Cooperation between the MTA, controlled by New York's governor, and the city was crucial, since the MTA needed city help shepherding the Western Rail Yards rezoning through ULURP. The Eastern Rail Yards had been rezoned as part of the broad 2004–2005 Hudson Yards rezoning from mostly industrial/manufacturing/transportation to commercial and residential. The Western Rail Yards had been deliberately excluded from that rezoning, since the NYSCC was buildable under existing industrial/manufacturing zoning and, in any case, Doctoroff had not wanted to expose the NYSCC to city critics during a ULURP process.

To ease the Western Rail Yards rezoning through ULURP, the MTA and city said the guidelines that the MTA would put up for bidding would have significant input from stakeholders, including not just the development industry but also the City Council and the community. But in practice the MTA, cash-strapped and anxious to attract the highest bids, wanted flexible guidelines that did not offer specifics about the makeup of buildings or infrastructure. By contrast, the community board and others said that key issues should be agreed upon at this early point so as to ensure eventual ULURP approval. For example, the chair of Community Board 4's Land Use Committee, Anna Levin, and others, pushed for guidelines to include specifications about affordable housing, building placement, infrastructure, and a school.

The High Line was also an issue. In 2007 Related's chairman Stephen Ross was adamant that the High Line section running alongside the Western Rail Yards should be demolished. He saw it as detracting hugely from potential condo and office purchases, as well as impeding the design and construction of profitable buildings. In response the Friends of the High Line lobbied heavily and successfully to save this section. Meanwhile

the MTA diplomatically sat on the fence, saying that it was committed to working with the city and other parties to find a solution "that would provide vital funding of the MTA's capital needs and ensure a wonderful addition to the West Side community." By May 2009 the city had sided with the Friends of the High Line and decided to keep section 3, to the anger of Stephen Ross, though by 2012 he had reversed his position, as the enormous success of sections 1–2 showed the High Line's asset as a real estate marketing tool.

On May 8, 2007, the MTA and the Hudson Yards Development Corporation presented guidelines for the Western Rail Yards rezoning to a public meeting. The guidelines allowed up to 13 million square feet of commercial, retail, and residential space; a building to house a cultural group yet to be named; and a public park. The platform over the Western and Eastern Rail Yards was now estimated as likely to cost the developer $1.5 billion, five times the $300 million estimate for the NYSCC platform back in 2004, although that platform would have covered just the Western Yards. The platform was always going to be expensive, because construction would have to take place without interrupting train service. Still, building costs were rising fast.

The Hudson Yards Advisory Committee, whose members included representatives from Community Board 4, distilled their wishes at the public meeting into two main points, which they stressed in a letter to the Hudson Yards Corporation and the MTA: first, as much affordable housing as possible; second, preservation of the High Line section that ran through the Hudson Yards.

Responding to concern about affordable housing, the city agreed to provide a subsidy of $40 million to build affordable housing on two sites it owned nearby, but which were not part of the railyards. The city did this partly because it argued that building on the Western Rail Yards would be very expensive, since a developer would have to pay for the platform over the yards, so it was probably not feasible to get a developer to include much affordable housing there, even under the incentives provided by the zoning for inclusionary housing program.

The two sites the city was offering for affordable housing, like the three sites the city had associated with the 2005 Hudson Yards rezoning, were part of the city's remaining, small stock of available city-owned sites for housing. One site, on the western side of 10th Avenue between 48th and 49th Streets, was currently in use by the Department of Environmental Protection for construction of the city's much-needed Water Tunnel 3, and would likely be available by 2013 or 2014. Partly justifying the city subsidy, this site would require a platform, since it included an Amtrak rail cut. In the final points of agreement (a December 10, 2009,

letter to City Council President Quinn, signed by the mayor's office and the selected developer Related just before the City Council vote on the 2009 Western Yards rezoning), that site was envisaged to be developed, using part of the city $40 million subsidy, to contain 204 units of permanently affordable rental housing for low-, middle- and moderate-income levels. The other city-owned site, on the eastern side of 9th Avenue between 53rd and 54th, included a parking lot and a large MTA building. That too, in the final points of agreement, would be developed, also using part of the city subsidy, to include a proportion of permanently affordable housing for low-, middle- and moderate-income levels, calculated as roughly 108 rental units. On both sites at least 50 percent of the affordable units would contain two or more bedrooms, a strong community board demand reflecting its belief that affordable housing should be available for families. For both sites, the request for proposals (RFPs) for a developer to build would be issued by the city's Department of Housing Preservation and Development (HDP).

These two sites, which would be part of the MTA's RFPs, constituted an unusual kind of public-private deal, with the affordable housing sites and Western Rail Yards bundled and studied together in one Environmental Impact Statement.

It was also agreed, though at the last moment, that the Western Rail Yards site itself would contain some inclusionary housing. The final agreement on this was complicated, with key parts included in the points of agreement (December 2009). Basically it said that Related promised to build at least 265 affordable rental units for low-income households on the Western Yards and at least another 265 for low-income households on either the Western or Eastern Yards, in either rental or condo buildings, provided the developer received tax-exempt bonds or equivalent low-cost financing (i.e., the 80/20 Housing Program). However, if a developer could document to the Department of City Planning having tried, unsuccessfully, to obtain such low-cost financing, then the developer need not include affordable housing in any rental residential building constructed. Further, a "density bonus" allowed a developer to build residential buildings with 5 percent more area, but if the developer used this 5 percent density bonus then the 20 percent affordable rental units must be "permanently affordable," which meant they were regulated forever, not just until the tax-exempt bonds issued under the 80/20 Program came due.[16]

The DCP estimated that if the developer used the full bonuses, the Western Rail Yards site would contain 1,948 rental units, of which 390 (20 percent) would be permanently affordable for low-income households under the terms of the applicable 80/20 Program. Under this scheme, space for a public school was also required.

In November 2007 the MTA made public five proposals it had received to develop the Eastern and Western Rail Yards. All included a series of residential and commercial towers, most at the northern and southern edges of the site, to minimize disruption of the tracks below. The commercial towers were generally on the Eastern Yards, already zoned for commercial/office, with the residential towers to the west offering Hudson River views.

In mid-May 2008 the MTA picked the proposal from the Related Companies, who were partnering with Goldman Sachs. Related's Hudson Yards proposal (for both Eastern and Western Yards) had 5.7 million square feet of office space and 5.3 million of residential space, together with a vast retail mall and plaza between 10th and 11th Avenues (figs. 7.2 and 7.3). The eventual value of the buildings to be constructed was estimated at roughly $15 billion, compared with Related's Time Warner Center's estimated value in 2006 of $1.1 billion (Chan and Rivera 2007).

The design for Related's Eastern and Western Rail Yards, by a team of architects that included Kohn Pedersen Fox, Arquitectonica, and Robert Stern, was anchored at its eastern end by a seventy-four-story office tower, roughly 750–850 feet tall. (For comparison, Time Warner Center's twin towers were 750 feet tall.) Three slightly smaller towers would flank it. *New York Times* architecture critic Ouroussoff complained that the eastern tower would "create an imposing barrier between the public park and the rest of the city to the east," as he and others had criticized the main Javits expansion proposal's failure to remedy how Javits blocked waterfront access.[17]

The site's western half, as clarified in detail in the ULURP application a year later, would have eight towers totaling 5.7 million square feet: seven wholly or primarily residential, and one commercial office or hotel space. The towers would range from 450 to 900 feet in height. As detailed above, in the final agreement (December 2009) a substantial amount of inclusionary affordable housing was included for the Western Yards residential buildings. The commercial tower would fill 1.5 to 2.2 million square feet, for either offices or a 1,200-room hotel.

Related would pay the MTA an annual rent for a ninety-nine-year lease, making a total rent over the length of the lease of $1 billion. Some critics of the proposed deal, such as former MTA chairman Ravitch, complained that the MTA needed an immediate large cash infusion, not a steady rental stream over ninety-nine years whose start date was uncertain. The earliest that work could begin on the platform was late 2009 (work actually began in early 2014), and the entire project was expected to take a decade. Ravitch complained that it could be years before the first building was erected and the transportation authority began to get a rent stream from Related. What's more, the agreement allowed Related to delay rent

payments for up to two years for various reasons, including litigation or the extension of the number 7 subway line not being completed by 2014.[18]

By contrast, the aborted deal with the Jets to build the NYSCC would have given the MTA an immediate $250 million in cash just for the Western Rail Yards, a deal which arguably looked better than Related's $1 billion stretched over ninety-nine years.

In any case, by February 2009 the real estate market, both residential and commercial, had soured. Related, though the designated site developer, had not signed a contract with the MTA, which agreed to delay closing the deal one year until the project had completed ULURP, also giving Related an extra year to pay the down payment due on signing.

In May 2009 the Department of City Planning certified the Western Rail Yards part of Related's plan as ready to start ULURP. Related had now made several changes to the western part, mostly in response to critics. It reintroduced the street grid by extending 31st and 33rd Streets through the site. Responding to criticism from the Friends of the High Line, it moved a proposed building that had been slated to be cantilevered over the High Line. Related agreed to build a public school (kindergarten through eighth grade), integrated into one of the residential buildings. Also, the new buildings would have green (environmentally sensitive) roofs. Related was not required to, and did not, reveal its detailed plans for the Eastern Rail Yards site, since that was not part of this rezoning application. Honoring its earlier agreement with the MTA, the city formally agreed to donate land for building the two off-site developments (fourteen blocks or more from the railyards) with more than 300 subsidized apartments as part of the project. The sites were estimated to be developed by 2018.

The debate with the community over Related's Western Yards proposal was familiar. The community board wanted the towers reduced. The community board also wanted more affordable housing on the site than in the current agreement.

The Planning Commission held its public hearing on the proposal in September and voted approval in October 2009. In a near-unanimous vote in December 2009 the City Council passed the rezoning, but only after eleventh-hour negotiations with elected officials in which Related agreed to raise the amount of affordable inclusionary residential units associated with the megaproject which were to be spread over the Eastern and Western Yards. Related also doubled the amount of cultural space to be available in the Eastern and Western Yards, from 8,000 square feet to 16,000. In the final agreement Related also committed to setting aside 120,000 square feet for a public school and 10,000 square feet for child care facilities.

The proposal completed ULURP in January 2010. "This rezoning reflects

years of conversation, outreach and input from community members," said City Council president Quinn about her district. "Soon thousands of New Yorkers will have the opportunity for new affordable housing and cultural space right in their neighborhoods. A rezoning of this magnitude that unlocks an unprecedented amount of developmental potential would only be tenable with a guaranteed affordable housing program" (Hedlund 2010).

THE PRESENT: 2010–

In order that Related could be certain the project had gone through ULURP, Related had been given a year's extension until January 31, 2010, to sign a contract with and make its first rent payment to the MTA. Then in January 2010, as New York's real estate market further worsened, Related's partner, Goldman Sachs, pulled out of the deal. In May 2010 Related signed the contract with the MTA after finding a new partner, Oxford Properties (a Canadian pension fund for the Ontario Municipal Employees Retirement System), that would contribute up to $475 million in equity. Although on signing the contract Related made the long-promised deposit of $21 million with another $21 million due in a year, the deal allowed Related to avoid actually closing the contract—and becoming liable for a stream of rental payments—until the economy had improved according to specific benchmarks such as a measurable rise in the residential rental market.

By July 2011 the deal with the MTA had still not officially closed; nothing had been built at the site; and Related had not found a lead tenant to commit to the eastern commercial tower, without which Related did not intend to close on the contract and start building. Jay Cross, who had been in charge of the Jets' failed NYSCC attempt for the site, and whom Related had then hired as its Hudson Yards president, put a brave face on the project. "We're sort of coming out of hibernation," he said, referring to the 2007–2008 financial and real estate crisis, adding that they were hoping to sign a lead tenant (Topousis 2010).

Then in November 2011 Related and the city announced that Coach, the leather goods corporation, would be the lead tenant for the fifty-one-story commercial tower on the Eastern Rail Yards and would move its corporate headquarters there, taking over the lower third of the building. Construction on the tower would start in mid-2012 and be finished by 2015. "The Far West Side's economic potential has now become an economic reality," said Mayor Bloomberg (Taylor 2011). Robert Hammond, for the Friends of the High Line, said this would now ensure the building of stage 3 of the Line, which would go right past the new tower.

The extension of the number 7 subway line was on schedule to open

in mid-2014, with a stop at 11th Avenue and 34th Street. A planned stop at 10th Avenue and 41st Street was eliminated for budgetary reasons, but the mayor's office had not given up hope of finding money for it.

As development in the Hudson Yards (defined both narrowly as the Eastern-Western Rail Yards and broadly to include the area rezoned in 2004–2005) unfolds, a series of issues and debates are unfolding with it—inevitably, given the scale of what is emerging. These include the character of the Culture Shed, TIF funding issues, questions about how "inclusionary" is "inclusionary housing," naming and branding debates revolving around the label "Hudson Yards," and debates over how to fund the newly created Hudson Park

The "Cultural Facility"/"Culture Shed," and Related-Community Board Tensions

By early 2013, as New York's real estate market strengthened, city officials and Related came to see the city's 2005 commitment to provide a cultural facility on the Eastern Rail Yards as far more than its original, unassuming community/social facility, granted as a deal to help persuade the community board and long-term local residents to accept the very tall buildings associated with the Hudson Yards rezonings. The city and cultural affairs commissioner Kate Levin now evidently saw a chance to create a major "Cultural" (i.e., arts) center, while Related now envisaged an attraction appealing to the wealthy and enhancing the saleability of its condo and office towers planned for the Eastern and Western Rail Yards. In March 2013 Kate Levin explained the project, which had been renamed the "Culture Shed," to a somewhat skeptical Community Board 4 Land Use Committee. (The new facility required some zoning amendments and so had to go through ULURP, which included the community board's advisory review.) Levin said it would be a nonprofit called "Culture Shed, Inc.," a grand enterprise run along the lines of many of the city's major museums. It would be controlled by a basically private board (though containing two ex officio city officials), on land that the city planned to acquire from the MTA and lease to Culture Shed, Inc. (IBO 2013). The Culture Shed would have a curator and include such attractions as galleries, dance, music, a farmers market, café, and film series, each appearing on a temporary basis. The Culture Shed's permanent building would be 13,000 square feet, located next to Related's residential tower on the Eastern Rail Yards (fig. 7.3). It would take over the adjoining plaza for special outdoor events, which would then be temporarily closed to the public, and in this way could expand to 40,000 square feet for such events. The city currently had nowhere to mount large, outdoor cultural events, so the Culture Shed would, Levin

believed, fill a huge gap. The Culture Shed's total cost was unclear, but seemed likely to be funded by a combination of public and private money (IBO 2013a).

Underlining the Culture Shed's transformation into a major development tool, Levin explained that right now just three people were on Culture Shed, Inc.'s board making the decisions—Related's chair Stephen Ross; Daniel Doctoroff, who as deputy mayor for economic development in 2005 had helped push through the first Hudson Yards rezoning and was now CEO of Bloomberg L.P.; and Levin herself. The physical Culture Shed would not be constructed until the planned luxury residential tower (Tower D) next to it was leased and built, which would not be earlier than 2014, and it was expected to open around 2017 (IBO 2013a).

Members of the community board, predictably, expressed a concern to shape the Culture Shed and its activities, noting especially that its origin in 2005 had been basically as a community facility for the neighborhood to compensate for the mega office and condo buildings the rezoning would allow. They now worried, for example, that the Culture Shed would not have enough free activities, and that the closings of the public plaza for special events would, albeit temporarily, deprive them of the use of another public space whose origin was intended to compensate them for megadevelopment. Still, the Culture Shed would clearly now, for better or worse, proceed on its own dynamic, driven mainly by the city and Related. In June 2013 the city gave the Culture Shed $50 million, the largest cultural capital grant of the year. It was also decided that the Culture Shed would be designed by Diller Scofidio & Renfro. By September, the Culture Shed had raised a huge $150 million from private donations.

Likewise underlining Related's power to influence the evolving life, cultural and otherwise, of the Hudson Yards, Community Board 4 lost an attempt to stop Related from building a driveway from 30th Street that would take vehicles to a basement garage and entrance to the South Office Tower. The community board complained that the driveway would interfere with the pedestrian walk along 30th Street. Likewise the community board and the Friends of the High Line failed to stop Related from building its South Office Tower over the High Line, which took away at that point an open view for those walking on the Line. They had wanted Related's tower to stop at the High Line, making for a slimmer, and less profitable, building.

The TIF Financing Calculus

The Hudson Yards Improvement Corporation, having now issued a total of $3 billion in bonds ($2 billion in 2006/7 and $1 billion more in 2012) to

fund the number 7 subway extension and the new Hudson Boulevard, needed an infusion of city funds, since the revenues from new and improved buildings in the Hudson Yards area—PILOTs and TEPs—did not yet cover the interest payments on the bonds. As of April 2013 there had been no revenue at all paid through PILOT agreements because there had been no new office construction meeting PILOT requirements in the Hudson Yards area. Related's first office tower in the Eastern Rail Yards (the Southen Tower) was expected to make the first PILOT agreement, and, assuming the building received the standard three-year construction permit, was unlikely to start paying PILOTs until 2017 or 2018. Some funds from TEPs (from residential development) did come in to the HYIC from 2008 to 2012, a total of $78.5 million (including $29 million from hotels, $28.6 million from rental buildings, and $11.8 million from condos) (IBO 2013a).

Meanwhile the City Council had previously agreed to subsidize the HYIC should its revenue fall short of its annual debt service payments on up to $3 billion of its bonds. The city's first payment came at the end of 2009 when it made a $15 million prepayment to HYIC out of the city's surplus for that year. The city followed this with payments to the HYIC of $42.7 million in 2011 and $79.3 million in 2012, and by mid-2013 had made a prepayment of $155 million from the city's 2012 budget surplus, expected to cover all the HYIC's interest support payment for 2013 and part of 2014.

Some critics now complained that taxpayers were paying for infrastructure projects that the city had originally said would be funded entirely by private development. The *New York Daily News* ran a prominent story titled "Your Tax Dollars Pay Hudson Yards' Debt, Thanks to Mayor Bloomberg."

> Private developers were supposed to pay for the grand Hudson Yards project on Manhattan's far West Side, but right now taxpayers are being made to finance an ever-growing bill for the development. The Bloomberg administration paid $234 million during fiscal year 2012 to a city-created development group [the HYIC] that oversees the huge new commercial and residential complex, one of the mayor's most ambitious projects. City Hall quietly earmarked most of that money — $155 million — to the Hudson Yards Infrastructure Corp. in late June, because the group has not been generating enough revenue to pay the annual interest due on $3 billion in bonds it issued.
>
> Hudson Yards Corp. floated those $3 billion in bonds to pay for an extension of the MTA's 7 subway line to 34th St. and 11th Ave., plus a new boulevard that will run between 10th and 11th Ave. Initial plans by Bloomberg's aides called for private developers to pay enough money in fees,

air rights, and taxes to Hudson Yards Corp. to pay back the $3 billion in bonds.

All the rosy predictions have not materialized of a new commercial district springing up in the Hudson Yards area once a new subway got underway. Maybe it will in 50 years, when most of us are dead. As you might expect, none of this was mentioned at the huge and happy groundbreaking ceremony that Bloomberg and other politicians attended Tuesday for the first office building to be built in the Hudson Yards area. (Gonzalez 2012)

Naturally such criticisms injected further urgency into the city's drive to get enough private development (if necessary by offering financial incentives such as tax rebates) to cover the current shortfall. The city could also, of course, reasonably respond that the number 7 subway was getting done in less than ten years as a result of the tax-increment financing structure of the Hudson Yards, while by contrast the arguably far more important Penn/Moynihan Station project, lacking any such financing structure, was languishing now twenty years after it had been first suggested.

Segregation within Inclusionary Housing?

Community Board 4 has expressed concerns that within inclusionary housing there may be some informal segregation by economic status, with those residents living in the subsidized housing units being separated in several ways (e.g., entrances for inferior residences on lower floors than those who are paying market rates). This charge was raised early, in connection with Related's Caledonia residential building sited next to the High Line at 17th Street to the south of, and outside, the Hudson Yards.

In the case of the Caledonia, by mid-2013 the situation was as follows. The Caledonia consisted of twenty-five floors and 475 residential units in total (a mix of condos and rentals). The top floors (10–25) were allocated for roughly 190 condos (owners paying market rates). The remaining (roughly 285 units) were rentals, and were located on the lower floors (1–9). Of these rental units, 20 percent were affordable with regulated rents, while the rest were renting at market rates. The affordable and market-rate rental units were mixed together on their various floors fairly randomly. As regards entrances, all residents—owners and renters—entered the building through the same main doors, but once inside, the renters (affordable and market) took a set of elevators to their floors separate from those taken by the condo owners.

In short, the Caledonia renters did occupy floors inferior to (lower than) those of the owners (which Community Board 4 had argued, apparently unsuccessfully, violated the 80/20 and Inclusionary Housing Program),

and were physically separated from the owners once they entered the building lobby. Still, among the renters there was no apparent separation of affordable (subsidized) renters from those paying market rates. It is, of course, possible that the absence of separation between the two categories of Caledonia renters was partly a result of Related's awarereness that the community board was scrutinizing this issue.

Community Board 4 continued to monitor the general issues. For example, in July 2013 the developer, Moinian Group, requested the required permission from the board's Clinton/Hell's Kitchen Land Use Committee to open a health club in a building that the developer had constructed using financing under the 80/20 program. The community board replied that approval would not be granted unless residents in the subsidized units were offered health club membership at discount rates (which the developer so far had not wanted to do). The community board, in general, suspected that developers wanted to reassure their market-rate customers that they would not mix too closely with the subsidized, whereas Community Board 4's goal was economic "diversity."

"Hudson Yards" (?) Business Improvement District

The new Hudson Park and Boulevard will run between 10th and 11th Avenues from West 33rd to West 39th Street. The first phase, designed by a team led by Michael Van Valkenburg Landscape Architects, began construction in 2012 and will open in 2014, along with the number 7 subway extension, both of whose entrances will be in the park (with the main entrance between 33rd and 34th Streets). The second phase of the park and boulevard runs from 36th to 39th Street and has not yet been designed.

Concerned about how to pay for maintenance of the new park and boulevard (the city had committed to pay for their construction but not upkeep), the Hudson Yards Development Corporation proposed a Hudson Yards Business Improvement District. The BID would impose a levy on just the commercial properties (the residential condo and co-op owners would pay a symbolic $1 a year). The BID's area (West 42nd Street to the north, 11th Avenue to the west, West 30th Street to the south, and 9th Avenue to the east) was roughly the area rezoned in 2004–2005, with the main difference being that it excluded most of the territory east of 9th Avenue (already part of either the Fashion Center BID or the 34th Street Partnership).

The Hudson Yards Development Corporation had hired a consultant, Barbara Cohen, who first persuaded a majority of the affected commercial property owners, and then the community board, that the BID was a good idea. The Hudson Yards BID's annual budget for its first two years

was capped at $1.2 million, rising to a maximum of $3.0 million after the fifth year and only if needed. The largest part of the first two years' budget ($445,000) was targeted for maintaining the new Hudson Park.

Still, as the BID wended its way through the approval process in 2013, familiar tensions (both among commercial developers/owners, and between the latter and community activists) surfaced. At a Community Board 4 meeting in July 2013 to discuss the BID, Joe Restuccia, the board's expert on housing and zoning issues (who had opposed the BID initially but been overruled by other community board members) expressed misgivings about the BID's likely trajectory, given its probable domination by large developers, but a fatalism about the ability to do much about this. On the one hand, Restuccia stressed that he and others now favored the BID as the best solution to the unresolved problem of funding the new park's maintenance. On the other hand, he was concerned: "This area has some of the biggest developers in the city—Extell, Moinian, Rockrose, Related. The concern is that they will be the driving factor and will homogenize, not foster diversity. For example they will plant the same mix of flowers everywhere, not the different ones each neighborhood would plant."

Community Board members also objected to the BID being named Hudson Yards, foregrounding as it did Related's strategy to brand its railyards development while suppressing the Clinton/Hell's Kitchen neighborhood, which Community Board members insisted was a "fabled neighborhood with a strong sense of identity and sizzle." So the community board made its support for the BID conditional on its being renamed the "Hudson Yards/Hell's Kitchen Alliance Business Improvement District," and also on its incorporating into any streetscape improvements "diversity" rather than "homogeneity" (August 1, 2013, letter, Community Board 4). Still, the BID's eventual name would be determined by the BID itself and only after the BID was formally established.

CONCLUSION

From a public policy point of view, the two Hudson Yards rezonings show the strengths of the city's approval process. For example, Related's Western Rail Yards project went through, but with significant concessions to critics, especially the community board, as Related saw what was needed to obtain a majority of City Council votes. This included Related agreeing to pay for a public school, accommodate the High Line, and provide a considerable amount of affordable housing, some on-site built by the developer as inclusionary housing for low-income tenants, and some off-site on city-owned land and targeted at an income range from low to middle, something the community board consistently pushed for from

the first discussions of rezoning the Hudson Yards (Brash 2011, 171–72). The extent to which there is informal separation of those who are subsidized from those who are not, within supposedly inclusionary housing, needs monitoring, as do other issues. At any rate, the process of making reasonable concessions, encouraged by ULURP and exemplified by these two rezonings, contrasted starkly with the failed Javits major expansion and the NYSCC (as well as the Penn/Moynihan Station project analyzed in the next chapter), in all of which New York State's broken approval process played a critical role.

A second point is that while both Hudson Yards rezonings successfully completed ULURP, they still exemplify one major reason megaprojects in New York can take so long—the difficulty of timing the real estate market. By the time the first rezoning, designed to encourage office buildings, passed ULURP, the office/commercial market had soured. By the time the second rezoning, for Related's megadevelopment, completed ULURP, the development's two intended markets, office and residential, had soured. All this meant that the tax revenue from new, private development, supposed to fund the bonds the city had issued to pay for the number 7 subway extension, was taking far longer to materialize than initially expected. As a result, the city had to step in and help fund the bond payments.

This raises a third point, which has to do with the complex politics of these situations. Critics can complain that the city and its taxpayers are providing an undue subsidy for the benefit of private developers. Bill de Blasio complained about subsidies to developers as he won a landslide mayoral election in November 2013. These subsidies include the various property tax rebates offered to developers to build in the Hudson Yards, and the city paying interest on the bonds issued by the Hudson Yards Infrastructure Corporation, even though the interest payments were supposed to be covered by private development in the Hudson Yards.

Defenders of these arrangements can point to the fact that the subway extension, of benefit to all residents of the Far West Side, is via this bond arrangement getting done, and with record speed for these times. They can also argue that the Hudson Yards (at least the railyards) is turning a dismal and unused section of the city into a dynamic generator of jobs.

Supporting this claim is the Independent Budget Office's projection, made in September 2013, of the likely demand for, and supply of, office space to 2040 in New York City. The IBO was asked to make this projection in the context of the city's ongoing effort to rezone Midtown East to encourage new office towers. The city was concerned that Midtown East, which in the first half of the twentieth century formed the original core of Midtown's business district around Grand Central Station, was now lagging. Critics, on the other hand, wondered whether the office market

might be saturated, and asked for the IBO estimate. The IBO projected that, on the contrary, the amount of new office space likely to be built (mostly as a result of various rezonings in the city, including the Hudson Yards and Midtown East) was roughly 48 million square feet, which was less than the 52 million square feet the city would need to meet a projected increase of 187,000 office jobs over this period (table 7.1). Roughly half of this projected 48 million square feet of new office space would be in the Hudson Yards (and only 3.7 million square feet from Midtown East).

In May 2014, Mayor de Blasio's excellent plan for the city's "huge affordable housing problem" appeared (NYC, 2014), written by his first-rate appointments (e.g. Alicia Glen, Vickie Been, Carl Weisbrod). Still, the policy recommendations resembled those under Bloomberg, including recognition of the problems created by the city's enormous desirability, short age of vacant land, and public funding constraints. Gone were ideological attacks on "two cities," and embraced were multiple policies including working with the private sector via, for example, tax breaks, and seeking maximum feasible building density. The plan envisaged, over 10 years, 120,000 preserved and 80,000 newly built "affordable units," comparable to Bloomberg's 165,000 units from 2003–14 (NIIMP). The main difference was a proposal to make it mandatory, not voluntary as under Bloomberg, for developers in areas newly rezoned as residential to include some "affordable housing."

Fig. 7.5. Hudson Yards 2014 (June). Note construction (on right) for the North and South office towers on the Eastern Rail Yards. Photo by Camilo Vergara.

Penn/Moynihan Station, 1992–?
Fixing Infrastructure

The Penn Station project has been under discussion for six years, which is longer than it took to build the original Station.

—Senator Daniel Moynihan, already complaining in 1998

That the new Moynihan/Penn Station isn't yet completed is the greatest failure in the city. The problem is that as a city we aren't sufficiently embarrassed that this hasn't happened.

—Vishaan Chakrabarti, director, Center for Urban Real Estate, Columbia University, November 2011

The Municipal Art Society insists that Madison Square Garden's life on top of Penn Station be limited to 10 more years, which gives us the time to develop a workable plan to move MSG and build a world-class train station."

—Municipal Art Society, May 2013

It's curious to see that there are so many ideas on how to tear down a privately owned building that is a thriving New York icon, supports thousands of jobs and is currently completing a $1 billion transformation.

—Madison Square Garden, May 2013

The attempt to improve Penn Station has been ongoing since 1992 and is among New York City's most important megaprojects.[1] Penn Station is probably the busiest transit hub in the Western world, busier than Kennedy, LaGuardia, and Newark airports combined (Kimmelman 2012). It serves and is operated by three rail systems—Amtrak, New Jersey Transit, and the Long Island Rail Road, with Amtrak owning the station. Around 400,000 rail passengers a day pass through Penn Station, with another 200,000 using the adjoining, linked subways, compared to 140,000 rail passengers a day at Grand Central Station across town. About 30 percent of intercity rail trips in the whole country, and 60 percent of intercity trips

in the Northeast Corridor, start or end there, making it the most heavily used passenger facility in the Amtrak system.[2]

Yet Penn Station is located below ground in what urban experts widely (though not unanimously—see below) criticize as a dreary, outmoded, and even dangerous facility at Penn Plaza, an urban complex between 7th and 8th Avenues from 31st to 33rd Street (fig. 5.1). The three railroads operating Penn Station described it in 2013 as "a makeshift underground station." At the time of the station's 1963 design only about 150,000 passengers used it daily, and rail travel was declining and widely expected to continue falling. By contrast, the current 400,000 daily rail passengers are the most in Penn Station's history and ought to increase considerably as the Hudson Yards develops, but cannot because of the station's limited capacity.

The list of Penn Station's problems is long. The platforms are too narrow, and space on them is further constricted because they include two sets of support columns, one for the station and another for Madison Square Garden located above. Further, only two train tunnels access the station from the west (New Jersey) under the Hudson River, and both are over a hundred years old and cannot handle high-speed rail, making Penn Station the main bottleneck of the Northeast Corridor rail system. By contrast, four tunnels access Penn Station from the east under the East River from Long Island. Security, in particular against a terrorist attack, is another problem. Although many areas of the city are vulnerable, such an attack would be especially catastrophic at Penn Station since it fails to meet National Fire Protection Association standards for safe exit from platforms and station corridors in an emergency—the standards require that exit from platforms to street be possible in four minutes, while a Penn Station exit could take at least ten (MAS 2013). Also, incredibly, the station has just one, hard-to-access elevator from ground level to the tracks below, creating a major problem for passengers with luggage and for the handicapped (NYC Planning Commission 2013).

The above-ground part of the complex is also deficient. Instead of a glorious station house, it contains two main buildings that have nothing to do with a station—a thirty-two-story office tower, 2 Penn Plaza, owned by Vornado (fig. 8.1), and the sports complex Madison Square Garden (MSG), which is an eight-story circular arena, the country's busiest with roughly 400 annual events. MSG moved to this site in 1963 and later purchased and owns the land on which the arena sits. Train passengers take humdrum ground-level entrances through 2 Penn Plaza and MSG down to the station and tracks below.

These two above-ground buildings replaced the original, neoclassical Penn Station that developers tore down in 1963, an act often viewed as

Fig. 8.1. Penn Station, main entrance, 2010. Its signage is overshadowed by Madison Square Garden's, home of the Knicks, and the interior has long been thought insufficiently grand. Photo by Malcolm Halle.

one of the greatest architectural desecrations in New York City's history (fig. 8.2). Contrasting the first Penn Station with its replacement, architectural historian Vincent Scully famously commented: "Through it one entered the city like a god . . . now one scuttles in like a rat." The difference between Penn Station and soaring stations in most global cities, as well as New York's Grand Central Station, is stark.

In an interesting dissent from this dominant view, architectural critics Tom Scocca and Choire Sicha in November 2010 wrote:

> What has been forgotten in this hysterical nostalgia [for the old Penn Station] is that our current Penn Station is also a miracle. . . . Three railroads and two subway lines deliver more than half a million people each day. . . . If you know where you are going, it will deliver you on your personal atomized commuter-trail, through the entrance of your choice, down the crazy dark stairs you want, to the very door you want of the train you want. Why should you be forced through a grand entrance and into a mob of thousands of people on the floor of a great hall, if all you desire is the 7:49 to Flushing? People love to say they miss the ragged, gritty, vivid aura of New York in the '70s. Yet it still lives! Down in the corridors of Penn Station. . . . Regardless, for our politicians and preservationists the model

Fig. 8.2. Pennsylvania Station, New York City, from the northeast (ca. 1910), designed by McKim, Mead & White in the epitome of the Beaux Arts style of the "American Renaissance." Outrage at its destruction in 1963 led to the creation of the New York City Landmarks Commission in 1965. Photo attributed to James S. Hall, modern gelatin-silver print from glass negative, George P. Hall & Son Collection, New-York Historical Society.

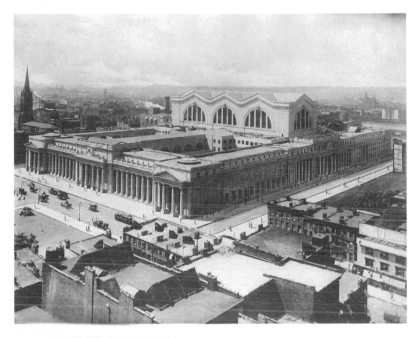

for an appropriately majestic rail hub seems to be Washington's Union Station, which is actually a shopping mall, and that is likely what we will get. (Scocca and Sicha 2010)

This defense of the existing Penn Station never gained much traction, and probably for most passengers the alternative—the grand station-mall model—would be a preferable way of spending time awaiting their train. (The existing Penn Station actually offers passengers plenty of small shops and refreshment places, but not organized as a grand mall.)

MODELS TO FIX PENN STATION

Moynihan Station—Model 1 to Fix Penn Station

It was in 1992 that the architectural engineering firm HOK first proposed what came to be known as the Moynihan Station plan, which, until

Fig. 8.3. Farley Building 2012 (constructed 1914). Efforts have been ongoing since 1992 to turn it into a grand home for Penn Station, to be renamed Moynihan Station. An official billboard outside Farley in 2013 proclaims, "Future Home of Moynihan Station." Unpromisingly, given the general role of squabbling politicians and overlapping government agencies as blocking factors in megaprojects, the billboard names no fewer than nine elected officials and seven federal, state, or bistate agencies as part of the project. Photo by Camilo Vergara.

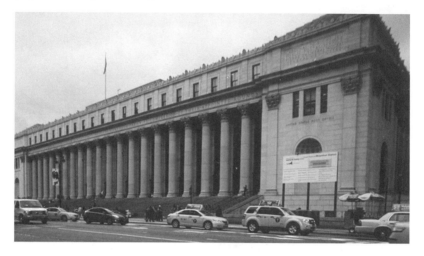

2012–2013, was the dominant model for solving Penn Station's problems. By 2013 it was just one of three models. The Moynihan Station plan involved moving one or more of Penn Station's three railroads across 8th Avenue into the Farley Post Office, a four-story building constructed in the same classical style as the original Penn Station. The Farley Building is set back from the street and accessed by a grand flight of steps along its entire 8th Avenue front (fig. 8.3). This proposal to move to Farley was widely acclaimed as a way of rectifying the 1963 act of desecration. In 1998 the plan was named "Moynihan Station" after New York's US senator Daniel Moynihan, who first obtained federal funding for it.

Yet implementing the Moynihan Station vision has been a long, still unfinished struggle. In September 2012, the project finally began construction on phase 1, which involves linking Penn Station to the Farley Building underground through two new entrances in Farley and a new concourse underneath Farley, and will take several years. Still, the main goal,

phase 2, converting part of Farley above ground into an impressive train station, is neither designed nor funded (estimated at roughly $1.5 billion).

Rebuilding Penn Station on MSG's Site: Model 2 to Fix Penn Station

By early 2013 phase 2 of Moynihan Station was basically on hold as critics questioned the entire project's logic. These critics, led by the Municipal Art Society, the Regional Plan Association, and *New York Times* architecture critic Michael Kimmelman, complained that the plan being implemented entailed only Amtrak's passengers moving to the Moynihan Station, leaving the vast majority (95 percent) of Penn Station's passengers, those taking the Long Island Rail Road or New Jersey Transit, in the old, dreary station. "Why spend all this money for that?" critics asked. (The question of which of the three railroads at Penn Station would move to the Moynihan Station has been an issue throughout, with the answer changing over time.)

The critics proposed basically starting again with a new plan that would force Madison Square Garden out of its site above Penn Station, and build there above ground a grand Penn Station that would link to the rail tracks below. The critics' proposed mechanism for forcing MSG off the site, which it owns, was that MSG's 1963 special permit from the New York City Planning Commission, to build a 22,000-seat (maximum) arena on the site, expired in January 2013. The special permit is needed because an arena or stadium with a capacity larger than 2,500 is not allowed as of right in any zoning district in the city. The critics urged that MSG, whose application for a permanent permit extension was now going through the city's approval process (ULURP) which culminates in a City Council vote, should receive only a ten-to-fifteen-year permit extension—enough time to move to a nearby site (they suggested various possibilities).

Modest Improvements to Penn Station: Model 3 to Fix Penn Station

Meanwhile, in May 2013, two months before the City Council vote on MSG's application, New York City's Planning Commission reviewed MSG's application, as part of the ULURP process. The commission issued a carefully hedged written recommendation that allowed for a third plan to handle Penn Station's problems. On the one hand the commission said its strong preference was for the radical proposal—the MSG relocation allowing a new Penn Station on the site, though the commission estimated that just the preconstruction stage for this (obtaining permissions, holding hearings, etc.) would take about ten years!

Yet the commission also said it would accept a compromise plan whereby MSG stayed but cooperated with the railroads, who would make what could inevitably be only very modest improvements to Penn Station—certainly no grand, above-ground station building—if MSG remained. The commission recommended that, should this compromise plan happen, then MSG's arena permit would automatically become permanent.

Naturally advocates for forcing MSG to move were angry at the appearance of this compromise plan and urged the City Council, as it made the final decision later in the summer, to remove the option allowing MSG's permit to become permanent if it cooperated as the railroads made minor station improvements, which the council duly did. The City Council also, at the urging of its speaker, Christine Quinn, then a leading New York City mayoral candidate, voted 47-1 to extend MSG's permit for only ten years. This vote was hailed by advocates of the radical plan to build a new Penn Station.

Still, the radical plan to force out MSG and build a new Penn Station on its site remains a difficult, and perhaps unlikely, goal. For one, MSG did not indicate any intention to move. Indeed, Madison Square Garden's owners, the Dolan family through Cablevision (James Dolan is executive chairman, president and chief executive of MSG Holdings, L.P.), had earlier dismissed the radical proposal as a "pie-in-the-sky" attack on "a thriving New York icon." Also, MSG is free to apply to the City Council for another permit extension after the new one expires in ten years.

Meanwhile these 2012–2013 discussions of a radically new, or even modestly improved, Penn Station on the existing site have undermined momentum for phase 2 of the Moynihan Station, the construction of a grand station in the former Farley Post Office (albeit only for Amtrak's passengers).

In short, there are now (mid-2014) three plans afoot for fixing Penn Station—the Moynihan Station plan, the plan for a brand-new Penn Station if MSG moves, and the compromise involving modest improvements to Penn Station with MSG remaining in place. Only time will tell whether the proposal for a brand-new Penn Station is a brilliant stroke that eventually happens or, on the contrary, what we have identified as the "unrealistically ambitious proposal" blocking factor that not only does not happen but also slows, and in the worst case entirely undermines, a more modest but workable proposal (here the Moynihan Station proposal), as Richard Rogers's glamorous but unworkable proposal for the Javits Center expansion undermined the existing, workable, and already approved and funded expansion plan. So this chapter explains how a series of now familiar megaproject blocking factors delayed the 1992 Moynihan Station

project until the 2012–2013 critics emerged to advocate a brand-new Penn Station.

This saga also illustrates a well-known difficulty of achieving major infrastructure projects in the United States these days. The American Society of Civil Engineers 2013 annual report on the state of the nation's infrastructure—water, energy, transport such as bridges, airports, ports, roads, trains—gave a near failing grade of D+, actually a slight improvement on the average grade of D since 1989 (ASCE 2013). If "high-speed rail" is defined as a system that supports trains that go faster than 155 mph, America currently has none. The country's only modern intercity rail service, the Acela from Washington to Boston, has trains able to travel at 165 mph, but they actually run on an older right-of-way and are not permitted to reach top speeds because of federal safety rules (Donlan 2012). A bright spot is that California in 2010 voted funds for the first 130 miles of a 432-mile bullet train from San Francisco to Los Angeles. Still, as of 2013, of the roughly 15,000 miles of high-speed rail worldwide, the five leading countries by mileage were: China (6,649), Japan (3,776), Spain (2,389), France (1,329) and Germany (1,039) (Chakrabarti 2013, 170).

PENN STATION: DEMOLITION AND LANDMARKING LEGISLATION

Pennsylvania Station was named for the Pennsylvania Railroad (PRR), its builder and original occupant/owner, and shares its name with several stations in other cities. The original Pennsylvania Station was designed by McKim, Mead & White as a monumental gateway modeled after the Baths of Caracalla and was consistent with the "city beautiful" movement. Completed in 1910, it required razing six city blocks of mostly housing and displacing their residents, which was not a political problem in those days.

Although the station performed a civic role, it was the private property of the Pennsylvania Railroad. It was built as part of a pathbreaking infrastructure project to construct two rail tunnels, started in 1902, enabling trains to cross under the Hudson River from New Jersey into Manhattan, only possible because of the electrification of the railroad. Before then, Penn Railroad dead-ended at its terminal in Hoboken, New Jersey, at the Hudson River, and passengers and freight had to cross to Manhattan by ferry. (The New York Central Railroad, PRR's bitter rival, had established a crossing over the Harlem River to Manhattan much earlier, by 1871, with a line from Grand Central Station to New England.)

Yet by the early 1950s, as automobile-dependent suburbs developed around America, revenues from long-distance rail travel sank while the

value of prime Midtown Manhattan real estate rose dramatically. Both of New York City's major railroad stations, Penn and Grand Central, experienced demolition controversies in the 1950s and 1960s. In 1954, the company that owned Grand Central planned to replace it entirely with a 6-million-square-foot office tower. Nothing came of this plan, but in 1958 the railroad arranged with a developer to demolish a six-story office structure behind Grand Central Terminal and replace it with a hulking, fifty-nine-story "brutalist"-style building, which ever since obscures the view of Grand Central Station from Park Avenue north of the station.

Meanwhile in the 1950s, across town, the owners of Penn Station optioned its air rights. The option called for the demolition of the main building, to be replaced by an office complex and new sports center. The rail tracks, located well below street level, would remain untouched. Demolition began in October 1963 to make way for a "futuristic sports palace" containing Madison Square Garden, current home of the Knicks, and a thirty-two-story office tower, 2 Penn Plaza. At the time, New York mayor Robert Wagner dismissed the preservationist opponents as a small group who do not understand the importance of a sports arena. The demolition was, in retrospect, widely seen as a catastrophic mistake. US Senator Moynihan said in 1998: "There was no such act of vandalism in the history of New York City as the destruction of the original Pennsylvania Station."

At that time there was no legal way in New York City to stop owners of old buildings from demolishing them. Preservationists had, for decades, been pushing for a way to do this and, just as important for many of them, to stop the construction of newer buildings that they disliked. Eventually opposition to new, tall apartment buildings in Greenwich Village and large buildings in Brooklyn Heights, as well as the controversies surrounding Grand Central Terminal and Penn Station, helped trigger two major pieces of preservation legislation—the New York State Bard Act of 1956, which gave New York City the legal right to pass landmarking legislation if it wished, and New York City's Landmarks Preservation Law of 1965, which set up the city's Landmarks Preservation Commission.

PENN STATION TO FARLEY/MOYNIHAN STATION

Origin of the Idea, and Fighting between Politicians as a Blocking Factor

By 1992 the new Penn Station was over twenty years old and needed minor renovations.[3] The architectural-engineering firm HOK was hired to work on the project and during the process suggested moving Penn Station across 8th Avenue into the Farley Post Office. (It was HOK that developed

the workable, horizontal Javits expansion proposal of 2004 that was then replaced by Richard Rogers's unworkable vertical expansion.)

Farley had been designed by the same architects as Penn Station, McKim, Mead & White, with a grand sweep of granite stairs and Corinthian columns. Opening in 1914, just four years after Penn Station, it was basically the western end of Penn Station, built to move mail, rather than passengers, between the trains below. In 1935 it was expanded west to 9th Avenue. Farley has a 150-by-230-foot central court under what was once a vast, gabled skylight. Above Farley's front is a 280-foot frieze that reads, "Neither snow nor rain nor heat nor gloom of night stays these couriers from the swift completion of their appointed rounds," a quotation inspired by Herodotus that over time became the Postal Service's unofficial motto. In 1966, just a year after New York City's Landmarks Commission was constituted, it designated Farley a landmark.

HOK's 1992 proposal envisioned Farley's interior space, then a work floor for letter carriers, as a great public hall leading to Amtrak's platforms and evoking Penn Station's original design. Working with a developer, the project's supporters came up with a $350 million budget. But when the Republicans took over Congress in 1995 the project died, since they didn't want to provide federal funding. This was the first of several instances of fighting between politicians as a factor blocking Moynihan Station.

In 1996 Senator Moynihan revived the project by persuading the US Senate to allocate $25 million for a new Penn Station in Farley as the "Gateway to New York." The New York State Development Corporation then established the Pennsylvania Station Redevelopment Corporation and held a design competition for the new station, which the firm of SOM won with a plan that came to be known as the "potato chip." This involved a 150-foot-high steel and glass shell proposed by architect David Childs, which would bisect the Farley Building at midblock and give it a strikingly modern profile extending well above the roofline. The new roof and skylight were to be about seventy feet over the upper floor of a new two-level concourse.

Multiple Government Agencies as a Blocking Factor

By 1998 the project had stalled. The main blocking factor now was multiple government agencies. So many governmental and quasi-public agencies, especially the post office and several railroads, had a stake that an imposed solution was out of the question.

A central difficulty was getting the US Postal Service to agree on how much of Farley it would give up for the new station. In 1998 it said it would relinquish no more than one-fifth (i.e., 350,000 square feet).

This was only half the 700,000 square feet requested by the Pennsylvania Station Redevelopment Corporation. Charles Gargano, chair of the corporation and of its parent organization, the Empire State Development Corporation, said the full extra space was needed for the new Farley Station so as to include 257,000 square feet of retail space—enough to attract private investors to the project to complete its funding (fueling the suspicion of critics such as Scocca, cited above, that a central goal was to create a giant shopping mall). Postal officials, by contrast, said they needed to retain enough space to keep Farley as a vital twenty-four-hour-a-day hub that contributed to mail delivery throughout Manhattan. "I think it's as important to the city to have viable postal service as to have a viable train station," said the Postal Service vice president for the New York region (Dunlap 1998).

Some advocates of the new station opposed any compromise with the post office and wanted to evict it altogether, seeing it as taking up valuable acreage in Midtown Manhattan doing sorting that could be performed almost anywhere. For example, the Municipal Art Society circulated a grand Farley plan, by Richard Nash Gould Architects, that included no post office—just a railroad concourse, auditorium and conference center, and a ticketing hall, between them equal in volume to the concourse at Grand Central Terminal. "We only have one opportunity to take this magnificent resource and we should make the most of it," said Philip K. Howard, the society's chairman, adding that the society was offering its own plan because "inspired solutions rarely come from political compromise." He did not explain how the post office could be ejected from the building it owned.

Moynihan quickly recognized this proposal as what we are calling an "unrealistically ambitious project" blocking factor. The Penn Station Redevelopment Corporation's plan for Farley was good enough for now, he urged. "If it's not big enough, make it bigger later, but get it done" (Dunlap 1998).

Still, the Postal Service was not the only government agency presenting a problem. A huge additional issue was getting the various railroads at Penn Station either to move to Farley or accommodate, and invest money in making, the changes Farley would require to the existing Penn Station. Amtrak was a key headache here. Since the Farley Building was owned by the US Postal Service, Amtrak, which owned and controlled the existing Penn Station, would become just a tenant in a new train station located in Farley. Also, while none of the money earmarked for the project would come out of Amtrak's operating budget, which was under attack in Congress, $12 million would come from the Northeast Corridor improvement program. So Amtrak was unenthusiastic about a move.

There was also the problem of raising the money to fully fund the project. By 1998 roughly $132 million of public financing was in place, according to the Pennsylvania Station Redevelopment Corporation, which foresaw that the project would require about $315 million. Of this, it expected to raise another $68 million in government funds, with the remaining $115 million from private investment; hence the need for retail space in a new Farley Station.

In February 1998 President Clinton, at Senator Moynihan's request, moved to solve the "squabbling government agencies" blocking factor. He asked Robert Peck, the federal commissioner of public buildings, to broker a solution. As commissioner Peck oversaw 1,800 public buildings for the General Services Administration. Clinton also included an additional $11.7 million for the project in the budget he sent Congress.

To add symbolic momentum to the stalled project, in November 1998 Charles Schumer, New York's newly elected US senator, proposed renaming the refurbished Penn Station after Senator Moynihan, his fellow Democrat, who had just announced his retirement in 2000 after four terms.

Still, Robert Peck made slow progress getting the government agencies to agree. A key problem remained in persuading any of the railroads involved to invest money in the project, whose cost kept rising. In May 1999 President Clinton flew to New York to join Republican and Democratic leaders to celebrate what was now a $484 million proposal. During the visit he announced that he would ask Congress to provide $60 million for the project. Officials said that an additional $60 million was still needed.

Mayor Giuliani now began to make trouble (even though he had earlier expressed support for the plan), reinjecting the "fighting between politicians" blocking factor. Giuliani, a Republican, was unwilling to promote the project of a Democratic senator and president, as well as one supported by Governor Pataki, with whom he was feuding. The Giuliani-Pataki feud was not patched until 2000.

Giuliani complained that the Moynihan Station project was underfunded and predicted that it would be plagued by cost overruns and eventually cost $600 million. He said: "The money isn't in place, and I don't want to give the false impression that it is, because then the city will have to pay for it." He also complained that the project that Clinton was celebrating was less ambitious than had originally been envisioned. He noted, in particular, that the post office would continue to have its grand entrance on 8th Avenue (presumably a concession made to persuade the post office to agree to the project) and that the entrances to the station would be on crosstown streets "in the middle of the block in an alleyway,"

as he dismissively commented. The project then stalled for two more years, primarily over Amtrak's hesitation about making a change, given its financial straits.

Then after the September 11, 2001, destruction of the World Trade Center, the Postal Service jeopardized the project, saying it needed to keep its major presence in Farley because one of its main centers in Lower Manhattan was severely damaged in the terrorist attack. So in October 2002, New York State intervened, and the Postal Service agreed to sell the Farley Building to the state for $230 million and vacate most of it (the sale eventually happened in 2007, with part of the funds coming from the developers Vornado Realty Trust and Related).

But uncertainty over the other key government agency, Amtrak, teetering on bankruptcy, continued as a serious problem. Then in early 2004 Amtrak, because of its financial problems, pulled out of the project altogether. New York State now began talking to New Jersey Transit and the Long Island Rail Road about filling the gap. Both agreed to replace Amtrak as the Moynihan Station's anchor tenant. But financing remained a major issue.

The Magic of Air Rights and Public-Private Partnerships: Unreasonable Cablevision (MSG) Followed by Reasonable Vornado-Related

The idea of bringing in the private sector with a major public-private partnership to fund the new Moynihan Station now came to the fore. This was clearly attractive, given the financial difficulties of the public agencies, especially the railroads, as well as the general problem of squabbling government agencies and feuding politicians. Also, the city administration was inclined to pursue these possibilities, given Bloomberg's private-sector background. For example, it was around this time that the city pushed through the West Chelsea Rezoning (2005) that successfully used air rights to buy off the Chelsea Property Owners and make the High Line possible. It was also around this time that Governor Pataki and Mayor Bloomberg announced the grand Hudson Yards plan for the area west of Penn/Moynihan Station, one of whose parts, the NYSCC, relied on a public-private partnership—the Jets would build and fund the new stadium, while the city and state would fund the platform over the railyards on which the stadium would stand.

So to facilitate public-private deals for Penn/Moynihan Station, the 2005 rezoning of the Hudson Yards area, which established the huge 301-acre Special Hudson Yards District, included a special "Farley Corridor Subdistrict (fig. 7.1, B2–3). This created a cornucopia of saleable

air rights—2 million square feet of development rights associated with the Farley Building, another 2.6 million square feet associated with the existing Penn Station/MSG site, plus 2.7 million square feet in incentive bonus to build a train station on that site.

The city and state now began to pursue public-private partnerships for the Moynihan Station. Still, the difficulty with the particular public-private partnership that emerged was that it allowed the private corporation, Cablevision, which was controlled by James and Chuck Dolan and was the parent company of the Madison Square Garden sports center, to become a major blocking factor. Cablevision under the Dolan family, especially James Dolan, was practically unmanageable as a partner on a public project (as difficult as, or even worse than, Larry Silverstein had been for the Javits expansion and the World Trade Center rebuilding). When the Dolans, after two years of squabbling, finally dropped out of the Moynihan Station negotiations in March 2008, the public-private partnership revived with more promising partners, Vornado and Related. The following account makes this clear.

Pursuing the idea of a public-private partnership, in mid- to late 2004 the Empire State Development Corporation created a subsidiary, the Moynihan Station Development Corporation (chaired by Gargano), which issued an RFP to private developers to convert Farley into Moynihan Station. By October 2004, the Moynihan Station Development Corporation had narrowed the proposals to four. All four envisaged Farley's eastern section as containing the new train station, but two, those from Related Companies and Vornado Realty Trust, included a sports arena in Farley's western section, near 9th Avenue. Most likely this would be a new Madison Square Garden, although the Dolans insisted they had not agreed to move to Farley.

The common idea behind all four proposals was to sell the air rights over Farley to developers and use the proceeds for part of the cost of building a new train station in Farley's eastern part. But for Related and Vornado the real prize was unlocking additional air rights around Madison Square Garden's current site, should it agree to move to Farley. Related and/or Vornado would then pay not only for most of the new train station in Farley, but also for a new stadium for Madison Square Garden in Farley, in return for those air rights and for the ability to build two tall skyscrapers on the former MSG site (with a glass wall looking down to Penn Station, a modest gesture to improving the latter).

This idea to divide Farley into a western part for MSG and an eastern part for trains was strongly supported by Vornado's chairman, Steven Roth, who in a letter to his shareholders estimated that under this project Vornado's properties in the area, using the purchased air rights, would

now be worth $6 billion. Vornado already owned One Penn Plaza, the tower parallel to the northern part of the existing Penn Station block (fig. 5.1), and was aggressively buying property in the area. By 2010 it owned eleven buildings—several for development. For example, in 2010 Vornado proposed tearing down the Hotel Pennsylvania that it owned on 34th Street opposite the entrance to the existing Penn Station/MSG, and building instead a sixty-seven-story skyscraper that would be almost as tall as the nearby Empire State Building. The latter's owners fought the project, saying it would detract from their iconic building, but lost, as the Department of City Planning approved the tower in 2010. "New York's skyline has never stopped changing, and one hopes it never will," said Vornado's New York president, David Greenbaum (Bagli 2010). Later, in March 2013, Vornado decided instead to renovate the hotel, on the grounds that the economic conditions for building a huge office tower were no longer right and that, as Roth said, a hotel renovation would anyway drive up the value of Vornado's 7.5 million square feet of office and retail space in the surrounding blocks.

In July 2005 the state selected for the Moynihan Station project what was now a joint Vornado-Related proposal, with HOK as architects. The Dolans had apparently come on board, since the project now explicitly involved moving Madison Square Garden to Farley's western part.

HOK's design for the new Farley dropped SOM's two-level concourse and potato chip skylight. Instead, their architects, James Carpenter and Kenneth Drucker, proposed a single-level concourse, which was less expensive to build. Roughly 100 feet over the interior courtyard would be an undulating grid of skylights supported on six great columns recalling the roof of the original McKim, Mead & White concourse. Gargano said that officials favored the Related-Vornado project for both economic and historic preservation reasons since it involved less change to the building's landmarked exterior than SOM's two concourses with skylight.

On the economic side, HOK's plan envisaged two different deals for developers. First, the plan would transfer unused development rights from Farley to a site on the corner, located to Farley's west and just north of Madison Square Garden, which currently hosted modest one- and two-story buildings (fig. 5.1, Dev. Transfer Site). In return for being allowed to build on that site, a developer would fund part of the new station's cost. The second development deal involved building on the Madison Square Garden site. Freeing that by moving MSG to Farley would create a huge opportunity for developers, in return for which they would provide more than sufficient funding for a new station.

The Vornado-Related plan also seemed tailored to entice Cablevision

and the Dolans to drop their ferocious opposition to the NYSCC (Far West Side stadium), which the Dolans viewed as competition with Madison Square Garden. The television ads the Dolans had run opposing the NYSCC had stressed that, while they were prepared to spend $300 million renovating the Garden without public subsidies, the Jets needed $600 million from the city and state to build the platform over the railyards for the NYSCC. Now, under the Vornado-Related plan for Moynihan Station, MSG and the Dolans would get a new stadium for free if they moved, arguably a far better deal than the Jets, who were paying for the NYSCC building, were getting. Mayor Bloomberg, furious with the Dolans for their opposition to the NYSCC but still intent on achieving that project, denied any connection between the Moynihan proposals and the Jets stadium, but his denial was unconvincing.

In February 2006 MSG (Cablevision/the Dolans) signed a nonbinding agreement with Vornado-Related to move to a new $1 billion Farley arena. Still, none of the developers trusted the Dolans. "Cablevision has all the marbles," said Vornado's chair Roth, underlining that if Cablevision/the Dolans decided not to move, the consequent inability to build on a vacated Madison Square Garden site would hugely diminish the project's value to the developers and cast doubt on whether there would be sufficient funding for the new station in Farley.

Preservationists

By mid-2006 negotiations were stalled, mainly because the Dolans were demanding that bold signage indicating *Madison Square Garden* be placed on Farley's 8th Avenue front entrance right between the classic Corinthian columns. The Dolans had in earlier negotiations complained that a major drawback of moving to Farley was that MSG would be in a less central location, on 9th Avenue at the back (west) of the Farley Building. Signage on 8th Avenue was intended to somewhat remedy this, though skeptics wondered if the Dolans ever really intended to move MSG, and were just seeking excuses to justify staying put.

Preservationists adamantly opposed the signage, insisting that the Farley project was primarily a train station, not a sports arena, and that signage on the classic exterior was totally inappropriate for a landmarked building. Fred Papert, president of the 42nd Street Development Corporation and a former president of the Municipal Arts Society, who had played a central role with Jackie Kennedy in saving Grand Central Station, joined with the Municipal Arts Society and others to found the Committee for a Landmark Train Station. He explained: "The Preservation

community wasn't going to let the Farley Building be the front end of Madison Square Garden." The new committee distributed flyers, such as:

> Don't let it happen again! In 1963, the historic Penn Station was demolished to make room for a new home for Madison Square Garden. ("A monumental act of vandalism.") In 2006, with the new Moynihan Station set to rise in the historic Farley Post Office across Eighth Avenue, history may repeat itself. Madison Square Garden wants to take over the Post Office, and shrink the station. If we let that happen, once again a landmark train station and a glorious New York City landmark will be destroyed. Keep Madison Square Garden out of Moynihan Station!

Squabbling Politicians and Political Lobbying/Cronyism

Pataki, with only a few months left as governor, now lost patience and told the developers, Vornado and Related, that they could not further delay signing a contract to move to Farley while waiting for the Dolans and MSG to resolve the signage issue. The developers, he insisted, had a contractual obligation to go into construction on Farley, otherwise the state would take the project from them. So Vornado and Related now detached the project from the blocking corporation, Madison Square Garden, and the Dolans. At least they tried to.

A version of the Moynihan Station proposal without Madison Square Garden, but not precluding it, began to wend its way through the state approval process. This version, referred to in the new proposal as stage 1, had two parts. The "Farley" part 1 would build the new train station in the eastern part of Farley, as always envisaged. An "off-site" part 2 allowed the developers, in return for funding part of the new Moynihan Station in Farley, to build a tall building on the development transfer site that currently hosted one- and two-story buildings.

The fuller proposal to move MSG to the western part of Farley, thus freeing up MSG's current site and air rights, was mentioned as stage 2 for future development, and was not included in stage 1. In June 2006, New York City's Planning Commission approved stage 1. (The City Planning Commission's approval was needed because the off-site component involved city land.)

The proposal then went to the state for approval, where it ran into infighting between various politicians, especially acute in an election year. Opposition candidates were eager to criticize. Both Eliot Spitzer, then state attorney general and running for governor in November, and state comptroller Alan Hevesi, later jailed for corrupt use of state pension funds

under his control, questioned the project's financing and the state's potential liability for hidden costs. Another issue raised was why the state had not conducted an appraisal of the off-site property (the development transfer site) before selling development rights. Was this a giveaway to developers?

Also, MSG and the Dolans, having refused to be part of the proposal, were now lobbying hard against it, perhaps fearing that once stage 1 was approved they would lose leverage over shaping their move to Farley in a possible stage 2. Or perhaps they did not want Moynihan Station to happen and had never intended to move. As always, no one could be sure what the Dolans wanted. As with their earlier success in getting state assembly speaker Sheldon Silver to veto the NYSCC, MSG continued to use lobbyist Patricia Lynch, Silver's former staff member.

Finally, in October 2006 just before the election for a new governor, Silver vetoed stage 1 in his capacity as a member of the three-person Public Authorities Control Board (as he had vetoed the NYSCC a year earlier). Silver's publicly stated reasons for his veto were illogical. He said he vetoed stage 1 because he favored the more comprehensive stage 2 that included the MSG move. He complained that, if the eventual goal was stage 2, he did not see why the state was being asked to ratify just stage 1, although he obviously knew the reason was the Dolans' unwillingness to agree to stage 2. Whether Silver really favored stage 2 or was just acting on behalf of MSG (and lobbyist Lynch's client) was hard to say, but the latter was plausible. As Gargano and Pataki pointed out, stage 1 was ready to move forward, and when and if stage 2 was ready, Silver and others would have a chance to approve or turn it down. In short, at this point political lobbying/cronyism probably entered as a blocking factor.

Spitzer's brief governorship, from January 2007 to his resignation in disgrace in April 2008, began with a bright spot for the project, but then collapsed into inaction. The bright spot came in March 2007, when the state (Empire State Development Corporation), pushed by Spitzer, who now saw the benefit of the project, completed its purchase of the Farley Building from the United States Postal Service for $230 million, with the Port Authority contributing $140 million, ESDC borrowing $35 million, and Related and Vornado contributing the rest, $55 million. The post office now leased its space in Farley from the state/Moynihan Station Development Corporation.

Still, by mid-July 2007, Governor Spitzer's relationship with State Senator Bruno was at a low, and Spitzer seemed unlikely to get anything major approved by the state legislature over which Bruno had major control, and certainly not megaprojects such as the Moynihan Station or

Javits expansion, both already in deep trouble before Spitzer's governorship. So an additional "fighting between politicians" factor—Spitzer versus Bruno—became a huge problem. In any case, to those involved in the Moynihan Station project and the Javits expansion, Patrick Foye, Spitzer's chief economic development officer, looked increasingly out of his depth.

In December 2007 MSG said that if a Moynihan Station agreement was not forthcoming in two months, they would pull out of discussions and simply renovate the existing garden. In March 2008, MSG duly pulled out, saying it would now focus on renovating its existing stadium. By late 2013 MSG had finished the renovations, involving more luxury seats on the lower level, more bathrooms, refurbished locker rooms, and a pair of skywalks—viewing bridges—suspended from the ceiling, all at a total cost of $1 billion and largely wasted should the mid-2013 move to force MSG to relocate succeed.

Governor David Paterson, who replaced Spitzer in March 2008, was ineffectual and soon became engulfed in his own corruption scandals, and was unlikely to provide the talent to rescue the Farley Station project.

More Squabbling Politicians and Fights between Quasi-Government Agencies

At this point Senator Schumer called for the Port Authority, which had already paid 60 percent of the $230 million cost of purchasing the Farley Building from the US Postal Service, to take over the entire project from the manifestly incompetent and disorganized state, an idea that the *New York Times* endorsed. In addition to general organization skills, the Port Authority seemed to have $2 billion to contribute, plus construction and building skills. In different times the Port Authority would have been the right agency to handle this project, which was just the kind of mega effort that, from its origins in 1921, it was intended to carry out, and had.

But Mayor Bloomberg opposed this on the grounds that the Port Authority had its hands full with the World Trade Center Redevelopment, now at a critical stage, and should not be diverted. Part of Bloomberg's concern was that any delays over the World Trade Center would leave New York City and State liable for $300 million in late penalties to Goldman Sachs as part of a 2005 agreement to persuade the company to build its new headquarters downtown, rather than in New Jersey (the 740-foot, forty-three-story tower began construction in 2005 and opened in 2010). The Port Authority was indeed bogged down on the immensely complicated World Trade Center rebuilding, which involved nineteen public agencies, two private developers, thirty-three architects and consulting firms, and

101 contractors and subcontractors. The Port Authority was now probably the only agency capable of handling the WTC rebuilding.

Bloomberg's view that the Port Authority should not take on Moynihan Station prevailed for the time being. Moynihan Station remained a stalled New York State project as the state's legislature, especially the senate, entered political paralysis amid a sea of corruption charges engulfing its leaders.

Another "Breakthrough"

A year later, in September 2009, another of the many touted "breakthroughs" that had dotted the Moynihan project since 1992 emerged. Amtrak reached a preliminary agreement to move to Farley, apparently paving the way for a transportation-based Moynihan Station project resembling the original HOK-Moynihan vision back in 1996.

Senator Schumer explained that he and Governor Paterson had been negotiating for six months with the new Amtrak chief, Joseph H. Boardman, formerly the New York State transportation commissioner, and found him "far more helpful" than his predecessor. Key to the breakthrough was the government agreeing to Amtrak's request to share in revenue from retail outlets in the expanded station and to make some design changes. The Farley/Moynihan project, which once included relocating Madison Square Garden and building a half dozen new office towers, was back to focusing on the train station annex.

Schumer said the next step would be to raise the rest of the money for a project he estimated would cost $1.1–1.5 billion. Schumer said the Amtrak agreement would make it easier to get federal stimulus funds—more than $200 million in federal funds was already earmarked.

HOK was commissioned to come up with "planning studies and possible designs." It now envisioned Amtrak's operations spanning the 1912 Farley Building and its 1934 annex, with space for dining, retail (including potentially a big-box tenant like Target), and about 250,000 square feet for a post office (i.e., the merging of train station and giant shopping mall that critics such as Scocca feared).

A grand main entrance to Farley would open onto 33rd Street, with two additional entrances on 8th Avenue and 32nd Street. In addition to moving Amtrak's passengers into the Farley Building, proposed renovations to the existing Penn Station would widen corridors and provide a pedestrian connection to a new station underneath Two Penn Plaza, which would house New Jersey Transit's planned mass-transit tunnel across the Hudson (another megaproject long in the works, which floundered amid

huge acrimony when New Jersey governor Christie vetoed it in 2010, apparently placing his personal short-run political gain over the region's long-run transportation needs—a version of the familiar squabbling-politicians blocking factor for megaprojects).[4]

The Real Estate Cycle Blocking Factor and Federal Stimulus Funds to the Rescue

By 2009, amid one of the worst public finance crises in the last six decades, the chances of the city and state finding the remaining funds needed (over $1 billion) seemed slim. The project had run into the changing economy/real estate cycle blocking factor, which exacerbated the overall funding blocking factor.

HOK's Drucker, a veteran of these megaprojects, took a cautious view of the Penn/Farley work he was currently engaged on, basically preparing both stations for low-grade work in connection with a possible move: "Right now everyone is waiting to hear what happens with funding. This could go on for another ten years. Battery Park City took forty! And a private developer doesn't have the stomach for the public timetable. . . . I know it's been very hard for Related-Vornado. Vishaan, in disgust, took an academic job as director of Columbia University Business School's Real Estate program." (Vishaan Chakrabarti had moved from being head of the Manhattan Office of the Department of City Planning from 2002 to 2004 to being head of Related's operations in Manhattan.)

Ironically, the 2008 economic crisis was so severe that, after first stalling things, it triggered a broad federal response that revived financing for the project. In February 2010 Senator Schumer announced that the Moynihan Station project had, as he had hoped a few months ago, received $83.3 million from the federal government's "stimulus funds" for the overall economy, enough to at least start the project. The funds came from the Transportation Investment Generating Economic Recovery (TIGER) program.

Organizationally, the project now took the former phase 1 of the Moynihan Station project and split it into two parts, preparatory work (part 1) which could start, and then building the new station (part 2), which would need funding. The former phase 2, involving a move by Madison Square Garden, was dead for the moment, until critics revived it in the radical proposal in 2013.

Part 1, the preparatory work basically linking Penn Station and the Farley Building at ground level and below and costing $270 million, was now said to be fully funded, with the federal stimulus funding providing the final amount.[5] In July 2010 New York State's Public Authorities Control Board, with Sheldon Silver voting in favor, approved part 1, and

the Moynihan Station Development Corporation (MSDC) and Empire State Development Corporation (ESDC) held a ground-breaking ceremony in October. Part 1 was expected to last until 2015. (Having vetoed this in 2006, Silver probably now accepted it for fear of triggering an outcry over rejecting federal stimulus money.) Amtrak now formally agreed to operate the new intercity passenger station in Farley. Long Island Rail Road and New Jersey Transit would continue to operate in Penn Station, but with greater capacity once the Farley hall was complete.

More Squabbling Politicians: Cuomo-Bloomberg

At this point the blocking factor of squabbling politicians returned. Governor Andrew Cuomo and Mayor Bloomberg were barely on speaking terms, in part because Cuomo had taken to treating Bloomberg as a lame-duck mayor who could be ignored. So Cuomo, with Governor Christie's cooperation, replaced Chris Ward as executive director of the Port Authority. Ward had been responsive to Bloomberg's views. In October 2011 Cuomo got Patrick Foye appointed as Port Authority director, an unpromising choice, since Foye had been out of his depth in 2007 when Spitzer had placed him in charge of the floundering Javits expansion. After making Foye head of the Port Authority, Cuomo announced that the Moynihan Station Development Corporation would be under the control of the Port Authority, despite Mayor Bloomberg's view that the PA had its hands full with the World Trade Center.

Anyway, in May 2012 the Port Authority awarded a $147 million construction contract to Skanska USA for work on part 1, and in September construction began. (Of the funds, $83 million came from the federal TIGER grant, $29.5 million from the MTA, $10 million from the Port Authority, and the rest from federal grants and other appropriations, including the $30 million from the Federal Railroad Administration.) The total cost of part 1 is estimated as $267 million and will take several years.

The main goal, part 2 (estimated at roughly $1.5 billion), is yet to be fully designed or funded. It involves turning Farley at ground level and above into a grand train hall, described as "an iconic railroad passenger station and mixed-use development befitting New York City" (Moynihan Station Development Corporation website, November 2013).

STARTING FROM SCRATCH WITH A BRAND-NEW PENN STATION? MODEL 2

Meanwhile efforts to fund part 2 of the Moynihan Station project were not helped by the emergence in late 2012 of a crescendo of public doubters

who dismissed the Moynihan Station plan as far too modest, a "Band-Aid," and proposed a fresh plan to force out Madison Square Garden and build an entirely new Penn Station in its place. (These criticisms echoed, perhaps ominously, how the workable and funded Javits expansion plan was denigrated as "Javits-lite" and was replaced with a grand, Richard Rogers design that was a fiasco.)

The plan for a brand-new Penn Station differed in three main ways from the failed 2005–2007 plan that had envisaged MSG relocating to the back of the Moynihan Station. First, advocates of the new plan believed they had found a mechanism to force MSG to move, whereas the earlier plan asked MSG to move voluntarily and fell through when MSG chose to stay. Second, the earlier plan, at least initially, had involved developers constructing two very profitable commercial towers on MSG's vacated site, not basically a new Penn Station there. In return for being able to construct these towers, the developers would have paid to turn Farley into a grand Moynihan Station, which was always the original plan's goal. Third, advocates of the new plan left open the question of where MSG might move to—the back of the Farley Building was now just one of several suggested sites, not the designated site as in the old plan.

Exemplifying advocates of the new plan, New York Times architecture critic Michael Kimmelman in 2012 voiced several objections to the Moynihan Station plan. Most important, only Amtrak's passengers, just 5 percent of Penn Station's commuters, would move to the Farley Building. The rest—passengers using the Long Island Rail Road and New Jersey Transit—would remain in the existing, dreary building, and the adjoining subway users would also remain in their current locations. Further, the entrances for passengers to the future Moynihan Station would be two mundane, street-level structures located on either side of, but not using, Farley's grand front staircase. The front of Farley would remain as the entrance to the post office, presumably because the post office had made this a condition of its willingness to vacate the rest of Farley. So the "uplifting experience" of entering Farley by mounting its grand staircase would be wasted on post office customers who, unlike long-distance train travelers, were not seen as needing a special boost when mailing their packages. "The experience for most people using the building will not be like the glory of moving through Grand Central or the old Penn Station" (Kimmelman 2012).

The mechanism that the critics believed they had identified to force MSG to leave the site it owned and had just renovated at a cost of $1 billion was the discovery that the 1963 special permit, granted to MSG by the New York City Planning Commission to build a 22,000-seat maximum arena on the site, expired in January 2013. So MSG had applied for a

permit extension—this time in perpetuity—and the application was go-
ing through the (ULURP) review process's stages which culminated in a
City Council decision to be made in the summer of 2013. The critics said
MSG should be given only a temporary, ten-year permit extension, just
long enough for it to arrange to move. Kimmelman told the City Council
to have the guts to stand up to the Dolans.

Regarding a new location for MSG, the critics had several sugges-
tions, none without difficulties and some highly implausible. The latter
included Pier 76 on the Hudson River (Hugh Hardy)—much too far from
mass transportation. A somewhat more promising location (identified as
MSG3, fig. 5.1) was the huge Morgan postal sorting site two blocks south-
east of the Farley Building from 30th to 29th Street between 9th and 10th
Avenues (Chakrabarti and Kimmelman). The argument here was that the
cash-strapped Postal Service was offering increasingly unneeded "snail
mail" and should be willing to sell the space (Kimmelman 2013), though
it had taken fifteen years to get the post office to sell Farley. Another
possible location for MSG was the back of the Farley Building (MSG2,
fig. 5.1), suggested by the Regional Planning Association and New York
City's Department of City Planning. This was the site MSG had under-
mined back in 2004–2005 by insisting that "Madison Square Garden"
should be in bold, neon lights on the façade of Farley. The critics figured
they could use the option of an expiring lease to force MSG into Farley
on their terms. Still, by 2013 some people (for example, Peg Breen of the
Landmarks Conservancy) were arguing that this site was not viable, since
the support columns required for a large arena (MSG) could not be added
given the existing train tracks underneath Farley.

In an effort to build momentum for the radical plan, the Municipal
Art Society announced a competition to design the new Penn Station
that would replace Madison Square Garden after it moved. The four in-
vited, high-profile architecture firms—SHoP Architects, SOM, H3 Hardy
Collaboration Architecture, and Diller Scofidio & Renfro—presented their
visionary proposals on May 29, 2013.

All the proposals presented a transformed Penn Station that would
also have abundant retail and park space (several proposals had an el-
evated park on top of the new station). The architects argued that their
new station would be a destination New Yorkers would want to come to
even if they were not using the station. SOM had train passengers arriv-
ing to a new, glass-enclosed Penn Station offering magnificent views
of the city from the train. Diller Scofidio & Renfro envisaged a multi-
layered "city within a city" with enormous amounts of residential ("more
than Tudor City"), retail, and commercial space ("more than Rockefeller
Center"), and with the station's layers ordered by the amount of waiting

time people had available (e.g., leisurely dining facilities would be on the top layer, fast food down by the tracks).

Regarding the key issue of how to pay for a new Penn Station and a new MSG arena, the central idea proposed was unlocking air rights that developers would then purchase. The extra air rights, in the "Farley Corridor" created by the 2005 Hudson Yards rezoning, were clearly crucial here. For ShoP, Vishaan Chakrabarti estimated there were 5.5 million square feet of saleable air rights above the Morgan Postal Facility site alone that could be used to pay for a new MSG arena there as well as for part of the new Penn Station. In similar fashion H3 Hardy suggested that saleable air rights could come from allowing four towers (one super tall with 180 stories) at each corner of the Penn Station site to create 14 million square feet, plus eight tall buildings along 7th Avenue to create another 10 million square feet (symbolized by the four hypothetical, dotted rectangles in fig. 5.1).

Chakrabarti also proposed a tax increment financing district (TIF) that would allow government to float bonds to finance the project's main costs—basically a new Penn Station and MSG. Legislation would allocate all property tax revenues arising from new private development in the Penn Station TIF district to pay the interest on the bonds (instead of going to the city's general revenue, where property tax normally went). The justification was that much of the new development would have been triggered by the perceived benefits of the new Penn Station, so it was reasonable to divert the resulting property taxes to finance government expenditure on the station. The city was already using the TIF model to fund the almost-completed 7th Avenue subway extension to the Javits Center.

MODEST IMPROVEMENTS WITH MSG
STAYING IN PLACE: MODEL 3

In May 2013 MSG's permit extension application, now roughly midway through the seven-to-eight-month approval process (ULURP), reached the key stage of City Planning Commission review. A negative review from the CPC ends an application; otherwise it continues to a final City Council vote (which the mayor can then veto, subject to a two-thirds City Council veto override). On May 22, the CPC issued a very conciliatory (to MSG) resolution, which infuriated advocates of the plan to force MSG to move. On the one hand, the commission said it strongly favored the radical plan relocating MSG so as to allow a new Penn Station on that site. The commission explained that this "fresh start on the Penn Station site" would "permit substantial improvements to be made below grade at the track and concourse levels, provide generous means of access and egress

from the ground level to the station below, and could also include a 'head house' structure to serve as a train hall in a manner befitting the busiest train station in the country." In this context, the commission noted "the many deficiencies of the current station and the challenges it currently faces being at maximum capacity" (NYC Planning Commission 2013).

On the other hand, the commission said it did not think it was appropriate to use the permit extension device to *force* MSG to move. For one thing, denial of a permit extension should generally only be used if the terms of the permit had not been complied with, and MSG had complied with the terms during the fifty years it had operated on the site. Perhaps far more important, the commission stressed that even if MSG was denied a permit to operate an arena, since it owned the site it could stay there and build anything that current zoning allowed (including presumably tall office towers). In short, there was no way to force MSG to move.

The commission said that it would, therefore, support a far more modest plan whereby MSG stayed in place and cooperated with the railroads as they made whatever, inevitably modest, improvements to Penn Station they could. The commission noted that the three railroads were already engaged in an ongoing study (the Penn Station Vision Study) on how to improve the station with MSG in place, and that MSG was talking to the Penn Station Vision group.

To ensure that at least one of these options occurred, the Planning Commission recommended giving MSG a new permit that expired after fifteen years, but said that the permit would not expire (i.e., apparently would become permanent) if MSG and the railroads negotiated the modest improvements (the compromise plan) within the fifteen years. Advocates of the radical plan were infuriated by the appearance of this compromise plan, which they dubbed "the loophole."

The commission also stressed the many obstacles preventing a successful outcome for any of the three major proposals—completing Moynihan Station, making modest improvements to Penn Station without moving MSG, as well as the grand plan for a new Penn Station after MSG moved. In this context the commission stressed the need for massive coordination especially to avoid what we have identified here as the squabbling government agencies problem:

The various projects being proposed for Penn Station and its surrounding area—Moynihan; Northeast Corridor Future (the Federal Railroad Administration's February 2012 plan to improve the 457-mile rail system from Boston through Penn Station to Washington's DC's Union Station); Penn Vision Study (Amtrak, LIRR and New Jersey Transit); and Gateway (Amtrak's high speed rail corridor between Newark and Penn Station)—

should be fully coordinated. While each is being undertaken by different state and federal agencies, each relies on the successful completion of the others to realize its full potential. . . . In effect, there should not be four individual projects—but instead one single Penn Station improvement project. To accomplish this, the various Railroads and agencies should designate a single group with the responsibility of coordination, as well as negotiation, with all parties—including MSG. For its part, the City should coordinate its efforts in the planning process. This type of coordination is needed whether it is for the current four individual projects, a project to relocate MSG, or planning for the integration of Penn Station infrastructure on the site with MSG remaining in place.

A WAY FORWARD?

On June 26, 2013, the City Council backed the radical proposal, voting overwhelmingly to give MSG just a ten-year permit and removing the ("loophole") option whereby if MSG stayed and cooperated with the railroads making minor improvements to Penn Station then MSG's permit became permanent. The City Council here was urged on by Speaker Chris Quinn, who had already endorsed a ten-year renewal and a commission to study how to find the Garden a newer and better home. Advocates of the radical plan for a new Penn Station greeted the vote enthusiastically.

Still, there was nothing in the resolution to stop MSG staying in place and applying for a further permit extension in 2023. Also, even if MSG could be forced to leave its site, advocates of the plan were not envisaging a new Penn Station emerging for at least two decades!

Overall, whether the new plan to force MSG out and build a brand-new Penn Station in its place was a masterstroke or a disaster—what we have called an "unrealistically ambitious project" that would not happen and, worse, might endanger the Moynihan Station project—only time would tell. Peg Breen, president of the Landmarks Conservancy, decided it was the latter, as she refused to join the "consortium" to evict MSG. She insisted in May 2013, as had Senator Moynihan back in 1998, that the existing Moynihan Station project was good enough.

> We should just get Farley/Moynihan done. I stood there with Moynihan and President Clinton in 1999 when they said now it would happen. It's absurd that it has taken so long. The recent move to get MSG out was started by the Regional Plan Association, which wants to put Madison Square Garden into the back of Moynihan Station. But we (LC) were opposed to MSG moving into Farley last time it was tried. MSG wanted to put neon signs on Farley.

Underlining the fact that the way forward for a grand train station in Farley was unclear, by mid-2012 attempts to raise funds for stage 2 of Moynihan Station were stuttering. Related was by 2013 focusing on building office and residential towers on the Hudson Yards, where it had a massive stake, rather than around Penn Station, especially after yet another deal to raise the needed funds for stage 2 fell through. This had involved Related making a huge real estate deal with the City University of New York (CUNY), according to which Manhattan Community College would relocate from its downtown, Far West Side location, and become anchor tenant (with 1.1 million square feet, an improvement on its current 780,000 square feet) in the Farley/Moynihan Station Building. Related would then build a huge residential development on the college's downtown site, the greater part of which has an unimpeded view of the Hudson River. With a 20 percent bonus for affordable housing or a public plaza, under current zoning Related could build 2.7 million square feet of space—slightly larger than 4 WTC. In return, Related would fund much, if not all, of the new, above-ground Farley Station. Sceptics said that Governor Cuomo, who effectively controls CUNY, would have to insist on a public bidding process (Smith 2013). Then Assembly Speaker Silver behind the scenes said he would veto the idea, which killed it.

Meanwhile the option of issuing a Request for Proposals (RFP) seeking new private partners to replace Vornado-Related was hampered by the fact that the state was liable for a $25 million "kill fee" if it replaced Vornado-Related. Anyway, insiders said that Governor Cuomo was unlikely to do anything to upset Related's Stephen Ross, one of his largest financial backers.

Gateway

A recent development further underlines the modest expectations and potential fragility of possibilities for Penn Station, as well as the absence of a powerful coordinating body. In May 2013 the US Department of Transportation allocated $185 million to build, under the about-to-develop Hudson Yards, a very short (just 800-foot long) stretch of concrete-encased tunnel that could accommodate a high-speed rail track. The purpose of this minitunnel is that *if* the larger $13 billion Gateway Project for a third and high-speed rail tunnel connecting Penn Station and New Jersey ever gets funding and acquires a timetable (it has neither right now), the project can happen. Had the general buildup of the Hudson Yards, now underway, proceeded without the concrete-encased tunnel, then Gateway would have been impossible. Underlining the exposure of these projects to sheer luck and the absence of a central, funded coordinating body, the

$185 million for the Hudson Yards section of the tunnel came from funds allocated as a result of 2012 Hurricane Sandy, which flooded the existing tunnels and showed the need for a new one. So without Hurricane Sandy, high-speed rail to Penn Station from the west would likely have become impossible as the Hudson Yards were developed.

Lessons from the Renovations of London's St. Pancras and King's Cross Stations

Finally, the recent renovations of London's St. Pancras Station and its neighbor King's Cross Station have been mentioned by several observers as examples of successful station renovations in a global city. These renovations offer lessons for the future of Penn Station. In both cases there were two related conditions for the successful renovation to occur, neither of which is currently present in the case of Penn Station. First, there was a strong coordinating body (private in both cases, though ultimately responsible to a strong political body). Second, there was at least one major event or circumstance (e.g., a deadly fire, the appearance of the Channel Tunnel high-speed rail link, the looming 2012 Olympic Games, a terrorist bomb) that dramatized the need for the renovation to happen.

Britain's rail system was originally built by private companies in the nineteenth century, was nationalized by the government in 1947, and was then reprivatized in the 1990s. This set the context for these two station renovations.

The St. Pancras renovation was triggered by the decision to make St. Pancras the London station for the new Channel Tunnel and high-speed Eurostar train (which runs from London to Paris and Brussels). The Channel Tunnel, financed and organized overall by a private entity, Eurotunnel, had began construction in 1988 and opened in 1994. In order to accommodate the unusually long Eurostar trains, St. Pancras's train shed needed extending a considerable distance northward with a new flat-roofed shed, as well as changes to accommodate high-speed rail. So in 1996 the British government selected London and Continental Railways (LCR), created at the time of British Rail's privatization in the 1990s and the owner of St. Pancras Station, to reconstruct St. Pancras, and also to build the Channel Tunnel Rail Link (CTRL) and to take over the British share of Eurostar. The CTRL, now called High Speed 1, runs sixty-nine miles from St. Pancras station to the Channel Tunnel portal at Folkestone at speeds up to 186 mph, completes the journey from London to Paris in two hours and fifteen minutes, and opened in 2007 along with the renovated St. Pancras International Station.

The subsequent King's Cross Station renovation, immediately to the east of St. Pancras International, opened in 2012. It was announced in 2005 by Network Rail, the private company which runs Britain's rail infrastructure. Network Rail's plan for King's Cross, approved in 2007 and completed in eight years, had several impetuses, including a desire to prepare for the 2012 Olympic Games. Still, safety was key. In addition to a 2005 terrorist bomb, incompetent handling by the government-run subway employees had allowed a fire in the King's Cross subway station to kill thirty-one people in 1987. A survivor commented (raising ominous echoes of Penn Station): "I've always believed that this station was a deathtrap. It's a rabbit warren down there."[6] The contrast with attempts to improve Penn Station, at present relatively uncoordinated, saddled with a difficult private company that owns the key site, and lacking an event or circumstance to dramatize the need for change, is clear.

CONCLUSION: BLOCKING FACTORS AND INGREDIENTS FOR PLANNING SUCCESS

By the end of 2013, most of New York's officials, elected and otherwise, whose jurisdiction included Penn Station and nearby, were predicting, albeit privately, that very little would happen soon—not stage 2 of the Moynihan Station, not minor improvements to Penn Station with MSG in place, and certainly not the radical plan for a new Penn Station on MSG's vacated site. Even the latter's advocates foresee a multidecade process. Raju Mann, director of planning for the Municipal Art Society, realistically concluded that the movement for a new Penn Station was now going to be a "multigenerational project"!

The attempt to fix Penn Station has encountered every factor that tends to block megaprojects except local/neighborhood opposition. The Moynihan Station project saw plenty of squabbling between various government agencies (at similar and different levels); mediocre and incompetent leadership (especially Spitzer and Paterson); much fighting between various politicians; political lobbying/cronyism (the MSG –Patricia Lynch – Sheldon Silver axis); the presence of a difficult private-sector corporation that is both key to the project's success and willing to block it (Cablevision); changes in the economy associated with the real estate/construction cycle and the expansion and bursting of bubbles; landmarking issues (MSG's desire to place its logo in large letters on the classical façade of Farley); unrealistically ambitious projects (the early Municipal Art Society plan to evict the post office from its own building, and perhaps the current effort to evict MSG and build a brand-new Penn Station); and funding issues.[7]

Finally, it is clear that part of the problem faced by megaprojects in today's New York is a result of a historically contingent factor, the absorption of the Port Authority's executives, engineers, and other staff, especially after 2006, in rebuilding the World Trade Center. As one study commented in 2011, "It is no wonder the PA concluded in 2008 that rebuilding the Center has become a major focus of the Port Authority's efforts. In 2010 alone, the PA's capital budget related to the WTC was $1.6 billion—three times the amount allocated for airport modernization and nearly eight times the funds made available for port improvements" (Doig 2013).

Arguably the Port Authority should never have been involved in the construction of the original World Trade Center in 1970, which was basically an office and real estate deal and scarcely related to its basic mission to carry out transportation infrastructure. Still, that was history, and the Port Authority was now absorbed in the rebuilding effort. So here is another, not much commented upon, fallout from 9/11.

PART IV

THE CHALLENGES
TO CHELSEA'S ART
GALLERY DISTRICT
FROM THE LOWER
EAST SIDE

The Lower East Side and the New Museum: The Next Chelsea, or Another "Wrong Turn"?

Chelsea is the enemy—there are 250 galleries there and one gets lost in just one more show. The problem with the Chelsea model is that they have a lot of everything but they don't believe in anything—except the market. So I decided to come to the LES. I like the intellectual atmosphere on the LES.

—Miguel Abreu, gallery owner, 2009

I'm perplexed. For example this one [points to artist Urs Fischer's work—a sword embedded in a large rock]. I cannot understand it. Maybe I need some help; I'm not totally stupid. But this I understand [brightens, pointing to a Martha Rosler photo of the Iraq war]. It shows American beliefs and contradictions, the Iraq war and the American preoccupation with the body and being fit and mobile.

—Swiss choreographer visiting *Unmonumental*, the 2007 New Museum's inaugural LES show

THE CHANGING WORLD OF CONTEMPORARY ART

Chelsea's dominance in the commercial art world clearly could not go undisputed, and especially after about 2006 a host of challenges emerged.[1] If Chelsea's art world was facing disequilibrium, that was partly because so was the Contemporary Art world in general. Still, each challenge to Chelsea has shown limitations—none has yet displaced it or caused a major change in the system of commercial galleries which has dominated the art market for roughly 120 years.

Further, the Far West Side is dynamic, with many moving parts. Several developments discussed in earlier chapters worked to strengthen Chelsea's art gallery district. In particular, the High Line's success, including a well-publicized program of displaying art, the growing determination of the city to make the new "Culture Shed" in the Hudson Yards a major venue for large-scale, outdoor cultural events, and the Whitney's decision to

open by 2015 a museum of American and Contemporary Art at the High Line's southern entrance have solidified this section of the Far West Side as an art and cultural center, which helped Chelsea's commercial gallery center.

On the other hand, a possible problem now emerging is that the High Line's success is triggering classic commercial gentrification in Chelsea's gallery center, as landlords can get higher rent from industries such as fashion and technology. How this will play out is unclear. For instance, many of the star galleries are protected because they own their buildings. Other galleries, who have been pushed out of the core gallery district, are moving north to sites just below the Hudson Yards.

We have already considered the main nontraditional challenges to Chelsea's commercial gallery center. The potentially most serious is the Internet's capacity for online sales of art, although the Internet revolution in retail selling is clearly still unfolding. What distinguishes art from music or books is that each artwork is usually unique (except, of course, editions) and cannot be adequately viewed online, unless the viewer is already familiar with the artist's works. Another radical challenge to the commercial galleries comes from auction houses trying to grab business by selling new art and stepping beyond their traditional terrain of already-owned art. Even so, this challenge too has stalled. Few of the art-buying public are yet willing to buy brand-new works sold in the auction process rather than in galleries. A third possible threat to neighborhood-based gallery districts comes from the mushrooming world of international art fairs. Still, art fairs are composed of art galleries, so basically complement and do not replace them.

THE LOWER EAST SIDE CHALLENGE: THE ART STORY AND THE REAL ESTATE STORY

In addition to these threats, there are more traditional, neighborhood-based pressures on Chelsea from rival art gallery "districts." The most obvious is from New York's Lower East Side, vying to supplant Chelsea as New York's dominant art gallery neighborhood for Contemporary Art. There is also potential pressure from art gallery neighborhoods in Berlin or Shanghai. Each of these other gallery neighborhoods has often been mentioned as the "next Chelsea," a reflection of Chelsea's status atop the gallery neighborhood hierarchy, which some others are naturally eager to usurp.

By early 2008 the possibility of the Lower East Side supplanting Chelsea was widely discussed. A rush of new galleries had opened there, including

several from Chelsea. A slew of media articles such as "The Lower East Side: New York's Fastest Growing Art District" (MacInnis 2008) fueled talk that Chelsea had peaked.

Another "Wrong Turn"?

The Lower East Side raises several interesting issues. First, is it just another "wrong turn" in the long history of New York gallery neighborhoods, failing to supplant Chelsea just as the East Village's flowering of galleries fizzled by 1987 and failed to supplant SoHo, or as Williamsburg's challenge to Chelsea had clearly failed by 2004? By 2013 most Chelsea gallery owners believed that the Lower East Side faced major obstacles if it was to replace Chelsea. For one thing, it lacked enough suitable and available spaces to accommodate the mass of Chelsea galleries. Also, that most star Chelsea galleries owned their own spaces (typically in converted garages) insulated them from a repeat of the massive rent rises that, after 1995, undermined SoHo as New York's dominant gallery district and led the center to shift to Chelsea. By February 2012 the number of galleries in Chelsea had recovered to the peaks before the 2007 recession (fig. 1.1), while the number of galleries on the LES, though having climbed steeply to 114 by May 2014, was still less than one-third the number of Chelsea's (fig. 9.3) Further, new ground-floor leases for LES galleries were rising to Chelsea levels. This suggests an equilibrium, with Chelsea still dominant but the LES having carved out a small-to-medium presence.

The New Museum: Role of Nonprofits

A second issue is that it was a nonprofit, the New Museum of Contemporary Art, opening with a new, brash building on the Bowery in 2007, that catalyzed the LES's possible emergence as a major commercial art gallery center, just as the nonprofit Dia Foundation catalyzed Chelsea in the mid-1990s and the Friends of the High Line and now the Whitney Museum are further transforming the area. Here yet again is the crucial role nonprofits often play in American cultural developments (Martel 2006), as well as their potential role as "urban planners."

"Edgy" and "Controversial" Art

A third issue raised by the Lower East Side is that of "edgy," "fresh," and "controversial" art and galleries, reflected in the widespread claim that the new Lower East Side art scene differed from, and was basically superior

to, Chelsea in cutting-edge ways. This was a corollary of the claim that Chelsea had become "corporate," which, as discussed in chapter 1, conflated a complex situation composed of some features that merited the term and some that did not.

The same conflation marks the claim that LES galleries and art were edgier than Chelsea's, which was in any case partly a branding and marketing strategy by LES cultural institutions. The claim typically combined several issues that should be separated, especially the distinction between controversial/shocking art on the one hand, and edgy art (and galleries) on the other. Art in the LES galleries was actually less likely than art in star Chelsea galleries to be "controversial" (defined as eliciting a reaction of strong disapproval in a significant number of people) and/or "shocking" (defined as eliciting a reaction of dismay and upset). This is because, first, LES galleries were typically far smaller than star Chelsea galleries and therefore lacked the resources to withstand possible fallout from a controversial show that might flop or trigger negative publicity. (Likewise smaller, upper-floor Chelsea galleries avoided shocking art too, as we saw.) Second, LES galleries were subject to the "neighborhood effect," a feeling that controversial art was not appropriate in the ethnic, and often working-class, mosaic, including families with young children, of the LES.

On the other hand, LES galleries were arguably edgy in the sense that they, and their art, could be unconventional in some ways. They were, for example, more likely to display art that did not fit any of the major or minor content categories outlined in Chelsea. While not shocking or controversial, neither was this art mainstream. Further, a few LES galleries were highly unconventional in organization and/or appearance, including a handful of decidedly "wacky" examples. Finally, some gallerists argued, plausibly, that the experience of viewing art in a LES neighborhood context made a difference. The same piece of art took on a different meaning when viewed in the LES than in Chelsea.

Imposing a Vision

A final issue raised by the LES is that of imposing an artistic vision on the public. The New Museum made an explicit effort to do so with its opening exhibition, *Unmonumental*, in which the curators presented their own vision of Contemporary Art, a vision in many ways out of the mainstream. For this reason the show was unpopular, as interviews with a sample of the audience found. These interviews underline that there is a mainstream structure of Contemporary Art that favors works that resonate with major issues in viewers' lives, which is why imposing a curatorial vision counter to that mainstream is hard.

Overall, developments on the LES show that, as the Chelsea discussion found, there are two important, but very different, stories to tell about art. There is the real estate story about galleries and rents and finance and the lead role of a major nonprofit—here the New Museum. Second, there is the story about the art's meaning for the audience. Both stories need to be told, which the following discussion does.

HISTORY: THE LOWER EAST SIDE'S LOSS OF THE "EAST VILLAGE," 1960S–1980S

The Lower East Side was, historically, a working-class and immigrant neighborhood with much larger borders than nowadays. It originally covered, roughly, the area east of 3rd Avenue and south from 14th Street past Houston Street to Canal Street. Then in the 1960s the section north of Houston Street was hived off as the "East Village," undergoing an image makeover associated with the in-movement of many artists, musicians, and hippies (Mele 2000).[2] Art galleries opened too, and briefly in the early 1980s there was talk of the East Village supplanting SoHo as the dominant gallery center for new art, before that turned out to be a wrong turn.

What was left of the Lower East Side was the area south of Houston Street, now seen as far less desirable than the East Village, more dangerous and drug-infested, especially as crime rose drastically in New York in the 1970s and 1980s. This section included the Bowery, an area long frequented by homeless, alcoholics, and drug addicts, and the country's most famous skid row. Also, from the 1870s to the early 1950s the elevated subway had run along 3rd Avenue, and as *The WPA Guide to New York* put it in 1939: "The tracks plunged the street into shadowy gloom, making it easy for bad things to happen in the dark." In the 1930s and 1940s, the 3rd Avenue El and its counterparts on 2nd, 6th, and 9th Avenues were viewed by mayor Fiorello La Guardia and his successors as neighborhood blights and obsolete, given that subways were being built or were on the drawing board to replace them (fig. 9.1). The idea of creating an above-ground park out of one of them, like the High Line, would likely have been viewed as preposterous. So the 2nd Avenue El was gradually demolished from 1940 to 1942, while the 3rd Avenue El was finally closed in 1973. (The 2nd Avenue subway, first authorized by the city in 1929 to replace the El, is supposed to finally open its first phase, which only reaches to 63rd Street, in 2016, making it New York's most delayed megaproject by far.)[3]

The distinction that emerged in the 1960s between the more upscale "East Village" and the rest of the LES was described by Deborah Fries, long-time director of the FusionArts Museum, a tiny LES space on Stanton Street which doubles as a museum and commercial gallery and is one of

Fig. 9.1. Second Avenue elevated subway, at Chatham Square (the Bowery). Unknown photographer, late nineteenth century, gelatin silver print reproduction, New-York Historical Society.

the few dating back over fifteen years. Fries commented in 2008: "Our visual art space has been here for over twenty-five years including the East Village's blossoming, but we were on the wrong side of Houston Street. This part of the LES South of Houston Street was called the 'Wild West,' and was very dangerous. The only visitors who came here at that time were smoking crack and heroin. You took your life in your hands down here."

Likewise Kristine Woodward, co-owner with her husband, John, of the Woodward Gallery that moved from SoHo to the LES in 2007, recalled the LES in the 1980s: "This was literally the 'Wild West.' It was the wrong side of Houston Street. I used to visit John, who lived at 161 Essex Street. I was a nineteen-year-old girl in 1986 and we were dating. It was so dangerous that people were shooting drugs, and each other, right outside his door."[4]

Geographer Neil Smith (1996) has argued that images of the LES as dangerous and drug-infested were exaggerated by the Giuliani mayoral administration to justify and promote a policy of aggressive classic gentrification, especially in the East Village and LES but also throughout the city, using middle-class invaders (including art galleries) to displace working-class residents, the homeless, and the poor. Smith argues, convincingly, that the Giuliani administration portrayed the Lower East Side to the white middle class as a historyless and dangerous place overrun

by undesirables and waiting for courageous gentrifying pioneers to res-
cue it and make it "liveable." Still, the LES clearly was very unsafe and
crime-ridden.

THE NEW MUSEUM ARRIVES

Marcia Tucker conceived the idea of the New Museum in 1975, the day after
being fired as curator at the Whitney Museum of American Art for putting
on a show by minimalist artist Richard Tuttle which *New York Times* art
critic Hilton Kramer lambasted as a "bore and a waste" and "a debacle"
(Lubow 1999).

The New Museum led a nomadic existence before settling on its new LES
site. In July 1977, it occupied a small gallery and office at the New School
for Social Research at 5th Avenue and 14th Street. In 1983, board president
Henry (Hank) Luce III negotiated a long-term lease for the New Museum
in the Astor Building in SoHo at 583 Broadway, where the New Museum
had a much larger gallery space and offices. Then in 2003 it announced
that it would locate its new building on a parking lot in the LES's Bowery
Construction there took two years to start and two more to complete.

Although Dia's move to Chelsea and the New Museum's to the LES both
involved a nonprofit paving the way for a commercial art gallery district,
there were major differences between the two cases. Dia's Chelsea move
was unobtrusive, involving a "contextual" renovation, keeping to the
height and look of the surrounding buildings, and seeking little publicity.
This low-key approach might be one reason why it was only several years
after its move to Chelsea that a band of commercial galleries joined Dia
there.

By contrast, the New Museum's move to the Lower East Side was bold
and brash. Officials commissioned an out-of-scale, modernistic building
designed by star Japanese architects Kazuyo Sejima and Ryue Nishizawa,
their first museum in the United States. The building was a seven-story
stack of rectangular boxes shifted off axis in different directions, clad in
silvery, zinc-plated steel, and basically windowless (fig. 9.2). It opened with
great fanfare in December 2007.

The New Museum made some gestures toward the area's industrial
past. For example, responding to criticism that the building was out of
context with the neighboring buildings, the museum's senior curator,
Laura Hoptman, explained that the structure's exterior material—silvery
galvanized, zinc-plated steel—was intended to reference the area's man-
ufacturing history. "The building's skin is a wonderful silver mesh that
looks like industrial trash cans" (Halle and Tiso 2008).

Fig. 9.2. The New Museum (2007). Opinions of its design ranged from "a wonderful silver mesh that . . . echoes the area's industrial past" (Laura Hoptman, New Museum senior curator) to "a monstrous building" (neighborhood social worker). In 2010 the architects received the prestigious Pritzker Prize for Architecture. Photo by David Halle.

This echoed the claims made by some architects of new buildings in the Gansevoort Meat Market. For example, the architects of the tall, new Hotel Gansevoort there said their building (e.g., its steel balconies) referenced the area's "gritty" manufacturing past.

Understandably, some long-time local residents of the Bowery opposed the New Museum's "Neo-modernistic" design, just as people had opposed the Hotel Gansevoort's appearance. A professional social worker who had spent many years helping the needy in a nearby Bowery organization ex-postulated in early 2008: "They've built a monstrous building. It takes a lot of audacity to come to a neighborhood and say, 'This is what we're going to do, and we're not even going to try to be part of the community, even aesthetically.'"

In 2010 the architecture profession sided with the New Museum, as it had with the Hotel Gansevoort, awarding the prestigious Pritzker Architecture Prize to the architects for their general work, including the museum.[5]

In any case, since zoning laws allowed the New Museum to be built as of right in the Bowery, there was little question it would happen once the funds were committed.

NEW COMMERCIAL GALLERIES, LES: WRONG TURN OR THE NEW CHELSEA?

The New Museum galvanized the commercial gallery scene on the LES. Director Lisa Phillips commented: "The minute we announced we were going to the Bowery there was a big land rush."[6] Before the plans were announced in 2003, there were probably only two commercial galleries in the LES—Miguel Abreu and New York Art World (plus a handful of non-profit galleries).[7] Then between 2005, when the museum broke ground for construction, and its December 2007 opening, the number of commercial galleries rose to fourteen, by 2010 had more than tripled to at least forty-four, and reached 107 by May 2014 (fig. 9.3).

Interviews with a random sample of twenty-five LES gallery owners, conducted between 2007 and 2008, underlined the New Museum's impact.

Fig. 9.3. Growth of galleries, Lower East Side, 2003–2014.

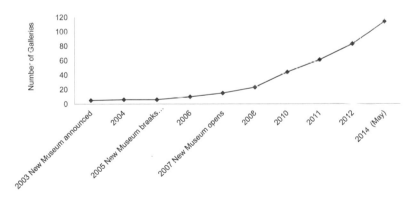

Sources: Data before 2007 are constructed from interviews. From January 2007 to January 2011 they are from *LES = More*, a publication started in January 2007 by Envoy, a Chelsea gallery which opened a branch in the LES in 2006. The data in *LES = More* (published every two months) probably somewhat understate the number of galleries, since galleries need to pay a modest listing fee ($297 in 2008). After January 2011 the data are based on *The Lower East Side Gallery Guide Map*, which has no charge for listings, since it is produced by the LES Business Improvement District.

Twenty-one of the galleries had opened on the LES after 2003, and all but one said the museum was a factor in their decision to do so, while two-thirds said it was key.

From Chelsea to the LES

Of the galleries sampled that opened on the LES after 2003, the largest group, almost half, had moved from Chelsea. All these except the Lehmann Maupin gallery had been struggling in relative obscurity, albeit paying modest rents, on upper floors saturated with like-situated small galleries, and wondering how to afford the rising rent for a ground-floor Chelsea space where they might attract a larger audience and attention. Their stories are full of complaints about avaricious Chelsea ground-floor landlords, especially as the market boomed after 2005, echoing stories of commercial gentrification told by galleries that left SoHo for Chelsea in the late 1990s.

For example, DCKT was founded in 2004 by two gallerists who previously worked at the Charles Cowles Gallery in Chelsea. DCKT existed for three years in marginal Chelsea spaces, the last of which, before the move to the LES, was the second floor of a rickety taxi garage on 24th Street just across from Gagosian's gallery. Their landlord would only give them a short-term lease, since he intended to replace the building with a far more profitable, nine-story mixed-use structure as soon as possible. DCKT co-owner Dennis Christie explained:

> We looked for a year for new space in Chelsea in 2007. It was crazy because of New York's real estate boom and new condo construction. Rents were insane, up to even $100 a square foot [per year]. We were looking for ground-floor space. A typical Chelsea space by 2007 was $18,000 a month, whereas years ago it had been $2,000 a month. The landlords were greedy. Several times we thought we had a deal, and then the landlords reneged and we realized they were just playing us along to get a better deal from someone else.

Giving up on Chelsea, DCKT opened in a ground-floor LES space in March 2008, just two blocks south of the New Museum. Christie explained: "We started looking in the LES in the summer of 2007. The New Museum was central, the defining thing for the neighborhood, though a lot of the spaces we looked at were too far from the museum. We have a ten-year lease here. This is now our fifth show, and we've gotten more attention for the gallery and the artists than ever in Chelsea. Chelsea is oversaturated, it's numbing, it's hard to stand out there, to get people in."

Ground-floor gallery space on the LES was cheaper for a newcomer than ground-floor space for a newcomer to Chelsea, although from 2006 to 2008 it was not especially cheap. Galleries moving to the LES during that time typically paid $50–$70 a square foot per year for a five-to-ten-year ground-floor lease, roughly $15–$40 less per square foot than a gallery signing a new, ground-floor lease in Chelsea would pay.[8] Underlining the fluidity of the situation, by early 2013 some ground-floor rents for a new LES lease reached $90–$95 a square foot, close to Chelsea levels.

Thierry Goldberg is another gallery, once lost in the sea of Chelsea galleries, that saw a chance to shine in the small pond of the LES and rise rapidly if it took off. Thierry Goldberg is owned by two artists—husband and wife. In 2000, fresh out of Hunter College's art program, they rented a commercial space in Williamsburg, on Metropolitan Avenue. They produced their own art there in a third-floor loft in what was then a run-down industrial neighborhood, and to save money lived there too, though the residential part was illegal. Then, to promote their art, they started to have shows and art parties in the space. (Like artists in SoHo in the 1960s, they sold their own work directly from their loft studio-residences.) The couple then evolved to selling other people's art too, and thus were operating as a gallery, which they called Thierry Goldberg (their respective mothers' maiden names).

Full of ambition, in 2003 they decided to take their fledgling gallery operation "to the next level," which at that point meant joining the stampede to Chelsea. Co-owner Ron Segev explained: "One gallery was doing it [i.e., moving from Williamsburg to Chelsea], then another was doing it." So they rented a third-floor space in Chelsea, operating there for three years. By 2006 they didn't want to stay on an upper floor in Chelsea. "It was hard to get people up to the third floor."

Seeing the skeleton of the New Museum rising, they took a ground-floor space on Rivington Street and opened in March 2007, six months before the New Museum, with rent at 30 percent less than they would have paid for a new lease on a ground-floor Chelsea space. Their goal was "more visibility and exposure to audiences for us and for our artists. In the art world things happen very quickly. There's the new hot artist, the new hot neighborhood. Now the LES is the new hot neighborhood. It happens every few years in New York."[9]

Lehmann Maupin, for a while the only "blue-chip" gallery to come to the LES (a second, Sperone Westwater, opened in 2010—see below), explained why they opened in February 2007 on Christie Street, in addition to their Chelsea gallery: "We were looking for a second space, to give our artists more opportunity to show. We decided on the LES because it was

thriving culturally and the New Museum made the decision a lot easier. Also, there were so many galleries in Chelsea."

Brand-New LES Galleries

About a third (35 percent) of the galleries that opened in the LES since 2003 were new, start-up ventures. For these too the main attractions were the New Museum and lower rents for a ground-floor space than in Chelsea. For example, Simon Preston had managed a gallery on 57th, and before that in London. He decided to open his own LES gallery on Broome Street in March 2008. Six months later he explained: "I opened here because the New Museum is here. There are forty or fifty galleries here now, and this was an opportunity to get a street-level space at a reasonable rent at a time when Chelsea was feeling saturated and corporate. This used to be a seafood storage building. The foot traffic here is extraordinary."

From Elsewhere to the LES

The remaining LES galleries (15 percent of the sample) came from various locations, including the Upper East Side, 57th Street, and SoHo. For example, in the summer of 2007 Janos Gat moved his gallery from the Upper East Side to a second-floor LES location. Taking a second floor in the LES was unusual, but it seemed worthwhile being just two blocks south of the New Museum, on the Bowery. The gallery, which specialized in Hungarian art—Contemporary and older—was previously on 82nd Street by Madison Avenue, in a ground-floor space near the Metropolitan Museum. Janos Gat moved because some of the nearby galleries, which drew customers to his gallery, had left:

> The Upper East Side was very good for Contemporary Art for a long time. We were by the Metropolitan Museum, and I worked well with a number of galleries there, especially the Ubu Gallery, one of the best in New York. If someone went to see them they came by me too, since we were next door. But then some of the galleries started to move, including Ubu [to East 59th Street], so it wasn't so good up there anymore. And I was tired of the Upper East Side. I wanted a change.

Gat explained how critical the New Museum was in his choice of the LES. "I heard the New Museum was moving here. For two years after they made the announcement nothing happened, so I waited. Then the day they broke ground on the museum building I took this space here. I like it a lot here; the New Museum has a good crowd." Well aware of the real estate–

driven cycle of art gallery neighborhoods, he had few illusions about the LES being different.

> I never liked Chelsea. Chelsea is about real estate, the new condos there around the High Line. Actually the LES is about real estate too, not about the art scene. But is there such a thing as an art scene separate from real estate? Good art is about creating in the basement. But the *art scene* anywhere is firmly real estate. People don't invest millions of dollars in just an art scene; it has to be real estate too. You have a nice beach, or something like that. Here too on the LES you have galleries and nightclubs and then the rich and it's over. That's progress! The world is flux! Still, this [the LES] *is* the next art scene. People who are any good are moving here.

The Woodward Gallery (run by a husband and wife) moved from SoHo to the LES in late 2006, faced with a massive rent increase in SoHo, and skipping the Chelsea stage. From 2005 to 2007 rents in SoHo more than doubled, from roughly $220 to roughly $500 per square foot per year (fig. 1.10). The Woodwards chose the LES for lower rents and because in their view SoHo was becoming a mall for clothing stores (the reasons that had driven many galleries from SoHo to Chelsea a decade earlier). As John Woodward explained in December 2008:

> We were in SoHo for fifteen years on Broome Street. We did very well there. But Gucci and Chanel were all over SoHo and we felt the soul had left the neighborhood. And our landlord doubled the rent.
>
> We were looking for an edgier experience, and we found this building. Now we own the first two floors. The first floor was a hole in the ground when we bought it. The building was originally a Spanish-Portuguese synagogue, then a factory making theatrical props. The neighborhood was all tenements, and the buildings were covered in graffiti. We painted our front door and then the other buildings started to paint theirs too.
>
> When we moved here [in late 2006] there were just about six galleries and the New Museum hadn't opened yet, but we knew they had broken ground. About fifty-two or more galleries moved in after us.

Renting, Not Owning

Almost all the new LES galleries rented. Asked why, everyone said they lacked the money to buy. By December 2008 only three of the LES galleries sampled had purchased their spaces.[10] This was a major difference from Chelsea, where many of the first-wave pioneers, stung by their SoHo experience of landlords raising rents to unaffordable levels, purchased spaces

in converted garages, giving Chelsea greater stability, since the core of its wealthier galleries were insulated from rising rents. The rarity of galleries that owned their spaces on the LES partly reflected the fact that the LES, probably because it had a residential core, did not present the bargain real estate opportunities that Chelsea's run-down garages had. Also, few of the galleries moving to the LES were the wealthy ones who might have been able to buy their spaces. Wealthy Chelsea galleries had not concluded in large numbers that their future lay on the LES, although there were exceptions. One exception was Sperone Westwater, which in 2010 opened to much fanfare on a lot, purchased in 2008, in a new eight-story building designed by starchitect Norman Foster, just a few doors from the New Museum. Sperone relocated from an upper floor in the Meatpacking District, to which it had moved after leaving SoHo.

In summary, the renter/owner balance of LES galleries left the vast majority of galleries there vulnerable to commercial gentrification if their landlords found wealthier businesses willing to move in, which was another reason why the LES was not, at least yet, going to supplant Chelsea. Indeed, by November 2013, 48 percent (12/25) of the galleries sampled in 2007–2008 had closed.

IS LES ART DIFFERENT (EDGIER/ MORE CONTROVERSIAL)?

The claims that art and galleries on the Lower East Side are "edgier," "fresher," and more "controversial" than in Chelsea confound several issues, especially the distinction between "controversial/shocking" art and "edgy" art. To research this systematically, we focused on shows at the twenty-five galleries in our LES sample. We drew a random sample of two shows from each gallery, making fifty shows in total, and tabulated the results following the same principles as in our Chelsea sample.

The content of much LES art was similar to that in Chelsea. For example, works that are basically decorative/abstract were the most common topic (25 percent of all shows), even more common than in Chelsea. Frequent too was the landscape (classic and environmental) (12 percent) and the troubled nuclear family (13 percent). Political art was also common (16 percent), more so than in Chelsea.

Confirming this overlap, when we asked LES gallery owners if the art there was especially innovative, in particular by comparison with art in Chelsea, the standard answer was that it really was not. This was especially obvious to the significant proportion of LES gallerists who had recently moved from Chelsea, since they were, by and large, showing the same kind of art and artists on the LES as they had shown in Chelsea.

Fig. 9.4. Lower East Side galleries, 2010.

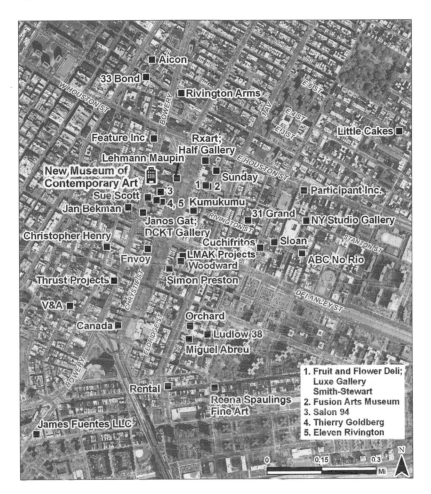

Ron Segev, co-owner of Thierry Goldberg, commented that the main difference was not content, but that LES galleries were more likely to display young, less-established artists than older ones, and rarely dead ones:

> A lot of the art in the LES is actually the same as in Chelsea. It's a cooler neighborhood—but actually it's the same art. For example, we were in Chelsea and now we're here and we're doing the same thing here as there. So a big group of galleries in Chelsea are doing the same thing as us. But others in Chelsea are not. For example, some in Chelsea are doing dead artists. Here it's all new and edgy, 100 percent cutting edge. It was the same in Williamsburg.

LES gallery owner Shannon Hartmann stressed another, non-content-related difference, namely the less elaborate and polished style of LES shows:

> The look is more of a DIY [do-it-yourself] by the artists here, especially in the smaller galleries on Orchard Street. You don't have the feeling of finesse and finish that you have in Chelsea. For example, Gagosian's gallery there feels more like a museum.

LES Controversial?

"Controversial" art was absent from the LES galleries we sampled. One explanation is gallery size. Small galleries are likely to be more cautious than large ones because they cannot afford a flop, and almost all LES galleries were small.[11] It was, therefore, probably no accident that in our sample of LES gallery shows the only LES show on sex, albeit tame (the kind of material that might have appeared on a public billboard), was held by Lehmann Maupin, one of the few large LES galleries. It was a 2008 show by Mr., the familiar name of the Japanese artist Masakatsu Iwamoto. The show depicted teenage girls in various coquettish poses.

A second reason why LES galleries did not display controversial art is the "neighborhood" effect. The area where most of the art galleries opened is zoned to allow both residential and commercial (fig. 9.5, designations R and C), so the galleries are located in residential neighborhoods with a series of ethnic groups—Latinos, Asians, Muslims, and Jews—each of whom could take offense at certain kinds of highly visible art. Ground-floor Chelsea galleries, by contrast, could freely display controversial art, since the heart of the Chelsea gallery section was zoned manufacturing, to exclude residential. This "neighborhood" argument was advanced plausibly by LES gallerist John Woodward. When his gallery was still in SoHo he put on a show a few months after 9/11 depicting the damage (*Charting Ground Zero: Before and After*, February 2002). He explained why this would not work in his new LES location:

> Something like the *Ground Zero* show wouldn't fly down here. The neighborhood is very important. You're in a spiritual epicenter here; there are Christians and Jews and Muslims. That *Ground Zero* show wasn't exactly "Joy, Hope, and Peace"! SoHo is very residential but mostly wealthy, not middle- or working-class residents and a far less varied ethnic mix. Or take the last show of Stefan Stux [in Chelsea]. It featured a life-size statue of the artist masturbating. That wouldn't fly here either.

LES galleries, almost all fairly new to the neighborhood, were doubtless also aware of a long history of local activists protesting gentrification,

Fig. 9.5. Lower East Side Zoning, 2009.

East Village/Lower East Side Existing Zoning

and were mostly anxious, as obvious agents and symbols of such change, not to be unnecessarily provocative. Indeed, the LES (unlike Chelsea's gallery section) was a site of classic gentrification where "working class residential neighborhoods are rehabilitated by middle class homebuyers, landlords and professional developers" (Smith 1986), while the working class and poor (if not protected by New York's rent regulations) are pushed out. As one study described the resistance to gentrification: "Lower East Siders consistently rejected both the symbolic and material threats of

community displacement, through collective action. Local activism, including rent strikes, marches and demonstrations, frequently posed effective challenges to the real estate sector's endeavors to redevelop . . . the Lower East Side" (Mele 2000).

This is not to say that there was never controversial art in the LES galleries. Still, the consequences of one notorious attempt validated the caution of most gallery owners. In March 2011 the Allegra LaViola Gallery at 179 East Broadway put on a show titled *Pornucopia*. Displayed in the window was a painting of a naked woman surrounded by pizza. Several other nudes were displayed inside.

The show triggered exactly the kind of neighborhood-based controversy that the other galleries had predicted and sought to avoid. Just to the east of the gallery is a long-established Orthodox Jewish enclave, including a boys' yeshiva. The perturbed local rabbi asked LaViola, the owner, to cover the paintings from outside view with a curtain. Neighbors called the gallery repeatedly to complain, and as a result the police visited on several occasions, though took no action. The gallery owner, LaViola, in turn countered that

> the images are nothing more explicit than you would see on a magazine stand. The real problem is that the Orthodox community does not like any kind of display of nudity whatsoever. They have been here for a long time and the relative newcomers who are starting to open up in the area are unsettling them a little bit. . . . I feel quite angry at these people because of the way they are trying to threaten me into closing off the gallery. They talked to me about being a part of the community but they don't want me to be part of their community, which is set up to be separate from the world. They live in New York City. They can't be entirely isolated.

Defiantly, LaViola extended the show for two weeks (Halperin 2011).[12]

By contrast, the New Museum, with its opening exhibition *Unmonumentalism*, courted "controversy." For example, a work by Kenneth Hung showed president George Bush and his advisor Karl Rove in female underwear and compared them to Hitler. As a large building with an entrance, the New Museum not only was suitably separated from the neighborhood but also had the resources to take some risk.

Still, the context is dynamic, and as classic gentrification continues, the implicit and explicit power of traditional class and ethnic groups to veto cultural content will likely erode. In September 2013 the owner of a brand-new gallery, Castle Fitzjohns at 98 Orchard Street, decided that this had happened. His opening show featured works by many artists, only one of which was possibly controversial, but that was the work that the

owner deliberately placed closest to the window so it was visible from the street. The work featured three words, "Original Cunt Sin," with "Cunt" in large red neon lights. The owner explained that his goal was to get attention for his gallery, commenting that "any exposure is good exposure," and adding that he believed the neighborhood had changed enough to accept such a work. "If it really was a family neighborhood I wouldn't do it, but now it's cutting-edge culture with cool bars and restaurants more than families." Whether he was correct remained to be seen. The work displayed, lacking graphic depiction of actual sexual activity, was tame compared with works displayed in Chelsea.[13]

More Edgy: Out of the Mainstream

LES art, and the experience of viewing it, did differ from art in Chelsea in two other ways. LES art was somewhat edgier, in the literal sense of being out of the mainstream, unconventional, and not fitting any of the main categories outlined above or found in Chelsea. Indeed, the second-largest category of LES art was the residual "hard to classify" (16 percent). An example is an October 2008 show at Fruit and Flower Deli at 53 Stanton Street by the artist Julieta Aranda. Titled *Tools for Infinite Monkeys*, it depicted the theorem which holds that if monkeys are given a typewriter to tap on, and an infinite amount of time to tap, they will eventually replicate a classic such as the Old Testament or a Shakespeare play. The show, accordingly, included an old typewriter on a table, and sheets of typed paper strewn over the floor.

It is not, of course, clear that this edgy art was popular with the public (either those who purchased or those who just came to look). Presumably this is why the Chelsea galleries, predominantly market-oriented, tended not to show it.

The Context

Several LES gallerists argued plausibly that though the content of the art might be similar, the context of the LES was edgier than that of Chelsea, and that this affected the viewing experience. They meant various things by this. First, LES galleries were mostly dotted around residential neighborhoods, with down-to-earth residents. Also, the LES galleries had far fewer immaculate, museum-style spaces than star Chelsea galleries. In addition the LES art was almost all by younger, less well-known (and not "star") artists. Finally, the whole atmosphere of the LES was less suffused with collectors and the serious aura of art as business. All these contextual

differences, it was reasonably claimed, might affect the experience of viewing the works, even though on the whole the art was the same. Stressing the LES's edgier context was also, for several gallerists, clearly a way of branding the area as different from, and superior to, Chelsea. As Augusto Arbiz, director of Eleven Rivington, commented:

> The context makes a difference. In Chelsea if you see this same show, it'll look very commercial. Here you're not going from one sold-out show to the next. Here there are restaurants and a cleaners and you might run into an artist on the street and go and have a cup of coffee. It's a warmer experience here. The way you walk in this neighborhood is how you walked in old Paris—you take your time. In Chelsea it's a different kind of excitement. It's business day and night. You run into twenty collectors, and they all talk about what they just bought.

Likewise Stephan Stoyanov, the owner of the Luxe Gallery on Stanton Street, which moved to the LES in 2007, thought the LES was edgier than Chelsea, though not necessarily the LES art. He was referring to the LES's less finished spaces and the more varied ethnic composition of the neighborhood.

> My last show was geared to the local area. It juxtaposed Pre-Columbian Art with Spanish Masters to make the point that we know all about the colonizer but not the colonized. The simple Hispanic people in the area reacted incredibly to the show. I'm not sure being in the LES made the show edgier. It was the same show—but it did involve the audience, the simple people.
>
> Chelsea has pristine, great spaces. Everything has to look super-well done. Here the spaces are more liberating. You walk in and you may fall into the basement!

Unconventional (Wacky) Galleries

Finally, while the majority of LES galleries were not hugely different in organization from their counterparts in Chelsea, a handful (three) were distinctly unconventional. They included Orchard, FusionArts Museum, and its neighbor, Fruit and Flower Deli.

Orchard was a radical, collectively owned gallery at 47 Orchard Street. Chelsea too had collectively owned galleries/cooperatives, but Orchard's participants took some radical ideas further. For example, they so opposed the corrupting effect of participating in a stable organization that they built the gallery's demise into its structure, taking a three-year, terminal lease, which expired in April 2008, at which time the gallery disbanded. (Some Orchard members then helped found the gallery Factory Fresh in

Bushwick). Orchard's members were also convinced that money corrupted art and ruined social relations. While this is a common view among artists and critics, Orchard was more committed to acting on it than many. For instance, they were reluctant even to try very much to make a profit from selling their work.

The idea for forming Orchard was born out of its founders' despair over Bush's 2004 election victory and also over the ongoing commercial power of Chelsea. Jeff Preiss, a filmmaker, explained: "We were very depressed after the 2004 election. And there was a nausea, you might say, about Chelsea, about how the art market was riding so high on the economy. We thought it would be a good moment to form an institution. To be with friends was like being in a group therapy session. We opened a gallery as an action."

Jeff Preiss and another founder, artist Andrea Fraser, produced a film to mark Orchard's opening titled, ironically, "May I Help You?" It showed Andrea Fraser taking clients around the gallery while warning them against buying art for investment rather than for its intrinsic merits. As she narrated in the film:

> I always tell my clients, the criterion for buying an artwork should be whether you want it in your home. Some people come into the gallery and they want to invest and they haven't the time to spend looking at the work. Imagine, no time! If you put a piece of shit on the wall, it would be all the same to them so long as people told them it was worth a lot of money. I detest that. That's the hedge-fund approach.

The film also warned against buying art that was reassuring or pleasing. Art should be edgy and unsettling. "My favorite clients are the ones who like to be on the edge. Art should be risky; you have to take risks. I don't like pretentious people, the Ivy League crowd. They are taunting us [a dig at the MFA degree costing up to $80,000]. That is what Contemporary Art has sunk to!"

The Orchard collective set up the gallery as a limited liability corporation. They rejected the main alternative, a nonprofit, on the altruistic grounds that claiming tax-exempt status was an unfair burden on the taxpayer, and also on the libertarian grounds that being a nonprofit allowed some undesirable state control over their activities.

The group did decide that one of them should be the unpaid director. Rebecca Quaytman did not have a job at the time, so she volunteered. She discussed how they functioned as a collective: "It's disintegrated a bit, which is usually the case with collectives. Still, we always knew it would be hard. Our first statement on our website says we are 'twelve people with no unified idea.' We can't even find clarity on the issue of how we want to

find clarity. We're very different people, with very different careers and statuses in the group. Our only goal was to close in three years."

Another unconventional gallery was Fruit and Flower Deli, at 53 Stanton Street. The owner, Rodriguez, had once curated in a museum in Stockholm. He referred to himself only in the third person as "the keeper" and also as "the Oracle," which he described as a "divine entity that makes things easier and more complex." He "never did mailing lists," and had no business cards or formal invitations to openings. Helped by funds from his wife, an artist, he opened the gallery in July 2007, paying rent of $3,000 a month for 300 square feet, "a little shoe box" as he described it (at $120 a square foot per year, this rent was high). Asked if he had another job to support himself, the Oracle took offense and said the gallery did actually sell work and make money. Still, up to now "the Oracle's paintings have not been for sale." By 2013 the gallery had moved to Stockholm.

In Chelsea, by contrast, unusual galleries are rare. There was only one example, the Wrong Gallery, started by the famous artist Maurizio Cattelan around 2001. It was just a front doorway (at 516A½ West 20th Street) with no interior, just a sign announcing "Fuck Off, We're Closed." Still, it had shows—installation pieces and occasional performance works by young artists. In 2003 the Wrong Gallery satirized Chelsea's multiple-space phenomenon, opening a second, identical doorway some twenty paces to the west. By 2005 the Wrong Gallery was evicted when the building was sold. It relocated until 2009 to the Tate Modern in London. In 2012 it reopened in Chelsea as a double glass door on 21st Street on which a handwritten sign announced "Family Business."

WILL THE LES SUPPLANT CHELSEA?

The most common view among Chelsea star gallery owners is that, while the number of Chelsea galleries might decline somewhat as the LES grows, the majority, especially the stars, will stay in Chelsea. This is because the LES lacks space for a switch of the kind that happened when the gallery center for Contemporary Art moved from 57th to SoHo and then to Chelsea. Above all, that is because there are now a lot more major galleries. The gallerist at Marlborough expressed this view clearly:

> The LES has younger, emerging artists. That element of the art world will still move around every ten years or so. Before the LES it was Williamsburg.
>
> But it would be tough for the epicenter to move to the LES. It would be nearly impossible to have a geographic shift of all the larger galleries these days, along the lines of what happened when they switched from 57th Street to SoHo and then to Chelsea, because there are a lot more large/

important galleries now. When the SoHo galleries switched to Chelsea there were only about twelve big names. Now there are about forty. There isn't space anywhere else in Manhattan for forty galleries each needing about 5,000 square feet.

Paula Cooper, who by November 2008 had opened three gallery spaces in Chelsea, was less certain what would happen: "The LES is very chic! They've got the New Museum down there and better restaurants than Chelsea! But Manhattan is like that; everything keeps changing. That's quite good and it'll continue. I see Chelsea growing a little smaller, maybe a few less galleries."

By May 2014, LES galleries, at roughly 114, were still less than a third the number of Chelsea galleries, roughly 384. Chelsea seemed likely to remain dominant, with the LES as a minor but important presence. The case of Hauser & Wirth, the Swiss star gallery, supports this. In 2008, seeking a large New York space, the gallery signed a lease to open in the LES opposite the New Museum. The ensuing world financial crisis placed this plan on hold, and in 2012 the gallery changed its mind about the LES, signing a lease in Chelsea for a huge, 23,000-square-foot space (another former garage), almost as large as Gagosian's main 25,000-square-foot Chelsea gallery. By early 2013 alarm bells were sounding in Chelsea about the future of ground-floor galleries as rents soared. Yet ground-floor rents on the LES were soaring too, reaching Chelsea levels ($90–$100) for a new lease.

THE NEW MUSEUM AND *UNMONUMENTAL*: ART THAT DOES NOT RESONATE WITH THE AUDIENCE'S LIVES

We have argued that there are two important, but very different, stories to tell about Contemporary Art. The first is about money and rents and entrepreneurial gallery owners. The second is about the meaning of the art for the audience. Interviews with the audience, and collectors, showed that when they like the art, that is typically because it resonates in one of various likely ways with their lives.

The same two stories need to be told about the LES. So far, our account has focused on galleries and comparative rents, and the role of a key non-profit, the New Museum. To address the second story—the meaning of the art for the audience—we interviewed a sample of the audience who attended LES galleries. The results basically duplicated the findings for the Chelsea audience, showing that if the audience like the art, on the whole that is because it resonates with their lives in one of a typically limited set of ways.

So instead of repeating these audience findings for LES galleries, we present here a major, negative case study from the New Museum's opening show *Unmonumental* that demonstrates what happens when audiences are presented with art that they are unable to see as resonating with their lives.

Although LES galleries are somewhat more likely to show nonmainstream art than were Chelsea galleries, most LES galleries still have to cover the rent and make a profit, which means generally displaying what was at least somewhat popular and saleable. By contrast, as a nonprofit, the New Museum is freer of these market-based considerations. Its 2007 opening show titled *Unmonumental: The Object in the 21st Century*, was a revealing case study of an exhibition composed mostly of nonmainstream, or at least very avant-garde, art. The curators, following a theory they had developed of what constituted the best of Contemporary Art, built the show around a series of "unmonumental" items, flimsy, transitory and noncommercial works, including collapsed packing boxes, a garden house, and discarded clothing.

Systematic interviews with the audience suggested that few sympathized with, or even really understood, the show. *Unmonumental* illustrates the limits on how far anyone, including experts, can impose an artistic vision on a nonreceptive public.

It has often been said that in the twentieth century artists were freed from constraints regarding what is art. Arthur Danto (1997, 29) for example, argued that in the 1960s artists were "liberated from the burden of history, no longer constrained by an imperative to carry the narrative forward." This was "the first time civilization had been in such a situation.... Artists could make of art whatever they wished," with Warhol's *Brillo Boxes* as a key moment. This is formally true. Still, the material presented here underlines that, even nowadays, it may be one thing to present something as "art," another for the audience to agree.

Curatorial versus Market-Based Approaches: Unmonumental Art

The "curatorial" approach, in general, involves experts selecting which artists and works are especially meritorious. It is part of a tradition that sees art and culture as educating and informing the public, but not necessarily entertaining them. The art scene in France is squarely in this tradition, dominated by (mostly government-appointed) experts who pick winners and losers in a series of competitions. So was the New Museum's founder, Marcia Tucker, who in 1975 braved the hostility of critics and puzzlement of the public to curate a show by Minimalist artist Richard Tuttle, and was fired for doing so.[14]

The New Museum has, especially since opening in its new LES space, to its credit put on several innovative and creative shows. We are not, here, criticizing these programs, but rather drawing on one that illustrates an instructive gap between curatorial intention and audience reception.

Unmonumental Art

In Tucker's spirit, the New Museum curators organized an opening show whose vision was not necessarily keyed to what was popular with the broad public or would sell to "collectors." Indeed, in catalogue essays for *Unmonumental*, several of the curators explicitly criticized market-based (and entertainment-based) approaches and popular taste. For example, chief curator Richard Flood lambasted the market's commercialism, writing:

> Making art in the early twenty-first century is just the same as making art in any other century, except for the money that coats everything like ash. It is accompanied by the creation of artistic hierarchies where vanity and insecurity go hand in hand. . . . Nowadays there are masterpieces everywhere, racing into the marketplace like sperm to the womb. . . . In an age of maximal distraction . . . there is no time wasted waiting for a masterpiece to achieve connoisseurial consensus. Some blowhard just pronounces it so, and that's all. Well, maybe it helps if there is a carefully choreographed auction where a manipulated record is set and an art riff on bad history commences, as dollars, euros, yen and rupees confirm the status of a masterpiece. But, really the appellation has replaced the reality. (Hoptman et al. 2007, 12)

Flood went on to criticize the general public—both those who purchase art (the "collectors") and those who do not—for its superficiality: "Reality is a collage of whatever grabs our attention and the compendium is limitless. People lunge needlessly into traffic with the Survivor soundtrack playing on their iPod. Others sit alone in restaurants with their mobiles, or stalk the Web in search of meaning. The real and the doppelganger coexist—that's the twenty-first century's Manichean malady" (Hoptman et al. 2007, 10–12).

The particular curatorial vision underlying *Unmonumental* was built into the show's title, which, for the curators, meant displaying works that were not permanent or made of lasting materials such as steel or rock, not massive, and not intended to memorialize events or people. Being unmonumental was a highly positive quality, the curators believed, and they argued that a growing number of artists in the last decade were doing this kind of work, though it did not yet constitute a movement.

Fig. 9.6. Gedi Sibony, *The Circumstance, The Illusion, and Light Absorbed as Light,* 2007. Installation view of *Unmonumental,* inaugural exhibition for the reopening of the New Museum, New York, 2007. Few people liked this work. A typical comment was: "Why should we be subjected to this? It looks like someone's garbage." Photo by David Halle.

Among the *Unmonumental* works featured were painted cardboard boxes (Carlos Bunga or Gedi Sibony), assemblages of bottles, paper, and milk cartons (John Bock), torn sofa beds from which protruded fluorescent lighting (Sarah Lucas), steel tubing and a metal deck chair (Martin Boyce), used clothes packed tightly in bales (Shinique Smith), wax figures that burned down like a candle during the show (Urs Fischer), and a bicycle with handbags and a poster of Mel Brooks (Rachel Harrison) (see figs. 9.6–9.8). Some artists in the show had made their reputations by presenting their works in other ways. For example, Sarah Lucas came to prominence as part of the iconoclastic and sensation-seeking Young British Artists (YBA) movement. However, in this show the works were presented under the umbrella category of "unmonumental."

What was so positive about unmonumental art, according to the curators? Their case was not presented especially clearly in the show, which avoided explanatory panels (probably deliberately—see below). But it

could, roughly, be derived from the catalogue essays, each written by a curator. These revealed two main arguments that, despite differences among the curators, together constituted a core position justifying un-monumental art.

One argument was that the world was in a perilous and chaotic state, fragmented and out of control. There was also specific alarm about the Iraq war and the US politicians who had started it, and also concern about the environment. Director Phillips wrote: "It is an uncertain time, at best, with threats ranging from religious wars and terrorism to global warming and species extinction. We are on the brink of a drastically changed world."

Hence unmonumental works were worthwhile because they mirrored this fragmented and chaotic world. Phillips wrote that the works were "reflecting the extreme delicacy and fragility of life in the twenty-first century."

A second component of the curators' support for unmonumental works was that the works were an antidote to the art world's commercialism and

Fig. 9.7. Sarah Lucas, *Fuck Destiny*, 2000. Installation view of *Unmonumental*, inaugural exhibition for the reopening of the New Museum, New York, 2007. Courtesy Gladstone Gallery, New York.

Fig. 9.8. *Foreground:* Martin Boyce, *We Climb Inside and Everything Else Disappears*, 2006. Boyce won the prestigious Turner Prize for art in 2011. *Rear wall:* Mark Bradford, *Work in Progress*, 2007. Installation view of *Unmonumental*, inaugural exhibition for the reopening of the New Museum, New York, 2007.

superficiality. Here such works might have some improving, even curative, effects, via their modesty and naturalness. For Flood, the works corrected for the corrupt and manipulative world and were, accordingly, "stubby, honest, natural/vegetative, conversational, modest and reassuring. . . . Our time demands the anti-masterpiece. . . . The materials used by many of today's artists are redeemed from the rubbish heap and are Franciscan in their simplicity. . . . The best of the work defies a simple knee-jerk response because it tends to be conversational, it wants to slow the passerby down. . . . The work is not about delivering last words" (Hoptman et al. 2007, 12).

This probably also factored into the curatorial decision to provide minimal labeling. Rather than offer packaged interpretations, the gallery was asking the audience to think.

In short, for the curators, unmonumental works were meritorious because they reflected the chaos of the world and also were an antidote to some of its worst aspects, including the public's corruption, excessive

focus on money, and wastefulness. Even art styles that seemed to have affinities with unmonumental art, such as minimalism, performance art, or earth art, were dismissed by the curators as having grandiose aspirations.[15]

THE AUDIENCE

The Puzzled Audience

How did the audience react to these works? We sampled sixty people at random. Eighty percent disliked the works. This was almost twice as high as the most disliked show in Chelsea of those we studied (Warhol's *Male Nudes*, disliked by 48 percent of the audience). Among those who disliked *Unmonumental*, the clearest reaction, 60 percent of the whole sample, was puzzlement and perplexity. They did not understand why the vast majority of the works were in the show.

Nor, except in rare cases, did they believe that being puzzled was a good thing: for example, a welcome chance to ponder the chaotic world and slow down, or an appropriate mirror of a fragmented world. Instead, almost all those perplexed thought that not understanding the works was a problem, for which they most often blamed the museum for providing insufficient explanation. Less often they blamed the artists, or themselves—their inadequate knowledge or ability to understand the works.

The root of this puzzlement was the category "unmonumental," which resonated with few of the audience. The show explained the concept only briefly in a single text panel that, interviews suggested, few of the audience actually read. Of those who did read it, few showed any enthusiasm for the idea. Almost none of the perplexed could see why a work of art should be transitory or modest or flimsy. Hence works such as painted cardboard boxes or bits of chain-link fence, included by the curators as quintessentially unmonumental, produced confusion and disbelief in many of the audience.

The following cases are illustrative of this 60 percent of the sample who felt they just could not understand the show. A lawyer in his fifties:

> For something to be displayed publicly there is a claim to be made; some curator has decided this is of value to display in a public space that is built to display art and done at great expense. But a lot of this doesn't have that value. Now Picasso was legitimate. He first did representative stuff and then went out to create a new kind of stuff. But you look at this [points to Sibony's collapsed cardboard boxes, fig. 9.6]. Why should we be subjected to this? It looks like someone's garbage.

A young woman visiting from Paris who worked in Human Resources for an IT company:

> There are no explanations to try to guide the visitor. It's *obtus*—that's the word in French. It's hard to understand the meaning, what the artist wanted to show.

A retired businessman who knew about the arts—he had just sold his architectural glassmaking company—likewise blamed the curators and artists for the lack of transparency.

> I can't figure anything out. It just seems pretentious, like a lot of people wanted to put their name on something they couldn't understand.

A small number of those who were puzzled blamed themselves, entirely or primarily, rather than the museum or the artists. A male choreographer in his thirties, visiting from Switzerland:

> I'm perplexed. For example, this one [points to Urs Fischer's sword embedded in a large rock]. I cannot understand it. I'm not an art specialist. Maybe I need some help, I'm not totally stupid.

The museum administration noticed this puzzlement. Soon after the show opened, they stationed a staff member wearing a large "Ask Me" button on each floor in order to address people's perplexity. An administrator explained: "People were asking the security guard why there are bicycles and megaphones hanging from the ceiling. And the guards didn't know. So now we have a full-time guide on each floor who explains the works to the public. I had a hard time myself. I like paintings and drawings, and here you find boxes, sinks, pots, and pans."

Still, the interviews revealed that the addition of "Ask Me" staff scarcely made a dent in the perplexity. One of the guides complained: "They [the audience] get very angry. They want to know what it's all about! And they blame me for there not being labels, which is ridiculous."

Comprehensible Themes

The structure of the art. The large group who were puzzled tended to grasp at the few works they found that they could link to comprehensible themes in the outside world. These themes almost always fitted one of the central ("structural") categories of art outlined earlier in the study of Chelsea art. Among the structural themes the audience for *Unmonumental* grasped at were the political, landscapes (classical and radical environmental), the decorative, and the poor. In some cases it took a lot of thought for an audience member to "find" one of these, but once they did so, the work usually

elicited approval and even enthusiasm, often like a solved crossword puzzle. This suggests that the basic problem for those who were puzzled was they did not see how the majority of works fitted these main structural themes, or indeed any other conventional categories of art.

The political. Among works that the audience grasped with relief as resonating with a structural theme, those with a political bent were the most common, by far. The works of three artists in the show were political. Actually, most of these works did not fit the curators' core notion of unmonumental art—they were not flimsy or transitory. But they did fit the curators' political outlook and were certainly critical of the chaotic and conflictual world the curators had outlined.

The photographs of Martha Rosler were especially well received here, probably because they creatively conveyed a clear political message—criticism of the ongoing Iraq war.

Her series of photomontages titled *Bringing the War Home: House Beautiful Series* (2004) juxtaposed brutal scenes from the Iraq war with scenes of self-indulgent life in the United States. She depicted American consumerism and normalcy, often with a sexual or narcissistic edge—women at the health club (fig. 9.9) or in fashionable and sensual clothing, a war veteran in an expensive, high-tech kitchen. Alongside were images of the Iraq war and its horrors—Iraq in flames, a soldier with a prosthetic leg, hooded Iraqis at Abu Ghraib.

A second political work, a video by Kenneth Hung, was even more radical, and was also effective with, and understood by, the audience. Hung's video compared President Bush with Hitler (they were depicted side by side, each under an eagle). Other Hung images had Vice President Cheney and Bush flying through the air grinning ghoulishly and wearing female underwear. (Hung's work, unlike Rosler's, did offend a few members of the audience, who saw it as too anti-American. To their credit, the New Museum administrators believed in displaying whatever they thought should be displayed. Almost none of New York's other major cultural institutions, highly dependent on government money, would have dared display this work.)[16]

A third political work with which several of the audience resonated was Sam Durant's metal cage with a large sign, "Obedience to the Law Is Freedom." The audience mostly saw this as satirizing the American (Western?) ideology of freedom.

Some audience members, though generally puzzled by most of the works in the show, found a beacon of light in one or more of these political works. A male visitor from Canada, in his thirties, asked what he thought of the show: "I don't know, I don't know," he repeated, trying to think of something to say. After another long pause he recalled that

Fig. 9.9. Martha Rosler, *Photo Op*, from the *Bringing the War Home: House Beautiful Series*, 2004, photomontage 20 × 24 inches.

he liked Martha Rosler's Iraq photographs. "I like the juxtapositions over there of the war and antiwar. They bring the war home to you, and it's obviously topical. I'm from Canada, so it's OK to be anti-American." A female New York psychiatrist, in her sixties, said of the show: "They need a little more explanation. They should put in benches, so we can sit down and figure this out. [She points to the anti-Bush video by Hung.] But I like that one. It shows the untruthfulness of the administration, the corruption."

The classical landscape. The show contained almost no works that resembled either the classic landscape or the environmental landscape, major Chelsea themes.[17] Still, the view from the museum building was seized upon as a classic landscape by significant numbers of the audience. The museum had a top-floor public balcony which offered broad views of the city. Almost 20 percent of those interviewed spontaneously mentioned that they liked this view. Since we did not specifically ask about that, this was a significantly large group.

For example, a women in her fifties who worked for many years in New York City's Percent for Art program dismissed the show as an uninspiring,

crowded jumble of works. Still, she added: "I like the building a lot; it reminds me of the Pompidou. And when you look out of the window on the second floor you see the grit of the Bowery."

A restaurant manager in his early thirties thought the show was "too underground. You know how with music there's pure music, classic jazz, and then underground jazz. With artists it's the same thing. This is too underground for me." Asked if there was anything here he understands, he said: "I like the seventh-floor balcony because you have this terrific view of the city. You can see the tops of SoHo buildings and even further west."

The decorative. The "decorative" was another structural theme that some members of the audience grasped at, despite its lack of affinity with "unmonumentalism." A woman in her fifties who was a docent at another New York museum commented: "What do I think? Oh my God! I think I'm not sure if we're being scammed. I'm not sure this has any longevity. I like beautiful things, Michelangelo and so on." A passing museum docent explained that Abraham Cruzvillegas's work *Cánon Enigmático a 100 Voces* was basically about the artist's poverty-stricken childhood in Mexico and his resulting efforts to use discarded and found materials in his art, both as a reminder of his humble origins and as an effort to conserve. Resolutely ignoring this interpretation, the interviewee found the "decorative" in Cruzvillegas's brightly colored water buoys hanging from the ceiling (which for the artist connoted his poor background in a dilapidated harbor setting): "This is rather pretty. I could see it hanging in someone's wonderful modern house. It's like a chandelier. I like the colors and textures, like balloons."

The poor. Poverty was another theme with which some of the audience could resonate. Here Shinique Smith's bales of clothing were appreciated. Those in the audience who liked this work typically believed that it evoked bales destined for third-world countries, and understood it as about American affluence and wastefulness and third-world poverty.

A couple from Los Angeles in their forties were perplexed by the exhibition as a whole. The husband, a businessman who had a degree from the UCLA film school:

> It would be helpful if there was some sort of guide or explanation as to what the artist was thinking. If you had it in a Sotheby's auction, there would be a catalogue that would give you a full explanation. They want you to understand it, because then you'll buy it!

The only work he thought he understood was Shinique Smith's:

> The bundle is about recycling and sending clothing back to Africa and third-world countries.

The Not-Puzzled Audience

Of the roughly 40 percent of the sample who did not complain that the works were inaccessible and hard to understand, almost all had occupations that steeped them in the world of the arts, or at least were highly intellectual. They included a female production manager of the Boston Contemporary Art Institute, a male professor of fine arts in New York, a female long-time administrator of a major public art program in New York, a female musician just retired from the San Francisco symphony orchestra, and a male scientist who was director of California's stem cell project.

Still, only about half of even these liked the works. The rest disliked them, though on the whole because they thought them banal, not because they could not understand them.

That left a group, about 20 percent of the sample, who tended to like *Unmonumentalism*. Typically they found it challenging, on the grounds that the works posed problems, or puzzles, or stimulation from the juxtaposition of materials and themes that are not ordinarily juxtaposed. For example, the male scientist in his seventies who had recently retired as head of the California stem cell project (one of the most important scientific initiatives in the country):

> It's very enjoyable and provocative. I like the juxtaposition of multiple images and materials, like collages, and the fancifulness and fantasy and surreal quality.

He talked in detail about Rachel Harrison's *Huffy Howler*, an assemblage of a Huffy Howler bicycle with black handbags strung over the handlebars and a long metal pole at the end of which were hanging, high in the air, several artificial furs and a publicity photo of Mel Gibson in *Braveheart*:

> It's a modern tech high-end road bicycle with purses hanging from the bars. Those aren't an accessory you'd expect to find on a bicycle, and the furs are a symbol of masculinity, and that strange papier maché base [colored purple, it was anchoring the entire assemblage], that's got a different feel and texture. All these elicit fashion, technology, and the whole thing has got a flow to it. It's fun. It makes you think of different things.

A woman who was production manager for the Boston Institute of Contemporary Art:

> [The show is] interesting. [Points to Martin Boyce's tree shape made of fluorescent light.] The tree is amazing. It's the natural forms made out of unnatural objects. [Points to Nate Lowman's *Not Sorry*, consisting of three bullet-resistant glass partitions riddled with bullet holes, with a sticker

from the game Sorry pasted on one of the partitions.] This one is terribly disturbing. It's titled *Not Sorry*. It's a reference to the game Sorry, so it's referencing a young person's game that's fun to play. But instead the bullet holes have gone into something intended to protect people, so it hasn't protected them. It's very violent. I think in the game you move to take over the other person's pieces.

CONCLUSION

There are the same two basic, though very different from each other, stories to tell about the LES art scene as there are about Chelsea's. Both stories are crucial for a proper understanding.

There is the rent and real estate story, much of whose drama revolves around whether the LES will replace Chelsea as New York's dominant gallery neighborhood for Contemporary Art. This story includes commercial galleries gambling by arriving early in the LES. Further, as with Chelsea, it was a nonprofit, the New Museum, that paved the way, making the LES gamble worth taking for the galleries.

By now it looks unlikely that the LES will replace Chelsea, for several reasons. There are not enough viable spaces to accommodate the mass of Chelsea galleries; the core star Chelsea galleries own their spaces in converted garages and so are protected from skyrocketing rents, giving Chelsea some stability; and new attractions such as the High Line and the impending opening of the Whitney Museum have reinvigorated Chelsea.

Another part of the real estate story is that the LES is, primarily, a residential neighborhood, historically working class, so the classic-gentrification scenario, whereby more affluent residents may replace poorer ones, is in play. By contrast, the area of Chelsea to which the commercial galleries moved in the 1990s and later was zoned manufacturing, so there were basically no residents to displace.

The second story about the LES art scene, which has little to do with the first, is about the art and its meaning. The case of the New Museum's opening show confirms that, on the whole, for art to be of interest to the audience it has to resonate with their lives. Otherwise, they tend to dislike or be indifferent to the works. It is true that in the twentieth century it was established that, in principle, anything can be art, as Marcel Duchamp argued, and as Andy Warhol repeated decades later (quipping it is "art because I said it is"), and as Arthur Danto has again stressed. But just because in principle anything can be art does not mean anything will be broadly accepted as art by the audience, as the case of *Unmonumentalism* underlines.

Balancing Urban Growth and Protection/Preservation

The three main types of projects considered here—Chelsea's commercial art gallery district; preservation projects, represented by the High Line and Gansevoort Market District; and megaprojects, including the Hudson Yards rezoning, Moynihan Station, and Javits expansion—are together a case study of the crucial process of fostering urban growth and positive change while protecting against change that is destructive and undesirable, including displacing vulnerable residents.

Achieving a reasonable balance is complicated and difficult, for several reasons. For one, these situations are inevitably fluid with many moving parts, making outcomes hard to control or predict. For another, preservation projects may well foster growth, either deliberately, as with the city's vision for the High Line, or accidentally, as with the Gansevoort Market Historic District, which, together with other local assets such as the commercial gallery district and High Line, helped attract job-creating titans of the high-technology sector like Google and Apple, as well as a boisterous, even out-of-control, nightlife.

A case study can uncover the subtleties and complexities of the process, and for several key features it is the only way to do so. These complexities include, for example, distinguishing different types of "gentrification" rather than conflating them; determining why some megaprojects happen while others do not; defining "globalization" so as to underline what is new about this particular stage of the process; analyzing the art market in its actual workings, not just as hypothesized; and assessing the merits of a complex package such as the Hudson Yards rezonings rather than sloganizing about "giveaways" to developers or residential "handouts" to lower-income groups.

This concluding chapter draws attention to the main points made, including complexities encountered. It also, as Mayor de Blasio's administration starts in 2014, allows for evaluation of signature projects of the Bloomberg administration which are centrally relevant to key themes of

de Blasio's election campaign—inequality, housing unaffordability, and tax breaks to developers. Examples are, in the Hudson Yards, inclusionary zoning for affordable housing and tax increment financing (TIF), which takes the tax revenues that result from any private development generated by an infrastructure improvement, in this case especially the number 7 subway extension, and uses those revenues to finance the infrastructure improvement. Other signature projects include the 2005 West Chelsea rezoning that made the High Line possible by allowing the Chelsea Property Owners, who owned the land under the High Line, to sell their air rights to sites that were not adjacent to the High Line; and creating in 2013–2014 a Hudson Yards Business Improvement District to finance, from taxes on local businesses, maintenance of the newly created Hudson Park. We have argued that, while there can and surely will be legitimate debate over the merits of each of these projects, they all fall within the scope of reasonability and well outside the terrain of one-sided and extreme projects and positions, of the kind which we begin this concluding discussion by outlining.

BALANCING URBAN GROWTH AND PROTECTION/PRESERVATION

Several one-sided and extreme approaches to balancing urban growth and protection have been promoted. These, on either end of the debate ranging from "fundamentalist preservationism" to "unbridled development," imply simple solutions to balancing problems that are typically neither simple nor easy.

Fundamentalist Preservationists and Opponents of Growth

At one extreme is what Paul Goldberger and others have called the "fundamentalist" wing of the preservationist movement, which, by contrast with the "moderate" or "liberal" wing, favors preservation at all costs and opposes all major and often even minor change to existing buildings—for example, campaigning to keep every old brownstone or factory building, or opposing new or tall buildings, or ignoring the need for growth and job-creating projects such as the Javits Convention expansion or Penn Station's upgrade to Moynihan Station.

When New York City's Landmarks Preservation Law was passed in 1965, the liberal or moderate wing was dominant, with the fundamentalist wing emerging later. The liberal wing not only expected to see some reasonable changes made in older, landmarked buildings; it also expected that new or tall, modern buildings could and should appear even in neighborhoods

located in historic districts, for example, on vacant lots. The rationale was that some of the iconic buildings in historic districts were architectural pioneers in their day and, as such, constituted one reason the historic district was worth designating, so that the process of innovation should continue.

Key leaders of the fundamentalist wing on the West Side of Manhattan are the Greenwich Village Society for Historic Preservation, led by Andrew Berman, whom *Crain's* magazine dubbed as having "rarely met a project he didn't oppose" (Kavanaugh 2012), and Landmark West, led by Arlene Simon. Both organizations have undoubtedly been positive forces in preserving some areas and buildings that reasonably should be preserved.[1] However, this fundamentalist wing commonly uses "gentrification," with its often negative connotations, so broadly as to refer to, and denigrate, almost any urban change.

Actually, a central attraction of the Far West Side for the city was that the sections where it planned its growth projects, such as the Javits Center expansion, were zoned for manufacturing and or transportation (e.g., the Eastern and Western Rail Yards), so there were few if any residents to displace. Indeed, the original Javits Center was sited on the Far West Side precisely to avoid the kind of displacement of residents and local businesses associated with earlier megaprojects, such as the construction of the Lincoln Center concert complex. To call projects sited in such conditions "gentrification" is not helpful, unless done with care to specify how they differ from other situations, and in particular from classic gentrification, where longer-standing poor- and working-class residents are displaced by middle-class and well-to-do residents. (Among the areas this book covers, "classic gentrification" is certainly an issue in the Hell's Kitchen–Clinton neighborhood north of the Hudson Yards, and in the Lower East Side.)

Indeed, since the 1980s, cities have increasingly operated in the "do no harm" era of megaprojects, marked by the need to avoid or fully mitigate any significant disruption, a reaction against the immediate post–World War II period of massive residential displacement ("slum clearance") carried out under the aegis of the 1949 Housing Act. An important driver of this new era was the 1969 National Environment Policy Act (NEPA) and its state and local analogues, which stop governments ramming through projects by requiring them to analyze, display to the public for comment, and take account of a project's environmental impact, defined broadly to include a host of socioeconomic factors, including any likely change to neighborhoods. This is not, of course, to deny that cities can come up with egregious projects or that a proposed project even in a former manufacturing area might have significant harmful effects. It is just that not every

proposed megaproject has such effects or is a bad idea, and each one needs to be scrutinized.

The contradictions in the "no-growth preservation fundamentalist" position can be glaring. On the Far West Side many buildings and projects that preservationists fight to save only exist because of radical and creative megaprojects of their day. For example, the meatpacking industry, whose presence in the Gansevoort Market area preservationists fought to retain, was only there because in 1905 the Manhattan Refrigerating Company drew on the latest technology to install underground refrigeration infrastructure in the district. Further, the Gansevoort Market and the entire High Line are built on a massive landfill project which created 10th and 11th Avenues in stages in the nineteenth century and is the kind of megaproject that radical preservationists would oppose if proposed nowadays. Indeed, roughly 10 percent of Manhattan consists of landfill. This is not to say new landfill projects are always a good idea, just that they might be. For example, Vishaan Chakrabarti in 2011 proposed an innovative, growth- and environmentally oriented landfill project to fill in Manhattan's East River between Governors Island and the Lower East Side shoreline. The landfill would serve as flood protection and a barrier reef in anticipation of rising waters from global warming, yet also create much-needed extra land to facilitate growth.

A modified version of this idea appeared in the city's 2013 list of flood protection measures triggered by Hurricane Sandy. The city's proposal was to build a multipurpose levee in the East River along the edge of Lower Manhattan running from the Battery Manhattan Building (near Manhattan's southern tip) to Pier 35 about three-quarters of a mile north. The levee would protect against storm surges and rising sea levels and also create new land for commercial and residential buildings to accommodate the city's population growth and provide revenue to help fund the levee's construction. This is a creative combination of preservation and growth (NYC Economic Development Corporation 2013, 385–92).

Ironically, by 2011 the Far West Side was the beneficiary of the refusal of fundamentalist preservationists to permit the Whitney Museum of American Art to demolish two undistinguished brownstones in order to expand its home building in the Upper East Side Historic District. Losing patience, the Whitney decided to move its entire operation downtown to the High Line entrance near the Gansevoort Historic District.

Another contradiction for the fundamentalist wing of the preservation movement is that opposing new, tall buildings in a desirable urban area whose population is growing causes rents and purchase prices of existing buildings and apartments there to become increasingly expensive,

affordable only for the wealthy, as economists have repeatedly pointed out. For example, the *Financial Times'* chief economist Martin Wolf (2001) complained that drastically restricting the supply of land and residences creates a "rigged market" and is "the most important way in which wealth is transferred from the unpropertied young to the propertied old." *New York Magazine's* architecture critic, Justin Davidson (2008), made a similar point: "Protect every tenement, and eventually millionaires can no longer afford them." Edward Glaeser (2011a) similarly argues that "in older cities like New York, nimbyism hides under the cover of preservationism, perverting the worthy cause of preserving the most beautiful reminders of our past into an attempt to freeze vast neighborhoods filled with undistinguished architecture. In highly attractive cities, the worst aspects of this opposition to change are that it ensures that building heights will be low, new homes will be few, prices will be high, and the city will be off-limits to all but rich people."[2] Rents and prices are prone, of course, to rise in desirable neighborhoods anyway even if some new, tall buildings do get built, but probably not as rapidly or sharply.

This is not, of course, to say that all or even a majority of buildings should be new or tall, but just to support a mixture of new and old, tall and short, along the lines of Jane Jacobs's vision. There should, and will, be endless reasonable debates over the appropriate balance of this mixture, but insisting on a city composed of just one component of the mix is not reasonable. These "no growth, preservation fundamentalist" approaches, if broadly applied (admittedly unlikely in today's New York City), risk turning a city into a period room along the lines of Venice, as several critics have pointed out (e.g., Ouroussoff 2005; Gardner 2005). These are some of the contradictions of fundamental preservationism.

No-Growth Positions

There is also a group of analysts who, while not fundamental preservationists, do not believe that projects to stimulate growth and jobs should be part of urban policy. This seems unreasonable. An interesting example is Julian Brash's recent study, *Bloomberg's New York*. Brash details how Bloomberg's mayoralty sought some growth projects in the Far West Side's Hudson Yards that would attract and generate employers and jobs, especially in the context of competition with other global cities. Since this strategy also typically entailed opportunities for private employers to make profits, it was easy to dismiss as being fundamentally about that (with the goals of creating jobs and financing city services as secondary, even just cover), but Brash concludes that this criticism is inaccurate and unfair, as do, on the whole, the case studies we have presented here of the High

Line, Javits expansion, and Hudson Yards rezonings. Brash also shows that Bloomberg's approach, and that of his Department of City Planning director Amanda Burden, was reasonably concerned to protect vulnerable neighborhoods and residents from adverse effects of development, as with the affordable housing features of the Hudson Yards rezoning.

Despite this, Brash goes on to oppose the growth projects. He says that instead, he, and many other opponents of such projects, prefer a conception of New York as a city that provides a "comfortable life to those not wealthy, well credentialed, or ambitious; a city that provided a place for those outside the mainstream of American culture; a city that honored and cared for longtime residents and the neighborhoods they created" (Brash 2011, 252).

For our part, we do not see how these worthy goals (e.g., "a comfortable life for those not wealthy") can be sustained without jobs and growth that also protects and even expands the tax base that supports services, which was basically the Bloomberg administration's attempt to reconcile growth and protection of existing residents. Indeed Bloomberg was elected a month after 9/11 had caused the city budget to fall into deficit amid a mild recession. He acted quickly to control spending and raised property taxes by 18 percent as an emergency measure (this is the only tax the city can raise without state approval), reasonably arguing that if New York City wants to continue attracting business and get people to stay, it needs to maintain services, not cut them, and to raise revenues to pay for services preferably by expanding the tax base rather than by raising taxes (Sweeting and Dinneen 2013). Underlining the importance of expanding the tax base is that New York City's taxes (e.g., for 2003–2004, the last time a comparative study was done) are the highest by far of the ten largest US cities, with roughly 22 percent of tax revenue going for the city's Medicaid payments, a far higher proportion than in any of the other largest cities (IBO 2007).

Brash agrees that opposing even well-conceived and balanced development projects is not a viable alternative. As he writes of such opposition: "Elite white cultural critics and Latina antipoverty activists, rich white sportswriters and poor black people—those people might have been able to make common cause in opposing a stadium, but they were unlikely to agree on 'what kind of city do we really want,' let alone a development or governmental strategy that would provide a coherent alternative. . . . They could not propose a way . . . to build that city; they could only say no" (Brash 2011, 253).[3]

Vishaan Chakrabarti expresses a criticism of the contradictions of "no growth" positions similar to ours. He writes that many urban planners and theorists pay lip service to density but tend to oppose growth projects, and

he complains that "it is a common trope in most schools of architecture and urban planning today to believe that density is good but development is bad" (Chakrabarti 2013, 127). Chakrabarti makes this point in a book that passionately argues for "cities," defined as "dense" (thirty dwelling units per acre) and even "hyperdense" (forty dwelling units per acre) environments, on the grounds that these levels of density are environmentally more sustainable than auto-dependent suburbs and can support, for example, services such as parks, good schools, effective policing, and affordable housing.

Developers Unrestrained

At the other extreme, and equally undesirable, are approaches that turn the city over to developers and landlords and market forces without constraints. The city, for example, properly recognized this when it protected the heart of Chelsea's art gallery district from condominium developments. It also insisted, albeit partly at the local community board's prodding, on bundling a substantial amount of affordable housing, especially via inclusionary zoning, into the West Side Hudson Yards megadevelopments (though, given needs and high rents, this is never enough affordable housing.)

Still, the previous chapters contain plenty of examples of unbridled developer greed, often facilitated by political lobbying/cronyism. The city and state, under Giuliani and Pataki, allowed Larry Silverstein to construct his mega Silver Towers apartment buildings on a site that could have contained a much-needed convention hotel linking Javits to Times Square. Since Silverstein was a major political donor, this seemed like a quid pro quo for campaign contributions. The Dolans, owners of Madison Square Garden, ran amok during the short period that they were part of the Farley/Penn Station expansion plans, insisting for example that "Madison Square Garden" be depicted in large neon lights on the façade of the classic, landmarked Farley Building. They also directed a costly advertising campaign against the New York Sports and Convention Center (which they saw as competing with Madison Square Garden), a campaign that even some of NYSCC's opponents agreed was full of "lies and distortions." All this was facilitated by hiring state assembly speaker Sheldon Silver's former chief of staff as lobbyist, the kind of political lobbying/cronyism that we have identified as one factor undermining megaprojects.

Another instance of unbridled landlord/developer/market forces greed unfolded in the Gansevoort District. There by 2013 the nightclub, restaurant, and hotel owners, eager to squeeze all they could from the night scene, had created an evening cacophony, Thursdays to Sundays, lasting

well past 4:00 a.m., of music blaring from rooftop spaces that, combined with a mass of honking automobiles, is the despair of many residents of the neighborhood to the south.

Likewise allying himself with advocates of unbridled growth and greed, starchitect Thom Mayne recently extolled Chinese cities as the new paradigm. "I have no use for zoning. I am definitely not interested. New York City is looking smaller and smaller compared to China. There are 20 million people in Shanghai—we are a third tier city" ("Zoning the City Conference" 2011).

Interestingly, recent reassessments of Robert Moses are now arguing that an important cause of the excesses of his "slum clearance" program of the late 1940s through the 1960s was that, once each redevelopment plan had legislative approval, the sites were turned over for development to for-profit and not-for-profit companies which had huge financial incentives to get the sites cleared and demolition done as quickly as possible (Garvin 2013, 157–58).

BALANCED POSITIONS

By contrast with these extreme antigrowth or progrowth positions, several groups and individuals have conceptualized, albeit in various ways because there are many reasonable possible approaches, the appropriate aim of achieving a balance between growth and protection (of older buildings and poorer residents). Architects, for example, have a concept of the "layered city" that envisions and fosters a city with buildings from various historical periods along with a good dose of new buildings. In a creative attempt to update zoning practices along these lines Vishaan Chakrabarti has recently proposed zoning that allows *each block* to contain a range of building types, ages, and heights with a "cap and trade" air rights exchange system that would preserve views, natural air, and sunlight (Chakrabarti 2013, 149). This contrasts with standard zoning, where density is specified at the level of the district (not block), causing uniform concentrations of tall buildings that block each other's views. Another major approach to balancing growth and preservation is the "adaptive reuse" movement to repurpose older buildings for a modern world, a movement of which Rem Koolhaas is in the vanguard. This approach, understandably especially popular in Europe with its store of older buildings, resonates with today's ecological sensitiveness for working with, not destroying, limited resources.

By 2004 the Bloomberg administration saw its plan for the Far West Side as a reasonable balance of growth and preservation in the spirit of Jane Jacobs, as Amanda Burden, Department of City Planning head throughout the period analyzed here, maintained. We have argued that this

interpretation of Jacobs as favoring a mix of growth and preservation is accurate, despite those who would turn her into a fundamentalist preservationist who hated tall, modern buildings.[4]

This is one reason why we have considered the various Far West Side projects together in a single study. It is not possible to properly and fairly evaluate, let alone understand, these projects—growth, preservation, and in-between—without considering them together. The Bloomberg administration supported preservation projects like the High Line and Meatpacking District as well as megaprojects such as the Javits expansion and Moynihan Station, on the grounds that the entire package represented a reasonable balance. By contrast, the previous Giuliani administration was disinclined to do much landmarking to balance growth and preservation—for example, rejecting attempts to landmark the Gansevoort (meat market) District, and trying to dismantle the High Line.

In the context of Mayor de Blasio's election, it is worth recalling *New York Magazine* architecture critic Justin Davidson's excellent statement in 2008, just after the last growth cycle, of the pros and cons of preservation versus development and the difficulties of achieving an appropriate balance. He pointed out that in the past fifteen years of New York City's major growth, over 76,000 new buildings had gone up; more than 44,000 were torn down; and another 83,000 were radically renovated. As this process slowed with the developing recession, and before the next boom began, he argued, it was a good time to assess whether "this ferment has improved New York or eaten away at the city's soul."

> Some see this sustained spasm of building as an urban lobotomy, in which the city has sacrificed its eccentricities and variety to placid prosperity. I am more optimistic. . . . Think of the alternatives. In the last 25 years, the city's population has increased by a million people, and another million will be here 25 years from now. The question is not whether to make room for them but how. We could, in theory, rope off most of Manhattan to new development and push new arrivals to the city's fringes. Had we done that years ago, we would have created a museum of shabbiness. Even doing so now would keep the city in a state of embalmed picturesqueness and let the cost of scarce space climb to even loonier heights than it already has. In its 43-year existence, the Landmarks Preservation Commission has tucked more than 25,000 buildings under its protective wing, which seems about right. Protect every tenement, and eventually millionaires can no longer afford them.

Davidson took up the issue of gentrification, which, he correctly stressed, "is a stark word for a complicated phenomenon."

[Gentrification] does not describe only the relentless territorial expansion of the rich at the expense of everybody else: Gentrification eddies across the city, polishing formerly middle-class enclaves to an affluent shine, prettying up once-decrepit neighborhoods for new middle-class arrivals, and making awful slums habitable. In the intricate ecology of New York, each current triggers a dizzying series of countercurrents. Low crime rates make city life more desirable, so fewer middle-class families feel like they are being forced to flee to the suburbs. That causes real estate prices to climb, which forces out some of those same middle-class families. Rising housing costs in low-income areas require the poor to spend a growing slice of their income on rent but also make it financially feasible for developers to build affordable housing.

Davidson argued that "the way to deal with this tangle of paradoxes is not to rail against gentrification but to mitigate its impact on the poor through activism, governance, and good design."

New York has the country's largest municipal affordable-housing program, not just now but ever. . . . The needle-strewn South Bronx seemed beyond redemption until a collective of developers, nonprofits, and city agencies built Melrose Commons, a low-rise, low-income housing complex that is safe, durable, and appealing. That, too, is gentrification.

Do the dedicated yearners who would roll back this tide look fondly on the charred South Bronx of the eighties? . . . *That New York was not authentic or quaint; it was miserable and dangerous. Intelligent preservation is precious, but nostalgia is cheap, and every era nurtures its own variety.*

There are, for sure, a host of legitimate and important debates that will certainly continue, with several focusing on the now developing Hudson Yards, the country's largest real-estate development. Critics will say that the tax breaks granted to developers such as Related are excessively generous. Defenders will say that the public sector lacked the political will to devote resources to build a platform over the railyards there on which development could occur, and that a site otherwise incapable of generating revenue is now being turned into one paying rent to the cash-starved MTA. Critics will say that the city's use of tax revenues in the Hudson Yards to fund the number 7 subway extension (tax increment financing, or TIF) was another giveaway to private developers since the city, contrary to the original plan and starting in 2008, had to contribute public funds to make up for the tax revenue shortfall from private development. Defenders will say that the revenue shortfall is temporary; the city will be paid back eventually; and meanwhile the number 7 subway extension will open in 2014

just about nine years from the start of construction, ending the Far West Side's absence of subway service, an amazing achievement given the difficulty of building new subway lines in New York City. Critics will say that maintenance of the new Hudson Park and the burgeoning Meat Market area are being turned over to corporate-dominated Business Improvement Districts that will impose an uninspired uniformity on aesthetic issues such as the choice of flowers and trees, and are unlikely to resist business-driven excesses such as an out-of-control nightlife. Defenders will say these tendencies can be resisted and that meanwhile residents are getting needed services in ways that do not further drain an already strained city budget.

Overall, defenders of the Bloomberg administration's activist role, not just in the Hudson Yards but also in, for example, saving and promoting the High Line and attracting a new engineering campus to Roosevelt Island, will likely argue that this is in line with the role, often underestimated, of government as an engine of innovation and entrepreneurship, as detailed in Mazzucato's recent study (Mazzucato 2013).

Debates over affordable housing generally, and in the Hudson Yards in particular, will certainly continue, especially since the growing unaffordability of the city was a cornerstone of de Blasio's mayoral campaign. A recent, sensible assessment of the Bloomberg adminstration's citywide record here, authored by a group that advocates for affordable housing (National Housing Institute), argues that, on the one hand, the 2003 New Housing Marketplace Plan (NHMP) for affordable housing has been "an impressive achievement that took great strides towards creating affordable housing opportunities for residents . . . and will almost certainly meet its goal of developing, by 2014, 165,000 units of affordable housing for NYC" (Dulchin et al. 2013).

Dulchin's study also concludes, on the other hand, that "there remains lots to do." Its six main recommendations on what else should be done are all interesting, though some are not especially easy to implement. They include:

(1) Closing loopholes that allow 15,000 units of housing that are part of the city's extensive system of "regulated housing" (rent controlled or regulated) to exit the system each year because of "high-rent decontrol" (that is, apartments whose legally allowable rent rises above a certain level become no longer subject to control). Because of the state Urstadt Law, which denies New York City home rule over rent regulation, changing such loopholes requires Albany approval.

(2) Breaking the cycle whereby "affordable housing" is only so for a set period, usually thirty years (the length of the tax-exempt bonds granted a developer). The study argues that the next mayor should adopt "permanent

affordability" as a core principle guiding all publicly subsidized housing units. One suggestion here is to create a new property tax abatement, and then implement a mandatory extension of a project's affordability restrictions when the initial term expires, with the project receiving the property tax abatement in compensation.

(3) A suggestion that Bill de Blasio embraced in his 2014 housing plan (NYC 2014): a mandatory inclusionary zoning policy that requires a developer to make a substantial portion of residential development projects affordable for the neighborhood's longtime residents, if the developer builds anything there at all. This would replace the voluntary inclusionary zoning (Inclusionary Housing Program, IHP) that the Bloomberg administration adopted in 2005 for the Hudson Yards and elsewhere. Although the voluntary program created from 2005 to 2011 roughly 1,900 affordable units, this is less than 2 percent of the over 100,000 units developed under the Bloomberg rezonings and far less than the 10,000 affordable units the city was projecting from IHP.

(4) Target affordable housing development to stabilize communities. The New Housing Marketplace's weakness, the study argues, is not in the number of units created—the 165,000 unit goal—but rather that about two-thirds of NHMP units are actually too expensive for the majority of local neighborhood residents. The NHMP makes no distinction between the value of a unit that targets a family of four earning their lower household income target, $24,900 (30 percent of US HUD-determined area median income, or AMI), and a unit that targets a family of four earning their highest household income target, $136,950 (165 percent of HUD-determined AMI). These two NHMP apartments are equally applauded. As a result, of the 38,670 NHMP units developed between 2009 and 2011 only about a third were actually affordable to households making the median income or below for the typical household in their neighborhood.

This disparity is greatest in the city's lowest-income communities. The study acknowledges that it is not easy to build for very low income families in New York City. Operating and construction costs are high and make it hard to support a building consisting entirely of tenants paying very low rents. The proposed solution is to have buildings in higher-income neighborhoods support the operating costs of lower-income housing units. The suggestion is to allow AMI spreading of all city and state affordable housing programs that would enable developments to trade off building units at a slightly higher affordability level in exchange for building the same number of units with deeper affordability for very low income households which require greater subsidies. For example, instead of building sixteen units at 60 percent AMI, developers could be allowed to build eight units at 30 percent AMI and eight units at 90 percent AMI.

(5) Build a new affordable housing pipeline. The Koch housing plan and Bloomberg housing plan both created most of their units by rehabilitating city-owned buildings or building new development on land owned by the Department of Housing Preservation and Development (HPD). These are finite resources and the city is near the end of both. Under current zoning there are only about 7,500 units of housing that can be developed on HPD-owned land that is left. So the city should use non-HPD-controlled city-owned land. As of February 2012 the city still owned over 1,500 plots of vacant land controlled by various departments and agencies. Some are optimal sites for affordable housing development.

(6) Strengthen the NYC Housing Authority. The NYCHA, one of New York City's great affordable housing resources, has about 100,000 apartments located in 286 developments scattered around the city, providing housing for almost 500,000 New Yorkers. While 5 percent of New Yorkers live in NYCHA housing, they include 14 percent of the city's poor. Overall, the NYCHA is a great success, with a tenant waiting list that is 161,000 families long.

Still, the NYCHA is underfunded, starting with major cuts in Reagan's administration, and continuing today. For example, the US Department of Housing and Urban Development's operating subsidies to NYCHA were cut by 35 percent in 2001–2011, causing an annual operating deficit of $60 million. And there is a serious shortage of capital repair funds, especially since NYCHA housing stock is getting older and needs repair.

In 2013 the Bloomberg administration made a start, announcing that NYCHA would clear its backlog of repairs by end of year. The study also suggests the NYCHA budget could be helped by discontinuing the payments it makes to the city for policing and sanitation. Also, the NYCHA should take advantage of the income-generating potential of vacant NYCHA land by partnering with HPD to build additional city-subsidized housing.

Of these six recommendations, two are already in effect in the Hudson Yards affordable housing package, as a result of pressure from Community Board 4. First, regarding making affordable housing permanent under some circumstances, CB4 called for the subsidized rents, under the older 80/20 inclusionary housing program that offered developers tax-exempt bonds, to be permanently affordable, not just temporary until the bond came due, in cases where the developer also used the inclusionary zoning bonus. Second, regarding finding some city-owned, but non-HPD, sites that could be used for affordable housing, CB4 pushed the city to identify and turn over five city-owned sites—three in the 2005 rezoning, two in the later 2009 rezoning—where the city could build affordable housing for a broad income band from "low" to "middle."

In any case, it is clear that the task of providing more affordable housing, and the associated problem of rising inequality, is arduous and complicated. Part of the problem is New York City's openness to new immigrants and growing general attractiveness (Beveridge and Beveridge 2013; Gladstone and Fainstein 2013). De Blasio's comprehensive housing plan, released in May 2014, basically continued Bloomberg's efforts except for suggesting inclusionary housing be mandatory, not voluntary, in any future rezoning for residential (NYC 2014).

In the spirit of those arguing for a mixture of growth and preservation, each of the three main sections of this book has shown the complexities of urban development and change remaining after rejecting the two, simplistic, extremes—unfettered growth and fundamentalist preservationism. The rest of this chapter underlines some of these complexities.

CHELSEA'S ART GALLERY DISTRICT: MARKET COMPLEXITIES, AND TWO STORIES ABOUT CONTEMPORARY ART

Chelsea's art gallery district basically developed as a reflection of the free market, though the nonprofit Dia Art Foundation crucially paved the way in 1986 by providing an art-related beachhead (as two decades later did the New Museum, for Manhattan's Lower East Side) and as happens so often in cultural developments in the United States. The analysis of Chelsea's art district market is what this study has called the first story about Chelsea's gallery district and contemporary art.

This first story contains a host of unexpected complexities. What forced the commercial galleries out of SoHo in the mid-1990s and later was rising commercial rents, or commercial gentrification, as SoHo landlords found they could get higher rent from clothing stores than from most galleries. The galleries that came to Chelsea settled in an area zoned manufacturing where residence was illegal. Since no residents were pushed out, this was not residential gentrification.

As Chelsea's gallery district developed there in the mid-1990s and later, the market produced a three-tier gallery hierarchy. The most privileged tier is the galleries that purchased their spaces, mostly former garages. Pristine gallery walls replaced auto-related grime, for more commercial gentrification, with galleries as the gentrifiers. Mostly these are galleries that are considered stars in the art world. Owning their land and spaces protects them from a repeat of the SoHo debacle—namely landlords finding they can get more rent from other commercial sectors.

Next in the Chelsea hierarchy are galleries paying an often hefty rent on the ground floor of huge, former warehouse buildings. They are subject

to full market forces but at least have the benefit of a visible, ground-floor location.

Finally, the most numerous by far of Chelsea's gallery hierarchy are galleries paying rent on upper floors in chopped-up spaces in former warehouse buildings. Economic life in Chelsea for these upper-floor galleries became increasingly rough, not mainly because of greedy landlords, but for almost the opposite reason. Rents were so modest that almost anyone could start an upper-floor gallery (e.g., paying $1,500 a month in 2007 for 1,500 square feet). So galleries multiplied until there were not enough customers to go around willing to climb to an upper floor, in a limited audience in the first place. In short, upper-floor galleries collectively entered the textbook, economically suicidal state of a perfectly competitive market facilitated by low entry costs.[5]

For the audience and the artists, on the other hand, this three-tier market structure was mostly positive. For the audience, the proliferation of galleries, none of which charged admission, in contrast to New York's major museums, created a huge and continuous "free art show," whose works far exceeded, in variety and freshness, the Contemporary Art displayed in New York's museums. For the artists, Chelsea's commercial gallery concentration offered many opportunities to show their work, opportunities far more plentiful, both for young and established artists, than the city's museums could provide.

Still, the most important way in which the simple idea of an "all-powerful market" misses the complexity of Chelsea's commercial galleries and of Contemporary Art overall is that it overlooks the central meaning of the art for most of the audience, including collectors. That is what this study has called the second main story about Chelsea's galleries and Contemporary Art. Interviews suggest that, if the audience likes a work, it is typically because it resonates with their lives in one of a variety of central ways. These ways nowadays include evoking the landscape (beautiful or environmentally challenged), the decorative, the troubled family, sex, ordinary objects in everyday life, politics, and other topics. There are, of course, a mass of complexities and qualifications to stress here. Still, the interview findings are robust enough to undermine the idea that, for the audience and even for most collectors, the art's meaning is typically about money and the market (i.e., the first story). The latter view, absent careful interview data, is routinely proposed these days, as in *New York Times* art critic Roberta Smith's 2013 lament, triggered by soaring prices for art in the November auctions, that "art is hard to see through the clutter of dollar signs" (Smith 2013).

This study's finding, that collectors and noncollectors like artworks because the work resonates with their lives, should somewhat reassure

cultural observers who have long worried about the adverse effects of culture on the public. Some of these supposed adverse effects include fears that the public are being tranquillized, narcotized, or corrupted. While this may happen from time to time, the case of Chelsea suggests that for Contemporary Art there is little need for overall concern.

Chelsea's gallery district also underlines uncertainties facing sections of the art world which, like many Far West Side developments we analyzed, are in various states of dynamic change. Still, the uncertainties have not yet destabilized Chelsea's art gallery district. At this point the Lower East Side gallery district seems unlikely to replace Chelsea, just as Williamsburg's gallery district failed to replace Chelsea's in the early 2000s, and as the East Village in the 1980s failed to replace SoHo's. Partly this is because the LES lacks enough suitable spaces, and partly it is because two nonprofits, the High Line and the impending new Whitney Museum, have reinvigorated the Chelsea area as an art and cultural center.

Some of these art world uncertainties have to do with globalization, a term that needs defining so as to highlight what is distinctive about its current stage. We have argued here that the two main features of today's globalization, for the art world at least, are the Internet and China's rise to join the duo of the United States and Western Europe as dominant macroregional forces.[6] The Internet's reach is genuinely global, with the potential to bring seller (artist) and buyer together, 24/7, anywhere in the world, cutting out entirely the middleman role of galleries, as it has increasingly with bookstores for print works and record stores for music. Still, art is different, at least so far. The Internet does not allow most viewers to see art in sufficient detail to make an informed choice. They still usually need to see the work physically, in person, at least if it is by an artist whose work they do not know, as shown by the limited success of recent attempts such as Saatchi's or Artsy to sell art online via a megasite. In this sense, art's salient characteristic—the fact that the vast majority of works are unique (apart from limited editions)—has protected galleries. Still, efforts to sell art online will certainly continue.

Finally, the very category of "Contemporary Art" is potentially in flux, likely someday to falter and be replaced, though this may take a while, even decades. We have argued that the submersion of "styles" within Contemporary Art's eclectic inclusion of all the works produced by living artists (and, by slippage, works by artists fairly recently dead) has reflected two factors. First, the booming art market since the 1960s. In such a market, art sells relatively easily, and there is less need for artists, dealers, and critics to foreground a subcategory of the art being produced—that is, to promote or brand a new style. This analysis implies the prediction that should the art market enter a prolonged downturn (not just one of its

periodic recessions), then the eclectic category of Contemporary Art may lose its hold, with styles re-emerging to front stage in the art world. There are nowadays a host of developed styles out there, such as Street Art. Still, these styles so far remain under the umbrella of Contemporary Art and have not displaced it. That may partly be because of the second factor supporting the eclectic category of Contemporary Art, namely, the West's loss of a long-held belief that art is moving in a linear direction (like science), getting better and better, with the search for the latest art style reflecting this improvement. This decline of faith in the linear development of art may support for a long time Contemporary Art's eclecticism.

PRESERVATION PROJECTS: BOTTLING HISTORY, AND HOW FAR TO GO

The second main type of project analyzed in this book, preservation projects, focused on the High Line and Meatpacking District. These two high-profile projects illustrate above all the difficulty of bottling up history, of controlling and limiting it. For example, early advocates of the High Line project said that converting the disused elevated railroad to a public path would vividly recall, for the public, part of the city's history, while the High Line's wild plant life would constitute a "survival" metaphor of making it through the city's tough years (1960s–1980s). As it turned out, neither the wildlife nor its associated metaphor for endurance through hard times could survive the High Line's conversion to a park. The High Line actually evolved more complicatedly, as an agreeable elevated walk, offering at its various stages a variety of views—new condo buildings by the world's starchitects, the Hudson River and Midtown Manhattan, the dwindling number of old historic buildings around the High Line, plus the High Line's physical structure to recall the city's brief history of above-ground rail lines. This complexity, especially the appearance of new buildings, partly resulted from the Bloomberg administration's realization that to overcome an attempt to demolish the High Line by the powerful Chelsea Property Owners who owned the land under and adjoining the rail, the city needed to rezone much of the area to allow major condominium developments to which the Chelsea Property Owners could sell their air rights. This was the West Chelsea Rezoning of 2005.

This was not necessarily bad. The preserved High Line and associated rezoning stimulated some of the boldest new architecture in the city by a coterie of star architects. In doing so, it helped change New York's reputation, earned over the previous three decades, for mediocre architecture. Nor did the new condos around the High Line directly displace poor or working-class people in a classic residential gentrification process. They

were built on land that had previously been zoned for manufacturing, and so contained no residences.

Instead of a metaphor for enduring difficult times, the High Line has become a metaphor for creative planning. Robert Hammond and Joshua David are urban heroes, DCP director Amanda Burden received a planning award, and the project has become a huge tourist attraction, with cities around the world looking to copy it.

The High Line is still evolving after its second stage opened to rave reviews in June 2011. It has now positioned itself as a major cultural attraction, via a highly creative program of art installations and artistic events. Its third, and final stage is now tightly linked to the Related Company's megadevelopment on the Western and Eastern Rail Yards. Until around 2011 Related's chairman Stephen Ross viewed this section of the High Line as impeding development and favored tearing it down, but then realized that, on the contrary, the High Line's success had made it a huge booster of property values—being in a condo or office next to the High Line was a major attraction. The main mechanism for fending off a looming critique that the third section, and Related's now linked development, are just profit-oriented projects for the wealthy, is that they include a "public plaza" (whose design is being hashed out), the new Hudson Park, and the "Culture Shed." Inevitably tensions will continue, as in the ongoing (as of mid-2013) controversy over whether the name of the proposed Hudson Yards Business Improvement District (intended to mostly fund maintenance of the Hudson Park) is too corporate and should be extended to include the Hell's Kitchen–Clinton neighborhood.

The Gansevoort Historic District (Meatpacking District) developed in unexpected directions too. It was originally conceived as a way to preserve the threatened meatpackers and low-rise warehouse buildings from which they operated. The area was zoned as a manufacturing district, so there were few residents to displace. Further, advocates for turning the Gansevoort Market into a historic district successfully fought to retain the manufacturing zoning so as to keep out new residential condos (unlike how the High Line developed), believing that condo residents would try to get rid of the meatpackers on the grounds that the meat smelled bad and the operations created much early morning noise, the very qualities that, by contrast, advocates believed were an important part of the area's prized "grittiness."

Still, by 2009 the meatpackers had dwindled to a small group paying way below market-level rents, surviving only because the city wanted to keep a vestige of the industry whose retention (evoking industrial grittiness) was a major justification for landmarking the area in the first place. The area developed, instead, as a center for fashion stores and a nightclub

location whose boisterousness was unrestrained by a need to placate residents. (Underlining the difficulty of achieving a balance, by 2011 residents nearby but outside the Gansevoort Market District became increasingly agitated by the nighttime noise and traffic from clubgoers passing through.) This was commercial gentrification, as fashionable clothing stores and nightclubs replaced meatpackers and prostitutes. In 2008 the process displaced Florent Morellet, one of the two people who had pushed to landmark the Gansevoort Market, but whose landlady demanded a 700 percent rent increase on his diner, Restaurant Florent. Still, it is not clear that commercial gentrification should be stopped, and the New York City Council has always voted down attempts to impose any form of commercial rent controls.

Morellet himself by 2013 was extolling the Gansevoort Market's exuberant nightclub life as a "fantastic" job-creation engine for the city. "The core of cities should be for the rich—that is where we raise the taxes to fund the city. The super-rich want to have a 'pied-à-terre' in New York, and we charge them a lot of taxes for that." He personally did not now enjoy the area of Manhattan (11th Street and Lafayette) where he had lived since coming to New York in 1978. "It's packed with people. But do I have to like every neighborhood?" So, acting on his mantra that life was "all about change, and nostalgia is a terrible thing," he moved in late 2013 to an art neighborhood, Northern Bushwick in Brooklyn, whose youthful energy and warehouse buildings reminded him of the Gansevoort Market when he had first moved there decades ago. There he saw a large, developing ecological zone, all subway accessible, spreading south from Newtown Creek in Brooklyn and Queens and including East Williamsburg and Ridgewood as well as his new neighborhood. Stressing the decline of Manhattan-centricness and the new coolness of Brooklyn and Queens, he commented: "New York used to be a city on an island [Manhattan]. Now it's a city with the East River running through it." He immediately got involved in a program to teach farming to students at the local public school (author interview, October 4, 2013).

By 2010 the area just to the northeast of the Gansevoort Market had added a thriving, job-providing computer industry spearheaded by Apple and Google, basically a further stage of commercial gentrification (possibly "supercommercial" gentrification). Part of the attraction of this area for Google were the many cultural assets (art galleries, nightlife, High Line, Gansevoort Historic District, trendy architecture, a large gay neighborhood, and so on) which Richard Florida has argued constitute major draws for the "creative class" that powers a modern economy.

Few disputed that the city was well served by this growing high-tech sector. As Facebook moved into offices in Grand Central and a planned

high-tech engineering school on Roosevelt Island went ahead, the city administration's view that New York could develop into a rival to California's Silicon Valley gained plausibility.

On balance, all this seems a major improvement on the meat market of the 1970s and 1980s—outmoded meatpacking along with nighttime prostitution.

Overall, the High Line and Gansevoort Market suggest that in considering proposed historic "preservation" projects it may be realistic to accept from the start that what will emerge will be historically themed in various ways, but not preserved.[7]

Finally, these two projects show that one or two gifted individuals, here Josh David and Robert Hammond for the High Line, and Florent Morellet and Jo Hamilton for the Gansevoort Market, can make a difference. A successful public project usually needs "public entrepreneurs," individuals talented enough to devise original proposals, and with the persistence and political skills to then lead the project to approval and success (Garvin 2002).

MEGAPROJECTS

Finally, megaprojects. A thriving city needs to pull these off. There can, of course, be legitimate disagreement over the value of particular megaprojects, as in the case of the New York Sports and Convention Center. Still, at least two of the megaprojects discussed in this book were widely agreed to be very desirable, the Javits Convention Center expansion and the Moynihan Station conversion. Neither involved the displacement of any residents nor was opposed by the community boards, often seen as the traditional downfall of megaprojects. Each, as mentioned, was conceived in the post-1970s "do no harm" climate where megaprojects are, on the whole, expected to involve little or no residential displacement and to fully compensate for any displacement that does occur. This was a central attraction for the city of the Hudson Yards, especially building on railyards.

Yet Moynihan Station took twenty years just to start its first stage, in 2012, and ironically, as soon as that stage began, a vocal group of critics emerged to argue for an entirely new project, moving out Madison Square Garden and building a new Penn Station, which cannot happen in less than two decades, if it happens at all.

It should be stressed that not all these or nearby megaprojects failed or failed completely. Both Hudson Yards rezonings happened, and both were linked to providing much-needed affordable housing, especially via inclusionary zoning. Further, the number 7 subway extension to 11th Avenue

and West 34th Street is set to open in 2014, just about nine years after it began, an incredible achievement. Also, the High Line, which runs through the Hudson Yards, is arguably a megaproject success, and the Hudson River Park certainly is.

Still, this is a very mixed record. One way of understanding megaprojects that succeed, fully or partially, is to see how they managed to avoid the numerous blocking factors that usually doom megaprojects. The High Line, for example, came within a hair's breadth of running into three key obstacles—implacable private corporations (the Chelsea Property Owners), economic downturns, and political lobbying/cronyism with a former Giuliani high official as paid lobbyist for the Chelsea Property Owners aiming to persuade Giuliani to tear down the High Line.

The detailed case studies presented here suggest a multicausal view of what typically goes wrong. Megaprojects have been hard to pull off because many key things can become blocking factors, of which local/neighborhood opposition, though usually blamed, is just one. These main blocking factors include squabbles between various government agencies; mediocre and incompetent leadership; fighting between various politicians; the intervention of lobbyists and cronyism; the presence of a private corporation that is key to the project's success but willing to block it; changes in the economy associated with the real estate/construction cycle; sheer lack of funding; and an unrealistically ambitious project. Neighborhood/local opposition can be a blocking factor too, though typically only by gaining the support of one or more politicians with blocking powers. This is a long list of potential obstacles.

In this context, New York State's disastrously arbitrary approval process, conferring veto power on any one of three people with no legislative override, contrasts with the city's process, ULURP, which is reasonable and flexible, requiring a two-thirds majority of legislators to block a project of which the mayor approves.

Arguably, a new problem the city faced was the increasing distraction of the Port Authority, the natural body to steer some of these megaprojects through the minefield of possible blocking factors. On the one hand, the Port Authority after 2006 assumed management of the World Trade Center rebuilding which until then had been stymied by several of the standard blocking factors we have outlined. As a result, the WTC rebuilding is now on course. On the other hand, as Chris Ward, the Port Authority's executive director, commented in 2011:

> The Port Authority has spent $11b on downtown Manhattan since 9/11. But our general agenda and our ability to do other projects has suffered, and this will have a legacy lasting for another ten years. Returning the Port

Authority to its true infrastructure roots is an important goal. Our central mission is transportation infrastructure."[8]

Perhaps in the future, when the WTC rebuilding is less of a constraint so that appropriate new infrastructure projects can to be assigned to the Port Authority, New York might find it easier to pull off megaprojects. Still, New Jersey Governor Christie has been rapidly politicizing the authority, making numerous appointments based on patronage, not competency, which will undermine its effectiveness, as Jameson Doig, the PA's major historian, has warned (Boburg and Reitmeyer 2012). In short, the Port Authority itself is not immune to the factors making megaprojects hard to achieve.

New York's latest megaproject—how to protect against floods like Hurricane Sandy—will be an instructive case study of the ability to negotiate the obstacles to megaproject success that we have outlined. It took a disaster to get the process started, but even now this will be long and gradual with few guarantees. Meanwhile fixing Penn Station, which fails to meet National Fire Protection Association standards for safe, emergency exit, remains stalled, with some experts predicting a "multidecade process," which leaves far too much time for a disaster there too!

INEQUALITY OF WEALTH AND INCOME

Finally, these case studies are centrally relevant to the now raging debate over economic inequality (of income and wealth) in the Western world. The best contributors to this debate stress both the problems and their complexity, as does this study. Economist Thomas Piketty's widely discussed book *Capital in the Twenty-First Century* (2014) likewise implies complexity in evaluating the situation in New York City. The general problem Piketty stresses is that throughout much of world history until the nineteenth century, r, the rate of return on capital (defined as rent, interest, dividends, profits, etc.—that is, derived from the ownership of assets, independent of any labor), significantly exceeded g, the growth rate of the economy (income from labor, and output). He argues that in the twentieth century two world wars temporarily reduced the rate of return on capital, but that we are returning in the twenty-first century, especially in the United States and major Western European countries, to the historically normal, imbalanced distribution of income and wealth (though the extent of this return is uncertain, since good wealth data are hard to obtain).

Piketty's preferred solution, plan A, is that this return not happen, and in particular for the growth rate of the economy to be boosted, which was basically the Bloomberg administration's approach to policy in New York

City as exemplified in the case studies we have detailed in this book. Absent elevating growth, Piketty's plan B is a progressive tax structure, which arguably New York has more than any other major US city (Sweeting 2013), but which federal politics has weakened nationally. His plan C is a progressive, "global" tax on capital/wealth, with annual rates of up to 0.5 percent on fortunes under 1 million euros, and up to 10 percent for fortunes of several hundred million euros, which he argues would contain growing global wealth inequality. The tax has to be "global" (i.e., in every country), since otherwise the wealthy would move their assets to locations lacking the tax, and is therefore highly unlikely to happen. So these debates will inevitably continue.

NOTES

INTRODUCTION

1. Art Basel website, https://www.artbasel.com/en/Basel.
2. A 1996 study of the art market in St. Louis, Missouri, stressed New York's domi-
 nance of the national, and in many ways international, art market. "Although
 Los Angeles, Chicago, San Francisco, Sante Fe, and other centers have large
 demand areas also, New York is hegemonic on the national and even the in-
 ternational level, meaning that only elite-gallery exposure in New York creates
 art-historical significance" (Plattner 1996). Recently French art market expert
 Alain Quemin (2012) likewise noted the "central role" of New York City in world
 cities. "Artists migrate from all over the world to try and succeed in New York
 City. It is highly probable . . . that this will go on and even accelerate in the next
 decade, as the general tendency seems to be an increasing concentration of the
 process of artistic recognition through being a part of the American/New York
 City art scene."
3. The nineteenth-century French Academy of Fine Arts was the most prominent
 such government institution. For some of this history see White and White
 (1965) and Zollberg (2005).
4. Organized by Koolhaus and Shohei Shigematsu and titled "Cronocaos," it was
 first shown at the 2010 architecture biennale in Venice, then at the New Museum
 in New York in June 2011.
5. This combines definitions from two experts. For Bent Flyberg (Ehrenfeucht
 2004) a megaproject is "a very big project looked at in the context of where it is
 being planned or built." For Altshuler and Luberoff (2003, 2), megaprojects are
 "initiatives that are physical, very expensive, and public."
6. The Hudson River Park went far more smoothly than its predecessor, Westway,
 which was mired in controversy for years before being shot down (Halle 2004).
7. On misreading Jacobs see also Halle (2008). The process of turning Jane Jacobs
 into a conservative opponent of modern architecture who favored "village life"
 in city neighborhoods full of low, old buildings was underway in New York City
 long before her death. Still, its fruits were apparent in some of the main obitu-
 aries and retrospective discussions. For example, *New York Times* architecture
 critic Nicholas Ourousoff wrote (April 30, 2006) that her death should be an op-
 portunity to "move on" beyond her vision, which had now become dominant to
 the detriment of good urban planning. According to Ourousoff, Jacobs "argued

for a return to the small-scale city she found in Greenwich Village and the North End of Boston," and detested modern architecture.

Not everyone misrepresented Jacobs in this way. The official *New York Times* obituary, written by Douglas Martin, accurately summarized her overall prescription for cities as "ever more diversity, density and dynamism—in effect, to crowd people and activities together in a joyous urban jumble" (April 26, 2006). His extensive discussion of Jacobs's life said nothing about a preference for low-rise architecture or dislike of the modern. Likewise Robert Gratz (2010, 255) presents Jacobs accurately, as favoring "adaptations, ameliorations, and densifications."

8. Garvin was centrally involved in planning New York's bid for the 2012 Olympic Games, which foregrounded the idea of a Far West Side stadium, one of the megaprojects analyzed in chapter 6.

9. Geographer Neil Smith's 1982 definition was similar (although in later writings he expanded the use of term). He wrote in 1982: "By gentrification I mean the process by which working class residential neighborhoods are rehabilitated by middle class homebuyers, landlords and professional developers." See Glass 1964 and Smith 1982. For overviews of the gentrification literature see Lees 2008 and Smith 1986.

CHAPTER ONE

1. Unless noted otherwise, all quotations are from a series of interviews by the authors between 2000 and 2013.

2. Caves argues that artworks are typically "horizontally differentiated" by a host of factors (topic, color, size, medium) that make each of them distinct (the "infinite variety" property), but do not easily permit them to be ranked by merit (i.e., "vertical differentiation").

3. Lynne Sagalyn (2001) stresses that commercial development in Manhattan usually moves organically, parcel by parcel and block by block. See also Bagli (2008) and Brash (2011, 160).

4. For a discussion of Martel see Riding (2006). For studies of nonprofits in American culture see Anheier (2005).

5. For example, Garvin (2002, 4) writes: "Government agencies are not the only entities in the planning game. . . . Nonprofit organizations are responsible for many activities that have encouraged property owners to invest in neighborhood improvements. That is why the definition of planning refers to *public* (rather than to government) action that generates a sustained and widespread private market reaction."

6. Already an LA dealer, Gagosian had bought a fifth-floor loft in the SoHo art district for $10,000 before 1985, but the failed Chelsea operation was what he called his "first real gallery in New York."

7. Caves (2000, 31), using such cases as SoHo and the East Village, discusses the cycles whereby art galleries become priced out of their neighborhoods.

8. The innovations studied range from health practices to agricultural breakthroughs.

9. Another factor keeping rents lower in Chelsea was that, while SoHo was near several major subway lines, Chelsea was not. Still, some of the relocated gallery owners in Chelsea saw this as a benefit, rather than a problem. "Being away from the subways means the area is not conducive to retail," Barbara Gladstone said. "That way, the neighborhood will keep its character." See also Holusha (1997).

10. The Buildings Department inspector was transferred, for overzealousness, to Staten Island. However, Mayor Bloomberg then appointed the first-ever lawyer to head the Buildings Department, who then also started systematically to enforce the artist residence requirement, to the consternation of long-time residents, some of whom are currently moving to get the requirement officially changed.

11. For a critique of this type of "authenticity" as a mishmash of old and new, see Zukin (2010).

Two classic studies of SoHo appeared in the early 1980s. Both celebrated its growth as an art neighborhood, but predicted that its days were numbered as an inexpensive site for artists to live and work and a refuge from the cut-throat commercial sectors of Manhattan. Zukin's (1982) pioneering study of loft living in SoHo was an early account of urban gentrification, for she situated the SoHo loft movement in that context. *Gentrification* she defined as typically occurring when "a higher class of people moves into a neighborhood, makes improvements to property that cause market prices and tax assessments to rise, and so drives out the previous, lower-class residents." Zukin wanted to counter the claim of the real estate industry, city officials, and the *New York Times* that loft living had social and economic benefits for all those involved. She pointed out that the process associated with loft living, first, the raising of rents, displaced the existing owners of small manufacturing businesses, who were often lower-middle class, and it also displaced their employees. Later, as rents and apartment prices continued to climb, the process devoured many of its early practitioners, who, in SoHo's case, were the artists.

The case of SoHo includes several types of changes that should be distinguished, not lumped together as undifferentiated "gentrification": first, the movement of commercial (galleries and artists selling their work) and residential users into a former manufacturing area, perhaps displacing small manufacturers; second, and later, "commercial gentrification," where one set of commercial users (clothing stores) displaces another (galleries). Note that classic gentrification, where middle-class residential users displace working-class and poor residential users, did not occur at first, but there was surely some of this later as, for example, artists who paid rent were replaced by wealthier newcomers.

The other study, on artists in SoHo, by Charles Simpson (1981), commented that commercial success was now paramount in SoHo, and art there had become unabashedly an entrepreneurial field. Art, including avant-garde art, was finding a growing market among the culturally sophisticated middle class, who were now choosing to leave the suburbs and live in the city, some purchasing SoHo lofts, for the variety of attractions it offered. Simpson stressed that

housing in SoHo was likely to become too expensive for the remaining industrial operators and for most artists just starting their careers.

12. The last group of artists to successfully ride the East Village media wave were those associated with the gallery International with Monument, especially Jeff Koons, Peter Halley, Ashley Bickerton, and the gallery's co-owner Meyer Vaisman. Important too in the neighborhood's eventual demise as a gallery district was the devastating role played by AIDS. For this period, see Taylor (2006) and Haden-Guest (1996).

13. One reason the decline in art prices was so precipitous was the withdrawal of Japanese buyers, hit by general economic problems compounded by damaging revelations that much art-buying in Japan had been undertaken to evade tax on real estate profits. See Stallabrass (2004, 23).

14. The building's fate was partly settled in 1999 when a developer bought three of the five floors, and its final demise as an art gallery space was settled by 2001 after the developer purchased air rights from the buildings next door to add penthouses and convert the building to condos. Ileana Sonnabend's third-floor gallery space became a condo for her family, and the ground floor was occupied by DKNY retail store. The building's demise merited an article in the New York Times' (2001) real estate section, which explained that with retailers willing to pay rents far higher than galleries can afford, most art dealers have been driven out of the neighborhood, many relocating to West Chelsea. SoHo retail rents on the first floor ranged from $230 to $300 a square foot; the condo penthouses were priced at $2 million to $5 million.

15. In 1998, Helmsley-Spear sold Starrett-Lehigh for $152 million to 601 West Associates, a group of investors who gutted and redesigned the interior. (Because it is landmarked, the building's exterior was off-limits.)

16. Wall Street Journal 2008, A8. A "small business" is defined as fewer than 500 employees. The data are from the Small Business Association.

17. See also DiMaggio (1987); Collins (1979, 58–60).

18. Michael Mann (2004) usefully distinguished six geographical/spatial interaction networks, five of which are less than "global." These are local (any subnational network of interaction), national (networks bounded by states, though not necessarily organized by states), international (between national units), macroregional (transnational but regionally bounded), transnational (transcending the boundaries of the national and potentially global) and global (the extension and intensification of social relations over the globe).

19. On the Internet and art in general see Stallabrass (2003). Earlier discussions of the Internet in general, not just in the art world, debated how far it would replace, or complement and enhance, face-to-face interactions. For example, Collins wrote: "The hypothesis of IR theory is that face-to-face communications will not disappear in the future; nor will people have a great desire to substitute electronic communication for bodily presence" (Collins [1987] 2004, 63).

20. The math and projections were not precise. For example, if each of seventy thousand artists on the site sold $3,900 a year, the total annual sales would be $273 million. Still, only 41 percent of the artists had said what their sales were; likely many of the rest had sold far less.

The text account is partly based on an interview with Bruce Livingstone, who runs the Saatchi Online website from LA's Chinatown.

21. Caves (2000, 334ff.) laid out the economic basis for the concentration of the auction industry, which is consistent with the recent emergence of important Chinese auction houses:

> Auction houses are among the few natural monopolies in creative industries. A basic proposition of economics holds that market participants as a group benefit from doing all their trading in one unified marketplace. . . . Auctions benefit by consolidating, so that buyers and sellers can contemplate many choices at one time. Art auction houses also gain scale economies in performing specialized tasks, such as appraising and valuing classes of art objects. Auctioneers face many problems of credibly maintaining fair dealing; while these might be solved in various ways, one possibility is to be a monopolistic market-maker (perhaps among a small number of firms) offering his or her reputation as collateral insuring continued scrupulous behavior.
>
> An auctioneer's natural monopoly does face a spatial limit; most people will not travel far to bid on a cookie. . . . The natural market structure for auctioneers hence tends to be worldwide for highly valuable and well-known objects, and more localized for lesser objects that slide into the categories of the decorative arts and household goods. The principal art auction houses clearly fit this pattern, with Christie's and Sotheby's sharing a world duopoly of high-value works that attract far-flung interest, while a few other houses handle important art of particular national markets and a large number conduct auctions of lower-value decorative objects. . . . It is thus expected that leading auction houses should tend to operate worldwide, conducting individual sales at focal sites.
>
> The same logic has not yet led the commercial gallery industry to consolidate into a few powerhouses, probably above all because a gallery needs to give each of the artists on its roster a show at least every two years.

22. A separate issue is online auctions. Like galleries faced with online sites selling art, the auction industry faces challenges from online auction sites such as Artnet and eBay. Christie's and Sotheby's now hold online auctions too. Still, art sold in online auctions rarely fetches over $100,000.

23. Velthuis argues (e.g., talk at the 2010 Armory fair) that galleries lack an effective business model and are hampered in competition with the auction houses because they are motivated not just by profit, but also by passion for the artworks and philanthropic goals of promoting art and artists that they believe in even if the work does not necessarily sell well.

24. For histories of auction houses see Hermann (1980), Faith (1985), and Herbert (1990).

25. A second, less radical intrusion than selling brand-new work has been the push by auction houses to sell works that have not been owned for very long. Such work was previously considered the sole domain of the galleries, to be resold only by them. As art analyst Marc Spiegler wrote, "The window in which work is considered 'too new' to sell at auction has grown increasingly narrow. In the

midnineties, works less than a decade old were still considered too untested by the market to bring into auction." In February 2006 Christie's sold $16.8 million dollars of Geneva gallery owner Pierre Huber's private collection, including over twelve pieces that dated back no more recently than 2003, and two produced in 2005. Chelsea star gallery owner David Zwirner was among many outraged gallery owners, accusing Huber of having lied about the age of the works.

26. For other major discussions of markets and globalization see Moulin (1967), Heilbrun and Gray (2001, 146), Sassen (2013).

27. For these reasons academic discussions of Contemporary Art that try to define it by intrinsic characteristics, as in a style, always end in confusion. A recent discussion of Chinese Contemporary Art sensibly rebukes those who would define it as, for instance, stylistically "modern," insisting that "'contemporaneity' cannot be ceded to any particular or exclusive 'brand' of Chinese art or theoretical approach.... All of those who participate in the contemporary production of Chinese art have a significant place...." (Silbergeld et al. 2010). An important recent edited collection that stresses the decline of styles under Contemporary Art begins by asking: "What is contemporary art? ... The question of where artistic movements have gone seems embedded in this question, if only because 'the contemporary' has become a single, hegemonic '-ism' that absorbs all proposals for others" (Aranda, Wood, and Vidokle 2010, 5–10). Still, some of the authors waver between accepting the comprehensiveness of the term "Contemporary Art" and pushing to treat it as though it were a style with extrinsic, definable characteristics. Again the problem here is that any stylistic definition ends up excluding some well-known living artists whose work is routinely considered to be Contemporary Art in the art world. For additional valuable discussions of Contemporary Art see Mainardi (2011), Siegel (2011), Agamben (2009), Smith (2009), and Kuspit (2005).

28. Likewise consumer spending on the live performing arts—opera, dance, theater, music—in the US rose from the 1960s to historic highs in the 1990s (Heilbrun and Gray 2001).

29. *Archives of American Art*, 1972, cited in Crane (1987). After World War II much of the action over styles switched to New York, with the rise of Abstract Expressionism in the 1940s, marking New York City as the acknowledged center of avant-garde art. This ushered in the heyday of New York's period of styles of the 1960s to the 1980s. There was Pop Art and Minimalism in the sixties, Figurative Painting, Photorealism, Conceptualism, and Pattern Painting in the early seventies, and Neo-Expressionism and Neo-Geo in the early eighties, followed in that decade by Postmodernism (Crane 1987).

30. On the history of YBA, see Nuir (2009). On the show *Sensation* at the Brooklyn Museum of Art, see Halle (2001) and Rothfield (2001).

31. Street Art as a style usually has at least two of the following extrinsic features: (1) The medium. The works are added to outdoor, typically urban, structures (buildings, trains, benches). Often the artist's act of placing art on such sites is illegal. (2) The content. Marginal, nonmainstream figures and scenes are often depicted, especially with a threatening edge to them. (3) Appearance. The look of the art is typically cartoonish.

32. On the use of "Contemporary Art" in the late 1920s, see Fry ([1909] 1924), (1926), and (1939).

33. Vera Zolberg (2005) has drawn attention to, and called for explanations of, the blurring of classificatory boundaries and hierarchies in fine art, as well as the arts generally in recent decades. Our explanation of Contemporary Art's eclecticism is applicable in principle to most of the other arts.

CHAPTER TWO

1. Unless noted otherwise, all quotations are from a series of interviews by the authors between 2000 and 2013.

2. Atlas (2012) is here discussing Harvard philosopher Michael Sandel's book *What Money Can't Buy: The Moral Limits of Markets* ([1998] 2012), which complains about how we have these days monetized many goods and services that were once free, though actually Sandel does not, unlike Atlas, argue that art is now primarily about investment.

3. For the plausible argument that this is true of culture more broadly see Jacobs and Hanrahan (2005).

4. Our approach here is in line with those who have called for, and undertaken, empirically based studies of the role of the market in the art world. Early theorists who called for the open-minded, empirical study of art markets include Moulin (1967) and Jameson (1983), who considered the market to be "the most crucial terrain of ideological struggle in our time" and called for examining the market not just as an ideological or rhetorical trope but as a "real market just as much as about metaphysics, psychology, advertising, culture, representations, and libidinal apparatuses." An evenhanded study of the rise of the commercial art market is Getty Research Institute (2004). A study of how the art world sets prices is Velthuis (2005).

5. Attendance at upper-floor galleries was typically so sparse—often they were mostly empty with just one or two people arriving from time to time—that obtaining a decent sample would have been difficult.

6. Explaining the emergence of environmental art in the late sixties, Gardner notes: "This was a time of increased concern for the American environment leading to the passage of the National Environmental Policy Act in 1969 and the creation of the federal Environmental Protection Agency. . . . The associated ecology movement of the 1960s and 1970s aimed to combat escalating pollution, depletion of natural resources, and the dangers of toxic waste as well as issues of 'public aesthetics' such as litter, urban sprawl, and compromised scenic areas. . . . Environmental artists used their art to call attention to the landscape and, in so doing, were part of this national dialogue" (Kleiner 2009).

7. In the first half of the twentieth century, Surrealist Salvador Dali painted devastated landscapes, such as his famous 1934 *Persistence of Memory*. But here dead trees, desolate landscapes, and sharp cliffs reflect the individual's tortured mind, not the artist's concerns about a degrading environment.

8. Further, some artists who produced these works were energetically trying to rectify the threat to nature. For example, Ansel Adams, who spent most of his

career during the twentieth century photographing the dramatic landscapes of the American West, by 1917 was a custodian for the Sierra Club in Yosemite National Park, whose agenda was conservation.

9. Likewise her Turner Prize entry *My Bed* depicted her bed as chaotic and filthy, as it had been after she stayed in it for several days, suicidal because of a failing relationship.

10. Another example from the past is Goya's *Saturn Devouring One of His Children*, 1819–1823. But Goya's painting is usually seen as atypical—a result of depression over his own declining health in his later life, and the topic is in any case mythological.

11. The photo of Richie Ferguson with a gun became iconic. See Edwards (2010).

12. In *Levittowners* (1982) Herbert Gans discusses one group of upwardly mobile New Jersey residents trying to learn how to be "middle class" in their occupationally mixed suburb.

13. Even the few examples of Contemporary artists who seem to depict the family positively are not clear-cut. For example, Tim Gardner, a Canadian artist (not in our sample), presents early photographs of himself and his family apparently in a positive mode (e.g., *Untitled Family Portrait*, 2005). Still, the press release, certainly approved by the artist, injects a dubious note, saying that Gardner's pastels "copy old posed portrait photographs of himself and his family. . . . The true miracle of his art is its revelation of middle-class inner lives, in precise ratios of innocence and dread. How does anyone survive?"

14. For studies of the modern family and its challenges see Chodorow (1978), Ehrenreich (1983), Epstein et al. (1999), Gerstel and Sarkisian (2006), Hertz (2006), Jacobs and Gerson (2004), and Stacey (1996).

15. Adam and Eve are the obvious first excuses for illustrating male and female nudes in art. The classic history of the nude is Clark (1959). Clark distinguishes between "the nude" and "nakedness," with the nude being the ways of depicting the naked body that have been and are artistically acceptable, while the naked is whatever is not considered at the time as acceptable.

16. Rogers writes: "The size of an organization has consistently been found to be positively related to its innovativeness. . . . This finding might seem surprising given that the conventional business wisdom is that smaller companies can be more flexible in their operations and freer of stifling bureaucracy. Still the size-to-innovativeness relationship holds across a number of investigations. . . . Why? Probably size is a surrogate measure of several dimensions that lead to innovation: total resources, slack resources (defined as the degree to which an organization has more resources than those required for its ongoing operations), employee's technical expertise, organizational structure."

17. The photographer artist Sante D'Orazio exhibits such "soft porn" nudes in Chelsea galleries.

18. Several studies have shown that conflict between different local groups is a key factor in producing disputes over artistic and cultural expression. See Beisel (1990), Dubin (1995), Gusfield (1986), and Tepper (2011). Still, these disputes don't typically become major unless a politician takes them up. See next note.

19. Paul DiMaggio and colleagues (1999) found that cultural conflict in Philadelphia between 1965 and 2001 was strongly linked to politicians using art to mobilize

voters. Likewise Larry Rothfield's (2001) essays on the controversial 1999 *Sensation* exhibition at the Brooklyn Museum showed that Mayor Giuliani's attempt to appeal to Catholic voters in the city was a crucial motive for his attack on the show.

20. In 1990 Orlan started a work titled *The Reincarnation of Saint-Orlan*, involving a series of plastic surgeries on her face. Her stated goal was to acquire the ideal of beauty as suggested by the men who painted women. So during surgery she would acquire the chin of Botticelli's Venus, the forehead of da Vinci's Mona Lisa, etc. The process was filmed and broadcast in art institutions throughout the world.

21. Another example is the hidden rooms in ancient Pompeii that contained depictions of mortals engaged in sexual intercourse with mythological figures. Art historians call them the "secret rooms." They were also apparently linked to mystical religious cults—the rites of the Greek god Dionysus (Roman Bacchus).

 The sixteenth-century engravings (*I modi*) by Giulio Romano illustrated sexual intercourse in various positions. The artist said they visualized descriptions in sonnets by Pietro Aretino. They caused a scandal at the time.

 In the early twentieth century Egon Schiele's *Men and Women Lovers* (1914), showing a couple almost positioned for sex, caused a predictable scandal in Vienna at the time. For the image see http://www.wikipaintings.org/en/egon -schiele/lovers-man-and-woman-1914. Picasso's 1907 *Les demoiselles d'Avignon* famously portrayed prostitutes and was very controversial at the time, but the women are not having sex.

22. Interviews with the audience for the show *Sensation* at the time revealed that although almost no one disapproved of the work that Mayor Giuliani had attacked (the Virgin Mary with elephant dung as breasts), there was considerable disapproval of a group of works by the Chapman brothers that showed children with disfigured sex organs. Several of the audience thought these were child pornography (Halle 2001).

23. For example, Julian Stallabrass (2004) writes: "As commodities have become more cultural, art has become further commodified, as its market has expanded and it has become increasingly integrated into the general run of capitalist activity." "The danger," he warns, is "the total identification with the commodity itself." There are of course many writers who have approached Pop Art differently, for example, stressing its focus on everyday things and domestic interiors, which fits with the interviews presented in this chapter. See, for example, Siegel (2011, chap. 4).

24. Oldenburg's *Store* was partially reconstructed in the show *Shopping*, at the Schirn Kunsthalle, Frankfurt, October-December 1, 2002, and then at Tate Liverpool, December 20-March 23, 2003.

25. Sarah Thornton (2008, 34) quotes art consultant Philippe Ségalot explaining: "To collect contemporary art is to buy a ticket into a club of passionate people who meet in extraordinary places, look at art together, and go to parties. It is extremely appealing." For additional economic studies of the returns to art see Baumol (1986) and the references cited there.

26. These included F. R. Leavis and the "mass culture" school as early as the 1920s and 1930s (Leavis and Thompson 1937; Rosenberg and White 1957); the (Marxist) Frankfurt School, such as Horkheimer and Adorno (1944) in the 1930s and later;

the formalist art critic Clement Greenberg (1939), who believed that the market system encouraged mass-produced products of low aesthetic quality ("kitsch") that were largely passively absorbed by an uncritical audience; and Western and Central European intellectuals such as Baudrillard (2004), Jameson (1979), and Václav Havel (1979) in the 1970s, as they contemplated the penetration of their societies by Western capitalist culture. Havel writes that in "the traditional parliamentary democracies . . . people are manipulated in ways that are infinitely more subtle and refined than the brutal methods used in the post-totalitarian societies . . . [for example by] the omnipresent dictatorship of consumption, production, advertising, commerce, consumer culture, and all that flood of information."

27. For some critics of this tradition see Bauer and Bauer (1960), Gans (1974), Frith (1981), Miller (1987), Halle (1993), and Velthuis (2005). For an argument that some of the most publicly successful artists are actually sustained by new forms and styles created by artists outside the mainstream, see Sholette (2011).

CHAPTER THREE

1. Unless noted otherwise, all quotations are from a series of interviews by the authors between 2000 and 2013.

2. For much of this history, see the High Line's website: http://www.thehighline .org/.

3. The Promenade Plantée crosses the entire 12th Arrondissement over auto traffic and occupies the rail line that goes from Varenne to Saint-Maur, running over Avenue Daumesnil just north of Gare de Lyon. It was conceived as a park by Philippe Mathieux and Jacques Vergely.

4. Talk at the AIA, April 21, 2003.

5. In a 2004 speech Burden said: "My relationships with William 'Holly' Whyte are at the core of everything that I believe in and that we're doing. Even though we are planning at a very broad level down, everything really comes down to how it affects the vibrancy and street life of communities. Last but not least, I believe . . . that good design is economic development" (Brash 2011).

6. Testimony, Hearing on the New York Sports and Convention Center, Economic Development Committee, New York City Council, New York, June 3, 2004 (Brash 2011, 201–2).

7. Brash (2011, introduction and chap. 8).

8. Brash (2011, intro., chap. 1, and conclusion). Brash also argues, plausibly, that Bloomberg and Doctoroff's approach reflects "neoliberalism's" attempt to grasp political power on behalf of its agenda and reflects in particular the interests and goals of two groups, first the Transnational Capitalist Class (TCC), defined as including those who own and directly control transnational capital, and, second, the Professional and Managerial Class (PMC). Despite this insightful and balanced account, Brash does not favor the growth and development parts of Bloomberg's approach. For our disagreement with this part of Brash's view see the concluding chapter of this book.

9. Winters, director of NYC Office of Capital Project Developments, reported to Doctoroff.

10. The most lucrative sites for development were the C6-4, which allow commercial and residential uses built to a floor area ratio of 10.0. For an explanation of floor area ratio (FAR) see the note at figure 1.4.

11. The Far West Side's reputation for innovative condo design began much earlier, in 2002, when condos designed by starchitect Richard Meier appeared on Perry Street, with Hudson River views. Meier's condos were widely credited with starting the glass-walled apartment craze in New York City. These Meier condos had also raised the wrath of the fundamentalist wing of the preservation movement, who objected to their Modernist appearance. (They had not displaced any residents, being built on land that had contained parking lots and sex shops.)

12. See also Wilson (2005).

13. The new purchaser was Chicago-based Equity Residential; the seller was Shaya Boymelgreen.

14. Under the museum model, the city appoints just one board member, even though the land or institution is publicly owned. By contrast, under the parks model the Conservancy's sixty-member board of trustees includes the parks commissioner, the borough president of Manhattan, and five trustees appointed by the mayor, with most of the rest being private-sector members representing the city's business and philanthropic communities.

 The Central Park Conservancy, founded in 1980, has since 1998 managed Central Park under a contract from the City of New York. Under the current eight-year agreement, which dates from April 2006, the Conservancy provides for the park's day-to-day care and maintenance, public programming, and capital restoration. In exchange for providing these services, the Conservancy receives from the city an annual fee whose amount is determined by a formula that requires the Conservancy to raise and spend in the park a specified minimum annual amount (currently $5 million) of private funds. The annual fee from the city depends on the Conservancy's expenditures in the park and on the revenues generated by concessions in Central Park which go into the City of New York's general fund. The city retains control and policy responsibility for Central Park.

15. Penn Central filed an $8 million lawsuit against the City of New York, essentially challenging the validity of the city's landmarks law. Penn Central wanted to replace Grand Central Terminal with an office tower. The Penn Central lawsuit went all the way to the United States Supreme Court, which on June 26, 1978, upheld New York's landmark law in a decision written by justice William J. Brennan for a six-to-three majority.

 The terminal's owners argued that the financial burden of "any restriction imposed on individual landmarks" should be borne by the taxpayers rather than the owner. They said that they were being prevented, without compensation, from making the most financially advantageous use of their property. (The idea that owners should at least get some compensation if their buildings were landmarked was in the original landmarks legislation, even if it was more moderate than Penn Central's claim that they should receive full, market-value compensation.)

 The dissenting justices believed that the Constitution did require the government to compensate owners, on behalf of all the citizens who would

theoretically benefit from the preservation. "If the cost of preserving Grand Central Terminal were spread evenly across the entire population of the City of New York," associate justice William Rehnquist wrote for the minority, "the burden per person would be in cents per year," a minor cost that the city "would surely concede for the benefit accrued." Instead, the city "would impose the entire cost of several million dollars per year on Penn Central—but it is precisely this sort of discrimination that the Fifth Amendment prohibits." (Joining in the dissent were chief justice Warren Burger and John Paul Stevens.) In affirming the majority, Brennan said: "It is, of course, true that the Landmarks Law has a more severe impact on some landowners than on others, but that, in itself, does not mean that the law effects a 'taking.' Legislation to promote the general welfare commonly burdens some more than others." For further discussion of compensating issues in New York see Tung (2001). He opposes compensation on the grounds that landmarking is not, from this point of view, different from zoning, which also imposes limits on owners.

CHAPTER FOUR

1. Unless noted otherwise, all quotations are from a series of interviews by the authors between 2000 and 2013.
2. In 2011 the Jehovah's Witnesses (the nonprofit Watchtower Bible and Tract Society of New York) owned thirty-four properties in Brooklyn Heights and Dumbo and were the largest landlord in Brooklyn Heights (Fung 2011).
3. The developer did not yet give up. He said that instead he planned to build a hotel, allowed in a district zoned manufacturing. The "hotel" rooms then turned out to include 49 percent condominiums! So the preservationists continued, and eventually won, the fight to keep out residents as the city overruled its Buildings Department, which had accepted the Jean Nouvel hybrid hotel/condo.
4. Letter to Tierney (October 8, 2003).
5. The distinction between the liberal/moderate and fundamentalist preservationists was stressed at a 2005 symposium, "40 Years of Landmarks Preservation in New York," held at the New School university (April 19). For example, Paul Goldberger argued that New York City's original landmarks law was liberal, but an increasing cadre of fundamentalists had appeared. Otis Pratt Pearsall, who had played a key role in making Brooklyn Heights the first district landmarked by the commission, argued at the symposium that the original commission had thought that if you had the opportunity to build a new building in a historic district then you should.

 In the Landmarks Commission's early days, the dominant philosophy was that new buildings should be welcome in historic districts. If you had the opportunity to build a new building in a historic district, it was felt then you should, because these districts had all kept developing in the past. Even in a historic district you ought not to be building a "background building" [an ordinary building that drew little attention]. You should be trying to express today's architecture as best you can in its final form. That is a concept that was rooted in the commission's philosophy, but somewhere along the line the commission

went astray. Historic preservation has gained some acceptance among developers because landmark designations can push up property values and rents, though as the Meilmans argued, if zoning allows a much larger building, then the landlord can still probably make more money by replacing it.

6. The Whitney had to overcome the doubts of one of its wealthiest trustees, Leonard Lauder, who was concerned it could not afford to operate in two locations.

7. See, for example, Andersson (2011). Florida, in turn, has argued that some of the criticisms misrepresent his approach and views.

8. In separate speeches, Mayor Bloomberg and Seth Pinsky, president, NYC Economic Development Corporation, at "Ten Years after 9/11: Rebirth of a City," The Future of New York City 2011 Conference organized by *Crain's*, July 19, 2011.

9. Partly this transition replicated similar cycles in many red-light/market districts in other cities. By mid-2008 Amsterdam's infamous red-light district was in the midst of a city-funded plan that called for the sale of broad swathes of the area to developers. Likewise for the gritty area of Hamburg known as Reeperbahn, the red-light district in Madrid, and Hong Kong's Wan Chai neighborhood. As a land use attorney specializing in conversions of adult entertainment zones commented. "Particularly in older cities in Europe and Asia, [the red-light district] is where you often find many historic buildings and architectural landmarks, and that's a very attractive selling point to builders and investors" (McMullen 2008).

CHAPTER FIVE

1. For an account of much of that history, see Brash (2011, chap. 6). For the city's 2004 Hudson Yards vision, see "Hudson Yards Overview," New York City Department of City Planning, http://www.nyc.gov/html/dcp/html/hyards/hymain .shtml.

2. Robert Moses is currently undergoing a major re-evaluation triggered especially by Ballon and Jackson's study (2008). The re-evaluation involves crediting Moses for some major achievements, though not forgetting the bad, which Robert Caro's 1974 biography *The Power Broker* so devastatingly laid out. For example, Jackson argues that Moses's achievements laid the basis for New York's resurgence since the 1970s. He writes that "had the city not undertaken a massive program of public works between 1924 and 1970, had it not built an arterial highway system, and had it not relocated 200,000 people from old-law tenements to new public housing projects, New York would not have been able to claim in the 1990s that it was the capital of the twentieth century" (Ballon and Jackson 2007, 68). Likewise, New York's parks commissioner Adrian Benepe concluded recently that in the domain of parks creation Moses's legacy is almost entirely positive, even while in some other areas, such as the destruction of neighborhoods associated with the Cross Bronx Expressway, it was a catastrophe.

3. Garvin's six ingredients include market (a specific population's desire and ability to pay for something); a suitable location and design (an appropriate layout); financing; entrepreneurship (talented public and private leaders); and

time (correctly judged in term of daily usages and the long run, including busi-
ness cycles). Many of the blocking factors we have identified are also, reason-
ably enough, exemplified in detailed case studies of specific megaprojects, as
in Lynne Sagalyn's (2001) magisterial account of the decades that the Times
Square redevelopment took.

4. For more on the history and role of the Port Authority in creating megaprojects
 see Conclusion, note viii.

5. This account is partly based on interviews with Robert Boyle, head of the Javits
 Operating Corporation; HOK architect Kenneth Drucker; and George Little of
 George Little Management, which puts on Javits convention shows.

6. Staff study prepared for senate Democratic leader Manfred Ohrenstein, "The
 New York City Convention Center: Project Status and Recommendations" (June
 1933). See also William Stern, report to governor Mario Cuomo, "New York City
 Convention Center: Status Report and Recommendations" (July 1983). Both re-
 ports were initiated to investigate massive cost, design, and management prob-
 lems that the center ran into during construction.

7. Minutes of Public Hearing, New York State Assembly Committee on Corpo-
 rations, Authorities and Commissions, December 14, 2005.

CHAPTER SIX

1. This interpretation is supported by Julian Brash (2011).

2. For another reasonable view, namely that megaprojects such as urban stadiums
 are far riskier propositions when used to revitalize cities whose populations are
 shrinking rather than expanding, such as New York, see Beauregard (2010). For
 studies that, unlike Baim's cited above, are highly critical of stadiums see Noll
 and Zimbalist (1997) and Delaney and Eckstein (2004).

3. For example, using the "economic substitution" argument against stadium sub-
 sidies, economist Alan Krueger (2002) opposed a 2001 plan by Mayor Giuliani
 to issue municipal bonds to fund half the cost of new stadiums for the Yankees
 and Mets to be built at their existing New York locations, on the grounds that
 "although a new stadium may entice more fans to come to the ballpark, the
 extra money they spend there is typically offset because they spend less else-
 where—they attend fewer movies or concerts. . . . The total budget devoted to
 leisure activities is fairly inflexible, so the rest of the city suffers."

4. The other $300 million of the city/state contribution would not be needed, since
 that would have been for the stadium's retractable roof, but under Cablevision's
 proposal there would be no stadium.

5. For example, Richard Ravitch and other critics complained about Related's pro-
 posal, pointing out that the MTA needed, but would not now get, an immediate
 large cash infusion (as the Jets would have provided).

6. See also *New York Times* 2004a, 2004b, 2004c.

7. Bruno said he would reconsider his abstention if the Olympic Games were
 awarded to New York.

8. The fourteen votes on the MTA board are cast by six representatives of the gov-
 ernor; four representatives of New York City's mayor; one representative each

from Nassau, Suffolk, and Westchester Counties; and four representatives of Dutchess, Orange, Putnam, and Rockland Counties who share one vote.

Responding to criticism that $250 million was too low, the MTA commissioned an appraisal, which valued the entire railyards site (Western and Eastern) at $923 million for 6.8 million square feet of development rights. Since the proposed stadium would occupy only the 2 million square feet on the Western Yards, the appraisers subtracted just under $600 million, producing a value, according to the MTA, of $330 million. The Jets appraiser came up with a price tag for the property of roughly $37 million—the presumed worth of the site minus the just under $300 million cost of building a platform over the railyards. So the Jets argued that their $250 million offer was a bonanza for the MTA, especially since without the platform, which the MTA could not afford to build, the property was worthless. Opponents, on the other hand, questioned why the Jets would receive credit for building the platform, considering that it would be paid for by the city and state ($600 million for it and a retractable roof for the stadium).

9. Joseph L. Bruno, the senate majority leader, also declined to support the project, saying he had not been given enough information about it. He tried, but failed, to win support for a plan to authorize the stadium only if the city won its bid for the Olympics.

CHAPTER SEVEN

1. For the final version of the Department of City Planning's Hudson Yards rezoning application that passed ULURP see http://www.nyc.gov/html/dcp/pdf/cpc/040500A.pdf.

2. For the final version of the Department of City Planning's Western Yards application that passed ULURP see http://www.nyc.gov/html/dcp/pdf/cpc/030133.pdf.

3. The ULURP process was formally approved on November 4, 1975, when the city's voters ratified a new city charter, section 197-c of which stated that "applications by any person or agency respecting the use, development, or improvement of real property subject to city regulation shall be reviewed pursuant to a uniform review procedure."

4. Chicago in the 1990s considered setting up some kind of community board structure, but in the end decided not to (not even with only advisory powers) on the grounds that community boards would reinforce and worsen the already highly exclusionary (on ethnic and racial grounds) character of Chicago's local neighborhoods.

5. As Dear writes, a series of acronyms has sprung up to take account of the proliferation of exclusionary sentiments—NOOS (for not on our street), LULU (locally unwanted land uses), NOPE (not on planet earth), CAVE (citizens against virtually everything), and NIMTOO (not in my term of office), the latter reflecting a perceived connection between politicians' behavior and citizens' movements. Community opposition gave rise in the 1970s to a new class of lawsuits, termed SLAPPs, or strategic lawsuits against public participation, which developers

used to discourage opposition; they have lost the vast majority of them. For another interesting discussion of the issues see Leo (1997).

Still, the NYSCC debate discussed in chapter 6 shows how complex nimby disputes can be in practice. One central problem throughout was that the data in this case (as in many such disputes) are quite complex . For example, a crucial document was the fifteen-volume Hudson Yards DEIS. Few people have the time to examine such a work, leaving the process of summarizing the data and presenting it to the public in the hands of leaders who might or might not do so responsibly. A second problem was how, in a highly complex project like the Hudson Yards, to distinguish, and to make it clear to the affected parties, which "transfer payments" were designed to compensate for which parts of the overall project (e.g., which were for the rezoning and its various components, which for the NYSCC, which for the Javits expansion.) A third problem was the need not only to make compensatory transfer payments that could be justified as fair, but also to come up with tangible benefits that were just part of the horse-trading needed to move a project through the political process, which could not really be justified as fair. A fourth problem was just plain disagreement about how valuable, as a goal, was the part of the NYSCC that involved a football stadium and New York hosting the Olympic Games.

6. In February 2009 the DCP decided to allow affordable units created through the Inclusionary Housing program to be either for-sale or rental units. Previously, only affordable rentals were created through this program. This would apply in all areas where Inclusionary Housing applies regardless of whether the area is governed by the old or new regulations. In keeping with the Inclusionary Housing Program's guiding principle of permanent affordability, the resale price of homeownership units would be restricted for the life of the bonused development. One goal was to increase the participation of condo and co-op developers in the Inclusionary Housing Program. DCP Commissioner Amanda Burden commented: "Home ownership is an important stabilizing force in a community, and we will be offering new opportunities for New Yorkers who want to invest in their neighborhoods to earn a safe and significant return at an affordable price. Not only will these changes provide a significant route to stable, affordable home ownership at a critical time but it will encourage broader participation in the Inclusionary Housing program" (DCP_ Press release).

7. Author interview, October 17, 2011.

8. For example, the city (the deputy mayor for economic development), business (e.g., Kathryn Wylde, president of Partnership for New York City and the Chamber of Commerce), and academia (e.g., Mitchell Moss of NYU's Urban Research Center). For a detailed account of the background to the rezoning, including lengthy discussions between the DCP and Community Board 4, see Brash (2011, chaps. 6–8).

9. Though the area was currently mostly zoned as manufacturing, not commercial, it already included a few commercial sections, especially along 43rd Street linking to Times Square.

10. "Hudson Yards Overview," New York City Department of City Planning, http:// www.nyc.gov/html/dcp/html/hyards/hymain.shtml.

11. The following pages draw heavily on the IBO report.

12. Personal interview, December 2004. Likewise Brash (2011, 169) observed that CB4's basic support for the rezoning was partly "political calculation in order to avoid appearing overly obstructionist. . . . While not averse to taking political stands when necessary, CB4's leaders tended toward engagement and compromise."

13. The plan projected that, of the affordable units created or preserved, 68 percent would be affordable to those earning less than 80 percent of Area Median Income (AMI), 11 percent were to be for households earning between 80 percent and 120 percent of AMI (up to $85,080 for a family of four), and the remaining 21 percent would be reserved for middle-income households earning up to 250 percent of AMI (NYC 2009).

14. "Low-income households" were defined as those whose incomes were 80 percent of an "income index," which itself was defined as twice a "very low income index" that HUD created. "Moderate-income households" earned 125 percent of the "income index." "Middle-income households" earned no more than 175 percent of the "income index." The details are, of course, complicated. See NYC (2005, esp. 29–32) and NYC (2011, chap. 3). Note that the above definitions of the income level categories differ slightly from those for the off-site affordable housing units on the three special sites discussed in the text.

15. Reviewing the area in 2010, Jake Mooney wrote in the *New York Times*: "At the corner of 10th Avenue and 33rd Street, opposite the high concrete barrier that surrounds the railyards, it is just possible to imagine what the far West Side of Midtown Manhattan looked like not long ago. There are parking lots and parking garages, a McDonald's, and a boarded-up Irish pub, and not much else. Car traffic is heavy, and foot traffic is sparse. Michael Roth owned a garage a few blocks south in the late 1970s. 'During those days,' he recalled recently, 'all you had was prostitutes, pimps, drug dealing like you've never seen before. It was a horrible place to be.' A cluster of high-rise rental and condominium buildings has sprouted in recent years, and more are planned" (Mooney 2010).

16. See City Planning Commission, Exhibit B "Western Rail Yard: Restrictive Declaration for the Western Rail Yard to be recorded in accordance with Section 93-06 of the NYC Zoning Resolution," January 2005.

17. City officials also promised Related that they would set aside a $500 million contingency fund to cover cost overruns on the subway project.

A version of Related's plan proposed two months earlier had News Corporation as its anchor tenant in the tower on the eastern part of the site, and able to use the mall/plaza for advertising, video projections, and outdoor films and concerts. But as the general financial crisis worsened News Corporation dropped out. So News Corporation's mall/plaza now became a civic plaza, pleasing Ouroussoff, who had complained that the ability of News Corporation to use the public space for movies and ads would turn the space into a corporate platform.

18. Related did pay $11 million in fees right away and then an $18.8 million down payment later in the year, as well as several millions in future architectural and engineering fees.

CHAPTER EIGHT

1. Unless noted otherwise, all quotations are from a series of interviews by the authors between 2000 and 2013.

2. See the Moynihan Station Development Project, Environmental Assessment, by AKRF, Inc. (2010).

3. This section also draws on interviews with HOK architect Kenneth Drucker; Fred Papert, president of the 42nd Street Development Corporation and a former president of the Municipal Arts Society; Peg Breen of the Landmarks Conservancy; and Raju Mann of the Municipal Art Society.

4. Advocates (who included New Jersey's Democratic US senator Frank Lautenberg) for the proposed Hudson River commuter train tunnel, which would add a second pair of tracks between New Jersey and Manhattan, said it would reduce traffic congestion and pollution, shorten commuting times, increase suburban property values and create six thousand construction jobs. Before Christie became governor in January, the state's elected officials had already lined up $6 billion for the project from agencies outside the state. The Federal Transit Administration, in the single largest investment it had ever made in a transit project, had agreed to match $3 billion that the Port Authority had pledged to spend on the tunnel. As proposed, the new tunnel would take trains from throughout northern New Jersey to a station more than 100 feet below street level at the foot of Macy's store on 34th Street. Those tracks would not connect to Pennsylvania Station, a block away (McGeehan 2010). Later, in April 2012, a report by the Government Accountability Office said Christie had deliberately misstated official project costs, which set a maximum of $10 billion, not $11–14 billion as Christie had stated. The report also found that Christie had misstated New Jersey's contribution to the whole project as 70 percent, whereas it would have been 14.4 percent. Christie's critics charged that his main motive had been to divert $4 billion of state funds from the tunnel to the state's near-bankrupt transportation trust fund, traditionally financed by the gasoline tax which Christie had made a campaign pledge not to raise (McGeehan 2010; Zernike 2012).

5. Part 1 included expanding the passageway below 33rd Street between Penn Station and Farley's west-end concourse, providing access to subways and the new New Jersey Transit station, and creating two additional entrances into the Farley Building on Eighth Avenue.

6. Http://www.mirror.co.uk/news/uk-news/kings-cross-fire-read-archive-1425370.

7. How do the "blocking factors" outlined here relate to the ingredients for a project's success that urban planners have discussed? Alexander Garvin's comprehensive prescription for reforming urban planning to avoid its numerous past mistakes stresses that any public project, to succeed, must facilitate a private market reaction that produces beneficial results. To this end, he redefines "planning" as "public action that generates a sustained and widespread private market reaction, which improves the quality of life of the affected community, thereby making it more attractive, convenient, and environmentally healthy." He stresses the following six ingredients needed for producing this desirable

outcome: market (i.e., sufficient demand), location, design, financing, entrepeneurship and time (Garvin 2002, chaps. 1 and 2).

The blocking factors we have identified in our discussion of Far West Side megaprojects are consistent with Garvin's list. But several stress different aspects of the problem, in particular aspects associated with achieving the "public action" in the first place. These include, as mentioned, squabbling government agencies, fighting between politicians, corruption, and the danger of hooking a public-private partnership to a specifically troublesome private partner. Most of the difference between Garvin's success ingredients and our noted blocking factors is explained because the "blocking factors" we have stressed account for the failure of the public project to even start, as well as its subsequent failures.

CHAPTER NINE

1. Unless noted otherwise, all quotations are from a series of interviews by the authors between 2000 and 2013.
2. "East Village" was a term especially popularized by real estate brokers and newcomers and was designed to benefit from the West Village's cachet. In its June 5, 1967, edition the *New York Times* informed readers that the area had come to be known as the East Village.
3. The demolition of the 2nd Avenue El left only the 3rd Avenue El, intended to stay in use until the 2nd Avenue subway was built to replace it. However, government bureaucracy and pressure from private developers eager to redevelop 3rd Avenue forced the closure of the El prematurely with no adequate subway replacement, leaving residents on the East Side of Manhattan with the overcrowded IRT Lexington Avenue Line as the only subway east of Fifth Avenue.
4. Later, the two married and began the Woodward Gallery in SoHo, which moved to the LES on Eldridge Street in 2007.
5. It has been argued that such buildings have returned to the once-discredited, tall, glass and steel blocks of Modernism, but modulated, even disguised, with various devices such as off-axis boxes and tilted towers. Hence the term *Neomodernistic*.
6. Discussing the decision, she said: "Third Ave began its long down slide when they built the El. For years no one wanted to see the Bowery. Then we saw the East Village developing, and this strip. Artists, as usual, were developing an area. We still looked all over the city, including Chelsea, but after 9/11 we realized we were a downtown place. So we decided to stay downtown and come here."
7. These included Cuchifritos, Fusion, and the Abrons Art Center in the Henry Street settlement.
8. For example, RxArt in 2008 paid $2,500 a month for 500 square feet, with a five-year lease, i.e., $60 per square foot per year.
9. Having bet on the LES, Ron Segev offered his analysis of the changed structure of the art gallery world in New York, with his core idea that an ambitious gallery no longer needed to move to Chelsea to make it. "Before, Chelsea absorbed everything. You had to move to Chelsea to get visibility. Then it got oversaturated.

Now it's 'big bang,' dispersal. In addition to the LES, galleries are opening in NoLita (North of Little Italy). And there's movement in another neighborhood, below Chelsea and the meat market district. Some very good galleries are going there, with bigger spaces. And now SoHo could merge with the LES. And although the last big move was galleries from Williamsburg to Chelsea, there are still some galleries in Williamsburg. Chelsea will stay, just like there are still galleries on 57th [the center of Contemporary Art before SoHo], but a number of galleries will move."

10. Two of the three LES galleries in the sample that owned their spaces were in the hands of older, more established people. For example, the owner of FusionArts Museum bought the building on Stanton Street back in 1985 when this was "the Wild West" section of the LES and he was an artist living on the second floor and paying rent. Faced with a landlord who wished to sell the building and evict him, he purchased the building from the landlord instead. A second LES gallery that owned its space was the Woodward Gallery. This was an established SoHo gallery with resources, and, now in their late forties or older, the Woodwards were not envisaging another move.

11. Organization theory throws light on this apparent paradox, as discussed in chapter 2.

12. Studies have shown that these kinds of local contexts in social flux involving both older (more established) and more recent groups are key generators of artistic and cultural disputes in the United States, though a politician needs to latch on to them if they are to become major public issues.

13. The owner acknowledged that his goal—attention for the gallery—was different from the artist's, a fireman, Jeff Campion, who had produced the work at a time when he deliberately wanted to express his anger at women.

14. The gulf between the curatorial and market approaches should not be exaggerated. For example, experts' selections of which works to show are likely to be influenced, at least sometimes, by their knowledge of which works and artists sell well and are liked by the public. Further, the kinds of works that sell well are often at least somewhat influenced by what the experts (critics, museum curators) have foregrounded in shows and praised in reviews.

15. Curator Massimiliano Gioni wrote: "Land Art is simply colossal and measures its duration according to geological time. It competes with Stonehenge and the pyramids . . . on the ageless dimension." Installation art he dismissed as . . . "creating experiences imbued with the same grandiosity associated with monumental sculpture." Even Minimalism, he argued, was monumental because it was intended to last and "to attain a sense of timelessness" (Hoptman et al. 2007).

16. Even so, the work generated no outside media controversy or attack from a politician. Shown in a large building by entrance fee only, it was suitably separated from the neighborhood. Also, the New Museum had the resources to take some risk, although it was not immune, since, as an institution receiving public grants, it might have been attacked had a politician seen any advantage in doing so. New York's cultural institutions are certainly aware of a history in the United States of politicians attacking controversial works displayed by public institutions that received public funds (including Mayor Giuliani's attempt to

cut public funding from the Brooklyn Museum for showing the Virgin Mary with elephant dung breasts).

17. The only example was Wangechi Mutu's environmental landscape, *Perhaps the Moon Will Save Us*.

CHAPTER TEN

1. For example the Greenwich Village Society for Historic Preservation successfully proposed or supported the Gansevoort Market Historic District (2003), the Greenwich Village Historic District Extension (2006), and the Far West Village Rezoning (2010).

2. Glaeser (2011a) showed that in Manhattan from 1980 to 2002, prices each year rose $6,000 more in historic districts than outside them. See also Glaeser (2011b).

3. Sharon Zukin's *Naked City* (2010) faces a similar issue. Zukin, one of New York's most distinguished urban critics, organizes her book around two different concepts of "authenticity." One concept, which she argues has become increasingly common but which she criticizes as a hopelessly contradictory mixture of old and new, would include for example Pastis restaurant, historically themed as a 1930s Paris bistro, and doubtless the High Line redesigned with Modernist benches and set in the context of new condos. The second concept, which she values but argues is on the wane, is what she calls the truly "authentic city" whose core is the "cultural vitality of its streets and the everyday lives of the men and women who work in small shops and diners, drive taxis, and clean offices." She writes that today this city is "less permanent and less authentic," as "cities have become sites of massive redevelopment, with bulldozers tearing down old buildings so other big machines can lay new foundations." "Too many favorite landmarks had disappeared, replaced by faceless towers. One neighborhood after another had lost its small scale and local identity. People who had been in place for what seemed like forever—tenement dwellers, mom and pop store owners, whole populations of artists and people of color—were suddenly gone. In their place we found gentrifiers, cocktail bars, Starbucks, and H&M. Though realists dismissed these complaints as blatant nostalgia and pointed out that cities are constantly changing, cynics, who are often the most idealistic city lovers, insisted that New York was no longer 'authentic.' The city, they said, had lost its soul. I am one of those New Yorkers."

"Authenticity" is, for Zukin, "a cultural right to make a permanent home in the city for all people to live and work." It is "the right to inhabit a space, not just to consume it as an experience . . . the expectation that neighbors and buildings that are here today will be here tomorrow." Zukin also complains that the City Planning Commission tends to approve big new development projects supported by the mayor.

The difficulty with this view, as with Brash's, is that it does not explain how, without projects that create jobs, the working-class people and small stores that give the city it's real "authenticity" will find or keep employment or where the city will find tax revenue for the services that provide "a comfortable life to those not wealthy, well credentialed, or ambitious." Nor does the view explain how, without creating some new and taller buildings, newcomers to the city

will find places to live, given the (admirable) goal of protecting the right to live there of all existing residents. Certainly, achieving a balance of creating jobs and protecting the vulnerable is difficult, but opposing even well-conceived major projects that create jobs does not seem a viable way of achieving either goal.

Artist Martha Rosler (2010, 2011a, 2011b), in a comprehensive discussion of the role of art and culture in today's city, shares several of Zukin's concerns, but, unlike Zukin or Brash, is not against urban growth, instead praising UK urbanist Max Nathan, who writes that cities should be "growing the economic base; sharpening skills, connectivity and access to markets; ensuring local people can access new opportunities; and improving key public services."

4. For examples of Amanda Burden's claim to be implementing the spirit of Jane Jacobs, see Brash (2011, 182–83). Brash argues that Burden's claim was misleading, stating that "Jacobs's model of vital urbanism was the West Village, not midtown Manhattan." For reasons stated in the introduction, we believe Burden's interpretation of Jacobs is reasonable.

5. By 2012 some analysts (e.g., Szántó 2012) were speculating that the "overproduction" might become a general problem in the art world, not just confined to upper-floor galleries and their artists.

6. What constitutes an appropriate definition of *globalization* does vary with the field being discussed. For example, discussions of finance tend to stress "interdependence," for obvious reasons, given the recent financial crisis. An urban theorist who stresses interdependence is Neil Brenner, who defines globalization as "spatial expansion of 'social interdependencies' on a world wide scale" (Brenner 2004).

7. Harvey Molotch (2005, 112–113) comments: "In Britain, the heritage industry has become one of the country's economic mainstays, involving visits to stately homes and affection for associated goods. Based on imaginings of pastoral gentility, these goods and services do not 'bring back' the past, which includes suffering and tedium as well as tea parties. . . . In the United States, nostalgia helps 'rebuild' old city neighborhoods but in ways that their earlier inhabitants would likely not recognize. Early colonial town buildings, for example, commonly had advertisements written across their brick facades at every level, something not usually tolerated by later preservationists." An excellent, balanced account of urban preservation worldwide is Anthony Tung (2001). An incisive account of some of the issues in art history is Brilliant (2011). Brilliant uses the concept of "spoliation" to refer to the deliberate placing of older artworks in contemporary contexts.

8. On the diversion of the PA during this period see Doig et al. (2013).

REFERENCE LIST

Abu-Lughod, Janet. 1994. *From Urban Village to East Village: The Battle for New York's Lower East Side.* Cambridge, MA: Blackwell.

Agamben, Giorgio. 2009. "What Is the Contemporary?" In *"What Is an Apparatus?" and Other Essays.* Stanford, CA: Stanford University Press.

AKRF, Inc. 2010. Moynihan Station Development Project, Environmental Assessment. Washington, DC. GPO. New York.

Altshuler, Alan, and David Luberoff. 2003. *Mega-Projects: The Changing Politics of Urban Public Investment.* Washington DC: Brookings Institution Press.

Amateau, Albert. 2006. "Dia High Line Runs Out of Steam; Whitney Now on Track?" *Villager,* November 1–7.

———. 2008. "Meat Market Icon Florent Tries to Avoid Marie's Fate." *Villager,* February 13–19.

Anderson, David, ed. 2011. *Handbook of Creative Cities.* Northampton: Edward Elgar.

Anderson, Lincoln. 2004. "Meat Market Gone Wild Raises Mention of 'R' Word." *Villager,* July 14–20.

Andrews, Malcolm. 1999. *Landscape and Western Art.* New York: Oxford University Press.

Anheier, H. K. 2005. *Nonprofit Organizations: Theory, Management, Policy.* New York: Routledge.

Anheier, Helmut, and Yudhishthir Raj Isar, eds. 2012. *Cultural Policy and Governance in a New Metropolitan Age: The Cultures and Globalization Series.* Vol. 5. Thousand Oaks, CA: Sage.

Aranda, Julieta, Brian Kuan Wood, and Anton Vidokle. 2010. *What Is Contemporary Art?* New York: E-Flux–Sternberg Press.

Artprice. *Contemporary Art Market: The Artprice Annual Report.* 2008–2009, 2011–2012, 2013, 2014. Www.artprice.com.

ASCE. 2013. *Report Card for America's Infrastructure.* Www.infrastructurereportcard.org.

Atlas, James. 2012. "Don't Show Me the Money." *New York Times,* September 16.

Bagli, Charles. 2007. "$4 Billion Price on Bigger Plan for Expansion of Javits Center." *New York Times,* June 22.

———. 2008a. "New York Settles on Far More Modest Expansion of Javits Convention Center." *New York Times,* January 19.

———. 2008b. "West Side Redevelopment Plans in Disarray." *New York Times*, April 14.

———. 2010. "A Fight on New York's Skyline." *New York Times*, August 23.

———. 2012. "Convention Experts Assail Plan to Close Javits Center." *New York Times*, February 21.

Bagli, Charles, and Michael Cooper. 2005. "Olympic Bid Hurt as New York Fails in West Side Stadium Quest." *New York Times*, June 7.

Baim, Dean. 1994. *The Sports Stadium as a Municipal Investment*. Westport, CT: Greenwood Press.

Ballon, Hilary, and Kenneth Jackson, eds., 2008. *Robert Moses and the Modern City*. New York: Norton.

Barbanel, Josh. 2011. "After 37 Years, Gotham West Site Is Rising." *Wall Street Journal*, October 24.

Baudrillard, Jean. 2004. "Hypermarket and Hypercommodity" and "The Beaubourg Effect." In *Simulacra and Simulation*. Ann Arbor: University of Michigan Press.

Bauer, Raymond, and Alice Bauer. 1960. "America, 'Mass Society' and Mass Media." *Journal of Social Issues* 16 (3): 3–66.

Baumol, William. 1986. "Unnatural Value, or Art Investment as a Floating Crap Game." *American Economic Review* 76, no. 2 (May): 10–14.

Beauregard, Robert. 2010. "Planning for Growth *and* Shrinkage: Redevelopment Policy in the United States." Paper.

Beisel, Nicola. 1990. "Class, Culture and Campaigns against Vice in Three American Cities, 1872–1892." *American Sociological Review* 55: 44–62.

Bernstein, Roslyn, and Shael Shapiro. 2010. *Illegal Living: 80 Wooster Street and the Evolution of SoHo*. New York: Jonas Mekas Foundation.

Beveridge, Andrew, and Beveridge, Sydney. "The Big Picture." In Halle and Beveridge 2013.

Billard, Mary. 2013. "When Just Being Alive Was Beyond Belief." *New York Times*, July 11.

Boburg, Shawn, and John Reitmeyer. 2012. "Dozens of Port Authority Jobs Go to Christie Loyalists." *Record*, January 28.

Brash, Julian. 2011. *Bloomberg's New York*. Atlanta: University of Georgia Press.

Brenner, Neil. 2004. *New State Spaces*. New York: Oxford University Press.

Brilliant, Richard. 2006. *Group Dynamics: Family Portraits & Scenes of Everyday Life at the New-York Historical Society*. New York: New Press.

———. 2011. "Authenticity and Alienation." In *Reuse Value: Spolia and Appropriation in Art and Architecture, from Constantine to Sherrie Levine*, edited by Richard Brilliant and Dale Kinney. Ashgate: Aldershot.

Bumiller, Elisabeth. 2000. "Mayor Renews Call for Arena, with Pataki's Backing." *New York Times*, September 21.

Campanile, Carl. 2010. "Reformers' Secret Weapon." *New York Post*, May 5.

Capgemini and Merrill Lynch. 2010. "World Wealth Report." Http://www.capgemini.com/resources/world-wealth-report-2010.

Cassidy, J. 2005. "Bloomberg's Game." *New Yorker*, April 4.

Caves, Richard. 2000. *Creative Industries: Contacts between Art and Commerce*. Cambridge, MA: Harvard University Press.

Chakrabarti, Vishaan. 2013. *A Country of Cities: A Manifesto for an Urban America.* New York: Metropolis Books

Chan, Sewell, and Ray Rivera. 2007. "Property Values in New York Show Vibrancy." *New York Times*, Jan. 13.

Chodorow, Nancy. 1978. *The Reproduction of Mothering.* Berkeley: University of California Press.

Chuang, Joshua. 2012. "Robert Adams' Retrospective Goes West." *Time Magazine*, March 9.

Clark, Gordon. 1984. *Innovation Diffusion: Contemporary Geographical Approaches.* Norwich, UK: Geo Books.

Clark, Kenneth. 1949. *Landscape into Art.* New York: Harper and Row.

———. [1959] 1973. *The Nude: A Study of Ideal Art.* London: John Murray.

Cohan, James, and Josh Baer. 2011. "The Future of the Physical Gallery in the Digital and Global Age." Art Basel Talk, Miami Beach, June 15.

Cohen, Stefanie, and Jennifer Maloney. 2013. "New Chief Envisions Performances on High Line." *Wall Street Journal*, October 18.

Collins, Randall. 1979. *The Credential Society: An Historical Sociology of Education and Stratification.* New York: Academic Press.

———. [1987] 2004. "Interaction Ritual Chain, Power and Property: The Micro-Macro Connection as an Empirically Based Theoretical Problem." In *The Micro-Macro Link*, edited by Jeffrey C. Alexander et al. Berkeley: University of California Press.

Crain's. 2011. "The Future of New York City." Conference, New York City, July 19.

Crane, Diana. 1987. *The Transformation of the Avant-Garde.* Chicago: University of Chicago Press.

Crow, Kelly. 2013. "The Attack of the Giant Art Galleries." *Wall Street Journal*, August 30.

Danto, Arthur. 1997. *After the End of Art: Contemporary Art and the Pale of History.* Princeton: Princeton University Press.

David, Josh, and Robert Hammond. 2011. *High Line: The Inside Story of New York City's Park in the Sky.* New York: Farrar, Straus and Giroux.

Davidson, Justin. 2008. "The Glass Stampede." *New York Magazine*, September 7.

———. 2012. "From 0 to 12 Million Square Feet." *New York Magazine*, October 7.

Dear, Michael. 1992. "Understanding and Overcoming the NIMBY Syndrome (Not-in-My-Backyard)." *Journal of the American Planning Association* 58, no. 3 (Summer): 288.

del Cerro Santamaría, Gerardo, ed. 2013. *Urban Mega Projects.* Bingley, UK: Emerald Group.

Delaney, Kevin, and Rick Eckstein. 2004. *Public Dollars and Private Stadiums: The Battle over Building Sports Stadiums.* New Brunswick, NJ: Rutgers University Press.

Dewan, Shaila. 2001. "After Blood and Cuts, Seeking Landmark Glory: Many Residents Aim to Save Meatpackers along with Neighborhood's Gritty Charm." *New York Times*, June 4.

Dewey, John. [1934] 1980. *Art as Experience.* New York: Perigree.

DiMaggio, Paul. 1987. "Classification in Art." *American Sociological Review* 52 (August): 440–55.

DiMaggio, Paul, Lynn Robinson, Brian Steensland, and Wendy Cadge. 1999. "Public

Conflict over the Arts: A Case Study of the Philadelphia Area, 1965–1997." Los Angeles: American Sociological Association.

Doig, Jameson W., Steven P. Erie, and Scott A. MacKenzie. 2013. "America's Leading International Trade Centers and Their Entrepreneurial Agencies: Challenges and Strategies in the New York and Los Angeles Regions." In Halle and Beveridge 2013.

Douglas, Sarah. 2008. "Restless in LA." *Intelligent Life*, Spring.

Dreishpoon, Douglas. 2013. "Creativity and Commerce." *Art in America*, May 1.

Dubin, Steven. 1995. *Arresting Images: Impolitic Art and Uncivil Actions*. New York: Routledge.

Dulchin, Benjamin, Moses Gates, and Barika Williams. 2013. "Housing Policy for a Strong and Equitable City." In John Mollenkopf, ed., *Toward a 21st Century for All*. New York: Graduate Center, City University of New York.

Dunlap, David. 1998. "Lost Colossus Draws Closer to Resurrection." *New York Times*, February 9.

———. 2005. "The Sky Is No Longer the Limit on Far West Side Buildings." *New York Times*, January 13.

Edgecliffe-Johnson, Andrew. 2007. "Saatchi Online Sales Top $130m." *Financial Times*, October 11.

Edwards, Owen. 2010. "Bill Owens Was Seeking a Fresh Take on Suburban Life When He Spotted a Plastic-Rifle-Toting Boy Named Richie Ferguson." *Smithsonian*, October.

Ehrenfeucht, Renia. 2004. "Megaprojects and Risk: A Conversation with Bent Flyberg." *Critical Planning* (Summer): 53.

Ehrenreich, Barbara. 1983. *The Hearts of Men*. New York: Anchor Books.

Elberse, Anita. 2013. *Blockbusters*. New York: Henry Holt.

Elberse, Anita, Ryan Barlow, and Sheldon Wong. 2009. "Marquee: The Business of Night Life." *Harvard Business School Case 509-019*, February.

Ellen, Ingrid Gould, and Brendan O'Flaherty. 2013. "How New York and Los Angeles Housing Policies Are Different—and Maybe Why." In Halle and Beveridge 2013.

Engquist, Eric. 2009. "No Lie: Javits Center Redo Finally Good to Go." *Crain's*, July 2.

Epstein, Cynthia, Carroll Seron, Bonnie Oglensky, and Robert Saute. 1999. *The Part-Time Paradox*. New York: Routledge.

Esman, Abigail. 2012. "VIP Artfair Bombs Again: A Lesson in Art Marketing and Online Sales." *Forbes*, February 14.

Faith, Nicholas. 1985. *Sold: The Revolution in the Art Market*. London: Hamish Hamilton.

Farago, Jason. 2013. "The Armory Show Turns One Hundred." Www.grandlifehotels .com/culture/the-armory-show-turns-one-hundred.

Fasche, Melanie. 2013. "Making Art History." In *Geographies of the Super-Rich*, edited by Iain Hay, 171–85. Cheltenham: Edward Elgar.

Ferber, Linda. 2009. *The Hudson River School*. New York: Rizzoli.

Fisher, Jean. 2005. "The Syncretic Turn: Cross-Cultural Practices in the Age of Multiculturalism." In *Theory in Contemporary Art since 1985*, edited by Zoya Kocur and Simon Leung. Cambridge, MA: Blackwell.

Florida, Richard. 2002. *The Rise of the Creative Class*. New York: Basic Books.

———. 2011. *The Great Reset*. New York: Harper.

Frith, Simon. 1981. *Sound Effects: Youth, Leisure and the Politics of Rock 'n' Roll*. New York: Pantheon.

Fry, Roger. 1924. "Essay in Aesthetics." In *Vision and Design*. London: Chatto and Windus.

———. 1926. *Transformations: Critical and Speculative Essays on Art*. London: Chatto and Windus.

———. 1939. *Last Lectures*. Cambridge: Cambridge University Press.

Fung, Amanda. 2011. "Hallelujah! Jehovah's Witnesses' Land Sell-Off Has Brooklyn Dreaming Big." *Crain's*, October 16.

Gans, Herbert. 1974. *Popular Culture and High Culture: An Analysis and Evaluation of Taste*. New York: Basic Books.

———. 1982. *Levittowners: Ways of Life and Politics in a New Suburban Community*. New York: Columbia University Press.

Gardner, James. 2005. "Not Everything Old Is Beautiful." *Sun*, December 13. Http:// www.nysun.com/article/24360.

Garrett, Craig. 2004. "Artists: Nigel Cooke." *Flash Art*, May–June.

Garvin, Alexander. 2002. *The American City: What Works and What Doesn't*. 2nd ed. New York: McGraw Hill.

———. 2013. *The Planning Game*. New York: Norton.

Geertz, Clifford. 1983. *Local Knowledge*. New York: Basic Books.

Gerson, Kathleen. 2009. *The Unfinished Revolution: How a New Generation Is Reshaping Family, Work, and Gender in America*. New York: Oxford University Press.

Gerstel, Naomi, and Natalia Sarkisian. 2006. "Marriage: The Good, the Bad, and the Greedy." *Contexts* 4, no. 5 (November): 16–21.

Getty Research Institute. 2004. *The Business of Art: Evidence from the Art Market*. Los Angeles: Getty Research Institute.

Gladstone, David, and Susan Fainstein. "New York and Los Angeles Economies from Boom to Crisis." In Halle and Beveridge 2013.

Glaeser, Edward. 2011a. "How Skyscrapers Can Save the City." *Atlantic*, March.

———. 2011b. *Triumph of the City: How Our Greatest Invention Makes Us Richer, Smarter, Greener, Healthier and Happier*. New York: Penguin Press.

Glass, Ruth. 1964. "Introduction: Aspects of Change." In *London: Aspects of Change*, edited by Centre for Urban Studies. London: MacKibbon and Kee.

Gomez, Edward. 2002. "If Art Is a Commodity, Shopping Can Be an Art." *New York Times*, December 8.

Gonzalez, Juan. 2012. "Your Tax Dollars Pay Hudson Yards' Debt, Thanks to Mayor Bloomberg." *New York Daily News*, December 5.

Gould, Claudia. 2000. "Screwing It On Straight." In *Lisa Yuskavage*. Philadelphia: Institute of Contemporary Art.

Gratz, Roberta. 2010. *The Battle for Gotham: New York in the Shadow of Robert Moses*. New York: Nation Books.

Greenberg, Clement. [1939] 1961. "Avant-Garde and Kitsch." Reprinted in Greenberg, *Art and Culture: Critical Essays*. Boston: Beacon Press.

Grimes, William. 2013. "Art Collections a Click Away." *New York Times*, October 1.

Groys, Boris. 2010. "Comrades of Time." In *What Is Contemporary Art?*, edited by Julieta Aranda, Brian Kuan Wood, and Anton Vidokle. New York: Sternberg Press.

Guilbaut, Serge. 1983. *How New York Stole the Idea of Modern Art: Abstract Expressionism, Freedom, and the Cold War*. Chicago: University of Chicago Press.

Gusfield, Joseph. 1986. *Symbolic Crusade: Status Politics and the American Temperance Movement*. Urbana: University of Illinois Press.

Haacke, Paul. 2010. "Meat Market Memories." *Pin-Up* 8 (Spring).

Haden-Guest. 1996. *True Colors: The Real Life of the Art World*. New York: Atlantic Monthly Press.

Halle, David. 1993. *Inside Culture*. Chicago: University of Chicago Press.

———. 2001. "The Controversy over the Show 'Sensation' at the Brooklyn Museum." In *Unsettling Sensation: Arts-Policy; Lessons from the Brooklyn Museum of Art Controversy*, edited by Lawrence Rothfield. New Brunswick, NJ: Rutgers University Press.

———, ed., 2004. *New York and Los Angeles*. Chicago: University of Chicago Press.

———. 2008. "Who Wears Jane Jacobs's Mantle in Today's New York City?" *Villager*, January 2–8.

Halle, David, and Andrew Beveridge, eds., 2013. *New York and Los Angeles: The Uncertain Future*. New York: Oxford University Press.

Halle, David, and Steve Lang. 2004. "Megaprojects in New York City." *Critical Planning* (Summer): 123–33.

Halle, David, and Louise Mirrer. 2012. "Cultural Policy and Governance in a New Metropolitan Age: New York." In *Cultural Policy and Governance in a New Metropolitan Age*, edited by Helmut Anheier, Yudhishthir Raj Isar, and Michael Hoelscher. Thousand Oaks, CA: Sage.

Halle, David, and Elisabeth Tiso. 2008. "Chelsea Still Center of Art World, but L.E.S. Beckons." *Downtown Express*, January 3.

Halperin, Julia. 2011. "No Nudes, Nu? Orthodox Community Clashes with LES Gallerist over XXX Art." *Artinfo*, March 11.

Havel, Václav. [1979] 1985. "The Power of the Powerless." In *The Power of the Powerless*, edited by John Keane. London: Hutchinson.

Hawthorne, Christopher. 2011a. "Architecture Review: National September 11 Memorial." *Los Angeles Times*, September 11.

———. 2011b. "Critics Notebook: Skyscrapers Remain Powerful Symbol." *Los Angeles Times*, September 4.

———. 2011c. "Architecture Review: HL23 in Manhattan." *Los Angeles Times*, April 4.

Hedlund, Patrick. 2010. "Developer on Track with Low-Cost Units at Rail Yards Site." *Villager*, January 6–10.

Heilbrun, James, and Charles M. Gray. 2001. *The Economics of Art and Culture*. Cambridge: Cambridge University Press.

Herbert, John. 1990. *Inside Christie's*. London: Hodder and Stoughton.

Hermann, Frank. 1980. *Sotheby's: Portrait of an Auction House*. London: Chatto and Windus.

Hertz, Rosanna. 2006. *Single by Chance, Mothers by Choice*. New York: Oxford University Press.

Higgins, Chester. 2013. "Art Collections a Click Away." *New York Times*, September 30.

Holusha, John. 1997. " Commercial Property/West Chelsea; Ex-Garages Attracting Art Galleries from Soho." *New York Times*, October 12.

Hoptman, Laura, Richard Flood, Massimiliano Gioni, and Trevor Smith. 2007. *Unmonumental: The Object in the 21st Century*. New York: Phaidon.

Horkheimer, Max, and Theodor Adorno. [1944] 1972. "The Culture Industry: Enlightenment as Mass Deception." In *Dialectic of Enlightenment*. Translated by John Cummings. New York: Herder and Herder.

Hu, Winnie. 2005. "Miller Vows to Block Plan on Stadium." *New York Times*, February 25.

IBO (Independent Budget Office, New York City). 2004. *Fiscal Brief*.

———. 2005. *The Long-Term Costs and Benefits of the New York Sports and Convention Center*. February.

———. 2007. *City's Fiscal Picture Continues to Brighten*.

———. 2009. *As Economy Weakens, City's Budget Gaps Swell*.

———. 2013a. "Financing Redevelopment on the Far West Side."

———. 2013b. "Is the City Making Way for More Office Space Than Needed over the Next 30 Years?"

Jackson, Kenneth. 2003. "From Rail to Ruin." *New York Times*, November 2.

Jacobs, Jane. 1961. *The Death and Life of Great American Cities*. New York: Random House.

Jacobs, Jerry, and Kathleen Gerson. 2004. *The Time Divide: Work, Family and Gender Inequality*. Cambridge, MA: Harvard University Press.

Jacobs, Mark, and Nancy Weiss Hanrahan. 2005. Introduction to *The Blackwell Companion to the Sociology of Culture*. New York: Blackwell Press.

Jameson, Fredric. 1979. "Reification and Utopia in Mass Culture." *Social Text* 1: 130–48.

———. 1983. "Postmodernism and Consumer Society." In *The Anti-Aesthetic: Essay on Postmodern Culture*, edited by Hal Foster. New York: New Press.

Kavanaugh, Shane. 2013. "The Obstructionist: Andrew Berman Irks Developers and Allies Alike." *Crain's*, February 26.

Kennedy, Randy. 2013. "2 Founders of Dia Sue to Stop Art Auction." *New York Times*, November 7.

Kimmelman, Michael. 2012. "Restore a Gateway to Dignity." *New York Times*, February 8.

———. 2013. "Flexibility and Moxie Can Save West Side." *New York Times*, March 20.

Kinetz, Erika. 2002. "Meat Market: Seeking to Preserve a Gritty Past So It Meshes with the City's Future." *New York Times*, December 8.

Kleiner, Fred. 2009. *Gardner's Art through the Ages*. 2nd ed. Boston, MA: Cengage Learning.

Koolhaas, Rem, and Shohei Shigematsu. 2011. *Cronocaos*. Exhibition, New Museum. May 23–June 5.

Krueger, Alan. 2002. "Take Me Out to the Ballgame, But Don't Make Taxpayers Build the Ballpark." *New York Times*, January 10.

Kusisto, Laura. 2011. "Google Hits Space Bar." *Wall Street Journal*, October 20.

———. 2013. "Mayor of Preservation." *Wall Street Journal*, April 1.

Kuspit, Donald. 2005. "The Contemporary and the Historical." *Artnet*, April 13.

Le Monde. 2010. "À New York, les galeries dépriment et guettent la reprise." January 1.

Leach, Edmund. [1965] 2004. *Political Systems of Highland Burma*. London: Berg Publishers.

Leavis, F. R., and Denys Thompson. 1937. *Culture and Environment*. London: Chatto and Windus.

Lees, Loretta, Tom Slater, and Elvin Wyly. 2008. *Gentrification*. New York: Routledge.

Leo, Christopher. 1997. "City Politics in an Era of Globalization." In *Reconstructing Urban Regime Theory: Regulating Local Government in a Global Economy*, edited by Mickey Lauria. Thousand Oaks, CA: Sage.

Lerner, Lawrence. 2006. "Inclusionary Housing Project Segregates, Advocates Say." *Chelsea Now*, November 24–30.

Lévi-Strauss, Claude. 1966. *The Savage Mind*. Chicago: University of Chicago Press.

Lubow, Arthur. 1999. "The Curse of the Whitney." *New York Times*, April 11.

Lueck, Thomas. 1999. "Up, But Not Running on the West Side." *New York Times*, July 25.

Lukes, Steven. 1977. *Essays in Social Theory*. New York: Columbia University Press.

MacInnis, M. Brendon. 2007. "The New York Art World.com." Special issue, *M Magazine*.

Mainardi, Patricia, ed. 2011. "The Crisis in Art History." Special issue, *Visual Resources* 27, no. 4 (December).

Mann, Michael. 2004. "Globalizations: An Introduction to the Spatial and Structural Networks of Globality." Paper.

———. 2012. *The Sources of Social Power: Volume 4, Globalizations, 1945–2011*. New York: Cambridge University Press.

Martel, Frédéric. 2006. *De la culture en Amérique*. Paris: Gallimard.

Martin, Douglas. 2006. "Jane Jacobs, 89, Who Saw Future in Cities, Is Dead." *New York Times*, April 26.

Mazzucato, Mariana. 2013. *The Entrepreneurial State*. London: Anthem Press.

McGeehan, Patrick. 2010. "Hudson Tunnel Review Raises Fear for Project." *New York Times*, September 19.

Mckinley, Jesse. 2004. "Packed Too Tight in Hipster Heaven." *New York Times*, July 4.

McMullen, Troy. 2008. "Red-Light Gets the Green Light." *Financial Times*, August 9.

Mears, Ashley. 2013. "Staging Conspicuous Consumption for the New Elite." Paper Presented at American Sociological Association, New York, August.

Mele, Christopher. 2000. *Selling the Lower East Side: Culture, Real Estate, and Resistance in New York City*. Minneapolis: University of Minnesota Press.

Miller, Daniel. 1987. *Material Culture and Mass Consumption*. Oxford: Basil Blackwell.

Mitchell, Paul. 1985. *Federal Housing Policy and Programs: Past and Present*. New Brunswick: Rutgers.

Mollenkopf, John, and Raphael J. Sonenshein. 2012. "New York City and Los Angeles: Politics in an Age of Diversity." In Halle and Beveridge 2013.

Molotch, Harvey. 2005. *Where Stuff Comes From*. New York: Routledge.

Molotch, Harvey, and Mark Treskon. 2009. "Changing Art: SoHo, Chelsea and the Dynamic Geography of Galleries in New York City." *International Journal of Urban and Regional Research* 33, no. 2 (June).

Mooney, Jake. 2010. "A Frontier with a View on the Far West Side." *New York Times*, August 27.

Moulin, Raymonde. 1967. *Le marché de la peinture en France.* Paris: Minuit. Translated as *The French Art Market* (New Brunswick, NJ: Rutgers University Press).

Municipal Art Society. 2013. "Next Steps for a New Penn Station." Session organized by Charles Bagli at MAS Summit for New York City conference, New York, October 17–18.

Navigant. 2012. *Phase 1: Interim Report to the Special Committee of the Port Authority of New York and New Jersey.* Http://www.panynj.gov/corporate-information/pdf/Phase-I-Deliverable-Final-with-Gov-Letter.pdf.

Nelson, Steve. 2006. "Diaspora: Multiple Practices, Multiple World Views." In *A Companion to Contemporary Art since 1945,* edited by Amelia Jones. Malden, MA: Blackwell.

New York Times. 2001a. "Mr. Giuliani's Last Opus." January 10.

New York Times. 2001b. "SoHo Galleries Are to Be Apartments." April 13.

New York Times. 2004a. "A Stadium Too Far." Op-Ed. January 26.

New York Times. 2004b. "The Rush to a Stadium." Op-Ed. March 25.

New York Times. 2004c. "Tailgaters Want Jets to Stay or Go to Shea." December 31.

New York Times. 2006. "A Better Javits All Around." May 22.

New York Times. 2010. Nicholas Confessore, "Top Lobbyist Ensnared in Pension Fund Scandal." December 8.

Noll, Roger, and Andrew Zimbalist, eds. 1997. *Sports, Jobs and Taxes: The Economic Impact of Sports Teams and Stadiums.* Washington, DC: Brookings Institution.

Nuir, Gregor. 2009. *Lucky Kunst: The Rise and Fall of Young British Art.* London: Aurum Press.

NYC (Department of City Planning). 2004. "Shadows: Special West Chelsea District Rezoning and High Line Open Space EIS." In *DEIS (The Draft Environmental Impact Statement).* New York.

———. 2005. "Special Hudson Yards District: Zoning Text Amendment as Adopted by City Council." January 19.

———. 2009. *The New Housing Marketplace: Reaching the Halfway Mark.* New York.

———. 2011. "Zoning Resolution: Article II: Residence District Regulations." Chapter 3, "Residential Bulk Regulations in Residence Districts, 23–911: General Definitions." August 12. Http://www.nyc.gov/html/dcp/html/zone/zonetext.shtml.NYC (New York City Department of Housing Preservation and Development).

NYC (Economic Development Corporation). 2013. *A Stronger, More Resilient New York.*

NYC (Housing & Economic Development). 2014. *Housing New York.* New York.

NYC (Industrial Development Agency). 2010. Appendix F, "Tax Exemption Policy for the Hudson Yards UTEP Area." In "First Amendment to Third Amended and Restated Uniform Tax Exemption Policy of the New York City Industrial Development Agency." November 9.

NYC (Landmarks Preservation Commission). 2003. *Gansevoort Market Historic District Designation Report.* New York.

———. 2008. *West Chelsea Historic District Designation Report.* New York.

NYC (Planning Commission). 2013. *Madison Square Garden.* May 22.

Ouroussoff, Nicholas. 2005. "Commission Preserves Past at the Cost of the Future." *New York Times,* May 26.

———. 2006a. "In Javits Expansion, Old Dreams Revisited." *New York Times,* January 31.

———. 2006b. "Outgrowing Jane Jacobs and Her New York." *New York Times*, April 30.

———. 2010. "At the Corner of Grit and Glamour." *New York Times*, March 14.

Owens, Bill. 1973. *Suburbia*. New York: Fotofolio.

Papageorge, Todd. 2002. *Robert Adams*. New Haven: Yale University Press.

Pevsner, Nikolaus. 1978. *The Englishness of English Art*. New York: Penguin Books.

Piketty, Thomas. 2014. *Capital in the Twenty-First Century*. Cambridge: Harvard.

Plattner, Stuart. 1996. *High Art Down Home: An Economic Ethnography of a Local Art Market*. Chicago: University of Chicago Press.

Quartetto. 1984. Exhibition catalogue. Milan: Arnoldo Mondadori Editore.

Quemin, Alain. 2006. "Globalization and Mixing in the Visual Arts: An Empirical Survey of 'High Culture' and Globalization." *International Sociology* (July): 522–50.

———. 2012. "The Internationalization of the Contemporary Art World and Market: The Role of Nationality and Territory in a Supposedly 'Globalized' Sector." In *Sociology of the Art Market*, edited by Maria Lind. Berlin: Sternberg Press.

———. 2013. *Les stars de l'art contemporain*. Paris: CNRS Editions.

———. Forthcoming. "International Art Worlds and Their Art Markets: The Case of the Visual Arts." In *Contemporary Art Worlds and the Challenge of Markets. How Have Art Worlds Reacted to the Market-Based Turn in Society?* Edited by Simo Häyrynen & Erkki Sevänen.

The Real Deal: New York City Real Estate News. 2009. "Glenwood Hopes for a Gem in Hudson Yards." By Steve Cutler. September 30.

———. 2010a. "New Task Force Assembled to Handle St. Vincent's Fate." February 3.

———. 2010b. "Painful as It Seemed, NYC's Bust Only Fourth-Worst in Past Century." By Sarah Ryley. Vol. 8, no. 7 (July 1): 58–59.

Riding, Alan. 2006. "American Culture's French Connection." *New York Times*, December 26.

Roberts, Selena. 2004. "Using Remote Control in Trying to Stop a Stadium." *New York Times*, November 18.

Robinson, Kim, and David Halle. 2010. "Is Bushwick the Next Chelsea?" Paper presented at the Eastern Sociological Society, Boston, March 19.

Rogers, Everett. 2006. *Diffusion of Innovation*. 5th ed. New York: Free Press.

Rosenberg, Bernard, and David White, eds. 1957. *Mass Culture: The Popular Arts in America*. Glencoe, IL: Free Press.

Rosler, Martha. 2010. "Culture Class: Art, Creativity, Urbanism, Part I: Art and Urbanism." *E-Flux* 21 (December).

———. 2011a. "Culture Class: Art, Creativity, Urbanism, Part II: Creativity and Its Discontents." *E-Flux* 23 (March).

———. 2011b. "Culture Class: Art, Creativity, Urbanism, Part III: In the Service of Experience(s)." *E-Flux* 25 (May).

Rothfield, Lawrence, ed. 2001. *Unsettling Sensation: Arts-Policy; Lessons from the Brooklyn Museum of Art Controversy*. New Brunswick, NJ: Rutgers.

Rubenstein, Hal. 2000. "Packing 'Em In." *New York Magazine*, December 4.

Rubinstein, Dana. 2010. "Google Sets Business Focus in Chelsea." *Wall Street Journal*, December 24.

Russeth, Andrew. 2013. "27th Street Galleries, Hit Hard by Sandy, Reopen Shows Jan. 12." *GalleristNY*, January 1.

Saatchi, Charles. 2011. "The Hideousness of the Art World." *Guardian*, December 2.

Sagalyn, Lynne. 2001. *Times Square Roulette: Remaking the City Icon*. Cambridge, MA: MIT Press.

Sandel, Michael J. [1998] 2012. *What Money Can't Buy: The Moral Limits of Markets*. New York: Farrar, Straus and Giroux.

Sassen, Saskia. 2013. *The Global City*. Princeton: Princeton University Press.

Schjeldahl, Peter. 2006. "Temptations of the Fair." *New Yorker*, December 25 and January 1, 2007.

————. 2012. "All Is Fairs." *New Yorker*, May 7.

Schuerman, Matthew. 2005. "High Line High-Rise Surprise." *New York Observer*, September 12.

Schumer, Charles, and Robert Rubin. 2001. *Preparing for the Future: A Commercial Development Strategy for New York City*. New York: Group of 35.

Schwartz, Alex. 2010. *Housing Policy in the United States*. 2nd ed. New York: Routledge.

Scocca, Tom, and Choire Sicha, 2010. "Miracle on 33rd Street." *New York Times*, Op-Ed, November 22.

Sherman, Gabriel. 2003. "Luxury Hotel in Meat Market Has Locals Wielding Cleavers." *New York Observer*, October 5.

Shiller, Robert J. 2008. *The Subprime Solution: How Today's Global Financial Crisis Happened and What to Do about It*. Princeton, NJ: Princeton University Press.

————. 2011. "Housing Bubbles Are Few and Far Between." *New York Times*, February 5.

Sholette, Gregory. 2011. *Dark Matter: Art and Politics in the Age of Enterprise Culture*. New York: Pluto Press.

Siegel, Katy. 2011. *Since '45: America and the Making of Contemporary Art*. London: Reaktion Books.

Silbergeld, Jerome, et al. 2010. *Exhibition Catalog. Outside In: Chinese × American × Contemporary Art*. Princeton, NJ: Princeton University Art Museum.

Simpson, R. Charles. 1981. *Soho: The Artist in the City*. Chicago: University of Chicago Press.

Smith, Neil. 1982. "Gentrification and Uneven Development." *Economic Geography* 58 (2): 139–55.

————. 1996. *The New Urban Frontier: Gentrification and the Revanchist City*. London: Routledge.

Smith, Neil, and Peter Williams, eds. 1986. *Gentrification of the City*. London: Allen and Unwin.

Smith, Roberta. 2004. "Chelsea Enters Its Baroque Period." *New York Times*, November 28.

————. 2013. "Art Is Hard to See through the Clutter of Dollar Signs." *New York Times*, November 14.

Smith, Stephen. 2013. "Related Seeks to Swap College's Tribeca Spread for a Spot in Moynihan Station." *New York Observer*, February 5.

Smith, Terry. 2009. *What Is Contemporary Art?* Chicago: University of Chicago Press.

Stacey, Judith. 1996. *In the Name of the Family: Rethinking Family Values in the Postmodern Age*. Boston: Beacon Press.

Stallabrass, Julian. 2003. *The Online Clash of Culture and Commerce*. London: Tate Publishing.

———. 2004. *Art Incorporated: The Story of Contemporary Art.* Oxford: Oxford University Press.

Steinhauer, Jennifer. 2004. "Bloomberg Sees an Attempt to Influence Mayor's Race." *New York Times*, November 24.

Sternbergh, Adam. 2007. "The High Line: It Brings Good Things to Life." *New York Magazine*, May 7.

Sweeting, George, and Andrea Dinneen. 2013. "New York City and Los Angeles: Taxes, Budgets and Managing the Financial Crisis." In Halle and Beveridge 2013.

Szántó, András. 1996. "Galleries: Transformations in the New York Art World in the 1980s." PhD diss., Columbia University.

———. 2003. "Hot and Cool: Some Contrasts between the Visual Art Worlds of New York and Los Angeles." In Halle, ed. 2004.

———. 2012. "Too Much of a Good Thing." *Artworld Salon*, March 4.

Taylor, Kate. 2011. "Coach Inc. Agrees to Occupy Third of Hudson Yards Tower." *New York Times*, November 1.

Taylor, Marvin, ed. 2006. *The DownTown Book: The New York Art Scene, 1974–1984.* Princeton: Princeton University Press.

Tepper, Steven. 2011. *Not Here, Not Now, Not That! Protest over Art and Culture in America.* Chicago: University of Chicago Press.

Thornton, Sarah. 2008. *Seven Days in the Art World.* New York: Norton.

———. 2010a. "Herr Cragg, Der Sculptor Boss." *Economist*, August 4.

———. 2010b. "Smoked Venison: Can an Auction House Successfully Manage a Living Artist's Primary Market?" *Economist*, June 2.

Topousis, Tom. 2010. "West Side Is Gaining 'Yard'age." *New York Post*, May 31.

Traster, Tina. 2011. "City's New Fashion Capitals: SoHo, Meatpacking District." *Crain's*, March 20.

Tung, Anthony. 2001. *Preserving the World's Great Cities.* New York: Three River Press.

Vatner, Jonathan. 2011. "Manhattan's Tech Start-Ups Settle in the Flatiron District and Chelsea." *New York Times*, April 19.

Velthuis, Olav. 2005. *Talking Prices: Symbolic Meaning of Prices on the Market for Contemporary Art.* Princeton: Princeton University Press.

Vogel, Carol. 2004. "I Like Ur Art: Saatchi Creates an Online Hangout for Art." *New York Times*, December 18.

Wallach, Alan. 2002. "Thomas Cole's 'River in the Catskills' as Antipastoral." *Art Bulletin* 84, no. 2 (June).

White, Harrison, and Cynthia White. 1965. *Canvases and Careers: Institutional Change in the French Painting World.* New York: Wiley.

Wilson, Claire. 2005. "Turning the High Line into . . . the High Life." *New York Times*, December 18.

Winters, Andrew. 2006. "The Far West Side: Tools of Policy." Talk at AIA, New York, May 6.

Wolf, Martin. 2001. "Why We Must Halt the Land Cycle." *Financial Times*, July 8.

Wood, Anthony. 2008. *Preserving New York.* New York: Routledge.

WPA. 1995. *The WPA Guide to New York City: The Federal Writers Project Guide to 1930s New York.* New York: New Press.

Zagat, Tim. 2005. "Convention Wisdom." *New York Sun*, June 12.

Zernike, Kate. 2012. "Report Disputes Christie's Basis for Halting Tunnel." *New York Times*, April 10.

Zolberg, Vera. 2005. "Aesthetic Uncertainty: The New Canon." In *The Blackwell Companion to the Sociology of Culture*, edited by Mark Jacobs and Nancy Weiss Hanrahan. Oxford: Blackwell Press.

Zoning Handbook. 2011. New York: Department of City Planning of New York City.

"Zoning the City Conference: Addressing New York City's 21st Century Challenges." 2011. November 15.

Zucker, Lynne G., and Michael R. Darby. 2006. "Movement of Star Scientists and Engineers and High-Tech Firm Entry." *National Bureau of Economics Research*. Working Paper 12172, October.

Zukin, Sharon. 1982. *Loft Living: Culture and Capital in Urban Change*. New Brunswick, NJ: Rutgers University Press.

———. 2010. *Naked City: The Death and Life of Authentic Urban Places*. New York: Oxford University Press.

INDEX